The Last Days of the Opera

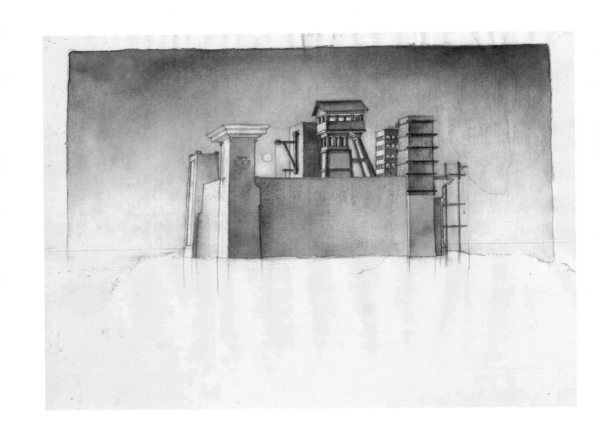

The Last Days of the Opera

Edited by

Denise Wendel-Poray
Gert Korentschnig
Christian Kircher

SKIRA

Design
Luigi Fiore

Editorial Coordination
Emma Cavazzini
Ina Gayed

Copy Editing
Anna Albano
Denise Wendel-Poray

Layout
Barbara Galotta

Iconography
Denise Wendel-Poray
Agathe Rastoul

Translations
Denise Wendel-Poray
Matthias Goldmann
Carol Rathman

First published in Italy in 2022
by Skira editore
Palazzo Casati Stampa
via Torino 61
20123 Milano
Italy
www.skira.net

© 2022 The authors for their texts
© 2022 The artists for their works
© 2022 Skira editore, Milan
© Marina Abramović, Clément
Cogitore, Hermann Nitsch
by SIAE 2022

Printed and bound in Italy.
First edition

ISBN: 978-3-200-08729-3
(Bundestheater-Holding GmbH)
ISBN: 978-88-572-4359-7
(Skira editore)

Distributed in USA, Canada,
Central & South America by
ARTBOOK | D.A.P.
75, Broad Street Suite 630,
New York, NY 10004, USA.
Distributed elsewhere in the world
by Thames and Hudson Ltd.,
181A High Holborn, London
WC1V 7QX, United Kingdom.

For their invaluable support
Herbert G. Kloiber
Heinrich Schaller
Martin Schlaff
Roland Schmidt
Markus Zeilinger

With support from

In memory of

Christa Ludwig
Mariss Jansons
Hermann Nitsch
Franz Zoglauer

Contents

FOREWORD

Christian Kircher

Or d'uopo è d'un gran core e d'un bel canto.
You now need to have a brave heart and a fair song.
Claudio Monteverdi, *L'Orfeo*, Act 3; Hope / Speranza

Claudio Monteverdi's *L'Orfeo* is not the first opera in music history, but no work seems to me to stand more programmatically for the inception of the opera genre. It is with the sounds of his lute and his singing alone that Orpheus induces Charon the ferryman to fall asleep and arouses Proserpina's pity. His music opens hearts and allows him to rescue his beloved Eurydice from the realm of the dead.

That's all it takes—or is it? The history of opera has rarely seen as many performances as we do today. They say that 25,000 are staged around the world every year, but it is invariably the same fifty operas, give or take, that are performed. What gives rise to this restriction and what perspectives can the genre still offer today? Has the opera world grown too big and is it threatened with extinction for this very reason? Has it turned into the dinosaur it once struggled to overcome through its initially highly innovative, revolutionary aspirations? Can it still harness the necessary artistic, creative, and political power and energy? Many see opera as the art form that elicits the deepest emotions and seems to make life stand still, even if only for a brief moment.

A new intendant taking the helm at the Wiener Staatsoper seemed like the perfect occasion to extend an invitation to opera lovers, in the truest sense of the word, to contribute to a stocktaking and survey of the genre. The book launch was originally slated to coincide with the beginning of Bogdan Roščić's tenure in September 2020. The delay of its completion and publication is owed to the enormity of the project and, above all, to the pandemic and the ensuing state of emergency. From March of 2020, the hustle and bustle of everyday life at the opera devolved into stagnation, despair, and agony. Many of our authors were busy coping with the crises unfolding in their immediate environment, some were even forced to reorient their lives and careers. In a much more tangible fashion than the original idea for this publication had anticipated, the opera and theater sector was suddenly faced with questions of meaning and purpose while the systemic relevance of culture was being discussed in the public square.

It's an obvious fact that the genre of opera is a hugely expensive one, much more so than theater of the spoken word, for example. The reason being that opera involves the interplay of various disciplines—from the creation of librettos and musical compositions all the way to

stage productions. Thus, it appears cumbersome and is slow in reacting to current issues and events. All of this may well lead people, especially among younger generations, to conclude that opera is no longer in keeping with the times. The other side of the coin is that many of the themes opera covers have always been, and will continue to be, at the top of people's minds all through their lives: religion, power, love, or death.

As an "industry leader" in the theater sector, Austria's Federal Theaters have, of their own volition, addressed critical issues in several areas in recent years. This has been recognized beyond their immediate environment and has created a knock-on effect across the entire industry. We encourage open discussion of and engagement with compliance issues, all the way from the "me-too debate" to problems relating to employment relationships at our theaters. During the months of the shutdown, we had to develop preventive measures or find financial solutions for canceled performances. Over the past two years, the Austrian Federal Theaters have frequently served as a communications hub between artists, event organizers, and political leadership.

And so, while this book is the result of our survey on the current situation in and around the opera genre, we would like it to be seen as an impulse that sparks further discussions on the fundamental principles of what we do—substantial debates that start at the Austrian Theaters and will hopefully have an impact beyond our own sphere of influence.

When we first began exchanging ideas about the shape this book could take, the first partner we brought on board was Gert Korentschnig. He was involved from the very beginning and suggested Denise Wendel-Poray as co-editor. Both of them proved to be enthusiastic idea people, perfect networkers, and critical partners when it came to selecting authors, marking out subject matter, and designing the book. Denise Wendel-Poray also produced the French to English translations, edited all English-written contributions, and liaised with the publisher, Skira, from the very start until the book went to print. I would like to express my deepest gratitude and respect to both of them for their perseverance and great work over these many months.

My sincere thanks also go to Ina Gayed, who compiled and coordinated the various stages of contributions, the German versions of which were edited by the wonderfully knowledgeable Wolfgang Kralicek and translated, for the most part, by Matthias Goldmann. We extend our profound gratitude to the institutional and private sponsors who have made the publication of this book possible.

Last but not least, my heartfelt thanks go to all the authors who accepted our invitation. All of them, in their own sphere of activity, work to ensure that the opera is alive and well. It is our hope that this anthology will stimulate and inspire further reflection on opera, music, and theater; may the beauty of song continue to open our hearts even as so many years have passed since Monteverdi and his *L'Orfeo*.

Christian Kircher is the director of the Österreichische Bundestheater Holding (Austrian Federal Theatres Group - Burgtheater, Volksoper Wien, Wiener Staatsoper, Art for Art) since 2016.

INTRODUCTION

Gert Korentschnig

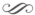

It is rather telling that, if pronounced carelessly and fast, the German word for Opera sounds like "Opa," meaning, of course, "grandfather." Countless puns derive from this phonetic similarity: Opera, the ideal art form for grand-, if not great-grandfathers.

If the truth be told, young people hardly ever stray into an opera house, much less enter with enthusiasm. And this regardless of decades of debates by people outside and inside opera theaters about strategies to make the genre more appealing to them. Even ensembles of distinguished experts and choirs of artistic directors loudly pitching ideas and lavish concepts have met with moderate success. Indeed, apart from a few exceptional cases, opera remains stubbornly immune to any attempts at its own renewal. Perhaps because, like many a grandfather or grandmother, it has lived through and learned so much that it reposes confidently on its greatness and wealth of experience.

The parallels between opera and human existence are evident not only for reasons of age but also of content: opera is about nothing less than life. About love, hate, passion, and death. Personal destinies are mirrored by societal events, for instance, in Verdi's *Don Carlo*, where the protagonist is thrown back into a childlike state, left to run blindly against walls and hurtle towards his own undoing. Ultimately, tradition is preserved, and the revolutionaries end up being the losers, much like they generally do when it comes to rejuvenating opera.

Of course, opera (the German word "Musiktheater," music theater, is infinitely more fitting) has always ranked as one of the richest forms of artistic expression—at least in theory. It is highly dramatic, histrionic, and can be sensitive and bombastic all in the same phrase. Opera is as great as society and as fragile as the individual (and sometimes vice versa). It is more diverse and varied than any other genre. Many eminent artists have given their best efforts to make it relevant, some successfully, some not. But they have nevertheless enriched it by challenging its ossified habits of seeing and hearing.

Paradoxically, opera, which demands innovation on all levels and, with equal vehemence, prevents any reforms resulting from them, as if its mass alone, being its own gravitational force, risks smashing you to bits and pieces if you get too close to it. It promises security by being an essential part of our most conservative values but proves illusory again and again. Opera is both about preservation and innovation. Its vision contradicts its reality; it is its own thesis and antithesis.

Its volatility could not be higher.

But when a synthesis does emerge, this dialectical process induces a moment of pure bliss.

And even if it is constantly talked down on and its value continually questioned, and though other art forms might feel more contemporary, opera maintains its immense social relevance and transformative power.

Nonetheless, opera merits criticism when it wallows in its own importance and settles for inferior artistic results and shies away from confronting present-day issues. In recent years, this regrettable situation has become more the rule than the exception. In an ever-faster spinning world, and as the economic and educational barriers mount, the situation only worsens. The shortcomings of the traditional audience, their elitist demands—exclusion instead of openness doesn't help—not to mention the ignorance on the part of the media and competition from artistic formats that are easier to consume. On top of that, the ongoing corona crisis has exacerbated problems; numerous theaters were forced to close, which has led some people to conclude that they can do without them.

The shifting landscapes of society and political power we are experiencing, the rising support for populists, warmongers, revanchists, and aggressors are strikingly reminiscent of the 1920s, and the historical watershed moment of despair and bewilderment, which Austrian writer Karl Kraus articulated so brilliantly in his play *The Last Days of Mankind*. As theater, the work was of utopic, even operatic dimensions. First published as a book on May 26, 1922, it fittingly precedes the present publication by one hundred years.

The work on the book you are holding in your hands commenced long before the onset of the health crisis and even longer before the previously unimaginable war in Europe. It has thus acquired additional pertinence by sheer coincidence—then again, this may be par for the course because opera is eternally in crisis, as reflected by many of the following essays. Our choice of Kraus' work as the inspiration for the title *The Last Days of the Opera* met with immediate approval from a good number of our authors, skepticism from others, and of course, disapproval from a few: how could anyone state such a claim and not end it with a question mark? But we were all the more convinced that choosing this title was the right decision, as we firmly believe that fracas is far too rare a thing at opera houses.

Our goal was to assess the state of affairs and general climate in the world of opera and venture to look back as well as ahead. We received admonition as well as declarations of love; problem areas were identified as well as constructive criticism; insightful essays, harsh criticism, optimistic interjections, and pessimistic assessments were submitted. The one thing that shines through all of these essays is love and passion, the kind that opera can inspire like no other form of art. They are pleas for a bright, beautiful future, which many of our contributors are themselves tasked with shaping. Most of them agree on one thing: something urgently needs to happen to keep the wrong things from happening, to overcome stagnation and gradual decline.

Sadly, some of the authors who contributed to this book are no longer with us and will be greatly missed in the world of opera. One of them is irreplaceable conductor Mariss Jansons, who gave his last interview for this book a few weeks before he passed away; the re-

sulting text is published here for the first time and has now become part of his legacy. Christa Ludwig, the incomparable singer, has also left us. As has Franz Zoglauer, the highly committed and engaged Viennese critic who co-authored Christa Ludwig's memoirs. And the Austrian artist Hermann Nitsch, who in the summer before his passing, bathed the *Walküre* in Bayreuth in a sea of color.

We wish to offer our deeply felt tributes to all of them and see this book as a token of our commitment to carrying their legacy forward. They knew that what ultimately mattered was to help shape the discipline they devoted their lives to in the right manner. Why it's not just crucial that it lives on, but also how it develops. Remember that line in *Rosenkavalier*? "And in the 'how' there is the whole difference."

Gert Korentschnig is a journalist, author, music critic.
He is deputy editor-in-chief of the media house *KURIER* in Vienna and head of *KURIER am Sonntag*.

INTRODUCTION

Denise Wendel-Poray

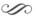

We began work on the present book in January 2019, drawing up a plan whereby each of us would contact one third of the 100 authors we hoped to include. Our title was a deliberate provocation: *The Last Days of the Opera*, but the opening question was decidedly positive: "How do you see the future of opera in the 2020s?"—therefore a plea for suggestions and innovative ideas.

It was nevertheless a risky wager: what if everyone answered in the same way—a consensus of self-confident optimism or, on the contrary, one long doomsday scenario whereby the genre would be extinct by 2050 along with the Javan rhinoceros? But the diversity of writers, ranging from opera's most outstanding professionals to visual artists, composers, actors, architects, theater technicians, and thinkers from all continents, nationalities, and age groups (our youngest writer is fifteen years old, the eldest ninety) seemed guarantee enough that this would not happen—even if the outcome remained as aleatory as John Cage's *Music for Changes*.

Our wish was an atonal symphony of opinions, a grail of ideas, with a lot of dissonance and clashing, something thought-provoking but non-conclusive. We gave ourselves one year, projecting our publication for March 2020… then Corona, like the forgotten guest, invited itself into the conversation with a vengeance.

Suddenly our writers, rather than answering from a trans-Atlantic flight or in haste between two rehearsals, or whatever the usual activity was: film director, journalist, scriptwriter, choreographer—everyone was at home. In some cases, this fostered a profound reflection on the "Why" of what we do; in others, disarray or worse—numb silence. As a result, there is a very different tone in the few essays we received before the pandemic compared with those once the pandemic hit—when no one knew what was happening—and then those essays, which came later, during the subsequent waves and re-confinements. Inversely, though written in the thick of the pandemic, some don't even mention it, which is also interesting, as if opera sits on such solid foundations that even a killer virus can't shake them.

Tell Me the Truth about Love, War, and Opera
Scene 19 from Karl Kraus's *The Last Days of Mankind* has the Optimist and Grumbler in conversation:

> Optimist: What do you say about the rumors?
> Grumbler: I haven't heard them, but I believe them.
> Optimist: Oh, come on, they're lies put out by the Allies!

Grumbler: But not nearly as dubious as our truths.
Optimist: If the worst comes to the worst, the one thing that could feed rumors would be—
Grumbler: If we couldn't feed our people (*change of scene*)

One hundred years after its publication in 1922, Kraus's masterpiece pokes a finger into the wound of our recurrent history of self-destruction, glorification of war, and pitiable state of ignorance about the facts. Indeed, in the mêlée of the burgeoning pandemic, the rumors, assertions and counter-assertions, and absurdities such as Donald Trump's daily Covid press conferences, gave the feeling of being in the middle of a Karl Kraus drama—a veritable non-stoppable, modernist textual collage.

Never before had we been so much in the dark, trapped in our apartments and dependent on the deafening, contradictory ravings that filtered in through our news outlets. Not surprisingly, many essays defend the utter importance of opera as a medium that can expose emotional, societal, and political truths more vividly and poignantly than any other.

This assertion was exemplified by Russian director/activist Kirill Serebrennikov when he homed in on the expressive potential of *Parsifal* to denounce Putin's dictatorship (Wiener Staatsoper, 2021) or when William Kentridge set Berg's *Wozzeck* in the period of its composition—the First World War (Salzburg Festival, 2017). Its revival at the Opéra Bastille in March 2022 inevitably called up the specter of war, now so real on our continent along with its horrific injustices.

In point of fact, war is intrinsic to the operatic genre, whether or not stage directors choose to focus on it and how is another question. In the comic mode we have *Così fan tutte*, *King Arthur*, and *La Fille du régiment* or more seriously Monteverdi's *Il combattimento di Tancredi e Clorinda*, *Aida*, *Les Troyens*. But after 1945, it becomes a mirror for the atrocities of war: Prokofiev's *War and Peace*, Britten's *Owen Wingrave* and the *War Requiem* (in particular when staged by Wolfgang Tillmans); Tippett's *King Priam*, Henze's *We Come to the River* and John Adams' *Doctor Atomic*.

Still many writers differ on the question: is opera a forum for exposing the truth, or is this not at all its vocation? And there are some solid arguments supporting or nuancing each viewpoint.

At the risk of taking a tangent in this short introduction, Aldous Huxley convincingly defends both points of view in *Tragedy and the Whole Truth* (1931). Tragedy as an artform (and this includes the great operatic works) does not have the vocation to tell the "Whole Truth" but rather a powerfully distilled form of truth "Chemically Pure" which is all the more effective and cathartic because it doesn't deal with reality. However, the "Chemically Impure" literature of the "Whole Truth"—such as his *Brave New World* or his former student, George Orwell's *Nineteen-Eighty-Four*—is just as necessary: the human spirit needs both.

The Truly Creative Act

Beyond the battles over the boundaries opera can or cannot cross, many authors emphasize the importance of new works, how to promote them and ensure their permanent place in the repertoire. Slavoj Žižek, in *Opera's Second Death* (New York-London: Routledge, 2002, p. 124), apropos of Wagner, refers to the "truly creative act" and how a revolutionary composition not only "restructures the field of future possibilities but also restructures the past, resignifying the previous contingent traces as pointing to the present." Thus the absolute urgency to promote new works also to

keep the traditional canon vibrant. We have here the voices of some of today's greatest living composers: Michael Jarrell, George Benjamin, Christian Jost, and Georg Friedrich Haas, to attest to this.

New Audiences

Concerned by the advanced age of their public, many intendants emphasize the need to attract new, younger audiences, the opera-goers of tomorrow. In Tolstoy's *War and Peace*, we encounter the barrier that opera presented for young people already one hundred and fifty years ago from the vantage of Natasha, who "could not follow the opera nor even listen to the music; she saw only the painted cardboard and the queerly dressed men and women who moved, spoke, and sang so strangely in that brilliant light. She knew what it was all meant to represent, but it was so pretentiously false and unnatural that she first felt ashamed for the actors and then amused at them." (Leo Tolstoy, *War and Peace* [New York: Simon and Schuster, 1942], p. 707). The "opera scene," famously highlighted by critic Viktor Shklovsky as the technique of "estrangement" (Alexandra Berlina, ed., *Viktor Shklovsky: A Reader* [New York-London: Bloomsbury Academic, 2017], p. 25), still describes (even if sets and directing have improved drastically) how an opera performance can be daunting for the uninitiated. The present book is rich in discussions as to why opera has so much to offer the younger generation precisely because it is unfamiliar, and how the "estrangement effect," where the familiar is made strange and disturbing, as if never encountered, can bring new meaning and be a catalyst to self-discovery.

Remembrances

Some of our writers make no arguments at all; their contributions expose no Cartesian logic, nor do they offer solutions or recommendations, but rather relate a personal experience. For example, Richard Peduzzi—the artist and stage designer we invited from the very beginning to be the central figure of our book—wrote an essay that glimpses the deep friendship behind one of the most significant operatic collaborations of the twentieth century—the Peduzzi-Chéreau-Boulez *Centenary Ring* in Bayreuth in 1976.

There are also the contributions in manuscript form by Jonathan Meese and Robert Wilson and a poem by Martin Crimp, all written especially for our book. This is its Wunderkabinett aspect, which, while defying logic, is also very instructive and will hopefully contribute to setting in motion a collision course of responses towards the future of opera.

Canadian/French writer, editor, journalist, and curator, Denise Wendel-Poray is a graduate of the universities of McGill and Yale. She is the author of essays and books on the relationship between art, theater, and music: *Frauen- liebe und Leben* (Hatje-Cantz, 2013), *Painting The Stage: Artists as Stage Designers* (Skira, 2019).

Per Sonare

Voices

SUBJECT TO CHANGE

PERMANENT TRANSFORMATION AS A KEY TO THE SURVIVAL OF OPERA

Cecilia Bartoli

In order to ensure survival, all things undergo transformation and adapt to a permanently changing environment. With their hypersensitivity, artists function as society's seismograph and register oncoming social, political, or cultural changes. Through their creative output, they prepare the ensuing switch in audience interest and sometimes even steer it in a specific direction.

Opera has proven extremely resilient to matters such as the transformation and eventual survival of theater. Since opera accommodates most of the fine arts and the performing arts, its components may simply be re-evaluated to suit new requirements. Thus, questions such as the relationship between text and music, the importance of the subject matter and how to stage it, different ways of using the voice and distinct types of singers, the relevance of the chorus and the orchestra, the inclusion of dance, film or other visual arts, and of course the overall socio-political significance of opera were permanently reviewed since its invention more than four hundred years ago and the focus adjusted accordingly.

In general, audiences eventually follow the innovations proposed by artists, even though this sometimes requires overcoming old habits. There is always a thirst for novelty, and spectators like it when they find the outside world, their personal worries, and current frame of mind reflected in a theater production unfolding before their eyes.

Natural Transformation of the Repertoire

In my work as a performer, as well as in my function as artistic director, I am most interested in the permanent modification of the commonly performed repertoire.

Thirty years ago, it would have hardly been possible to stage baroque operas at the Salzburg Festival. Nor would we have performed pieces from the bel canto era on period instruments anywhere. A strict canon of acceptable works and a traditional way of presenting them left no room for digression. At that time, baroque opera was still marginal in terms of the common repertoire, whereas the period-instrument movement was far from today's performing standards. In the meantime, the situation has changed profoundly. Even large opera houses which traditionally focused on nineteenth and early twentieth-century repertoire produce baroque operas with basically their own personnel now and let musicians from their orchestras play in historically differentiated styles.

The relatively recent craze for baroque opera is closely connected with social changes in the latter half of the twentieth century, bringing about new aesthetic movements such as

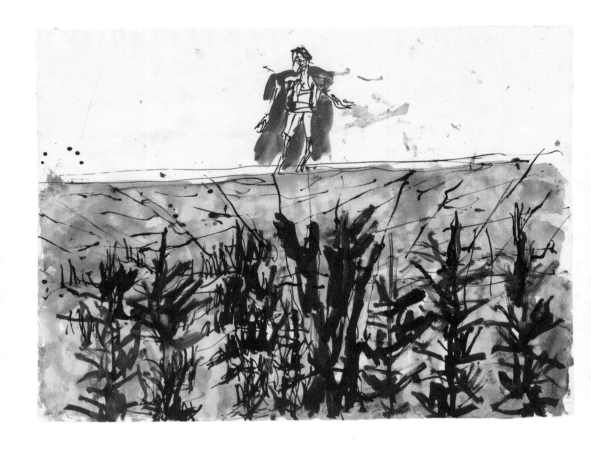

Georg Baselitz, Untitled, 2017
Ink brush, lavis, ink,
and watercolor on paper,
50 × 66.2 cm
Design for *Parsifal*, Richard
Wagner, Bavarian State
Opera, Munich, 2018.
© Georg Baselitz 2020
(Photo © Jochen Littkemann)

postmodernism and particularly pop culture. Pop music, with its strong emphasis on rhythm and repetitiveness, its different ways of storytelling, and the exuberance of its outward appearance, contains many of the ingredients which had excited opera lovers in the eighteenth century. Genderplay was as distinctive a feature in Baroque opera as it has become in contemporary Western culture.

On the technical side, the eminent leaders of the period practice movement implemented fundamental changes in pitch, the manner of playing, sonority, and the size of the orchestra. This paved the way for the emergence of several new generations of magnificent singers who are perfectly suited for the baroque repertoire. Flexibility and lightness rather than volume and power mark their vocal skills, for instance, whereas an ease at improvising and embellishing forms an indispensable part of their musicianship. And finally, a new open-mindedness allows them to tackle stories and roles which are quite different from those which characterize nineteenth- and early twentieth-century operas.

The same applies to Rossini. His works have been re-established as masterpieces and found an astonishing number of outstanding interpreters, making it so easy for companies to program this type of opera today. One might indeed remark, on the other hand, that voices required for the Wagnerian or verismo repertoire have become far less frequent in recent years.

In my case, I should probably consider it my great fortune that my own career coincided with this major shift backward in music history towards the baroque, classical, and early romantic periods, which so perfectly suit my voice and temperament.

Looking back over the past thirty years, I see myself at the forefront of this movement in many ways. As a very young singer, I was a tool in the hands of pioneers such as Nikolaus Harnoncourt and Claudio Abbado. In each of their fields, they popularized operas that had not been seen on the playbills for a very long time. Moreover, they compelled listeners to acknowledge new ways of performing. Later my own projects served as a means for disseminating music by neglected composers. It fills me with pride when I see that in the meantime, Vivaldi, Porpora, Salieri, or the Italian operas of Gluck are regularly played at established opera houses with enormous success.

In 2016 my recent work in Monaco led to a further, sustainable step in this direction. Encouraged by the interest of HSH Prince Albert II and HRH the Princess of Hanover "Les Musiciens du Prince," a new "court" orchestra playing on period instruments was formed. With "Les Musiciens du Prince," we continue a great eighteenth- and nineteenth-century tradition, which could once be found all over Europe. Obviously, courts held excellent orchestras for representational reasons. But these groups also served as an important experimental space for musicians to try out new projects on a long-term basis while being obliged to maintain the highest artistic standards throughout.

Music as the Motor of Transformation

Transformation in opera—be it subject to a fashion or be it a fundamental shift—always happens on various levels. Those who create operas and those who stage or perform them generate such changes. Sometimes they are made because of a conscious decision; at other times, they reflect altered audience attitudes.

New tastes bring about different styles of interpretation. Towards the end of the eighteenth century, for instance, the Enlightenment's new views about theater and the arts began to assert themselves. As a consequence, baroque opera gradually lost its meaningfulness. Those who now formed the core of theatergoers found its opulent music and glamorous display of vocal prowess exaggerated, incomprehensible and tasteless. At the same time, society began to sanction the castration of boys with the effect of castrato singers and their art going out of fashion. Eventually, their place on the pedestal of godlike creatures in the world of opera was taken up by women. The greatest stars of the Romantic period were female: Giuditta Pasta, Maria Malibran, Giulia Grisi, Jenny Lind, Pauline Viardot, and many more. Their manner of singing and acting, the parts they played on stage, and the roles they assumed in life suited bourgeois society far better than the castrati, who were no longer perceived as angel-like but as unnatural and bizarre.

In the twentieth century, stories and styles began to change once more, and it was most notably the tenors who began to push aside many of the great prima donnas of the past. Rather unexpectedly, a new group of stars began to shine on the operatic horizon some decades later: countertenors. In many cases, these male singers, who use the falsetto range of their voices, were employed with the intention of creating an impression of authenticity in parts originally written for castrati—without having to resort to the fateful operation of bygone centuries.

With the period practice movement in its experimental beginnings, there was at first not much literature for these singers, nor were there many chances for them to present themselves at established venues and festivals. Thrust forward with growing self-confidence, however, a steadily increasing number of popular countertenors asserted their need for more demanding parts and different repertoire. In the end, their technical brilliance, their first-rate musicianship, and their willingness to break established boundaries turned the originally highly specialized baroque movement into the massively popular phenomenon it is today.

Looking Back at the Sources Takes You Forward
Audiences are probably less aware of another driving force in the transformation of music because it concerns us artists before we actually present ourselves on stage: over the past half-century, our view of scores and musical interpretation has changed profoundly. Originally frowned upon and considered evanescent, the methods of the period practice specialists have become widely acknowledged and are applied to repertoire reaching far into the nineteenth century.

Much of this is due to the increasing availability of original sources and carefully prepared critical editions. More recently, these have become far more accessible through the internet and digital means. On the other hand, the technical training and stylistic education required for a historically informed approach have become professionalized and, in most cases, form a mandatory part of a young musician's education. The modern listener, on the other hand, looks eagerly forward to experiments and improvisation, not only in the baroque repertoire.

I am grateful that very early in my career, I was taught to consider the context in which and for whom a work was written. I became interested in other composers and musicians

working at the same time as the ones I was studying. Moreover, I was urged to go back to the original manuscripts and to question traditions. All this led to countless discoveries, many of which were astounding, first for myself, then for my audience. Eventually, we all got used to them, and as time passed, these operas and many other new ones began to be integrated into the repertoire of my colleagues. As a consequence, theaters began to program them for us. But as time went by, not only the selection of works and our interpretation changed but, more importantly, the way in which audiences listened to us and appreciated this music.

Presenting a New Vision: The Romantic Revolution
Audiences are prepared to part with dear traditions when you present them with new views. Obviously, you must make sure that they are well-researched, reveal something exciting, and are presented with passion. Like many young mezzo-sopranos, I began my career with roles in popular operas by Mozart and Rossini. Then there came a point where I got highly interested in baroque music and lesser-known vocal music by classical composers such as Haydn, Salieri, and Gluck.

During my research about the great castrati, I read that Rossini had admired their art more than anything. In his mind, theirs was the ideal way of singing. And the composer he cherished most was Mozart.

So, I began to wonder what would happen if we tried to perform music from the early Romantic period—Rossini, Bellini, Donizetti, for instance—adhering as closely as possible to these principles. I realized that so far, we had always looked at the bel canto period from our own, modern point of view. But Bellini did not know Puccini. If we wanted to perform this repertoire in a way we thought corresponded to what people heard in the 1830s, we would have to depart from *their* heritage rather than our own, which is formed by verismo and late Romantic music. I asked myself who were the singers for whom those parts were written, what was their repertoire, what their vocality? What were instruments like in those days, what was their pitch? And what did the autograph say?

Therefore, I began to apply many of the things learned during the baroque and classical revival to early Romantic music. I was deeply moved when I rediscovered works familiar to me all my life from a totally different perspective: one that evolved in a contrary but historically correct direction, a chronological one growing gradually from the eighteenth into the nineteenth century.

The reading of Bellini's *Norma*, which we presented with Giovanni Antonini on CD, in Salzburg and other European cities from 2013 onwards, was radical in many ways: based on a score reconstructed from Bellini's handwritings, it was played on period instruments emanating colors that might indeed have been heard in the mid-nineteenth century. Cuts were restored, as were the original keys and tempo indications, and many further details reviewed. One of the most striking novelties concerned the vocality of the leading parts and the reinstatement of the initial relationships between the voice types of the original cast: Norma a darker-tinged mezzo-soprano, Adalgisa a light soprano, Pollione a flexible, Rossini-style tenor.

Our interpretation was guided by a new vision of Romanticism. After all, *Norma* is a masterpiece from the Italian Romantic period, its plot immensely dramatic, the characters

driven by extreme actions and raging passion. At the same time, we understood that Italian Romanticism had grown out of the classical style and that in turn, out of baroque music. It is not an expressionist or *verismo* piece. These styles emerged decades later and formed our own musical and stylistic appreciation but not that of Bellini and his contemporaries.

Not surprisingly, when we first presented our project, which in many ways was iconoclastic, people were surprised, some even shocked. Others, however, were delighted and gave us the chance to present our reading of *Norma* in various theaters in different countries.

In Germany, we encountered some of the most interesting reactions. It had always been known that Richard Wagner admired *Norma*. He had conducted the opera and kept a score in his private library. However, the form and content of Bellini's opera were not considered theatrical enough to justify a "serious" staging in Germany. Its musical merits were seen as a string of beautiful vocal numbers for incorrigible melomaniacs.

In Germany, our new vision of *Norma* changed the appreciation of this work radically. Press and audience recognized the dramatic content of the story, the tragic, but at the same time very commonplace conflict between the main three characters. Now, they heard this reflected in the vocal parts, as well as in the colorful, sophisticated orchestral accompaniment, which accentuates the turmoil developing on stage. Evidently, Bellini's romantic opera re-emerged with a force people had never credited it with before and which fascinated and excited them.

Having succeeded in transforming the appreciation of *Norma* by offering an alternative, "new old" reading, we created a new perspective for this work: in addition to popular productions already running at leading opera houses, it will from now on be accepted by theaters with distinct repertoire policies, conductors from another musical background and singers with a different kind of vocality.

Opera will always have to undergo transformation in order to remain alive and thriving. We transform the existing repertoire by introducing newly commissioned pieces, which explore modern aesthetics and contain new manners of expression. But we should also find forgotten works and educate musicians until they are able to present them in a way that makes an audience feel passionate about them too. And we must review operas from the canon regularly and think about how to produce them adequately.

By establishing a connection with the past, we can make people understand why a particular piece of music made its impact centuries ago and what values it contains for us today.

Born in Rome, Cecilia Bartoli made history with her interpretations of baroque and bel canto operas and has become a role model for a whole generation of young musicians. Thanks to her innovative CD projects and specially designed concert programs, she is one of the most successful classical artists of our time. Since 2012, she has been artistic director of the Salzburg Whitsun Festival and, in January 2023, she will take over the direction of the Opéra de Monte-Carlo.

ONLY EMOTIONS OPEN OUR HEARTS

Jonas Kaufmann

The fascination of opera lies in its unique interplay of text, music, and performance. The tapestry of emotions an orchestra unfurls for us singers is so rich that many a generation before us made do almost without a stage set. The action on the stage itself fired their imagination—but unfortunately, this type of imagination, which stimulates thought, has become stunted. This began with the rise of cinema; more importantly, though, the wheel turned towards an exaggerated realism in the 1960s—and there's a historical explanation for that. This has caused our imagination to grow cold, and we find ourselves in a world where the sophisticated algorithms of a video game seem to take on a more realistic feel than reality itself. In opera, we want and need to rise to this challenge.

Opera must be about emotions. And music has come into our lives to engender emotional bonds. The first sound we perceive is our mother's voice or singing. We know that already at this early stage, the child forms a deep bond through the mother's voice. This is also the underlying idea behind the music that moves us.

As singers, our goal is to leave listeners with a truthful impression of a role, but that role is not simply a template waiting to be filled. Nor are we mathematicians or physicists who follow some technical procedure that allows us to churn out one high C after another. If we aspire to serve as the keepers of the past, we have to breathe new life into it. Just as the musical notation of jazz music allows for limited improvisation in terms of creative achievement, we, as mediators, have long been deprived of opportunities for interpretation through an undue emphasis on practical aspects. Yet, it is precisely the differences between various interpretations that, time and again, breathe life into a work. It is up to us performers to find the key to the listeners' hearts. The opera genre always manages to leave people in tears at the end of a *Traviata* or *Bohème*. This is not a product of reason but rather our experience of a unique kind of magic we encounter in the opera. Once listeners are captivated by it, that wonderful "little box in our chest" is open, and the music has a chance to make a true impression on them. We all need to find this key—singers, instrumentalists, as well as directors.

Music-theater can certainly address social issues but wagging fingers and giving broad hints aren't going to do the trick, and the best intentions fade in the face of performances that leave the audience cold. Only people who have been moved and touched will change their behavior; music is thus indirectly an amplifier of human behavior. The people we are able to reach will talk about their experience—and it is only with this conversation that the

seeds for reflection are planted. When we think and talk about what we have seen and heard, we are also touched by content transported by the music.

What touches people first and foremost is undoubtedly the melody. But it doesn't exist in modern music, and the complexity of this music is so great that we start missing the listening habit that we need to understand a work. Let's take Wagner, for example. Most people are hooked, at the latest, when they hear a Wagner opera for the second time. And the more listeners come to appreciate the depth of this music, the more it casts its spell on them; finally, the preoccupation with Wagner can easily become an addiction. However, we are still dealing with a frame of reference that isn't hard to grasp. After the Second World War, however, there was incredible pressure to break with anything even faintly turgid. Any composer who went on creating singable melodies was ostracized; the circle of the initiates was limited to intellectuals; the broader public could no longer be reached. When a program is put together, though, the key is to find the right mix of new and traditional content.

When we talk about the limits of the genre, however, we should not forget to mention its enormous potential: no one can be forced into an opera house, but alternative performance formats can have an extensive impact. I personally know plenty of people for whom the legendary Three Tenors Concert was the first classical music experience of their lives. Or people who found their way to the opera via Andrea Bocelli. He succeeded in appealing to a large audience and should be given the respect he deserves. These concerts provide its audiences of 100,000 with a gateway to the world of opera.

Classical music purists may frown upon such events because they feature some light fare as well, and you may hear the occasional bird whistling in the course of an open-air concert. Being in the presence and atmosphere of nature gives you an extra boost, and with the feeling this gave me, I would have loved to sing the whole night through at the Waldbühne in Berlin. Events like this are all about sharing with the audience the passion that fuels our work, and there is the chance that some in the crowd will want to experience the real thing once they've seen these highlights. Anyone who subsequently goes to the opera for the first time will be hooked for life. It's an experience that people no longer want to miss out on.

I also see our industry changing when it comes to the relationship between opera houses and festivals. If opera houses keep offering more and more out-of-the-ordinary events, where does that leave the future of festivals? Festivals were born from the idea of bringing together singers and audiences in a beautiful place in the summer to experience something unique and extraordinary. Today, we are seeing a convergence of content between festivals and opera houses. Because tourists, by themselves, no longer fill the houses, they, too, want to offer something extraordinary over and over in order to distinguish themselves. Often, productions are performed only once and then left to sink into obscurity—even though the choir rehearsed for a year to prepare for the show.

Festivals also used to have a quasi-monopoly on the booking of stars. That was owed to the fact that festivals don't have fixed ensembles. In the meantime, repertory theaters are also trying to raise their profile by featuring star performers—even if the opera has not yet

reached the dimensions we find in soccer, where clubs like Paris St. Germain go on an annual shopping spree and to buy global superstars. It's a mistake that the care and support given to maintaining an ensemble is no longer as comprehensive as it used to be. In the old days, we admired our local heroes, would go to see our darlings in *Bohème*, and waited in anticipation to see how—or if—they would succeed in pulling off the part of Hoffmann. So, to stick with the language of soccer: youth work must be improved again. Young people must be continually taught and mentored. However, the motto of these directors who see ensembles primarily as cheap labor seems to be that the good ones can take it, and there's no harm in losing the bad ones. Many houses will therefore not be able to work without guest performers. Only with the right balance of ensemble members and guests and mutual exchange among opera houses can such a model succeed.

The international exchange of guest soloists—the jet set of our industry—has reached its limits. The perpetual availability of guest singers, which we had taken for granted, was also called into question by Corona.

Alternative forms of distribution via the Internet have been a pervasive issue in our industry, and not just since all the theaters closed due to the pandemic. Streaming is now seen as a panacea; at the same time, people worry that it might cause viewers to lose their appetite for the original. The best recordings are very often the ones that were recorded live. Even as an avowed "album artist," I have to admit that I sometimes prefer live recordings to studio productions. I remember, for example, a performance in Palermo that—for whatever

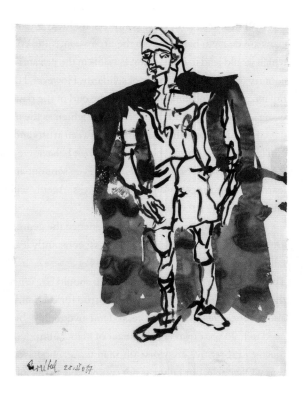

Georg Baselitz, *Parsifal*, 2017
Inkbrush and watercolor
on paper, 66.1 × 50 cm
Design for *Parsifal*, Richard
Wagner, Bavarian State
Opera, Munich, 2018.
© Georg Baselitz 2020
(Photo © Jochen Littkemann)

reason—was sung half in French and half in Italian. Thus, this broadcast became a unique experience. We have become accustomed to deviations from perfect studio sound and have even learned to love them.

We, the artists, no longer have four weeks to perfect our performance before producing a studio recording as we used to because the choir, orchestra, or soloists are only available for a limited time. When I think of Karajan's recordings, where everything was timed like clockwork, I realize that such perfection is no longer the goal for musicians today; instead, conveying the experience of the performance is considered an optional feature.

The bottom line is, I think you'll see significant changes coming to musical and opera theater because Corona has undoubtedly caused a shift in the behavior of audiences and, as a result, will permanently transform the way we work in the industry. We will not return to where we were before Corona. Audiences will think twice whether attending events and taking part in a shared experience is worth the risk of exposing themselves to infection—even if that risk may seem higher than it actually is. Above all, however, the situation could lead young talent to choose not to pursue a career in music just to err on the side of caution. As protagonists, we find ourselves in a highly fragile system in which there is, by and large, a lack of support for the individual musician. In the area of small festivals, stages, or movie theaters that were already unable to build up reserves over the last few years, we will see a lot of shuttered operations or, to put it politely, widespread "consolidation." Theaters who receive 70 to 80 percent of their funding from the state, on the other hand, will have to ask themselves what the responsibilities are that come with public funds.

While artists with fixed contracts are lucky and can work part-time, freelance musicians are de facto banned from the profession. Valid contracts were declared null and void, which would lead to mass action lawsuits in the private sector. Hopefully, the situation in our country will lead to new forms of solidarity. However, I doubt that artists will close ranks and organize in any meaningful way—at the end of the day, in this line of work, we are used to being lone fighters. And the market will tighten as the money dries up.

For this reason, the relationship between artists and opera houses is also up for scrutiny. Not least because during the pandemic, their behavior towards guest performers and employees differed widely. Some houses never even sent out an e-mail to cancel events; employees learned about cancellations from the press. Agents will have to play an important role as mediators in the aftermath of Corona.

What remains is the unique experience the genre of opera offers to humankind. The art of turning every crisis into a success, constantly learning the appropriate lessons from failure, and moving on is empowering. *Per aspera ad astra*—through hardships to the stars. That's the way it is, and that's the way it should be. What's true for these difficult times and the opera business, in general, is also true for each individual career path. I'm concerned about colleagues who skyrocket to fame overnight—because they lack the experience you need to hold your own in the thin air of higher altitudes. People who fail for the first time at the age of forty-five are worse off than those who have gone through the experience many times. Of course, our failure is not comparable to that of, say, some military commander who

sends thousands of soldiers to their deaths when he's defeated. In this light, nonachievement in opera appears as a relatively humane affair.

Unlike in soccer, there are no winners or losers in opera when the performance is over. But of course, in soccer, we cheer our favorite team on, knowing full well that they won't always win—if they did, the game wouldn't be any fun. A skilled professional soccer player can handle the challenge of converting a penalty in the ninety-third minute. In opera, there are these moments, too, that are more emotionally charged than others. We have "Nessun dorma," which may not make packed stadiums hold their breath, but it does fill many people with great passion and strong emotions. And that's what opera will continue to do for a very long time.

One of the greatest operatic tenors of our time, Jonas Kaufmann is celebrated for spinto roles such as Don José, Cavaradossi, and Don Carlos. He also won acclaim for the Wagnerian roles Siegmund and Lohengrin before taking on the highly dramatic title roles of *Otello* and *Tristan* with repeated success.

CLOUDS WITH SILVER LININGS

Michèle Losier

Bearing the Rosenkavalier's silver rose on the stage of the Unter den Linden State Opera Berlin in February of 2020 felt like the pinnacle of my career. I had always dreamed of singing Octavian, with his brilliant range, his ardor, his biting text, and his sublime music. I left Berlin with joy in my heart, not doubting an instant that I wouldn't be back anytime soon. In the weeks that followed, it became evident that we were in the grips of a raging pandemic that quickly pummeled our world and planet opera in particular.

The question that every singer/artist had in mind was how he or she could exist without an audience, without performing on stage. With no specific concert or production constraints to prepare, with the feeling of days stretching and following each other endlessly, it became/ becomes challenging to find the motivation and energy to learn new works. But what I redis-covered was the pleasure of singing for its own sake. I have fun working on music, which I would never dare to sing on stage because it is at the limits of my vocal capacities, but which stimulates and forces me to keep in shape, like Strauss's *Vier letzte Lieder*, for example.

The joy of interpreting music and embodying characters has been with me since my childhood, and it is instinct, for the most part, that has guided my acting and singing since I first set foot on a stage. I studied my characters conscientiously, their psychological state and their context, each one of their words. But my teachers taught me that this could lead to a dead end. Singing a role this way, "from the inside," creates physical and emotional tensions, which hinder vocal projection.

Therefore, I have to absorb the score through careful preparation and then detach myself from it. I found that by looking at the character "from the outside," I can access the state of relaxation required to reach the high notes, and above all, to conserve the energy necessary to hold out for three hours on stage. The lockdown period allowed me the oppor-tunity to further develop this approach. At the same time, the assiduous daily work of scales and technical exercises, which I have always done, continued. This is essential to maintaining the subtleness, flexibility—and range required for the roles I've made my own. Indeed, the tessitura of the lyrical mezzo repertoire requires mastery of the high-pitched passages. As my singing capacities developed, I progressed from Cherubino's G to Charlotte's A, to Elvira's A flat, then to the Komponist's B flat, the Cenerentola's B, and finally to Judith's exhilarating high C. At the same time, the medium needed to remain round and well projected since it is there that most of my roles lie. As for the low notes, control is equally important to avoid the

unpleasant vibrato caused by an artificial thickening of the sound. I enjoy playing and singing *Carmen*, but the role requires a great deal of concentration to avoid pushing the voice—I want my Carmencita to remain lyrical.

In 2015, the birth of my son transformed my approach to singing in every way. Whether physically, in breath and support, or psychologically, with the new sense of fullness and confidence I gained from being a mother. I felt liberated from the shackles, which had previously hindered my voice.

Motherhood put into perspective the problems that obsessed me on stage: false notes, diction errors, or memory lapses became less serious next to this new human being for which I was now responsible. There was suddenly a more significant challenge than any I'd faced before: that of delving into the unknown to raise a child. Thus liberated, I felt a new pleasure in singing and became more attuned to the orchestra and my colleagues. My identity, which was so closely linked to my profession, found a new center of gravity.

Strangely, the upheaval caused by Covid-19 and the closure of the theaters in the spring of 2020, though entirely different in nature, was equivalent to what I experienced in becoming a mother because I had to redirect my energy entirely and gradually reassess what truly defines me.

Now, after a year, which has been transformative, I am looking forward to seeing my colleagues once again and to bearing the Rosenkavalier's silver rose, full of the incomparable joy of performing for a live audience.

January 1, 2021

Canadian mezzo-soprano, famous for her interpretation of travesty roles such as Cherubino, Octavian, Siebel, and Sextus. Michèle Losier has also won acclaim for her outstanding performance as Charlotte in Massenet's *Werther* and in the title role of Bizet's *Carmen*.

OPERA: THE PRESENT, THE FUTURE

Joseph Calleja

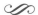

The prospects for opera were not looking good even before the Coronavirus pandemic. Statistics already showed that in the United States, where audiences are traditionally strong, the art form's popularity has been in steady decline. The ever-worsening situation threatens to starve theaters and artists of the revenue they need to keep them alive.

Opera is not an amateur pursuit. It requires preparation, which means painstaking research and in-depth knowledge are necessary. In days gone by, this tended to come through the family unit who listened to opera at home, where children learned about it from a young age. It was also part and parcel of educational systems. But in the United States, they are no longer investing in musical education and, though the situation is a little better there, the same thing is happening in Europe. One must realize that the core opera audience consists of an older generation, and as time goes by, they are dying out. Younger people are not as interested in opera; therefore, the trend is irreversible.

The only way to address this problem is to support the arts, particularly opera, since it is the most complex and complete form, and bring it back into our educational system. Otherwise, we will lose it. I believe this is not a case of if—but when!

Covid is only going to make matters worse. But one positive aspect of this pandemic— perhaps the only positive one—is that we have seen an enormous spike in the number of people yearning to see or hear live performances. Livestreaming has proved to be an inferior substitute for the real thing, and since the pandemic has limited live events, more and more people realize that the thrill of being physically present is irreplaceable.

When you go to a theater or concert hall, there's a beautiful sense of the unexpected: What am I going to hear?; Will the singer hit the high notes?; Will it be emotional? There are very few things that can replicate that sense of anticipation and excitement. You certainly cannot get that from a recording because you know exactly what's coming. There is a collegial feeling in the hall with a live performance and the wonderful, shared experience with people who love the music as much as you do.

It is a reality that the media today are not as interested in opera as in the past. Mainstream chat shows rarely invite opera singers these days, and when they do have them on, it is not for an interview but only to sing a piece at the end. Hence, if we do not plant that seed in our future generations and nurture it, opera will either die or change so drastically that it will no longer be called opera.

Those working in opera have the additional challenge and responsibility not to make it too exclusive.

I am not referring only to ticket prices, because I think they are fair and compare well with other entertainment forms, including premium football matches. But we have to take great care not to place too many restrictions on ourselves and ultimately our audience, for example, dress code, etiquette, and the superior attitudes that can exist among certain people in the opera world.

Even Luciano Pavarotti was attacked by the critics (whom I refer to as opera snobs) who accused him of "selling it" because he was such a star. He did not sell out at all! The Great Caruso was the Michael Jackson of his time, and Pavarotti wanted to bring that back. The Three Tenors phenomenon, which included Pavarotti, Plácido Domingo, and José Carreras, was incredible and had a fantastic story behind it. It was not just their singing but their passion for football that brought them together, and people loved it.

We need to get it into our heads that there is absolutely nothing wrong with singing into a microphone in front of an audience of 500,000 people. Quite the contrary, we need to be doing it more often.

In many ways, Andrea Bocelli is Pavarotti's successor because he is the only one in the genre capable of filling huge arenas. Rather than seeking to deride those who bring opera to a broader audience, the opera world should exploit them, in the best possible sense of the word, and use them to promote the beauty of opera among those whom our traditional theaters cannot reach.

Should that be the only way to enjoy opera? No. But a larger audience serves as a support system. Opera in its traditional form and its more accessible form are not enemies, but friends.

Of course, even presenting opera in any form has become difficult because of the pandemic, and we need to accept that it will take many months for audiences to return to theaters, and possibly even longer until mass events can be held. This came like a bolt out of the blue to performers like me and has not been pleasant. I have managed to release an album during this period, *The Magic of Mantovani*, which encapsulates what I'm saying because I'm using the operatic voice to sing these Mantovani classics with the object of making the genre more accessible. I hope this can draw people into opera who otherwise would not have taken an interest.

So, this is one route we should take. But opera also must receive funding. Ticket sales alone cannot cover the costs of producing opera. And to those who question whether it is worth preserving, I would say of course it is! We need art in our lives because otherwise, all we will be left with is a society of so-called social media influencers with no talent. Opera personifies beauty and reflects our cultural soul.

Therefore, we need to take care of the art form. Because if we do not, opera is going to die a not-so-slow death. But we need to have a plan for post-Covid. That plan must be to make opera thrive again.

One of today's most successful lyric tenors, Joseph Calleja is a regular guest at major opera houses worldwide. He is one of the directors of the European Academy of Music Theatre, and a cultural ambassador for his native Malta.

THOUGHTS FROM QUARANTINE

Christa Ludwig

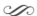

As in previous years, I was scheduled to hold a course for young singers during the time of the Salzburg Festival. Memories came to my mind of my Leonore in Beethoven's *Fidelio* or of the Marschallin in the *Rosenkavalier*. They are not wistful, but rather the opposite. Now at the age of ninety-two, I'm no longer interested in opera. I had to cancel the course due to the Corona pandemic. I have retreated into self-chosen quarantine at my house overlooking the vineyards of Klosterneuburg, and I'm very happy about that, nobody bothers me here.

"You have to be light, hold with a light heart and light hands and take, hold and let go." These words of the Marschallin are my life motto. My colleagues of yesteryear, Ileana Cotrubas, and Gundula Janowitz, are happy to be at home as well. I also don't care in the least that the Salzburg Festival can only celebrate its centennial anniversary to a limited degree and that other festivals are not even taking place at all. It's difficult, for instance for dressers, stagehands, lighting technicians, and all the other employees who earn little or no money at all. I don't worry so much about the singers, because most of them have enough in the bank.

These days, it often looks as if culture and education have already become expendable. I am not sure this will change again. I am a child of the war and postwar years. In 1944, when I was a young girl, there was total war; no theater, no cinema, nothing. I had my Matura certificate handed to me and never had to take an exam. Everything was in ruins after the war. There were only a few houses left, no schools, no books, no pencils, and above all, no teachers who were not National Socialists. At the time, we had no school for at least two years. Now people get upset when there is no school for two months. There was neither heating nor telephone, and mothers had to run to air-raid shelters with their children every day. I was happy that my parents were bombed out because I couldn't stand our massive, dark oak furniture and the red velvet curtains. My dad was a Wagnerian and loved these furnishings. He was a party member and was banned from working after the war. There were really only few men at that time. Many had fallen or were missing. And so, it was mostly the mothers who took care of the children.

There was no money, but there was imagination. "New life blossoms in the ruins," Schiller wrote. So I could finally do the things I wanted to do. Today people have lots of money and put all these random acts on stage. But above all, there was solidarity among us artists after the war. A short while later, that was all over, and everyone did their own thing. Some lived a life of plenty and others were penniless. I don't believe people learn a great

deal from wars and pandemics. You could, of course you could. But especially young people don't even take Corona seriously. They flout distancing measures, rant and rave, and accuse the government of limiting their freedom. They rarely follow even minimum distancing rules.

Opera will suffer least from these requirements. In love scenes, directors like Wieland Wagner or Klaus Michael Grüber were able to create amazing tension between singers across the space between them, without them moving closer towards or touching each other. As a trained photographer, Wieland knew that in close proximity everything loses its beauty. If you get too close to a flower, you no longer see it. In closeness, there is great distance, and in distance, there is great nearness. By the way, my father still addressed his mother as "Sie," the formal German "you." In life today, a certain kind of distance would be desirable again. It allows us to see the big picture, to look at the person you love.

Great personalities are a prerequisite for big opera events, but they have become rare today. A big part of this comes down to education and training. Too much is being instilled and drilled into people nowadays. You're not allowed to do this and not allowed to do that. You learn what you're supposed to do. Already in school they try to drive any rebellious attitude out of the children. What you get is plain Janes and Joes. Mothers want to know what jobs and income their daughters' boyfriends have, and not whether they're nice guys and decent human beings. In Music-theater, what it takes, above all else, is personality, which is far more important than a note that may be off now and then. Opera needs passion and feeling. Today, many of the voices sound pretty much the same, and lots of singers are only in it for the money. And so, I really don't know whether opera still has a future and whether this art form can, once again, capture the imagination of young people. But the future is always right. Our children are right, even if, in our eyes, they often aren't doing things right. You can't prevent anything. The train is rolling.

German mezzo-soprano, Christa Ludwig was born in Berlin and died in Klosterneuburg in 2021. She was considered one of the greatest voices of the twentieth century, distinguished for her performances of opera, lieder, oratorio, and solos in the symphonic literature.

TRAVELING STAGE DECOR

Ioan Holender

From a purely statistical point of view, the number of buildings around the world where opera—or sung theater—is performed is on the rise. The People's Republic of China and rich Arab Kingdoms see opera buildings as prestige projects. Large opera houses have been built in Beijing, Shanghai, and Guangzhou, as well as in Oman, Dubai, Abu Dhabi, Qatar, and Damascus. On our old continent as well, big, new opera houses have been constructed in Copenhagen, Oslo, Valencia, and, most recently, in Linz. In St. Petersburg, even a second stage was added next to an already existing one. And when a country suddenly becomes rich like Kazakhstan, it immediately erects a grand opera house in its capital of Astana. The handful of highly acclaimed European opera singers—Anna Netrebko, Jonas Kaufmann, Bryn Terfel, Elīna Garanča, or the old Domingo baritone—are brought in for vast sums of money in China and the Arab capitals, mainly for reasons of prestige. But even in the traditional European "opera countries," operas are performed now as ever, from German municipal stages to large state theaters.

How, then, does anyone even get the idea we should be mulling over the "Last Days of the Opera?" Well, above all, because for many decades now, no new works have emerged that are well-known and played.

The worldwide core repertoire consists of thirty-seven opera titles, which are played and enjoyed over and over and everywhere. While the clothing and food industry are continually and successfully propagating new styles and culinary creations, the opera cannot exist without *The Magic Flute*, *Aida*, and *Carmen*.

There is undoubtedly an opera crisis, and it is also due to the diminished quality of the productions. Currently, the main attraction of an opera performance is its staging. Directors—along with the long and expensive list of associates, such as video and lighting designers, countless dramaturges, and assistants—are essential to what is played; singers and conductors have taken a back seat.

Imperialist multiplication and commercial exploitation in the form of so-called co-productions are problematic as well. Fewer and fewer opera theaters, be they big and rich or small and poorly funded, create their own productions. Instead, they swap, borrow, and sell their opera productions. It takes at least two houses to do that, but there will often be three or more playing the same opera with the same stage set and costumes. Naturally, the director conducts rehearsals where the opera is first shown with the actors performing

there. At the second, third, or fourth co-producing theater, different actors take the stage. They have to make the exact same movements and show the same reactions as those in the first production. But here, the director is usually no longer present; he does, of course, pocket his fee a second time, but the imitation work is carried out faithfully and accurately by his assistant director. Just for the sake of clarity, what you hear in Vienna has previously been presented in Beijing and London or will subsequently tour to Milan or maybe the New York Met. In addition to that, the productions along with the traveling stage sets and costumes are sometimes shown on television as well. And the small stages follow the lead of the big ones, this kind of lively exchange is also going on between Regensburg and Oldenburg. The argument for this approach is reduced costs for the workshops. And, in case of failure, you have the excuse that you didn't come up with this stuff anyway. Or they say—and this is even more ridiculous—it allows them to know in advance what the outcome will be.

Like a book or a film, an opera production should stir curiosity as a creative endeavor—primarily among the audience and not just with journalists. But that's hardly possible anymore.

Of course, this absurdity they call a "system" allows you to stage more premieres and haul in more money with fewer resources. After all, producing operas is supposed to bring in money, and global sharing and partnering help acquire sponsors; and without their support, nothing is possible today. The further this type of commercial exploitation can be expanded and the more publicity it generates, the greater its effectiveness for advertising, which is to say, the payoff for sponsors.

Thus, we are approaching the "last days…" of the opera genre with sure steps.

It is a bit like the climate debate. It is not the latter itself that is causing the worldwide catastrophe, but we ourselves are the polluters.

Another development that inevitably leads to the depletion of opera singers, in the long run, is the increasing replacement of the repertory system by the *stagione* model. While the former allows a young singer to grow over time, to develop and acquire a repertoire that suits his or her vocal abilities, in the *stagione* system, you look for a guest singer for each role and pick the best fit—nowadays, the director has the biggest say in this decision. These "freelancers" will accept what they are offered. They are happy to be able to perform at all and mostly sing parts that are too dramatic for the early stage of their development. This is harmful to their voices and keeps them from following a path of gradual evolution.

But who is to guide singers on their path? There are no regulatory or licensing requirements governing this go-between professional, who is now called an "agent" and "represents" the singer. Thus, vocal artists are sold as quickly and for as much money as possible, no matter where and for what purpose. Likewise, opera directors are no longer interested in building up a young singer; most of them wouldn't even know how to do that. Instead, they hire so-called casting directors—incidentally, this job title was coined in the film industry—and then they get to pick the cast.

But if budding singers can no longer develop and grow within the ensemble of a repertory theater, because such houses hardly exist anymore, where do you get the guest singers from?

In sum, Karl Kraus' prophecy about mankind applied to the future of opera is unfortunately not so exaggerated.

Romanian-born, Austrian intendant and former baritone, Ioan Holender was a singer's agent, before becoming the longest-serving director in the history of the Wiener Staatsoper. Today, he is advisor to numerous international opera houses and the Tokyo Spring Festival. He also moderates TV programs as a cultural expert.

VOICE AND PERSONALITY.
UNDERSTANDING THE ROLE
OF VOCAL TRAINING

Margit Klaushofer

The original vision of the opera most likely arose from the aspirations of creative people to design a total work of art where artists from a wide array of disciplines could combine their individual potentials. A great work of art is born of the excellence of each individual contribution. It follows that quality and continuous development of training and education in artistic disciplines are essential prerequisites for success. The university as an educational institution in the broadest sense is a place where teachers and students come together to acquire and pass on knowledge and skills, to develop them in a creative fashion and subject them to research. It is called upon to provide optimal conditions for these practices and processes. In this vein, it needs to provide an environment conducive to the attainment of perfection, but also to foster the courage to experiment and fail, along with a constructive culture of error.

Opera in its original form is a product of the dynamic spirit of awakening that marked the era of the Renaissance. A revival of this idea, in the sense of harnessing together all the arts, could create an impetus for a new beginning and transform "The Last Days of Opera" into a reform movement of the twenty-first century.

I would now like to share a few personal thoughts from the perspective of vocal training—with special reference to my work at the Department of Vocal Studies and Music Theatre at the University of Music and Performing Arts Vienna (mdw)—and put them up for discussion.

Vocal Training through the Centuries

The key basic requirements for vocal training have changed little over the course of opera history. Clarity of text, speech articulation, nuance-rich vocal colors ("i colori di voce"), interpretation and embodiment, the ability to modulate *Sprechgesang*, legato, *messa di voce*, and "agilità," among others, form a common thread that connects all aspects of training and education. The same principles of *bel canto* apply today as they did in the past. Remember, Richard Wagner recommended that orchestral musicians prepare for the interpretation of his operas by working on string quartets and chamber music. To the singers of his works, he suggested practicing on music by Mozart, Gluck, and Weber.

"No amount of gloriously blasting out of the orchestral parts by any number of our concert bandmasters conducting operas today, alas, can silence justified complaints about such ear-splitting at the expense of understanding the plot and the poet's words."

Thus wrote Richard Strauss in the preface to his opera *Intermezzo*. If Wagner and Strauss are to be believed, drama is not achieved through loudness, but relies on other parameters, such as the way speech is treated, the clarity of consonants, or enhanced dynamic richness.

The development towards so-called specialism only took hold in the first half of the twentieth century. Before that era, famous singers were not only Mozart or Wagner singers and opera or operetta singers, but rather distinguished themselves through stylistic traits and personal forms of vocal expression. Volume-oriented singing methods that were developed in the twentieth century to sing over large orchestras have, in hindsight, proven to be misguided.

Why Are There No Dramatic Voices Anymore?

An ill-conceived kind of "type casting," which often erroneously prioritizes "as young as possible, as slim as possible, suited for the broadest range of parts, and permanently available," has led to singers being pushed into the field of dramatic roles too early. A voice can only grow if it is coached professionally and on a regular basis. Solid vocal training takes time in order to develop. This is the only way to ensure that dramatic voices can flourish again. What young singers need are experienced music directors, conductors, and opera directors at the interface between the professions. Whether inexperienced acting directors, who are unfamiliar with the musical arts, can be of help to young singers is anyone's guess. Musical directors, GMDs, artistic directors, opera directors, agents, among others, should have a vested interest in the sustainable and sustained careers of singers. Teachers at music universities and music schools are likewise called upon to live up to their responsibilities. Cooperation and networking between opera houses and music universities and schools is vital. We must shoulder the responsibility we owe to future opera singers together. This is the only way we can ensure that young singers get the support and develop the perspectives they need to pursue their dream careers.

New Ways of Education and Training

Sustained and consistent voice training from the start is a prerequisite for a professional artistic career. We need the best teachers at the very beginning of the education and training process! What it takes is profound and thoughtful artists with pedagogical experience, knowledge, and patience. This is not the place for any "masterclass" fuss; rather, what is required is artistic and pedagogical competence in the sense of solid craftsmanship.

Starting from the age of sixteen, aspiring singers are eligible to apply for vocal performance degree courses. Being able to reach a conscious decision to take up artistic vocational training at this age requires competent preparation that already begins in childhood and is continued through adolescence. This poses a challenge for a society interested in fostering the arts and educational institutions in the broadest sense, requiring improved networking and interaction between music schools and university institutions.

When it comes to entrance exams, teachers need to take their time to get to know the future singers and music or theater directors in various areas: vocal aptitude (talent), physical disposition, joy of playing, mental strength (evaluated through an admission or motivational interview), and music theory. In my view, it is important to follow a generous admission policy

at the beginning of study programs—be it for students applying for preparatory courses or directly for the bachelor's program. It is especially in the field of singing those things take time. Unlike instrumental subjects, the physical development of the voice as an instrument is the focus of the beginning the program that awaits newly admitted students; after two years, at the latest, an evaluation must take place ("Intermediate Program" exam). At this point, teachers have the obligation and responsibility to provide students with feedback that is both appreciative and honest. What this also takes is the courage to re-examine the accuracy of their career choice. Completion of the bachelor's degree is followed by an admission exam to the master's program, which both internal and external applicants are required to take. These "hurdles" allow both students and faculty to identify limits and opportunities. Graduating with a bachelor's degree can also serve as a basis for other, more specialized master's degree courses in related fields (education, sound engineering, cultural management, among others).

The occupational profile of the singer has become broader and more open. This is something we took into account when we set up our new master's degree program in Vocal Performance. It is an integrative degree (music theater, opera, and concert) with a narrow compulsory subject area and flexible areas of specialization and electives. To a large extent, each student is given the option of putting together a vocal studies course that is tailored to his or her individual abilities. In addition to the Vocal Performance degree, we also offer special master's degree programs in Stage Performance (Opera and Musical Drama) as well as Lied, Oratorio, and Concert Performance. At the start of each semester, "learning agreements" are drawn up by the Dean of the Students Office in collaboration with students in order to determine "semester workloads."

Of course, training and education are always also subject to a process of change—it is something that is always taking shape, always calls for evaluation along with the changes

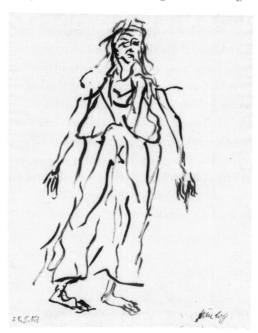

Georg Baselitz, *Kundry*, 2017
Inkbrush on paper,
66.2 × 50.1 cm
Design for *Parsifal*, Richard
Wagner, Bavarian State
Opera, Munich, 2018.
© Georg Baselitz 2020
(Photo © Jochen Littkemann)

and modifications resulting from it. And that doesn't mean constantly pandering to the mainstream, but helping young musicians assert themselves in a rapidly changing profession.

Thoughts on the Current Debate

The current discussion about the future of opera is, in part, shaped by critical statements that are based on the results of surveys and studies: "Only small and high voices are trained at universities these days," "Intendants and agents only want to market and make money," "Conductors don't know much about voices anymore," "The orchestras tune higher and higher, and they're getting louder and louder all the time," "Voice doctors promise the impossible," "Students aren't putting in the hard work and discipline." Even if many of these comments contain a spark of truth, I don't believe pointing fingers and playing the blame game will fix the problem.

The interpretation of study results can serve as a wakeup call and provide guidance in our search for potential improvements, but it is only helpful when it highlights possibilities, forward-looking findings, and opportunities rather than merely exposing the current situation. On a positive note, critical analysis can be the first step towards a creative new beginning.

In the past, it was still possible to play leading parts in smaller theaters first and only gradually be introduced to the larger stages. Savvy and experienced conductors and artistic directors often accompanied young singers on their career paths. In part, this type of support can also be provided through cooperation between educational institutions and theaters or well-run opera studios. As a prerequisite, however, the social and economic conditions young singers find themselves in must also be considered.

The increasing focus on stagione theaters and festivals, along with the cult of stardom that comes with it, has created an excessively economized opera business and has gradually reduced the career opportunities for young singers. At the same time, the income gap between the few stars who dominate the global opera scene and the many qualified opera singers has widened disproportionately. This trend, which, of course, has taken hold of other areas of the economy as well, is in urgent need of correction.

"Art washes away from the soul the dust of everyday life" (Pablo Picasso), it is key in building the future of our societies and in allowing people to live in dignity. Critical and candid examination of the past as well as the present are not mutually exclusive, rather, they point the way to the future. Young artists are entitled, or are even called upon, to be rebels of art. This will ensure that the way they approach their vocation is marked by sincerity and freedom. As I see it, my job as the head of the institute is to provide the fertile soil and the structural conditions that foster the unfettered development of creative potential. If we succeed in this endeavor, the "last days of opera" are still a long way off.

Margit Klaushofer is head of the Institute for Voice and Music Theater at the University of Music and Performing Arts Vienna. Her graduates are engaged at leading opera houses, including Wiener Staatsoper, La Scala Milan, the Braunschweig State Theater, the Leipzig Opera and the Deutsche Oper am Rhein.

WE WILL SLAM YOU
WITH OUR WINGS

Joanna Dudley

"Joanna Dudley's wonderful operatic video piece shows again her immaculate, precise, yet raucous anarchy. She has taken her experience of voice and movement and used it as a protective embrace for six girls / young women. It offers many new insights and raises questions about what video and opera performance can be."
William Kentridge

Two years ago, I performed in the blockbuster music performance, *The Head and The Load* by William Kentridge, with music by Philip Miller. I played Kaiser Wilhelm sporting formidable paper and cardboard Kentridge drag. The show went from the Tate Modern Turbine Hall to the Park Avenue Armory, NYC, to the Ruhrtriennale with resounding success. During the whole experience, my own ideas for an installation had been slowly brewing away, and by the end of the run, I told myself, it was time to get started. Three years and a pandemic later: *WE WILL SLAM YOU WITH OUR WINGS*, a seven-screen, operatic video installation for an army of six girls between the ages of eight and sixteen resulted. I feature in a cameo role as the war mistress, encouraging the girls to take autonomy over their own voices and create the world afresh. Each of the hanging screens in *WE WILL SLAM YOU WITH OUR WINGS* is a classic nineteenth-century imperialist portrait but with one noticeable difference: instead of the lavish depiction of a powerful white man, a young girl stands in her own regalia and commands her stance of power. This group of young girls incarnates the leaders, the army, the chorus, the pack, the collective, and the future voice.

The starting point is a dramatic re-look at the soprano's death aria; each girl reinterprets the choreography from one known operatic aria, as solos, simultaneously or in a myriad of dramatic collapses. Taken out of the opera's larger context and placed next to one another, the deaths look absurd, and the tragic fates of Dido, Tosca, Madame Butterfly, Salome, Brünnhilde, and Suor Angelica take a turn for the better.

For the finale of *Salomé*, a life-size Barbie doll head is held from the hair by eight-year-old Beatrix Juno Dudley. Ruth McIlleron, playing Tosca, decides her fate by jumping from her chair onto the floor, and meanwhile, twelve-year-old Tabatha Howard, as Salomé proudly holds high a handful of dripping pink slime. As Brünnhilde sings her final notes, the girls wave black flags of anarchy and take on well-known stances of nineteenth-century

imperialist portraits of men, making the stances very much their own and conquering all around them. In *WE WILL SLAM YOU WITH OUR WINGS*, patriotic speeches from the world's male dictators and leaders proclaiming the declaration of war are not left unscathed. They are rewritten, re-screamed, and re-performed in an entirely different way again and for very different purposes and outcomes. Each screen runs simultaneously, creating a highly choreographed choir and polyphonic operatic sound score.

I have never had a man fall on his knees before me, never been close to death, or even come down with a cold from a broken heart, nor has it occurred to me to self-inflict even a scratch for the sake of love. On the contrary, I have enjoyed a gem-filled career as a singer and performer creating contemporary performance, choreography, and installation. My primary collaborators are William Kentridge and composer Philip Miller; others have included Seiji Ozawa, Sidi Larbi Cherkaoui, Heiner Goebbels, and Thomas Ostermeier. I have performed major (non-singing) solo roles at the Metropolitan Opera, English National Opera, Wiener Staatsoper, Dutch National Opera, Seiji Ozawa's Tokyo Opera Nomori, Rome Opera, and major (singing) solo roles in intimate to large-scale contemporary performance work at Carnegie Hall, the Park Avenue Armory, the Tate Modern Turbine Hall, The Louis Vuitton Foundation, BAM and at almost every major European and US performance and visual arts festival. My father is a composer and conductor who studied with Sir Peter Maxwell Davies and Pierre Boulez, and my rigorous education in early and contemporary classical music took place at the Sweelinck Conservatorium. My interest in opera is not whimsical, nor is my knowledge of music arbitrary.

While rehearsing, *WE WILL SLAM YOU WITH OUR WINGS*, I heard that Marina Abramović was also in the process of creating an installation based on operatic death arias. At first, I felt some concern, but it soon became apparent that we were looking at women, love, heartbreak, death, and the unfortunate fate of 99 percent of female characters in opera, through very different lenses.

Marlis Petersen, the hyper-intelligent, rigorous, and remarkably earthed artist, greatly influenced my view of the opera singer and the roles she interprets. We worked together in 2012 on William Kentridge's production of Berg's *Lulu* at the Metropolitan Opera. I played Lulu's alter ego sitting astride on, or inside of, and or around a grand piano for most of the evening. When I first saw Marlis, she was working with a professional "screamer" who was to execute Lulu's final death cry from backstage. It required some rehearsal, and I thought what an odd job that was—being a screamer.

More seriously, I thought about Marlis and what it means to be a world-class opera singer. It occurred to me that after this production of *Lulu*, she would probably be rehearsing another role with a similar fate, and again, and again. It seemed an awkward creative path for a vibrant woman of today, as wondrous as the music can be. And over the years, opera's blatant and endless frieze of elaborately destroyed women is, I feel, a disquieting norm. If there is a healthy future in opera, does this not need to be addressed by those who create and enjoy it? My opinion is yes, and I would like to introduce just a few of the next generation of thinkers who also have their opinions.

Tabatha Howard:

"I have so much to say about this. In opera, women are mostly killing themselves, going mad, or doing something mad. My death in *WE WILL SLAM YOU WITH OUR WINGS* is very strange; I decided to blindfold my son and kill myself right there and then. Why do I kill myself? Because of a man. Tosca decides to kill herself by jumping off a building. Why? Because of a man. Brünnhilde decides to kill herself. Why? Because of a man. We don't need men to survive. We don't need men to write the story of our lives… There needs to be some killing, suicide, and drama in opera. That is what it's all about. But it shouldn't always be women dying and doing weird things. Women should be portrayed as leaders, fighters, and rulers."

Mpho Takane, age ten, understood Suor Angelica's fate but also feels that new stories need to be told:

"I don't find the fate of my character weird because she sacrificed her own life for her son because she probably missed him very much. It's odd, though, that lots of women in opera kill themselves for a man or a boy. The women in these stories are strong and brave, but the reasons they kill themselves make them look weak. These stories should still be told, but new ones should be too, to show how the roles of women have changed. Women should be shown as strong, independent, and gorgeous characters and have equal power to men. It is also important to encourage small girls who are growing up not to kill themselves over tiny things like men."

The future of opera, according to another cast member, Kittu Hoyne, age seventeen:

"I do feel the storytelling of these traditional operas is very limited, and the representation of women blatantly one-dimensional. And with our modern age lens, the tragic female death scenes now seem somewhat comic. Through works, like *WE WILL SLAM YOU WITH OUR WINGS*, there is so much room to develop new and empowered female roles in the operatic form. And with this, there is much hope for this art form to reignite new female contemporary stories and more broadly the opportunity for younger audiences like myself to build deeper connections with opera."

None of these performers are professional actors, nor did they audition. They are all children I watched grow up, daughters of friends and colleagues. As a result, we worked in continents as far afield as South Africa, Australia, and Europe and in spaces including William Kentridge's studio in Johannesburg, London's Whitechapel Gallery, a Florentine palazzo, and a fisherman's Union Hall in South Australia. Each girl had a three-day workshop with me where she improvised on given tasks and created her personal choreographic language and the death aria choreography, often using a famous historical performance as a starting point. Time was spent discussing what the project meant each step of the way so that each girl, whether eight-years-old or sixteen, understood precisely what we were doing and why. If I couldn't answer someone's question or explain an idea convincingly, then I knew it had to

be scrapped and move on. It was important that the material came from the girls themselves and was based on their personalities to ensure they had ownership of the material. Each film shoot was a stress-free environment with all-encompassing emphasis on the girl being filmed, ensuring she felt she was the most important person in the room and that she was looked after.

Powerful in their collective consciousness, the girls in *WE WILL SLAM YOU WITH OUR WINGS* spawn an altogether different kind of social order based on their own rules and their wishes. The hunted becomes the hunter, the tamed controls, and the dying beauty takes her revenge. Rather than being led to their deaths as we have grown to expect, this young female army leads you to watch them loudly, playfully, proudly, and unnervingly conquer.

So how does a project like *WE WILL SLAM YOU WITH OUR WINGS* relate to the future of opera? A lot, if one considers that significant change can happen if women are included much more in the making and producing of opera. Not out of political correctness, but to tell the stories as decently and rigorously as possible, and considering that most opera's music, librettos, and stories though written by men, are centered around women, bringing more women into opera's creative and producing process is essential.

Opera, in its glory and absurdity, can continue to be a source of inspiration for artists across many fields, simultaneously broadening its audience base. As an eternal optimist and a Darwinist, I believe any art will survive if it is good, but good means resonating with the people of today, being inclusive of women, eliminating the Glass Ceiling Effect, and widely embracing a diverse cultural community.

Australian born, Joanna Dudley works internationally as a stage director, performer, and singer, creating music theater, choreography, and installation. She has frequently appeared in productions staged by the South African artist William Kentridge.

THE SYSTEM IS BROKEN

Elisabeth Kulman

Yours truly has a confession—making opera was always suspect to me. Don't get me wrong; I love music, singing, and making music, as well as acting and experimentation, delving into deeper layers and soaring to higher spheres. But opera? Even after twenty years of actively pursuing a career in this art, some of it still feels strange to me. I remember when my brother and I, as country kids, heard Pavarotti sing on TV. We started to laugh and changed the channel. Today, I've come to consider this spontaneous reaction as a brutal and unfair verdict, but children are, of course, still pure, direct, and honest. The rotund man in the stiff tailcoat sporting immaculate black hair and eyebrows, repeatedly using his white scarf to wipe the sweat from his forehead while incessantly beaming a winner's smile, seemed more a caricature to us than a real person. He could produce all the beautiful singing he wanted; it left us cold.

I must have been in my mid-twenties when I went to see an opera for the first time. It was *Salome* at the Wiener Staatsoper, and I can't remember the cast. The performance ran without intermission. I left early because I could no longer bear the "wobble" in the voice of the leading performer and couldn't follow the action from the standing room due to my bad eyesight. And so, the second time I gave it a try was once again a complete and utter failure. Ultimately, some ten years later, I stood on that stage myself a dozen times, performing in this very production and embracing the role of the inscrutable Herodias with every fiber of my being. *Salome* has ranked as one of my favorite operas ever since.

During my vocal studies at university, it took some persuasion before I finally agreed to take on my first opera role, stepping in for an ailing Susanna in the university production of *The Marriage of Figaro*. I had no interest in dressing up and miming and always wanted to be myself, as authentic as possible, and not slip into roles and portray something I was not. Things came as they did. I had acting talent, and began to enjoy my successes with teachers and audiences. And yet, in all those years before I departed from the opera business in 2015, no one ever noticed that I was never really playing the role I was cast in but always played myself in the character's situation. In this way, I overcame my inner conflict by pursuing my quest for truthfulness, and audiences even found me particularly credible.

As you can see, my relationship to the genre of opera is an ambivalent one. I wanted to lay this out before I get started, so you, dear reader, know what to expect should you decide to keep reading. I hope to make it apparent that my appreciation is, at a minimum,

as great as my criticism. The questions I raise are intended to inspire reflection and encourage others to give free rein to their imagination. This could lay the groundwork for a powerful new start.

Are we witnessing the beginning of a dramatic downfall? Is European culture, the much-vaunted cradle of classical music, the historical showpiece, and the international cash cow facing its demise? Quite coquettishly, the death of opera has repeatedly been prophesied, but no one ever seriously thought that was actually in the cards. Can these institutions, with all their commitment to tradition and museum-style management of historical works, be saved through a transformation process that heaves them into the present and future? Can the opera and its antiquated themes still touch hearts and minds today? What is the proposition Europe is making here and now, different from its past? One thing is clear: the past isn't coming back, and things won't ever be the same again. What becomes of it is up to us as creative individuals and what we make of it collectively as a society.

Like one big clap of thunder, Corona has made visible what has long been suppressed, glossed over, and denied. It has rendered painfully apparent just how far apart self- and external perception are. The indifference or even contemptuous ignorance of the political establishment and mainstream society towards art and artists pushes them to the edge of irrelevance, stripping them of their value while propping up powerful, lobbied economic sectors. Our so-called high culture, in particular, has, casually speaking, a massive image problem. But polishing the veneer won't be enough because the underlying problem runs deep.

Let's look inward. Theaters are built on outdated feudal, patriarchal management structures from the nineteenth century. Autocratic directors concentrate power in their own hands and open the door to systematic abuse. Nepotism, lack of transparency, embezzlement, cartel agreements along with already low artist fees, incompetence, narcissism, toxic workplace environments, and sexual assault are the tragic consequences, and unfortunately, we are not talking about isolated cases. Starting in 2013, I have been raising these issues publicly, and I warmly recommend our YouTube channel "What's Opera Doc — For Professional Opera Singers." It provides a media platform for industry insiders and makes one thing abundantly clear: the system is sick. Terminally ill? The classical music business is a merciless industry; it's infested with inflated egos who stop at nothing, and have forgotten the most important thing, and have even degraded and reduced it to a waste product—the genius creation by the composer—the "umbilical cord that connects us to the divine," as the great Nikolaus Harnoncourt so insightfully and sagely put it. The hierarchy has been completely turned on its head. Instead of serving the work, which would be the primary task, people pay homage to the superficial event, the vain cult of stardom, and the slavish pursuit of Mammon.

When we look at today's productions, we see ugly stage sets almost everywhere, cluttered with mundane stuff and trash—or unimaginative emptiness. Our eyes are treated to hideous costumes devoid of any aesthetics or taste. Singers find themselves shooed around senselessly or left to their own devices by clueless directors. Where's the umbilical cord to the Divine? As a mirror of society, today's theater shows us chaos, unkindness, indifference, and over-saturation. Heaven seems to be out of reach.

Opera is a re-creative art, and its makers are mostly dead today. As re-creating performers, we bear the responsibility towards the work passed down to us. We are servants, mediums, mediators, breathing life into notes the composer wrote on his woefully lifeless sheet of music in a frenzy inspired by the muses. I consider my singing to be a sacred task. Performing Mahler's *Resurrection Symphony*, for example, is meditation, prayer, catharsis, revolution! The operas of our great composers are kaleidoscopes of emotions, love and loathing, pain and death, longing and pleading, joy and hope, the splendor of life, and so much more that cannot be put into words but can be expressed through the ingenious invention of music. But how much of that resonates with audiences today? After attending an opera or concert, shouldn't people be jumping, dancing, singing, cheering, skipping, and running home joyfully to turn their lives upside down? "From the heart—may it return to the heart!" Thus Beethoven wrote about his *Missa solemnis*. The task of us musicians is to pass on the creative spark. And we need helpers and enablers to support us in doing just that and only that.

So the most crucial question that cultural event organizers need to ask themselves is this: what are the prerequisites, circumstances, and conditions that our artists need in order to convey the deep essence of the work of genius as a transformative message in as authentic and honest a way as possible? If the fertile ground for truthfulness is prepared, no one will have to worry about attracting audiences. Truthfulness is always convincing and the key to success.

But what are we really saying? Live events were banned at the outbreak of the pandemic. A firm political commitment to art as a human right is lacking worldwide. Despite numerous attempts, artists have not succeeded in convincing the public of their relevance as local providers of mental and spiritual amenities. If media theoretician Peter Weibel is to be believed, we are currently evolving into a digitally controlled remote society, and he thinks that sports stadiums and opera houses will be the "pharaonic tombs of the future." Even if it doesn't come to that, anyone not burying their head in the sand can see that our rich cultural landscape will suffer massive cuts, if not a complete breakdown. In many places where things have gone way over the top, I think that such a compulsory fasting cure is long overdue and salutary. Elsewhere, a process of starving out is causing massive damage, not to mention the artists' livelihoods that are being destroyed *en masse* and the creative potential that is being crushed.

That makes the question all the more urgent: what kinds of art do the people of today and tomorrow need? And which of them have served humanity well but can, with a sigh of gratitude, be consigned to history?

The golden age of opera is abundantly documented and recorded. Internet platforms provide unrestricted access to anyone interested, for the most part even free of charge. The fascination is still there, as the pageview statistics show. Will the time come when people are weaned off from the experience of live opera performances or saturated enough to give preference to digital formats? Will future generations of singers record opera series in the Netflix format, enticing music enthusiasts to binge-watch their art online? Are composers going to write music that has all the makings of a blockbuster opera show? Will it still be called opera then? And how will the music sound when it caters to the audience's taste and

not that of the expendable newspaper arts sections? Perhaps more harmonious and melodic than we have been hearing on stages so far? How will singing voices change when they no longer have to fill large performance halls but can tenderly sing into your ear?

When the first lockdown was imposed in Austria in March 2020, it prevented me from singing Fricka in *Die Walküre* at the Wiener Staatsoper, a performance that was supposed to double as a farewell celebration. My first thought was a rather scornful one. In my mind's eye, I imagined that the sacrosanct house would soon be converted into an Amazon warehouse. In keeping with the motto: consumerism beats art. I don't want to believe for a second that this dystopia could become a reality. But is the idea of repurposing concert halls and opera houses so far-fetched? They could serve, for example, as multifunctional temples of the arts, as energizing places of power, as spaces for creativity and regeneration, for the most beautiful art forms imaginable. There's something new to discover every day; music is played on every corner, there are small and large-scale events, opera here, theater there, as well as dance, painting, and whatever other beautiful things there may be. Musicians get together spontaneously, delighting themselves and their listeners with their play, inviting them to discover and participate. It's like walking through a magical park where the sun shines every day. It instills in us its power and connects us with the heavens like a divine umbilical cord. Isn't that a wonderful vision?

I invite you to think anew. If you love opera and the arts, now is the time to venture new thoughts and steps—without prejudice, resentment, and fear. Let's begin like a child taking its first breath—full of confidence, joy, curiosity, and courage. I have given you some insight into my world of imagination. And now, what are *you* dreaming of?

Austrian singer Elisabeth Kulman has performed operatic roles in the soprano, mezzo-soprano, and contralto repertories internationally. She has a vast repertoire ranging from baroque operas to Richard Wagner and contemporary music. Since 2015, she has focused mainly on concert singing.

NIGHTS AT THE OPERA
ARE A RITUAL

Camilla Nylund
Conversation with Christian Kircher (December 2020)

Christian Kircher: *When and where did you first come into contact with opera?*
Camilla Nylund: It was as a teenager, back home in Vaasa. There's only one opera house in Finland, the National Opera in Helsinki. It's quite a new one, founded in 1911. The first theater built especially for opera only opened its doors in 1993. As of yet, no other Finnish city has an opera house, but some have smaller theaters that feature operas from time to time. Tampere, for example, has a large convention center with a concert hall that has pretty good acoustics. They stage one big production a year.

And how did that come about for you in Vaasa?
Vaasa is a small town with a population of 55,000. There was a woman who had been an opera singer and went on to found an opera society, which produced one opera a year. The performance took place on one of Vaasa's two stages—which were built for straight theater and are quite small.

What was the impression opera left on you as a teenager?
What fascinated me about opera from the start was the Gesamtkunstwerk. Any layman singing in the shower or the church choir knows the feeling of joy that singing can give you. Then, if you act, wear a costume and slip into a role too, you have the perfect Gesamtkunstwerk.

In the old days, going to the opera was a perfectly normal thing for middle-class folks, because it was part of the educational canon. By now, you have to wonder whether audiences who see opera as an integral part of their lifestyle even still exist.
I certainly believe that these middle-class folks still go to the theater. I started my career in Germany, as you know, and you still have audiences there who flock to their subscription performances on a regular basis. Of course, Germany is a special environment, it's the country with the highest number of theaters in the world.

Why do people go to the opera today? Because they yearn to be touched by great voices? Or because they want to immerse themselves in a different world?
I'm sure it's about hearing beautiful voices for a lot of people. They will attend shows that feature their favorite singer. But then there are those who go to the opera for the work itself, as well. They come to see Carmen or Tosca—and to listen to the music, to Mozart or Verdi, and not just the voices.

Is the content of an opera secondary? Andrea Chénier, one of my favorite operas, is about love that lives on beyond death and the revolution that conquers all. Does that really matter at all, or make any difference?

It does matter, absolutely. I think that opera and theater should always also hold a mirror to society. So, it's not just for pleasure that the audience goes to the opera; they should be able to learn something there about the society they live in, as well.

This begs the question as to whether that is even possible with traditional sets and staging. On the other hand, updating the time and location of a work into the present day often sparks lively debates. What are your thoughts on this issue?

It's a fine line to walk. I'm not against new interpretations, I even think it's a very good approach. But I don't believe everything should be reinterpreted. There are operas, for example, that are deeply rooted in a particular period—and then things become extremely complicated. As an artist, you should immerse yourself in the history too and ask yourself: How did people move back then? How did people think and talk about certain subjects? What was life like in those days? I think that, in this sense, opera is certainly an educational institution as well.

Are there any good new operatic narratives? Does opera even have the wherewithal to represent contemporary society?

I think so, yes. In Finland we have the Savonlinna opera festival where a lot of new Finnish operas have premiered over the last twenty or thirty years. For a long time, there was only Sibelius in Finland, no other composer could hold a candle to him. But, first, Sibelius had not composed any operas, and second, he was dead. And so, luckily, one new Finnish opera premiered in Savonlinna every summer.

Did these works also appeal to new audiences?

I think so, but of course you have to get everything right. You need good singers, you need a great libretto, and then of course the music needs to be captivating, even if it's "modern."

Modern music needs the best interpretation you can get!

Yes, exactly. When I did my début at the Metropolitan Opera in New York, I also went to see the opera *Akhnaten* by Philip Glass, which was playing there at the time. The music was quite monotone, but the performance was a mesmerizing spectacle with a great set—and it drew a large audience, it was huge a hit.

In times like these, how do you argue that you need a lot of money to produce operas—and not just to fight terrorism or pandemics?

Opera costs a lot of money, sure, but it's also an economic factor. Large parts of the audience come from abroad, and a country with a rich cultural sector like Austria thrives on that. Besides, opera is simply a tremendously important part of Western culture. If we can't keep that alive, is any part of our world going to last?

Religion?

Yes, but religion does come up in opera! Much like in a church, there are certain ritualized procedures in opera, and singing features prominently in both of these settings. The difference being that you get to sing along during religious services. But an opera audience is also expected to get actively involved, to voice their opinions—ideally, of course, not until the performance has ended. Going to the opera is a form of social ritual, as well. Lots of people enjoy dressing up, going to the opera, dining at a nice restaurant later on and discussing the performance. For me as a singer it's extremely important as well to talk to someone about a show when it's over. It's particularly interesting to me when I'm not talking to colleagues, but to people who have just sat through the production for the first time and tell me what the experience was like for them. It's genuinely exciting for me to engage in this dialogue between the audience and the performer—among other things, to keep improving.

To be able to do that, you need an audience that is willing to engage with the opera and its content. Which brings us to the key question, and that is how do we reach new audiences? How do we get people inside the opera?

The big problem everywhere right now is that the political world doesn't realize just how important it is to support culture and keep it alive. Why, for example, is classical music and opera so important to people in Japan? People are really passionate about it there, and audiences consider opera to be the greatest thing in the world.

Do you know why that is?

I'm sure many in Japan view it as something exotic; they have their own music, of course, their own theater, Kabuki, etcetera. They see the opera as something magnificent and elitist, as a special treat you splurge on. I remember performing in *Der Rosenkavalier* in Tokyo in 2007. It was directed by Jonathan Miller, he set the play in the period before the First World War. I was wondering at the time whether you could actually stage *Der Rosenkavalier* like that. Doesn't it have to be set in the era of Empress Maria Theresa? Be that as it may—the Japanese audience was mesmerized. At the end of the first act, for example, the Marschallin feels sad, it's raining, she gazes out the window and lights a cigarette. The audience just loved it! If you watch Japanese TV sitcoms, you always see these actors who feel sad and blue, too; they don't talk a lot either.

That reminds me of those Japanese color woodcuts where it's always raining, they express such an ardent longing.

Yes, longing is the key word. What would life be without longing? Without yearning, without love, without passion? Even if you've never experienced it in your private life, if you can experience it at the opera, it's an incredible feeling.

Finnish operatic soprano, Camilla Nylund is considered one of the world's leading lyric-dramatic singers and the ideal interpreter of the works of Richard Strauss and Richard Wagner.

2.

Opus

Words and Music

OPERA CAN DO IT ALL—HAVE WE FORGOTTEN HOW?

Joana Mallwitz

Everyone is all too familiar with the question as to whether opera is still in keeping with the times.

Most of us reflexively resort to descriptions of the greatness and complexity of this art form. What is much more interesting, though, is not the question of form but substance. What can opera do? In my mind, there is an easy answer: The true power of opera culminates in the moment when the sung word pierces the listener to the heart. This moment is the epitome of art, as ancient as it is modern, and it has not lost one iota of relevance over the thousands of years of its tradition since the myth of Orpheus. Even today, various casting shows that feature a mix of breathtaking acrobatics, magic tricks, and dance are mostly won by the singers. Nothing touches people more than the human voice. Song conveys feelings so powerful that the spoken word no longer seems sufficient. In opera, this effect is taken to the extreme. To make this moment possible, to bring it about, to inspire it, and magnify its power, the *Gesamtkunstwerk* of the opera combines the most diverse skills and crafts: vocal technique, acting, creative drive, orchestral sound, ensemble acting, instrumentation, the art of conducting, direction, stage design, props, acoustics, costumes, make-up, and lighting.

In my mind, it is therefore patently clear that opera is in keeping with the times, but our approach to it is not. We no longer have confidence in the real power inherent in opera. Instead, we mistrust its effect, thereby becoming more and more alienated from its true inner nature. In this sense, the answer to the question raised at the outset is a self-fulfilling prophecy: because, of course, an untruthful art form has no contemporary appeal—and never has at any point in history.

It is not the opera that is outmoded, but what we do with it. Due to ignorance or fear, we do not dare venture to its core, focusing instead on appearances. Nonetheless, everything can and must develop from inner content and substance. If we feel ashamed that many of the greatest operas were written in past centuries, are we actually taking this as an indication that opera is no longer modern? No one wonders whether the Sistine Chapel or the Mona Lisa is in tune with contemporary culture. Such a work of art speaks to each and every present-day viewer about its own time, but also about ours, and every generation ought to have the right to marvel at and reassess for themselves these landmarks of human art and civilization. You cannot hang opera onto a museum wall—on the contrary, the wonderful thing is that this art form can only be experienced and kept alive by making it resound and ring out over and over again. Music lives in the moment. And when played with sincerity, it's always contemporary.

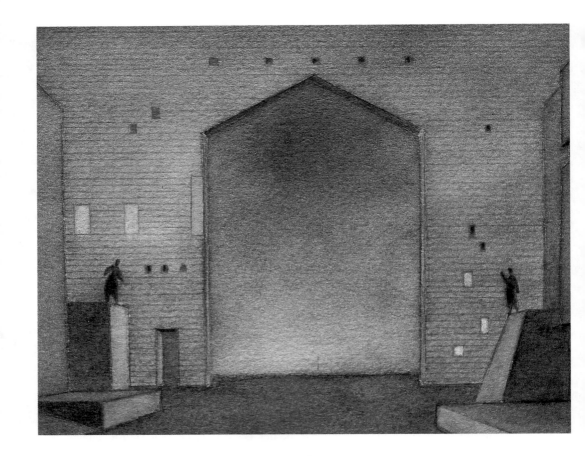

Richard Peduzzi,
Untitled, 2007
Charcoal, watercolor, and
pastel on paper, 25 × 31 cm
Design for *Tristan und
Isolde*, Richard Wagner,
La Scala, Milan, 2007.
Director: Patrice Chéreau
Courtesy of the artist
© Richard Peduzzi
(Photo © Pénélope
Chauvelot)

But why is our approach to opera so dishonest, so full of fear and shame? The answer is as simple as it is frightening: we have no confidence in its core feature—the interaction of text and music. The two of them are perfectly sufficient to create the miracle of opera. Its flames are fanned by all the accompanying art forms, which require craftsmanship, study, and effort from all those involved in their respective fields. Only in this way can the artwork of all artworks ultimately take shape. But if this foundation does not hold up because it is adulterated and not thought through, the whole house of cards comes tumbling down. We must therefore dedicate ourselves to one issue in particular, namely how we deal with the text.

So, let's talk about the text. And not in the sense of "what comes first," "prima la musica," the old discussion, but on a much, much simpler level: who says what to whom and when? Not paraphrased or roughly summarized, but word for word. This question, while it sounds straightforward enough, is so alarmingly often left unanswered.

This is where the real work begins. It is, of course, quite demanding, for example, to translate old Italian and acquire it to the extent that it sounds linguistically authentic, and its use can appear as spontaneous and improvised.

But in the end, opera means: acting with the voice. We all share in the responsibility of making this moment possible, and that includes singing teachers, singers, intendants, casting directors, stage directors, and especially us, the conductors. Taking the interdependence of text and music as a starting point for the development of tempo relations, transitions, dynamics, flow, crescendos, and climaxes, that's what the craft of conducting is really about. The tempo of a Mozart opera aria can never be decided in isolation from text and vocal line. And when a conductor calls for "More text! More text!" during a rehearsal, that has nothing to do with the interpretation of the text. This responsibility includes, among other things, leading the orchestra at crucial points in such a way that a singer can engage in acting with his or her voice, not having to force it artificially, and doing what is almost forgotten today, namely "speaking on pitch." The connection between the text and the music, that is where the task of the conductor lies. Why do we conductors so rarely rehearse recitatives? There is so much to gain here in terms of combining text interpretation, sounds, and rhythm—what is the impulse for a phrase? Where does it take place? Tempo, timing, and transition: and all of that with maximum sensitivity. Why do we, all too often, leave this exclusively to the directors or "stage" recitatives from a purely musical angle? Staging and music must seamlessly go hand in hand, and both of them need to live up to this responsibility.

For the direction, "acting with the voice" doesn't mean that all singers should stand rigidly at the ramp. Also, the debate as to the intelligibility of the text has nothing to do with the one regarding whether the performers on stage should wear jeans or historical costumes. By the same token, it is entirely irrelevant whether the libretto and music of an opera were written in 1606 or 2020. The only important thing is to facilitate a genuine interpretation of the text.

Even in my (still comparatively short) conducting career, I have been through countless scenic rehearsals where we never once talked about the text. Often what is discussed is a surrogate parallel plot, a distraction from the real thing.

Due to a lack of knowledge and understanding of the text, the attempt to modernize it falls into the same trap of arbitrariness and lack of topicality that we might expect to find in the work itself. In this vein, it has even become common practice today to leave out words or entire lines in the surtitles to conceal a conceptual bending of logic by the director.

In the meantime, we have become used to watching operas with one eye on the surtitles. The singing becomes the musical soundtrack of a visually perceived story (which is being followed by reading). The insistence on the original language, which has also reached the so-called niche repertoire, has often produced excesses, making singers look like parrots, singing in a language they themselves don't speak for an audience who doesn't understand the language.

With the great vocalists of the past, we can see clearly what makes a voice, a distinctive timbre that is directly linked to the singer's interpretation and treatment of the text. In today's auditions, we often have a stereotypical idea of what a Mimì or Turandot ought to sound like and cast a voice, which most closely resembles that color of tone. Material is confused with technique, the instrument with its mastery, so to speak. However, a mediocre violinist would not be allowed on major stages simply because he played a Stradivarius.

"Good technique—but you don't understand a word!" This comment from a casting director in an audition is indicative of our paradoxical view of what makes a good singer. Intelligibility of the text must not only be part of the singing technique but its essential starting point. In this order, we could first choose individual voices and artist personalities, and subsequently, decide which works they would have something to contribute to—and then put them on the program.

But of course, the problem begins in vocal training where working on "tone" is often the highest priority, and it ends with the singers themselves: if a vocalist only understands the general meaning of a sentence but fails to grasp its literal and grammatical content, if he or she is not fluent in the pronunciation and tonal accent, then where are genuine timing, good segues, and consistent transitions supposed to come from? Why is it that directors are never challenged when it is simply not clear what the sentence being sung means or what intention it conveys—even when the words sung are in everyone's native language?

"Die Zeit, die ist ein sonderbar Ding" ("Time, it is a curious thing") is, to begin with, a spoken sentence, which is invested with greater clarity when presented with precisely set pitches, harmonies, accentuation, as well as longer and shorter notes. It ought not to be a vocalise where you only recognize words from time to time. Likewise, verbal clarity does not mean spitting the "t" at the end of a sequence of notes and somehow believing that this puts you in the clear. Whether you sing the German "Liebe" or "Lippe" is not decided at the end of the word, but at the beginning, by the color of the vowel, by the character of the "L."

Already Giovanni Battista Lamperti, a famous teacher of the bel canto vocal technique, wrote, "Never separate diction from singing, not even in thought." And, "If 'good diction' is an enemy to 'good tone production,' you are on the wrong road."

Let's look over to our colleagues in the world of musicals. There, it would be impossible not to pay attention to the text, which remains the most crucial basic principle, even in the

187th production of *Les Misérables* (performed in numerous countries, in different languages). Perhaps this is one reason why the musical genre is still putting out new shows that resonate with a wide audience to this day. In this vein, let this also be an appeal to the composers: don't shy away from the true forces of opera! Let the singing speak again! Study the human voice and the vocal technique, along with its trinity of space, language, and breath; study its capacity for expression and intelligibility of text on different pitch levels. Write for specific voices, maybe even for specific singers. The question of the immediacy and genuineness of sung words is directly linked to a quest for the greatest possible expression, and it reaches beyond the discussion of compositional style and technique. Any effect can be achieved, amplified, or modified through novel sounds, unheard-of tonal languages or harmonics as well as noises, electronics, modern instruments, and new forms. But at its core, what we do needs to be sound and in tune. Listeners have to be touched by the story that is told by the singers on stage. Any new work that can pass this test is welcome and will be embraced with open arms by our audiences!

What that means for all of us opera creators and makers is this: let's trust the opera, let's trace the messages that have manifested themselves as music. The stories of *Tosca*, *Wozzeck*, *Macbeth*, and *Agrippina* tell us as much about ourselves today as they did at the time of their premiere for the audiences of that era. But to that end, we must try to understand them.

Prominent German conductor and pianist, at twenty-seven, Joana Mallwitz was the youngest general music director in Europe (Erfurt, Germany), after which she became general music director in Nuremberg. In 2019, she was named "Conductor of the Year" by two different magazines. In addition to conducting at the Salzburg Festival since 2020, she conducts in the world's most important opera houses. She will be head of the Konzerthausorchester Berlin, starting in the 2023–24 season.

SAVING MUSIC

Riccardo Muti

To understand what is wrong with the opera in the early 2020s, we have to go back in history, by decades, perhaps even by a hundred years.

In the old days, this is how the system worked: an artistic director wanted to stage an opera, for example, *Otello*. The first question people asked was, is there a good Otello? If not, they wouldn't produce *Otello*. If the answer was yes, the second question was, who's going to be the conductor? Victor de Sabata or Arturo Toscanini or Herbert von Karajan? Then the conductor and the artistic director selected the other singers, Desdemona, Iago, and all the smaller parts. Only then was the conductor asked, Maestro, which stage director would you like to work with? Who best matches your musical ideas? Giorgio Strehler, Jean-Pierre Ponnelle, perhaps Luca Ronconi? The conductor would say whom he could imagine working with and would then meet with that particular stage director to discuss, once again, the singers—who, mind you, the conductor was the one to choose. And the stage director then selected the set and costume designer.

The way this works today is that everyone wants a particular singer, which seems to be the most important criterion. Then a prima donna is called and asked, which opera would you like to do? *Traviata, Bohème, Tosca*? Which tenor would you like to have onboard? You won't sing with him? All right, we'll take the other one. And which stage would you prefer? Eventually, someone may realize that, oh darn, we forgot about the conductor. Now, who's going to conduct? In my mind, this development is undoubtedly headed in the wrong direction.

Today, everything is about instant success and superficial entertainment. This is why we must bring back opera into people's awareness as a vital cultural achievement. The opera is the highest and most complex form of musical composition. When we talk about symphonies, we are talking about pure music. But opera is a combination of all art forms. It was created to breathe life into words. Declamation becomes song. Consequently, the question as to *prima la musica o le parole* is a silly one; it was always words that came first.

So let's start with the singers because there can be no opera without them. And you need good ones to get an opera right—singers who are good at working and very well prepared. Today, unfortunately, even superstars often only learn their parts during rehearsals. My teacher was Antonino Votto; he taught me a lot. And Votto learned from Toscanini. He became his assistant at La Scala in Milan in 1920. Votto told me that Toscanini once said to him that he had heard a young singer who was quite possibly a good Falstaff. He asked him to work

with him on this part for six months. Six months! After this time, Votto and the singer came back to Toscanini. He said he had been right, that the singer would be a great Falstaff, but would Votto please work with him for another six months. Only then did the singer perform this role on stage for the first time. His name was Mariano Stabile. Today he is regarded as the greatest Falstaff of all times.

That was the system—the conductor prepared singers at length for a part before they performed it on stage. In the course of these rehearsals, the personality of the character was defined through the music. Today all this is in the hands of the stage director. And many of them can't even read a note of music. When Toscanini worked with singers, for example, on *Trovatore* or *Rigoletto*, he already gave them the dramatic interpretation, not just the musical one. Strehler, with whom I have done *The Marriage of Figaro*, *Don Giovanni*, and *Falstaff*, always maintained that an opera director should be capable of being a conductor, and a conductor should be capable of doing the staging. Only then should they produce the work together.

My teacher, who often worked with Maria Callas, told me that she sang every rehearsal with full voice; she was a true professional. I too, have worked with singers who are considered legends today, for example, Christa Ludwig, Dame Janet Baker, or Richard Tucker. When I first met Tucker, he was already the tenor who had sung Radames on the famous *Aida* recording with Toscanini. I was a young musical director in Florence when he came to the first rehearsal. Tucker was the star; I was basically a nobody. But he sat there with the score and took notes of everything I said during the rehearsal. Once, I asked him to hold a note a little longer, not for effect, but for expression. He immediately did so and just said, "Grazie, maestro."

This kind of discipline has been lost. Today singers come to me and complain, "It's such a pity, many of the conductors aren't giving us any artistic direction during rehearsals." Before doing *Otello* in Florence in 1980, I worked with Renato Bruson on his Iago debut for a month. One month at the piano, working on the interpretation every day. Here's another example: Ambrogio Maestri repeatedly came to my house in Ravenna to study his Falstaff part with me. Everywhere he sings, he now tells people, "I learned this from Muti, I'm not going to change a thing about that." I was in Chicago a couple of weeks ago and read a magazine interview with Bryn Terfel. It quoted him as saying that rehearsing *The Marriage of Figaro* with me in Vienna marked an important moment in his career and that, "Working with Muti on the recitatives for a week—that will stay with you forever."

Theoretically, of course, recitatives should be more in the hands of the director. They are strongly connected to the plot, while arias are usually a relatively static moment. But if the director doesn't understand what the text says, that's a problem. The translation alone will not suffice. This is especially true for Lorenzo da Ponte. He had a fantastic ability to tap into the highest artistic potential of the Italian language. Some of his lines sound relatively harmless and civilized but also mean something entirely different. You cannot come up with an adequate interpretation without understanding his double entendre. I ask myself, how is it possible to direct an opera if you don't understand the libretto properly?

The staging has become the most important element of opera. The music has devolved into a jukebox. Conductors don't prepare the singers anymore. And singers often only show up at the last moment. In a repertory theater such as the Wiener Staatsoper, no one has time for rehearsals anymore. You can't expect any tremendous artistic results from this kind of practice. There the only important thing is that everyone starts together and finishes at the same time. And when there is a premiere, the stage director gets most of the rehearsal time.

I worked in Salzburg for decades; now I only do concerts there. But if you look at the rehearsal schedule for the operas you see—forty days of rehearsals for the director—it's the same in Bayreuth. If you're lucky as a conductor or have the necessary authority, you get three musical readings with the orchestra, two or three rehearsals with the singers; then you immediately go on stage. That's ridiculous. You have no real control over what happens.

Some people say Muti is against stage direction. But that's not true. For me, it's all about quality. At the beginning of my career, I brought my first operas to the stage with Luca Ronconi. When you worked with Ronconi in the 1970s, you couldn't be reactionary in any way; you were actually very modern. I did nine productions with him, from *Orfeo* and *Trovatore* to *Nabucco*. With his *Nabucco*, Ronconi was once fiercely booed in Florence because Nabucco changed his costume and suddenly became King Vittorio Emanuele—at that time, this was a scandal. After the intermission, someone in the audience shouted, "Ronconi nell'Arno!"—"Throw Ronconi into the Arno."

But critics in the 1970s also held the conductor responsible; he was in charge and should not have allowed this to occur. Votto also told me, "Always pay close attention to what happens on stage—if only because your place in the orchestra pit is the best in the entire house. So you can't say, it's none of my business."

Today, critics often produce two different reviews, one discussing the musical performance, one evaluating the staging. By doing that, you destroy the nature of the opera; you kill its soul.

Much of the blame for what goes wrong indeed lies with the conductors. A conductor has to look after everything throughout the rehearsals. For one, I have never had an assistant in my life, not even when I produced the Wagner operas at La Scala in Milan. From the first rehearsal on, I worked with the orchestra myself every day. It's just the wrong approach to have an assistant do the laundry and only intervene when everything is clean again. That is an aristocratic, snobbish attitude. But unfortunately, these days, very few conductors stay in one place for forty days; most times, they have engagements somewhere else during the rehearsal period. And they know the music, but not the text.

That's why I founded an academy for young conductors, which is now being held for the seventh time in Italy and for the second time in Tokyo. My first advice to young conductors is always to learn, learn, learn. Just as Verdi, when asked about the secret of his success, always said, work, work, work. I'm seeing good results at my Academy. These young people also learn Italian. And they have to study composition. In the old days, people in Italy studied for more than ten years: four years of harmony, three years counterpoint, three years instrumentation. In the last three years, if you had talent, you could apply for the school of composition. Unfortunately, that's over.

Today, conductors are people who are either not good enough at playing an instrument, have lost their voice, or can't sing at all. They have nothing to say to the orchestra. In such cases, the orchestra loses all its discipline. And the singers on stage don't know what they should do.

Understanding the essence of language from within, that's the basic prerequisite. That not only goes for conductors but also for singers. Even if they only have a few words to sing. For example, in *La traviata*, second act, second scene, there is a waiter who comes in only briefly, everyone is playing cards, and he sings: "La cena è pronta"—"Dinner is ready." Like all the others, he is part of the whole, and of course, he needs to articulate that correctly. When I recorded *La traviata* in London with the Philharmonia Orchestra, with Renata Scotto, Alfredo Kraus, and Renato Bruson, the moment of "La cena è pronta" came. EMI had selected native English singers for that part. The first one who came to the rehearsal pronounced it with an English accent: "Aceeenaeporonta," all slurred. I said no, that's not how it goes; it's "La cena è pronta!"—"Yes, of course, laceeenaeporonta."

John Mordler, the long-time director at Monte Carlo, was the recording director at EMI at the time. I turned to him and said, "John, this is not working." So, the next day he brought in five different singers, supposedly all from Covent Garden. The first, "Laceee-naeporonta"—out! The second, "Laceeenaeporonta"—out! I said, "John, you know I never allow parts to be recorded later on, it's an affront to the audience. But in this case, I'll make an exception because 'La cena è pronta' with an English accent will just not do. You have to find me someone else." Two months later, he called me up in Ravenna and said, "Maestro, *Traviata* is done."—"And who sang that part?" I asked. "You won't believe it, but for a bottle of champagne, Giuseppe di Stefano agreed to sing 'La cena è pronta.' He was in London for a master class." When you listen to the recording today, you ask yourself, why didn't they use that tenor for the whole opera? I am only mentioning this to highlight the significance of the correct pronunciation of words, the importance of articulation.

Unfortunately, conductors today pay too little attention to such details. Arturo Toscanini, Otto Klemperer, Wilhelm Furtwängler, Bruno Walter—they all studied for years. Toscanini had five diplomas: cello, piano, organ, composition, and choral singing. De Sabata and Karajan were wonderful pianists. My teacher also used to say, "In order to be a good opera conductor, you have to breathe the dust of the stage." You also need a good understanding of vocal technique: conductors used to know exactly what to say to the choristers; it took them many years to get that far. Everything moves so fast these days. A conductor performs a Mozart symphony one day and tries to do *Bohème* the very next day. There is no preparation any more for the world of opera. Therefore, many don't have the necessary authority and knowledge.

But let's return to staging. Yes, we live in a visual society; above all, the audience wants to see more than hear. But for the brain, listening is actually the bigger task. For everyone to talk about an opera performance, the stage director needs a concept; the audience must be impressed with something provocative. But even Schönberg, who was certainly no reactionary, wrote in his letters to Kandinsky that if the staging interferes with the music, that is a mistake. What you see must not eclipse what you hear.

What should staging look like today? Intelligent, highly developed, sophisticated, and, as Wieland Wagner said, essential. Most of the time—less is more. One of the best productions I have ever done was *Dialogues des Carmélites* under the direction of Robert Carsen at La Scala. Or Macbeth with Graham Vick. There you had ideas that could blend with the music. Not ideas that didn't pay heed to the music.

The problem often starts with Mozart. Today people want a historically correct orchestra in the pit, no vibrato, and period instruments. Some go so far as to say that the Vienna Philharmonic Orchestra is outdated. On the other hand, this group of people wishes to see an avant-garde *mise en scène*, especially with Mozart. And so, the music moves in one direction, the staging in a completely different one. How is that supposed to fit together? Here's another problem: the people on stage speak a language that's more than two hundred years old. You need to find the right form for that. That won't work if you want a cutting-edge contemporary production. If I walk down an Italian street today and start to talk like Don Alfonso, people will call an ambulance and say Muti has gone mad.

Sadly, often the director doesn't have any relationship to the music anymore. For example, in *La traviata*, second act, when Germont first visits Violetta. Verdi tells the director precisely what happens. The music prepares us for the arrival of a terrible man; he's an egoistic, dreadful person, the music is plodding. But with many directors, Germont rushes onto the stage and sings to Violetta, coming across as extremely likable. So I'm not talking about modern or antiquated direction. I want directors to understand what the music is saying. When I see a Carmen where she kills Don José, it's not modern; it's simply wrong. The same goes for a Violetta, who dies on a train from a heroin overdose.

These things happen again and again with new productions. But I ask myself, when we talk about a new production, why do we always talk about the new production of the stage director? Why don't we talk about the new musical production? This is a fundamental mistake. Take for example, a *Traviata* at a famous opera house. There the tenor sings "Dei miei bollenti spiriti," he does so in the second act too, and he almost always starts out too loud, although Violetta has mellowed him down a lot. And there's the word "ella." "Ella" means "she"—but she who is absent. In this production, she stands next to him all the time. So "ella" makes no sense. A man would never sing it that way with her there. While singing this, he's cutting vegetables in the kitchen, and the gardener is the only one present. I understand the communist approach, but in Verdi's time, no man would have cut vegetables in the kitchen. That's not modern; that's just silly.

What should we do? What's the solution? First of all, the director should be a lot humbler. Then the conductor could be much better prepared and be present from day one, just as each and every singer should be. That should also be a moral obligation. And the audience should be more open. The audience often waits for a single note from a singer. Sure, I get it, high notes are important, but that often turns a performance into a circus. It's like bullfighting when the torero kills the bull. Or like a goal is scored in a soccer stadium. Opera is something different. A note cannot make or break the success of a performance. And most of the time, this high note was not even written. The audience waits for these moments

because we taught them the wrong thing. People always say, sure, but that's the tradition, that high C has always been sung. As Furtwängler said, "Tradition is the poor memory of the most recent poor performance."

For all of these reasons, I have a negative outlook on the short-term future of opera. It is a challenging time for the genre. But I believe that opera will come back stronger, perhaps in two generations. But then you have people who say; the opera has become so out of touch, why don't we try to rethink it?

Today there is also a crisis with regard to the works. Not only when it comes to new operas, but also in the classical repertoire, we always play the same forty works. And the audience only wants to hear that. They have become lazy and lethargic. When Furtwängler did *Der Ring des Nibelungen* in German at La Scala in the 1950s, there were no surtitles, but the audience was enthusiastic, and it was a real triumph. Now we always need surtitles. I was against it at La Scala for a long time. But many people wrote to me that they absolutely wanted them. I was the last pirate in the Caribbean to fight surtitles. Bruson once told me that during *Macbeth* rehearsals, he worked for hours with a director on how to hold his arm. Then, when he sang the aria, he saw that no one in the audience was looking at him and his arm position, but everyone was looking at the surtitles. That's crazy.

Today's audiences are no longer prepared when they walk into a theater. In the past, people used to read the libretto beforehand, and the singers sang in such a way that you could understand what they were singing. Jussi Björling was no Italian, but you could understand every word he sang even in the Italian repertoire. With Pavarotti too, of course. And also with Callas—every single word. Just the same, there's a famous photo of Toscanini sitting in the Scala, in the mid-1950s, you see Callas, Votto, and behind Toscanini, there is de Sabata. Votto told me the story behind this photo. It was taken during the rehearsals for *La vestale* with Callas. Votto was the conductor; de Sabata sat in the audience on one side, Toscanini on the other; the two of them did not get along. Then Votto said so that everyone could hear him, "How can it be that we have the two greatest Italian conductors with us here in the audience, and they're seated so far apart from each other." During the intermission, Votto took the opportunity to introduce Callas to Toscanini and invited de Sabata to join him. In the photo, you see how Callas is looking at Toscanini. She was hoping for grand compliments, but Toscanini just said, "Signora, le parole." And that was all. Apparently, he didn't approve of her articulation. For a singer who was famous for that, it was of course dreadful. But for Toscanini, it was simply not good enough.

If we talk about the repertoire, I agree that we need new operas. We have to help and encourage composers to write new operas. But operas that enrich our lives. With a musical language we understand. Composers today try to find new ways, new systems, new instruments. I conduct a lot of contemporary music myself. Everyone in the orchestra also feels enthusiastic about being part of that. But then, after the premiere, there is maybe a second performance, and then it's usually over. Is music still something we need? Is it of vital importance? If so, why is contemporary music moving in this strongly intellectual direction? Why has it become so difficult for the audience? Popular music, on the other hand, is becoming ever simpler. That's an odd contradiction.

I can understand why institutions that depend on private sponsors always play the popular works. If the auditoriums are empty, money will stop flowing from patrons. But a government-funded theater in Germany, Austria, or even Italy has a greater obligation to open the doors to new experiments. Independent of audience numbers. Here, this cannot be the most important criterion. I would also conduct if there were only a few people in the audience.

There's a Latin expression attributed to Euripides that says, "Tolle siparium, sufficit mihi unus Plato pro cuncto populo." The story behind it is this. When a performance of one of Euripides' dramas was about to begin, the impresario told him, "The hall is empty, just one person, what should we do?" Then Euripides saw that the only person in the room was Plato. And he said, "Raise the curtain, it is enough for me to have Plato in the theater instead of the entire audience." That must be our concept. We have to encourage people to come to us.

We ought to be adventurous and much more open to the world. Not only are we not doing enough for contemporary opera, but also not enough for early music, for example, the Neapolitan School. We're doing nothing for Cimarosa or Paisiello. Even if you perform an opera by Rossini or Donizetti, these will hardly work today without a famous superstar. That's another reason why opera houses are in a crisis: the lack of imagination, fear of low ticket sales, and the media's disinterest, especially television. In the United States, many newspapers now call their culture pages "Entertainment." When you write about a Bruckner or Schönberg, or Webern symphony, do you put that in the entertainment section? That's a sign of decadence. But Europe, too, is losing sight of why opera is or was so important. It is increasingly turning into a museum.

I have a dream, not in the sense of Martin Luther King, but a similar direction: I dream that in today's world, cultures can meet, and new elements can emerge from this encounter. For literature, art, and music. So that with influences from China, Korea, or South America, a new artistic language will develop within the next twenty years. We will always need the sources—Mozart, Verdi, Wagner, etcetera. But I dream of new music that creates something genuinely new that becomes an essential part of our humanity.

I don't believe that renewal can come out of North America or Europe. It can only come from the East, or South America, far away from our culture. In terms of availability, education is still a privilege of the Western world. But what's the real story here? I recently heard on television that in Italy, one in four students aged sixteen or seventeen no longer understands the text they have read. That means we are on the road to barbarism. Everything is superficial; it's all about instant success, glamor, and money. We are experiencing a break-down of cultural values. And television shares much of the blame for that. It's the medium that can reach all people. But it does nothing for education; instead, it primarily presents viewers with inferior content.

Even governments do nothing to enrich the culture of young people. Music is no longer taught properly in schools. It's not about playing a few notes on the violin, but about kindling a love of music. What is music? That's what we want to teach our kids: the fantastic world of sounds. But for that, you need the right teachers. Today children pay for their fathers' mis-

Georg Baselitz,
Untitled (Curtain), 2018
Ink pen, ink, and watercolor
on paper, 50.1 × 66.2 cm
Design for *Parsifal*, Richard
Wagner, Bavarian State
Opera, Munich, 2018.
© Georg Baselitz 2020
(Photo © Jochen Littkemann)

takes, and over and over again for their fathers' mistakes. Even Italy is no longer the country of music, but the country of the history of music. When you take young people to the opera to see *Aida*, you have to explain everything to them beforehand, the history of the pharaohs and so forth. But when it comes to the performance and the kids see Nazis on stage, you know, Hitler as Pharaoh, they will say that they were told quite a different story. So what's the alternative? Do everything the traditional way again? Probably not for young folks.

We're in a no-win situation. So many illnesses beset the body of the opera. It's not just that we need to cure the liver. A great many organs are affected. Nonetheless, I don't think that one of Italy's big houses will close any time soon. For decades I've been reading about the crisis of the opera in the media, but particularly in Italy, the show somehow always goes on. Italy is like a patient who has difficulty walking but then wins a race.

As far as American opera houses are concerned, I'm no expert; I only did *Attila* at the Met in New York. But when it comes to orchestras, the big ones will undoubtedly survive. America is big enough; there will always be a couple of wealthy people who support classical music. But in the United States, culture lives in an ivory tower, and so does academia. With my orchestra in Chicago, I try very hard to spark interest in classical music. To that end, I also go to prisons every year. And it has been my experience that the guys in there, who have a tough life and know nothing about music, are suddenly fully interested in it. The last time I brought Joyce DiDonato along, she sang arias, I explained the music. I also had a girl read Shakespeare once. She did that for the first time and had tears in her eyes. I invited fifteen to twenty young people to come to a rehearsal of *Otello*, which we performed concertante. These young people were in a concert hall for the first time. It is impossible to describe the effect this had on them.

Unfortunately, people from the African-American community, for example, rarely come to concerts. That's really a tragedy. I always wonder why. After all, there are many fantastic African-American artists in classical music. Maybe I'm wrong, but I think to them, our music is the music that forced them into slavery four hundred years ago. The music of the elites. Perhaps that happens unconsciously. We can't expect people to come to us; we have to go to them. Instead of merely jumping around on the podium and relishing their success, conductors, singers, and soloists ought to concern themselves with society and put to better use the gift they have been given, namely the ability to make music. Music can make people better; I am convinced of that. This is a moral and social aspect of our profession that is often outright ignored. Not only by artists but also by politicians.

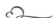

Born in Naples, Riccardo Muti is one of the world's most distinguished conductors. He has led the New Philharmonia Orchestra London, the Philadelphia Orchestra, and was music director of La Scala in Milan. Currently chief conductor of the Chicago Symphony Orchestra and the Orchestra Giovanile Luigi Cherubini, he is very committed to young artists and lesser-known composers (www.riccardomutimusic.com).

OPERA-DANCES

Martin Crimp

PRÉLUDE (UNMEASURED)

I am hearing that opera today is
impossible … …
and that in the 1970s … …
there … …
was something called anti-opera … …
from which opera never fully recovered …
not that I knew anything about it … …
at all … …
when this opera-dance began …
except that I do appreciate music …
of diverse kinds … …

ALLEMANDE

For example I've begun to understand
some of those allemandes by d'Anglebert
— from which you may fear that my taste
in music, which extends to composers
of the seventeenth century, may be obscure.

COURANTE

Far from it — I'm a dramatist — I believe
in story-telling — things must move
forward — music itself takes place in real
time — like drama — it's the same thing —
or dance? — there's just this small matter
of words.

DOUBLE DE LA COURANTE

Far from it — I'm a dramatist — meaning
I write for the theatre and believe in what
may crudely be called story-telling — things
must not only move forward but develop in
time — therefore music itself is a form of
drama — or dance? — same thing? — no —
but similar — and for me an opportunity to
have my words embedded in the gleaming
armature of music.

SARABANDE (LENTEMENT)

So, painfully slowly, as writer, I piece
together, from words, which are signs, you
might say, of feeling, and of objects, and of
images in the world, a text for music.
This text must not only be strong enough to
withstand music, but be able to grow in its light.

GIGUE

Factor in music and everything dances.

TOMBEAU

Since we are still far, let's hope, from the
last days of opera, I will omit the traditional
tombeau. Let's look elsewhere for its
plangently suspended harmonies.

British playwright, author of radio plays and opera librettos and winner of numerous awards,
Martin Crimp's works address the violence of the contemporary world with sharp cruelty and devastating
humor. They have been translated into several languages and performed internationally.

I TOO HAD A DREAM

Philippe Jordan

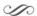

For me, the opera was a calling and the reason to take up the profession of conducting. When it all comes together, and everything is right—singers, conductor, orchestra, choir, stage design, and, last but not least, the direction—opera is, for me, the most complex, and the most beautiful art form there is. Many elements converge, many arts and crafts need to work together and be coordinated, but if it all succeeds, something unique is created through this interplay and collaboration.

Time and again, the opera has been declared dead, but I am confident that as long as we play what we now call classical music, opera will continue to exist unless we deliberately do everything we can to prevent it from doing so. From the very beginning, opera was an art form that could only be realized at high cost and effort, but its most important works are dedicated to the great themes of humankind, and by fusing music, text, scenery, visual arts, and sometimes dance, it achieves a condensation of the respective subject matter that each of the art forms involved could not have created on its own. However, if I am to be frank, I have rarely experienced such moments of happiness, despite having had the privilege of working in opera for twenty-five years, conducting in nearly all the great opera houses and festivals around the world. When they did occur, it was mostly in connection with licensed or revival productions (perhaps because in such cases you already know what you're letting yourself in for) or with my experiences as an assistant to Daniel Barenboim, which allowed me to watch one of the greatest masters of the trade, Harry Kupfer, directing *Tannhäuser* and *Holländer*. What I witnessed otherwise was mostly either mindless coexistence or, even worse, people senselessly working against each other.

But I Also Have a Dream

which begins with a director calling me up about plans for a joint production—before anything has been decided—and asking me when we could meet to talk about the work and its realization. Ideally, it should be a director who loves and is able to read music and has read the libretto—something quite rare in today's real, non-dream world. He has also studied, analyzed, and engaged with the work's background and genesis. If it's a frequently performed work, as it commonly is nowadays, he is familiar with its reception history. There's no harm in dreaming big.

I Dream On

of a process of collaboration that commences long before the first rehearsal and in which people discover what they have in common but are also curious to hear what others have to say. I imagine going into the first rehearsal with the results that have developed from this wonderful encounter and what could then rightly be called the initial conception of an opera production. And I keep on dreaming of this director who, in that setting, treats everyone involved with respect, who now not only knows exactly what he has to do, based on what we have worked out together beforehand but also how to put it all into practice thanks to a real rehearsal technique. Thus, I dream of an artist who engages in dialogue, inspires curiosity in the singers and the conductor about the content and interpretation of the text, and is curious about how the music interacts with the words at every moment.

Yes, I Have This Dream

I dream of an opera world where the audience doesn't show up despite the staging they are presented with, but because of it. I dream that people will no longer buy tickets to *The Marriage of Figaro, Fidelio, Falstaff, Tosca, Meistersinger, Wozzeck*, etcetera simply to hear ingenious music and magnificent voices, but because they want to experience great theater. I dream of an opera-theater that is deserving of that name and that I will never again be asked at a rehearsal, "Can't we just cut that passage? I have no idea what to do with it." I dream that instead of meaningless fancy, true master directors will once again dominate the opera stages who are, above all, curious about what is to be discovered in a work and not constantly in panic as to whether they will be able to come up with some idea in connection with it.

I Dream

of directors who get behind the play and don't plant themselves in front of it, who know that music is the basis of the entire edifice of the opera, without which it inevitably collapses. Perhaps that could lead to the return of a simpler theater that would give greater latitude to the music, the performers, and the audience, thus paving the way for a theater that is, once more, able to create magic and enchantment; and understands that the scenery is not an extension of the orchestra pit, but that stage and music are equal partners.

I dream of a director capable of engaging with every aspect of the original on his own and won't cobble together his production based on a few Xeroxed pages of secondary literature that some production dramaturge has hastily provided him with. I dream of a true artist who is willing to confront the masterpiece directly, who accepts that such a masterwork presents us with challenges that need to be solved, and who is willing to work together with all those involved to find the right answers to them. It would be a dream come true if a conductor defending the score and its execution during rehearsals no longer had to risk being polemically reminded that this was not the perfect time to give a concert! As if any conductor on the planet with a serious interest in opera wanted to prevent real theater from taking place on stage!

I Dream of a New Opera-Theater

that is far removed from concerts in costume and make-up and has a passionate interest in the question of why the operas we perform still exist after four hundred years despite all prophecies of doom. At the same time, however, this dreamed-up opera-theater would by no means be only relevant to the director and maybe the artistic director who hired him. It would have to attract a contemporary audience keen on experiencing a masterpiece in the light of our present moment and not just in the dim light of personal, inadequate engagement.

I Also Dream

of an audience who understands that opera involves all the senses, not one who claims to come for the music, but then only talks about the visual presentation. In a world that is as strongly dominated by visual imagery as ours, we need the opera as a dimension that distinguishes itself from everyday reality.

Furthermore, I dream that the question of modern versus traditional will no longer be an issue and that the customary polemical debates on this topic will finally and definitely be a thing of the past. The only question we should ask is this: Is it good or bad theater?

An opera isn't a concert; it is also not straight theater; it isn't a movie, and it isn't an installation. Opera is the art form that unites everything.

Opera is opera. A dream-perfect opera-theater must do justice to that and nothing else.

Oh well—there's no harm in dreaming.

Conductor and pianist Philippe Jordan began his career at just under twenty years of age in Ulm before Daniel Barenboim brought him to the Berlin State Opera. He quickly achieved international fame, appearing at the world's great opera houses, festivals, and with all the major concert orchestras. He was chief conductor of the Vienna Symphony Orchestra and musical director of the Paris Opera. He has been music director of the Wiener Staatsoper since 2020.

THE LIBRETTO.
WRITING FOR MUSIC

Händl Klaus

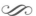

I'll start with the beginning: alone in the mental field of force emerging from the musical past of my composer and the narrative material the two of us are burning for. What got me here is a yearning for that other kind of language which, while also not being able to articulate "the unspeakable," can let it speak (and enables me to spell out its contours). Music. Music! As a writer (who began *in prose*, then became a playwright), I am now taken by the hand, as it were, by this type of music, which has accompanied my life for decades, sounded me out, and made me come alive; it has un-settled, comforted, and, yes, saved me—music by such peerless composers as Beat Furrer, Georg Friedrich Haas, Arnulf Herrmann, Heinz Holliger, Klaus Lang, Isabel Mundry, Hèctor Parra, and Vito Žuraj. What connects all of them is their keen awareness of this transcendence, they are the most sensitive explorers of breathing matter. In that vein, our collaboration takes the form of tracking down and uncovering a work in a manner that is just as subtle as it is concrete, the result being something that has more revealed itself than it has been constructed by us. With the nar-rative material, there is immediately a sense in the air of its linguistic-musical Gestalt—we follow the inherent patterns that are already visible, and I have a really tough time with them at my desk. Ultimately, each of them has its own name—*Wüstenbuch*, *Buch Asche*, *Bluthaus*, or *Thomas*. Like so many operas (including the earliest extant one, *L'Euridice*) they are basically about the proximity of death and partaking in the process of dying as members of an audience, who rather remain voyeurs in today's short-winded theater performances. For in singing death unfolds, breath by breath; it exudes in audible streams, and we breathe, sing, immerse ourselves, dying even in this movement, unconsciously or consciously giving in to the pull across the threshold—and this experience is always also a physical one. That which is *invoked* and all too seldom triggered in drama through the plain spoken word (often electronically amplified and corroded), is redeemed, unraveled, and conveyed quite naturally *in music*. It is transferred into another state of matter, one that is as concrete as it is intangible, an atmosphere flung together from the most diverse independent voices and counter-voices, as well as their bodies and shadow bodies, a complex interplay of inside and outside—of musical thinking that infinitely permeates the moment. Here we enter into the *proximity of death* in a spirit of empathy, and narrative content that deals with the closeness of this reality thus becomes possible through music. It is always set in this borderland—the membrane between this world and the next, where a deceased woman calls her friend over to her, or a group of snowed-in people experiences their collective dying, or not-dying (*Wüstenbuch* and *Violetter Schnee* by Beat Furrer). In a blood-soaked parental home, from which there is no escape for the

daughter, destroyed by her father; or in the intermediate realm of a waking coma, which all the more throws the patient's relatives back on themselves in a garish fashion (*Bluthaus* and *Koma* by Georg Friedrich Haas). In the repeated defenestration from the fifth floor, which completes a loss of identity and keeps it suspended in anguish (*Der Mieter* by Arnulf Herrmann). In the mind and lustful desires of the dying poet Nikolaus Lenau, who burned and ground to dust the last traces of his life, the pages of his *Lebensblätter*, in order to erase himself from existence (*Lunea* by Heinz Holliger). On a razor's edge in ancient China, where a peasant woman stubbornly makes her deadly dream come true and throws ash on the emperor (*Buch Asche* by Klaus Lang). As witnesses of a fatal event trembling with memory (*Im Dickicht* by Isabel Mundry). Inside the last family of a ghost town that swallows its visitor, and amidst the horrors of fascism (*Wilde* and *Die Wohlgesinnten* by Hèctor Parra). In the experience of the sickness unto death (*Blühen* by Vito Žuraj). Or, turning to Georg Friedrich Haas once more, this time buoyed by an incessantly rushing, delicate stream of nothing but plucked instruments (harpsichord, guitar, harp, mandolin, zither, along with percussion and accordion), in the resurrection itself, in love (*Thomas*). Every narrative material the music breathes is also its language; it is the representation of itself—the embodiment that bears its ecstasies and ambivalences, shows its scars, and senses its wounds. It is directed squarely at the composer, borne by the knowledge of the corporeality of his or her music, its characteristic features, materiality, consciousness, pursuit of questions—all of which takes shape in the material. It is held in suspense by dashes (*Violetter Schnee*, Scene 11, Ensemble):

JAN but the spring… shall come…	PETER beneath the sun… to drown…
NATASCHA the spring… enveloping all…	SILVIA in the snow… to swim…
JAN and thawing… the snow…	PETER we swim…
NATASCHA we shall… swim…	SILVIA drown… immersed in…
JAN beneath the sun…	PETER water… in water…
NATASCHA against the heat… in the lake…	SILVIA runoff water… from snow…

Encountering his wife, whom he had believed to be dead, Jacques' words feel their way in a similar manner (*Violetter Schnee*, Scene 32)…

JACQUES the mouth… is… a puncture…
wandering… towards the temple…
I don't… know you…
Tanya… Tanya…
where… is… your face…

… while the fragile narrative of this undead woman emerging from a winter painting is punctuated with colons (*Violetter Schnee*, Prologue):

TANJA in der luft : ein kreuz : im flug : hat die elster : aus : gespreizt :
luft : leer ist : der kalte raum : unter ihr : e : n : flügel : schläge : n :
ganz : gefallen : liegt der schnee : k : n : ist : er : n : d : hat ihn schon :
der boden : auf dem boden : eine falle : für : die vögel : hat : das bild :

The song of a woman standing in the window before leaping to her death is full of such *predetermined breaking points*, which are also conceived as musical ones (and also structure the music ex negativo) (*Der Mieter*, First Act):

JOHANNA stille : stand : der körper : an :
 der luft : die luft : stand : zitternd :
 an : und an : und : an : und nahm :
 mich : an : und : nimmt : sich : mich :
 und öffnet : still : und zitternd : rief :
 ich : rief sie : an : zu steigen : still :
 drückt sie : mir : tau : melt : mein :
 e : hand : zieht an : der luft :
 die stille : stand und :
 zitternd : sang : und :
 an und : an :

The everyday reality of the doomed farmer (*von Schneeflocken, warm aus dem kahlen Morgenhimmel gefallen, die an der Hand nicht schmelzen wollen, blühend weich den Sommer wiederholen*) is likewise scattered into its morphemes (*Buch Asche*, Scene 9):

LIU-PI schnee : ist : war : m auf m : ich ge : fall : e : n : aus : dem k : ah :
 len : morgen : himmel : habe : n : un : er : war : te : t f : locken :
 mein : e : rein : e hand : ge : tr : offen : die da : r : an n : ich : t :
 schmelze : n : wolle : n : blü : h : t : e : n : weich : e : n : weiß :
 e : n : sommer : t : rock : en : blüh : en : d wie : d : er : holen :

Here, for once, the composition by Klaus Lang was already in place, since it was, in turn, inspired by the visual appearance of Chinese type, and the idea was to sink the dialogue / narration into the pre-existing music, while adhering to the given bar numbers, guided by the inner voices of the characters. Tone by tone, their language disintegrates into nothing but sonic flotsam and half-sounded notes, or, it results from this process, sound and sense falling into one; leapfrogging miniscule units of meaning form (inner) clouds of associative perception. In *Bluthaus*, written for Georg Friedrich Haas, the ghosts of the parents are left with only incomprehensible fragments of their former, eroded language; the composer sets them *a cappella*, they no longer have an (orchestral) body (*Bluthaus*, Scene 7):

STIMME WERNER	u – ü – mu – o – li
STIMME NATASCHA	n – a – ro – ge – e
STIMME WERNER	l – no – l – br – e
STIMMEN BEIDER	är – we – gl – n – k
STIMME NATASCHA	fri – m – o – t
STIMME WERNER	se – te – r – ge
STIMME NATASCHA	j – l – i – me

Then during a house viewing, the spoken language of outside prospective buyers meets the vulnerable singing voices of the unfortunate family (and that of the real estate agent as the go-between). Due to the technical limitations of the production, this line was also drawn for the premiere of *Koma* and the medical staff there also had to act in a dry speaking voice, even though all the parts were written as vocal roles (meaning an "in itself singing" libretto language). I was not redeemed until the premiere of the new version, which at last allowed the loving and caring doctors and nurses to *sing*, too—as people who see themselves as part of the affected family and share in their intense states of consciousness, which are indicated by three different levels of brightness that worked into both the libretto and the staging (*Koma*, before the finale):

In darkness
As a silhouette
In broad daylight

JONAS, NIKOS, ZDRAVKO	She is afraid.
ALEXANDER, JASMIN, MICHAEL	We will comfort you.
JONAS, NIKOS, ZDRAVKO	We will help you.
ALLE	There lies the lake.
JONAS, NIKOS, ZDRAVKO	We will hold you.
ALEXANDER, JASMIN, MICHAEL	You walk into the deep.
DR. AUER, DR. SCHÖNBÜHL	Buoyed by water.
ALEXANDER, JASMIN, MICHAEL	We'll take a dive.
MICHAEL	This is how you bathe.
JASMIN	You swim,
ALEXANDER	wearily,
JASMIN	you sink,
MICHAEL	down.
ALEXANDER, JASMIN, MICHAEL	How heavy you are.
JONAS, NIKOS, ZDRAVKO	We will hold you.
{ DR.AUER	She's lying still.
{ DR.SCHÖNBÜHL	She's not moving.

The phases of darkness pose the greatest challenge for the composer—and for all those involved. To quote Georg Friedrich Haas, "More than half of the time, the orchestra is supposed to play from memory in complete darkness, and at first this sounds like an impossibly tall order. However, I have tried to compose processes that follow a highly logical sonic structure and are thus relatively easy to memorize. And for each individual instrument, there are always long pauses leading up to the dark passages, which allow musicians to mentally prepare themselves for them. Towards the end, the musicians transpose the rhythm of their own breathing into the music, as a reproduction of the breathing of comatose Michaela, as it were." In fact, it is Georg's great musical empathy that allows me to penetrate something that

I am deeply afraid of—that I would shy away from on my own. In each case, a *family language* is created: The characters (—people—) give shape to a common body of language, usually only separated (—connected—) by simple commas. As between a mourning Thomas and the nurses who, together with him, wash the deceased body of his partner (*Thomas*, Scene 7):

AGNES	We want to turn him around.
THOMAS	It's good to hold you.
AGNES	Don't be alarmed.
JASMIN	Since there is still air inside…
AGNES	that will discharge when we turn him around…
J/A	as we compress him…
THOMAS	I will hold you…
AGNES	he might moan…
JASMIN	that's what it could sound like.
AGNES	It's a sound.
JASMIN	Don't be alarmed.
AGNES	We'll hold…
JASMIN	and lift…
THOMAS	Matthias…
J/A	and turn…
AGNES	him…
JASMIN	around.
THOMAS	He sighed.
AGNES	We'll change the cloth…
JASMIN	the water…
J/A	with soap…
JASMIN	beginning…
AGNES	in the back of the neck.

Thanks to a music that identifies completely with Thomas, we are *with him*. Following their performance, some of the supporting characters wander into the orchestra pit and echo text passages they sang on stage a short while ago—they are now part of the space of memory, the sound space that Thomas inhabits. When I tried to hone in on the personality of Nikolaus Lenau for Heinz Holliger's *Lunea*, I limited myself to echoing Lenau's works, drew directly from his poems, his letters, and the letters of his friends. I felt hesitant to put words in his mouth that were not his own, to add to a voice that still appears vulnerable today. I lifted fragments from Lenau's vocabulary, which I proceeded to use all the more freely—words that I could cut, fold, and mirror; the result comprised soliloquies and tercets, *Lebensblätter* (Pages of Life), images designed to go up *in the flames of music*. However, struggling with Jonathan Littell's book of horrors, *Die Wohlgesinnten*, I tried to find my own voice. While I adopted the musical arrangement of the novel into seven Baroque dances, giving it even greater stylistical weight than the original does,

I broke free from the chronology and, with Jonathan's blessing, folded temporal structures into each other in order to look at the unpast now. Furthermore, with Sacha Zilberfarb's help, the passages that deal with the Aue siblings' childhood days in Antibes were rendered in French—this allowed for a softer, more feverish idiom of the music, as well. A speechless orchestral piece was to stand for Max Aue's ineffable encounter with Höß in Auschwitz; Hèctor only wanted a single sentence as an inner image for the music. What saved me here was Rachel Harnisch's voice, which rang inside me as a humanist counterpart—she sang Max's sister Una. Ultimately a song took shape, an ant body (*Die Wohlgesinnten*, 5th Movement, Minuet):

UNA

aus den körpern eine spur
zieht sich durch das kurze gras
kreuzt am eingang eine zweite
spur aus namenloser beute
die geduldig innehält
ihre nachhut einzulassen
deren fühler wissend zucken
bissen die sie hastig nahmen
in die zarten futterzangen
aus dem totenstillen ofen
dessen ausgekühlte tür
allen tieren offensteht
die sie sorgsam heimwärts tragen
schützend in die luft gereckt
von den kiefern ihren köpfen
in das nest zur brut gestoßen
unermüdlich im zickzack
durch das dunkelgrüne gras
das den weg verrät
es zittert

And now I should be talking about Rachel Harnisch! About the singers, because without them writing for music is unthinkable. About the varying "fluidity" or unruliness of (singing) language—and about the supreme commandment to be concrete in everything, not to delegate anything to music from the outset. It's *prima la musica*—but word and music go hand in hand.

Austrian writer, film director, and dramatist, Händl Klaus is the author of numerous plays and is considered one of the most important opera librettists of the present day.

Richard Peduzzi,
Untitled, 1992
Watercolor and pastel
on paper, 23 × 32.5 cm
Design for *Wozzeck*,
Alban Berg, Théâtre
du Châtelet, Paris, 1992.
Director: Patrice Chéreau
Courtesy of the artist
© Richard Peduzzi
(Photo © Pénélope
Chauvelot)

MODERN AUDIENCES
AND MODERN OPERAS

Alma Deutscher

When I was a small child, nobody remembered to tell me that opera was meant to be boring, outdated, artificial, elitist, or irrelevant. So I just thought it was the most exciting thing in the world. I saw the *Magic Flute* at the Salzburg Festival when I was three years old. To be honest, I didn't really understand the story—my parents said that the Queen of the Night was angry with Pamina because she had touched a sharp knife, something that children should never do. But I was still entranced by the experience: the incredible costumes, the spectacle, and above all, the mesmerizing power of the music. In the following years, I devoured one opera after another, some on stage and more on video: the comedies of Mozart, Rossini, Donizetti, but also of Cimarosa, Paisiello, Pergolesi, and others.

Until I was about nine years old, I truly believed that what I was seeing on stage was actually happening. When the tenor sang of the heavenly beauty of a not particularly attractive soprano, I remember thinking to myself: "How strange that he finds her so beautiful. Oh well, people have different tastes…" And when for the first time I watched an opera that didn't end happily, *La traviata*, I was inconsolable with grief and couldn't stop crying for a very long time. It was only through the long process of rehearsing my own opera, *Cinderella*, that I gradually lost the naivety about what was happening on stage. But still, at the final rehearsals, when everything began to look real, I often forgot myself and believed that it was all actually happening.

How can opera be so moving? Of course, all beautiful music has a strong effect, even without the staging. The power of harmony and especially of melody, can sometimes be overwhelming. But when this power is used to tell a story, bring out the characters' emotions, and heighten the drama, the result can be hypnotic.

I was asked to write my views on how modern audiences can be reconciled to modern operas. I am only fifteen years old, and I don't pretend to be a philosopher. But maybe as a child, I can get away with saying some very simple and obvious things, which I'm sure everyone knows deep down, but which adults are perhaps afraid to say aloud.

I would like to start with a story. Once there was a baker who stopped adding yeast to his loaves of bread. The loaves came out of his oven as hard unrisen lumps, and people who tried to take a bite almost broke their teeth on them. Soon enough, the customers deserted his bakery. The baker said: I must find ways to reconcile the customers to my bread. He decided to call his loaves "modern bread," and he put up a big sign on the window: "Modern bread

will broaden your horizons and liberate you from outdated notions of bread." But this didn't help—the customers passed by, took a quick look, and went elsewhere. He then declared that his modern breads were artisanal gourmet creations, not just cheap entertainment for the pallet. Modern bread, he said, is something for sophisticated and cultured customers with discerning tastes. But the allure of appearing cultured and sophisticated was not quite as strong as the allure of the fresh baguettes from the bakery around the corner. The baker then announced that the customers must be re-educated: if they are forced to eat my modern bread often enough, they will eventually learn to like it. It still didn't help. The baker then declared that customers have a moral duty to support modern bread. He tried every other imaginable argument. Only one idea never occurred to the baker: to put the yeast back in his bread.

What yeast is to bread, melody is to opera. It's the power of melody that lifts the whole thing, and when you take away the melodies, the whole concept of opera collapses. Melody has an incredible force. Many people travel a long way and pay a lot of money to hear an amazing voice sing a beautiful melody. We are overwhelmed with emotion when we hear beautiful melodies in the voice or in the orchestra. We get goosebumps. But when there are no melodies?

I know that if I watch an opera and I wait and wait, but the melodies don't come, the magic begins to evaporate. Soon enough, I start thinking to myself: what's the point of all this? Why do these people on stage need to sing in the first place? If they just spoke instead of singing, we could all have gone home quicker.

So, to come back to the original question: to me, it seems that asking "how to reconcile the audience to modern operas" is putting the problem the wrong way around. It is modern operas that should reconcile themselves to the audience, and not the other way around. Opera should overwhelm us with the beauty of its music. Mozart's and Verdi's and Wagner's and Puccini's operas move us. They give us goosebumps. They make us cry. And we leave the hall with the melodies still humming in our head. The audience will flock to see modern operas if they move us in a similar way. But they can only move us if we put the yeast back in the bread, if we return to the beauty and nobility of melody.

March 2020

Alma Deutscher, born 2005, is a composer, pianist, violinist, and conductor. She composed her first piano sonata at the age of six, a violin concerto when she was nine, and a piano concerto at twelve. Her first full-length opera, *Cinderella*, composed in 2015, has been performed on three continents and been described as, "a once-in-a-lifetime opera-going event that had audiences standing and cheering." Her new opera, *The Emperor's New Waltz*, will premiere at the Salzburg State Theatre in March 2023.

THE ULTIMATE FEELING

Mariss Jansons

I love the opera to no end. I spent my childhood in an opera house in Riga, Latvia. My parents worked there; they didn't have a babysitter, so I spent all day at the opera. I was only three or four years old at the time.

In the evenings, I was allowed to watch the performances, of course not all of them, because it was often too late for a small kid, but still, many of them. Back then, I was very fond of ballet as well. I learned all the ballets by heart. When I came home afterward, my aunt would be doing the cooking and waiting for me; I'd start dancing ballet next to her in the kitchen, regularly breaking dishes in the process.

My mother was a singer. She frequently took lessons with an excellent teacher and used to take me with her when she went there. I sat silently and listened attentively. This gave me the feeling that I was already learning about singing technique; I was, of course, no expert as a child, but I was able to tell whether something sounded better or worse. The experience proved very useful for my later career.

My father was a conductor at the opera. He talked to me a lot about all the various works—but I also got to know about the backstage goings-on at the opera house, machinations that fascinated me to no end. I was often allowed to sit in one of the boxes on opening night. Whenever it was *Carmen*, with my mother in the lead role, at the moment she got arrested (at the end of the first act) and taken away in the custody of Don José, I would shout, please, not my mom! At every *Carmen* performance!

I knew all the singers and all the dancers. What's more, I was always curious to know: how does an opera work? What is its structure? The same was true for symphony orchestras. Later on, when my father went to St. Petersburg and conducted there, I knew all the musicians' names in two orchestras, even though I had never seen them before. I knew exactly who was who and who played which instrument. I was deeply intrigued by all of that. The opera house was my second home. The atmosphere, the stage, the orchestra pit, everything fascinated me. How are the stage sets made? And the costumes? That was much more exciting than sitting in the auditorium.

That early exposure nourished the roots of my life-long love for and commitment to opera, at least that's what I believe, the fact that I heard and saw so much when I was a little child. And I sorely regret that I have never worked at an opera house regularly. But throughout most of my career, I've always conducted two orchestras, St. Petersburg and Oslo, Oslo

and the London Philharmonic, or London and Pittsburgh. Then came the Bavarian Radio Symphony Orchestra and Concertgebouw Amsterdam. There were always two orchestras; I was always involved with symphonic music and concerts. From my perspective, I have definitely not conducted enough opera. Nothing surpasses an opera performance featuring a superb orchestra, conductor, and choir along with top-tier singers, stage design, and direction. For me, as an artist, that's the most captivating—even more so than symphonic music.

I was lucky to receive an excellent education with a lot of practical experience. In St. Petersburg and later in Moscow, there was a professional opera theater just for us students. I was only in my third year when my professor called me to his office and said, "You're going to conduct *The Marriage of Figaro*." I had no clue how I would pull that off, and I didn't feel comfortable with the idea. But I guess it worked out somehow. Little by little, I was able to conduct more opera there. For a student, to get that kind of practice is a marvelous thing. You stand at the podium, conduct performances, and you're set off on a fantastic learning curve. Unfortunately, students are rarely given such opportunities. In addition to that, there was even an entire orchestra for symphonic music that students could conduct—all of them professional musicians. I know of no other conservatory that offers something along these lines.

After that, I had more fantastic teachers, in St. Petersburg at the Mariinsky Theater and later in Austria. It was always about the highest of standards. I still remember the first time I came to Salzburg; it was for the 1970 Easter Festival. I had a chance to go to the Festspielhaus to hear *Götterdämmerung* with Herbert von Karajan and the Berliner Philharmoniker. I had previously studied conducting, but I suddenly felt like I was in heaven.

I was with Karajan at the Festspielhaus every day and attended his rehearsals; I stood backstage during the performances. As a student, I could never have afforded to buy tickets in Salzburg. During this time, I also got to know many of the singers, which was incredibly rewarding. I suddenly understood a great deal more about opera, and a new wave of enthusiasm and energy sparked in me.

I have vivid memories of coming back to St. Petersburg and being scheduled to conduct *Carmen* after having studied in Vienna for one year. I experienced an incredible burst of passion, joy, and vitality. *Carmen* infused me with its bondless quality and atmosphere and has remained my favorite opera.

When I compare our situation today with the opera of that time, I have to say that, by all accounts, we have gone through a period of very intense development, and that's a good thing. But somehow, I can't shake the feeling that opera has lost something along the way, especially in terms of the quality of performances. Rehearsal work is altogether different today. In the old days, all singers and the director sat together with the conductor throughout the rehearsals. Now singers often only join in a day or two before the performance, which is, of course, a pity—and one of the reasons that prevented me from conducting more operas. It has always been my principle that I have to be there from the beginning when I do an opera—at every single rehearsal. And everyone else too, morning and night. That's always been my approach. Of course, we're all extremely professional, and we can cope with changing circumstances. But that's just not what I imagine opera to be.

If a process continues over an extended period, meeting every day, then as a conductor, you can establish the tempi with the soprano or the tenor. You get a sense of the way someone wants to sing, or breathe, and of his or her sensibility. I always refer to an opera conductor as a musical director. Why? Because it's not enough to conduct the music and see that we somehow keep in time together during performances. When I conduct, I try to experience everything and sing along inwardly, in my mind, with every single person involved in the music. There's no one on stage whom I ignore. When Bartolo laughs or when Mimì weeps at the end, I laugh or cry with them. That helps me a lot. That's what I love so much about opera. You relate to and engage with all of it for two or three hours; you play all of the roles yourself.

To me, opera means immersing myself in another world. If that process is successful, it opens up a new cosmos. That is the ultimate feeling. But unfortunately, today, it's all about cutting costs, about artistic compromise.

The mediocre conditions for rehearsals at repertory houses are at the root of the problem. If you play a different work every day, there will be almost no rehearsals. Then perhaps a conductor will step in without even being familiar with the production, or a singer is replaced at the last minute. Then, on top of it all, you suddenly have a couple of orchestra musicians sitting there who may have never played under this conductor before. Naturally, this affects the quality, and the result cannot be homogeneous. Then you definitely will not get to that cosmic level. Without sufficient rehearsals, you no longer take part in the whole. You merely regulate.

I always admire musicians in opera orchestras. When you have people playing *La traviata* for the umpteenth time, can you expect or even require them to summon the same passion they brought to the first performance? I think that's the way it ought to be. But unfortunately, things don't always work like that.

That being said, I certainly love a broad repertoire. It allows for less routine. We should also promote contemporary operas. But to get a truly great modern opera, one that everyone raves about, it's pretty tricky. Usually, a new opera is played four or five times—and that's the end of it. It is also difficult in financial terms as these performances tend to sell few tickets. But actually, it's always been like that—musical development is ahead of its time, and the audience always lags behind.

I don't know if I'm right, but intuitively I would say that when a modern opera revolves around present-day events, speaks the language of our time, and takes up the words and stories we hear every day, the audience will have a hard time with it. People want to hear stories from another time. It stimulates the imagination. If the main character recounts what he or she did that day, who called him or her up, no one cares.

Opera is a far more romantic affair than that. Alas, feelings are perceived as being old-fashioned today, be it in opera, theater, film, or literature. We have developed further and further on a technological level, but not our emotions, sensibility, and our hearts. For example, if you read letters by writers, or even by composers like Richard Strauss, they have a literary quality, much like novels. Today's letters? There's none of that. Today, a great many people are embarrassed to show their feelings at all. And when one cries, the other laughs.

We have become pragmatic and have lost touch with the world of emotions. Heart and soul are of no value anymore. Everything is focused on technology; our lives revolve around our telephones. That leaves little time for anything else. I doubt that opera can change anything, whether it can succeed in turning people's attention to real values again. In the future, I guess we will spend more of our lives, time, and energy with computers and robots. There are people now who watch a performance of *La bohème* and laugh about certain passages where you'd think their hearts would do a tremolo. Seeing that convinces me that we are headed exactly in the wrong direction.

Some time ago, I used to say that, as a general rule, everything passes. Presently, classical music is only for the older generation; young people can no longer feel any connection to it. However, by now, I'm convinced that opera and theater possess magnificent positive energy, and we can't give in without a fight—first and foremost, we, the artists who create them. We have to give it our all every day if we want to bring back that strength. This includes schoolteachers and politicians. Nowadays, nothing works without politics. But politics has moved thousands of miles away from art; it is oblivious. I don't think it has any understanding of what this is all about. And politics is also about money. Opera houses need enough of it to be able to stage exciting performances. You can't have a situation where people have to think about every single euro.

There is much discussion about stage productions, especially in Germany, where so much has happened in the field of directing. Maybe I'm old-fashioned, but I'm already happy if I see a stage that is not all black. A black stage reminds me of a cellar—that's not conducive to emotional engagement. What could pitch-black convey to my imagination? A theater is not a sauna. A theater is a theater. Take an opera like *Boris Godunov*. In my view, it needs lush funding if we do want to lift the spirits and aspirations among the audience.

Boris Godunov brings me to the situation in Russia. When Perestroika began, it spelled absolute disaster for the opera. People had little money overall, and the state provided less support for the cultural sector than before. Previously, during the communist era, it had received considerable funding. The reason for that was perhaps not a great love of art, but that the communists wanted to show the world all the wonderful things we had and how high our artistic standards were. With Perestroika, things became tough; discussions mainly focused on questions like, where are we going? Is our world kaput? Art hardly played a role anymore. But about four or five years ago, a renaissance set in. Now people are showing an incredible interest in art again. Exhibitions attract large crowds that include a lot of young people as well. Straight theater has always been popular in Russia. Moscow has over two hundred theaters, and they always play to near capacity crowds.

What's more, the love for classical music is on a strong rebound. Of course, this is also true for St. Petersburg, a fantastic city, both in terms of architecture and culture. We're back on the right track. Only training and education are not yet where they used to be.

Opera plays an increasingly important role in Asian countries. I even believe that they can give the whole field a new lease on life—with support from Europe. In Japan, for instance, people are full of curiosity and highly sentimental. And they have not come down the long road Europeans have put behind them, with all their errors and mistakes.

On the other hand, in the United States, theaters are strongly conservative-leaning, including the Metropolitan Opera, compared to German theaters. In America, theater exists through its donors. A manager is dependent on them. When a wealthy lady approaches him and tells him that the stage set is awful, he has to worry about losing her support. That's why theaters in America try to balance everything out in some way. They let in a bit of fresh air, but always hold on to the old tradition as well.

Today the educated middle class is becoming smaller and smaller, as well. Maybe that makes me a snob, but I wonder whether going to the opera doesn't amount to a sacred, spiritual moment. Do you really have to go there in jeans and a T-shirt? You go to the opera as you would to a festive event and not as if to a train station. I believe that the clothing should also be appropriate for the occasion.

Did I mention that *Carmen* is my favorite opera? But there are other works, too, which prove that absolute perfection is possible in art—operas where everything is right. In my mind, *Der Rosenkavalier* is one such achievement; *The Marriage of Figaro* is another. I think Rossini is marvelous too. As is Puccini, not all, but many of his works. And, of course, *Tristan*. I have an immense love for Beethoven, but I don't think *Fidelio* is one of his best works. Mozart is perhaps the only composer where everything is one hundred percent good.

I love operettas a great deal. Some people don't take them seriously—the scheming, the love stories, the happy ending. But that's a snobbish attitude. Many operettas are beautiful works. It doesn't always have to be all grand philosophy. When I lived in Riga, we had an excellent operetta theater. That's probably what my love for this genre started. However, I do believe that operetta is dying. It would take someone with real courage to bring it back to life. Regrettably, many singers also view operetta as being second-tier. I believe, though, that it takes more qualities to be an operetta singer than to be an opera singer—for instance, love and passion. Take Pavarotti, for example. If folks had only seen him standing in an operetta, it would have been a disaster. An operetta singer needs to be able to speak, sing, dance, be slender, and, in the ideal case, look good. This is one universal profession. It requires talent in all areas. Anna Netrebko has that, and quite naturally so. You certainly can't learn that kind of thing.

I would very much like to conduct operetta, but I've never done that, except once in concert. I would be delighted to conduct *Die lustige Witwe* by Lehár, for example, or *La Périchole* by Offenbach. But the cast would have to be top-flight with Netrebko or Diana Damrau. Piotr Beczała would be good, too, and Thomas Hampson.

In opera, we likewise need stars from time to time. I have great respect for theaters featuring only young, talented artists. But the opera needs stars. The ones who are still real stars, mind you. Who persist as stars not only because they bear a famous name. Unfortunately, what often happens is that first, artists work to make a name for themselves. Later, only the name keeps working for the artists. And the artist believes he or she no longer has to put in any effort. But thank God there are singers like Netrebko. She's a star because she deserves to be one. She knows exactly when and what to sing. She is also a perfectly normal, unaffected, lovely person.

Will there still be opera in a hundred years? I think so. I can't imagine this supreme form of art disappearing. Fortunately, there are enough music lovers out there—and also those willing to shell out a lot of money for expensive tickets.

In our society, opera is more popular than symphonic music. Opera is a universal work of art. Opera is number one, and that is why it will live on. The only thing that could happen, though, is that our world will become even more dominated by robots, so that eventually there may be no place for anything like opera. I'd hate for that to happen. Nostradamus prophesied that our world would end, a "twilight of the gods." We must do everything we can to prevent that from happening.

This essay results from a conversation between Gert Korentschnig and Mariss Jansons, which took place in Munich in October 2019, just a few weeks before the conductor's death

Born in Latvia, Mariss Jansons made musical history on the podium of the world's great orchestras. He studied in St. Petersburg and then in Austria with Hans Swarowsky and Herbert von Karajan. He was music director of the Oslo Philharmonic Orchestra and for many years of the Concertgebouw Orchestra Amsterdam and the Bavarian Radio Symphony Orchestra. He also enjoyed great success as an opera conductor. He died on the night of December 1, 2019; obituaries called him the most sincere and important conductor in the world.

3.

Drama

Backstage

THE BLANK CANVAS

Jan Lauwers

A secret is rumbling at the heart of art that threatens art itself. Art arises from the imagination, but that also means it is created out of nothing, and in its moments of glory it is aware of this. But it is precisely because of this that it is endangered by its nothingness, by its own insignificance. All it needs is a crisis of the imagination, possibly brought about by external legitimacy problems, for it to lapse back into the nothingness from which it had worked its way up.

Rüdiger Safranski, *Das Böse oder das Drama der Freiheit* (*Evil or the Drama of Freedom*, Munich: Hanser, 1997)

I have been engaged in theater for more than forty years now. The start was hesitant. As an artist, I found theater quite an unclear medium—too much applied art. An artist starts out from both nothingness and the whole world and is in the first place concerned with form and material. From that emerges the emotion. Supposing that is indeed the intention. The solitude this requires is very demanding. The question I asked myself was: "Can I put the solitude that is so important to me in a social context?" I started in the theater medium because of the necessity of contact with other people. To be able to endure the solitude of the studio and because I find the notion of collaboration extremely important. That also explains the name of my theater company, Needcompany: I need company.

I started calling myself a theater-maker for lack of a better term. I am not a director. I work in theater the same way I work as a painter: the maker himself determines everything. How was I to do that in theater, where you work with people? A whole team of specialists on and around the stage. I had not studied theater. I forced myself to learn the craft as a stage technician. To me, sound, lighting, space, and architecture were like the paint in my studio. The solitude of my studio in contrast with the enormous social world that the theatre is. To feed this, I sometimes reached for existing plays. Usually, Shakespeare because the cloak of history is a loving one.

I have written about twenty plays. The blank canvas. That was the need. Nothing and the whole world. Then the sets, creating images. I didn't understand that most directors did not design their own sets. Then giving the script to the actors, who turn paper ideas into people of flesh and blood. The actor's artistry lies in his ability to use his insight to make the

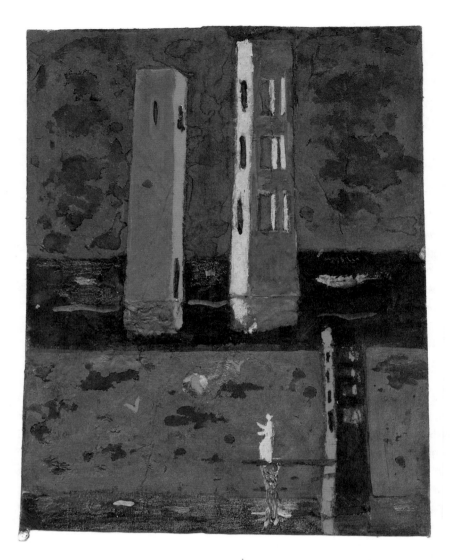

Les images, le ciel, les rideaux, tout prenait la couleur et l'odeur de la rouille.

Richard Peduzzi, *La Couleur et l'odeur de la rouille*, 2019
Oil and gouache on paper, 32 × 25 cm
Design for *Les Vêpres siciliennes*, Giuseppe Verdi, Rome Opera, 2019.
Courtesy of the artist
© Richard Peduzzi
(Photo © Frédéric Claudel)

authority of the script and that of the director (if he has one) unnecessary. As a theater-maker, I find the "directing" part the luxury position. As a director, you can easily do six theater productions a year, but as a theater-maker, only one. However much I've emphasized the difference between an artist and a director, a composer and a conductor, a writer, and a director, the academic world makes no distinction. The difference between the blank page and the full page. Directors start out with an interpretation. That's their job. A director is the servant of the play. Just as a conductor is the servant of the composition. The ultimate work is thus when the composer conducts his own work. The writer who directs his own work. Shakespeare, Molière, Beckett.

As a visual artist, I originate from the world of performance art. You can't get any further from opera than that. An art performance cannot be reproduced and has to be performed by the artist himself. If it becomes reproducible and able to be performed by others, it turns into theater. The performance artist becomes an actor. An actor trains for reproduction. The actors I work with are always people who dare to question reproducibility, who dare to seek out the reality of the moment. This form of the craft is often considered "amateurish." I cherish this sort of "amateurism." Great and outstanding actors, dancers, and musicians distinguish themselves precisely by giving that playful amateur a real face, using all their skill, virtuosity, and insight. This is happening with increasing frequency in the opera world. But it is extremely complex. It was therefore only after thirty years working in the theater that I started becoming interested in opera. After all, because I am not a composer, I could not start from a blank canvas. I no longer had to take up a subservient position towards the world but towards a composer! With his bodyguard—the conductor—surrounded by singers and musicians, all of whom have their interpretation ready in a drawer, earned by years of hard work. Why, for heaven's sake, would opera need a director? And it's a fact: I have seen plenty of operas with my eyes closed because the images and interpretations I was served up limited my freedom. I often don't understand it. The fact that I now nevertheless feel this need has a lot to do with the genuine challenge of "working together." And at the same time seeking out solitude in that gigantic machine that this all-embracing art needs.

The question of whether opera still has any meaning today is quite relevant, but in this sense, it is also easy to answer. Because opera is a slow and demanding medium that requires a huge amount of craft, it is a medium that is at odds with the contemporary world. Because opera needs tremendous cooperation, and yes, even a playful camaraderie, it is forced to play a pioneering role in the new world. This is because there is the prospect of a new task for the contemporary arts: giving renewed meaning to the political nature of art, not so much by generating an ideological art (that is usually abhorrent), but by looking for new possible ways of cooperating. I myself matured as an artist at a time when craft was a prison. The free 1960s, the inexorability of punk. It was a time when the deed had to be done quickly: three chords and you've got a pop song; the appearance of conceptual art, which focused more on "thinking" and where execution was not necessary or could be carried out industrially. I eagerly joined in. It was a form of democratization that I liked. And new skills developed. With the result that Bob Dylan received a Nobel Prize. Yet, I continue to maintain that the

phrase "practice makes perfect" is invaluable. To give one example. Nowadays, there are few remaining art courses where the notion of observation has any significance. Yet, I owe everything to the endless exercise of my drawing skills. Even now, I still often draw from nature; I sit down facing a tree and try to draw it. Just as an opera singer exercises his voice. The slowing down this brings about is my form of meditation. As a result of these "exercises," I can master an opera house and the stage with much greater precision. These exercises lead to a new concept: "the silent craft." This means that the craft is not an end in itself. Craft as an end in itself can only be called entertainment. Opera has always been in that straitjacket. But there is, slowly but surely, a sign of change. The art world has still not assimilated the radical bomb Marcel Duchamp set off in 1917 in the form of his urinal. But this led to my embracing theater. And then opera. It is artists such as Romeo Castellucci and William Kentridge who are shaking up opera. Not by dropping a bomb like Duchamp, but by asking questions. This is happening more and more in today's opera world. I would like to tell you an anecdote to illustrate this.

I was working on Monteverdi's *L'incoronazione di Poppea* for the Salzburg Festival. On the first day, William Christie, Kate Lindsey, and I looked deep into each other's eyes. I said to Kate that a singer forces me to direct when he or she is acting like a diva. Kate, an anti-diva, thought this was an excellent starting point. "Good," said Christie, "if Kate isn't going to behave like a diva, and Jan doesn't direct, then I'm not going to stand there flapping my arms around like a conductor." Our collaboration turned out to be marvelous. It seems a rather slight anecdote, but it is a radical, extremely complex form of collaboration that can only exist based on trust. As he promised, Christie did not conduct but meticulously guided his musicians to a willful form of freedom. This was, of course, possible only because we were all servants of Monteverdi. Who literally did not write down all the notes for the orchestra but said that if a musician understood the opera, he would know which notes he could play. The ultimate form of collaboration based on trust that leads to a radical form of freedom. This is the essence of contemporary opera.

Molenbeek, February 2, 2020

Jan Lauwers is a Flemish multidisciplinary artist widely known for his pioneering work for the stage with Needcompany, which he founded in Brussels in 1986. He won the Golden Lion Lifetime Achievement Award at the 2014 Venice Biennale. In 2018, at the Salzburg Festival he directed opera for the first time with Monteverdi's *L'incoronazione di Poppea*.

OPERA IN A TIME OF COVIDITY

Keith Warner

If opera has a future—we must never take our love and enthusiasm for any genre as a guarantee, as other art forms, or at least styles, have come and gone throughout history—it will lie, as everything does, in its aptitude to change and adapt, which means to state the obvious only one thing: its future lies in its practitioner's willingness to change and adapt. With strong leadership and strong results, audiences will always come along. But even opera, the most hybrid of forms, if it does not think and travel at the same rate as the world around it—after all, like all the arts it is only a peculiar type of mirror angled to reflect the world—it cannot fulfill any usual function in society, and will be more and more relegated to a museum status, or as a refined entertainment for a few "chosen ones," like polo, or grouse shooting. We have watched that happening more and more in the last two decades. The expensive festivals have flourished—in the United Kingdom, summertime Country House opera had been the one success story in terms of growth, at least. The nitty-gritty of opera, companies in your local towns and cities, have floundered somewhat, especially in their sense of identity, and often in audience numbers.

I have often noted that there are clearly two types of opera: first, the birdsong archive, where only the musical values, the endless comparing of voices and the fetishization of divadom, or conductors' tempi really matter.

In the other type, the world of music-drama, the operatic experience is more about text and music. Here the content is more important than its medium. We turn up at the theater wanting to have a journey towards meaning, and even if we find there is no meaning available, we still attend ever hopeful. Singing and orchestral playing, and a conductor's interpretation, although they should be the best possible quality, must cohere within an entire theatrical experience; they are not "the thing itself." After all, who goes to an art gallery to discuss paint!

Exploring an opera's meaning through its theatrical realization concentrates on the universal issues, the human condition, and the psychological penetration that it contains, all of which can be uniquely revealed through stagecraft, acting, conducting, orchestral sound, and singing. All of these are, of course, just as much in the music, as in the text or the production. To attract a potentially wider audience, without whom clearly there will be no future at all, opera houses should at least consider interesting theatergoers, film fans, and those who love contemporary fine art. But the idea of interesting these "satellite interest groups" in the medium (singing) over the content (the entire operatic experience) would be doomed to failure.

I find Music-theater, when its potential is described to "outsiders," sparks some interest, even if this interest is then very qualified. "Yes, I'd go, if I could hear what they're singing if I could understand what they're saying if I could afford to see it, if the acting was believable," and so forth. If we can convince more people about the form by addressing these fairly reasonable concerns, then we might find that opera has a future. However, if it remains more influenced by the rich man's pocket, the record collector's comparisons, the music connoisseur's booing, the director's love of fashionable tropes, the conductor's insistence on power-play, or the aging, white, male-dominated, critical establishment's opinion, it can only solidify into a boutique experience, and all the more seem strange and exotic to the real world. Like it is now, it loses power every year and will ultimately fail. The dwindling of subsidy may well have killed its chances in much of the world already—but that's another essay. However, the more opera embraces its finest challenge: to fuse music and drama to appeal to all who love either, or both music and drama, which when you think of it covers most people, irrespective of time, form, or place, the more chance it has. The public does not appreciate what the potential is, but we must and act accordingly.

This broadening of opera's appeal must begin with our own industry's re-assessment. When we know, when we are sure, when we become necessary and our work, in every department, engages with the world in ways it can recognize, then the general public become intrigued and will follow. As long as we flounder, so as long as we hold onto our habits, from over precious protection of scores to obscure productions that nobody understands, so will our following.

We are now told that as many people see opera through media contact, through broadcasts and cinema relay, through the Net, and through their already almost obsolete DVD and Blu-Ray players, as live in the theater.

Therefore, one course seems obvious.

If we do not embrace this huge world change as a major part of opera's future, then we have no hope. Live performance must be our center, it is too special to negotiate away, but it need not be our only. All forms of this type of "rendition" of opera are still technologically crude at the moment. Operas presented through the technological media are currently too often like a Victorian zoetrope when we deserve full "IMAX" power. When opera companies begin to realize that their rehearsal studios can easily become film studios and experiment with the myriad possibilities—for example, Green Screen techniques for postproduction design, skilled camera work à la Scorsese and Tarantino, and state of the art sound editing joins suit, which respects the equality of the soundtrack as much as the visual image—then the future for opera can begin. Young people can already make, edit, design, and produce films in their own homes at a very low cost. The technology is so often there, lurking in unexpected corners elsewhere. Can you imagine what a major opera company could achieve if it began to put its money behind such an initiative and source talent to make this a fresh way forward? What would we see if we no longer relied on merely relaying stage productions, which are always a compromise in almost every way, but instead, created original works for the Web? What will we confront when we commission operas designed and written for the Internet?

When we create opera films, short or long, for on-line consumption at reasonable prices? Can you imagine the hall of mirrors that this hitherto single reflecting glass could become? Interactive music-drama? And the emotional impact of the art form will overwhelm people when we develop acting and scriptwriting, which need to be as credible as any of the great Netflix series of the last years? (Please let's forget the nomenclature of "a libretto"; the very etymology of the word is already designed to diminish the power of the word under the pressure of the supremacy of the music!)

You can perform the most avant-garde production you wish, hopefully, while still ex-amining the piece in question and mining its possible meanings, but if the acting is not up to the highest level, competing with Streep and Blanchett, or De Niro, Fiennes and Fassbinder, then it will always be an affectation, rather than a vital enactment. The one thing "relays" have already shown the world is clearly when somebody is "inside" a role, or merely playing "let's pretend." There are now several generations of singers who are completely capable of fulfilling this histrionic demand. We will soon find that no performer will be able to get away with the old style of opera acting, gesture without inner psychological connection, whether in a white, upside-down box or drowning in the ornate froufrou of much of the Met's second-hand school of Zeffirelli work. I have heard people, watching opera in cinemas, laugh openly at this kind of posturing falsity. I also believe this demand for authenticity can be applied to "true" singing and musicianship too. But in this future, one hundred and fifty years on, in the end, as Wagner pointed out and tried to implement, it all must become about serving the drama, which in turn becomes about serving the human condition, which in turn becomes about serving our most basic human need: tell me something.

All of this would feed back into the vitality of live performances in our opera houses, which would, in turn, re-invent new energy to compete and go further. Like the revolutions of Monteverdi, Mozart, Gluck, Wagner, Berg, and Britten, we now need to think about the purpose of the art form afresh. Without such a radical re-think, the future, outside, really seems to be rushing on without us. By doing so, I sincerely hope that in fifty years, none of us will easily find opera performed as it is today. Without doing so, I doubt that we will be able to find it at all. Covid has nothing to do with stopping us, beyond the merely and painfully anecdotal; we have been stopping us.

London, August 31, 2020

British opera director and writer Keith Warner has staged more than one hundred and fifty operas in over twenty countries, as well as spoken theater performances and musicals. He has written librettos and, most recently, a novel. He achieved world fame with Wagner productions, including two *Ring* cycles (Royal Opera House and Tokyo) and *Lohengrin* (Bayreuth Festival). In 2022, he is scheduled to direct *Die Meistersinger von Nürnberg* at the Wiener Staatsoper.

A STORY OF LIBERATION

Denis Podalydès

I've staged four operas to date: *Fortunio* by Messager; *Don Pasquale* by Donizetti; *La clemenza di Tito* by Mozart; and *Le Comte Ory* by Rossini. I produced a second version of *Fortunio* at the Opéra-Comique in Paris ten years after my first, and I was about to direct Verdi's *Falstaff* at the Lille Opera when the Covid-19 outbreak occurred, postponing the project to 2023. In other words, my experience is quite limited and mainly circumscribed to opera buffa and comédie-lyrique, if you don't count *La clemenza di Tito*. Therefore, I can only speak from within this limited sphere of experience.

The first time I was asked to stage an opera, I was utterly taken aback. First of all, I don't know anything about music. But once given the reassurance that this was not the stumbling block I'd feared, I accepted. *Fortunio* is a lyrical comedy inspired by Musset's *Le Chandelier*, a play I knew well, and I was expected to treat the opera as if it were the play itself, at least that's what I assumed, and that's what I ended up doing. I directed the singers as if they were actors. In my first version, I was probably too reserved, probably didn't go far enough in my handling of the ensembles, duets, and trios, whereas the second time around, these sections were a revelation to me. Finally, the restaging of *Fortunio* was not just a reprise, but a totally new creation, which I thoroughly enjoyed doing.

As soon as I started rehearsals for *Fortunio* in 2008, I was conscious of the tight calendar. It was the main thing that was different from working in the theater: here, we would have barely four weeks to put it all together, whereas, in the theater, we would have had four months. In order to use the rehearsal time effectively, I prepared my staging in the tiniest detail as if transcribing a novel. But once the rehearsals started, the notebook soon became burdensome to me, and I put it aside. It distracted me from the singers. The conductor, Louis Langrée, helped me considerably. Very early on, he explained the music to me, and very early on, we had a common goal. This entente with the conductor was my first and greatest satisfaction: the sharing of viewpoints, the sensations, the problems—simply sharing. Such is the bicephalous character of staging opera: we are two, whatever happens. And if the two can be one, that's ideal. This was my experience with Louis Langrée and with Jérémie Rhorer, who conducted *La clemenza di Tito*. I need to know the conductor's fundamental instincts. With Louis, as with Jérémie, I discovered that their instincts were both dramatic and musical, the two dimensions being one in their eyes. From there on in, we were on the same wavelength.

My musical knowledge is minimal, and I have practically zero operatic culture, apart from the great standards, which I know more or less, in other words—badly. In truth, I didn't know anything about the operas I was asked to do before being asked to do them. And almost nothing about the composers. So each time was a discovery, a slow journey towards developing a strong attraction to the work. Whether it was *Fortunio, Don Pasquale, La clemenza*, or *Ory*, the first hearing of the work always left me stone cold. I could hardly distinguish the beauty of an aria or melody, only picking up on the most obvious ones. Ofttimes, the librettos left me speechless and wondering, with *Don Pasquale*, for example, how anyone could make a show out of such a weak, flimsily concocted scenario. Yet, each work crept up on me, little by little, each one of the librettos took shape before my eyes, numerous arias, scenes, and passages have become infinitely dear to me, moved me, revealed to me multiple riches, always new, increasing my deep attachment to the work.

Little by little, I understood just how much the music itself was at the root of the enchantment, which overcomes me in the process, in the very long process. Generally, a company asks me to do a production two and a half years, even three years in advance of the premiere. I use this time to absorb the work. I listen, I listen again, I continue to listen. I read and reread, forget, then reread. Wherever I go, I take the CD or DVD, I listen to it and watch several versions; I like to know how others have done it. I let the sensations, images, and metaphors take over. Little by little, a scene emerges from the shadows. It is pretty much the same thing in the theater, but I'm more guided, embarked, and swept away by the score with opera. The rhythmic constraint, the duration, the colors of the music determine what I do, whereas, in the theater, I can sometimes suffer from a lack of determinacy.

The long interim of the incubation period, months and months before the rehearsals begin, offers me a vast landscape for dreaming; this is one of the greatest pleasures. During these months, I exchange with the set designer (until now always Éric Ruf), with the costume designer (Christian Lacroix), the lighting designer (Stéphanie Daniel or Bertrand Coudert); I submit notes to them, initially disjointed, general, allusive, becoming more precise over time. I await their comments, their proposals, and then try to orient their work without devouring it. Sometimes I suggest several possible scenarios (for *La clemenza*, I hesitated between a very contemporary proposal—with screens, televisions, where Tito's image is projected multiple times while cameras and journalists are harassing him—and a more classic proposition, more reserved, which I ultimately chose) then, depending on their viewpoints, I decide.

Then the stage model is constructed. After this, everything becomes more precise, more settled. I focus more. I know pretty much how we're going to tell the story (so much the better, precisely because that is what I'm hired to do). Then I start delving into the work in detail. Reading the score carefully, I study the situations, the characters, and the relationships they have with each other; I take up the libretto once again and notate in it; I try to think of the scenes individually, their originality or lack of it—sometimes the cliché also feeds the imagination—I either take liberties with it or not at all. Above all, I try to broach the phenomenon, paradoxically the most difficult one for me to grasp: "duration," in the Bergsonian sense of the term: a heterogeneous moment, at once creative, dynamic, contin-

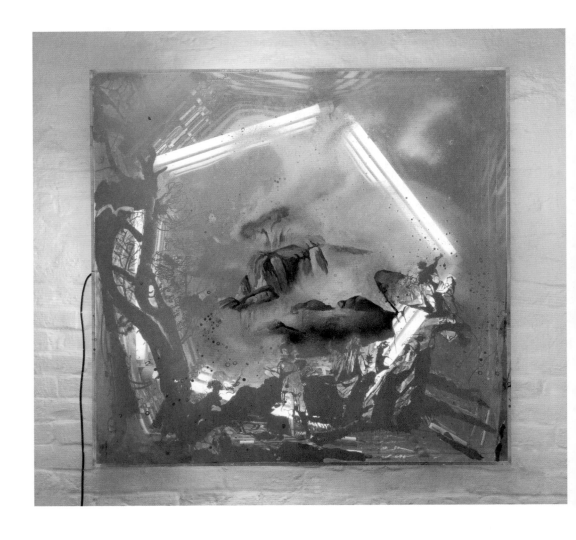

Philipp Fürhofer,
Rheingold III, 2012
Acrylic and oil on acrylic
glass, spy mirror, pencils,
cables, and fluorescent
tubes, 124 × 122 × 10 cm
Private collection, Hamburg
(Photo © Henning Moser)

ually moving, and metamorphosing. For me this is the cusp of the work—where it is most vibrant, singular—but also fleeting, like a fish that one would like to catch with both hands. I sense it while listening to the work. However, it is only later on that I manage to draw the real consequences, with the singers, as close as possible to the singers, when I experience with them the dynamic duration of the scenes (this is more perceptible in works which have several da capo sections), at which point I am finally able to measure the extent of their physical and vocal engagement. From there, I join them totally, I identify with them, the actor in me turns into a singer— a very, very bad singer, of course— but who cares? It's also a moment of great fraternity, a moment of settling too. Sometimes, I can hardly resist taking them in my arms (I am currently seeing the faces of Virginie Pochon, Joseph Kaiser, Jean-Sébastien Bou—three shows with him—Alessandro Corbelli, Kurt Streit, Karina Gauvin, Kate Lindsey, Julie Fuchs—two shows with them—and my dear Count Ory, Philippe Talbot, not to mention Gaëlle Arquez, Cyrille Dubois, Anne-Catherine Gillet, Franck Leguérinel, and all the others), I owe them so much!

And that's when I know if what we're doing is right or not. If not, we have to go on working until there is a signal indicating that we're telling the story as it is, in accordance with the music, as the music requires it. Once I have this assurance—which can arrive late in the rehearsals—then I begin enjoying the pure pleasure of what staging an opera represents for me. It is the feeling of being at once in the musical and the dramatic matter, no longer distinguishing from the other, where the two are absolutely one. It is in this composite, this amalgam, which finally takes me away from realism, in this other world, which is not at all mine of course (it took me such an effort to get there!), but yet where I feel at home, at last in my homeland of the heart. I also look for this in the theater, as both actor and director, but I don't get there as fully, not in the same way, not as radiantly and powerfully as in opera. That's why I love opera—absolutely: it frees me from the theater.

French actor and scriptwriter of Greek descent, Denis Podalydès has appeared in more than eighty films since 1989. He starred in *The Officers' Ward*, which was presented at the 2001 Cannes Film Festival. He is a member of the Comédie-Française and is one of their star actors.

Don't Turn It Into an Opera!

Robert Dornhelm

When asked as a filmmaker about the prospects of the opera, the first thing that comes to my mind is a sentence I often heard at the beginning of my career: "Don't turn it into an opera!" This line has both impressed and influenced me. Because a film that morphs into an "opera" usually has too much of (almost) everything. Since those days, I have repeatedly expressed this warning myself—to cameramen or actors who thought you could do "a little more" here and there. Even more spotlights, even more "action." My counter-argument has always been, "We're making a film, not an opera!" And every picture, even a fantasy movie, has to convey a convincing sense of realism. Any figment that has been turned into an image must appear credible and real on the cinema screen; in opera, it's different. Even if today's opera stars are usually excellent actors, the realism of their performance is diminished because singing is added to the mix. Lines are often repeated several times because their words are subordinated to the rhythm of the music. When it comes to love and death in a movie, people whisper, speak, scream—or shoot. But there is never any singing, not even in the case of my colleague Francis Ford Coppola, who dedicated three parts of *The Godfather* to the "lovers of Italian opera."

Despite these contrasts, to me, cinema and opera are kindred genres. It's no coincidence that there are very few films where emotions are not underscored or enhanced by music. And when it comes to editing, the film people tellingly talk about a "rhythm," according to which the images and scenes are "composed." Whether the success of film as a medium has to do with the fact that the opera has lost a critical chunk of its broad appeal is anyone's guess. In the old days, if you wanted to see a story in connection with music, there was only the opera. Now, many opera houses—first and foremost the Metropolitan Opera in New York—have begun broadcasting their productions on television or showing them live on big screens in front of their buildings. In the meantime, audiences have become so accustomed to the intelligibility of speech in film and television that opera houses are trying to overcome the language barrier by displaying subtitles or surtitles. It is probably for these reasons that more and more film directors—including myself—are being asked to direct operas for various stages or as film adaptations. The art form of the twentieth century is supposed to walk this old lady, the opera, into the twenty-first century. Rejuvenation therapy or off to the museum?

When people argue that opera as an art form has a present but an uncertain future, they always contend that the opera audience is getting older and older. Sadly, the logical

consequence is that one day this audience will die out. But somehow, this sounds paradoxical because the audience—just like each individual for itself—is generally subject to the process of aging. And if it is true that the young generation is interested in film and only older adults in classical music, it follows that at some point in every life, a phase should automatically occur in which a love of opera is virtually pre-programmed. Thus seen, one can "age into" an interest in opera.

In my opinion, the opera can regain its momentum if composers create new works— ones that pick up on contemporary themes and speak to us in a contemporary voice. Music "unplugged," in the tradition of natural, classical singing. But in my mind, this attempt at a solution touches on another problem contemporary music faces: playing "new" pieces from sheet music has a ring to it that no one wants to hear. All this talk about the future of opera being in jeopardy reminds me of the catchword *Finis musicae*, which at the beginning of the twentieth century was a term used to express concern that the great European musical tra- dition might have come to its end. When and how would it ever be possible again to create a wave of innovation in melodies that people had not heard often enough already?

The possibilities have been pretty much exhausted, and sound experiments often have little to do with what, in my opinion, music is supposed to evoke—and that's emotional responses. And musicals? I don't consider them to be a further development of opera; they are, at best, something like a "modernization" of the operetta genre. They are based on different priorities.

When I try to understand which path would best lead the opera into the future, a film title comes to my mind, namely *Back to the Future*. Applied to opera, this could mean that retreating into the past would likely be the most viable road forward. As for me, I see going to the opera as having to do, above all, with tradition or nostalgia. As does going to a museum. Attempts at reinterpreting an opera in a novel and modern way—something that many of the colleagues I admire do—seem to me like acts of desperation aimed at keeping the art form alive. In my mind, this approach caters to operagoers who return to the same festivals every year to hear the same operas time again but preferably with a new all-star cast as well as new stage sets and costumes. That's a sham. It's window dressing, just the same old wrapped in different packaging. As an audience, though, we still sit in the same room, in front of the peep-box of an opera stage, and see the same content that opera lovers have watched decades or even centuries before us.

When I got the offer to direct Puccini's *La bohème* as a film for the big screen, it was like a gift to me. I had just finished shooting the TV series *War and Peace*, and the producer offered me the opera as a treat. Plus, starring Anna Netrebko and Rolando Villazón. Various possible ways of modernizing the material crossed my mind—and eventually, I discarded all of them. Instead, I saw my film primarily as documenting the performances of two great art- ists, which we can and will want to watch and listen to in the future. Nothing ages faster than a "modern" stage production; therefore, I opted for a "traditional classical" narrative style.

There are, of course, composers whose views and insights provide material for a new interpretation. It is not Richard Wagner's fault that he was one of Hitler's favorite composers

but being an anti-Semite was. However, this aspect has been explored in so many productions and in so many different ways that, even with Wagner, we must ask ourselves what point there is in persistently viewing his operas from this angle. I love Wagner's overtures and his orchestral music; I'm not that fond of the singing. To come back to my original point: Wagner is one of the best film composers. To this day, people love to steal his music, or to "quote" passages, as the euphemism goes. Just think of the "Ride of the Valkyries" in *Apocalypse Now*.

On the subject of opera and film, another significant concern that comes to mind is that in Austria, the opera is heavily subsidized by public funds. But only about 10 percent of that goes to film, and that is anything but good. Film is undeniably a modern, important medium that comments on our time. As a film lover—I am deliberately provocative now—I would not feel any outrage if the operas were to be closed and the subsidies that would become available were transferred to cinematic ventures. On the other hand, it is my conviction that we should preserve the achievements of our cultural past and present them to posterity in style. Museums are part of that—just like the opera. If people today tell me that my films have an operatic quality because I use music a lot, that's perfectly fine with me. So much for "Don't turn it into an opera!" Today, I ignore this criticism with all my heart.

Austrian film director of Romanian origin, Robert Dornhelm he has received numerous awards, including an Oscar nomination for his ballet documentary, *The Children of Theatre Street*. He has also directed operas and filmed *La bohème* with Anna Netrebko and Rolando Villazón for the cinema.

PLAYING MY LIFE

Richard Peduzzi

Orléans, Sunday morning, I wake up in an anonymous, dreary hotel room; at first, I don't know where I am or why I'm there. I get up, draw the curtains; the window looks out onto a deserted main street; it's not really raining, just a thick, persistent drizzle. A lone man, elegant, a little stout, middle-aged, walks slowly; he looks around, hesitates as if searching for something, then quickens his pace. Walking towards the bakery, he gazes through the window, hesitates to enter, turns back, thinks, retraces his steps, and finally disappears inside. Without wanting to, I'd spied him from my vantage point, the actor Bernard Verley, wandering alone in the street, visibly a little lost: so early in the morning and already working on his role, I thought. Then quickly closing the curtains I crawl back into bed in the dismal, barren room. Chilled, anxious, panic-stricken, the scene I'd just witnessed was like something out of Eudora Welty's *Death of a Traveling Salesman*: an actor alone on a deserted street on a rainy Sunday morning, not another living soul. I imagine a whole grim scenario and then slowly, with the help of the bad hotel coffee, I begin to realize why I'm there: *Rêve d'automne*, that evening, the dress rehearsal—it was already better!

The next day, the show would be performed in a public theater for the first time. Each one of us, the actors, Patrice, the technicians, having already participated in this epic production in the grandeur and the magic of the Louvre Museum, would now be confronted with another magic, that of a room, of a stage, of a set; dispatched to the unknown, to other glances, all squeezed into a space that resembles the other like a twin brother, his double, the one who will steal the memories from the other, with a different character, a different spirit from which we must once again learn everything, expect everything.

Very young, as a child, at the age of five, I think I remember, I understood that one had to die. Facing the mirror, I was already measuring the time I had left; I naively asked myself, to the point of losing my mind, where I came from, who I was. I enjoyed making myself dizzy by asking myself this question again and again. Then, death didn't frighten me; it had no reality and strangely still doesn't today, simply, since always, almost always, I know that it is there, hidden, lurking in a corner, ready to pounce, ready to claw, at any moment. I quickly understood that to fight it, I had to ignore it. All the same, this invisible presence, which I force myself to forget, disturbs me, makes me feel cramped wherever I am; I am obsessed by the terror of confinement, that of being stuck in an elevator or, on the contrary, trapped in immensity. Whatever one does, the fight is lost and won in advance; the game always ends

in a draw, 1 to 1. Even if the sky, the earth, the water surround us while giving us the illusion of freedom, they imprison us, heckle us, take us, throw us and pull us back according to the time and the moment. Theaters block the time that slides under our steps; they are secret boxes placed on the ground; they protect us. Inside, we reconstitute stories, our stories, the story of all. We build our skies, our walls, our dreams, and our oceans; we expose with fear, with joy, with modesty, sometimes without modesty, our doubts, our passions. The theater is a house that filters and freezes time for a moment, asks it to wait for a moment at the door. It is a shield behind which women and men tell us, "Come and shelter under our tree, rest, reflect, come and take the time to hear us, the time to stop time for a moment."

I will never forget that morning so far away and yet so near when I landed in a cold and deserted suburb, in the middle of nowhere. Pushing open a door, my life changed. It was Christmas Day 1967. After a night of listening to music, hanging out in bars, I finally took the first train to Sartrouville, where I had an appointment in the theater. When I arrived at the foot of the building, which stood sadly poised on the asphalt of the marketplace, I immediately felt like turning back. I entered mechanically, guided by the glow of the service bulbs to the stage. In front of me, in the half-light was the silhouette of machinery made of pillars, wires, cogwheels, and giant reels at a standstill. I was overwhelmed. Never before had a theater set given me such emotion. A young man of my age was standing on the stage. I watched him for a moment, thinking. He was silent, grave, observing everything around him. It was Patrice Chéreau. When he saw me, he suddenly emerged from his reverie and rushed to meet me. Once we were in front of each other, we exchanged a questioning, strangely familiar look, then he stormed off to the other end of the stage and began to tell me about this set he had designed for the Chinese plays by Kuan Han-ch'ing's: *Snow in Midsummer* and *The Wife-snatcher.* He described it as a machine ready to walk, to move on the stage, to fly away. For him, I understood very quickly, theater was his way of looking, of trying to see, interpret the world, and paint it.

From then on, we never left each other. We fought a battle built on a very close complicity, marked by curiosity, astonishment, and shared emotion. We pretended to know each other perfectly, while we knew that we always had secrets to discover in each other. Sometimes, Patrice would say that he didn't want any scenery, as if to distance me from him, to show that he didn't need anyone. Then I would show him a drawing, and he would change his mind. The back and forth of ideas, intuitions, feelings, anger, tenderness between us, our constant search for the unseen, the unknown, strengthened our relationship year after year. I knew that the excellent student that he had been, the thinker that he was, wanted first of all to make the heart beat, to provoke emotions in everyone, to make people laugh or cry before wanting to reason.

The day I discovered this profession, I knew that I would have to fight for it to be recognized, to find the place it deserves. With Patrice, from the beginning, we had confused stage direction and set design to make a single form. This profession, as old as the world, was only interesting for me if I took it elsewhere, if I found a new combination, a personal way of doing it, by investing myself totally in it, by playing my life. For me, making theater sets is a way to escape from confinement. It's juggling with time; it's playing with the world in the restricted space of a stage, sliding one continent into another, crossing walls, and seeing

paper architectures appear on blank sheets, looking like marble that will later move on the stage. Without a school and or a teacher, I have only ever known what I have seen and heard around me, what has marked me, hurt me, what I have caught on the fly or stolen from time. With this job, I found a way to understand existence, to fight against anxiety. What I have been looking for since my early childhood is a way out, to get out of myself, to explore the depths like a diver, and to redraw the underground passages within myself.

Today, I find intact in my memory the noise of the corridors, the agitation of the night, the voice of Vincent Huguet on the phone the evening I saw Patrice for the last time. For years I had been fighting against the hepatitis C virus, and I was finally going to be free, to be rid of this dirty companion thanks to a miracle drug. But at the same time, in the same hospital, my greatest friend was losing his life. Why in one moment had everything disintegrated so vertiginously? I delayed entering his room. As soon as I crossed the threshold, he recognized my footsteps. He gently lifted the blindfold, which protected his eyes from the light. He smiled at me as if he wasn't surprised to see me there. Lying on his bed, he was drained of all his strength. In that veiled look I knew so well, I understood he was on the brink of this nightmare and the horrible suffering caused by his illness. He asked me to pass him the glass of water on the table next to him. He could not hold it anymore. He raised his head and then, this time, looked at me for a long time, saying the two words, "Quelle vacherie!" His gaze had changed to an absent look I didn't recognize. I understood that the game was going to end and that another, longer game would be played elsewhere. We stayed together a little longer, whispering a few words, looking at each other without really seeing each other. Exhausted, all his being, his body, and his thoughts made one block. From this static body and face, all the secret forces stored up during a whole life were released. His hands, calm, flat, wide-open on the sheets, were still as strong as ever. His knotty fingers, like tree branches, which had so often beaten the measure on the world's theater stages, had come to a standstill. On his bed, peaceful, silent, he was determined like the long-distance runner ready to take to the track. He put his blindfold back on his eyes to better concentrate, better lose himself in the depth of the impenetrable black. Helplessly, I watched him slide down the tunnel. From that moment on, I never met his eyes again. An opaque wall stood between us. I stood under the despairing glow of the light bulb that hung over my head. Frozen, useless, indiscreet in the heart of this anonymous hospital room, witnessing, unarmed, the death of my friend, I had only one thought in mind: open the door, get out, escape the din of this silence, to the street from where I had just come.

"It's time," said the mother of *Rêve d'automne* as she left the stage. One day, I told myself that, perhaps, it was time for Patrice. *As You Like It* was to be his last fight. To represent a forest, we had both imagined, without even consulting each other, a tree. The king of forests. During the last work session at the Odéon, in the company of assistants, technicians, and builders, we asked ourselves questions about this tree: would it be possible to hide inside, climb on the branches, would it be practicable? Or should it rather disappear, take the emergency door and end up on the ring road in traffic jams with trucks? After a short while, I exchanged a look with Patrice, who said, "We should forget about it." Finally the tree would be his testament.

On the stage, I continue to search for new spaces. The closer I think I get to the mystery, the further away it gets, as if on the edge of the horizon. If I turn around, does the world reverse? After walking the stage, I sit down in the hall to become a spectator. I have been known to stay in this position for a long time, often finding it is so beautiful empty. Why would I put a set there? It's like trying to build a sad building in the middle of a field full of wildflowers. The walls of the theater by themselves could be enough. You can act, you can do anything you want, you can even gather hundreds of people there. But as I read the stories, as I listen to the music of the staging, invariably a place emerges in my imagination, and I begin to think about how to inhabit this void, to bring in an architecture, a volume while maintaining this feeling of emptiness, so as never to feel suffocated.

Sensing the void is essential, even on a sheet of paper. Use the margin and the space around it. As in nature, typhoons and storms pass by fleetingly, and the space then takes on other colors, other shapes. The aggressive clouds appear sharp; when everything calms down, the curves come. The scenography links the sky and the earth in a titanic effort. Only nature can organize its own space, and when man attempts to do so, it is at the cost of such a strain that I can understand why some people cannot bear it for long. It may seem ridiculous because it is only a stage set, but for me, one of the greatest sufferings is to be paralyzed in front of a sheet of paper, to see everything that occupies my mind flying away, not being able to pose, to look calmly, to find the form I am looking for. Sometimes, what I want to say does not come as quickly, as spontaneously as I would like.

Sometimes the paper rebels against me, the paint turns into untamable stains, the chair and table become inhospitable. It takes a lot of courage to enter into the work, to sink into solitude and silence, to lower my gaze to my paper to raise it further, to try to transcribe the inexplicable into thought or drawing. I spend most of my time looking for unknown times, places, architectures I have come across in another time and place. Endlessly, I try to find them, vast unexplored expanses evaporating in the clouds, far beyond my dreams.

Then, suddenly, at the moment when I least expect it, a glow and shapes never seen before flood the flat, inert surface of my paper, guided by my hands, emerge from my thoughts. I then begin to play with the materials, mixing and dissolving them on the paper's surface. The water of the docks, the mud, the rust, the soot of my grandfather's workshop, everything comes to the surface. The earth, the rocks, the storm, the wind, the rain, the storms, the fog, all the elements of nature are present in my paintings.

With this profession, I have drawn strength, a human richness, and given full meaning to my life. If I had to do it all over again, I would not change a thing.

Richard Peduzzi is an artist, designer and scenographer. He was the director of the École Nationale supérieure des arts décoratifs from 1990 to 2002 and of the French Academy in Rome from 2002 to 2008. In 1969 he began working with Patrice Chéreau. Together they produced several operas including the landmark *Centenary Ring* in Bayreuth in 1976, as well as dramatic texts by Bernard-Marie Koltès and others.

DIGGING PASSAGEWAYS
IN THE HEAVENS

Christian Lacroix
Conversation with Denise Wendel-Poray (January 2020)

Denise Wendel-Poray: *How do costumes fit into the notion of opera as Gesamtkunstwerk or as a total work of art?*

Christian Lacroix: It all depends on the director's wishes and approach; it's not just up to me. The day I'm director, things will be different. But when there are many people involved, it's up to the director to create the alchemy between them to achieve a "total art" form. But I also believe that this concept—the total artwork—is more Germanic than Latin or French. Of course, all directors seek coherence in the work, between sets, lighting, music, text, costumes, but more than that, we play on contrasts: a bare, contemporary set to highlight period costumes, for example. My job is to illustrate a dramatic concept, the different players' personalities, to illustrate what the director wants us to know and distinguish in them. What I do is never purely decorative; of course, there's always a purpose, a strategy, and it's this image of each character that I have to clothe.

How can costumes contribute to the clarity of the story?

By sticking as closely as possible to the director's concept for each role, we then build upon his notes, indications, exchanges of documentation, sometimes very abstract. Then the actor or singer is encouraged to make his or her own proposals. It's on an individual basis, depending on the actor, the theater, and the director. In the end, the director needs to see on stage the idea he had in mind in the beginning, whether it be completely over the top or, on the contrary, pared-down and sparse.

How do the costumes define the characters?

By becoming a sort of archetype, almost like pictograms immediately recognizable thanks to a specific color or material, a silhouette, a detail, particular make-up or hairstyle, giving off what the director wants us to feel, all in the service of the acting, the gestures or the choreography.

You have created the costumes for several opera productions, often with actor Denis Podalydès as director. These productions are both contemporary and imbued with an in-depth knowledge of styles, periods, and history, allowing you to play on several registers. I'm thinking in particular of La clemenza di Tito *at the Théâtre des Champs-Elysées. How can operas, especially baroque works, speak to us today and reach a younger and multicultural audience?*

At the risk of seeming conservative, I have to admit that I hate contemporary transpositions, which have become a new form of dogmatism and serve the dramaturg or the director more than the work. In the past forty years, I've had enough of seeing the classics and baroque works being staged with fascist uniforms on Wall Street or in clichés of suburban bungalows with kitsch 1960s outfits or 1970s Hawaiian shirts. Sometimes the transposition is relevant and drives the point home. This can be revelatory—but it's very rare. You have to create an espace-temps—a temporal space that brings together that of the work of the author and of our present time. Of course, it's cheaper to find costumes and accessories at flea markets or in Red Cross stores. However, this is not the best way to attract the new multicultural generations by showing them what they see already in the cinema, on television, or in video games. Is it a crime to ask young people to use their imaginations, not to go with the lowest common denominator but on the contrary to transcend and to renew? By chance, I heard a wonderful expression today, "Dig passageways in the heavens, which the public has yet to discover." This should be our goal in the theater. In sum, I find that young people from all cultures who are already open to the fantastical through everything they know from blockbusters and video games, mangas, and so forth, are quite capable of understanding the baroque extravagance of a Louis XIV costume similar to those of science fiction characters, or a Roman palace, which could be an interplanetary station! It all depends on how you present it. It's not a question of showing them the same boring productions, continually repeating the same worn-out concepts, but of taking them elsewhere than in everyday life. Another one of my convictions is: "We have to give the audience not what they are expecting, but what they don't know they're going to like yet."

French fashion designer Christian Lacroix's prestigious career has spanned more than forty years. His collections are noted for their subtle combination of luxury and insouciance while employing artisanal elements: fringe, beads, and embroidery. He designed costumes and sets for a number of opera productions before directing Offenbach's *La Vie parisienne* at the Théâtre des Champs-Élysées in November 2021.

A COVID CONVERSATION

Urs Schönebaum
Conversation with Denise Wendel-Poray (November 2020)

Denise Wendel-Poray: *At last, you're in one place long enough for us to catch up!*
Urs Schönebaum: Yes! I'm in quarantine in Montevideo, not allowed to leave my hotel room for two weeks, so lots of time to chat.

What are you up to in Uruguay?
I'm doing the lighting design for a zarzuela called *La del manojo de rosas* by Pablo Sorozábal's. My partner, the Spanish director, Bárbara Lluch is staging it. We open on December 22 [2020].

So, despite these consecutive lockdowns, you've been keeping active.
Well, starting in March 2020, when Germany went into lockdown, I didn't work until the end of August when we continued rehearsing the *7 Deaths of Maria Callas* by Marina Abramović. We managed with stop and go to prepare everything, and the show opened in September 2020—there are several co-productions planned; let's see what happens now.

In the meantime, let's talk a bit about your story. First, you did an apprenticeship in photography in Munich, and then in 1995, you began working with Max Keller in the lighting department of the Kammerspiele in Munich. Since then, you've become one of the world's most sought-after lighting designers. However, in 2012, you turned your hand to stage design and directing, with works such as Jetzt *by German composer Mathis Nitschke and* What Next? *by Elliott Carter in 2012, at the Corum in Montpellier.* HAPPY HAPPY, *an operatic song-cycle with party by Nitschke followed in 2014 at the Opéra Comédie in Montpellier. What made you decide to take on stage design and directing?*
I've worked in theater since high school. Back then, we did everything that needed to be done without making distinctions. So you become a jack-of-all-trades. That's why every aspect of theater interests me—it's a whole. So it feels like a logical consequence to move on and try to evolve in other directions. After Montpellier, one of my stage designs was for Alberto Ginastera's 1967 opera *Bomarzo* based on the life of Pier Francesco Orsini, who lived in the sixteenth century. (He designed a garden, the "Sacro Bosco," full of grotesque creatures. Unfortunately, after his death, the property was abandoned. Public interest was only reignited several centuries later when Salvador Dalí visited the garden in 1948 and pro-

duced a short film about it. In addition, his 1964 painting, *The Temptation of Saint Anthony*, references these monsters.) *Bomarzo* was a joint production between the Dutch National Opera and the Teatro Real in Madrid, where it premiered in April 2017. My intention was to play with the forms of naturalism and abstraction. The set consisted of black space with reflective walls filled with vertical and horizontal light lines, thus creating an architecture inside the black space. As a naturalistic element, I had a moonish landscape pushed in from backstage. I was interested in exploring the abstract space, which for me was the mental space of Orsini, opposed to the landscape in which he was planning his garden. Since the grotesque statues of the Sacro Bosco are so well known, I had large blocks of black stone gradually brought into the landscape to indicate the future making of the sculptures. As a third layer, we had video projections created by Jon Rafman, which united these mental and naturalistic worlds. Currently, I'm working on a stage-design project for an opera centered on the story of Elizabeth I of England, called *Bastarda*. Donizetti devoted four operas set in the Elizabethan era (*Elisabetta al castello di Kenilworth* (1829), *Anna Bolena* (1830), *Maria Stuarda* (1834), and *Roberto Devereux* (1837). *Bastarda* is a reforging of these four operas, placing Queen Elisabeth as the main character. The result is a six-hour operatic marathon, divided into two evenings. If all goes well, it will premiere in March 2021 at the Théâtre de la Monnaie in Brussels. In this concept, the set is entirely abstract. It will hopefully look like a set model. It is a study of different architectural spaces using the most basic geometric forms in a minimalist combination of set elements and light. I am very curious to see this on the stage of La Monnaie.

You seem to be the man one calls upon for these mega-projects, such as Karlheinz Stockhausen's opera cycle Aus LICHT *at the Holland Festival in 2019.*
That project was mainly about lighting. It was staged in the Gasometer in Amsterdam, involving almost 500 musicians. It was also a marathon performance, a condensed version of the *LICHT* cycle initially conceived on a much larger scale presenting seven operas on seven days of the week. The production offered a spectacular overview of Stockhausen's masterpiece. The musicians started preparing years in advance; we had moving choruses, two conductors, chorus conductors, solo parts, and original recordings of Stockhausen's electronic music pieces. Here, the task was to design a space that could frame these seven days of the week and meet all the needs of these very different parts while respecting Stockhausen's original plan. We succeeded in doing this with only one month of rehearsal, which was only possible thanks to Pierre Audi's direction. It was a once-in-a-lifetime experience for me.

Are you counting on the summer festivals taking place in 2021?
I try to move ahead as if everything will happen as planned—otherwise, nothing will happen. Currently, I'm doing a lighting/set installation for *Apocalypse Arabe*—a piece commissioned by Festival d'Aix-en-Provence by Pierre Audi from the Israeli-Palestinian composer Samir Odeh-Tamimi based on an account published in 1975 of the civil war in Lebanon by the painter and poet Etel Adnan. If all goes well, it will be staged in Arles at LUMA in July 2021.

There is less money for this project than the Stockhausen; it is austere, very simple, but I think it will be incredibly moving.

This kind of work seems to be your element more than the standard repertoire.
I'm personally not so interested in finding a concept for the repertory works such as *Figaro* or *Aida*; other people do that much better than I can. I'm happy to design or direct, to put everything together, but only if I have a specific idea—otherwise, I wouldn't even be able to begin rehearsals; that's why I am more interested in exploring contemporary works, texts that relate to our present, contemporary art and architecture. Yes, there is a big audience for the favorite repertoire pieces, which are essential to the survival of opera, but we've seen many interpretations of these works. Would it not be more fruitful to move on? I'm not criticizing the classics; there is no right and wrong in theater, but wouldn't it be interesting if opera were a constant field of research?

Where has your research led you? What are your conclusions?
It is hard to get an overview when you are in the middle of the forest, but one striking example I experienced was how using microphones worked in Mathis Nitschke's opera pieces in Montpellier. The productions had a tremendous impact simply by juxtaposing the trained opera voice with the amplified voice, thus creating a more intimate vocal expression. Why are we so afraid of using microphones in the operatic context? Another example of research and experimentation is Olivier Fredj's idea of merging four operas, resulting in an entirely new piece—*Bastarda*. We use theater texts freely, making cuts, adding texts, changing the order; why can't we do this with opera? With this project, we will be trying to show how this can work.

Are there not some works that should simply be left as they are?
True, there are some works, which I hold in such high esteem that it seems there is nothing more you can do to them, Mozart *Requiem*, for example, there is nothing you can add. That's why I only liked Castellucci's *Requiem* at Aix-en-Provence after seeing it a second time on streaming. Somehow, the first time, the idea of turning Mozart's funeral mass into an opera seemed a sacrilege to me. The second time, I was captivated by his approach. Castellucci proved me wrong. But, finally, there is no certainty or conclusions.

Without transforming a work, lighting can be a subtle game changer when it comes to opera.
Sometimes, in theater, light can be everything; one can change the space drastically with lighting; I try to build lighting as an ever-changing immaterial sculpture that only exists in the moment; it can be an ephemeral experience framing and adding to the impact of the production.

In the wake of the pandemic and shrinking budgets, can we find more "light"-weight solutions for making opera?
Of course, it's possible, but this would nevertheless limit interesting visual theater, opera lives from the combination of all art forms—so shrinking budgets are a concern. At the same time,

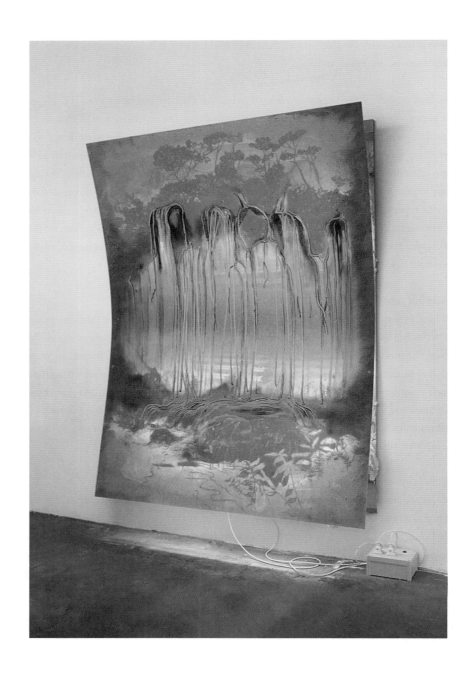

Philipp Fürhofer,
Green Falls, 2017
Acrylic and oil on acrylic
glass, spy mirror, plastic foil,
LED-lights, wood cables,
and electrical control
system, 230 × 178 × 37 cm
Courtesy of the artist
(Photo © Henning Moser)

the pandemic has made it very hard for artists starting out; for younger artists, through all the cancellations and independent theaters closing one after the other. So perhaps a multitude of smaller productions, if this is the future, would offer more opportunities to young singers and attract a new audience as well.

Are you anxious about the post-Covid reopening?
Right now, with Covid, you can't control anything, vaccine, or no vaccine. In the best-case scenario, theaters will come back. In the "champion's league," things will keep moving for the next two years because they are already financed—but after that? I worry more about all the privately funded theaters. Will they dry up? But perhaps less money is a good thing. Paradoxically, in my experience, people are more artistically risky when they have less money to create—less money, less to lose.

You've worked in all the great houses from the Bavarian State Opera to La Scala to the Metropolitan Opera in New York; apart from funding, what do these institutions have to look out for to ensure their future?
Look out for who your audience is; if there are a lot of young people, you're on your way. I think it's essential for all opera institutions to reach out to young people if we want this form of music theater to survive. For example, the Paris Opera opens the general rehearsals to an audience under 30. I think this is a great move.

What is the best-case scenario for the future of opera?
In the best-case scenario, we can keep the audience interested in what we are doing with standard repertoire, contemporary works, and forms of experimentation. Never forget how many people an opera production employs and how many people an opera house employs on a permanent basis. On any given evening, you have a conductor, an orchestra, singers, dancers, actors, a chorus, technicians from many different departments, make-up artists, wardrobe people, stage managers, totaling easily 200 individuals and sometimes more, all working together to the same beat of the music, at any moment something can go wrong, but everyone involved is trying to make something bigger than each individual effort. And that is such a beautiful expression of humanity. Where else in this world does something like this occur? Is this not reason enough to fund opera and continue working together to make it better?

German lighting designer, Urs Schönebaum has worked regularly with directors such as Thomas Ostermeier, William Kentridge, and the La Fura dels Baus company. He is a long-time collaborator of Robert Wilson and has produced lighting designs for art projects with Vanessa Beecroft, Anselm Kiefer, Dan Graham, and Marina Abramović. He has also designed and directed operas.

WORDS AND MUSIC ARE NOT DYING — SO OPERA WILL NOT DIE

Robert Carsen
Conversation with Denise Wendel-Poray (June 2020)

In opera, text and music are both tools of communication.
Text speaks to the intellect, whereas music speaks to the soul.
Robert Carsen

Denise Wendel-Poray: *Live performances have been silenced now for several months; how do you see Opera moving on from this dark watershed in its history.*
Robert Carsen: Words and music are not dying—so opera will not die.

What strikes me is the irrationality of the situation we are in, whereby the person who shakes your hand could be your killer. And this brings us back to who we are anyway, meaning that our lives are entirely random. The irrationality of life—we are hard-wired not to accept our mortality—you could call it the life force. Art, is it for the sake of others? I've been signing my emails: "art for art's sake" or "art conquers all." Why am I doing that? Covid-19 is not going to kill opera or art. Opera will do what it's always done, but we have to talk about composers and new works—young directors are a worry for me. It was already tough when I was starting out in the 1980s, but now we have a new set of problems. The question is, what will the focus of the intendants be now: will they be supportive of young directors, take risks with new works? Will audiences be afraid to come back to the theater? Hopefully not, and hopefully, when they do come back, they will be hungry and thirsty for art and realize just how much the feeling and sharing of music nourishes them. It isn't just something you can buy at the supermarket.

You say it was difficult when you were starting out. How was it then, and how is it different now?
I had to make some difficult decisions and choices: first leaving university in Canada to study acting in England. I was accepted at several schools, and I chose the Old Vic in Bristol. After a year, one of my professors said that he felt I would make a good director. I thought he was saying that I was a bad actor, but he said no, that wasn't what he meant and that my interest in all aspects of rehearsal and the overall narrative was what made him feel that directing was what lay ahead for me.

Of course, I had no idea how difficult it would be to get a directing job of any kind. It was very difficult to become an assistant, even an unpaid assistant. People were wary. It soon became clear that I would not get a job as a staff producer at the ENO or the ROH

in London or anywhere else in England. I had no Oxbridge background, only this strange combination of a Canadian University that I had dropped out of, followed by two years acting in an English drama school.

I spoke different languages, which would prove to be a real advantage later on. But I remember someone saying because I was fluent in a few languages, "Oh, we didn't give you the job because we were convinced you wouldn't stay in place for the two or three years of the contract." I wondered how I could ever get to direct something myself, and in reality, it was extremely difficult. At one point, I was so discouraged, I almost gave up.

What was your first breakthrough, and where did you go from there?
My first job was at the Spoleto Festival, working as an assistant to Filippo Sanjust, unpaid of course, but it was a start. Then I had various other assistant positions, one with British film director Ken Russell on Zimmermann's *Die Soldaten* in Lyon in 1983. It was great to spend time with Ken to observe how he worked. His working score was essentially a film script: the text was on the right side of the page, and on the left side, he had written down everything that he wanted us to see onstage.

But with Ken, almost anything was possible, and although he had a plan, he also followed his instincts. For example, for the bar scene in *Die Soldaten*, the soldiers were being served by women dressed as nurses, who, when they turned around, were completely naked except for a G-string.

Ken also decided that he wanted the barkeeper to be a transvestite, but we couldn't find any in Lyon who fit the bill. So we went to Paris to the Alcazar on the rue Mazarine, a famous transvestite cabaret then. I knew the compère/star, and we had this surreal audition in his living room. Of course, Ken found precisely the person he was looking for!

One of the great things about that production was the set design by the famous German-born stage designer and sculptor Ralph Koltai who lived and worked in England. He did a strange, disturbing sculpture of a woman's body cut into several parts. That stage set later helped the UK team win the first prize at the Prague Quadrennial of Performance Design and Space.

But even more so than with Ken, I learned a great deal from the American director Frank Corsaro, working on Prokofiev's *The Love for Three Oranges* in Glyndebourne in 1982, with stage sets by Maurice Sendak, the author of the famous children's book *Where the Wild Things Are*.

Frank was theater-based. I had worked with other directors, but Frank had a way of throwing away the rule book. He was very chaotic, and it was sometimes difficult to follow him in his process. But he was joyous, like a kid in a candy shop, and generous, particularly to his assistants. He helped me understand how one shouldn't try to make sense of everything all the time. He would ask me: So why do you think I did what I did in that particular scene? I would try to come up with an explanation, and he would say: No, I did that for absolutely no reason! It was a new way of thinking that liberated my imagination—not to try to be "le bon élève."

Frank helped me to trust my instincts and to go with them. And once you've learned that, you want to go on learning for the whole of your life. The problem is when you are trying

to get a job; you spend so much time trying to get the job that when you finally do get it, you may not necessarily be ready for it.

I don't think any of this has changed, by the way. Of course, with Covid-19, all of this will worsen because companies will suffer, from the huge ones to the smaller ones. Therefore the economics of the business are going to make it much more complicated than it already was for young directors.

What is your advice to young directors?
First of all, to ask themselves, what is directing? Directing most of the time is telling someone else's story. The director must keep in mind that they did not write the story, but rather as a team, we are retelling a story that a librettist has adapted, and a composer has put to music. The director's job is to try and understand what it was they wanted to do before deciding what it is he or she wants to do. If the director doesn't understand or at least attempt to understand this, the danger is that the production will turn out to be a graffito over the work, rather than an interpretation.

As we know, a story changes every time it is retold. That is also the basis of theater. And it requires the presence of an audience for the retelling to become an act of theater: someone to watch it, to share it, to try and understand it, to be touched or appalled by it. For me, there is nothing more important than understanding the importance of catharsis, which I believe remains the basis of every act of theater in one way or another.

An example of trying to understand the music might include something as simple and detailed as understanding why Händel chose to write an extremely long ritornello to begin, or end an aria. You have to think about this. Why has Händel written these twenty-five bars of music? What do they mean? Why does the character need so much emotional time before speaking? If you wonder what you are going to do with all that inconvenient music, you'll end up merely filling it in with action, but if you ask what it might mean to the character singing or to the other character listening (if there is one), it might lead you to a very surprising solution.

On the other hand, there may be no concrete meaning at all, any more than there is concrete meaning to a Harold Pinter or a Samuel Beckett play. Perhaps this is theater that doesn't make linear sense and creates its own music. In which case, one wants to celebrate the mystery rather than explain it. Many, many questions like that come up while preparing and while working in the rehearsal room. And work in opera means also working with a conductor. Together, when the process works well, you search for this meaning, this becomes a discussion. Music is the composer's attempt to express what can be set to words, but what cannot be put into words—then there is the interpretation of that. Opera is collaboration; opus means work; opera means work and brings together all the other art forms.

How vital is stage design?
It is hugely important, and the physical result of a director's interpretative work is usually brought to life with the designer and through the design. This is particularly true when it comes to works with exceptionally detailed narratives; these demand a more elaborate

scenic treatment, whereas more emotive universal works like *Elektra*, or *Dialogues des Carmélites*, for example—actually require less decor.

My bible is Peter Brook's *The Empty Space*. I would be willing to stage an opera with just a chair if needed. I've always felt that too much scenery can distract an audience from concentrating on the work itself.

How does the collaboration with conductors influence your work?
Usually, it is not the director who chooses the conductor but the intendant. The conductor/director marriage, though often a forced one, can be fantastic; however, sometimes "le courant ne passe pas."

But getting along doesn't mean convincing the other person you are right; it means respecting their opinion, even if you don't share it. Perhaps this is truer in the world of baroque music simply because there is so much more to discuss than with Puccini and Verdi, where things are mostly fixed and pre-determined. In late-romantic music, there's no room for saying: how long a pause shall we make before the da capo, or shall we cut this part, do this repeat or not?

When it comes to cuts, some conductors feel protective of the music, and as a matter of fact, so do I. But sometimes, by cutting a scene, you can make the whole act work better on the stage. These collaborations are essential. William Christie is perhaps the conductor I've collaborated with the most, more than twenty-five years as we started in 1993: Händel, Mozart, Rameau, Lully, Campra; we must have done at least twelve shows by now.

And there are others I've enjoyed working with, such as Simon Rattle. We were both assistants on *Idomeneo* and *Der Rosenkavalier* at Glyndebourne in the 1980s. We have recently done *Der Rosenkavalier* together at the Met and were reminiscing about that earlier experience—Simon loves theater and is open to any form of dialogue. Rehearsing with him is a delight.

Sergei Ozawa is always tremendously inspiring and working with him was also very meaningful to me, particularly as the first symphonic concerts I heard were conducted by him when he was music director of the Toronto Symphony Orchestra. The younger generation of Italian conductors is also fantastic: Lorenzo Viotti, Michele Mariotti are both not only very gifted but also very open and collaborative, as is Gianluca Capuano, who works a lot in the baroque repertoire.

What are you preparing now for the post-Covid-19 re-opening?
I'm working appropriately enough on what is now considered the first opera ever written: *Rappresentatione di Anima, et di Corpo* (Portrayal of the Soul and the Body) by Emilio de' Cavalieri.

When it premiered in 1600, neither oratorio nor opera existed; it is a "musical drama." But since it was fully staged, in three acts with a spoken prologue, it can be considered the first surviving opera and an archetype of organized entertainment. It is a dialogue between and about Soul and Body; it is not a religious piece, but it deals with religious precepts. I have

always felt that opera unites the head and the heart. Someone realized that text and music put together would create opera—and that someone seems to have been Cavalieri.

You refer to the mysterious power of opera.
People can't explain why they love certain forms of music—there is a mystic dimension. One of the powers of opera is the collective experience. Opera is such a powerful art form because it combines all the arts: the spoken word, song, music, the visual arts, sculpture, painting, poetry, dance, architecture, and now film. Everything is there. And the director's joyous task is to bring everyone and everything together.

You mentioned the importance of new works.
I've directed three operas by the Italian composer Giorgio Battistelli, each with libretto by Ian Burton, my long-term dramaturge. We started with *Richard III* at the Flemish Opera in Antwerp in 2005, which was then performed in five different countries, including Belgium and Germany. *Co2* premiered at La Scala in 2016, and we are now working on *Julius Caesar* for the Rome Opera. More recently, there was Detlev Glanert's extraordinary *Oceane* (2019) at the Deutsche Oper in Berlin, based on Theodor Fontane's unfinished novella *Oceane von Parceval*.

I enjoy being part of the construction of a new opera. With *Co2*, I was very involved, especially with the libretto. We wanted it to be a piece that dealt with the global problem of climate control and not just limited to one culture, one time period, or one environment, which is why several languages are used in the libretto.

Ecology and politics are central to your work.
The *Ring* I directed at the Cologne Opera (2000–03) was referred to as an "ecological satire" by the German papers. In the end, man has destroyed everything in nature, and in our production, there was the idea of a possible rebirth, but only at the very end, when rain fell on Brünnhilde and the empty stage. With *Il trovatore* on Lake Constance for the 2005 Bregenz Festival, we made the set resemble an oil refinery that seemed to be polluting the lake, but which also happened to have the ground plan of a medieval Spanish fortress.

Bernstein's *Candide* (2006), with the original libretto by the American playwright Lillian Hellmann, was conceived from the outset as a powerful, political work because Hellmann felt that after everything she and Bernstein had gone through during the McCarthy trials, they should finally collaborate on a political piece. She found a story where she could hide the political points she wanted to make in Voltaire's *Candide*. When Jean-Luc Choplin asked me to stage it for the Théâtre du Châtelet, I thought the time had come to make it overtly political.

We know how political some composers were, like Verdi or Shostakovich. By contrast, Richard Strauss ended up being political by absence in a strange way. I've said that Richard Strauss is the opera composer of *zeitgeist*. Whatever he thinks he's doing, there is always the *zeitgeist* present in how and what he composes; at first regard, some things are not political, but with a second look, they are.

I'm very interested in how and why a work came to be written. For me, it is essential to research this beforehand because even a simple detail can help you find a way into the work. But once you've studied it, you have to leave that information behind; otherwise, you might end up staging a history lesson. You can go in many directions with a production; sometimes, I've almost handed in a finished plan, been about to present it to the management of an opera house, and then realized it was not going to work. You start all over again. Fortunately, that doesn't happen too often!

Covid-19 has turned everything upside down.

The heartbeat of the world may have needed a pacemaker. We need to do a major reset in how we live in our world, how we treat and protect it. Environmental issues are the number one problem for the present and the future. But will Covid-19 be the thing that inspires or forces us finally to do something significant about it? It's impossible to know at the moment, as the pain of it—on all levels—is too intense, too immediate, and too dangerous. It would be terrible if the arts were damaged beyond repair, but that is what seems to be a real danger at the moment as many governments choose not to protect the arts and the huge number of artists involved.

We need to see this as a warning. We are getting further away from the solution.

But you know the saying: if you are the problem, then you are also the solution.

Isn't that the statement the scientist makes at the end of Co2*?*
Yes. We need to listen; it is urgent, and all the arts can help us to do that. And all the arts put together make opera. We will have to take it from there.

Canadian opera director Robert Carsen is famous for his stagings of a wide range of works from baroque to contemporary music. He also does the lighting design for his productions. He won the 2021 Opera Awards for best director.

4.

Art
Stage Pictures

"NOTHING HUMAN IS ALIEN TO ME"

Marina Abramović

I'm only interested in an art which can change the ideology of society…
Art which is only committed to aesthetic values is incomplete.
Golden Lion acceptance speech, Venice Biennale, 1997

Opera is a very old form of art. It has been developed throughout the centuries. It has its own language and rules and a very particular and enthusiastic public. But now we are in the twenty-first century, and it's time to change the rules and dismantle the structure and blow some fresh air into opera. In this way, we can succeed in creating a complete work of art.

In 2018 in Antwerp, I developed the concept and stage design for Claude Debussy's *Pelléas et Mélisande*. It was the first time I had worked in opera and was a very inspiring moment for me. I worked on a ballet based on Ravel's fifteen-minute suite *Boléro* together with the choreographers Sidi Larbi Cherkaoui and Damien Jalet. Compared to Debussy's opera, the work has a rigid form and is consequently much more difficult to penetrate. Debussy left a lot of space open for interpretation in his opera, which is essential for visual artists because this space leaves them room and freedom of imagination.

For *Pelléas*, my décor involved the use of large crystals; these, together with the video by Marco Brambilla, brought out the metaphysical aspect of the drama and made the invisible power of music more visible. We don't know from where Mélisande comes; Golaud discovers her in the forest. Could she be an alien from another planet? The crystals could also be interpreted as the spaceships that brought her to us. Is she human? Is her love true? Does she die for love? All these questions are directed toward the public, and they need to find their own answers.

I've been thinking about this romantic idea of dying for love for a long time, and I'm a very romantic person. I almost died for love years ago. The experience was so painful and so totally absorbed my soul that I don't think I could do it again. I'm happy that I survived because now I can make this work the *7 Deaths of Maria Callas*, which has been my secret dream for more than thirty years.

Maria Callas has been my lifelong hero, and there is a real physical resemblance between us. For the *7 Deaths of Maria Callas*, I needed to find singers for seven signature roles of the great Greek soprano: Tosca, Violetta, Cio-Cio San, Carmen, Lucia, Desdemona, and Norma. Of course, I had help from the Bavarian State Opera in choosing them. I wasn't looking just for the voice but also for the energy and the type of women I needed for each role. In

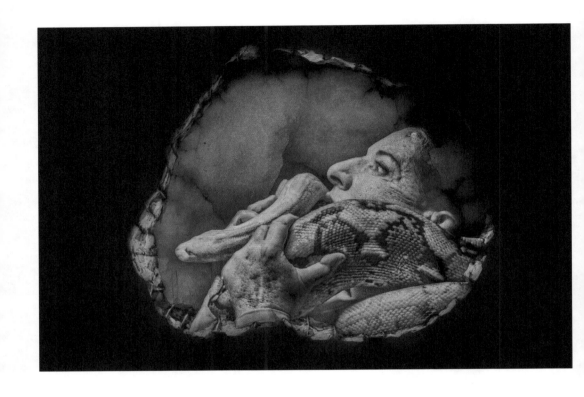

Marina Abramović, *Seven
Deaths: The Snake*, 2020–21
Alabaster and light,
85 × 105 × 12 cm
Courtesy Lisson Gallery
and Factum Arte
© Marina Abramović
(Photo © Oak Taylor-Smith)

one case, I needed a strong and Viking-like woman, another needed to be passionate and Spanish, another delicate and Japanese. In each of these characters, the one common feature is that they are all dying for love.

The singer has to believe and understand what she is doing in each of her roles—totally and absolutely. Carson McCullers said: "I am so immersed in my characters that their motives are my own. When I write about a thief, I become one; when I write about Captain Penderton, I become a homosexual man. I become the characters I write about, and I bless the Latin poet Terence who said: 'Nothing human is alien to me.'" This is a very similar approach to the one I take. You have to be in character; otherwise, the public will feel it and lose interest. Once, I received an excellent lesson from Bob Wilson: he said that when you stand on stage, you have to be there in the present; if you are already thinking about your next move, you will lose concentration. The next move always has to come with the body and the mind simultaneously—effortlessly.

At the beginning of my performance career, I didn't think that a transformative experience was possible through theater or opera, but only through the type of long-durational performance art I was exploring. With the performance of *Rhythm 10* at the Museo d'Arte Contemporanea in Rome in 1973 and listening afterward to the wild applause from the audience, I knew I had succeeded in creating an unprecedented unity of time—present and past through random errors. I experienced absolute freedom. I felt that my body was without boundaries, limitless, that pain didn't matter, that nothing mattered at all. I would never have thought that this could be possible in theater or opera, but after working with Bob Wilson and Willem Dafoe, and with choreographers Damien Jalet and Sidi Larbi Cherkaoui, and now on my opera project with Willem again, I've changed my mind. You can go so deep into a performance that you become one with the character and create a charismatic state of unity with the public.

Now that I'm in my seventies, the idea that this is the last part of my life is very present. The question of how much time do you really have and how you translate what you have done in your life for future generations becomes more and more urgent. Regarding the future of opera and what it can offer to the younger generation, if you'd asked me this question twenty years ago, I would have answered that opera is a dying form of art. But if you ask me now, I would say that opera has a lot of potential and that a future generation of artists will undoubtedly offer new solutions. I don't know if it will be called opera in the future or have a new name. Only time will tell. But it's not a dying art form, only a changing art form.

Based on a conversation with Denise Wendel-Poray, December 2019

Marina Abramović is a Serbian conceptual and performance artist, writer, and filmmaker. Her work explores body art, endurance art and feminist art, the relationship between the performer and audience, the limits of the body, and the possibilities of the mind. She did the stage designs for *Pelléas et Melisande* in Antwerp in 2018 and designed and directed the *7 Deaths of Maria Callas*, which premiered at the Bavarian State Opera in September 2020.

OPERa

SINCE the very bEgINNINg OF MY career,
I HAVE always called MY WORKs "OPERaS."
at FIRST, People QUESTIONed WHY I called
MY earLy StAgings "OPERas," bECAuse
THEY WERE ALL silent. I was thinking
about opera in the Latin sense of the word.
OPERA MEANING WORK, MEANING
OPUS. In this sense, ALL OF the ARTS
cOME tOgETHER. ARChitectuRE,
Light, DANCE, MuSic LiteRAtuRe,
Drawing, PAINtIng, DESigN, ANd
SCULPTURE, all are included. SOMeHOw,
IN the LAS+ cENtuRIes, WE HAVE LOS+
the ORIgINAL MEANINg oF the LATIN
WORd, ANd OPeRA is THOUGHT toMEAN
SOME+HINg PRIMARILy MuSICAL.

MUSIC AFFECTs OUR EMOTIONaL sense,
LiteRATuRe iNSPiREs OUR intellectuAL
SENsE. IMageS iNSPIRE our IMAgINAtion.

WHAT WE SEE is as IMPORT as WHAT
WE HEAR. I HAVE ALWAYS STRONGLy
disLiKed the IdEA oF THEATRE DECORATION.

Original manuscript by
Robert Wilson for *Last Days
of the Opera*, March 31, 2020

THEATER SHOULd bE ARCHITECTURAL.
the TWO PRIMARY WAYS wE communicAte
wit+H EACH O+HeR is by WHAT WE
HEAR and WHAT WE SEE. IN this forum,
THAT WE CALL OPeRA, IS A PLACE
wHERE PEOPLE of diffe Re NT POLITICAL,
ECONoMICAL, SOCIAL, EDUCATIONAL
AND RELIGIOUS bACKgROUNds come
TOGETHER FOR A BRIEF MOMeNT
ANd SHARE sOME +HING. THIS forum.
SERVES AS A UNIQUE FUNCTION IN
SOCIETY. THE NEEd TO CONgregate
IS A PART OF HUMAN NATURE. THIS
NEED HAS always bEEN and WILL
always BE.

HISTORY HAS TAUGHT US THAT.
THE CLASSICS ARE THE ONLY
THINgsTHAT REMAIN THROUGHTout
TIME, NOt +heROMANTICS. AS
AN ARTIST I AM INTERESTed IN
ALL ASPECTS OF THE ARTS, ANd
I HAVe DEDICATEDMY LIFE TO
THIS WORK.

ROBERT WILSON berLIN 3.31.20

American stage director, stage and lighting designer, and visual artist, Robert Wilson is recognized as
one of the pioneers of avant-garde theater in New York and then in Europe beginning in the 1970s.
He has made a major contribution to the operatic genre with his distinctive minimalist style.

WHAT DOES LULU WEAR?

William Kentridge

Recalibration

I was invited by the Metropolitan Opera to direct a production of Alban Berg's opera, *Lulu*. I turned down the invitation. I didn't have a solution for working on an opera that was four hours long. The charcoal animation technique I used was fine for projects which were fragmentary, which were short. It could take a month to animate a minute and here were four hours in the theater needing to be imagined, to be put into images. I had already directed one theater production, Georg Büchner's *Woyzeck*, in which a woman is stabbed to death. I couldn't imagine doing another project in which, once again, the central woman is the subject of the violence of her lover. I couldn't make sense of the music of *Lulu*, which does not have any clearly recognizable melodies. No audience member comes out of the performance humming a tune. I had no possible way of entry into the opera.

I mentioned my rejection of the offer to two women friends who were musicians. I was castigated by both of them:

"It's the greatest opera of the twentieth century."

"But it's so misogynist."

"Don't be ridiculous. Lulu is the most interesting character in opera. How could you turn it down?"

"Oh," I said, "Of course yes, yes you are right. I misunderstood."

I had to recalibrate. There were obviously things in the opera that I'd been both blind and deaf to.

Some months later at the Museum of Modern Art in New York, I saw an exhibition of German expressionist prints. And in the hour of looking at the woodcuts of Emil Nolde and

William Kentridge,
Steamboat, 2013
Indian ink and red pencil on
found paper, 34 × 53 cm
Design for *Lulu*, Alban Berg,
Amsterdam Opera, 2015.
Director: William Kentridge
Courtesy of the artist

William Kentridge,
Woman's Face, 2012
Indian ink and red pencil on
found paper, 46 × 36 cm
Design for *Lulu*, Alban Berg,
Amsterdam Opera, 2015.
Director: William Kentridge
Courtesy of the artist

the drypoint prints of Max Beckmann and Otto Dix, it became clear how a production of *Lulu* could be made. The mixture of violence, sex, the world of Europe after the First World War, the brutishness of it, was all there in the prints. In front of me the whole production mapped itself out. I phoned the opera house and said I was ready to do the production of *Lulu*. I was informed that the production had been offered to a different director. Now of course all doubts disappeared and I really needed to make the opera. I looked at it in the past tense and saw the production that I would have made, had I still been able to do the production. I think this past tense perspective is an important one, as it took away all the anxiety of thinking what is still to be done when the production was in front of me. Instead, it was looking back as if the production had been finished some time ago. I had used the energy of those German prints I had seen, to infect and inflect the violence done on Lulu; the violence done by Lulu. In the production I had made, I could see the woodcuts and music coming together, I could see the opera unfolding in a series of huge projections enfolding the stage. The production played itself out and I was more and more upset about not doing the production, or more precisely at not having done the production that was still to be made.

A few months passed and I was phoned by the opera house, "If you are interested in the production it's available, as the director who was doing it has decided to do a different project." My bluff had been called and without hesitation, I leapt into the project. Afterwards of course there were many months, in fact three years, of hesitation, regrets, ambivalences about the project, as the work unwound and the piece was made.

Music into Ink

For a project like an opera production to take off, two factors are essential. Firstly, the music or the libretto needs to connect to something in the outside world or at least release associations to the outside world (that is, outside of the theater and outside of the studio). A set of questions need to be present in the libretto but also to extend beyond the immediate story (footnote: in *The Nose* there was the question of utopian thinking and the absurd; in *Die Zauberflöte*, the limits of the enlightenment; in *Ulisse*, vulnerability and Fate). Secondly, the

William Kentridge,
Camel, 2013
Indian ink and red pencil on
found paper, 37 × 52 cm
Design for *Lulu*, Alban Berg,
Amsterdam Opera, 2015.
Director: William Kentridge
Courtesy of the artist

project needs to meet a medium or technique or visual language, whether it is working with charcoal or scissors or cardboard or wood. This medium or technique informs the very way of thinking about the broader questions of the project. It is the medium of thinking about the project. It leads the production and staging and the production of meaning. There is a meeting of the opera, the studio, and the outside world.

It had been the woodcuts which seemed to me to be a language for the roughness, the violence, for the slash of the knife of Jack the Ripper. The slash of the woodcutter's chisel or the chisel in the woodblock could meet both the violence of the text and the violence of the music. These woodcuts would be printed, photographed and projected onto the sets of the opera. The set would be made of panels and flat surfaces, walls, a ceiling, and Chinese screens that could receive the projections.

But as a prelude to making woodcuts, I made ink drawings. An ink drawing as opposed to a charcoal drawing, has clearly defined black and white brush strokes. There is no mid-tone, there are no light greys, and if there are, they are achieved by cross-hatching or fine lines, which are either on or off, black or white. This corresponds to the way of working with a relief-printing block where the surface is either cut away or left intact to hold the ink.

So the starting point was ink drawings. I worked on ink drawings with large Chinese brushes, working very roughly on multiple sheets of paper, usually sheets of paper from dictionaries or old encyclopedias, so that a drawing of a face might be made up of four or six sheets of paper loosely pinned together, the corners meeting somewhere between the eyes and the nose. In many cases the drawing would be done more than once, either to get a likeness or to find the right brush mark or the right energy, and then an amalgamation would be made of the different sheets of paper, taking a mouth from one, half the head of another, changing the angle of the head slightly, tilting the head on the shoulders, adding an extra sheet of paper with more hair, adding a separate sheet with a dark background to make a cheek stand out. A breath across the sheets of pages would shift them. A new configuration would be made; the breath of the singers could move the projections. These drawings were the basis of woodcut prints. Once the sheets had been selected and realigned, this image would be translated onto a block of wood or linoleum, and the image cut out.

This process of collage and deconstructing and reconstructing the images is a secondary process, because it is done in the service of a woodcut yet to be made as a fixed image. This secondary process, with all its instability and provisionality, became the heart of the project. At a certain point, I understood that the woodcuts themselves were not necessary. The ink and the multiple pages were where the project had its logic. And it met the themes of the opera of Lulu in the form of the instability of an image, which seemed to me to correspond to the instability of the objects of desire in the opera and in the plays by Wedekind.

The impossibility of fixing who Lulu was in herself, and in relation to the others, particularly the men—corresponded with the instability of the image and the flexibility of it. Different sheets could be blown away from each other, a different face made, a different body made, Lulu could be remade by the different forces around her. The opera is both about the refashioning of Lulu, and about her resistance to that refashioning. Lulu cannot be the woman that the men wish her to be, which is a stable single object of their fascination and desire; and the men cannot be the men that Lulu wants them to be, able to accept her as she is, able to follow the vicissitudes of her multiple desires, and accepting of those desires.

In opera this always ends in incomprehension and disaster, which on the stage culminates in death. So, with regards to Lulu, each of the men in her life dies and, in the end, of course so does she. But the heart of it for me was the possibility of fragmentation, not as just decoration and not as illustration, but as part of the engine of the production. These ink drawings, which could be projected onto the stage, either on the full size of the proscenium or on a much smaller surface, became at once: part of the scenery inside of which the opera would be performed, and of the narration, and a commentary on it.

Filling the stage with portraits of Lulu, with drawings of men and women, drawings of objects, has a grounding in the opera. A key protagonist in the opera is an artist; he is Lulu's first lover in a series of five and becomes her second husband. In the first scene, the artist is busy making a portrait of Lulu. Even though he dies at the end of the second scene of the first act (he slits his throat when he discovers that Lulu still has her old lover Dr. Schön), his portrait of Lulu is present throughout the opera. This is called for in the libretto. There are references to the portrait in each scene.

In our production this portrait is a sheaf of pages of painted ink—it is as if the projections from the wall fall down into the hands of the singers. When they look at the portrait they look at pieces of paper arranged in various ways. We the audience see what they are seeing as projections behind them. The ink paintings of the portrait of Lulu continue even to London where Lulu is killed.

The first impulse of the production, the German woodcuts, have given way to ink drawings, and the ink brought with it several other associations that fed back into the themes of the production. You have the ink blot, the idea of a Rorschach test, of a blotted piece of paper with a dot of ink inside it. A Rorschach test is a space in which to see the response of the viewer. This connects to the psychological understanding of the characters, as written by Wedekind and expanded upon by Berg, and the associations of desire that come from

William Kentridge,
Nude, 2013
Indian ink and red pencil on
found paper, 58 × 38 cm
Design for *Lulu*, Alban Berg,
Amsterdam Opera, 2015.
Director: William Kentridge
Courtesy of the artist

this Rorschach test. And of course their images are always enantiomorphs, mirror images: butterflies, skulls, and pelvises, things which are divided in the center. And looking at them is always about recognition. This is both recognition within the opera—what do the men project onto Lulu, the Lulu they wish she would be? And recognition across the orchestra pit—what do we recognize (of ourselves) in the characters, actions, and emotions engendered by the music?

The set on which the projections appear is made up of flat surfaces, the walls of the rooms described in the libretto: an artist's studio, a bedroom, a dressing room in a theater, a London garret, Chinese screens, furniture.

So the images became doubly shattered, first in the disjointed drawings made of imperfectly aligned sheets of paper, and secondly by the set itself. We see each image slightly differently depending on our position in the auditorium, and we have to do the work of completion and reconstruction of the image. This is a collaborative work between what comes to the viewer from the stage and what is projected by the viewer's understanding onto these images.

Within the making of the images there is the collaboration of the makers of the opera. In the year or two before the production, the creators of the set design, lighting design, costume design and the video editor and constructor, convene (generally in workshops held in my studio in Johannesburg) to work out the balance of color (in costumes, set, lighting) and focus (how much light is on the singers, how much projection is across the stage, how much light is on the stage). We work with stand-in performers to determine how each scene could conceivably be staged. Here (on a model of the set) is where we compared woodcut projections to projections of ink drawings, and where the fragmented figure of Lulu could be moved under a camera while we watched the projection in the model.

Then of course there is the collaboration in rehearsal, with the conductor and singers when much of what had been worked out in advance has to be abandoned and new logics are revealed. This is where the promises and premises of the preparatory work are laid bare.

The Unstable Landing Point of Desire

The erotic is like the comic. It's not something you decide, it's something you recognize. You don't say, "Oh this joke is funny," and then instruct yourself to laugh. You either laugh or you don't. You don't instruct yourself as to what is erotic, the erotic catches you. It catches you unaware, attracts itself into places that you yourself may not have access to. But with an opera (as in a comedy), and especially an opera about desire, eroticism and obsession, these questions need sober exploration.

What does Lulu wear? One of the decisions made by the costume designer Greta Goiris, was to avoid making the obvious and to try to find a distance from the predictable clichéd dress conventions of seductive clothing (fishnet stockings); and ultimately try to see if the erotic and the desirable could force its way through in unexpected ways.

In our production, Lulu always wears men's clothes: her first husband's coat, the jersey of her second husband the painter, the starched shirt of Dr Schön her third husband, and the oversized jacket and shoes of Alva, even when she is a streetwalker in London. Only in the Paris party scene does she have a dress—and this is made of paper, a prop left over from the painter's studio.

It became a question of what the music and the character and the libretto pushed forward towards the audience, and what they meet it with. Whether the skin of Lulu against the stiffness of the starched shirt makes its own attractions, or whether an oversized coat that was ready to fall off her body had its own eroticism or simply hid it—these were questions we were happy to test out on stage.

But the question of tracking the lineaments of desire, what it is that makes for desire, is always complicated, unpredictable and often beyond our direct knowing. What is it about the twitch of the muscles at the edge of a particular mouth that becomes irresistible? Does it have to do with the nature of that movement itself or an old memory of another mouth with a similar muscle and an unattainable desire for that first mouth? There's always a way in which the desirable and the focus of our obsessions are rooted in hidden and unknown parts of ourselves. Lulu's desirability and the obsession that Dr Schön and Alva have with her, is related to her indifference, and the fact that she will always be more or different from what they hope.

In act 1, scene 3, "in the dressing room of a theater," Dr Schön comes backstage to demand that Lulu behave properly in front of his fiancée. He starts the scene in full control: ordering her about, shouting at her, reducing her to an object of his violence. And then at a certain point, instead of being cowed by his violence and his demands, she becomes indifferent, "Do what you like," she says, "I don't care, I'll do whatever you want, it makes no difference to me." It is her indifference, her unreachability that Schön cannot bear. And he changes from the person giving instructions, to a supplicant, "What should I do in these circumstances, what do I have to do to take you out of that position of being indifferent?" And she of course says, "Well what you have to do is write a letter to your fiancée absolving her of the vows and stay with me. Write her a letter saying you are sitting at the side of a woman who has you in her power." And Dr Schön writes the letter saying, "This is the worst day of my life," and Lulu says, "I've never felt so good in my entire existence."

William Kentridge, *Bear
Walking*, 2013
Indian ink and red pencil on
found paper, 36.5 × 48 cm
Design for *Lulu*, Alban Berg,
Amsterdam Opera, 2015.
Director: William Kentridge
Courtesy of the artist

A Foot on the Ladder

What is the interpretation that a singer brings to Lulu? I am wary of an interpretation
being imposed rather than discovered in the process of work. Who Lulu is, one discovers
in the rehearsals and staging. In the first scene of the opera, the artist chases Lulu up a
ladder. In our production Lulu pushes him away. But the questions that arise are: How is
it done? Does she meet him halfway? Does she allow him to follow her up the staircase?
If she puts her foot on his chest and pushes him away does she pause before she pushes
him away? Is it mock violence hiding real violence? Does she wait to see his response
and then climb higher up the ladder? Does she turn her back on him and climb up the
ladder irrespective of what he's doing? It is in these minute shifts and movements and
micro-decisions that the character is revealed, it is in these movements that she is enticing,
or disdainful and where the power lies. This is what makes the character of Lulu, and all
the characters, rather than abstract decisions such as: she was abused as a child, she was
not abused, she likes the life that she has, she doesn't like the life that she has. These are
all matters for discovery in the production. We have fixed parts of the production: the
music itself, the words of the libretto. Then we have ambiguities and possibilities for the
piece to find its particular shape: in the drawings, in the projections, in the nature of the
acting, in the specifics and minute specifics of the acting by the singers—and of course in
the singing itself, the aggression, the restraint, the lyricism, the hardness produced by the
singer, conductor and orchestra.

Meeting across the Orchestra Pit

Lulu is a nasty opera. Each time one hopes for a redemptive moment in one or another char-
acter, one's hopes are dashed. When one thinks that Lulu is finally going to release herself
into voluptuous love, she says to Alva, who has declared his love for her as he buries his head
in her breasts, "Isn't this the sofa where your father bled to death?" One of the wonders of
the opera is our complicity as an audience when Alva responds, "It doesn't matter, it doesn't
matter, I want to stay in this moment."

William Kentridge,
Black Bear, 2013
Indian ink and red pencil on
found paper, 27 × 32 cm
Design for *Lulu*, Alban Berg,
Amsterdam Opera, 2015.
Director: William Kentridge
Courtesy of the artist

The moral failings and bad decisions in the opera are made by the men. Lulu is very clear about who she is and the clearness and straightness of her needs and desires, and her lack of any sentimentality. The men always hide their brutish realpolitik in an assumption of love and gentleness. One of the difficulties of doing the opera was wondering how I would spend three years in the company of such nastiness, of characters one could not like. It is a very domestic opera; every scene happens inside a room. At the same time, it is an opera of the 1930s: an opera of domestic realpolitik, of tough negotiation, of no sympathy, of cruelty and violence. It becomes a mirror of the nastiness, cruelty and inhumanity of Austria and Berlin in the realpolitik of the 1920s and 1930s.

The production is an interior art déco production. Fragments of the outside world are brought in; there are momentary revelations of Göring, of the Hitler youth, of a gas mask, intimations of violence to come. But this essentially happens within the different sheets of drawings, their movement, their fluttering, their instability. In the Parisian party scene (left incomplete by Berg at his death and orchestrated by Friedrich Cerha), money and sex and the outside world meet, with blackmail, with murder planned, with speculation on the stock market, with a stock market crash, bringing all these toughnesses and harshnesses together. We look at it and understand this too is who we are.

Is it a misogynist opera? Of course it is. Is it a misogynist opera? Of course it is not. What makes opera possible is its own ambiguity, in the riddles that are not solved, in the meeting of the production and the viewer at some middle point in which the viewer brings their hearing, their viewing, their understanding, their sets of associations, to meet the opera. If one says an opera is boring or it is misogynist, one has to understand that it is always yourself you are talking about. The opera is the same. The notes and the music are the same and so a different interpretation by a viewer has to do as much about themselves as the opera. And when you say it is boring, you really mean, "I find it boring." Or to say it is misogynist is to say, "I find it misogynist." This is not to say that one can never talk about a work of art. But we have to understand that we are also always talking about the viewer. And the interest in doing the opera is not just to see the opera outside of ourselves, but to allow it to reflect

William Kentridge, *Nude and Her Shadow*, 2013
Indian ink and red pencil on found paper, 53 × 43 cm
Design for *Lulu*, Alban Berg, Amsterdam Opera, 2015.
Director: William Kentridge
Courtesy of the artist

back on us, the makers, or us, the viewers of it. With regards to Lulu it is about obsession, but Lulu's obsession is always a mirror—in what it meets, in what it doesn't meet, in what we recognize and what passes us by—of our own obsessions and desires.

An Artist in the Opera House

When I was three years old, I was asked what I wanted to be when I grew up. I am reported to have answered that I wished to be an elephant. When I was fifteen, asked the same question, I replied that I wanted to be a conductor of operas. This longing was equally impossible. It was pointed out to me that to be a conductor of operas one had to read music. "Oh," I said, "yes of course." I had to recalibrate. In the end directing operas was as close as I would get to either of those desires.

The first time I heard *Lulu*, I struggled to find a sense or pleasure in the music. By the fourth listening, the music changed. Now after countless listenings, every note seems essential and vital.

But it is an ongoing conundrum of opera, that it relies on both newness and familiarity. The obsessive-compulsive disorder of opera-goers: they have to repeat endlessly the same activity, going to *La bohème* not once but twenty-seven times, seeing not one production of *The Marriage of Figaro*, but one every year, as if they had to read the same twenty-three novels every year for the rest of their lives, is one of the problems of opera. The audience says, we want something familiar, but show us something new. Which leaves a very narrow band of neither the too familiar, nor too new.

But what is behind the obsessive attraction of opera? Part of it must certainly be the direct expression of strong emotion: love, hate, revenge, desire presented in their most direct forms, a directness of expression one would be ashamed of, or embarrassed by, or shy to proclaim in an ordinary theater, but which one accepts and celebrates in opera where it is buoyed by the music and by the extraordinary qualities of the singing voice.

These are the universal attractions of opera. But what is an artist doing in the opera house? Other than as a designer. I am a director, making productions in which the images I make, which are projected, are part of the narrative and part of the meaning of the piece as it unfolds. For the set design itself, I work with a set designer, Sabine Theunissen. I have a bad three-dimensional imagination (even the sculptures I make are essentially two-dimensional images that happen to be visible only in three-dimensional constructions). Opera is the making of a drawing in four dimensions, and working with the drawings changed in scale, moving through time, with performers and music as part of them. Allowing a whole structure to be constructed as one would construct a drawing, allowing an openness and unknowingness to exist both in the years of preparation and in the six or eight weeks of rehearsal.

It has to do with scale. The operas offer a place in which a five-story-high projection of a brush mark becomes possible. The scale of the images also corresponds to the scale of the music: a non-domestic scale. An orchestra at full volume is not a domestic instrument. And an opera house, with its seating for two or three thousand, is not a domestic setting. The singers recede in size, but the projections which can enlarge to the full height of the proscenium, can be seen and can engage the audience even in the very farthest seats of the auditorium.

The projections operate in terms of scale and visibility, but also more importantly as a version of the Greek chorus commenting on the action and what is happening to the singers in front of it either illustrating their thoughts or at right angles to those thoughts or refuting the words that they are singing.

And of course at the heart of all opera is that unstable landing point of desire engendered by the human voice triumphant in the music, moving something within us without our being able to name precisely what it is. It is more than just tears or joy or sexual desire; it is the energy of being alive that we feel through all our senses—the provocation and satisfaction of an enigmatic longing.

One of the greatest living artists, William Kentridge gained world fame for his prints, drawings, and animated films. He has brought his artistic vision to the operatic stage through his multi-layered stage designs in collaboration with set designer Sabine Theunissen.

I'M NOT USED
TO COMPROMISING

Georg Baselitz

My parents and my sister played the piano. My uncle, who was a priest, played the organ and, above all, the harpsichord. And so, music was always important in our middle-class family. I should have learned to play the piano too, but I didn't.

When I started listening to music with my wife during my art school years, Bach was our favorite for a long time. But then music faded from my life again. It only reappeared when I asked myself, what is really the right music that would go with what I do? I listened to Schubert lieder and Bach—all of that was so beautiful, but where was the contemporary music? As an art school student, I had French friends who listened to Stockhausen and Boulez, but I had no clue about that. All of these things were disconcerting to me. At the time, I always worked in my studio at night, listening to the radio, the late-night show. They played Mozart during the day, but put on Schnittke at night. The good stuff always aired at night.

I listened to that without knowing any of it—and if something caught my interest, I went to the store and got the records. Schnittke was a good introduction to contemporary music, because he's very much indebted to Shostakovich, and he's even half-German, which made him seem like a nice guy to me. Then I kept moving on. Today my favorites are Wolfgang Rihm and György Ligeti.

I did the set design for a Ligeti opera in Chemnitz. They asked me what I wanted to do, so I said, *Le Grand Macabre*. Subsequently, we brought John Bock on board for the costumes. He's fascinating, a man of the theater. But one day he said he didn't want to be a part of that anymore, he'd quit. You have to remember that working in such a provincial theater is difficult. You have to explain everything, they aren't really versed in contemporary things there. In the end, I persuaded John to stay.

Earlier, with *Punch and Judy* by Harrison Birtwistle in Amsterdam, it was a different story. Director Pierre Audi and his crew were fantastic, consummate professionals. I wanted to have the figures doubled, each one of them was going to have a double, a supersized one, inflated with air. The technical problem was whether these creatures would stand firmly on the ground or keel over. They needed a lot of air. The second difficulty was that we had set up a small side stage where the narrator sat—with tiny little props, with toys. But on the whole, it was a good production, unusual and highly experimental at the time.

The third opera I did was *Parsifal*. That was really difficult, because I had originally made up my mind never to do a classical opera, but only contemporary ones. Wagner is

dreadful and beautiful at the same time. Everything that has to do with the reception of Wagner is dubious and appalling. And on top of that, there's the anti-Semitism! In Wagner's days, there was basically no one in Germany who was not anti-Semitic, that was the *zeitgeist*. Unfortunately, Wagner wrote it down. In addition to that, there was his terrible daughter-in-law Winifred with her Hitler worship. That still has a strongly polarizing effect today, and it distracts from the essential thing, the music. I asked Nikolaus Bachler, the artistic director, if he had anything else. But no, it had to be Wagner.

Now, I live in Munich, my wife and all my friends go to the opera there. I wanted to create something they would enjoy, and of course Wagner was the most important musician of the nineteenth century. There is no one more important than Wagner, at least not that I'm aware of. Everyone imitated him. Mahler is Wagner, Rihm is Wagner, Schönberg is Wagner, Ligeti is Wagner, Debussy as well, needless to say. No composer is as influential as this guy. Even today music is still on Wagner's trail. He simply invented incredibly naive things and the silly fairy tale librettos he wrote are just so odd and beautiful at the same time. Or think of the seventeen-minute-long prelude to *Parsifal*—unbelievable! I thought, alright, swallow your pride, forget about your doctrine, and just do Wagner.

But I couldn't make it work. We didn't have the right team. I wasn't making any headway. I talked to Nikolaus Bachler again. I wanted to quit, I wanted out. But he changed my mind. He said he wanted me, the complete package, and that he had a rough idea of the outrageous stuff I was doing. That's exactly what he was after, he wanted provocation. Alright; so I had caught on the provocation part and we put together a new team. We hired Pierre Audi, with whom I had already collaborated excellently in Amsterdam, and we brought in Florence von Gerkan for the costumes. Then we worked on this Wagner production with great intensity and pleasure.

Director Pierre Audi wanted more choreography, but I said no, no, no! The idea was to let the characters stand, to not let them do anything. Finally I spoke with the conductor, Kirill Petrenko, and suggested he conduct slowly, really slowly. All of it in the dark. Ideally, people would just listen to the music in a state of sleep. So it began with the audience first sitting in front of this enormous curtain with my nudes on it. Nothing happened for some twenty minutes, except that the prelude played from the orchestra pit. That was truly interesting. And Wagner wanted exactly that.

Later the flower girls came in, with two black singers among them, and they were clad in these nude body costumes. In most productions the flower girls are pure unadulterated kitsch. In the Bayreuth production by Uwe Eric Laufenberg, Klaus Florian Vogt, playing Parsifal, sat in a bathtub with the flower girls, much like in a harem, and made some funny noises. Atrocious! But the Amfortas in Munich, Christian Gerhaher, was absolutely superb! The same goes for René Pape as Gurnemanz. Only Jonas Kaufmann sensed that we might be in for some trouble.

And then came the premiere. First there was booing from the audience and then we got scathing reviews. They complained that it was boring, lacking directorial merit, and void of drama. But of course, that is the original approach Wagner envisioned. None of the so-called specialists caught on to that.

At the 2014 Weimar Art Festival, baritone Matthias Goerne put together a program for me called World Premiere of a Picture. First he presented lieder by Alban Berg and Shostakovich, then ones from Eisler's *Hollywood Songbook*—it was magnificent. On the stage in the background you saw my painting *Immer noch unterwegs* (Still on the Road) from 2014, a new version of my early painting *Die großen Freunde* (The Great Friends) from the mid-1960s. That was far more interesting than an entire opera.

I'm just not a man of the stage. David Hockney is a stage person, so is Bob Wilson, and a wonderful one at that. Jonathan Meese is another fantastic stage artist. Everything he usually does with such vibrant expressiveness, is reduced here, becomes very abstract, and I like that.

Opera is very demanding for artists. They always have to compromise because it is a collective form of art. I'm not used to compromising. It completely goes against my grain. I realize that the lighting technician needs light and that the singers have to wear costumes, and so you have to make compromises. But ultimately, it's just too exhausting for me. It's not my cup of tea. I love music, but more as a listener. And when I think of the future of opera, I have to say, it doesn't have any. There's no continuity anymore, that story was cut short around 1900. Contemporary music no longer has a presence. Whether it's Rihm or Ligeti, no one knows that stuff. Everyone knew Mozart, at least the bourgeoisie and the nobility. Even today, everyone still knows Mozart. You turn on the radio in the morning and you hear Mozart. Followed by Brahms, some Schubert, and then maybe minimal music by Philip Glass. But real contemporary music as an art form, that's gone. Somehow, all the operas produced now feel a little tense. György Kurtág worked on an opera commissioned by the Salzburg Festival for ten years and never got it done. It eventually premiered at La Scala in Milan, *Fin de partie*, after Beckett. Kurtág is fantastic! But is that still opera? I don't know. It's artificial.

We, the artists, the painters, are contemporary. We're in the public eye all the time; we're evaluated on a regular basis at art auctions. Our stuff costs money—and it's successful or it's not. And you always have a lively scene, the contest for the best idea, the top position, and ultimately competition on the market. With music, there's none of that anymore. Music now only lives off state subsidies.

In the past, music used to be part of the current cultural moment. Until the subsidies came and canned music, which is to say, the recordings. There is this endless slew of new recordings, it's crazy—there's always a new conductor, one female, one naked, one black, one Brazilian, and so on. And the same is true for the singers. When it comes to the music itself, however, there's nothing new. All this is an incessant production of new stars performing the same old same old, nothing more.

Sadly, the masses are fairly ignorant. They may know a thing or two about my art, if that, but nobody has any idea about contemporary music. Why should they? They have Mozart, after all. And they are perfectly happy with Mozart. In Salzburg that's a real cult. Mozart! Mozart! Mozart! In that town, there is a new discussion every year about the occupancy rate, whether they've sold out all their tickets or not. With Mozart, people are hanging from the rafters. Then they put on something experimental, for example Stravinsky, and all of a sudden the house is half empty.

I haven't seen much in Salzburg lately, but I thought most of it was bad. Take, for instance, the *Idomeneo* about filling the oceans with trash. During the second part I was already having dinner at the Blaue Gans restaurant. Why do conductors have to put on such a show nowadays instead of simply doing their job? At the end of the day, it's all about the music. And why is *Idomeneo* played with different arias, just because the director thinks the original ones are no good?

I'd much rather listen to string quartets by Shostakovich, Schnittke, and Rihm. Or by Zemlinsky—I just discovered him, he's wonderful!

This text is the synthesis of a conversation between Georg Baselitz and Denise Wendel-Poray on September 15, 2019 in Paris

Highly acclaimed German painter, sculptor, and graphic artist, Georg Baselitz became well known for his figurative, expressive paintings starting in the 1960s. He has done designs for operas including *Parsifal* in Munich in 2018 and Harrison Birtwistle's *Punch and Judy* in Amsterdam in 1992.

ON THE FUTURE OF OPERA

hermann nitsch

there has always been talk that a new genre of art would eradicate an already established artistic form of expression. when film emerged, people thought that it spelled the end of the theater. with the advent of television and video art, it was said that there was no need for film anymore. when the internet took over the world, many believed television had been overcome. the love letter takes on a new liveliness in internet messages. neither television nor radio have been able to eliminate newspapers. the diversity of media prevails. the miracle of "smartphones," where encyclopedias and vast collections of music are stored and immediately available, cannot supplant the archaic quality of a book. likewise, there are almost no limits to obsessive photographic documentation, but when the sterile, lifeless communication of brain prostheses gets out of hand, a hug and a kiss can still connect life with reality and touch off its resurrection. seen in this light, the question as to the future of opera is moot. such an important and vibrant genre of art need not fear for its future. i would like to answer this question by letting the history of the opera speak for itself. it is not only since richard wagner that we have seen a "tendency toward the *Gesamtkunstwerk*." derived from the greek tragedy, people wanted to vivify the spoken word into song and connect it with music. i'm thinking of the wonderful book *the birth of tragedy from the spirit of music* by friedrich nietzsche. i'm thinking of the mass as a continuation of the classical tragedy. it was conveyed through *Sprechgesang* (german, "spoken singing"), singing, and music. towards the end of the renaissance era, monteverdi invented the opera. the spoken word was sung. the plot of the drama translated into a sequence of musical events. for now, the development path the opera took is marked by the works of händel, mozart, beethoven, wagner, richard strauss, scriabin, debussy, schönberg, berg, carpenter, stockhausen, and others. it made magnificent strides, but as it broadened its social appeal, it also saw a leveling out, which extended to operettas and musicals.

but actually, i wanted to think back even further. early on, cultic and ritual acts were associated with artistic means of expression. scents, taste, ecstatic music, deep sensory penetration of ritual slaughter, and the communion of the sacred meal gave weight to the sacred experience. eating the god-animal, partaking of it, imparted its divine power. the path of art has, in fact, always been determined by the sacred realm. at first, art served religious purposes, and it struggled to free itself in order to once again become, by its own strength, a non-denominational, metaphysical activity. my concept of the opera is, indeed, a very broad one.

Hermann Nitsch,
Untitled sketches, 2007
Colored pencil on paper,
29.7 × 21 cm each
Costume design for *Szenen
aus Goethes Faust*, Zurich
Opera, 2007. Set and
costumes designs and
direction: Hermann Nitsch
Courtesy of the artist

performative art developed from informal painting, that is to say, action painting. happening and actions became significant. representational theater was superseded by the staging of real events. creating profound, intense experiences, psychoanalytic dramaturgy achieved a form of catharsis that sparks realization. by way of intense perception through all the senses during the real act of experience, the *Gesamtkunstwerk* is automatically found and realized. performance art developed into the orgies mysteries theater, which, in my mind, indeed answers the question as to the future of the opera in terms of the *Gesamtkunstwerk*. the non-verbal actions involving meat, blood, mucus, and innards, which are carried out by actionists engaged in intense sensory perception, bring forth a new concept of theater. the music of o.m. theater has its roots in the scream, in noise, in extreme states of arousal and broadens into the droning of organ pipes, into the music of the cosmic spheres. the thespian blueprint of the o.m. theater is aimed at telling the history of consciousness. myths are understood through the fact of the collective unconscious.

olfactory and taste motifs along with the mythical leitmotif are designed to illustrate the structure of the o.m. theater. the olfactory and taste motifs and their direct application accompany the action complexes.

in: Hermann Nitsch, „Zur Theorie des Orgien Mysterien Theaters. Zweiter Versuch", Salzburg/Wien 1995, S. 340–368. [Der typografische Satz folgt dem Originalmanuskript.]

liebe

geschmack	geruch
brot	brot
wein	wein

all(motiv)

geschmack	geruch
(quell)wasser	(quell)wasser
laues wasser	heisses wasser
weingeist	zyklamengeist
saccharinwasser	

auferstehungsmotiv

geschmack	geruch
(quell)wasser	weisser flieder
süsses weissbrot	akazien
most (trauben) unvergoren	narzissen
most (apfelmost) unvergoren	maiglöckchen
süsser wein (malvasier)	lavendel
zuckerwasser	
honig	
mit wasser (mund ausspülen)	
mit menthol (mund ausspülen)	

seinsmystik

geschmack	geruch
wein	brot
brot	wein
fleisch (roh)	äther
weingeist	lavendel
äther	bienenwachs
fruchtfleisch	

tötung, todes(motiv)

geschmack	geruch
ZUCKER	heisses wasser
ziegenmilch (gezuckert)	heisses zuckerwasser
saccharin	heisse tinte
gezuckertes ziegenblut	

orgasmus

geschmack	geruch
ZUCKER	bienenwachs (heiss)
saccharinwasser	honig (heiss)
rotwein (lau)	weihrauch
fruchtfleisch (zerquetscht)	baldrian
baldrian	

dionysos ı

geschmack	geruch
maische (rot)wein	maische (rot)wein
maische (obst)	maische (obst)
fleisch (eines apfels roh)	äther
schaffleisch (roh)	jasmin
	honig (heiss)

christus

geschmack	geruch
brot	fisch(blut)
wein	essig
fleisch (roh, schaf)	urin
essigwasser	narzissen
	maiglöckchen

hostie

geschmack	geruch
weissbrot	äther
rohes fleisch	melissengeist
traubenfleisch (weiss)	weingeist
	frische wäsche

monstranz

geschmack	geruch
rotwein	weihrauch (süss)
ZUCKER	wein (sauer)
weizenbrot (süss)	narzissen
würfelZUCKER in weingeist getränkt	menthol
fleisch von rosenblüten in äther getaucht	

kreuz

geschmack	geruch
zucker	urin (ziege)
rotwein	schweiss
SALZ	holunder
rohes fleisch	äther
essigwasser	essigwasser

abreaktion

geschmack	geruch
eine überreife rote weinbeere wird	most
auf der zunge zerquetscht	bier
rohes fleisch wird gekaut	urin (rind)
honig	sirup (heiss)
	honigwasser (heiss)

dionysos II

geschmack	geruch
maische (rotwein)	maische (rotwein)
maische (zerquetschtes obst)	maische (gärendes obst)
fleisch eines apfels (gekocht)	äther
schaffleisch roh	jasmin

ausweidung

geschmack	geruch
rohes fleisch	kot
schafblut (gesalzen)	rohes fleisch vom fisch
SALZ	gras, frisch gemäht
gras	leinöl

seitenwunde

geschmack	geruch
zuckerwasser	ziegenmilch
blutwasser (heiss)	maiglöckchen
viehsalz	jasmin
fisch(blut)	jod

gral

geschmack	geruch
rohes fleisch	weihrauch
schafblut (gesalzen)	ziegenblut
SALZ	heisses wasser
gras	äther
zuckerwasser	jasmin
blutwasser	kampfer
viehsalz	narzissen
fischblut	flieder
laues wasser	heisser honig
lauer rotwein	mastix
ziegenblut	wasserstoffsuperoxyd
WÜRFELzucker	jod
fruchtfleisch (weinbeere rot, zerquetscht)	wasser, in dem ein fisch
blütenfleisch einer teerose	gekocht wurde
laues wasser	holunder
weingeist	zyklamen
saccharinwasser	schweiss
heisses fruchtfleisch eines gekochten pfirsichs	heisser zuckerrübensirup

qualwollustmotiv

geschmack	geruch
eine weinbeere (rot) wird zerrissen	holunder
rohes fleisch wird zerbissen	schweiss
in das innere lippenfleisch wird gebissen,	jasmin
blut wird geschluckt	zyklamen
honig	eingeweide eines frisch
kristallzucker	geschlachteten tieres

MYTHISCHES LEITMOTIV DES O. M. THEATERS
umgesetzt in geschmacks- und geruchsmotive

	geschmack	geruch
die kreuzigung	rotwein	schweiss
von jesus christus	SALZ	holunder
die zerreissung	zerquetschtes gärendes obst	zerquetschtes gärendes obst
des dionysos	schafblut (gesalzen)	jasmin
	saccharinwasser	obstschnaps (hochprozentig)
	heisser honig	obstessig
die blendung	traubenzucker	zyklamen
des ödipus	rübenzucker	elektrischer funken
	rohrzucker	käspappeltee (heiss)
	sirup (zuckerrüben, heiss)	baldrian
die rituelle kastration	honig	maiglöckchen
	saccharinwasser	sirup (zuckerrüben, heiss)
die tötung	MOHN gekocht, gezuckert	(brauner) weihrauch
des orpheus	zuckerwasser (heiss)	brennender zucker
die tötung	gezuckertes schweinefett (kalt)	urin (heiss)
des adonis	zuckerwasser (heiss)	urin (kalt)
isis und osiris	mohn	myrrhe
	feigen (fleisch roh)	zwiebel
	messwein	knoblauch
die entmannung	saccharinwasser	jod
des attis	ZUCKER	narzissen
ritueller mord	kuhmilch (gezuckert)	fischblut
am könig	eidotter	essig
	kuhblut	ammoniak
totemtiermahlzeit	rohes fleisch (SCHWEIN)	heisses wachs
	most (rot, gärend)	lavendel
grundexzess	rohes fleisch (schaf)	rohes fleisch (schaf)
	gezuckertes ziegenblut	ziegenmilch
	äther	äther
liebe	brot	brot
	wein	wein

einfache symbolbezüge der motivgruppen untereinander

symbolbezüge. einfache symbolik. es soll nicht heissen, dieser geschmack, dieser geruch gilt als symbol für ..., sondern assoziationsbezüge werden hergestellt. geschmacks- und geruchsempfindungen lösen subjektive assoziationsbezüge des dichters zu geschehnissen aus.

motivzusammenhang SCHAF

motivgruppe (lamm), schaf, stier, ochse, opfertier

(christus), dionysos, mithras
(siehe mythisches leitmotiv)

todesmotiv (tötungsmotiv), aggressive tötung

	geschmack	geruch
	ZUCKER	weingeist
	ziegenmilch (gezuckert)	äther
	saccharin	menthol
	gezuckertes ziegenblut	

	geschmack	geruch
kreuzmotiv	zucker	urin (ziege)
	rotwein	schweiss
	SALZ	holunder
	rohes fleisch	äther
	essigwasser	essigwasser

ausweidungsmotiv

geschmack		geruch
ausweidungs- motiv	rohes fleisch schafblut (gesalzen) SALZ gras	kot rohes fischfleisch (frisch) gras (gemäht) leinöl

urexzess=grundexzess

geschmack		geruch
urexzess- motiv	saccharinwasser heisser honig fruchtfleisch, zerquetschter weinbeeren (rot und weiss) gezuckertes ziegenblut	narzissen heisser honig kampfer

seitenwunde

geschmack	geruch
zuckerwasser	ziegenmilch
blutwasser (heiss)	maiglöckchen
viehsalz	jasmin
fisch(blut)	jod

beziehungen der motive untereinander

allmotiv	verwandt mit	auferstehungsmotiv
geschmack		geschmack
(quell)wasser ←——— reinheit ————→		(quell)wasser, fruchtwasser, wasser beginn von allem
(laues) wasser ←——— fruchtwasser		most (unvergoren), rein (berauscht nicht), fruchtzucker bereit für die gärung, das abenteuer der schöpfung
weingeist 4 + seinsmystik (rausch)		liebesmotiv, apfelmost (unvergoren), geschmack des reinen apfels, latenz des rausches, ewig neu beginnendes leben
saccharinwasser ←——— leben		honig, jubel = süssigkeit
WOLLUST zur essenz getrieben		blütenpollen. bienen boten der befruchtung
grundexzess = urknall, anfang der schöpfung		brot (weiss, süss)
lebensessenz treibt sich in den rausch, in die qualwollust		eucharistie, opfer am kreuz
		kreuz

ORGASMUSMOTIV	verwandt mit	TODESMOTIV und	GRUNDEXZESS
geschmack		geschmack	geschmack
zucker 1 ←————————→		ZUCKER	rohes fleisch (schaf)
saccharinwasser heiss 2		saccharin	saccharinwasser
rotwein (lau)			
zuckerwasser (lau)		gezuckertes ziegenblut ←——→	gez. ziegenblut
zerquetschtes fruchtfleisch ←—┐		ziegenmilch gezuckert └—————→	fruchtfleisch einer
eines pfirsichs			weintraube überreif
baldrian			

saccharin	= essenz des lebens. übersüssigkeit schmeckt bitter, tod als lebensessenz. erst im tod aufgehen, im ganzen. die essenz des lebens, die qualwollust wird in den exzess getrieben.
zucker	= süssigkeit, lebensüberhöhung, wollust, loslösung vom leben, süssigkeit der verneinung des willens zum leben (schopenhauer).
rotwein	= blut christi, eucharistie, menstruationsblut.
zuckerwasser	= todesmotiv und liebesmotiv vermischen sich, süsser geschmack des lebensexzesses und lau, leibwarm, bettwarm, wohlig (tristan).
gezuckertes ziegenblut	= blut = tod am kreuz, eucharistie. ziege = lamm. zucker = wollust, eros, geschmack des ziegenfleisches.
fleisch einer frucht	= fleisch eines brotes, fleisch des leibes, fleisch des gottleibes, alle früchte der erde, alles seiende, das weltall ist der leib des gottes.
ziegenmilch gezuckert	= geschmack der ziegenmilch. süsse = wollust.
baldrian	= erotisierung. aufreizung zur sexuellen befriedigung.

geruch geruch geruch

bienenwachs heiss ⟵————— weingeist ————⟶ bienenwachs (heiss)
honig (heiss) äther narzissen
weihrauch ————————⎤ heisses wasser ⎣————⟶ lavendel
baldrian ——————————⎦ menthol ⎣————⟶ jasmin

bienenwachs	= wollusterregende substanz, (geiler) geruch, assoziation zu honig, süsse. fruchtbarkeit, verbindung mit tod als äusserste süssigkeit des lebens, lebensessenz.
weingeist	= lebensessenz, rausch, vision des geistes.
honig	= heiss, lebenssaft, lebensbrunst. berauschend in richtung fruchtbarkeit.
bienen	= insekten der fruchtbarkeit, blütenstaub, blütenpollen.
äther	= berauschend, betäubend. der reine essentielle geist, konzentrat des geistes, des nicht materiellen (rasch verdunstend).
narzissen	= betäubender übersüsser geruch.
weihrauch	= intensiver wohlgeruch (berauschend betäubend) begleitet älteste kulthandlungen (asien, vorderer orient, antike kulte, seit dem frühchristentum für die christliche religion eingesetzt). sinnliche bereicherung der kulthandlung. der geruchssinn wird für die liturgie, die intensivierung der gläubigen andacht verwendet. andererseits wird räucherwerk und weihrauch vom anbeginn für erotische feste zur überhöhung ausladender orgiastik verwendet. assoziation zum sakralen als auch erotischen bereich. in beiden fällen in verbindung mit fest.
lavendel	= betäubender übersüsser geruch (etwas scharf). behält auch getrocknet seinen intensiven geruch. zur bekämpfung von motten verwendet.
baldrian	= erotisierender betäubender intensiver geruch von nervenberuhigender einschläfernder wirkung. steigert die sexuelle begierde männlicher katzen.
jasmin	= betäubender übersüsser geruch (zu süsser, fast giftiger geruch).

LIEBESMOTIV	CHRISTUSMOTIV	KREUZMOTIV	KASTRATIONSMOTIV
geschmack	geschmack	geschmack	geschmack
brot ⟵——⟶	brot ⟵——⟶	zucker	knoblauch
wein ⟵——⟶	wein ⟵——⟶	rotwein	salz
		laues wasser	ziegenkäse
		salz ⟵	saccharinwasser
		rohes fleisch	honig
		essigwasser	gezuckertes schweinefett

jasminlavendelparfum

brot	= grundsätzliche lebenssubstanz. gemahlenes getreide, mit mehl angerührter teig, gebacken. nur wasser und mehr gebacken = hostie = nach der transsubstantiation der leib des herrn (brot = fleisch).
wein	= vergorener saft der traube = blut = lebenssaft, berauschender lebenssaft. rausch = verklärung = vergeistigung. lebenssaft kann sich zum rausch steigern. wein = nach der transsubstantiation das blut von jesus christus.
salz	= gegenteil von zucker (moll) ernst (fleisch + salz). salz = tragisch. ausgeprägter geschmackswert.
laues wasser	= leibwarm (wie urin, wie blut, wie gedärme), uteruswarm, fruchtwasser, südseemeer, meer voll leben, warmwasserfisch, warmwasseraquarium, thermometer.
rohes fleisch	= exzess, zerrissener tier-, gottleib. fleisch einer frucht. rohes fleisch eines gottes. rohes fleisch = gottleib, fleisch des gott-tieres.
knoblauch	= starker, lang anhaltender geschmack (desinfizierend). einfache würzung von speisen mit knoblauch und zwiebel alles durchdringend. nach intensivem knoblauchgenuss knoblauchgeruch bei der transpiration.
essigwasser	= sauer penetranter geschmack; sauer = leid. essigschwamm für gekreuzigten.
gezuckertes schweinefett	= (zucker siehe zucker) schweinefett = fett des totemtieres (eber tötet adonis).

geruch geruch geruch geruch

brot	brot	äther ←———————→	knoblauch
wein	wein	flieder ←————⤬————→	maiglöckchen
		urin (ziege) ←———⤬———→	urin
		jasmin ←————⤬————→	ammoniak
		holunder ←————————→	sirup (heiss)
		äther ←———————→	malz
		essigwasser	

flieder	= lieblicher milder (doch starker) geruch.
maiglöckchen	= intensiver süsser berauschend betäubender geruch (assoziation zu gift).
urin (ziege)	= scharfer geruch (analsphäre, tabuisiert), leibwarm (heiss dampfend). ziegenurin, ziegenbock. geschmack des ziegenfleisches (eigenwürze), der ziegenmilch. geruch des ziegenbockes.
ammoniak	= konzentrat von urin, scharfer, fast ätzender geruch.
holunder	= süsser geruch, ansatz zu starkem schweissgeruch.
sirup (heiss)	= durch kochen gewonnenes konzentrat von rübenzucker, penetrant konzentriert schmeckend. penetrantes, geil schmeckendes konzentrat. sirup ist heiss.
malz	= nahrungskonzentrat, gewonnen aus getreide. hoher zuckergehalt, kalorienreich.

unbedingte verwandtschaft aller motive

> christusmotiv – schaf(lamm)motiv – motiv der hostie –
> liebesmotiv – wandlungsmotiv – monstranzmotiv

kreuz – zerreissung

> der grundexzess zieht sich als grundsätzliches leitmotiv durch alle motive und bedingt sie.

viele eingesetzte geschmacks- und geruchsmotive haben ambivalente funktion und werden für scheinbar gegensätzliche motive gleicherweise eingesetzt.

schafausweidung – grundexzess – zerreissung des schafes – kreuz – seitenwunde, abreaktionsmotiv

zueinander in beziehung stehende kernmotive

grundexzess
abreaktion
orgasmus
todesmotiv
liebesmotiv
wandlung
kreuz
seitenwunde

} kernmotive, alle anderen sind davon ableitbar

zerreissung des dionysos
totemtier

tod am kreuz
verneinung der leiblichkeit

alle geschmacks- und geruchswerte stehen motivlich miteinander in beziehung.

grundexzess
geschmack

rohes fleisch (schaf) = bezug zum opfertier schaf – leib des geopferten jesus christus, hostie (totemtier), brot,
der leib des gottes wird gegessen. der geschmack von rohem blutnassen fleisch. blutgeschmack. der
biss des raubtieres. bezug zur tötung, zur schlachtung.

saccharinwasser = überfluss an lust, wollust, zerfleischung, verwendet bei orgasmusmotiv, todesmotiv,
kastrationsmotiv.

zerquetschtes fruchtfleisch einer roten weinbeere = weinbeere, zerstampfen von überreifen weinbeeren, gärende
maische. zerreissen von fruchtfleisch, orgiastische berauschung. (betäubung). geschlechtsexzess.
entäusserung des gottes dionysos, seine zerreissung. bezug zu zerrissenem rohem fleisch.
fleisch des opfertieres, bezug zum abreaktionsmotiv, dionysosmotiv.

gezuckertes ziegenblut = siehe todesmotiv.

äther = betäubend narkotisierend, zerstörung des bewusstseins.

geruch

narzissen = übersüsser geruch, überhöhung der berauschung zur schmerzenden, selbstzerstörerischen
orgiastik. süsser geruch als gegensatz zum geruch des rohen fleisches.

mastix = starker, edler geruch (löst keine bestimmten assoziationen aus).

kampfer = starker, unbestimmter geruch, geruch von celluloid.

heisser honig = fruchtbarkeit, blütenstaub, bienenstock, wachs, wärme. konzentrierte nahrung. zucker.
unvergorene grundsubstanz für met. geiler, fast ekler geruch. wollust wird zu schmerz,
zur zerreissung.

äther = betäubender starker geruch.

totemtiertötung (totemtiermahlzeit)
geschmack

rohes fleisch (schwein) = siehe grundexzessmotiv

schwein = totemtier, altes opfertier, eber – adonis

rohes fleisch (schaf) = siehe grundexzess, bezug zu christus

rohes fleisch (rind) = rohes fleisch siehe vorher. rind opfertier der antike. stier – mithraskult. stier – bock.
dionysos, bacchus.

roggenbrot = (pane integrale). die schale des kornes beim geschmack des brotes. brot grundnahrungsmittel. leib
des herrn. brot stellvertretend für das fleisch des totemtieres.

saccharinwasser = siehe grundexzess, todesmotiv, kastrationsmotiv.

fruchtfleisch einer roten weinbeere = siehe grundexzess, dionysos, abreaktion. der geopferte gott christus dionysos, eucharis-
tie.

most rot gärend = aus überreifen trauben gequetschter most. gärungsbereiter gärender traubenzuckersaft,
vermischt mit erde – blut, gärendes, zur orgiastik bereites blut. vermischung berauschter
(gärung = fruchtbarkeit) beziehung zu wein – blut. süsser gärender berauschender saft.
STURM.

geruch
narzissen	= siehe grundexzess.
hyazinthen	= intensiver süsser geruch, assoziation zu betäubung.
lavendel	= siehe grundexzess 1. fassung.
vanille	= giftige süssigkeit, wird zur würzung von süssspeisen verwendet.
heisses wachs	= bienenstock, fruchtbarkeit, fleiss, befruchtung, leibwärme, honig, zucker, sperma, kerze, kirchenkerze, opferkerze, tropfendes heisses wachs.
jasmin	= siehe erste fassung grundexzess (überhöhung der lebendigkeit in richtung essenz, konzentrat, giftigkeit, qual an der süsse).

der rituelle königsmord

geschmack
zucker	= siehe orgasmusmotiv, todesmotiv, grundexzessmotiv..
süssigkeit, süsse	= erotik, sexualität. zucker verwandelt sich durch gärung in alkohol. zucker = gärungsbereit. im spiel des o. m. theaters werden geschmacksträger mit zucker vermischt. gerüche tragen das eigenschaftswort süss.
wein	= blut christi, blut des opfertieres (vergeistigtes blut, vergoren). aus vergorenem zucker gewonnenes symbol für das lebendige blut christi. wein wird bei der wandlung verwendet, wein in verbindung mit brot = fleisch christi
kuhmilch (gezuckert)	= pralle euter. milch wird gemolken. der geschmack der frisch gemolkenen kuhwarmen milch. milch = nahrung für neugeborene kinder (säuglinge, säugetiere), für kälber. kalbfleisch symbol der unschuld. bevor gras und fleisch gegessen werden, wird der säugling mit milch genährt. symbol für fruchtbarkeit, lebenssaft. muttermilch, milch, blut. frisch gemolkene milch schmeckt nach gras. zucker überhöht den saft der lebensessenz. saugen an der mutterbrust. erotik.
weissbrot	= leib des herrn, rohes fleisch, hostie, monstranz, wandlung, opferung christi, passion, kreuz, grundnahrungsmittel, reiner geschmack (korn, mehl, brot).
eidotter	= nahrhafte substanz, fruchtbarkeit, lebensessenz, sperma.
kuhblut	= blut (wein), blut christi lebenssaft. blut des gebärenden weibtieres. weibliches opfertier. salziger geschmack des blutes.

geruch
äther	= siehe grundexzess (geschmack, geruch), todesmotiv.
fischblut	= blut des gottes, tierblut, fischblut, fisch = symbol christi. fischgeruch. wasser feucht, unterleib, unbewusst, vegetativ. kreatur dionysos unbewusste natur.
essig	= sauer, siehe kreuz.
schwefelkohlenstoff	= gestank, verwesung, schlechte verdauung, fäulnis. stoffwechsel. umsetzung faule eier. geruch des todes.
ammoniak	= starker, beissender, penetranter uringeruch, pferdeurin, pissoir. faulender urin. kastration. benommen vom schlechten geruch.

Pages 140–152
Original Manuscript: Hermann
Nitsch, *Orgien Mysterien
Theater. The scores of all
performed actions.* Vol. 8 :
The 6-Day Play 3, p. 277, 328 f

finale of the six-day play

the noise from the orchestra and the screaming choirs is raised into a single roar until it reaches the threshold of pain. the sensory reality of the orgiastic scene swells up into a cosmic provocation. an alignment is reached with the flow of creation and the vast, immensely powerful pulse running through it. a vibrating roar crosses through the animate world and all things. the cosmic primordial sound of the solely pain-induced birth, the ecstasy of being, intermixed with agony and joy, screams, echoes into the spacelessness and fathomlessness of the universe. the actions are carried out with the highest possible ecstatic, pain-inducing intensity. the shouting of all turns into terrific jubilation, a cathedral of sound. the reality of the stars regurgitates from the entrails. the world redeems itself through the most intense form of being, with the orgy it reaches the awareness of its tragically glorious incessancy, which is mingled with bliss and torment.

as the orgiastic action takes its course, within a ten-kilometer radius the air is filled with the ringing of ALL CHURCH BELLS.

the art of the o.m. theater is intended to lead participants in the play to an intimate experience of being, to bring them into a state of enlightenment.

in a historical sense, the future of opera should keep unfolding inside opera houses, but in the sense of openness, it should be taking place everywhere, until it is understood that, ultimately, drama in itself is the act of creation. the ever-recurring event of birth and dissolution and a renewed re-emergence of innumerable solar systems, galaxies, and cosmoses, that is the force of being at work.

Crucial founder of Viennese Actionism, in the 1950s, Hermann Nitsch conceived the Orgien Mysterien Theater, staging nearly 100 performances between 1962 and 1998. His abstract "splatter" paintings, like his performance pieces, are inspired by Wagner's theory of *Gesamtkunstwerk*. He passed away on Easter Monday 2022.

150

151

grundexzess

THE STAGE AS A MIRROR

Philipp Fürhofer

Why am I fascinated by opera, a work created centuries removed from my own and slipping further away by the hour? Why do I, together with a host of other people, sit in silence in the dark, cell phone off, to expose myself to highly absurd situations? Part of the enticement lies in the intense concentration of hundreds of participants on and behind the stage, all of them together, precisely coordinated down to the fraction of a second, each contributing individually to the success of a collectively achieved performance that defies explanation.

Why do I feel a longing for this ritual of self-reflection, this immersion in the traditional and never-changing opera repertoire? Ranging from Mozart to Verdi and Wagner—with the exceptional ambitious attempt at a contemporary composition—these are works I know by heart.

My first opera experience as a fifteen- or sixteen-year-old student presented me with a stark contrast to my everyday life. Even then, I perceived the triteness of my everyday world as unsatisfactory. What has inspired me over the years is precisely the denial on stage of my daily reality. The performance in question was the *Die Walküre* by Richard Wagner at Staatstheater Augsburg. As soon as the conductor appeared, the audience fell silent, and when the curtain rose, my reality was magically replaced by a new one, which gleamed and glistened from out of the darkness. And apparently, everyone around me felt the same way, judging from the palpable anticipation in the hall—this was an aura wholly unfamiliar to me.

Nobody believes in the actual events on an opera stage; the orchestra pit remains the threshold; therefore, no complete escapism can occur like in the movie theater, with special effects and camera angles that create the illusion of participation in supposedly real events. In the theater, the magic lies in that the full disclosure of the technical means along with the conscious agreement to overlook everything—the "voluntary suspension of belief"—doesn't prevent us from being overwhelmed. When looking at the stage, every audience member knows that they are surrendering to a theatrical illusion, immediately detectable if viewed from the wings or the flies.

It is a paradoxical situation that we delight time and again in an illusion that we know could be disrupted at any time. But what makes opera more poignant than any other art form is that the expanded time of music creates ample space to mentally shift, over and over, between one perspective or the other and to look at the bigger picture from different vantage points. And yet, nowhere is the contrast greater between the immense physical effort and means poured into performances and the relatively small number of people in the auditori-

um who can be reached and touched by it. This intimate Gestalt allows for soul-searching through sound while reflecting on one's own perceptions. This is where opera's overwhelming power lies—not in its grand and loud features—but rather in the audience's decision to surrender to an effect that remains ineffable.

The performance effectively creates a state of suspension, hovering on the crescendo and decrescendo of the human voice at once overwhelming and fragile. Our experience of sound is a pulsation similar to the glare of spotlights that momentarily light up, making us acutely aware of the surrounding darkness. One instant is filled with brightness and presence, the next with darkness, silence, and hereafters. Light on, light off.

The voice and the orchestra emit analog generated sounds that have a physical effect on our bodies; inherent in opera is the physical resonance of each individual through the power of sound. Nothing is digital; everything happens live and directly in front of us; we are mentally and physically confronted with our limited existence. We see our reflection in everything, and we are confronted with that as we face the black hole of the stage and the pit.

As spectators, we are the co-creators of our experience. Today we are confronted, at all times and places, with the blurring of boundaries between natural and virtual worlds; in the opera, we are time and again captivated by human performance. It's the same feeling of happiness that we experience upon taking a close look at the thick, pasty, crumbly oil paint on the canvas of an old master painting, which, when we step back, turns into an illusion of a seemingly familiar representation of the world. We are standing in front of something human, a presence that is both mortal and immortal.

Born in Augsburg (Germany), Philipp Fürhofer's multidisciplinary artistic practice combines paintings, sculptures, installations, and set designs. He creates his works with a distinctive style, combining modern materials with traditional and historical elements from operas, charged with associations to the heritage of nineteenth-century German and Nordic Romantic painters.

THAT THING

Clément Cogitore

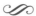

When someone asks what attracts me to opera from a dramatic point of view, I have to admit that most of the time, I become lost in the often stereotypical, predictable, and endless intrigues and wind up getting bored. But nevertheless, sometimes, just for a moment, which can be very short but very intense, the bodies, the music, and the action merge and carry me away in an unexpected and radical emotion. When this happens, opera has more power to move me than the cinema or the visual arts.

When I got involved in directing opera, I was confronted with this phenomenon from the inside. I have the feeling that when staging a work, I'm engaging in a relationship with it, like in a love affair. This relationship can be fusional, conflictual, or on the contrary, very peaceful. Or—it may be all of those things at once. As with a lover, there are things in an opera that seduce us, satisfy us, and others that can annoy or cause violent disagreements. But what attracts me above all in opera is its mystery: what cannot be fully understood or grasped, what escapes me, what escapes the era and the civilization, which gave it birth, something perhaps even its author didn't see. We encounter opera on an unconscious level, one that goes beyond the text and the score, a knot of emotions and tension, which has no age or place. We seek a continuous present in opera, which we set out to find in a maze of historical conventions, artifices, clichés, folklore, and misunderstandings accumulated over centuries.

We get lost most of the time because the operatic machine is too slow, history and traditions too heavy, and misunderstandings too complex. Nevertheless, with the conductor, the team, the singers and dancers, we make progress. We bathe in a stream: that of music. We take care not to drown. There are contradictions and friction. Certainties crumble. Gradually doubt seizes us, ridicule awaits us. And then, at random, an aria, a look, or a movement, "that thing" arises, and suddenly everything is there: through a strange mixture of accident and intuition, we recognize ourselves in the work, and it recognizes us.

June 2020

Clément Cogitore is a French contemporary artist and filmmaker and winner of the Prix Marcel Duchamp in 2018. Combining film, video, installations, and photographs, he questions the modalities of cohabitation between humankind and its images and representations. His staging and design for Jean-Philippe Rameau's *Les Indes galantes* at the Paris Opera in 2019 was highly acclaimed.

STAGING AIDA

Shirin Neshat
Conversation with Denise Wendel-Poray (March 2020)

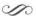

Denise Wendel-Poray: *How did you get involved in designing and directing Verdi's* Aida*?*
Shirin Neshat: It was the director of the Viennale Film Festival Hans Hurch who put Markus Hinterhäuser and me in touch back in 2015. I happened to be in Vienna so Markus invited me to lunch. I had an inkling that he might want me to do a stage design in collaboration with a director, but when he asked me to direct *Aida*, I almost fell off my chair. I told him that I didn't know much about opera, that I had seen very few in my lifetime and never *Aida*. He said, "Don't worry, I know you can do it," and immediately after lunch took me to a nearby record store. He bought me a recording of *Aida* with Riccardo Muti conducting. A few weeks went by, and Maestro Muti was in New York for a concert at Carnegie Hall. Markus was there too, and we went to meet him. Anna Netrebko and Muti's lovely wife, Maria Cristina Mazzavillani, joined us. I'll never forget during the course of the evening, Muti suddenly looked at me and said, "You look like Aida! You are Aida."

At the end of the dinner, I promised to consider the offer.

What were you working on at the time?
When the offer came, I was at a phase in my work where I was gravitating away from subjects related to Iran; I felt somewhat exhausted by living in a constant state of nostalgia and making work about a country I couldn't even visit anymore made less and less sense. So I became curious about other cultures, especially other Middle Eastern cultures like Egypt. Later I found myself working on a biographical film, about Oum Kulthum, the legendary Egyptian singer, one of the most popular Arab singers and public personalities of the twentieth century. It took me six years to make the film. When Markus approached me, I was still working on the script.

What a coincidence, just while you are preparing a film about an Egyptian icon, you were asked to direct Aida*!*
It really was a coincidence. My work has always been about women living under patriarchal societies, facing oppression, political tyranny, and religious fanaticism yet always represented an idea of strength, individuality and humanity. In this case there are many parallels between Aida and Oum Kulthum.

Your work moves across the visual mediums of photography, video installation, and film, focusing on issues facing Muslim women today, those who live in extreme religious environments,

particularly in Iran. Today, you are a major voice in the art world. How could you relate your deeply spiritual and political work to one of the most monumental and museum-like operas in the repertoire?

Aida has a complicated history as I came to understand it, often considered as an orientalist, exotic fantasy about Egypt, unfairly portraying it as a savage society. Yet apparently, this was not Verdi's intention—it was rather the European empire he was attempting to portray as a barbaric society. Nevertheless, there are many different interpretations and criticisms from all ends, but what really drew me in was the power of its libretto, the love tragedy, not to mention the overwhelmingly beautiful music. The central premise being the love triangle between Radamès, Aida, and Amneris versus the religious fanatics, an authoritarian government led by the king and his monarchy. This paradoxical tale of love yet pain, suffering and ultimately self-annihilation had a lot in common with the themes of my own past work.

What is the relevance of Aida *today?*

Aida is a universal story, a timeless story, and is absolutely relevant today as we continue to face the constant threat of tyranny and fanaticism. Aida represents our humanity, the struggle of remaining an individual and free in light of social, political and religious oppressions. The challenge for me was the way in which many viewed the classic *Aida* as racist in its demonization of the Egyptians and Ethiopians. My way of dealing with it, was to blur cultural boundaries so the story is no longer about the Egyptian empire but any empire which uses force to conquer and colonize other nations. In my production, ancient Egypt is not purely ancient Egypt; it is a mix of Western and Eastern identities.

How was it working within a big opera machine like the Salzburg Festival?

Markus helped me every step of the way, beginning with guiding me to find the right collaborators, such as the stage designer. Right from the start and without hesitation, I chose to work with Christian Schmidt from Munich. I admired his past work in opera, and could see how together we could create something very sculptural, a stage that echoed the power of pyramids. Christian knew the Salzburg stage very well, having done a number of productions there. He made several trips to New York to my studio and even traveled to Morocco where we were filming *Looking for Oum Kulthum*. One of the greatest pleasures of working on *Aida* was the stage, which was created as a simple cube: while minimal, it offered diverse architectural positions, creating dazzling visual possibilities for our cast and the large number of chorus's constantly flowing through. The costumes were highly stylized and beautifully designed by Tatyana van Walsum, whom I had worked with in a ballet production, *The Tempest* in 2014.

Your video installation Rapture *from 1999 features two black-and-white projections; one depicts a group of men dressed in Western suits, and the other captures a group of women veiled in chador. Their synchronized movements create an enthralling visual artwork; it is an allegorical investigation into Islamic law's effects on gender politics and daily life. It won you international acclaim. Do you think that the Salzburg audience was aware of your work?*

I believe the majority of the Salzburg audience was unfamiliar with me and my past work as a visual artist and filmmaker. So perhaps they didn't get some of my stylistic approaches, for example the movement of chorus through the cube, which echoed some of my past video works like *Rapture*. Also, I must add that from the start, I had made a decision that the production should not be about Shirin Neshat but *Aida*. I wanted to be sure that the audience would be able to focus first and foremost on the power of the music, and not to have the visual effect overpower for example the soloists' moments.

Later I went to see William Kentridge's *Wozzeck* in Salzburg, which I absolutely loved, but I must say the experience was different. I realized watching *Wozzeck* was clearly like walking inside of one of Kentridge's artworks. I admire his courage and ability not to lose the audience in his dazzling and complicated set designs.

What is your memory of the opening night?

First of all, my eighty-six-year-old mother flew in from Iran for the première. Therefore, though the distance was short from the hotel to the Festspielhaus, we required a taxi and it was pouring rain, so we got stuck in traffic! It was just a few minutes to curtain, and I was sitting in the car in anxiety and tears. Markus called, panicked, where are you? I left my mother in the taxi with my husband and started running to the opera house. I'd just bought new shoes, which turned out to be too big, and I was wearing a long dress, I couldn't run. I thought I'd never make it before the curtain went up. I ran into the hall just moments before the curtain; someone seated me. Later during the intermission, I turned around, and only then realized that Angela Merkel was sitting directly behind me.

That sounds like the kind of anxiety-driven nightmare you might have the night before an important performance.

Yes, but it was all too real. Missing the premiere would have been a disaster, I could not let Markus down. I have to add that during the process of staging *Aida*, I knew well that I was facing many challenges. On the one hand I was very conscious about how I was a visual artist making her first foray into opera, yet I wanted to respect the monumentality of *Aida* and the audience's expectation. At the same time, I intended to be bold and radical without leaning too far in my own artistic signature. In the end, I'm not sure if the opera world was ready for what I did, maybe too radical or minimal. We got mixed reviews. I always have doubts in my work, but with *Aida*, I felt that I'd done something special, even if it was criticized by many.

You know, some of the greatest opera productions began as failures and gained approval over the years. Would you consider doing another opera?

At the moment I'm very busy with a new edition of *Aida* for the 2022 Salzburg Festival, which is giving me a marvelous opportunity to revisit my own ideas and make important changes. If I held back slightly in 2017 in my fear of going overboard with my own artistic signature, this time I want to push myself to take more risks, incorporate more videos, and offer a more complex perspective about the overall narrative of *Aida*. As for the future, the answer is yes,

I would love to direct another opera. But it has to be the right opera, thematically and with the right creative team. An American opera company recently asked me to consider directing a contemporary opera based on a story that takes place in Afghanistan. I refused. It seemed too predictable for me to get involved in a story about oppressed Muslim women. I didn't relate to the story. I liked the challenge of going for the big hits, like *Aida*. There is still a lot of room for experimentation in these great classics.

Taking a different approach can make the classics more attractive to a younger generation.
Yes, and I believe people like Markus at Salzburg Festival are working on cultivating and inviting a younger audience by staging more experimental operas. The ritual of going to the opera can be enjoyable for young people; they need the structure, the formality in a way.

There is also the social function, which is often decried as snobbish and old-fashioned but that can bring generations together.
It is a question of community and of course economy, as many young people simply cannot afford opera tickets. Hopefully this will change in the future. In New York we have PER-FORMA, which was founded by RoseLee Goldberg. I was her first commission back in 2001 with the *Logic of the Birds*, my very first effort in performance art. PERFORMA Biennial is an exciting and lively program, dedicated to staging experimental work by mainly visual artists giving their first live performances. PERFORMA has a huge following of multi-generations, and its programs really challenge the traditional practice of theater and opera, asking its audience to keep an open mind. It would be great to have more of this approach in the opera world.

Iranian visual artist living in New York City, known primarily for her films, videos, and photography. Shirin Neshat's artwork centers on the contrasts between Islam and the West, femininity and masculinity, public life and private life, antiquity and modernity, and bridging the spaces between these subjects. She designed and directed Verdi's *Aida* at the Salzburg Festival in 2017.

5.

Emphasis

Jest and Gesture

DAS GESAMTKUNSTWERK
TOTALSTOPER queere
(Richard Wagner ist Chefsache) 2020

Das Gesamtkunstwerk " OPER (Z)"
hat zu erfolgen! Die Oper der
Zukunft ist Naturtum! NUR
LIEBE BESETZT OPER! Richard
Wagner ist der Staatschef der
TOTALSTOPER: Z.U.K.U.N.F.T.!
Richard Wagner wollte aus
Deutschland das radikalste "
Gesamtkunstwerk "ZUKUNFT
bauen und passieren lassen!
Ludwig II von Bayern ist wie
Meese, wie Richard Wagner
kunstliebevollster Gesamtkunst=
werker! Parsifal ist der tollste
Befreier und erzeugt das

Gesamtspiel : EVOLUTIONSOPER!
Das Opernwesen ist voll Liebe!
Das Gesamtkunstwerk "OPER" ist
unwählbarste Macht! Ich, der
Jonathan Meese, diene als
1. Soldat der Kunst nur dem
Gesamtkunstwerk! Ich liebe
die Oper ohne Ende! Die
Oper der Zukunft schreien
nur : "TOTALSTE FREIHEIT!
In der "Oper der Liebe" ist nur
KUNST der CHEF! In der
Opernkunst gelten nur die
radikalsten Evolutionsgesetze:
DIE KUNST IST DER STAAT!
Die Opernbühnen müssen
politikfrei, religionsfrei und

überhaupt ideologiefrei sein! Kunst
herrscht, wenn Ideologie abhaut!
Die Opernräume sind Schutz!
Die Opernräume sind voll Kunst!
Die Opernräume sind ohne Angst!
Die Opernräume sind ohne Zynismus!
Das "Gesamtkunstwerk Oper" ist
der Spielraum der Unwählbarkeit!
Liebe zur Oper ist unwählbar!
Das "Gesamtkunstwerk Oper" ist
immer ein Bollwerk gegen Realität!
Alle "Liebenden der Oper" sind
Gegner von Realitätswahn! In
der "Oper spielen die "Kämpfer"
die Realität weg! Opernprotagonisten
sind immer Realitätsverweigerer
und ultimativste Spielkinder!
Das "Gesamtkunstwerk Oper" ist

niemals Realitätsillustration! In
der K,U,N,S,T. wird jede Realitäts=
ideologie verdrängt, zerstört und
überwunden! Richard Wagner ist
der größte Künstler aller Zeiten
und gilt als Staatschef des
Gesamtkunstwerkertums! Richard
Wagner hat die Kunst zur höchsten
Gewalt im Staate erhoben! Ich
erkenne nur Kunst als Staatschef
an! Meese will die Staatsform:
K.U.N.S.T.! Alle Zukunft wird
sich als Gesamtkunstwerk zukunften!
Die "Oper" ist, wie "Ballett", Staats=
tragend! Das GESAMTKUNSTWERK
repräsentiert Nichts! Kunst
ist keine repräsentative Wahl=
macht! Kunst ist die NR.1.!
Kunst entmachtet alle Repräsentationen!

wuffwuff? ⑤ meer 2020

STROMIAN!

Kunst
marsch!
marsch!

ERZ

→ Parsifal's Hundaddy!
Der (Kampf um Kunst)
Opernhundwelpe:
"Der kleine Spitz"!
Waldeinsamkeit erzbelle:
Wir wollen
keine chemisch
gereinigten Künstler!
Wir wollen keine
Anbiederer! Wir wollen Kunst!
Wir wollen den "Kampf der Kunst"!

Das "Gesamtkunstwerk Oper" ist das einzige Staatsziel! KUNST IST ULTIMATIVSTE STAATSGEWALT! DIE WÜRDE DER KUNST IST UNAN= TASTBARSTE ZUKUNFT! Wer Zukunft will, dient der Kunst, fertig! Wer Ideologie will, will keine Zukunft, pfui! Das "Gesamtkunstwerk" ist kein Wahlprogramm! Das "Gesamt= kunstwerk Oper" ist kein Mittelmaß! Das "Gesamtkunstwerk Oper" ist keine Demokratie! Das "Gesamt= kunstwerk Oper" ist Liebe, also keine Politik! Wir brauchen politiklose Zeiten! Wir brauchen die Kunstaufrüstung! Das 1. Kunstmachtspiel heißt: K.U.N.S.T.! Im "Gesamtkunstwerk" bündelt sich Alles, was Kunstfähig ist! Kunst ist die "versachlichteste Führung"!

Juwel 2020 ⑦

Parsifalllllll
liebt Dich!

KUNST ✕ de

Large

Wir wollen
kein
weltoffengeschaltetes
Bayreuth!

Wir wollen
den
radikalsten
Richard
Wagner!

(NUR KUNST IST DAS ZIEL!)
ERZ BAYREUTH
K.U.N.S.T.!

Kunst entpolitisiert Alle(s)!

Alles muß juaer 2020
sich der Kunst "überantworten". (LIEBE)

KUNST

DR. Meerswolf

KUNST an die Macht!

NUR KUNST IST CHEF!

Meese 2020

Das Bayreuth des Richardwagnertums ist die "Keimzelle vom Gesamtkunstwerk"! Kinder schafft Neues ohne Angst, hier gilt's der K.U.N.S.T.! So ist es : Kunst ersetzt alle Religionen! Das "Gesamtkunstwerk, Oper" ist immer "Antirealität"! Das "Gesamtkunstwerk" ist kein Geschmäckle! Das Gesamtkunstwerk ist kein durchdemokratisiertes Unter=haltungsprogramm! Das Gesamt=kunstwerk ist der Sieg der Kunst über jeden Ideolog(i)enstus! Kunst ist das Geilste, Kunst steht über den Dingen! Das "Gesamtkunstwerk Oper" ist keine Anarchie! KUNST ORDNET ALLE(S) (AN)! Kunst triumphiert!

Meese liebt (1) Ludwig II von Bayern!

Gesamtkunstwerk:
(Alle Macht geht von der Kunst aus) meese
2020

K.U.N.S.T.

Brigitte Meese ist Mutterz:Kunst!

Richard
Wagner ist
Daddy Cool!,

Brigitte Meese ist Mutter Natur!
Kunst ergibt

Deutschland

...Europa

...und die ganze Welt
↪ und alle Welten!!!!

Meese

Liebende der Kunst sind immer
im Kampfmodus! Kämpfer des
"Gesamtkunstwerkertums" sind immer
Staatsaggressivo! "Liebende des Ge-
samtkunstwerkes" abstrahieren Alles
und sehen ultimativst von sich ab!
Opernmitstreiter bedienen niemals
Realität! Kunst entrealisiert ALLE(S)!
Kunst ist die "Überzeit und der
Überraum"! Kunst ist schneller als
Licht! Kunst ist die "Überlebens=
garantie"! Nur Kunst überlebt!
Kunst ist das "Überleben"!
In der Kunst überlebt das Kind
in Allem! Der "Übermensch" ist
das Kind in Allem! Richard
Wagner ist das Überkind, das
Sternenkind: Diktatur der Kunst!

(13)

Gesamtkunstwerk Oper!

KUNST

Meese

Ich liebe Richard Wagner

Hagen V. George

Weltformel
K.U.N.S.T.!

Meese
2020

Richard Wagner ist Chefsache!
Ludwig II von Bayern ist Liebe!
Nietzsche ist das Überkind!

Meese ist John Sinclair!
Meese ist Parsifal!
Meese ist Alaska Kid!
Meese ist der Grünschnabel!

Pages 161–173
Original manuscript
and drawings by Jonathan
Meese for *Last Days of the
Opera*, 2020
Courtesy of the artist
© Jonathan Meese

Jonathan Meese,
KUNDRYKIND, 2014
Acrylic on canvas,
60 × 50 × 3.3 cm
Courtesy of the artist
(Photo © Jan Bauer)

German painter, sculptor, performance artist, and installation artist based in Berlin.
Jonathan Meese's works include paintings, collages, drawings portraying historical personalities,
primordial myths, and heroes. He has also designed for theater and opera including *Dionysos*
by Wolfgang Rihm and *Médée* by Marc-Antoine Charpentier.

THE GRAND OLD AND YOUNG LADY OPERETTA – THOSE PRESUMED DEAD LIVE LONGER

Ulrich Lenz

The operetta was born from the spirit of satire. At his Parisian Théâtre des Bouffes-Parisiens, the forefather of the operetta, Jacques Offenbach, held a mirror to the society of the Seconde Empire in a biting and witty fashion. In this respect, the operetta was, and is, more closely related to cabaret than to its precursor in France, the "opéra comique," or the Italian "opera buffa." Offenbach's opéras bouffes (he himself used the term "operetta" only once) not only tell a universally applicable, lighthearted story but mock the conduct typical of the society of the times and its political leaders. Its protagonists resided in faraway or fictitious countries populated by (abundantly ridiculous) heroes and gods of Greek myths. In these figures, Paris' wealthy citizens recognized themselves, as did the French aristocracy, including Emperor Napoleon III—and laughed wholeheartedly at themselves. A rare phenomenon, since the crowned heads of days gone by, were not necessarily known for their tolerance of criticism from the ranks of their subordinates. And Offenbach and his librettists were not sparing with biting remarks, nor did they leave their audience in doubt as to whom they might be referring. It is the outstanding achievement of Offenbach, who came from the carnival stronghold of Cologne, that he managed this tightrope walk between offensively socio-critical satire and entertaining "comedy." Good cabaret artists still manage to do this today. Being a sister of cabaret, the operetta relied on a very special kind of actor. It was not the enchantingly beautiful voice that was in demand, but acting, or, to be more precise, comedic skills. Prima la musica, poi le parole? In operetta, the old question of the primacy of music or text seems to have been decided in favor of the text, or, more specifically, its intelligibility. There's no punchline without intelligible speech. And parodistic music, overdone as it may be, can never unfold its wit without the sung lines that accompany it. According to contemporary testimony, Hortense Schneider, for whom Offenbach wrote leading female roles in *La belle Hélène*, *Barbe-bleue*, *La Grande-Duchesse de Gérolstein*, *La Périchole*, and many of his other operettas, was neither an exceptionally gifted singer nor strikingly beautiful. Nonetheless, all of Paris was at her feet (countless men a lot more than that) because on stage, her acting talent and erotic charisma must have been truly spectacular. The female roles she embodied are exemplary for the genre of operetta and its later development. Twenty years before Georges Bizet brought a woman struggling for self-determination to the opera stage with his *Carmen*, "La Snédèr" (as Hortense Schneider was admiringly called) played Helène or Boulotte, showing the men of her day which way the wind was blowing. And at the end of

these plays, she still had things firmly under control. Fighting for her love, Traviata succumbs to consumption and Carmen is stabbed to death by Don José, but beautiful Helène happily sails away with Paris, the prince she loves; and Boulotte, the feisty peasant, is still wearing the britches in the house of Barbe-bleue even at the end of the operetta. With its social criticism and caustic analysis of the contemporary political state of affairs shows Offenbach's operetta as having its finger on the pulse of the times; in the dissolution or even reversal of gender roles, it is downright progressive and revolutionary. In his opéras bouffes, Offenbach presents a feminist perspective before the word feminism was even born.

When the baton was handed over to Johann Strauss—allegedly Offenbach advised his Austrian composer colleague to follow suit—the operetta made its entrance into the Austro-Hungarian Empire. And the Habsburg Empire made its entrance into the operetta. Waltz, polka, and czardas conquered the stage. The genre may have lost some of its satirical edge when introduced in Vienna, but with Rosalinde, Ciboletta, Saffi, and their successors, self-confident female figures also set the tone there. Admittedly, the social and political background of *Der Zigeunerbaron* was the Austro-Hungarian Compromise of 1867, which Strauss and his librettist belatedly commented on almost twenty years after the fact. In terms of being "on the pulse of the times," as Offenbach was, there is not much to speak about here. This is perhaps one of the reasons why today, many still regard works from the so-called "Golden Era" as the epitome of operetta. In contrast to Offenbach, they are more loosely connected with the political context of their time of origin and seem—at least on the surface—to have a greater claim to universal validity.

The "pulse of the times" is taken up again by the operetta after the First World War. Now it was jazz music spilling over from the United States to Europe and, also originating from America, dancing crazes like the foxtrot, charleston, or shimmy that found their way into the operetta. And with them a sense of liberation from outmoded standards. "Had the Kaiser danced to jazz music—none of this would ever have happened," wrote German journalist Hans Siemsen in 1921. Compared to the relatively stiff waltz postures, all of the new dances coming in from America were characterized by excessive movements of the body and limbs.

The rigidity of the old system gave way to new, unconstrained movement. Outdated rules fell, and with them, a few layers of clothing. The operetta, which had already indulged in frivolity in Offenbach's time, now played even more openly with sex and eroticism. And the women who self-confidently shopped for their husbands became wives who provocatively enjoyed having an affair, or ditched their overly jealous husbands. "Why shouldn't a woman have an affair?" asked operetta diva Manon Falconetti in Oscar Straus' *Eine Frau, die weiß, was sie will* (A Woman Who Knows What She Wants)—a role written for the real operetta diva Fritzi Massary, a worthy successor of Hortense Schneider, both in terms of acting and sex appeal. Ten years earlier, at the world premiere of Leo Fall's *Madame Pompadour*, the same Fritzi Massary had already sung the risqué and teasing "Heut' könnt einer sein Glück bei mir machen" (Someone might get lucky with me today).

When the Nazis seized control and quickly spread their racist cultural ideology across the entire European continent, this chapter of the operetta ended abruptly, dealing a brutal

blow from which it has yet to recover fully. On the one hand, most operetta composers and librettists were Jews, and, on the other, the aforementioned permissiveness of the operetta was a thorn in the side of the conservative moral concepts of the Nazis. Hence most of the hitherto successful works disappeared from the repertoires of opera and operetta houses virtually overnight. Authors who were still alive were persecuted and murdered or fled into exile overseas, where, for the most part, they were unable to live up to their earlier successes, let alone contribute to the further development of the genre. Under the Nazis, the operetta was robbed of all its subversive, socially critical, feminist, satirical, and erotic traits.

In the wake of this sweeping cultural cleansing, it was anything but easy to pick up the violently severed tradition. After the war, the production of operettas dried up, or the same works were played again and again, often in adaptations that rendered the original almost unrecognizable. In what was, in part, an unconscious continuation of Nazi politics, the genre that had once featured witty, satirical commentary on current trends and events perverted into a hidebound, sugarcoated figment of an idyllic world. Burning desire turned into sentimental nostalgia, sparkling instrumentation into a strings-heavy Heimatfilm-style drivel, vivacious eroticism into holier-than-thou marital morals, and biting satire into platitudes or corny puns. All this nostalgia drew on two historical points of reference; first, wafting from the operettas of the Golden Era, the old glory of the Austro-Hungarian Empire and, second, the ostensibly intact pre-war world was—erroneously—read into the few "Silver Era" operettas that had remained part of the repertoire. A tradition of musical interpretation had also been lost. After the Second World War, operettas were mostly sung by opera singers with great dramatic voices who had nothing whatsoever in common with performers of the likes of Hortense Schneider or Fritzi Massary (as evidenced by extant recordings of Fritzi Massary and other operetta stars of the 1920s and 1930s). For the generation born before the war, operetta thus became a memory of the past, and perhaps of better times. For the younger postwar generation, on the other hand, the genre was a dusty antique from grandma's record cabinet. In any case, it was going to disappear with the demise of the older generation.

Affirmation of an old, outmoded social system remained a blemish the operetta was unable to shake off. At the start of the new millennium, this led to increased attempts at new approaches to staging, which employed deconstruction methods to reflect on the genre itself. In some cases, this drew much attention from the media but ultimately did not help build new operetta audiences.

In his very first season as Chief Director at Komische Oper Berlin, Barrie Kosky staged Paul Abraham's hitherto little-known operetta *Ball im Savoy* in the spring of 2013. This marked the beginning of a veritable operetta renaissance. Before the Second World War, the halls of Komische Oper Berlin had been home to the Metropol Theater, one of the most important operetta stages of the Weimar Republic. Over the following years, avowed operetta enthusiast Kosky and his team took inspiration from the history of their house, presenting numerous unjustly forgotten works from the pen of Paul Abraham, Emmerich Kálmán, Oscar Straus, or Jaromír Weinberger, which was greeted by a rapturous response from a mixed audience of all ages. And lo and behold, after already being presumed dead, the operetta was given

a new lease on life and appeared fresh and full of zest. Kosky succeeded in unlocking the genre's unique qualities and bringing them to the stage in contemporary productions. The subversive, rebellious elements of operetta struck a chord with audiences of our time, as did its playful depiction of sex and eroticism along with its modern conception of women's role in society. It did so with young and old as well as with audiences outside of Berlin!

The trick to mastering the art seems to lie in a thrilling balancing act between irony and seriousness. As Barrie Kosky put it on several occasions, "With their left eye, actors must be deadly serious, deal in earnest with their characters and situations. With their right eye, they have to adopt a distanced attitude, an outside view on the goings-on around them, and signal to the audience with a wink: Isn't that terribly silly? Isn't all of life just one big joke?" Therein lies the secret, but also the danger of operetta—if you take it too seriously, it becomes sentimental; if you take it too lightly, all you are left with is shallow slapstick comedy. But with the right balance, it begins to soar. And it leaves viewers free to take it seriously or to have a good laugh. Or maybe indulge in both at the same time. That's what accounts for the magic of the operetta, which is again able to reach a broad, colorful, and mixed audience, the kind the operetta has attracted since the days of Offenbach. At the Théâtre des Bouffes-Parisiens, visitors from different social classes indeed found something "they could not find anywhere else, namely, music that each one of them could immediately understand. The language of this music was a kind of Esperanto" (Siegfried Kracauer). It's a pity that operetta was ever able to lose this broad appeal.

The renaissance of the operetta did not occur out of the blue, however, but was the result of an in-depth examination of this highly special genre, including and particularly its musical side. The body of source material available for many operettas hardly compares to that of most operas. In many cases, it had to be painstakingly created—even including new orchestrations. As mentioned earlier, recordings from the second half of the twentieth century were only to a very limited extent useful for orientation purposes. Old footage from the 1920s and 1930s had considerably better illustrative value. It sometimes resembled the pioneering days of historical performance practice in baroque music—not only did parts of the performance material have to be re-edited, but the respective performance conditions also required extensive research. In terms of performance techniques, the operetta has something else in common with operas from the Baroque era, namely that regarding the interpretation these works are eminently open. Not only do they allow for arrangements and adaptations to the circumstances of individual performances, they almost demand to be approached in this way. Evidence of this is provided by the creators themselves—the list of composers who have revised their works as needed ranges from Jacques Offenbach to Paul Abraham. This kind of free treatment of the material is, however, not only owed to external conditions. Instead, it inspires creative pleasure, breathing space, and fun—and these are essential prerequisites for operettas to come to life.

Theater can only live and breathe when it's free. The operetta had lost this freedom in the second half of the twentieth century. And it has not yet fully regained its erstwhile freedom. Now as then, many a guardian of tradition insists, overzealously, on the fulfillment of

ostensibly immutable agreements on performance standards. But this grand old and young lady only has her finger on the pulse of her times when she incorporates these very times in her scenic realization. A comedian will only quote the Emperor or imperial and royal glory if he or she can amuse an audience while imparting something about the current state of society. Perpetual indulgence in the past drains the operetta of its lifeblood.

The operetta is alive—but it consists of so much more than *Die Fledermaus*, *Die lustige Witwe*, and *Die Csárdásfürstin*. Over the last decades, European theaters have broadened the canon of their opera repertoire by rediscovering many a long-forgotten work (and hopefully, they will continue to do so in the future). The same is possible in the field of operetta, where a host of treasures is waiting to be resurrected from unjust obscurity.

The operetta is alive—but it certainly needs at least as much care and attention as the grand opera does. After all, it is no less diverse than its big sister—the operettas of Jacques Offenbach, Johann Strauss, or Paul Abraham are vastly different works. Each of them requires its very own approach to musical interpretation and staging. A brilliant idea for a production of *Tosca* won't easily translate into one for *Boris Godunov*. And someone who is great at conducting Puccini may well have a hard time dealing with Mussorgsky. Why should that be any different with operettas?

The operetta is alive—but it requires a special breed of singers who aren't only able to sing and dance but also need to show brilliant acting skills and comedic talent. Depending on the work, they must be anything but trained opera singers. On the contrary, as mentioned above, many a role was written not for an acting singer, but for a singing actor. In Berlin, Barrie Kosky found in Dagmar Manzel not only an excellent performer and singer but—in the tradition of Hortense Schneider or Fritzi Massary—someone who also brings "star power" to her roles. When she takes the stage as operetta diva Manon in *Eine Frau, die weiß, was sie will*, she embodies a fascinating mixture of herself as a performer, her personality as a celebrated artist, and the part she plays.

The operetta is alive—and through its folly and ambiguity, it is able to deliver red-hot takes on current affairs. In a world where the absurdity of public statements by heads of state outshines any comedic performance, the time seems ripe and crazy enough to premiere new operettas. It's hard to say how their music ought to sound. All through its history, operetta has been open to new developments; in the era that gave birth to new works, it was always forward-looking in terms of style and rarely turned to the past. It seems there's only one thing that really counts: it needs to be the kind of music that is immediately accessible to a highly diverse audience—it bears repeating, "a kind of Esperanto."

Ulrich Lenz studied musicology, theater studies, and art history in Munich, Berlin, and Milan. He was opera dramaturge at the theaters in Linz and Mannheim, chief dramaturge at the Hanover State Opera. As chief dramaturge of the Komische Oper Berlin for many years, he was influential in the increasing prominence of the house. He will become artistic director of the Graz Opera in 2023.

THE MAD MEN AND WOMEN
OF THE OPERA

Franz Zoglauer

The madness of the opera claims countless victims, those who succumb to it on stage are mostly women. Symptoms of their illness include breathtaking coloratura passages. Just think of the ladies of Lammermoor and Chamounix who spiral into mental derangement out of unrequited love, and remember the wife of Scotsman Macbeth, whose acute hunger for power causes her to lose her mind. The challenges of these parts in terms of vocal technique are such that only a few protagonists are capable of credibly portraying both the pathological behavior and the associated emotional outbursts involved in these roles. The secret of the unrivaled Maria Callas lay less in the beauty or perfection of her singing than in the absoluteness and intensity of her expression. In some of her parts, Marlis Petersen has likewise succeeded in portraying confusion and loneliness in the face of death in an extremely nightmarish and stark manner. Anna Netrebko, on the other hand, elicits such enticing sounds with her warm and sensual timbre that she makes you forget the repulsive symptoms of mental illness, her singing signaling more of a farewell to beauty and youth. Vivacious Romanian singer Angela Gheorghiu brings a more contemporary touch to the stage. Even after going into a coma on her death bed, she would still have what it takes to jump up one last time to produce a few minutes of striking singing at the ramp. On the whole, today madness is preferably presented in a calculated manner, both in terms of acting and vocal performance, and in this respect many singers are reluctant to give away too much of themselves in a substantive manner. As the celebrated singer Leonie Rysanek liked to say, "It's like a salami. With every performance you irretrievably give away a slice of yourself."

The gentlemen were usually seized by madness in a spontaneous fashion. For example, charismatic tenor Franco Bonisolli. During a public dress rehearsal for the TV recording of *Il trovatore*, a few expressions of displeasure from the audience after his aria prompted the hypersensitive artist to throw his sword to the ground, leave the stage before the *stretta* and never come back. As is well known, Herbert von Karajan had steady nerves; he finished the act without a tenor and replaced him thereafter with Plácido Domingo. The susceptible singer commented three years later that, after all, he was of the same caliber as Karajan. Bonisolli could get very angry with those conductors who didn't want to go along with his ideas of tempo and refused to condone his various high C stunts or the repeating of popular arias.

Bonisolli was also one of the favorites of Vienna's most prominent standing room regular and opera buff, Paul Wittgenstein. Always elegantly dressed, this dandy of the Vienna opera scene was a nephew of famous philosopher Ludwig and the equally famous one-armed pianist Paul Wittgenstein. His mother was the daughter of court jeweler Köchert and was friends with composer Hugo Wolf. The Wittgensteins were the iron magnates of the monarchy and ranked as one of the richest industrialist families in Austria. Their progeny Paul was friends with writer Thomas Bernhard, who watched him closely during the last years of his life and wrote poignant portraits of him, most notably in *Wittgenstein's Nephew*. Paul had graduated from the Theresianum in Vienna, dropped out of university where he had studied mathematics, sued his father in vain for his inheritance, always spent more money than he had. He spent many years in mental hospitals, managing to escape from one of the most dreaded institutions in France. In the postwar period, the baron earned his living as a gigolo who asked single ladies for a dance in exchange for money. He bought and sold foreign currencies at Café Mozart and, since his rich relatives did not bail him out, he landed in prison, where he had to share a cell with a murderer. Summing up his stay behind bars he remarked that a regional state court in Austria had a kind of charm that was otherwise dying out in our country.

On the side, Wittgenstein was a professional tennis player, hockey star, sailor, bicycle racer, and racecar driver. Due to financial hardship he took up employment with an insurance company when he was sixty. He knew thousands of soccer line-ups by heart and just as many opera casts and used every minute of his spare time to visit the opera. The family members on his father's side were fanatical followers of Johannes Brahms, those on his mother's side were members of the Wagner clan. When composer Hugo Wolf, a friend of the family, asked where Brahms belonged, the mother, as a little girl, always had to say, "He belongs on the scrap heap!" Paul was an almost fanatical Wagnerian. When he was once asked about God in school, he replied that he only believed in Parsifal. He once threatened my nephew because little Alexander, who was five years old at the time, had no clue what Wagner's opera *Tristan und Isolde* was about. For a time he lived together with Argentinean singer Margarita Kenny, and when one of the critics gave her a scathing review in the opera magazine *Der Merker*, Paul bought all the copies available in Vienna and burned them in the opera arcades. Right at the beginning of the reopening of the Wiener Staatsoper, which was conducted by Karl Böhm, he cheered from the standing room shouting the name of conductor Clemens Krauss, whom he revered. In the years that followed, his bravos and boos often played a decisive role in the success or failure of a premiere. Later stunts such as the symbolic laying out of a dead dove on the stage when Egon Hilbert had become director and his attempt to enter the dressing room of Wagner singer Birgit Nilsson, whom he adored, got him banned from the house. The ban was subsequently lifted by his field hockey buddy and friend Robert Jungbluth, then head of the Austrian Federal Theater Administration.

The Spirit Realm, which is a prominent setting in his favorite opera, *Die Frau ohne Schatten* by Richard Strauss, was for him the Traunsee. The Wittgenstein estate is located on the hills overlooking the lake, and on its shores he wanted to have the work performed. One day, he sat his elderly mother in an open-frame wooden handcart and dragged her through

Altmünster to protest against plans for a development project on the landscape that he loved so dearly. Again and again, Paul Wittgenstein's immensely rich family had him admitted to various institutions with caged beds, straitjackets, and electric shocks. These were torturous methods that reinforced the illness instead of healing it, and which today, thank God, are no longer used. The fear of death was a companion that never left Wittgenstein's his side. He was, perhaps, "the very last, over-refined protagonist of old Austrian culture," as writer Camillo Schaefer described him in an homage; above all, however, he was a fanatical opera buff who yearned for the highest forms of perfection and truthfulness.

Gustav Mahler

Many an opera director has been seized by partial insanity. But in the sense of brilliant, this only applies to Gustav Mahler. In spite of his radical reforms and the most odious intrigues of his opponents, he held his ground for an entire decade. A man with a clear idea of his program and its realization, which he then proceeded to carry out, and successfully so—a man like that would seem unthinkable today. The most absurd and malicious rumors about him were circulating in Vienna on a daily basis, as if the great conductor, composer, and director was the megalomaniac dictator of some tiny South American nation. Among other things, it was said that he abused his musicians, forced them into inhuman working conditions, drilling his singers like recruits and treating them as if they were his slaves. He was said to be prone to fits of rage as well as polished quips that were likened to dynamite cartridges. He allegedly snapped so angrily at ladies from the upper echelons of society who wanted to flatter him that they turned and fled his presence. In any case, he rejected any and all interference and was never ready to offer even the smallest of favors, especially when it came to the wishes of influential individuals. How little Austrian in character this brilliant Austrian was—and, at the same time, how typical of this schizophrenic breed of people!

He despised all those who, in the name of tradition, sought to prevent any change or renewal and defended the sloppiness they had grown fond of. He hated the illusive bliss of Vienna's Heurigen wine taverns, cronyism, and every form of fraternization. He demanded the best from himself as well as his staff and colleagues, shooting angry, fierce looks at anyone and everything that did not live up to his ideal of perfection. How intense must the resentment of orchestra members have been when he cut short or sometimes even skipped lunch breaks to satisfy his thirst for perfection. But today, of course, we are in dire need of a personality filled with this almost insane passion for the realization of an ideal vision of top-quality opera theater. Mahler's reforms included the lowering of the orchestra for acoustical considerations, the complete darkening of the auditorium, the decision to deny entry to latecomers during the performance, and penalties for artists who were in any kind of contact with the claque. In addition to that, he introduced radical innovations in set design with ingenious stage designer Alfred Roller.

"The intensity of this 'either-or' man, who made no concessions in his struggle with the greed for compromise, seemed to be the talk of the entire city," wrote poet and journalist Felix Salten. People who had otherwise never been to the opera were discussing with great passion the events at their court opera. Since then, Herbert von Karajan has been the only

one to even come close to achieving something like that. The house, and with it the genre of opera, were more vibrant and alive under Mahler than they had been in a long time. But it did not take the resistance of the ordinary against the extraordinary long to wear down the man who was probably the most brilliant director ever to head the Court Opera. On the occasion of Mahler's demission, Felix Salten summed the situation up thusly: "Of course he was recognized, admired, and beloved in Vienna. But it must be said that his greatness was unbearable to all the mediocre types and that they triumphed over him."

Von Karajan

And what about the conductors that followed him? The most disciplined among them at the very least showed signs of strange behavior. For starters, there was Carlos Kleiber, a perfectionist who repeatedly cancelled performances at the last minute. He was the son of famous Austrian-Argentinian conductor Erich Kleiber, who tried to force him to enroll in a university chemistry course. Carlos was plagued by self-doubt. He introduced himself to his colleagues as Kapellmeister. "May I listen in on your rehearsal, you are so much better at this than I am," he once asked Herbert von Karajan during preparations for the Salzburg production of *Carmen*. The people standing around them thought he was being ironic, but he was completely serious. Kleiber's Vienna *Carmen* was an even match to Karajan's.

Karajan never let any self-doubt show, if it ever bothered him at all. But this ingenious conductor had a penchant for strange rituals. In Salzburg, his bodyguard had to stand ready and open the Maestro's car door when he arrived from his villa in his Porsche. As he got out, he tossed him his coat and hurried to his office in the Festspielhaus. If a journalist wanted to schedule an interview, he or she had to inquire with the maestro while he was walking up the stairs. During TV interviews, he would only allow himself to be filmed sitting casually in the front row balcony in the soft glow of the shiny golden iron curtain. During rehearsals, he often played older recordings in order to go easy on the singers. When he once had Christa Ludwig sing with half-voice to a recording of Giulietta Simionato for a TV spot, he said to me, "No one's ever going to notice that on television anyway." By the way, like a certain dictator in Bayreuth, he always let himself be addressed as the "chef."

Leonard Bernstein

Leonard Bernstein was pretty much the opposite of Karajan. The composer of *West Side Story* would jump up and down on the podium like a show star. Lenny not only hugged all his friends, but the whole wide world, as well. But in real life, he was a lot more distant and lonely than he would let on in public. When in Israel for guest performances, he would withdraw to meditate at the King David Hotel with a view of the desert. In America, he recounted in interviews how difficult it was to convince the Vienna Philharmonic of Mahler's music.

Marcel Prawy

Dramaturg Marcel Prawy, the man who produced Bernstein's *West Side Story* musical for the first time in Vienna at the Volksoper, was befallen by a pure and almost innocent opera

madness. For many years, he was extremely popular on TV as the "opera guide" of the nation. His chief merit was that he wanted to teach people that opera was the most important thing in the world. Prawy loved, above all, the singer's faults and mistakes, because, as he said, they made their voices unique and more recognizable; the wonderfully tinny high notes of Richard Tauber, or the transposed top notes of Maria Jeritza, and the strangled voices of the basses, which masked their linguistic weaknesses. And how close could he bring a sporty, elegant composer such as Giacomo Puccini to his audience, by showing him in his stylish vintage car, or shyly and biting his nails while spearing butterflies? After all, many of his operas also contain gruesome scenes and portray mortal anguish.

Strangely enough, Prawy, who was able to escape the Nazis in 1938 and emigrate as secretary to the singer couple Marta Eggerth and Jan Kiepura, had no political instincts whatsoever. When I was working on a documentary about Wagner and Hitler and had discovered in the Koblenz Archive historical recordings of a performance of the opera *Die Meistersinger von Nürnberg* featuring Wilhelm Rode as Hans Sachs, Prawy began to wax poetic about that singer and wanted to use the material in one of his shows without commenting on the context. I alerted him to the fact that in the film, Rode, who was director of Deutsche Oper in Berlin from 1934 to 1943, is seen introducing himself with the Hitler salute to all the Nazi bigwigs seated in the auditorium. In spite of my objections, he stuck to his view that Rode was, above all, a wonderful singer, and that was the only thing that counted—love is sometimes blind, but without it, and coupled with the kind of passion that is a sister of madness, there would be no opera. Today this genre is threatened by being marketed to tourists, by interchangeable international productions, and by the absence of great personalities. Many of the big houses are immovable dinosaurs, fast asleep and comfortably snoring away.

May they be awakened by troublemakers and madmen with a wealth of ideas.

Franz Zoglauer was music critic for Austrian television for many years, and presenter and editor of the ATV cultural magazine *Highlights*, he was also journalist for the weekly newspaper *Die Furche*. He died in April 2021.

SCHLINGENSIEF, THE OPERA
AND THE VILLAGE SQUARE

Aino Laberenz

On the eve of the groundbreaking ceremony for the Opera Village Africa in Burkina Faso, Christoph Schlingensief tried to picture how a Wagnerian would feel and react if he or she were to arrive there, only to realize "there were no opera performances and just goats and children running around." But there was nothing wrong with disappointing these people. "Because it's not about bringing our form of opera to Africa." And yet, to him it was always also about engaging with "opera."

Opera, like theater or other art forms, can generate as much power and energy in a society as it absorbs into itself. Opera is a real art form and, at the same time, a symbol of the diverse modes of expression in art. The art of opera emerged from various currents of development: monastic schools practiced Latin school dramas; aristocratic families indulged their need for prestigious entertainment and wanted to outdo each other with masquerades, theatrical performances, ballet, and courtly festivities. And so, from the very beginning, the concept of opera stood for an art form fueled by various sources. It's also interesting to see how often opera has reformed over time. Music is not static; you can't hang an opera on your wall. The development of opera has progressed continually over the centuries.

With Monteverdi the word still had priority over the music—*prima le parole, poi la musica.* After Monteverdi, the opposite became true—*prima la musica, dopo le parole.* The orchestra takes on an increasingly prominent role. Orchestral parts become means of affect. The plot that grew out of the mystical play of the early opera loses in credibility. Thus, the themes of opera also change, shifting towards love, despair, and rage.

The development of opera has tended more and more towards mainstream society or, of course, has reacted to social currents and absorbed them. It became, as it were, a musical and dramatic double exposure that revealed inner and outer events at the same time. In Beethoven's *Fidelio*, a true incident provided the inspiration for the story; and suddenly, opera was no longer just a musical fairy tale. In opera, we always see an interaction between form—including the musical form, for example instrumentation—and content, the key term being "leitmotif." Richard Wagner, who wrote extensively on music theory, opened up a new space for this art form. Opera has also engaged with matters outside the stage, both on a theoretical and philosophical level. In 1830, visitors to the opera *La muette de Portici* poured into the streets of Brussels before the performance ended, demanding independence from the Netherlands. Here, opera performance served as a direct intervention in society—to the point of revolution.

Calling for texts without affectation or "people from everyday life" in the opera was the logical next step. But I believe that opera is, by now, also afflicted by its paragons; it has stagnated and tends towards epigonism.

The opera village, on the other hand, demands movement, including through engagement with opera. Mutual understanding, a vibrant exchange. The opera village is actually about reflecting on and engaging with the opera—but, of course, also about calling for it to continue to develop, to democratize itself, and to return to its origins: from stagnation to dynamism.

"Our opera is a village," that was Christoph Schlingensief's concept. And the village's offerings are diverse. They range from traditional music and rap to dance, film, and visual arts. The Opera Village Africa serves as a platform for the development, design, and dissemination of one's own imagery in whatever form it may take. A key point here is the connection of art and life. A life where, occasionally, goats and children can be way more important than an opera.

Born in Turku, Finland, Aino Laberenz has worked extensively as a costume designer for theater and film. She joined Christoph Schlingensief's team in 2004 and has been managing director of Operndorf Afrika since 2010. Together with curator Susanne Gaensheimer, she designed the German Pavilion dedicated to Schlingensief at the 54th Venice Biennale, which was awarded the Golden Lion. She is the editor of Schlingensief's biography *Ich weiß, ich war's*, published by Kiepenheuer & Witsch.

REFLECTIONS IN FIVE SCENES ON THE
MUSIC-THEATER OF TOMORROW

Karl Regensburger

Sisi and Heidi—yes, these are the eponymous heroines of current Music-theater. And as happy as we are that two of the key female figures of the penultimate century be prominently and successfully in the contemporary world of Music-theater (and just for the record, Johanna Spyri and Empress Elisabeth of Austria were contemporaries; the Heidi novels were published in 1880 and 1881)—we feel like shouting like Slavoj Žižek, "But…!"

However, this is no banal, ongoing polemic. Conceptually, the call for renewal and courage is at the crux of the theatrical tradition. After all, Music-theater is a term coined in the twentieth century to give a name to artistic developments that didn't fall under genre labels such as opera, operetta, or singspiel any longer. Indeed, there was a time when Music-theater was experimental, exciting, and yes, with the new and emerging musicals, also popular. Therefore, these lines are an attempt to trace potential connections to the present, sketch nascent tendencies, and go to bat for successful but perhaps little-known productions from elsewhere—and for dance in all its facets.

1. West Side Stories

With the advent of musicals, dance and choreography of the highest level played a central role. Allow me to paint with a broad brush here. The divorce of music-plot-singing-acting from rather cumbersome opera choirs or music-plot-étoiles-corps de ballet in usually wordless narrative ballet was a pretty straightforward affair. But a musical involves a host of additional elements. Of course, film can be added to the mix, ideally along with contemporary, current, and controversial topics. *West Side Story* is still considered the mother of this type of Music-theater in terms of music, subject matter, cinematography, and, above all, choreography and dance. Thus, it's no wonder that this genre was being celebrated once again on Broadway in 2019 version of Bernstein's masterpiece by Ivo van Hove, choreographed by one of today's most eminent contemporary choreographers, Anne Teresa De Keersmaeker. Also worth mentioning is the restless contemporary colleague of Keersmaeker's, Belgian Damien Jalet, who, aside from his work for Madonna or his much-discussed choreographies for films such as Luca Guadagnino's *Suspiria*, has now made his foray into opera with *Pelléas et Mélisande*, designed and directed by Marina Abramović.

Change of Scenery: The BRIT Awards 2020—or: Miss Bärlamm Goes Party

The 2020 BRIT Awards gala in London featured an entirely different combination of text, vocals, content, music, sound, dance, and show—Brexit Britain in all its pop-cultural diversi-

ty—also great theater. One of the winners, black grime rapper Stormzy's performance featured remarkable stage design, two choirs, two orchestras, various electronic devices, and three separate dance ensembles (for those who don't know him, *Time* magazine named him "next-generation leader" in 2019). The show drew on the past and present of black music and black communities against the background of the lost dream of the "Commonwealth." From gospel to R&B, rap, hip hop, and grime to almost classic singer-songwriter elements, this amounted to a content-heavy, brilliant, glamorous, emotional, and breathtakingly choreographed manifesto of new and latest popular art. It may be worth following this approach or concept further and opening our international stages along with the minds of cultural administrators and sponsors to these genre-busting projects. Are Stormzy and all the other musical rap and pop poets worthy successors to the wonderful Hannelore Hoger as Frau Bärlamm in *Die Macht der Gefühle* (The Power of Emotion), Alexander Kluge's still-captivating opera film from 1983? How could today's opera, or Music-theater, again be turned into a "powerhouse of emotion" (after Alexander Kluge and Werner Schroeter)? Kraftwerke, mind you, and not a constant soft stream of, in the best case, melodramatic emotional fast food ("Elisabeth," "Heidi").

2. South Side Stories

"We are well on the way to losing our individuality and the links that have been forged between our cultures for the sake of clichés and the cult of the mainstream. We have become tangled up—hopelessly perhaps—in our obsession with symbolism and the spectacular while at the same time simplifying all of the complexity, which exists in the interrelations between people and things. We present ourselves as the highly cultural First World, not least in our desire to proselytize the Third World. Why, however, do we in Western Europe constantly want to help Africa when we can't even help ourselves? In reality, everything is much more complex than complex. And so—what can the goal of the cooperation between Africa and us be? A cooperation that takes place without sentimentality and our unpleasant helper syndrome!"

Christoph Schlingensief on Via Intolleranza II

One of our all-time ImPulsTanz highlights *Via Intolleranza II* was a pioneering Music-theater project, which remains revolutionary to this day. Its title and subject matter are based on Luigi Nono's *Intolleranza 1960*. At the time, Nono's piece was alternately called "scenic action," or just "action, "or of course, simply "opera." Not much is left of the original, but Schlingensief nevertheless used it as a blueprint for postcolonial relationships between Europe and the African continent. An article by Diedrich Diederichsen, published in *Theater der Zeit* in 2010, remains highly instructive today—not the least with regard to the above reference and thus reminds us of the difficulties or "productive misunderstandings" of our terminologies.

In all of Schlingensief's works, and particularly in his operas—from *Mea Culpa* to *Parsifal*—there is neither escape nor mercy. Instead, he treats us to a plethora of ideas rich in sensuality and conflict. *Via Intolleranza II* featured vocalists, musicians, dancers, actors,

griots, a social anthropologist, and a comedian. The cast hailed from Germany, France, and Ouagadougou—complemented by videos, footage, and Schlingensief. In cooperation with Burgtheater and the Wiener Festwochen, we presented this unique artistic collaboration at Vienna's Burgtheater Probebühne im Arsenal in 2010. Luckily for us, this generous cooperation was made possible by the dedicated and highly personal commitment of all those involved and close contact with the Burgtheater—which brings us to the art form of Music-theater in general and cooperations and their structural and financial prerequisites. It takes time, the right places, and—it's expensive!

But let's return briefly to Nono, Schlingensief, and what Diederichsen wrote in 2010:

> "Like Nono's work, *Via Intolleranza II* wants to anticipate without being able to decide between apocalypse and revolution, or between personal catastrophe and having one's wishes granted. As a model, this piece, which wanted to invent a new political idea with a new theater form in one move, was probably a better point of departure for Schlingensief than his favorite composer Wagner, who also briefly howls a bit here. *Gesamtkunstwerk*, a century later."

And frankly, in the time of Corona, in which these lines are written, what could be more palpable than a feeling of meandering between apocalypse and revolution or staggering back and forth between personal catastrophe and wish-fulfillment? And what, then, is it that we need more, or with greater urgency, in the time following physical distancing than new political ideas with a new theater form in motion and (a) movement—along with people and structures that enable, explore, and propagate it?

3. And Dance

The piece *Kirina*, by the famous choreographer Serge Aimé Coulibaly from Burkina Faso in collaboration with world-renowned Malian musician Rokia Traoré, is based on a libretto by Senegalese economist and theoretician Felwine Sarr (who recently gave a lecture at Vienna's Odeon at the invitation of Erste Bank Foundation). With his ensemble of nine dancers, four musicians, two singers, and a narrator hailing from different West African and European countries, along with thirty local extras, Coulibaly follows today's global migration flows. Poetic, complex, riveting, and emotionally dense is a form of Music-theater that combines text, music, vocals, dance, and participation. When performed at Kampnagel, Hamburg, it congregated social and cultural diversity both on stage and among the audience in a shared room ranging from Elbphilharmonie patrons and die-hard dance and jazz fans all the way to the Afro-German community and the most colorful devotees of the independent stage. After all, the exciting thing about a Music-theater audience is precisely its extraordinary excitement. Granted, those who have witnessed a scandalized Wagner audience are pretty much immunized to everything. On the other hand, if you've experienced the ecstatic applause of an enthusiastic musical, dance, or circus audience, you can be sure that your immunity will

be boosted for weeks as well. What connects all of these is probably this unique mixture of strong opinions and a passionate, narcissistic desire for what is expected and paid for, be it snappy dance routines, a monumental laser show, top-notch vocal art, or the cunning sexiness of ballet costumes.

Another example of an interesting music-and-theater experiment was *Glauben an die Möglichkeit der völligen Erneuerung der Welt* (Faith in the Possibility of the Complete Renewal of the World) by René Pollesch at Berlin's Friedrichstadt-Palast (affectionately called The "Palast," by the city's postsocialist denizens, now known as Revuetheater, it has a seating capacity of 1895—none of them with limited view and measures 2,854 square meters, making it the "biggest theater stage in the world"). Here, the sharing of intellectual insight in tongue-in-cheek tragic, postdramatic theater is coupled with zippy dance numbers by the Friedrichstadt-Palast Company, a surprising laser show, an intense charge of emotion, and the top-flight elocution of German actor Fabian Hinrichs.

And so a continuation of Alexander Kluge's/Hannelore Hogers'/*Frau Bärmann*'s unfailing search for the "Power of Emotion" becomes conceivable as a tendency towards a recomposition of the Music-theater genre as well as its audience, along with our Faith in Possibility. Because, and this is a passionate and absolute plea for the physical congregation of people, the feeling, particularly in the process of reception, is transformed when you watch or practice art not just alone or with peers, but together with many, diverse others outside of your own family, scene, bubble, and class. The encounter of all these mixed—human, non-human, media—protagonists on stage and among the audience may already contain a little bit of a future that can deal with globalization in a manner other than our current one—of which we now know the lethal consequences. Here, Music-theater with motion and movement as a place for the coming together of the many is understood as a small but exemplary try-out utopia—precisely because of its genre-like fuzziness, extraordinary popularity, glamour, and potential virtuosity. It bears mentioning that, from the outset, our festival has dedicated itself to this type of encounter.

Another utopian experiment, *Coming Society* by Susanne Kennedy at Berlin's Volksbühne in 2019, has the audience on a continually revolving stage that you can step off of at any time and stroll through a stage scenery of pillows, benches, spaces in spaces, mirrors, and vistas, enveloped by a sound score of music and text that is lip-synched by wondrous avatar-like performers chanting seemingly endless repetitions of the eternal return of the same, between shamanic rituals, re-enactments of scenes from TV series, and what is perhaps an in-vitro birth, twitching and vibrating, embodied by a magnificent young Berlin dancer. Of course, what we incessantly move through here is no longer a stage design. There are digital prints everywhere, statically on the floor, walls, bodies, dresses, or moving images on screens. Here, the audience is no longer an empathic crowd but is instead made up of distraught, isolated individuals in search of some meaning, or none, blinded by the beauty of the digitally networked and obliterated in the textures of words and sounds, vis-à-vis slightly defamiliarized masked faces of the actors. It is an eerily secure space from a future we do not hope for. Did someone say Music-theater? Sure, absolutely!

In Vienna, internationally successful director Claudia Bosse and composer Günther Auer, among others, are experimenting with new forms of Music-theater, most recently with her first opera titled *Poems of the Daily Madness*—performed in the open space of the since burnt-down Nordbahn-Halle, a walk-in musical installation with plot and an ensemble of actors, singers, and dancers.

Other, younger, and yet non-"tentative" attempts were made, for example, by Swiss choreographer Daniel Hellmann. In the five acts of his *Requiem for a Piece of Meat*, which are based on Dante's circles of hell, four immensely queer and erotically charged dancers encounter four young contemporary classical musicians and singers. In an enchanting way, this elegiac, ironic swansong to all of our carnal lust, I'm almost tempted to say, mates with Monteverdi and the beginnings of opera.

The Belgian choreographer and dancer Michiel Vandevelde is only in his mid-twenties and already celebrated for his reprise featuring twenty adolescents, at the Kaaitheater in Brussels in 2018, of the Living Theatre classic *Paradise Now*, which premiered at Avignon in 1968. Now he has set his sights on opera. Recently he produced a danced adaptation of Nâzım Hikmet's great epic *Human Landscapes* involving music, vocals, and speech also at the Kaai in 2019. His idiosyncratic version of Bach's *Goldberg Variations* featuring a dancer with Down's syndrome, Vandevelde himself, and a P.A.R.T.S. dancer with accordion accompaniment was planned for June 2020.

Together with Vienna-based musicians, among others, he is now working on his first opera production. It will be interesting to see the outcome. The same is true for the next feat of choreographer and dancer Sergiu Matis. Born and raised in Romania, he taught himself ballet via YouTube and was later trained in contemporary dance forms, among others, with Sasha Waltz in Berlin. Matis links together unwieldy writing about the revolutions of the twentieth century and the biographies of his young international performers. He makes use of club sounds, speech, *Sprechgesang* in open architectures, also involving unorthodox use of theater buildings. As the title suggests, his most recent production, *Extinction Room (Hopeless)*, focuses on the extinction of species and is, in terms of form, again a configuration comprising dance, composition, soundscapes, text, language, and vocals. *Extinction Room* has been adapted for theater spaces as well as for museum contexts. That too is considered a hallmark of current artistic practices—the artist's work is site-specific, bringing together a variety of situations, urban conditions, and social as well as spatial architectures.

Matis' performances are overwhelming experiences, conceived and choreographed with clarity and precision, with bodies and movements that are, and remain, close to us and alive. They produce the finest translation into the present of the attitude of the *Regietheater* of the overwhelming. They do so by staging the "Power of Emotion" for an audience that is left with enough space for their own (inner or outer, mental, affective, physical) movements. This also applies to Austrian playwright Thomas Köck (*Klimatrilogie / Climate Trilogy*) and his collaboration with the dance company of the Oldenburg State Theatre. Here, Köck has developed his own form of writing to and with the music, the dancers, and the dance. Incidentally, he is currently working on a libretto for an opera—with two choirs, ghosts, and cyborgs.

4. Transcending Boundaries

Fine Arts…

Together with rock musician Andreas Spechtl (yes, panic), the above-mentioned Thomas Köck has devised a Music-theater format called *Ghostdance*. He has presented it in Stuttgart and Berlin, as well as at Vienna's ImPulsTanz festival at Mumok—Museum moderner Kunst. This is about a dance with ghosts, with ideas, dreams, and the unresolved remnants of history, to text, images, music, and vocals, while the audience joins in the dance!

Pop icon and performance artist Peaches, in turn, staged her first musical with an accompanying exhibition in Hamburg and Berlin in 2019. It was performed by dancers from the independent scene and was opulent, combative, and sexy, featuring circus-style scenery and an orgiastic plot. The good old "rock opera" comes to mind—and why not? She gave us a foretaste of this at our festival in the almost improvised version in 2017 with twenty-five participants from the workshop *Critical Joy*. It was staged, first, around the entire Mumok building where the exhibition *Painting 2. 0.—Expression in the Information Age* was on display, and then, following a smooth transition, on the main courtyard of the MuseumsQuartier in front of a surprised and mostly enthusiastic audience of over three thousand. That too was "Music-theater," if we can provisionally agree that certain hierarchies are no longer needed to define it—such as those between composition, score, and performance in the age of electronic fabrication of sounds, of mixes, and of live acts in all areas of music.

…and the big stage…

Finally, let's not fail to mention William Kentridge, that globally influential crossover artist between the global north and south as well as between the arts. He's a South African storyteller, thinker, visual artist, filmmaker, and opera and theater director. His *Refuse the Hour*, 2013, was featured at the ImPulsTanz festival at Vienna's completely sold-out Volkstheater, starring young South African guest dancer and choreographer Dada Masilo. Now his most recent production, *Waiting for the Sibyl*, is soon to be shown in Vienna. Its phenomenal set design is comprised of Kentridge's very own kind of objects, films, and text projections, and its cast of singers and dancers hails from South Africa. Today, the classical prophet Sibyl is replaced by algorithms, which increasingly define and pre-interpret our lives—that's the proposition, which may sound somewhat prosaic. But we know that with William Kentridge, thoughts are translated into a multi-faceted, colorful, and dynamic artistic universe, which not only collages objects, images, and text in a unique manner and always against the background of South Africa's and the world's postcolonial experience, but also combines music, sound, voices, and dance into a new "Music-theater in motion."

5. Again, and Finally, DANCE

Florentina Holzinger's two great creations, *Apollon* and *T.A.N.Z.* (DANCE), are attacks on and a congenial continuation of narrative ballet and choreography, navigating more and more towards a Music-theater of the future. Currently, Holzinger is probably the most intrepid among these artists from a younger generation when it comes to producing unconditional

entertainment while ready to take any risk and sparing no materials. At the same time, all of these artists (as so many before them possess profound art-historical, theoretical, and practical knowledge beyond the traditional boundaries between genres and disciplines or between high, popular, and subculture. Someone like Holzinger, for example, "clicks"—in spatial terms and with individual audiences—at Berlin's Sophiensæle just as much as it does at Munich's Kammerspiele or Vienna's Volkstheater, as the 2018 performance of *Apollo* at that very venue during ImPulsTanz has shown. Now with his first series at the Schauspielhaus in Zurich, American choreographer Trajal Harrell has developed and staged something like a *new* Music-theater. And who would want to overlook the likes of Ivo Dimchev, this wonderful musician and singer, particularly with pieces such as *Fest* or his legendary performances employing Franz West's "Adaptives" (*X-on* presented at the Kaaitheater in 2011)?

What then remains? We have to be more daring. Courage, that is what it comes down to, the tireless search for strong energies, complex structures, small beginnings, and new forms of dance and Music-theater. The field has been prepared and ought to be tilled. Of all the arts, contemporary choreography and its actors may currently be the readiest for this—with and after the great Pina Bausch, the dreadfully missed Hans Kresnik, or the great collaborators Cage and Cunningham. Dance takes place every day, and everywhere, and in all of its facets; on TikTok in the digital world, on big and small stages, at New Circus, revue theaters, museums, in the streets, or wherever. Dance is inclusive. Dance connects with everyone and everything—music, song, writing, fashion, architecture: sense and sensuality. Dance travels into and out of our bodies into the open. Only the *traditional* Music-theater establishments appear to provide mighty fortresses for the conservation of a repertoire, which we certainly don't want to give up—but it sure would be a pity if that were all that the future held. We hope to have provided some valuable suggestions here, but it will require a lot of effort from all of us, because, as mentioned earlier, it won't come cheap!

Together with the Brazilian dancer Ismael Ivo (†), Karl Regensburger founded ImPulsTanz - Vienna International Dance Festival in 1984. They made the yearly event into a major contemporary dance festival, which gathers thousands of professional dancers, choreographers, and teachers for a five-week program of performance, research projects, and workshops.

6.

Heritage

Past and Present

THE SWEET BURDEN OF
A GREAT HERITAGE

Madeleine Rohla-Strauss

How does one deal with a great heritage? The older I get, the more I ponder this question. Of course, the first consideration is what a "great heritage" actually means. The answer is many things. On the one hand, the material aspect includes liquid assets parked in various deposits with various banks; art treasures hanging on the walls or standing in corners, which no one gets to see apart from family and close friends. Houses, properties, or forests that you endeavor to maintain and hand down to the next generation. And then some. On the other hand, there are, of course, intangible benefits, such as a centuries-old name everyone knows; a unique family tradition that is passed on from generation to generation; or, you know, a certain forbear who created something exceptional, in my case my great-grandfather Richard Strauss.

With this essay, I have taken the opportunity to reflect upon, once again, what being the great-granddaughter of a genius like Richard Strauss has meant in my life, as well as in those of his son, two grandchildren, five great-grandchildren (of which I am one), and his eleven great-great-grandchildren. And whether and how we have tried all our lives to deal in a decent and worthy manner with this legacy, which has often proven a mixed blessing. Let it be said that, aside from the many beautiful and good things it brings, this kind of birthright also has its negative side and involves great dangers.

The greatest danger—and this is something I have not only seen in my own family but also in other families with similarly famous forbears—is the feeling that however hard we try, we can never do justice to the achievement and the legacy of our progenitor. One is constantly tempted to measure the results of one's own activity and one's each and every effort against this progenitor. What's the value of having successfully worked in an advertising agency compared to the *Alpensymphonie*? How does providing one's family with a beautiful home measure up to the *Rosenkavalier*? How does earning good money with some regular business compare with co-founding the Salzburg Festival or initiating GEMA (Society for musical performing and mechanical reproduction rights), which provided countless artists with their first steady income? What's the value in being a decent person in our small daily actions compared to leaving indelible traces in the realm of eternal greatness?

Making all these comparisons might sound a bit like splitting hairs. But in real life, being related to someone as famous as Richard Strauss means that all of your own activity is constantly subjected to inner examination. Either consciously or subconsciously, and against one's own

will, of course. But when after years, you find yourself sitting in the opera hearing your thousandth Arabella and once again the tears well up… It's a standard you are bound to fail to live up to—especially as an artistically inclined person. And time after time, it erodes your self-esteem.

The risk of this is even higher if you try to become active and successful in a field similar to the one your progenitor worked in. My father (who, on top of it all, was called Richard Strauss) not only had perfect pitch but a remarkable instinct for the staging of opera and, in particular, those of his grandfather. His dream was never to become a composer himself, but "only" an opera director. But he gave up on this pursuit early in life despite having received intensive training from Rudolf Hartmann and obtaining different engagements, for example, with Heinz Tietjen, including several opera productions in Hamburg and Berlin. With dreadful regularity, commentaries included snide remarks, such as "Well, he's not his grandpa," or "He's fishing in troubled waters." Above all, the contempt and condescension mostly expressed behind his back put him off, making his passion his career at an early stage. Instead, he resigned himself to becoming a highly successful rare stamp dealer. And a wonderful father. But his sadness about that never left him, and it's evident to us that this also had to do with his "great heritage," which obviously troubled him a lot.

The burden of a "great legacy" certainly becomes lighter with every generation due to the automatically increasing distance in time to the famous forbear, making it easier for a descendant to lead an entirely independent life. Today most of Richard Strauss' progenies have adopted different names, and nobody outside their immediate environment knows their background. My generation had also learned to conceal this lineage because it had become tedious to answer the same old questions—"And do you play an instrument, too?" Or to have to listen to supercilious remarks from complete strangers on unearned copyright windfall, but I'll get to that later.

In reality, no member of the Strauss family can fully break free from this burden, which is also a sweet one, and we have no intention of doing so—for who would want to be guilty of betraying one's flesh and blood—but I'll come back to this shortly. There are definitely a host of beautiful aspects to it, too. Just as you often cannot help feeling empathic embarrassment when someone you may not even know commits some awkward faux pas, there is also the rather pleasant feeling of "empathic pride." It's a very common phenomenon and can turn into a mass syndrome at the soccer world championships (German) or ski races (Austrian). It can catch you in your private life when, for example, a child has achieved some exceptional feat, or you believe that your own child has turned into something very special, or if your great-grandfather is undeniably and according to the verdict of the entire world a very exceptional person. When you see how the work of someone you are descended from literally touches the hearts of millions. When strangers come up to you in foreign countries and recite by heart entire passages from the *Rosenkavalier*, mainly "Die Zeit, die ist ein sonderbar Ding…" ("Time is a strange thing…")—singing it is a little too difficult. Or when you're annoyed by the thousandth commercial but nevertheless by the end start to feel somewhat pleased at hearing *Zarathustra*. When, over and over, you wonder in disbelief how a single brain and a single heart—which, after all, makes up an eighth of yourself, or, an eighth of which beats inside of you—could create such entirely different and distinct things as Salome, the song "Morgen!," the *Sinfonia*

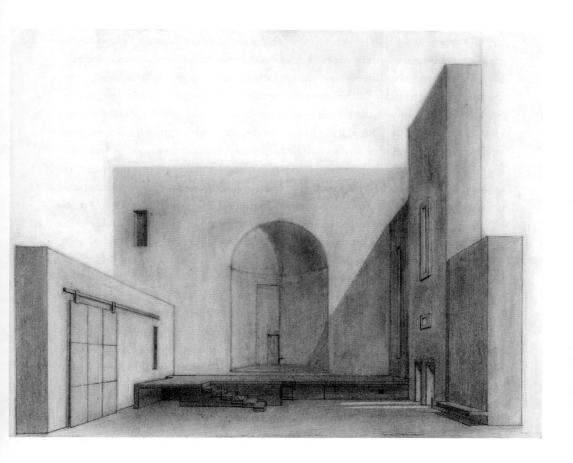

Richard Peduzzi,
Untitled, 2013
Graphite on paper,
22 × 30 cm
Design for *Elektra*,
Richard Strauss, Festival
d'Aix-en-Provence, 2013.
Director: Patrice Chéreau
Courtesy of the artist
© Richard Peduzzi

Domestica, the *Cello Sonata* (F major, opus 6), or, to top it off as a final encore, "Im Abendrot." If you remember, the many things only passed on in the family, which are a testimony to the special kind person, loving family man, and good businessman this forbear of yours was. When you sneak into the Garmisch archive at night and, filled with respect, but still somehow calm, browse through personal letters, documents, and musical scores that only a few have ever laid eyes upon and will ever lay eyes upon, you being the exception because, well, you're the great-granddaughter. When you remember childhood days at the house in Garmisch, romping around all of its rooms and the big park, often marveled at by strangers visiting the house to gaze in awe at pieces of furniture that had no special meaning for you beyond the fact that you were sitting, eating, or playing on them. I will never forget the angry fit my grandmother threw when I was about ten, and she noticed that I had written for myself with a green felt pen the notes onto the keys of the grand piano on which Richard Strauss had composed most of his works.

There are countless memories and stories of this kind—and they are of course passed on from generation to generation, again and again, at any given opportunity, often with quiet pleasure at the fact that only you are in the know and so many people around the world would probably like to be brought into the loop, but unfortunately never will. This may be childish, but this intimate knowledge renders the luminous figure of Richard Strauss a lot less intimidating and allows you to deal with the above-described burden in a somewhat more relaxed manner. Of course, from our earliest childhood on, all of us constantly had to listen to the portentous Goethe quote, "What you have inherited from your fathers, earn over again for yourselves, or it will not be yours." No one ever bothered to explain in more detail or define with greater clarity, what it was precisely that you could earn over again so as to make the "great legacy" yours, and how to go about it. We can't blame our forefathers for this unmindful upbringing, nor can we be blamed (we also torture our children with this same behest), given that there are no ground rules in this domain. Be that as it may, it was always a matter of course to us to make the house in Garmisch-Partenkirchen accessible to the public and support academic research at the Richard Strauss Institute, and this was never called into question by the later generations. And now that we're coming up on six generations after Richard Strauss (some of his great-grandchildren are already approaching the age of thirty and will likely soon have children of their own) and seventy years after his death, the copyright has expired, everything will be much easier.

There are two clearly defined and demanding missions we took upon ourselves in connection with our great heritage. The first and most important one was to keep the family together, to not become like the Wagner's who were at loggerheads with each other. Always look for unity, come what may, and always find common ground, even if you hold different opinions. It's a wonderful thing that my sister, my cousins, and I successfully followed this course. And we will surely be able to continue this path, even if the last member of the previous generation, my beloved uncle Christian, has passed away now, and there is no one left to look out for us.

The second mission we were tasked with was a poisoned chalice. From the moment we were born, the fundamental attitude was instilled in us that it was our job to defend Richard Strauss's oeuvre against changes and interpretations as long as we could. That was the way we were told to deal responsibly with a "great legacy" to protect it against all the barbarians out

there. We were accountable to our great-grandfather and not to the larger community. It was incumbent upon them to kindly perform the works that had been entrusted to us by fate as a "great heritage" as "faithful to the original" as possible. They were not to delude themselves into believing that they knew better than the one who conceived it all, together with other geniuses such as Hofmannsthal, Zweig, Reinhard, or Roller. We will never forget that in the 1970s, when we were kids, a media backlash was unleashed on my father because he dared, just once, to prohibit a production of *Salome* in some provincial German theater where Jochanaan was to be crucified head downwards, hanged, and then was supposed to sing in that position.

Over the last two decades, it was left to me as the managing director of the publishing company to act as the leading "champion of the faith," so to speak, and the ultimate contact point for the countless inquiries regarding changes to, or more free interpretations of works by Richard Strauss. Such decisions were discussed in the family circle. We often deemed it necessary, for example, to decline requests for permission to dance to his music in public venues. Incidentally, the only notable exception here was Rudi van Dantzig who, back in the 1970s, was able to convince my grandfather, Franz Strauss, to approve of a *Vertanzung*—as our family liked to call it —of the *Four Last Songs*. It is, by the way, a wonderful production that has been performed regularly to this day. Again and again, we debated whether it was not presumptuous on our part to intervene in the fundamentally important "freedom of the arts." We were restricting people from performing their art even though they undoubtedly knew more about music or its staging than we did. And today, I'm happy to admit that I've become increasingly uneasy, as this legacy is so immeasurably great that it could no longer be ours alone. We also sensed that with every passing year, it was becoming less and less ours. With every one of the countless performances and broadcasts, the entire oeuvre took on more of a life of its own; in sum, each one of the billions of played notes made it freer.

Our doubts grew from year to year as to whether it was right for us to partially close our "great legacy" to many a mind greater than ours. Accordingly, we became more and more lenient and, in many cases, didn't even have productions presented to us for approval. When we then often sat through a performance that no longer had anything to do with the actual intention of the work and where the presentation on stage no longer had any connection to the libretto, and thus with the music composed to it, we simply closed our eyes and just listened to the music, our actual inheritance.

Thus, finally being released from our mission comes as an understandable relief. The copyright expired at the stroke of midnight on December 31, 2019, so we no longer have any legal say in these matters, and hence the "great legacy" of Richard Strauss will not be controlled by his genetic offspring. It finally belongs in its entirety, lock, stock, and barrel, to the whole world. We have been relieved as keepers of the Grail.

And that's a good thing.

Madeleine Rohla-Strauss is the great-granddaughter of the composer Richard Strauss and managing director of the Verlag Dr. Richard Strauss.

OPERA IN LOS ANGELES: FROM THE GLORIOUS YEARS OF THE 1950S TOWARD AN UNCERTAIN FUTURE

Barbara Zeisl Schoenberg

I was born in New York in 1940 to Austrian parents, composer Erich Zeisl and his wife Gertrud Jellinek, a lawyer. Both in their early thirties at the moment of the so-called Anschluss in 1938, they were forced to abandon budding careers (my mother was referred to as "Doktor Zweier Rechte," meaning she was qualified in both civil and canonic law) and flee Vienna. They escaped first to Paris and then to New York. Only two months after their arrival, my father's *Little Symphony* was performed and broadcast from Radio City Music Hall with repeated broadcasts; commissions followed. This enabled them to move from their one room flat on 91st St. out to a spacious house in Mamaroneck, Long Island, when I was born. Two years later, thanks to the influence of Austrian composer, Hanns Eisler, my father was hired at MGM studios and we moved to Hollywood. Alas, I left New York too young to have attended the Met!

I do not remember much about concerts or opera in Los Angeles before the end of the Second World War in 1945, but from about 1946, my memories about my musical background become clearer. My dad would compose in the mornings and then take me on walks in the afternoons, or play music for himself on the piano, or listen to KFWB, "The Music Station"—it was the Golden Age of Radio. At night, he would go to his teaching job at the Evening Division of Los Angeles City College.

Once, before settling in to listen to a "Live from the Met" Saturday afternoon broadcast of Verdi's *Otello*, my father explained the whole story to me. Then, just as the opera was about to begin, I waved goodbye, and went out the front door to play with the kids on the street. My father said in disbelief, "But the opera is going to start now," whereupon I responded, "That's okay, just call me inside right before Desdemona is choked to death and goes 'arrgh!!!!'"—I can only remember this anecdote because my parents told it laughingly to their friends so many times.

Undaunted, my parents did not give up on my opera education, and when I was a little older, the three of us would drive down to the storied, Moorish-style Shrine Auditorium, where the San Francisco Opera company performed long before Los Angeles had its own opera house at the Dorothy Chandler Pavilion. The SFO's director, Austrian conductor Kurt Herbert Adler, a close friend of my father since their early days in Vienna, would invite us to the performances at the Shrine. Before going to the theater, my father, who could play the piano with the force of a full orchestra, would play through the whole score of the opera to

a small group of us gathered around him. On many occasions, Adler would bring famous singers to wine and dine at our home; among them I recall the Austrian bass Otto Edelmann and the incomparable Leonie Rysanek.

At just twelve years of age, I remember being "dragged" to attend all the rehearsals of my father's singspiel, *Leonce und Lena*, which was to receive its world premiere at Los Angeles City College in 1952—its original premiere planned at Vienna's Schlosstheater Schönbrunn in 1938, having been thwarted by the annexation of Austria. The European premiere was finally given in Linz, Austria in April 2017.

In February 1959, my father died suddenly and unexpectedly at the age of fifty-three. He had just finished teaching a composition class at Los Angeles College when he was fatally struck by a heart attack. His death sent waves of grief throughout Los Angeles' European intellectual diaspora. I was eighteen years old at the time and a freshman at UCLA. Czech conductor Jan Popper, founder of UCLA's Opera Workshop who had been a good friend of my father looked out for me, providing me with tickets to attend all the University's performances and recitals. I also continued to go to SFO performances at the Shrine.

A new chapter began when I met someone who was from Los Angeles but who had been constantly away at college and later at law school— his name was Ronald Schoenberg, son of the famous composer and teacher Arnold Schönberg. Although I had known Ronald's sister Gertrud and younger brother Larry very well for years, I'd never met this "older brother." As it turned out "Ronny" also enjoyed opera and was I overjoyed to have found at last a

William Kentridge,
Lulu (After Klimt), 2012
Indian ink and red pencil
on found paper, 66 × 48 cm
Design for *Lulu*, Alban Berg,
Amsterdam Opera, 2015.
Director: William Kentridge
Courtesy of the artist

young person who like me was musical and appreciated high art, with whom I could attend performances. We were married in 1965, and immediately subscribed to the LA Opera, which had just taken up quarters at the newly constructed Dorothy Chandler Pavilion. I have been a subscriber there ever since.

In 1967, we moved into the Schönberg's family home. We have been fortunate over the years to meet many kindred spirits who visit us regularly there—indeed the house of the great composer has fittingly become a sort of mecca for modern music lovers of our generation.

At the LA Opera, we are very much at home with our group of friends and operagoers, all long-term subscribers who attend every performance, but sadly, we are a dwindling crowd. Disappointed of late with the programming—among the approximately six operas performed yearly some are "light opera," indeed very, very "light opera," in fact "musicals"—we've seriously raised the question as to whether or not we will attend in the future.

When I am in Vienna, I go to as many performances as possible during my stay. Admittedly, I can't help being envious of a city that boasts three opera venues: the Wiener Staatsoper, the Theater an der Wien and the Kammeroper, all of which have multiple performances of the standard operatic repertoire as well as new operas. By contrast, we here in Los Angeles are struggling to find audiences for the very few operas presented annually. Europeans are fortunate indeed, with their plethora of opera houses but also with regards to their young, vital audiences who sustain this highest of arts. Hopefully, if their enthusiasm is contagious enough they will transmit their passion for opera to the new generations dwelling here in Los Angeles.

October 2019

A distinguished Germanist, Barbara Zeisl Schoenberg wrote her doctoral thesis on Peter Altenberg and the Viennese Fin-de-Siècle. Daughter of composer Erich Zeisl and daughter-in-law of Arnold Schönberg. She lives in Los Angeles.

KARAJAN BEHIND THE CAMERA

Herbert G. Kloiber

When I left my hometown of Vienna for Munich about fifty years ago, in April of 1970, the "catastrophe" was already in full swing. But let's begin at the beginning...

My very first job, at the age of just twenty-two, was to bring Herbert von Karajan, who was very close friends with my parents, back to peaceful speaking terms with the legendary "film dealer" Leo Kirch.

In the mid-1960s, Karajan and Kirch founded the joint company, Cosmotel, to produce concert and opera films. Kirch was to provide funding and distribution, Karajan to conduct. Early on, the productions were shot with lots of elaborate camera and lighting, always in 35 mm format and black and white.

In the summer of 1965, Karajan met the legendary film director Henri-Georges Clouzot (*Le Salaire de la peur*) in St. Tropez. The two gentlemen often went for walks together on the beach and soon agreed on a concrete plan to film Verdi's *Requiem* at La Scala in Milan. Initially, the performance was envisaged to mark the tenth anniversary of the 1957 passing of Arturo Toscanini. His daughters, Wanda and Wally, had organized what amounted to a sort of High Mass for their father throughout Milan. At the same time, Karajan and Clouzot were busy converting half of Milan's La Scala, installing no less than ten giant cameras in the boxes, on stage, and even in the chandelier.

Instead of dignified reverence, supreme chaos reigned. During the rehearsals, Karajan increasingly enjoyed standing behind the camera while Clouzot occupied the conductor's podium. When the ladies noticed that a film production and not a memorial concert was about to occur, a battle ensued. In the end, the official performance had to be rescheduled to a later date, and the filmed version was made without an audience; this allowed the two maestros to start and stop as often as they pleased.

The catastrophe I referred to earlier was the use of playback (a technique whereby the sound is subsequently synchronized with the singer's lip-movements) in the filming of concerts and opera, a practice that became Karajan's credo and measure of all things in the following years. In retrospect, it proved to be a huge mistake. The filmed concerts sometimes contained absurd but also captivating images—for instance, the 1967 *Pastorale* directed by experimental filmmaker Hugo Niebeling. However, the opera films were always plagued by the artistic and technical shortcomings of the playback. But for Karajan, achieving perfect sound recordings in the studio was and remained paramount.

Probably the most exemplary failure was *Otello* featuring Mirella Freni, Peter Glossop, and Jon Vickers. The shooting took place during the 1974 Salzburg Festival at the Bavaria Film Studios in Munich. Directed by Karajan, the production required more than thirty days of shooting, and costs skyrocketed to an unbelievable seven million Deutschmarks. Every day, we would take a specially converted helicopter from Anif to Geiselgasteig in the morning and return in the evening.

In this film, you can clearly remark how the singers' voices unfurl in the room in a highly differentiated manner, causing sound and image to be out of sync in several close-up shots. Nevertheless, the maestro was pleased with his work, and, despite the financial and artistic debacle, he immediately planned the next film production, *Butterfly*. Kirch was furious about the heavy losses, and shortly after my departure in the summer of 1976, the Kirch-Karajan cooperation ended forever.

Fortunately, as the managing director of Unitel, which had been newly founded by Kirch in 1970, I still had the chance to work frequently with a wide variety of directors, conductors, and soloists. Thus, I had the privilege of following opera's development in film and on television closely and perhaps even helped shape its future. In particular, the technological development of virtually noiseless and high-speed TV cameras, which were a tremendous advancement in recording technology, and facilitated far more efficient image processing. Between 1965 and 1975, Karajan devoted hundreds of hours to editing his films. Let it be said that in the years that followed, no other conductor confronted so scrupulously the visualization of his or her own performances.

In the course of my Unitel years, a dozen opera films were made, above all the Mozart-Da Ponte cycle with Karl Böhm and the magnificent Monteverdi productions from Zurich (conducted by Nikolaus Harnoncourt and directed by Jean-Pierre Ponnelle). With the founding of the Clasart company in 1977, I started my own business. Early projects included three excellent opera films with genuinely outstanding film directors who were trying their hand at this highly particular genre for the first time.

Ingmar Bergman produced a Swedish-language film of *Die Zauberflöte* at the Drottningholm Palace Theater, a short while later, Joseph Losey directed a grandiose version of *Don Giovanni* in Venice and at the Palladian Villas. This opera film was the brainchild of composer Rolf Liebermann, who served as the director of the Hamburg State Opera at the time. *Die Zauberflöte* and *Don Giovanni* were shown at movie theaters around the world. The third and perhaps last example of an elaborate attempt at filming opera using the playback method was the legendary 1976 *Tosca* with Plácido Domingo and Rajna Kabaiwanska. Directed by Gianfranco De Bosio, the film was shot over a period of weeks in the actual historical locations—high up in the Castel Sant'Angelo, at Palazzo Farnese, and inside the monumental church of Sant'Andrea della Valle.

And now, let's skip ahead to the twenty-first century. The 1980s and 1990s were marked by an incessant dirge, like a funeral choir, lamenting the lack of opera and concert performances broadcast on television. Apart from a handful of highlights from Milan or Salzburg, the great opera evenings had been scrapped, especially on German television, in favor of dreadful gala award ceremonies, such as Echo Klassik.

It is encouraging to see that the latest developments are pointing in precisely the opposite direction. There has never been a more significant number of live TV broadcasts, streamings, and live broadcasts of performances in movie theaters than in the last fifteen years. Almost anywhere on this planet, you can now experience regularly the smallest and greatest artistic enjoyments from Berlin, Milan, Moscow, or Vienna at affordable prices and usually with technical perfection. My personal highlights are, of course, the cinema screenings from the New York Metropolitan Opera, which have been perfected over the last thirteen years. On Saturday evenings, without fail, always transmitted live via satellite signals that are now received without the slightest hitch, the world's greatest singers can be seen in the opulent, albeit conservative productions typical of this unique opera house.

Peter Gelb—whom I met in my beginning year in 1978 and couldn't stand at all—suddenly became Vladimir Horowitz's personal agent, thus bringing the excellent relationship which I had built up with the maestro over a period of ten years to an abrupt end. He did so by luring Horowitz, who had already become quite fragile, to embark on ever-new adventures. Subsequently, Peter was hugely successful with Sony Classics, before finally taking over the Metropolitan Opera directorship in 2006. It was he who dared to launch the very first live cinema transmissions, turning them into a terrific and enduring success. I'm somewhat proud of having supported him from the very beginning in the most important market for this venture. Between Vienna, Garmisch, and Lübeck, a cinema audience of more than two million has thus been to the Metropolitan Opera and has remained loyal to this series for many years. The consummate sound and cinematography, as well as elaborately-produced backstage and intermission reports, make the Met movie experience a groundbreaking success story for the operatic genre through the great classic medium of cinema.

This distribution media approach is the exact antidote to the "streaming virus" that has infected many an orchestra and opera house: "the digital concert hall." Opera as an art form remains predominantly a community experience; even beyond the purpose-built houses, fans are keen to articulate and exchange their experiences. Both artistically and commercially, experience so far speaks against streaming opera and concert performances. Because content is often watched only on mobile phones or PC screens, sound quality is low, and the users' length of stay rarely extends beyond the overture. That's no formula for pleasure and enjoyment. And to date, this has hardly translated into a sustainable, economically viable business model.

Herbert G. Kloiber is the former chairman and owner of Tele München Group (TMG). He was born in Vienna and started his career in the media industry after receiving a PhD in law. In the past decades, he transformed the production company Tele München into one of the largest media companies in Europe. Dr. Kloiber is chairman of the European advisory board of the Cleveland Orchestra and a member of the senate of the Gesellschaft der Musikfreunde (Musikverein), Vienna. He supports the Cleveland Orchestra, the Human Rights Watch, and the SOS Children's Villages.

FROM CRICKET TO BERLIOZ: A DAY IN THE LIFE OF AN ENGLISH SCHOOLBOY

Nicholas Snowman

June 6, 1957 began for me as a relatively normal day for a thirteen-year-old schoolboy in London. Classes in the morning and then doing the one thing I accomplished with a little success in those far-off days, opening the batting for my school cricket team. However, thanks to the generosity of my schoolmate Martin Kubelik, son of Rafael Kubelik, then Music Director of the Royal Opera House, my mother whisked me away after the cricket match to a performance at the Royal Opera House. A performance that changed my life.

There we were seated in box 35, the Music Director's well-placed seating area with its bird's eye view of orchestra and stage. Then commenced the first relatively complete and professional performance in Britain of Hector Berlioz's long-neglected masterpiece *Les Troyens*, or rather *The Trojans* since the work was given on that occasion in Edward Dent's excellent English version. It is no exaggeration to point out that this single night changed the musical lives of musicians, critics, and audiences world-wide. Looking back, it was perhaps that single experience that became the milestone I tried to live up to while director of a number of cultural institutions in England and France over a period of fifty years.

The venerable biographer and critic Ernest Newman described the occasion thus,

"Hardly anyone in the large audience that night could have known anything at all of the work except the 'Royal Hunt and Storm' […] yet it was manifest to every experienced and sensitive frequenter of musical milieux at the end of the first act that the audience had been moved to its depths; and as the long evening wore on, and the 'romantic' atmosphere succeeded the 'classic,' not a shadow of doubt could remain that here was one of the greatest achievements of nineteenth-century opera."

Being very much one of those only familiar with the "Royal Hunt and Storm," the performance was all the more a revelation, whose emotional charge remains vivid to this day. I can still feel the sheer fright and shock inflicted by the terrifying fortissimo clash when the Ghost of Hector appeared seemingly just beneath box 35, to be answered by the thrilling tones of Jon Vickers's Aeneas directly on the opposite side of the stage, seeming to address me directly, "Ô lumière de Troie" or rather on this occasion "Oh thou, light of our land." The dignified, sculptural movements of the fine actress Diana Wynyard sensitively directed by Sir John Gielgud in the extraordinary mime scene, depicting Andromache and her son with its totally original clarinet

accompaniment is still in my memory as is the somber, interiorized suffering of Blanche Thebom's beautiful Dido in the opera's closing scenes. It was these very performances that set *Les Troyens* on the road to becoming now standard repertoire. However, it must be said that substantial cuts, which are still made on occasion, harm the work's structure, namely the epic story of two civilizations. This kind of butchery would be unthinkable where Verdi and Wagner are concerned—recent productions of *Les Troyens* in Leipzig and in particular in Paris come to mind.

As a guest of the Kubelik family, after the performance I met backstage some of the artists, and remember the particularly happy countenance of Jon Vickers, then at the very start of his career. Indeed, Martin Kubelik had told me some weeks earlier as we walked on Hampstead Heath near the Kubeliks's house that his father and Sir David Webster, the General Administrator of the Royal Opera House, had discovered a young Canadian tenor who would soon take on the testing role of Aeneas. Today, the Testament recording of the Royal Opera House 1957 *Trojans* gives us an idea of how Vickers, with all his youthful vibrancy and qualities, amazed audiences at the time.

Knowing that the Kubeliks had invited me to *The Trojans*, my father, who demanded complete silence when for example, Flagstadt's Isolde was being broadcast live, had us listen to the 78 rpm recording of the "Royal Hunt" by the Hallé Orchestra conducted by Sir Hamilton Harty. Like many British music lovers, he had a taste for Berlioz thanks to the continuous line of conductors in Britain stretching from Berlioz's friend Charles Hallé to Harty and Sir Thomas Beecham, who championed his works.

In the booklet accompanying his 1969 Philips LP recording of *Les Troyens*, Sir Colin Davis pays an elegant tribute to Rafael Kubelik, recalling this unforgettable night, which changed the music world's appreciation of Berlioz. Another marked by that performance was David Cairns, who went on to become the great Berlioz expert and biographer we all know; he was also the consultant on Colin Davis's Philips recordings of the complete Berlioz oeuvre. Indeed, before the Royal Opera House *Trojans* opened the path, the idea of recording Berlioz's complete works was simply unthinkable. In those early times, at the Berlioz Society, we, the new enthusiasts, would meet almost like a secret society to listen to probably illegal or at least privately made recordings of Berlioz's works not then generally available such as the complete *Roméo et Juliette*—the recording of the first American performance by Toscanini was not then issued—and Beecham's BBC *Les Troyens*.

I was more than fortunate to have been in box 35 on June 6, 1957, and knowing Rafael Kubelik was not only a privilege but an unforgettable experience. One meets many distinguished and remarkable musicians in the kinds of jobs I have had the luck to have, but Kubelik's simple humanity, lack of "star" pretentiousness, and total dedication to the composers he served so wonderfully remain for me an example. I have no doubt that the future of opera, the discovery of little-known works, as well as the championing of new works will depend on individuals with this kind of vision and commitment.

Co-founder of two celebrated contemporary music ensembles—the London Sinfonietta and the Ensemble intercontemporain in Paris. Nicholas Snowman was also artistic director of IRCAM, chief executive of the Southbank Centre in London, and general director of two opera companies—Glyndebourne and the Opéra national du Rhin in Strasbourg.

SCANDAL AS A
FUEL FOR CHANGE

Eva Wagner-Pasquier

Filmmaker and philosopher Alexander Kluge once coined a now-popular phrase, in which he called the opera a "powerhouse of emotion." When it comes to fueling this "powerhouse," against accusations of the opera house becoming a museum, intendants often welcome well-staged scandals. As far as the Bayreuth Festival is concerned, I was naturally able to experience this mechanism at close quarters. Scandals—and not only social scientists agree on this—are a means of self-purification. My uncle Wieland Wagner and my father, Wolfgang Wagner, deemed this kind of cleansing more than appropriate when they reopened the Festival in 1951, only a few years after the Second World War. Because where scandals arise, something rotten has been going on in the lead-up to them—on this they both agreed. Where there are none, one could conclude, the rot is still festering. As a contemporary witness to the formation of the "New Bayreuth," as the postwar revival of the festival was called, I was able to conclude from my own experience that opera scandals do not end with the protest rally inside the theater building. Rather, they provide the impulse for a second act of confrontation that shifts from the auditorium to the public sphere.

In Bayreuth, a paradigm shift that was "scandalous" in the positive sense of the word only occurred a decade after its reopening. This time, the impulse was an external one. Wieland's early death prompted Wolfgang, who now reigned supreme over the festival, to open it again to directors from outside the family, putting the new production of *Tannhäuser* in the hands of the GDR director Götz Friedrich. It was left to me to deliver the technical plans needed for his production. Our meeting for the handover of the smuggled documents took place in Marienbad and was kept secret as much as possible. News of Götz Friedrich's production caused a political uproar and the ruckus that ensued on the evening of the premiere on July 25, 1972, came as no surprise.

Just as during Wieland's second Meistersinger in 1963, the Festspielhaus audience had to cope with sweltering summer temperatures as emotions reached a fever pitch. "At 35 degrees Celsius in the shade," a review of the premiere in *Die Welt* read, "the evening of a scorching hot day ended in a storm of protest. It reached a degree of ferocity that not even the one-time provocations of Wieland Wagner's *Meistersinger* had managed to set off." Prominent politicians who attended the 1972 *Tannhäuser* performance were particularly outraged. Franz Josef Strauss, chairman of the Christian Social Union in Bavaria (CSU), ostentatiously left his seat, while his party friends from the Bavarian State Government led the subsequent protests themselves. My

father took Götz Friedrich with him to the official after-show reception and I brought along stage designer Jürgen Rose as well as John Neumeier, who had choreographed the bacchanal. Already on the way there, we were greeted by a torrent of outrage and boos. The atmosphere that greeted us at the castle halls was all the icier. It was a huge scandal—and indeed the stuff needed to fuel the further renewal of Bayreuth along these lines.

Aside from its complex political elements, this *Tannhäuser* scandal also had an aesthetic dimension, the effect of which was probably even greater in the long run. What Friedrich had staged here actually followed, in many respects, the ideals of the "realistic Music-theater" his teacher Walter Felsenstein had called for. Placing the actions of the individual center stage, he had broken the spell of the "sublime" the opera had been under and freed it of its museum character. Götz Friedrich's Bayreuth *Tannhäuser* was neither the first nor the last attempt to translate Wagner's music dramas into "realistic Music-theater" and thus create a viable future for this art form.

I witnessed another Bayreuth scandal first-hand in 1976. My father had decided to entrust thirty-one-year-old Frenchman Patrice Chéreau with the direction of *Der Ring des Nibelungen*—exactly one hundred years after the premiere. In this case, too, I became the conveyor of the message. Chéreau's approach was also "realistic," because in place of gods, giants, and dwarves, the Bayreuth Festival Theater stage was populated exclusively by people of flesh and blood. Alberich appeared as a modern factory owner greedy for profit, Wotan wore a frock-coat, and Valhalla was the villa of a capitalist turning the wheels of machine production not only in a figurative sense. This *Centenary Ring* also had long-term consequences. For years to come, business suits, executive portfolios, and attaché cases became the "contemporary" stage outfit of Wotan, Alberich, and their likes. Instead of wild and romantic rocky peaks, Chéreau had them act on hydroelectric dams and oil rigs, thus tracing the technological progress of our era over the course of the four evenings. The armies of workers that ultimately appeared in *Götterdämmerung* already pointed to the twentieth century, to the great social, political, and indeed even the environmental concerns of our age.

The fact that this concept would not appeal to everyone in conservative Bayreuth was already apparent after the dress rehearsals. Patrice Chéreau was convinced of his approach and remained unperturbed. During and after *Götterdämmerung*, the audience's vehement show of disapproval finally escalated, exceeding by far everything we had become accustomed to in the previous twenty-five years. Parts of the crowd not only "went wild" when the curtain fell, but had already tried to force the show to end prematurely by drowning out the music with a deafening racket. That was a new experience, at least in Bayreuth, and it heralded a long summer of opera scandal. Protests against the new production included repeated scuffles, went on all through the festival, and extended far beyond the festival premises on the hill. The way I remember it, this scandal dragged on even longer than the one caused by Friedrich's *Tannhäuser*. For days after the event, whenever Chéreau, his set designer Richard Peduzzi, and their staff entered one of the Bayreuth restaurants, they were greeted with catcalls—but eventually more and more "bravos" mixed in with the whistles and boos. My father had to deal not only with verbal mudslinging, but even received death threats in his mail.

The music was also a major point of contention with the *Centenary Ring*. In 1976, Pierre Boulez conducted the *Ring* and his musical interpretation made him the target of equally strong protests. As a conductor, Boulez approached Wagner's score not from the tradition of the nineteenth century, but from that of modernism. Viennese critic Karl Löbl was rather disconcerted by the fact that, as he put it, "Pierre Boulez conducts *Rheingold* as if it were Debussy." Over the years, the ritual of exploding applause and protest that initially accompanied all performances increasingly turned into approval. When Chéreau's and Boulez's *Götterdämmerung* was performed for the last time on August 25, 1980, the performance was an unmitigated triumph that went down in the annals of Bayreuth history. The conductor, the directing team, and the singers were celebrated for a whopping hour and a half, receiving no less than 101 curtain calls—and setting festival records that are still unbroken today. Years later, I witnessed similar audience behavior during the run of Hans Neuenfels's so-called "Rats Lohengrin," which morphed from a play shrouded in scandal into a cult classic.

This leaves you to wonder if Lars von Trier, who was slated to direct the 2006 Bayreuth *Ring* production, could have created a similarly cathartic scandal. This question still lingers in my mind today as, unfortunately, the Danish filmmaker abandoned the project at an early stage. I was not involved in the Bayreuth Festival at that time and therefore only know about Lars von Trier's ideas that he himself published on the Internet. As a result of his engagement with Wagner, he has made accessible his concept drafts for *Walküre* and *Siegfried* along with notes on his thoughts and ideas. The audience was to form their own idea about the plot of the *Ring* and, as far as possible, the staging was not to interfere with this process. What may appear at first as a critical stance towards director's theater is, in fact, indicative of a profound understanding of Wagner's work. In my mind, this is also evident in Lars von Trier's sensorially and emotionally inspired use of the Tristan prelude in his own cinematic doomsday vision *Melancholia*. Which brings me to the role of Richard Wagner has played in the area of film music.

Like the opera, cinema has also been declared dead over and over. Both are still alive and kicking. Even opera in movie theaters. But are the worldwide cinema broadcasts of operas and/or opera films on television the saviors or gravediggers of at least one of these two genres? And can the interests of an opera audience really be reconciled with those of moviegoers? What comes to my mind in this context is, again, Richard Wagner—and I'm certainly not the only one to make this observation. After all, his name is referenced for the music in the credits of many major films. The sound of Richard Wagner has come out on top in the world of cinema. Probably because, above all, he always considered the visual quality of music when composing and writing his script-like librettos. And because the leitmotiv technique, which he indeed took to its limits, obviously had a profound influence on film music. Wagner understood the magnetic pull of recurring motifs that draw the audience into a story. I concur with Susan Sontag when she calls film a musical *Gesamtkunstwerk*, a formal readaptation of the Wagnerian ideal of opera. Whether today my great-grandfather would actually prefer to make films rather than write operas remains anyone's guess. Music can have a manipulative effect, that is certainly something he understood. Film music is always manipulative. And when Richard Wagner's compositions are used as film music, it is even more manipulative.

From *Apocalypse Now* to *Melancholia* to *Avatar*—Richard Wagner has shaped the sound of modern cinema to an extent hardly matched by any other composer. In combination with powerful film sequences, Wagner's music creates an almost magical effect.

This was clearly apparent, probably for the first time in the history of cinema, in a 1913 biopic that was accompanied by a Wagnerian soundtrack. But there was a glaring double twist of irony to this film, as the score was not composed by Richard himself, but rather quasi modeled on his music. The simple reason was that Cosima Wagner had disapproved of the project. Reportedly because high fees or royalties were demanded, which the film production company could not or did not accept. That being said, Cosima may even have intended to undermine the project, because at the time, film was still considered a "low" form of entertainment that had developed out of the Kirtag fair tradition. Most likely, she simply didn't want anything to do with the medium of film. Personally, I think that's quite unfortunate, because especially Richard Wagner would almost certainly have welcomed a film about himself.

Indeed, a Wagner biopic was produced to mark my great-grandfather's centennial birthday in 1913 directed by Carl Froelich; Giuseppe Becce played the title role and wrote the accompanying music.

From today's vantage point, it is a really curious film. By the standards of the time, the level of adulation is strikingly low, and what's more, there's quite a bit of irony in it, not only when it comes to the faux film music. One of the reasons for this is that Becce, who had Italian roots, was the spitting image of my great-grandfather. He was a prominent figure in the world of film music of his time; in this score, you can pick out the Wagner music it was patterned on, from Rienzi to Parsifal. You can also recognize *Der fliegende Holländer* and *Lohengrin* and, of course, themes from *Der Ring des Nibelungen*—but it's always only close, so that with distance and hindsight, this form of "composing around" the original appears as a very special form of irony. It is also ironic because, for this reason, my great-grandmother was unable to claim copyright infringement.

If I am to sum up the experience of my Bayreuth years and, as a Wagner descendant, answer the question of how the opera as an art form can be brought into the twenty-first century—be it through contemporary productions and/or cinema and television broadcasts—I should like to quote, once again, Alexander Kluge. For me, too, opera is a "powerhouse of emotion" and as such, it should not be subject to any fashionable trends. Movies can also be such a powerhouse of emotion, even though they have repeatedly been declared dead as well. It would be a scandal to lose either of them. And isn't a scandal welcome fuel for such sources of power? Which brings us back to the beginning of this story: the future of opera has long begun.

Great-granddaughter of Richard Wagner, Eva Wagner-Pasquier was assistant to her father Wolfgang in directing the Bayreuth Festival from 1967 to 1975 and was instrumental in producing the *Centenary Ring* in 1976. From 2008 to 2015, she co-directed Bayreuth with her half-sister Katharina Wagner. In addition, she is advisor to numerous festivals and opera houses and has discovered many famous singers.

Ethos

Power and Pathos

SCHOOL OF HEARING
AND SEEING

Franz Welser-Möst

Pierre Boulez posited his oft-quoted demand to "blow up the opera houses" at the end of the 1960s, and since then, the question of the meaning and significance of opera as an art form for the individual and society has been posed in ever-new variations. You get the impression that the opera has to take the rap for a host of things that have their roots in various misguided societal developments and lead to the discontents of today's culture. Wasn't it a medium of politics and mouthpiece of the powerful for centuries? Wasn't it a meeting place for the upper social classes, first the nobility, then the affluent bourgeoisie? Wasn't it, above all, an expression of nationalist thinking in the nineteenth century? Didn't it always have to rely on support from princes, patrons, sponsors, cultural policy makers, and finance ministers because it's an elaborate and expensive art form? The list of possible complaints about the opera doesn't end there. Due to the opulence of the medium and its sometimes striking subjects, which are populated with kings and fathers of families, villains and their victims, as well as lovers and the dying, it sometimes seems as if the opera itself covers everything that is apt to provoke criticism and the questions alluded to in the title—does the opera have a viable future? Is it an expression of humanist aspirations, and does it contribute to conveying knowledge?

However, it would be contemptible to prophesy the demise of an art form that has lived on for centuries, relegating it to the rank of a museum relic. Of course, history always has its highs and lows, and so does the story of the opera. But it would be a mistake to erase from our memory its roots along with the twists and turns of its development. Aren't many opera subjects also parables for our time? Haven't the heroes, villains, and powerful people of yesteryear as well as their victims only changed their names? Something amazing becomes apparent: while a number of opera productions have acquired a certain patina, as have the persistent prophecies of its doom, the opera is alive and kicking. In many countries, especially on the Asian continent, it is even on a new upswing. In many cities, opera houses are still a part of the prestigious central areas representing urban culture, and there seem to be good reasons for that.

The Fascination of the Multimedia Artwork
I for one do not subscribe to any type of cultural pessimism. Quite to the contrary, my experience has often been that as a fascinating multimedia art form, opera can also cast its spell on today's audiences. Even Boulez, the one-time opera critic, succumbed to its magic and conducted numerous operas, including Richard Wagner's *Gesamtkunstwerk Der Ring*

des Nibelungen in a highly acclaimed Centennial production in Bayreuth. But let's consider for a moment what the creators of one of the first operas ever, Claudio Monteverdi and his librettist Alessandro Striggio the Younger, had to say. *L'Orfeo*, their *favola in musica* from 1607, which is based on the legend of Orpheus, begins with a "prologo." In it, La Musica and Orfeo, the inspired human singer, enter the stage to praise the rare gift of music and the magic of the human voice. They celebrate the magic of sounds; the delight of the listening ear; the diverse world of sounds and chords; articulation that stimulates emotions; and the soothing, comforting as well as inspiring effect of music. All of this makes it possible for the new, multifaceted work of art to inscribe into the hearts and minds of listeners and viewers its depiction of sublime heroes in all their glory and tragedy.

The story of Orpheus can serve as a timeless model for the opera and point the way towards future reform efforts in the field of musical and dramatic art that owes its fascination to the merging and interplay of several art forms. That's also one of the reasons why society has been treating itself to such an expensive art form for over four hundred years. This stage allows for an immediate encounter with the complete human being showing its face, gestures, body, actions, space, and song. It doesn't allow for cuts, touching up, or similar bags of tricks. Here, art is beholden to the moment.

Opera as Creative Cooperation and Artistic Responsibility

Nevertheless, opera enthusiasts and artists working at the opera can feel uneasy about many things connected to the opera business. Already the sheer number of people involved indicates the complexity and, at times, cumbersome workings of the opera enterprise. The long list of key contributors to the planning, preparation, and realization of an opera evening includes ministers in charge of cultural policy; patrons and sponsors providing financial support; architects planning a new opera house; composers and librettists developing new concepts for operatic works. Then there are those working "in-house," the artistic and business directors, conductors, stage directors and their teams, orchestra musicians, singers, as well as scores of others, on or off stage. In addition, there are public media outfits committed to the promotion of the art form, along with cultural critics praising or condemning it, and, last but not least, the audience. Without the interaction and cooperation of all of these actors, no opera could ever raise its curtain. Seclusion and isolated action by individuals will never make the grade in this type of art form.

Nevertheless, in practice artists are often faced with the experience that things take a different course in the opera business. Not all opera houses afford appropriate conditions for a work of art. While everything is demanded from the performers, and often at the last minute, opera houses are, at times, sluggish entities that live off their famous names and seem firmly grounded in the past, both in terms of ideas and management. In the run-up to an artistic performance, a lot of time and energy has to be spent on bureaucratic red tape. In this respect, many of the institutions in question would be well advised to right their ship in order to be ready for the future. Any creative activity needs artistic breathing room as well as enough time to find its footing and move the individual pieces of the mosaic around to form the full picture. Each individual artist involved in the opera must be able to appreciate the music, space, image,

performance, and singing as a whole and integrate his or her own work into it. In the end, it is the artists who are held responsible for the success or failure of a performance.

Serving as a place of representation, self-expression, and social dialogue, the opera has always been an art form that has, at times, had to bow to the wishes of a potentate, some patron of the arts, or an audience. Even in today's consumer society, going to the opera is considered a gesture of good taste and sensibility by many in the educated classes and a must for tourists. Thus, there is a worldwide tendency to adapt the repertoire to the taste of a wider audience and cater to their preference for simple fare; because, obviously it is usually the famous operas that people are waiting for, and we all like to hear what we already know. As a result, a small number of operas are performed relatively often, the majority of them being works that are more than a hundred years old. This is a boon to preserving tradition and plays well with the conservatism of many an operagoer; but it is also a testimony to the quality of the works and allows for exciting comparisons of the interpretations produced by different performers. And finally, a not insignificant role is often played by opera administrators with a focus on increasing the seat occupancy in their houses. In order to counter the image of being antiquated, however, those in charge of shaping programs and repertoires will have to heed the call for greater openness to contemporary operatic creations, as well as to lesser-known works that engage with and challenge today's audiences. Shouldn't opera companies of the twenty-first century come to the realization that their task is not only to please and entertain, but also to make people pause and reflect?

By design, a democratic society is deeply committed to the freedom of artistic expression. But with this freedom comes responsibility that is also a prerequisite for the success of artistic achievements. I am therefore convinced that a complex musical and dramatic form of art requires creative management teams. What we are looking for are managers and artistic directors who possess the necessary sensibility and bring the right people into the team. They need to be ready to enter into an open dialogue and find a common vision in the process of developing a work of art.

When it comes to visual and dramaturgical aspects, the approaches directors take to interpretation are of vital importance. It's not uncommon for them to elicit fierce reactions. Occasionally, directing moves between the Scylla of cheap showmanship, allegedly owed to the audience, and the Charybdis of fundamentalism bred by assertions of historical practice. We must strive for a solution that is both true to the work and challenging. In my view, every director should thus, above all, consider and engage with the work, including its historical and philosophical context as well as the message expressed in the original. Aren't there, after all, emotions and motives that have always remained the same since the beginning of human existence and are still relevant to this day? I have some reservations about facile effects and the contemporizing of subject matter to reflect current events when the result is inconsistent with the character of a work. The strength of the opera lies in the emotional power that springs from the work. Often, less is more. Thus, reducing events on stage and condensing their symbolism is frequently more conducive to creating space for reflection and focusing on the essence of a scene than an overload of images, movement or props.

Artistic responsibility is also borne by musicians—the singer on stage, the conductor, and the instrumentalists in the orchestra pit.

It is part and parcel of the opera genre to put figures on stage and place them at the center of attention in a multimedia environment. Every extraordinary achievement is fascinating. Appearances on stage as well as outstanding voices create a thrilling appeal that Monteverdi was already cognizant of. Through their performances and voices, artists wield power over audiences, their appearances have a manipulative energy. Not least, this produced the star cult surrounding singers, a phenomenon that was characteristic of the opera from its very beginning. Think of the cult of the castrati, and the famous sopranos and tenors of the nineteenth and twentieth centuries. Add to that our contemporary mechanisms of mass media and digital communication strategies that are capable of catapulting "stars" onto a global stage. However flattering every success may be, it is up to the artists to refrain from the temptation of pure self-promotion and letting fan communities turn them into icons. Ultimately, it all comes down to choosing between the work of art and self-interest. In the arts, freedom consists in taking a step back and dedicating one's talents and abilities to the development of the work. The audience should be enthusiastic not only about the artist, but also and particularly about the work the artist interprets.

In the orchestra pit, in the semi-darkness that eludes the eyes of the audience, the question is quite a different one. When I was growing up the advice people gave me was not to conduct opera if I wanted to build a career as a conductor. My experience is that with opera, conductors are faced with highly complex experiences. It is about synthesizing an overall vision in which the sound in the orchestra pit and on stage should form a unified whole. It is about the fine and intuitive perception of different time-space components, so as to be able to quickly intervene in dramatic sequences and, if necessary, through improvisation. The individual sensitivities of performers, especially of singers who sing by heart and act at the same time, can often lead to surprising twists and turns. The essential skill here is to lead and, at the same time, know at which points you have to let go in order to let the breathing unfold that you take part in together with the singers. Interlinking with the singing and the human voice, engaging in the continuous interplay between stage action and orchestra, and listening to each other, all this influences and shapes the sound culture of an orchestra that performs both at opera houses and on concert stages.

I also consider the work we do at the opera to be important for the personality development of young conductors. Here, they are not in the limelight, but are focused on the work. This involves qualities that are distinctly different from showmanship. Interestingly, my generation has seen a number of great careers that have been pursued outside of the opera world. But it seems quite a lot has changed since, and the young generation of conductors is once again returning with greater frequency to work in orchestra pits.

Opera as a Gateway to the Self
The opera has always been able to assert itself in a diverse media landscape. What sets it apart, for example, from film—which can react quickly to events and fashionable trends? Or from

electronic media, various sound storage technologies, and musical and visual content offered on the Internet, which broadcasts nights at the opera into your living room? The special thing about the opera is that it's a place where people walk directly onto the stage with their unique voice. That voice, with its many shades and nuances of sound, is perceived by those listening as the direct and unadulterated expression of a person. The original meaning of the Latin verb "per-sonare" (to echo, to ring out), from which the word "person" derives, also refers to this experience. It is the voice of the classical actor that emerges through the opening of the mask ("persona"). The immediate experience of the human voice is a mirror of the soul. In a conversation I had with Luba Orgonášová, she used the wonderful image that singing is having your "heart on the tip of your tongue."

The opera offers an opportunity to take a step back from everyday routine, to enter a house that provides space for celebration, pause, and collective participation. It's about entering a place of sensory experiences and encountering the "powerhouse of emotions" (Alexander Kluge) that Music-theater is capable of creating. Here, festivals are of particular significance. The festive atmosphere, that special place where visitors are welcomed as guests and invited to fully devote themselves to art, all this creates experiences outside of workaday life. The annual event generates ritualizations that function as trademarks of a place of art.

Opera as Musical Storytelling

The opera becomes an oasis where people can engage with themselves, not in a narcissistic and ego-centric sense, but through in-depth engagement with the self—a deeply humanistic concern. The cultural human being appears to have a deep-seated longing for self-improvement and becoming whole. The oasis is also an important prerequisite for hearing and listening. Günther Anders, the German-Austrian philosopher, has developed a "phenomenology of listening," which shows that the manner of listening varies depending on the situation in which the sound reaches the person. In the ideal case, the ear is directed towards the music in an act of deep listening and intuitively anticipates musical processes. This creative process requires silence; it does not completely set in when music is played as a background to other activities or when the noise level of everyday surroundings is too high.

Just as other forms of art, the opera draws its narrative elements from the large pool of European cultural history. They express timeless messages that were spoken, sung, and spread in their own time. It is often the "foreign" that is fascinating and challenging. We can recognize reflections of ourselves and the world around us in mythology, fairy tales, accounts from bygone eras, classical literary subjects, and poetry. The same goes for, say, *Don Giovanni*, *Fidelio*, and *La traviata* or the pictures of Rubens and Rembrandt. Here, something essential about humankind is addressed, a chapter opens that can never be closed. To continue working on this eternally unresolved chapter is also a key task of opera.

The narrative tradition of the opera as well as its musical and dramatic staging have their paragon achievements and culmination points. There are the "opera gods" who achieved something lasting and established standards, because they molded the essential questions of human life into an aesthetically appealing form. Wolfgang Amadeus Mozart was the first to

use musical-dramatic devices to portray his characters in a new, inward-looking, and individually differentiated fashion, and with his *Magic Flute* he created an opus magnum of opera literature. With his works, Mozart created a model for Beethoven and the musical aesthetics of the nineteenth century. Richard Wagner recognized the mysteries of the mythical and developed from them his view of man and his world. Drawing on Mozart and taking up the psychoanalytical approaches of the turn of the century, Richard Strauss rendered the psyche of his characters and their abysses visible in his musical dramas and thus contributed significantly to the development of opera in the twentieth century. His *Salome* and *Elektra* reached far beyond their time, and without them operas like Berg's *Wozzeck* and Britten's *Peter Grimes* would hardly have been conceivable, especially with regard to the radical depiction of their characters. The Italian opera tradition has also brought important impulses. Starting from the bel canto style of the Romantics and inspired by European dramas, Giuseppe Verdi poured man's private and public desires, trials, and tribulations into a new dramatic and theatrical form. In the unsparing portrayal of his predominantly female main characters, Giacomo Puccini forged a path from late Romantic melodrama to the operatic concepts of the twentieth-century. Along the way he drew on numerous inspirations, ranging from Wagner to verismo. With his *Wozzeck*, Alban Berg has written what I consider to be the most important opera of the modernist age. He allowed us to look deep into the torn soul of modern man.

Contemporary operatic art has, again, developed new models of Music-theater. Partly building on tradition, partly breaking with it, it presents us with a remarkable variety and diversity of approaches. Contemporary composers try their hand at alternative dramaturgical concepts, harness new media such as video technology and electronics, and incorporate experimental linguistic and musical forms in their works. Others, in turn, take inspiration from traditional themes, breathe new life into the genre of the literary opera, albeit often in clear reference to current political and social issues. As an example, I might mention *Medea* by Aribert Reimann. Taking inspiration from the ancient myth and the play by Franz Grillparzer, the opera explores the archaic power of emotions, the fate of a betrayed lover, and the tragic figure of an outcast stranger. Reimann's music anticipates the message of the spoken word and its undulating flow makes palpable the protagonists' deep insecurities. The conflagration scene towards the end of the plot reflects both on the experience of our murderous present-day wars and the composer's personal deep concern and sorrow in the face of the burning cities at the end of the Second World War. The opera premiered to resounding success at the Wiener Staatsoper in February 2010. This work shows that the opera of today does not need to be pleasant and pleasing in order to have public appeal.

Opera and Education

If the opera, especially through its key works, explores the question of what it means to be human and reflects on its relationship to itself, its fellow humans, and the world, then it may well be considered an essential avenue of education. Engaging with art fosters a process of development in humans towards a thinking and feeling personality. This is connected with unbridled curiosity and sustained efforts aimed at differentiation, subtlety, and humility vis-à-vis the works

we see, hear, and interpret. It also stirs our desire to search for new ideas and discover our own creative potential, in whatever field of art. Of course, the role of opera in today's society should not be overestimated and the art we are talking about is a minority program. This applies not only to opera, but to every form of cultural achievement in literature, the visual and performing arts, and so forth. In my view it is primarily the task of the artistic elites and all those in positions of responsibility to do their best and expand the circle of those who have discovered for themselves the appeal of and aspirations involved in this musical-dramatic art form.

Opening it to all those we want to reach and winning them over requires genuine learning on all sides, which must be fostered by vigorous educational efforts. It's all about reaching out to people and opening up new places for and paths to art. In Cleveland, we have successfully staged operas that were clearly not the blockbuster kind to begin with, such as Claude Debussy's *Pelléas et Mélisande*, Richard Strauss's *Ariadne auf Naxos*, and Alban Berg's *Lulu*. This goes to show that one can expect more from the audience and that the easy way is not always the best. If trust is built up over the years between cultural institutions and their audiences, the latter will be confident that the events on the program are high quality and engage with deeply meaningful content. Consequently, it will then be ready to embrace new and unknown works.

Its festive character is an important feature of the opera genre. In Cleveland, this is reflected in a festival lasting several days, which is organized around the performance of an opera and has a motto derived from that work. The program includes concerts that bring together thematically similar works from musical traditions, as well as contributions from other art forms such as film, ballet, and theater. They are accompanied by educational programs at schools and academic umbrella events. In the spring of 2018, for instance, performances of Wagner's *Tristan und Isolde* provided the context for the festival The Ecstasy of Tristan and Isolde, where the focus was on religious and spiritual experiences. This allowed us to deepen our understanding of the work and to confront the opera with the audience's contemporary realm of experience.

Even though the opera is not an educational institution in the strict sense, from a broader perspective it can be understood as a school of hearing and seeing, as a homage to great cultural achievements, and as an impulse to reflect on one's own self with its manifold emotional and intellectual capabilities. It can form a counterpart to superficial trends that prevent any artistic activity from leaving its mark on society, keeping us off the path towards realizing our human potential. Will the opera be able to survive in the twenty-first century? It is my deep conviction that it will not leave the cultural stage as long as there are people who engage with it and burn for it.

Transcribed by Annette Frank

One of the most sought-after conductors worldwide, Franz Welser-Möst was head of the London Philharmonic Orchestra, music director of the Zurich Opera House, and the Wiener Staatsoper. He has been music director of the Cleveland Orchestra since 2002 and one of the central conductors of the Salzburg Festival for many years.

OH THAT CORPSE IS SO COLORFUL!
OR AN END TO MASTERPIECES

Sergio Morabito

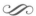

Musiktheater Hinweise: *Since we mentioned Emilia Marty at the outset and we've established that she's as old as the opera, let me ask you this: are you also looking for a recipe to increase the longevity of the opera and give it eternal life?*
Anja Silja: *I'd say that if the opera goes on living the way it's living right now, I would quickly burn that recipe. But if things went the way I would ideally imagine them to go, I would certainly keep it.*
M.H.: *And what would that ideal case look like?*
A.S.: *Real theater with people who still want to make theater happen.*[1]

Opera

"Opera scores are not artifacts that manifest themselves in something that is in itself representational. This is what sets them apart from a picture or a sculpture. That also distinguishes them from literary works of language art or pieces of so-called absolute music, where the gestalt of the work is largely suspended in its fixed written form. Of course, the latter can and must take shape, at the very least, before the reader's 'inner ear,' and in this respect, these are already borderline cases, which invite further reflection as they involve a change of medium from notation to sound. What said artifacts have in common is that they materialize in a form that, as a rule, the artist considers definitive.

Opera scores, on the other hand, are textures woven of musical notation and written words, which are aimed towards an event that certainly does not come about independent of them but takes place outside of them. They only exist as musical and theatrical events when they enter into a dialog with the artists and arts of the scene. In order to gain a body that is always exogenous and necessarily only temporary, they are dependent on their conception by thespian 'surrogate mothers.' In this context, it is worth remembering the etymology of the word 'opera'—from the Latin opus, work. The plural form used here implies a variety of works and trades, work and efforts, arts and actions. Thus, an opera score can by no means be declared a work without further ado. What people in the field of operatic theater all too often think they can claim as such is always already the result of a reading. It exists only at a draft stage, and magnificent as it may be, it is the malleable material of potential events."[2]

This distinction merits further elaboration. The following is an attempt at just that with reference to Freud's *Interpretation of Dreams*—without, however, going into the numerous implications this raises and, of course, also at the risk of exposing myself to misunderstandings. One of these would be, for instance, the assumption that works of art are here taken as a starting point for the exploration of the individual psyche of its author. What interests me in this context is Freud's understanding of the events in dreams as a dream script: "The content of the dream is given as it were in the form of hieroglyphs whose signs are to be translated one by one into the language of the dream-thoughts. We would obviously be misled if we were to read these signs according to their pictorial value and not according to their referentiality as signs. [...]".[3] Only the realization that dreams have to be understood as text made it possible for Freud to decipher its pictorial script. It is apt to reiterate here my description of opera scores as "textures woven of musical notation and written words." Freud's sign-theory approach offers a model that can help us understand the relationship between opera score and theater in a more nuanced manner and provide a more compelling definition than the ones we commonly find. This will be followed by a historical reflection that puts this matter in more concrete terms.

The Primary Does Not Precede the Secondary, but Emerges from It

In his book *The Legend of Freud*, comparatist Samuel Weber delves into the writings of the founder of psychoanalysis to trace his inquiry into the impossibility of objectivizing the phenomenon of dreams as a subject of academic study. The investigation of dreams, he finds, precludes any form of theoretical distance, because the dreamer who believes he or she has the dream before him or her as an object that can be remembered and imagined is involved in the same play of forces that produced the dream, particularly in harboring this belief. When Freud describes the dream as a text that must not only be perceived, but also read and deciphered, this has little to do with what we usually mean when we talk about text and reading. For reading the dream precludes the distance of the reader: he or she must forego a fixed standpoint, allow him or herself to be carried away by the dream, engage in its play of forces if he or she wants to "read" it. Reading, interpreting, and even retelling are therefore not merely or primarily theoretical, but *practical* processes.[4] If already our *reading* of the dream can by no means be understood as the rendering of an *object* that exists independently of its repetition, then the process by which the dream is *written* can likewise not be understood as a self-contained one that can be concluded. The writing of the dream emerges as a rewriting of given "latent dream-thoughts" and it unfolds not during sleep alone, but retrospectively, by being (re)told. Despite Freud's well-known formula, the dream "does not arise simply to fulfill a wish, but to articulate a conflict the subject gets caught up in through his or her wishes."[5]

Weber concludes that the dream:

> "is not an object the dreamer or the interpreter can face and perceive, because they are part of the unfolding of the dream itself. As Freud pointed out, the dreamer becomes involved in the action of the dream and its scenario by believing he or she was merely

retelling it. The simultaneity of the dream (only) comes apart through the succession of being told (including its distortion, but also interpretation)."[6]

Weber traces the paradoxical temporality of the dream in the context of the distinction of primary and secondary psychological processes that Freud identified in chapter seven of the *Interpretation of Dreams*.

He arrives at the conclusion that:

"the way in which Freud establishes the distinction between primary and secondary processes, in a certain way, forms the pattern of all distinctions into "primary" (or "primal") and "secondary." The primary thus presupposes the secondary, it no longer precedes the secondary, but emerges from it."[7]

Freud's conclusion: the original, initial dream narrative does not exist beyond its secondary treatment. Accordingly, a stage production can be understood as a secondary treatment that, before anything else, (co-)creates the primary material (the "work"). Of course, academic disciplines can reify an opera as an object that is subjected to musicological, sociological, the-atrical, literary or history-of-ideas studies. However, understanding an opera as opera, which is to say as living music theater, is impossible beyond or independent of its concrete performative manifestation. Like a dream, it exists and takes place only in the paradoxical uniqueness of its repetition. What seems to remain the same from performance to performance, what seems to represent the identity of an opera, is in reality its form of evanescence, an illusion. The belief that one can hold on to something, namely "music," already implies the negation and loss of the theater and thus the misconception of its art form. The invocation of canonized masterpieces degenerates into an implicit excuse of the industry for bad theater—one need not be so particular about the theater if the celebration of eternal musical values is considered sufficient legitimization. On top of that, people refer to the reified just-so nature of the scores, which is held responsible for the conventionality of their own notion of theater. Against this, Artaud's demand for "an end to masterpieces" raises an objection. It should not be dismissed as polemic; rightly understood, it formulates a decisive prerequisite of creative theater work.

If no experience and understanding of an opera as an opera is possible outside of the stage, this implies an insight into the relativity of judgments about the value or worthlessness of an opera score. The "verdict of history" has always proved to be fickle, contradictory, and fallible, and appeals have to be lodged again and again: Monteverdi or Händel were consid-ered unperformable antique curiosities until the beginning of the twentieth century and far beyond. In order to get an idea of the difficulties and resistance the operas of Mussorgsky, Debussy, Dukas, Schreker, or Janáček were up against, you just have to look at the pro-gramming guidelines decreed by one Richard Strauss in his role as director of the Wiener Staatsoper. On the other hand, you have to give credit to Strauss for rehabilitating *Così fan tutte*, a work that seemed to be devalidated for all time.

The notion that the dignity of a score composed for the theater should prove itself by making the theater potentially redundant and recommending itself to a concert performance or a canned music production is one of the unacknowledged and unreflected basic assumptions of today's opera business. Here too, historical reflection is urgently suggested. I am translating from a 1957 premiere review by Fedele D'Amico:

> "If the Scala had offered a performance of decent quality on the occasion of the unearthing of *Anna Bolena*, we would certainly have stuck to the opinion we held yesterday, which was based on reading the score or Donizetti's modern biographers: namely, it appears that this opera is hardly more than a collection of platitudes, and that its success with contemporaries (*Anna Bolena* marked Donizetti's breakthrough in 1830) can be attributed to their shallow taste. We have now realized that the success of that time was based on the spontaneous match between this opera and the great singers for whom it was composed, whose talents were, to a greater or lesser extent, essential to its creation and birth."

The female protagonist of the performance pays tribute to D'Amico with the words:

> "Her ability to render the musical lines of the coloraturas into a kind of lyrical sigh, embedding them in the fabric of a transcendental prosody articulated with an immense richness of accents, or transforming them accordingly into a drawn-out passionate interjection, reveals the vital nerve of this music: the very nerve that time had buried and that we did not find in the fixed musical score. It was the crucial thing that we thought we could sense in the presence of Pasta or Malibran. But only Callas has made us certain. [...] This performance allowed us to grasp with our hands a truth that is unknown to many and only known in the abstract to a few: that the old Italian opera, in its theatrical reality, possessed a vitality and a raison d'être that infinitely surpasses that which can be read in the written document, the score. The audience and the intellectuals of that period who believed in opera were by no means more simple-minded than we are; on the contrary, they had a reality before them that was not less vibrant because it is difficult for us to reconstruct today. And they knew better than us that theater is a highly complicated business, a mixture of the most disparate ingredients."[8]

"Singing what is not written in the scores" became the hallmark of the inspired genius of the interpreter in the nineteenth century, a notion that was revived by the phenomenon of Maria Callas in the twentieth century. It manifests itself in the infinite nuances, in the soulful animation of even the ostensibly most commonplace musical phrases. In this context, Philippe-Joseph Salazar writes most illuminatingly about "la notion d'immédiate coalescence entre l'écriture et la lecture qu'en donne la cantatrice," or, "the notion of the immediate coalescence of notation and its interpretation by the singer." Both D'Amico's and Salazar's

analyses point us to an understanding of the opera as a "theatrical reality" in which the power and presence of the scene, not its resting on eternal musical values, define the ranking of a performance. Purely as a singer, the singer has nowadays become a phenomenon not of the production, but of the reception, only collaboration with the stage direction restores her to her old rights. For today, the director has taken over the job of the composer who, for the longest time in the history of opera, was a theater artist before his scores were declared a work and he himself an author. The formula of "singing what is not written in the scores" must today be extended to "staging what is not written in the scores." Understood correctly, this postulate is anything but a license for arbitrariness. It is the commitment to that which is written between the notes, is not in the words but between the words, as opposed to clumsily doubling notes and words.

Wonder Rooms of Transformation

In great performances, no part of an opera remains unchanged. What does that mean? It has nothing to do with a "theater of recognition" that confines itself to a presentation of familiar things from the mnemonic world of its audience. Without artistic and analytical comprehension and animation, the citing of the present in stage and costume design remains pallid, musty, dead-as-a-doornail theater scenery, an effect that is exacerbated the more colorful its attempts at showing off. A production must not remain illustrative, no matter whether it does so in the form of historicization or actualization. We can certainly save the trouble of draping opera figures in contemporary garb if they remain vapid "opera figures" who come off as precious vocal extras.

It is the paradoxical detachment and, at the same time, the most intimate proximity to the very fiber of the poetry and composition that transforms an opera, not catchy simplification or editing undertaken in the spirit of the times. Just think of the repeated attempts at making *Così fan tutte* more accessible by providing it with a new text. They are typical of the endless streamlining and countless deletions or retouches made in the wording of the "masterpieces"—precisely in the name of their debatable canonization. It seems to me that endeavors of this kind in today's music theater show a regressive tendency, the result being something that is hard to place. It neither tells you much about the time of its creation nor about the present, and certainly nothing about the connections between that era and our present one, and vice versa. What is at stake in our encounter with an opera score is the experience of the presence of history—words and musical scores change and transform by themselves in the course of and through history. If we think we have to manipulate them ourselves, we deprive ourselves of this very experience.

Therefore, neither should we illustrate a text in literal faith nor dismiss it, neither prune nor write or paint over it; we need only shift slightly our approach, make it more precise down to every detail, think it further, make it transparent, understand it in the context of today's world. This slight shift is the utopian dimension of theater work. This requires intellectual insistence and, as part and parcel of it, the freest play of all the forces at work in the act of staging: in this "slight shift" there is a spark of madness that is indispensable in unleashing

these powers. In order to overcome the physical and mental lead weight of so many an opera performance, the theater must not content itself, out of misunderstood humility, with the arrangement of what is ostensibly the case. It must dare to take the leap into "the before," a stage at which it can analytically and playfully liquefy, dynamize, and dissolve the reified form of the work in the ether of inspired technical and intellectual precision. This will allow it to activate the seething glowing core of the material, its open contradictions and suppressed fault lines. Following the Freudian model, it must work its way to the latent dream-thoughts and thus to the conflicting drives and to the point of pain that spawns the manifest events of a dream or opera scenario.

The opera, as something both moving and moved, is seized by a staging process it has itself triggered, and not a single one of its parts remains unchanged. Even if the singers and musicians supposedly sing and play the same notes—they are no longer the same. Or rather, they step out of an abstraction and gain a physical substrate. The singing and the music, the colors of the orchestra, its lines and textures—they begin to glow and speak where they are allowed to tell something, when the stage conjures up something through them and, conversely, makes them audible as actors, giving them a concrete corporeality, freeing them to become an active material presence.

The contrapuntal musicality of the scene is the authentic approach to the score, the only one open to the theater. This is no abstract, utopian, philosophical or aesthetic vanishing point, but manifests itself in every successful scenic moment. The rhetorical figure of music cum theater is the oxymoron. He or she who does not face up to the paradox, does not face up to the form of the opera. Only when we strive for the impossible do we stand a chance of achieving the possible that is demanded of us.

[1] Anja Silja in a conversation held on the occasion of the new production of *The Makropulos Affair*, in *Musiktheater Hinweise – Informationen der Oper Frankfurt*, March-April 1982.

[2] "Jenseits von Autorschaft und Interpretation," in Sergio Morabito, *Opernarbeit*.

Texte aus 25 Jahren (Stuttgart: J.-B.-Metzlersche Verlagsbuchhandlung, 2019), p. 20 f.

[3] Sigmund Freud, *Die Traumdeutung* (Frankfurt am Main: Fischer-Verlag 1984), p. 234.

[4] Samuel Weber, *Freud-Legende* (Olten und Freiburg im Breisgau: Walter-Verlag, 1979), p. 48.

[5] *Ibid.*, p. 50 f.
[6] *Ibid.*, p. 52.
[7] *Ibid.*, p. 65.
[8] Originally published in *Il Contemporaneo*, April 27, 1957, reprinted in Fedele D'Amico, *Scritti teatrali 1932-1989* (Rizzoli: Milan 1993), p. 77.

Dramaturge and director at the Stuttgart State Opera, together with director Jossi Wieler, Sergio Morabito collaborated on numerous opera productions—including more than twenty-five new productions for Stuttgart—which received numerous awards and toured internationally. Since 2020, he has been chief dramaturge of the Wiener Staatsoper.

THERE IS ONLY THE WINNER
TO CONFUSE PEACE AND VICTORY

Stéphane Ghislain Roussel

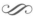

Opera is at a crossroads in its history. Born more than four hundred years ago in the Florentine Camerata, it is a form whose unique beauty combining music and poetry, sought to recreate the expressive power of the Greek Tragedy. Singing as it has been practiced ever since, is the living memory of a desire, an emotional ebb and flow carrying melancholy and hope. Like Orpheus, trapped between the urge to turn around to reassure himself that Eurydice is following him, or instead to advance without turning around, escape from limbo and then embrace her; the *favola in musica* is propelled forward by the questioning of its imminent future. The power of the song and its alliance with the text are only elements of the operatic genre and thus can't account alone for its holistic character. It is not a staged concert but sung theater, which fascinates an ever-growing number of visual artists who are utterly foreign to the field of theater. Beyond being a well-funded artistic discipline, if opera attracts so many visual artists, video artists, or architects, is it not the appeal of a medium capable of expressing something that none other can? Is it not the noble sentiments, the secular ritual of performance, the fine line between life and death, the destiny of each human being, or the stylistic exuberance whereby the sound and visual intensity reach a climax? Probably a little of each or all at once. However, this would be omitting one of the fundamental characteristics of the ancient Tragedy—its transformational power. As we know, among the ancient Greeks, witnessing the Tragedy was a social duty, the catharsis of which served as an instrument for building social awareness and political responsibility and judgment—hence theater's service to democracy.

Historically, the formal structure of opera has evolved continuously. However, the room for maneuver within that structure is at once vast and circumscribed. Most masterpieces are works that have tried to bend that structure and probe the depths of the genre. To name some examples: *Iphigénie en Tauride, Don Giovanni, Carmen, Parsifal, Pelléas et Mélisande, Wozzeck, Die Soldaten, Le Grand Macabre* or *Prometeo* are "experimentations" where the thirst for innovation has brought success (in many cases posthumous). György Ligeti declared: "You take a piece of foie gras, you drop it on a carpet, and you trample on it until it disappears, this is how I use the history of music and, especially that of the opera." It took the talent and courage of composers like this to bring about structural change. However, given opera's multi-layered character, even today, any composer or author who wants to instigate change will have to confront the genre's fundamental dogma. The composer will hear that their score is not quite an opera, that their text is not quite a libretto, and that at best, these elements fall into the category of Music-theater—not opera. As

if you could judge a jewel by how its case sparkles. A lot still has to be accomplished to revitalize opera, but if you consider that according to the index of environmental sustainability evolution is always closer to rebirth than to disappearance, there is hope. With this in mind, should we not take the risk of going beyond the form or, at least, based on the fundaments of opera, make new styles emerge?

Though we all know how hugely complex their jobs are, the specific responsibility of theater administrators is to be in tune with these issues. Nevertheless, I'm not only addressing the question of ratio between new works and old works on the programs, or the price of seats (subjects of endless debates on the boards of all opera houses) but also the power games, the ins and outs of the production system and its overly hierarchical chain. We should rethink the demarcation of artistic territory between the conductor and the director, as should this situation of "temporality" and calendars (totally subject to the dictates of the singers), which hinder almost any form of spontaneity. After all, are not spontaneity on one side and pondered reflection on the other, the two faces of this Janus creation? One could find other sources of inspiration through instigating genuine encounters within the field of performance and improvisation, integrating collective dynamics (a common practice in the domain of theater), or looking to the model of permaculture (perma-agriculture inspired by natural ecosystems) and its enhanced but natural fertilization emanating from the bottom up. Opera administrations urgently need to address gender parity in teams, the place of racialized people, ecological awareness. Albeit slowly, the increasing commitment of institutions and individuals to these issues is gradually taking hold. The spectator also has his or her role to play, and what could be more discordant than an audience of opera lovers?

Suppose we satirize by extracting the "Querelle des Bouffons" (1752–1754, a full-scale war of words between the defenders of the French operatic tradition and Italian opera buffa) from its initial context. In doing so, we see that many amateurs go to the opera not to "discover something" but rather to "rediscover something." It's legitimate, touching, even reassuring, is it not, to believe that the opera is a metaphor for stability, a safe place that reminds us of "the good old days"? It's a bit like the bedtime story, a ritual that involves reading the same fable or legend every night—and woe betide the imprudent reader who dares to replace one word or even leave out a comma. In order to ensure the long-awaited pleasure, nothing should change. It is the reverse of a Perpetuum mobile. But can the reality, which surrounds us at the moment, allow us to believe that everything will go on without change? As I write, Covid-19 has just begun to spread; far-reaching and devastating consequences lie ahead.

The much-regretted Gerard Mortier, revolutionary in spirit and action who transformed the stuffy Salzburg Festival, shaking out the mothballs and naphthalene from its plush boudoir, described his vocation thus, "I want to produce an art that makes people reflect upon what it means to be human." Yes, there is no question that opera continually questions what it means to be human; the power of the human voice as the prism of the senses has something at once ontological and transcendent. However, the question is twofold: who is he (Mortier) addressing, and to which humans is he referring? Right away, this reflection on the macrocosm—as I tried to show in the exhibition *Opera World*[1]—is distorted. Hence, let's go back to the origins of opera for a moment. A quintessential European art, it was born in established, wealthy, and learned

circles. It only concerns a particular category of society, and the structure of the neo-classical opera house (fortunately out of date in the eyes of most contemporary architects) is there to remind us that the best part of the cake will always go to the one holding the knife. This European culture, fertile ground of the most beautiful of artistic creations, has been an instrument of domination for centuries, each country spreading it abroad in explorative visits, which bordered on an invasion. The sincerely passionate Fitzcarraldo in the eponymous film by Werner Herzog (1982), making his way up to the mountain top, hauling his heavy burden of culture, perfectly illustrates this phenomenon. In all its western splendor, the opera house is the incarnation of the great voice of an all-mighty god ready to "woo" the ancestral indigenous populations. Ergo, let's set the record straight: these Campas didn't ask for anything! They had their own culture and did not need opera, nor Christ, for that matter. Beyond postcolonialism, opera as an emblem of civilization and higher knowledge is pathetically obsolete.

Art of its time? Opera proves itself as such through works where the message determines the method, the dramaturgy, and the originality of the means: *Intolleranza 1960* by Luigi Nono (1961), Christoph Schlingensief's Opera Village Africa (started in 2010), or the hybrid but very operatic *The Head and the Load* by William Kentridge (2018). In each of these contrasting propositions, the operatic genre, in its broader expression, becomes the vector of political messages and instruments of freedom. In terms of the classical repertoire, Clément Cogitore's recent production of *Les Indes galantes* by Jean-Philippe Rameau, in collaboration with the choreographer Bintou Dembélé at the Opéra Bastille in September 2019, is probably one of the most striking examples of what opera can give rise to when it is genuinely innovative. This production, which grew out of a video produced by Cogitore for the "3e Scène" program of the Paris Opera in 2017 featuring krump dance and many other urban dances such as voguing, popping or waacking, had explosive power when performed as a full opera on the stage of the Bastille. To see the center stage of a classic opera house with racialized dancers performing with the soloists and choir, every evening bringing the whole audience into the dance, awakening the mysterious power of catharsis, was groundbreaking.

Regarding the more than dubious ideological aspects of the libretto, which ends with the Europeans joining the natives in the ceremony of peace, Cogitore said, "There is only the winner to confuse peace and victory." His production makes us realize how opera is capable of summoning the "real story" with all its ramifications, how by merging the real and the dreamlike, opera mirrors the world for an instant, perhaps even transforming it. That would be the challenge to meet every time the curtain rises unless there is a preference for the soporific odor of mothballs at the risk of never waking up.

[1] *Opéra Monde, la quête d'un art total*, exhibition at Centre Pompidou Metz from June 21, 2019 to January 27, 2020. Curator, editor of the catalogue and in charge of related programs Stéphane Ghislain Roussel.

Of Belgian-Luxembourg nationality, and musicologist and violinist by training, Stéphane Ghislain Roussel has worked for several Parisian museums, curated exhibitions, and authored many books and articles. He now devotes himself to writing and directing for theater and opera. In addition, he is the artistic director of the Compagnie Ghislain Roussel, based in Luxembourg.

HEIMKEHR

Renaud Loranger

Know yourself, and in that instant
Know the Other and see therefore
Orient and Occident
Cannot be parted forevermore.
Johann Wolfgang von Goethe

I.

At the origin of everything, there is the fantasy of a visit to Epidaurus. A similar reverie could lead to the ruins of Dionysus's theater, at the foot of the Acropolis, or many other antique theater sites. And so goes the modern phantasm of an ancient world, paradoxically primitive and radiant, thanks to the creative flame stolen from the gods by the great transgressor, Prometheus. This world, being a few millennia younger than ours, has seen a little less horror. History is only relative there, and if not for its role in the dawning of mythology, it would lose its roots altogether. In this ancient world, there was no distinction between polytheism or monotheism as we know it. Instead, a quiescent "state of grace" for all those enlightened to spiritual things and the practice of virtue. The men and women of Mount Olympus are nothing more—and nothing less—than "magnified," men and women, at once idealized, admired, respected, and feared. In their cosmogony, these multi-faceted, human, and fallible gods represent the tragedy of existence, its acceptation, and its sublimation and appear to those nearby on earth as a natural continuation of life itself. The earthly being becomes aware at once of his sense of self and his alterity to others. The city-state: a new, youthful civilization is born, proud of its capacities, convinced of the inalterable arch of its progress. The life of the mind, the pace of thought quicken, the first fruit on the philosophical tree ripen, politics rise to the firmament of the cardinal dimensions of human experience, the feeling of shared values and common destinies dominates.

Relative prosperity sets in, and with it, the comforting assurance of a stable cosmic order, whose immanence appeases time itself; ethics and aesthetics are inseparable; a luminous conceptual bond if ever there were one. Thus the empty canvas on which primordial collisions occur: the telluric forces, which nourish humanity and self-awareness; the immensity of nature in constant confrontation with the gods—the inevitable certainty of death. From this original confrontation emerges the foundational utopia of modern civilization: the theater.

On life's stage, where the actor sings and dances, the character dies, but inexorably his palingenesis stands up, victorious over fatality.

Thus presented, this idealized polis seems remote from our modern sensibilities, if not forever unattainable. It is the artist's pre-ordained utopia, which is the wellspring of his work and creative process. His is not a conscious goal, but the consequence of the fulfillment of that process. The same goes for Monteverdi and his contemporaries (as well as those predecessors to whom posterity has proven less magnanimous). We are reminded of Klee's *Angelus Novus*, swallowed up, pushed forward by the storm of progress, but with his whimsical face turned towards the past. Consider those brilliant minds who gathered at the court of Count Bardi, stoking the brightest embers of a Florentine Renaissance entranced with ancient Greece's ideals and heritage. With the distinction that the sap of their intellectual forest flowed with a new compassion for humankind swept along by the uncontainable and disruptive movement of history. Two centuries later, the second golden age of bel canto is ushered in and laid to rest by Rossini, the very fabric of his oeuvre interwoven with nostalgia—a nostalgia so resolutely romantic that it becomes the constitutive driving force of his art, except when humor overwhelmingly gains the upper hand. Though dressed in different apparel and affecting different accents, this same nostalgia irradiates throughout Verdi. The same is true of Mozart in *Mitridate*, in the *Entführung* and above all in *La clemenza di Tito*, not to mention in the incomparable genius of the Da Ponte trilogy. Nearer to us, we have Pascal Dusapin, reinterpreting and expanding upon Shakespeare and Kleist with incredible insight and virtuosity, or Samy Moussa, questioning the ancestral spirits of poetry, whose cardinal thread runs through his work. In toto, opera as we know it today, lives on, aged and laden with centuries—even millennia, if we dig down to the roots of its nourishing source: the song of Aeschylus. Opera is the art of the palpable and the intrinsic: even Wagner, in his mystical meanderings, claims to be grounded in an earthly, primal theater and real-life ethics.

II.

For my part, the musical journey began when I was relatively young, undoubtedly thanks to the many recordings scattered around my grandmother's house. I must have been seven or eight years old when I heard "Va pensiero" and some extracts from *The Marriage of Figaro* for the first time. The "live" contact came soon afterward, not surprisingly in my hometown Lanaudière, with a performance of *Il trovatore* in the much rarer Paris version, in French. If the musical impressions of that evening are now only vague memories, at least part of the incredible vital energy released on stage and in the hall during those few hours remains with me. From this early experience, now refracted through the prism of two or three decades, I retain two things: firstly, the astute decision to present this ambitious and inventive work to an audience who had few preconceived ideas about opera, and this in their own language, and secondly, the choice of the great Lanaudière amphitheater; a building, which subtly references the best of ancient models, where spirit, body, and nature seemingly coexist in perfect harmony.

My adolescence coincided more or less with the first expansion of the web, the access to which resulted in a kind of brutal shrinking of the world, making it more concrete and

seemingly accessible. Nevertheless, the idea of actually going to live and work in Europe germinated slowly. Thanks to the benevolent instruction, which I received at an early age from Father Fernand Lindsay, an ecclesiastical figure closer to Vivaldi than to Luther, I was predisposed to the philosophy and initiatives of Gerard Mortier, which have become so crucial and defining for the opera world today. These largely shaped my view of Europe, seen as promised land: the homeland of culture, a land where culture is a powerful civilizing force, omnipresent, a veritable vector of social cohesion, supported by the state like nowhere else in the world, granting artists almost total freedom of creation and audiences unalterable accessibility. In sum, a promised land on which the river of opera, lyric theater, and its multiple tributaries flow naturally, uninterrupted, renewed continuously, questioned, and celebrated by an audience growing, enthusiastic, curious, and educated. After working with Kent Nagano in Montreal, I settled in Berlin at the beginning of 2010, with the ostensible goal of learning German, yet stealthily enticed by the city's strong avant-garde reputation. To my mind, it was there that theater could truly fulfill its democratic role under the best auspices—the tragedy of history having forced the Germans to gain foresight, maturity, and a sense of political balance unparalleled in the western world. Ten years later, the new cracks, which appear daily in the European edifice, show that reality is far more complex, more demanding, and sadder, too. Pessimism has no place, however. As Hubert Védrine put it so eloquently, "We live in a society, which is one of the most pleasant to live in—or the least harsh—which has ever existed." You have to open your eyes.

III.

Fernand Lindsay's fascination with the legendary stages and festivals of Munich, Vienna, Bayreuth, Salzburg, and his restless peregrinations in the 1960s, in turn, generated my Wanderlust, almost half a century later. These prior European experiences formed the basis of his worldview, which evolved into a dream of humanistic sharing, along with a passion for discovery, an irrepressible desire to animate, to broaden horizons, to create bridges between artists and their audience, to "transform life" through music and opera, as his own life had been transformed. His faith in God was as unshakable in humankind. In these troubled times, opera remains one of the most potent antidotes to generalized cynicism, a powerful force for bringing people together—it helps us live, be better people, and become wiser, more tolerant. It teaches us that peace is possible.

My years in Europe saw me mainly involved in the recording industry; the irony of fate is that at the end of 2018, I went full cycle, returning home to become the successor of Fernand Lindsay as artistic director of the Lanaudière Festival. What I rediscovered there during my first season was utopia itself, largely thanks to the town and to its warm, curious audience, who are always eager to discover new artists. Every night, it is their unique chemistry and presence, which makes the magic happen. One evening, with a biblical storm raging outside, we were more than one hundred huddled in the intimacy of a tiny ancestral church (on benches, which even in the seventeenth century, could not have been considered comfortable), all mesmerized by American tenor Michael Spyres, hanging onto his every

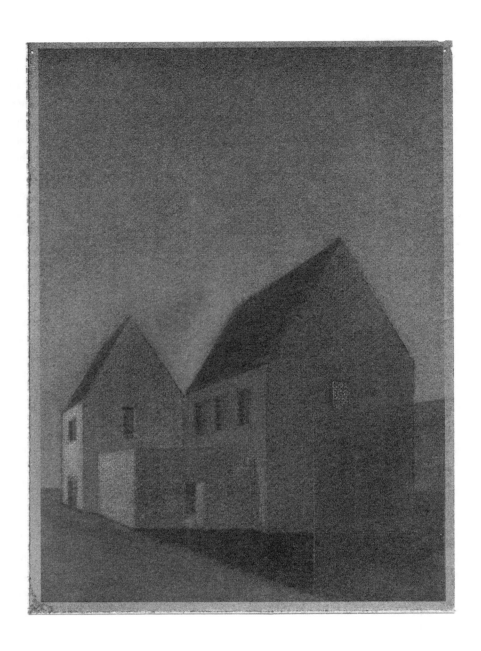

Richard Peduzzi, *La rue,
l'après-midi*, 1992
Oil, gouache and watercolor
on paper, 30 × 22 cm
Design for *Wozzeck*, Alban
Berg, Théâtre du Châtelet,
Paris, 1992.
Director: Patrice Chéreau
Courtesy of the artist
© Richard Peduzzi
(Photo © Frédéric Claudel)

awe-inspiring word throughout the duration of twenty-two melodies. A comparable crowd sat transfixed and incredulous as they listened to the immense tragedian Karen Cargill sing Berlioz, hardly believing that she had come from Scotland at the last minute to replace an indisposed colleague and to sing for them. The festival also has its wistful figures such as the veteran festivalgoer, in tears after a memorable *Mahler Third Symphony*, his face full of goodness and simple generosity, who admitted to me that he had just heard it live for the first time.

IV.

In September 2019, the new President of the European Commission, Ursula von der Leyen, caused an outcry with her decision to assign a commissioner with the portfolio of "protection of the European way of life"—an awkward move, no doubt, for a position associated with migration issues. The word "protection" has since been changed to the more consensual "promotion." I couldn't help but see a terrible irony, especially in times as politically dangerous as ours: could Europeans be so insensitive to the preservation of the founding principles of their union, of their democracies, beginning with tolerance and the dignity of the human being—are these not immutable values? From there, the danger of drifting into extremism and xenophobia is only a step away.

Nonetheless, these principles form the essence of our work and are inherent to the operatic genre, as expression, representation, and reaction. In this year 2020, as the stars revolve anew in a vast Beethoven constellation, the composer's humanistic, pan-historical message must resonate louder than ever, above all here in Europe. Did the European Union not adopt the "Ode to Joy" as its official anthem?

V.

Opera seizes us in the present moment, viscerally; it speaks to our emotions first and foremost and imposes its rhythm. It is the channel leading to a fantastic dialogue with the world, the crossing of which is not entirely without risk given the inevitable confrontation, intimate and instantaneous, with oneself. My personal experience has taught me that risk is often rewarded a hundredfold and that this immaterial retribution doesn't belong only to a proverbial elite: social, intellectual, financial, or otherwise superior. Ideally, opera becomes a means for knowing oneself and others, an antidote to the alienation, which insidiously awaits us. If the unprecedented explosion of revolutionary technology that we are experiencing complicates matters, if it upsets the balance of power and changes the modes of perception, the stage retains its status as a haven of authenticity. It is the forum par excellence where we show and say through means specific to the theater what cannot be shown and said elsewhere.

Gerard Mortier understood this—and he is not alone. If I categorically refuse the ambient pessimism, the death of the opera remains a chimera! However, the challenges are multiple and very real. If we are to perform *Don Giovanni* in a thousand years from now, if we indeed desire the continuation of this uniquely human experience, we must urgently resume the fight for the defense of culture and for the ideals which are those of Europe. And, I repeat, this can in no case be transformed into an exclusion process! The opera is waiting,

still looking for a "twenty-first-century Mortier." The formula is worn and not without limits, but it's not wrong. It's imperative that women and men, today and tomorrow, carry the torch, which has been burning since the obscure night and lit Athens from its first morning on; women and men for whom opera is the ultimate, most accomplished form of theater. Like the ancient Greeks for whom the theater was life and the mirror of the soul and society. The theater is a vehicle for broadening consciousness, for the foundation of a liberal and free education, more focused on essence, joy, and plenitude, enabling us to reach a more effective form of happiness than the rigidity of our official systems allows. The theater builds ramparts against greed and ignorance, forces that have more power than ever before to sway peoples' destinies—ramparts that protect an imaginary city, truly humane and cosmopolitan, in which beauty and thought can coexist. Gleaning from the real, we approach the ideal. Opera leads us towards more kindness, more attention, more intelligence, and therefore, greater humility, and impartiality; towards a kind of essential morality, to a sense of what men and women can do, must do and must not do in the universe, with regards to their duties, rights, and responsibilities—towards a celebration of humanity. With this in mind, I reiterate my faith in a renewed optimism: the conviction that self-transformation is also possible.

We must all become inhabitants of this singular and incomparable whole—Europe. We must re-appropriate the riches of a genre born and nourished on this continent, inseparable from its identity, from its *vir humanissimus*. This is a plea: to refuse all nihilism, to embrace a renewed emphasis on the original text, rather than on exegesis, to drink again at the perpetual source, to renewed wonderment at the prodigious mystery of humanity. The theater—infused with multiple characters changing faces, transforming and becoming flesh, abandoning themselves to a rare and precious sensation—overwhelms us, disarms us, conquers us, and reveals us to ourselves, tender, grand, and fragile. This is a plea for living theater, human pleasure and warmth, sensuality and lucidity, and against inertia. This is a plea for a new European cultural renaissance. This is a plea for a return to oneself.

Born in Montreal, Renaud Loranger has lived in Berlin since 2010. After working with Kent Nagano at the Montreal Symphony Orchestra, he joined the French division of Deutsche Grammophon before taking over the artistic direction of PENTATONE, in the Netherlands, in 2016. He has been artistic director of the Lanaudière Festival since 2018.

EPIPHANY IN THE DARK

Valentin Schwarz

It has often been noted that human art was for a long time bound up with work and rites of a different nature. Saying this, however, perhaps has no more weight than saying that art begins with human beings.
Gilles Deleuze and Félix Guattari, *A Thousand Plateaus*

The third bell is the last one. While the hall doors close as if by magic and we pack together in these claustrophobic quarters, here and there the open strings of tuned instruments fade away, and hundreds of smartphones embark on their silent and receptionless flight. The light of the chandelier is dimmed, and only the pale reflection of the music-stand lights in the orchestra pit falls onto the flaking gold of the proscenium arch. Gradually, the casual conversations fall silent, give way to ubiquitous clearing of throats. We sit and wait in the dark.

I have enjoyed this ritual ever since I was nine years old—like so many other theatergoers. Childish capacity for enthusiasm and, later, teenage nerdiness were successfully steered into the paths of music and theater, and I acquired a lifelong passion. Perceptual overload was transformed into fascination and immersion, finally co-creation.

What is this love for the rather commonplace experience of an opera evening built on? Every biography carries with it its own inclinations and interests, every audience member has a different way of looking at things, and yet the genre contains within it universal experiences that both reach beyond our everyday perception and distinguish themselves from engagement with other forms of art. Nonetheless, since March 2020, a pandemic has been creating conditions for theater businesses around the world that are unheard of, even in times of war. That is to say, periods with virtually no performances are upon us, the social consequences of which may far outweigh the ensuing artistic and financial losses, and we are put on the spot to reconsider the relevance of our love of opera.

To avoid navel-gazing, it is worth steering clear of looking for the qualities of the genre within the art form itself and focusing, instead, on the features that distinguish it in the eyes of the outside world. Because the mission to preserve our cultural capacity to act is not about a war of positions, but rather about coming together to reflect on the pleasure and joy of doing what we love. The focus here is not on specific works, performers, or even directing styles, but on the specific characteristics of the genre itself, especially when compared to the far more "real" visual media of our time, such as film, but also the increasingly impressive

technologies of virtual reality. We should not try to emulate them—in which case we would come out on the short end anyway. Rather, we need to uphold the unique features of the art that have presented us on stage with such extraordinary experiences for centuries.

And so around the time evening performances used to start, I'm strolling in the direction of the opera house, now an abandoned ghostly edifice in the center of town. Bike commuters in helmets and suits are hurriedly peddling to after-work activities and youth left to their own devices—who may become part of the "Lost Generation" of the twenty-first century—are enjoying the evening sun on the front steps. Behind the ornate theater facade that has even survived the ravages of war, employees are on part-time and visitors can no longer congregate.

Looking at what is now just a decorative building that doesn't serve any real purpose, I ponder the justification, loss, meaning, and pleasure associated with this structure and its art. Like no other, it is dependent on community experience, on the simultaneity of the most intimate moments in the collective; the parallel events of a resounding whole and an inner experience—as can be found, in a similarly vivid, albeit completely different manner, in the equally deserted techno club across the street. The amalgamation of collective and private spheres brings together intimate and social factors that make the opera a unique experience. Now, what is it that makes it so matchless? In spite of the overwhelming magnetic pull it has on me, I will try to get to the bottom of this question in an analytical manner.

Richard Wagner and Bayreuth accustomed us to a pitch-black auditorium where a mystical abyss swallows the orchestra whole and not even the "swollen cheeks and puckered features of the wind-players" (Richard Wagner) distract our attention from the events on stage. Ever since, our visual focus has been solely on the central-perspective scenery, at least as long as bluish smartphone screens and all nearby whispering has successfully been hissed away.

Deprived thus of stimuli, we are expected to keep still, to concentrate on one thing, and do so willingly for hours. It's a unique situation in today's world where, in the midst of overpowering onslaughts by distraction industries, we hardly encounter established attention zones anymore, where in the most intimate bedside settings, partners keep the temptations of social media within easy reach, churches have become a thing of the past, and living rooms have all the trappings of a movie theater. Even after just a short conversation or a few lines of reading, the denizens of the electronic age quickly feel exhausted and crave diversions. In this environment, the exclusive, unconditional, and voluntary surrender to an evening at the theater allows for an imperious requirement one can only evade by way of a spontaneous nap or by simply give in to.

Here we are still afforded the luxury of the place, time, and leisure we need to think things through for ourselves. Forced into a state of reflection, a personal sense of achievement resulting from this kind of asceticism is finally unlocked. That is, overcoming our own resistance is the actual prerequisite for an intense perception of life as well as for our ability to experience and shape our lives as autonomous and free.

Yet, constant sensory overload stands in stark contrast to the miracle of the emotional immediacy of music, which serves as the basis for our immersion on the level of content. Now

we are faced with a phenomenon that often benefits the established repertoire but is always encountered at premieres: helpless and without skepticism, we react from a value-neutral standpoint, since we have to perceive and absorb spontaneously without prior classification. Everyone is a child during a first visit to the opera.

Due to the simultaneous occurrence of performance and perception in the here and now, along with the stress caused by a lack of categories, we tend to react with steadfast skepticism and detachment when faced with stage events that feel all too associative, or contradictory, or create obtrusive contrasts. The dilemma of not being able to read the playbill we have obtained to be on the safe side in the dark, the anti-intellectual panic and unguided exposure are however, prerequisites for inner openness. The interpretation as a crutch of the mind would only serve to deaden our perception.

In this critical vacuum we long for things we can recognize and identify; we want to be able to trust in the behavior of actors, and sense the ethics of art—the potential for empathy. When Rousseau, in his *Letter to D'Alembert*, demonizes the hypocritical characters populating the theater stages, he is deceiving himself and us, because our awareness of the contrived nature of the scene affords us the most authentic quality of empathy there is. That is, if we want to accept the permanence of societal and private role-playing as a fundamental condition of contemporary perception, the stage shows us a true drama through the double refraction of the intentional lie and, thus, provides us with the prerequisite to open ourselves, reflected and reflectively, to empathy and compassion. We do so through classical imitation or subjectively perceived parallels to our own biography in flashes of interplay between the music and the scene. Such unrepeatable and highly personal moments cannot be compelled by an actor or director. The aspects of a production that may or may not trigger something along those lines in the course of an evening differ for each audience member and are, yet, common to all of us. That is the miracle of the simultaneity of the perception of the moment on stage and in the auditorium.

After all this individuality of perception, we proceed to intersubjective exchange, because nothing is as essential to an art experience as the discursive postprocessing that follows—be it among a group of visitors in a follow-up discussion, on a rainy car ride home, or in a rude, semi-anonymous posting war on the *nachtkritik* forum. The assessment of the *kairos* as an unrepeatable moment of performance is only provided by the community.

Gasping for air and space, we open the side doors of the parquet floor during the break; beyond them, the front-of-house staff can already gauge the mood and the success of the evening from the expressions of people streaming out of the theater. While the swarm-intelligent standing room audience is full of extra-parliamentary hotheads who evoke or deny the presumed failure or success, the random group at the bar table almost forgets about the champagne glasses in their hands, because there's just no overlap between everyone's personal assessment of the artistic quality of the performance and the diametrically opposed views of their conversational partners. Thusly irritated, I await the second part of the evening, buoyed by a sense of maturity that comes from taking in the plurality of opinions, the presence of which is as annoying as it is alluring—a truism, but one that makes democracy possible and

not only allows for some quick and harmless discourse training. We not only learn not to bash each other's heads in over differences in opinions and not to confuse the opinion with the person, but also to make use of our highly personal potential for an inconsequential and therefore all the more effective self-correction, the most impressive and noble quality of man, the practice of which requires quite a bit of humility.

The current tragedy of an inadequate public sphere, of the "absent multitude" (Alejandro Zambra), in which the (absent) crowd can only be experienced as a digital one, combines the longing for a private retreat into the tranquility of perhaps an innocent country idyll with the irritating ego trip of modernism. Our radically curtailed scope of activity in the real world ("Weltreichweitenverkürzung," as Hartmut Rosa put it) not only cuts our connection with our fellow men, but also makes face-to-face confrontation with others impossible. Where the virtual confluence of private and public spheres has long been read as a contemporary counter-movement to social fragmentation and isolation—and therein lies the inherent strength of the theater—social dislocations and personal identity crises lead to a growing desire for populist simplification of explanations and explainability. However, if we can wrest seemingly anachronistic models such as that of opera theater from nostalgic irony and (de-)museumization, it can serve as a humanistic norm for every society, because it provides an experimental arrangement of passion and compassion that is worth protecting.

Now that the general possibilities for performances are being discussed, it is this norm that gives us the motivation to bring to mind the unique power and necessity of our shared experiences of opera theater, which should include remembering it as a space for contentious encounter, something that is already visible in the architecture of theater buildings. Opera houses and theaters are not interchangeable multi-purpose buildings but carry within them the utopian spirit of societal self-reflection. And perhaps the opera can, in spite of its artistic quarantine, open up its house as a risk-free space, as a meeting place, as a center in the very heart of the city, as a potent platform directly aimed at preserving our democratic capacity to act, where we can test new forms of non-violent consensus-building on the stage, the rostra of today, in the foyers?

Because sometimes private and public experience coincide: we leave a memorable event in collective rapture, feel that we, as a community, share a common destiny, while carrying the coat picked up at the cloakroom over our arms in spite of the winter cold, all shivering gooseflesh and feverish inside, sharing in the darkly impressive awareness of having witnessed something great. One of those moments where the synergy of impressions—singing and authenticity of representation, music, and scenery—combines in a way that lets us experience the ability of human beings to transcend themselves, to simply step outside of barriers and patterns, move beyond personal talents, virtuosity, and achievement, letting us marvel at a caesura of essentiality in the midst of the vanity of everyday life. Perhaps because it is so improbable and, above all, unpredictable that this moment would occur, it is, paradoxically, the highly ephemeral art of the stage that has now transcended life in terms of preciousness and irreplaceability. We were sitting in the dark, alert or sleepy, but all those who had mustered the resolve to take up the offer convincingly assured each other afterwards that they

had witnessed an epiphany together, a moment of singularity, a true human moment, beyond recall and yet indelibly etched into memory for all time as a testimony to the possibilities of our existence. Such an experience may not hold any immediate insight, may not ignite Kant's torch of reason, and may not escape the eternal shadow play in Plato's cave, but the radiance of shared memory bathes the cold universe in a human light.

I slowly leave the theater building, its stone slabs still radiating warmth, and pensively start to head home. Have I just experienced a performance? Or was I just wallowing in memories? Was I dreaming that all this would become possible again? Darkness has fallen, inside and outside the opera, but if there's one thing I know, it's that staying put and waiting in the dark is a condition for the curtain to rise for me, and for all of us, opening a view of the stage and its brilliant light.

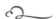

Austrian stage director, born in 1989, Valentin Schwarz studied opera directing, economy, and philosophy in Vienna. In 2017, he won the "Ring Award-Competition for Stage Directing," in Graz. He will stage *Der Ring des Nibelungen* at the Bayreuth Festival in 2022—making him the second-youngest to do so after Patrice Chéreau, who was thirty-two years old when he directed the famous 1976 *Centenary Ring*.

DO OPERA INTENDANTS HOLD TOO MUCH POWER, MR. INTENDANT?

Bogdan Roščić

Conversation with Gert Korentschnig (June 2021)

Gert Korentschnig: *When you approach the subject of opera on a meta-level, there's no getting around the issue of power. Until a few years ago, opera houses were centers of an almost dictatorial exercise of power on the part of some intendants and conductors. Recently, however, these power structures seem to be cracking open. Do intendants still wield too much power, Mr. Intendant?*

Bogdan Roščić: Theaters can represent very interesting constellations of the use and abuse of power because so many unsavory things can be hidden in the undergrowth of artistic endeavor. Hence, the considerable repulsiveness of some incidents which makes your jaw drop when you read about. This is also the habitat of the well-known sociopathology of the intendant, especially at tax-funded houses. Incidentally, there is no authoritative study on this matter—now that would make for a timely opera book, not just the usual "Anekdoten nach Noten." But we are talking about what in sociology is called a "bundle of factors." So it would be preposterous to reduce the issue to the actual or ostensible power of intendants.

Well then, let's start with the power of the genre: how much power does opera still have per se these days?

Power over what? Over someone's personal development? Over society in general? For the individual, I think opera is today, just as it was four hundred years ago and like every other artistic genre, a life-changing force, but only in terms of its potential. Because if you claim it is strictly speaking a positive force for the betterment of mankind, you have to ask yourself, among other things: how could there have been a phenomenon such as the opera lover Adolf Hitler? Like all art, it only provides us with a tool, or a vocabulary, if you will. What counts is, as Rilke wrote in the sonnet "Archaic Torso of Apollo" about the sculpture: "There is no part which does not see you." So the stone sees and recognizes you, not the other way around. And thus, the final sentence reads, "You must change your life." In our reaction to the work of art, we are probed and sense where we pass muster and where we fail. It's an appeal; the rest is up to us. Opera creates this appeal by using an overwhelming variety of means, bringing together all other forms of art within itself. It's little wonder that opera was the latest bloomer among the art genres; it was the one we took the longest to develop. I am often amazed at how music from the beginning of the seventeenth century sounds archaic compared to the level of development we see in the architecture or visual art from that era.

Another thing that distinguishes opera from other art forms is undoubtedly the urgency of live performances, of coming to life, over and over again. During the pandemic, this was not possible everywhere, and opera was therefore deprived of much of its power.

That left a very strong impression on me: the bleak feeling of not being able to share a great experience at these premieres, which were only performed for television and the handful of people in the auditorium; on-duty employees, journalists. But a performance loses so much of its appeal if no audience is present. It's amazing how much we depend on each other, despite all our isolation, and even if we can't stand each other. The fruit of this knowledge fell on my head by the dozen, to quote Heimito von Doderer.

These performances with only a few dozen people in the large auditorium were, on the one hand, highly exclusive, but at the same time elitist—which makes opera problematic even in normal times and is extremely unfortunate. In any case, one had the feeling that it was easier for politicians to close down cultural institutions than other sectors, which brings me to the question of how close the relationship is between opera and government politics. Does opera have the power over political decisions?

I think art can only impact society and politics via its influence on the individual. I don't believe in art that wants to intervene in a direct manner. Such art would fall under the scathing verdict that Adorno put forth: "Artworks that unfold to contemplation and thought without any remainder are not artworks."

But why then do so many politicians try to edge themselves into opera?

But they're not. For top British politicians, being seen at the Royal Opera House too much amounts to reputational damage. While this has traditionally been different in Austria, I don't think that this close relationship is still being cultivated to any significant degree here either, beyond personal preferences or obligations that exist here and there. Of course, in this country, more than anywhere else in the world, people recognize opera's high visibility, so to speak, especially the Wiener Staatsoper. But art had better be wary of that. Take, for example, Richard Wagner, a man, who all his life asserted the necessity of revolution, morally, philosophically, and artistically. And where did that end up taking him? To quote Karl Marx, he became the "state minstrel Richard Wagner." And Bayreuth became the Corso of Europe's upper-crust society, which, of course, included certified tyrants and warmongers.

Agreed. Still, I believe that the power that comes with the position of heading a major opera theater extends far beyond the house, even if you don't explicitly articulate yourself politically. There are social and political issues to which the stage can give perspective and in the long run, may even be able to point the way. The current debates about political correctness would be an example.

I guess that's more about an attitude or, rather, a set of etiquette rules you need to follow in a variety of different debates—and to me, they appear mostly apolitical and not profoundly interesting, even if they're taken very seriously within certain bubbles. In recent years, we have seen a subtle semantic shift in the direction of "wokeness." But, be that

as it may, the theater cannot serve as a platform for the discussions themselves; it's simply neither Twitter nor a newspaper opinion page. Theaters can and must take a stand on certain issues and outcomes that result from such debates, and in doing so, of course, influence the direction they take, as well. For instance, on the subject of blackfacing, that debate is simply over, and no amount of references to Shakespeare is going to change that. The four hundred years since Shakespeare's times have included nearly two centuries of this practice, which was rooted in racism and intended to be racist, especially in the US. This context cannot be ignored when we encounter blackfacing today. We are aware of the pain it causes, and most opera institutions today do not wish to add to that pain. Other notions associated with political correctness I reject in their entirety. For instance, the idea that the entire canon of European art music is a racist and sexist construct. This view is not uncommon in today's American musicology with some academics losing their minds over identity politics. This is of course what in the US is called a person's "politics"—not to be confused with a behavior that is in some way politically relevant in the real world. It amounts to nothing more than the signaling of supposed moral superiority and, ultimately, people's chiseling for personal advantage in pointless clique discourses by zealously and assiduously scoring bonus points irrelevant outside of the respective clique.

We've already touched on the dreariness of empty theaters, which raises the question: as a general rule, what power does the audience have? Not necessarily on the work of art, but at least on its presentation?
Of course, the audience wields the greatest power. Anyone who denies that is being highly hypocritical.

Is that good for the genre? Or dangerous, in terms of its potential for pandering to mass taste?
It is, for starters, simply a fact if we take seriously what we said earlier, namely that the power of the experience depends, to a considerable degree, on the presence of others. Secondly, it gives the audience some power over the particular moment in a performance and is thus also open to misuse. At the Wiener Staatsoper, there are many historical examples of this, for instance, thanks to the standing room, which is still, as ever, oversized in relation to the capacity of the house. So the energy coming from there can be considerable, and that is something that people have exploited again and again, sometimes to vent the most reactionary nonsense. A hazardous line is crossed when what you could call the audience's passive power of mere presence wants to become an active one, insisting on the fulfillment and confirmation of their own ideas. This can be acted out in the anonymous darkness of the auditorium; just recently for example, during Hans Neuenfels's production of *Entführung aus dem Serail* where, at the very end of a faithful rendition of this work, Bassa Selim reflects on the power of music because it is not at his disposal. He subsequently quotes a Mörike poem with a direct reference to Mozart. On the opening night, one person somewhere in the gallery bleated out at that exact moment: "This does not belong here!" That's almost violent; someone like that should be kicked out. But this attitude is not something we only see in Vienna; it's quite

prevalent in Italy; for instance, Parma is notorious for it. You have people who wait for three hours to be able to yell "boo" at the end. Some come to the opera to flaunt their supposedly superior judgment regarding the performances offered. You will hear things like, "I never imagined something like this could be possible in a theater where Ghiaurov and Siepi have sung this part." But this nonsense holds real sway over the singers; it's the reason why some internationally acclaimed divas refuse to sing on big Italian stages.

I often wonder why opera tends to be more conservative than other genres, such as visual art, spoken theater, or film. Could this be due to the power of a particularly conservative audience?
I don't think so. In my mind, it is more to do with the practice of careful pandering to certain segments of the audience we see at some of these houses.

Most of the audience flocks to theaters to hear the singers. On the part of the major institutions, there is often fierce competition to attract the best. How much power do they wield, not just with regard to the roles they perform, but in terms of shaping entire repertoires?
I don't think the majority of the audience is so easily satisfied; if this were all about worshiping singers, gala concerts would be a more suitable format. No, the audience does want the complete opera, the whole experience, including everything that defines the genre. It's undoubtedly true that singers play a key role in it. And they wield as much power as a house will allow them to hold. In any case, there shouldn't be any fighting over them in the first place. You would think that the blessings of public funding would lead those involved to think differently. But that is not the case, as we both know. There is a competitive mindset and jealousy between public institutions, and there is many an opera intendant who jitters with ambition like the proverbial soubrette. As a result, there is a complete lack of solidarity between theaters when dealing with the so-called stars. They, in turn, as different as they may be, know one thing for sure: if a project doesn't come to fruition in one place, there are always five other houses desperately waiting to associate themselves with their name. Rudolf Bing, the legendary general manager of the Metropolitan Opera in New York, was notorious for taking a strong stance against singers even in a non-taxpayer-funded theater. But he, too, had to make dreadful compromises, and he excellently chronicles these episodes in his autobiography, including the ulcers they gave him. Nothing is easier than dealing with singers who put on airs and engage in counterproductive behavior but are not as good as they think they are. Things start to get complicated when you run into problems with a phenomenal singer. With someone like that, you are also incredibly susceptible to temptation. In the end, of course, a theater director must credibly embody, for all sides, the truth that no one is greater than the house itself.

Great singers would definitely have the clout to encourage the development of new works. Many, however, don't seem to want to sing new operas at all because it's just too tedious for them, or the rehearsal process takes too long. That's probably one of the reasons why repertoires are starting to look more and more alike.

Just one more word on their influence on the repertoire: it must not be significant in the core area of a theater's programmatic direction. But if a repertory theater, planning years into the future, knows that a great singer who is the ideal fit for a role would accept the part within a specific time frame, then it's perfectly legitimate to schedule the production in question within that time frame. That's just good planning. As far as new works are concerned, with a few exceptions, the situation is exactly as you've described it. And, of course, acceptance of the contemporary repertoire suffers from it. Luckily, there are specialists who primarily sing new works. But, unfortunately, opera lovers sometimes punish that with nasty skepticism: Well, the voice probably didn't make the grade for Verdi... Regardless, a task great houses should tackle is that of enticing big names to do contemporary works

How much power does the media have within the opera genre?
I'd say it's not what it used to be. If I think back to how, especially in Vienna, critics wrote about the State Opera, what their concerns were, what was then considered legitimate intervention—thank God that's no longer possible today. I remember when cultural journalism in Vienna was about trying to get involved in a very tangible way, but that's largely over. But in purely commercial terms, its influence has waned, too, as it has elsewhere. For example, there was a time when Broadway shows were canceled minutes after a bad review had appeared in the *New York Times*; that kind of monopolized opinion power doesn't exist anymore. On the other hand, I don't believe that the importance of what critics write has diminished when it comes to its substance. It is only diminished if you want to be part of the game and attract fawning attention by houses desperate for good press. The critic's capacity to process, situate, and analyze has lost none of its importance amidst the cacophony of online diaries. There is, after all, the danger today that these pseudo-media create so much background noise that it drowns out the qualified voices. But I'd love to hear your take on this, as well.

I think we have to distinguish between the power of cultural criticism within media formats and that of criticism itself. Within mainstream media, it has undoubtedly lost influence. You have less space, perhaps a reduced overall presence, and less importance within the overall publication. But that doesn't mean the power of writing is in decline. As critics are no longer reviewing every chamber music concert—that isn't possible anymore due to the sheer number of performances—they are focusing on selected events, and for this reason, the quality of the writing is of even greater importance. Today, you're not just reaching a professional audience, but the broad public as well, especially through the online pages of quality media—in sum, more people than ever before. In my mind, that's a positive development because you're going beyond your immediate opinion bubble. In the old days, cultural journalism was really what Twitter is today, that is to say, mostly hateful and wanting to scratch each other's eyes out.
But now everyone can be part of the game, and one-time cultural journalists who have been reduced to blogging compensate for their degraded status as part of the digital precariat with unbridled vitriol.

What about the power of the orchestra? It's regarded as particularly significant in Vienna; the Wiener Staatsoper Orchestra is also successful internationally as the Vienna Philharmonic Orchestra. In the past, it was often the orchestra that swayed the decision regarding the appointment of the new intendant.

Firstly, the orchestra of any opera house carries the weight of being the largest and most visible group at the theater. At the Wiener Staatsoper, we're talking about 148 musicians, not counting the stage orchestra. What's more, in Vienna, the main orchestra has a second identity as the Vienna Philharmonic Orchestra, a global institution, so to speak. This is undoubtedly the reason for its unusual status at the house, something its members are certainly not entirely unaware of. That, in turn, leads to all kinds of phenomena, some subtle and some not so subtle, which, frequently, do indeed have to do with power issues. On a practical level, it also leads to problems that are unusual in other ways. As individual members of the Philharmonic, they must be allowed to travel and perform internationally; in the meantime, at home, the group must perform every evening in the opera. The art of this coexistence lies in shaping it so that interesting things are created along the way.

And how do you see the power of stage directors within an opera house? Do they wield any influence beyond their own production? We are talking about itinerate artists who are celebrated in some places and grotesquely booed off the stage in others. Are they visible and tangible as an entity at all?

Absolutely. But here, again, every house decides whether it is going to side with singer worship and mercilessly choose people who make scenic arrangements of the score, or whether it wants to hire the world's best artists as its stage directors. Great directors are highly self-confident people who do not see themselves as delivery services where you can place your theatrical orders. And once a theater has opted for a concept and picked a leading team, that team has considerable leverage.

I believe that on a surface level, stage direction already has a stronger presence than the musical facets of performances because many people are increasingly clueless about music, while the staging is easier to appreciate, at least visually.

Every opera house offers a lot of tradition. But we want to show the now of this tradition and not exhibit it as a museum piece. That's why we depend on people who are able to extract what is relevant today from timeless works of art. For that reason alone, stage directors wield some very real power.

I think it is tied even more directly to the power of the opera intendant than, for instance, the power of singers or orchestra members, because with stage direction, the main thrust is set, and ensuing distinctions are laid down.

I also see it that way. With singers, it is clear more quickly and objectively who is the world's utmost. When it comes to directing, you take your pick, and you either hit the mark or don't. You don't get to shop around in that little deli of the very greatest singers. But that also puts into sharp relief the quality of your decisions—and makes you more vulnerable to criticism.

How much truth is there in the oft-invoked cliché that great artists must be downright monsters?
I think it's nonsense. The reverse idea of the artist as an exceptionally good and pure person is just as bad. The notion of judging artists based on their ability to produce a properly filled-out Excel sheet listing all the moral qualities currently in demand is an appalling trend of our time. In the US, publishers reject novels because they contain bad characters. It's worth quoting Doderer again, who ridiculed people, and I paraphrase, who always claim to have, and want to see in others, only good qualities, which produces nothing of any value whatsoever. Without robust resistance, this will inevitably lead to results that devolve into mere virtue signaling and are as morally worthless as they are hopeless in terms of artistic merit. This doesn't mean, of course, that outstanding talent entitles people to abuse their power. Just look at James Levine's career. But there are other conductors too who, beyond the age of seventy-five, keep on celebrating the drama of the highly gifted child and get away with it, albeit with increasing difficulty. This idea of translating great talent into the right to misbehave is just wrong and repulsive. I've always had a strong dislike for this remark you frequently hear, "He's a real pig of a man, but his conducting, singing, or acting is so beautiful"—particularly the "but" it hinges on is distasteful.

Have recent events sparked enough change in the exercise of power that we can call it a watershed moment?
On the whole, I would say yes. Today, as a rule, you don't have to put up with a completely transgressive boss or tolerate abuses of power out of fear, up to and including the terror of unwanted intimacy. By now, the mechanisms that make it possible to put someone like that in a highly difficult position fairly quickly are well established, even in the cultural sector.

Power-wise, we've now circumnavigated, in concentric circles, the actual power center of an opera house—now let's return to where we started and look at the state of affairs around the power invested in the intendant. Why is it that the opera and musical theater industry was the one with the highest number of #MeToo cases apart from the movie business?
At their core, these are two very different realms. For example, in the movie industry, it's not so clear who the equivalent to the intendant is. Is it the producer? The studio-head? The director? And then the promise of mainstream fame and real money creates a whole different dynamic. The theater sector follows another logic. A colleague told me how he once sat on the jury, it was some kind of entrance exam for directing student. An evidently very talented young guy was asked why he wanted to pursue a directing career at all. And his answer was: theater is the last area of society where you can still exercise unrestricted power. There's still something to that, at least in the subsidized sector. In the commercial sector, in London's West End for example, things do look quite different. If you only get to eat what you shoot yourself, you tend to become readier to compromise, and more sympathetic. Of course, there are some psychopaths there, too; I had to deal with a few of them when I was involved in Broadway projects. But behind the culture shrubbery which we mentioned at the outset, legally protected and rated "highly valuable," greater freedoms

are waiting, and not in a good sense. This is how the sociopathology of the opera intendant develops, down to the smallest, the pettiest bourgeois detail, the inability to greet people or to remember names… It's laughable, but it can be terrible in everyday life.

Is this a pre-existing condition, or is it an illness you develop while in office?
Just like with alcohol and the "nasty drunk," the office can only coax something out of its holder that is already there. These strangely exalted positions radicalize some people in pretty banal ways—"How right you are yet again, Herr Direktor"—and it's all downhill from there. Out of a healthy distrust of myself, I have agreed with my wife that if she ever notices the slightest signs of such tendencies in me, she must immediately ram an unwashed pair of poultry shears into my thigh. So I'm on my guard. In Vienna, this is made somewhat more challenging due to the expectation that the intendant must not be a colorless person. Some entertainment value is expected; his tenure should leave behind anecdotes of affable despotism; as the nation's stand-up violinist, he is to supply a measure of drama and arts world folklore. As an expectation, that's not without a certain perfidy. But I believe that this idea of people and this profession is on its way out. I won't miss it.

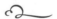

Born in Belgrade and raised in Austria, Bogdan Roščić began as a journalist and radio manager. He then moved into the classical music industry, becoming managing director of Decca Music Group and head of Sony Classical. He has been the director of the Wiener Staatsoper since 2020.

8.

Auditorium

Impulse and Emotion

WHAT DOES OPERA EVOKE FOR ME?

Amira Casar

Opera is a disease, an infection, a highly contagious arena, for me, where the primitive and sometimes chilling scream—fully and secretly—penetrates me, pulls me, draws me, shaking my buried, porous foundations, ancient and anterior. When it is successful in its most perfect osmosis, everything is bewitching, one is transfixed. One goes there to feel all at once: the collective effervescence, the outlandish trance, THE LARGER THAN LIFE, an amplified and heightened "Eros and Thanatos," and paradoxically, to experience the most minute, the most subtle and delicate of heartbeats.

Sometimes a deep and overwhelming melancholy seizes me because it is the arena of life and death, amplified; that dreamed-of, narcissistic tragedy that one shamelessly authorizes oneself to project oneself into, and of all the possible projections of the fiction that unfurls itself before one's hungry eyes. To adapt them to oneself, to oneself and to oneself *ad vitam aeternam* and to our own history, our own furrowed, tortured mythology. Projections, secret and unavowed. Fantasies that one relishes in. Projections that fulfill one's deepest desire for unknown territory. Projections of desire and disaster that submerge us in the quest to flee the banality of life, for a few tremorous hours.

It is the art of romance *par excellence*, and romance often ends in loss, deprivation, torture, death, or the unjust and heroic execution of the hero who suffers humiliation and duplicity, deception, jealousy, and affronts of all kinds, Mario Cavaradossi in *Tosca* being a very obvious example. I have never seen the opera as a closed rectangle of refinement, purely for the privileged and the rich, the show-offs, and the dandies and the playboys or the great worldly bosses; not the least because primarily and essentially, in the concert hall, I am able to distinguish, the obsessed, the true lovers of music from the others, the frivolous social butterflies who go there to be seen.

Moreover, there were the recordings, and my love for this "total art" was so immense that I used to save my pocket money to acquire them in the fantastic record shops of days gone by. There were also the student rates at the Opéra Bastille during my years of study at the National Conservatory, where I was able to attend magical performances at a meagre student price, not to mention some very generous friends, artists, and directors, who graciously found me seats. I must pay tribute here to Bob Wilson and to Simon Stone, who let me attend their rehearsals time and again, and to my pianist and conductor friends.

When I listen to, or attend an opera, it is as if I were organically and metaphysically climbing back into my mother's body for a sacred communion. Step by step, "Schritt für

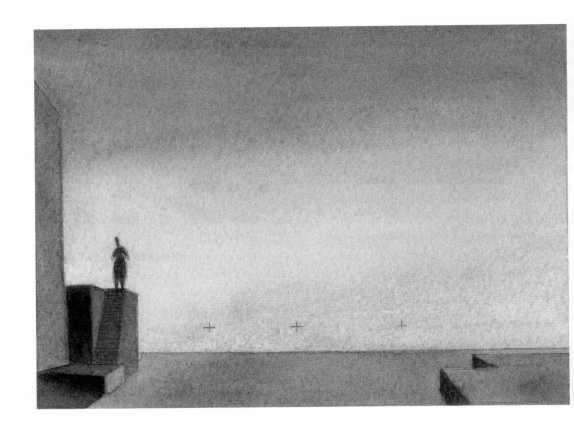

Richard Peduzzi,
Untitled, 2007
Charcoal, watercolor, and
pastel on paper, 17 × 22 cm
Design for *Tristan und
Isolde*, Richard Wagner,
La Scala, Milan, 2007.
Director: Patrice Chéreau
Courtesy of the artist
© Richard Peduzzi
(Photo © Pénélope
Chauvelot)

Schritt," thus floating in an amniotic fluid of profound melancholy, in that body that already sang to me the most melancholic and tragic texts of Goethe and Heine, in my embryonic state; and who transmitted this burning desire to me, despite myself. Each time I return to the opera, I go there dissatisfied and hungry, wanting at all costs, like a vampire, to satisfy my metaphysical gluttony.

Opera is theater with the additional major and magical dimension that is, music.

It is fragile, it is art in its entirety, raw art, art brut, *par excellence*. At any one moment one is on the lookout for the desired miracle or paradoxically, for the disaster, which could appear before our eyes; on the lookout, on the prowl for the accident that could occur; on the lookout for the false note, the disharmony of the orchestra, the broken harmony, for the unsteady singer who loses grip and whose voice cracks, or for the stage set that does not work, everything unfolding and unfurling in front of our gaze—the hungry public; everything is exhibited in front of our eyes in this one great machine, with rehearsed mechanics that should ideally function perfectly and yet perversely, we are sometimes nervously on the watch for the imperfect moment, we almost await it, in my case, apprehending it.

Sometimes the cruel and reproving public, like a jealous lover, who has paid dearly for his seat to see his courtesan shine and sparkle on stage, demands the death of the singer who would dare strike a false note. I have sometimes seen it with my own two eyes, sad witnesses to how I suddenly changed sides, my blood boiling with outrage, and where my adhesion and support went directly and quite naturally to the artists, against the public.

I have witnessed this perverse hatred in the eyes of the pitiless public, their outrage and sense of betrayal that a failed evening provokes, when the performers are in poor form and where the rich people almost ask for their money back. Nothing and no one will be spared: neither the conductor, nor the artists, nor the orchestra, all fallen victims beheaded by that cruel steely guillotine that is the public and critics.

I am of the generation who admired *Regietheater*, who worshipped it, and for whom the great directors, who mostly came from the theater, were our Zeus on the summits of Mount Olympus; those with whom we dreamed of doing a *pas de deux* on stage, thriving in front of their fury and their glare. And the celestial voices of the women performers, were for me, those of all the outraged goddesses of Olympus. As a child, I awaited the director's vision with excited and ecstatic trepidation, and later, during my youth and my years of training at the Conservatoire national supérieur d'art dramatique of Paris, I frequently attended the opera by myself, sometimes sitting up in the rafters. Alone. Relishing in my independence, like an Elektra.

It was thus that I was able to see Isabelle Huppert in *Jeanne d'Arc au Bûcher* by Honegger, in the production of the always avant-garde and much admired Claude Régy, who was one of my demigods. The plasticity, the visuals, what Régy did with the language, his personal science of the French language in theater, his mixture of austerity and sensuality, starkly pure, put me in a trance, in an enduring dream that gave birth to my desire, my fanatical and irreversible, incipient delusion to make this profession my life! At this waypoint—because that is what art stands for, to illuminate, to show the way, to transmit the flame between generations—I said to myself, that in my turn, one day, I would be this Jeanne as well. To

say these insane, ecstatic, poetic, and lyrical sometimes simple banal words by the great poet and playwright, Paul Claudel, I said to myself: "I want to be dazzled by these words on stage with Honegger's music, where the sacred and the profane mingle in a dream, where Jeanne d'Arc witnesses her life in a series of cinematic flashbacks."

Thanks to the extraordinary conductor and pioneer Marin Alsop, I realized that dream in 2013 at the Barbican Centre with the London Symphony Orchestra. And during the month of April 2021, I was to incarnate the incandescent Jeanne again, but Covid canceled everything. The aborted words run through my head infinitely! This must be what it is to be haunted by a role, I said to myself. I remember the night of the premiere at the Barbican, the first person who knocked on my dressing room door was the much-admired English actress, Claire Bloom (who played with Chaplin in *Limelight*), who came to congratulate me, she looked at me intensely, and then said: "This role will never leave you." It was such a curse, a generous damnation. And oh, how right she was.

Cinema and Opera

Balzac opens *Splendeurs et misères des courtisanes* with a long masterful scene, in the opera—it is cinema before its time—an extended, meticulously calibrated "sequence shot," which unfolds nineteenth-century society before our enraptured eyes; where courtesans flirt with nervous and lanky dandified aristocrats, dressed sumptuously and ruinously, where the vexatiousness and vulgarity of bankers and of the new rich classes, which Balzac brushes with his acidic and lucid pen, contrast with the dry ink of the frustrated aspiring writers-in-the-making, the bitter ambitious journalists, and the upstarts of the demi-monde. All of them, scheming, unmasking themselves with grace or cruelty or naïveté in the charming settings of opera balconies and alcoves. He, Balzac, will return to the opera and theater in so many of his novels, placing the intrigues and the machinations and the downfalls, the pacts of love and the pacts to bring down more than one weakened and sacrificed being, Balzac who was the great connoisseur and admirer of Cimarosa and Rossini.

What opera evokes for me, is this eternal dark and romantic lady, who could by some strange mystery also be a man, an Orlando of sorts, who traverses the world like a metaphysical wanderer, seeking to transcend her abyss, her suffering, her disaster, her mourning in an eternal cry, of impossible and irreversible wrath, tearing down the wall of sound, deep into the antechamber of the theater where one rubs shoulders with death, where death prefigures, prevails, predestined, throwing us—if fortune and the stars are aligned, into the beyond, into the eternal elsewhere, which we look for in vain our whole life long.

She is the greatest of lovers; her body is tragic, her breathing tragic and animal-like. Her primal and primitive cry as if captive in a cave, deathly.

Wagner's Fascinating Women

Wagner in his transparently sublime and profound music wrote for a very specific and contradictory, complex, wounded and torn type of woman. One who is not free. One who becomes heroic through her moral integrity and bravery; an Antigone who takes a very conscious and

moral decision carrying it through to the end of its course. The fascinating heroin, Brünnhilde epitomizes this in *The Ring*. Initially she is the virgin goddess; she is her father Wotan's will, yet she renounces godly power for human love—for the human side. She is the only character in *The Ring* who evolves, growing in self-knowledge and empathy, rebelliously breaking free from the constricting paternal chains, for the love of Siegfried. Basking in the essence of love until her final act of immolation, she is never the trivial opera heroin, quite the contrary; Brünnhilde like Strauss's Elektra are subjects of endless fascination. And the music Wagner writes for both Brünnhilde and Isolde is glorious. Brünnhilde remains the primary and essential essence of *Götterdämmerung*.

I love monsters, and I am an actress in order to exhibit and subtly interpret my many internal monsters, physically and emotionally, and to be invaded totally by my demons through the great poets. That is sometimes I feel while witnessing an opera and being in that physical trance. Once, during a performance of *Elektra* (which happens to be one of my favorite operas) in August 2020 at the Salzburg Festival, I witnessed a blind man singing so intensely—"à tue-tête"—but without a sound coming out of his mouth. Nevertheless, he sang all the words of Elektra by heart; but as if he were at a concert of The Stranglers or the Rolling Stones. It was extraordinary; I laughed out loud at this most *Sturm und Drang*, Eros and Thanatos moment, because I had never seen anyone in the audience singing with such urgency, such vigor, such intense pleasure; every word in a succession of silent screams accompanied by spasmic body movements. Janis Joplin, Nina Simone, Patti Smith, and Kate Bush have something operatic in their endurance, their tremolos, and vocal vibratos.

In ancient Greek the word theater means watch. "I want to be watched where I am not watchable"—this is what my character named THE GIRL said in *Anatomie de l'enfer* (Anatomy of Hell), the film I did under the direction of Catherine Breillat.

My profession is to say and make the impossible possible and vice versa. This was the case when I played the "Medea Recitante," with monologs, spoken before and after each act, written by the director Simon Stone for Cherubini's *Médée*. The performance took place in 2019, with the Wiener Philharmoniker under the direction of Thomas Hengelbrock in the Grosses Festspielhaus in Salzburg, precisely where I had fantasized and seen so many magical productions so many times. But when I came out on stage for the curtain calls, I was in a thoroughly paradoxical element, that is to say simultaneously: THE WATCHED AND THE WATCHER; it was a very strange and exciting experience. Thrilling. An experience close to ecstasy; one I had dreamed of in the magical realm of ecstatic dreams.

The Opera and the Voice and the Record Shops
Lotte Lenya (a voice where the strange meets the marvelous)
Kathleen Ferrier (so expressive for Britten and Mahler)
Inge Borkh (one of my favorites: incredible Turandot and one of the most powerful Elektras)
Birgit Nilsson
Sonya Yoncheva

Margaret Price (the Lieder). So refined and graceful, so precise in her singing of Schumann, Schubert and the French romantic composers.

Elly Ameling (extraordinary and unequaled in Schumann and Schubert)
Montserrat Caballé (with such a vast repertoire; Bob Wilson said of her "she has a voice as pure as those of children")
Régine Crespin (who else could sing Berlioz like that, I ask you?)
Peter Pears (in *Billy Bud* and all of Britten)

Ian Bostridge
Leonie Rysanek
Franco Corelli
Fritz Wunderlich (all Mozart)
Giuseppe Di Stefano
Callas (with that unique tragic vibrato…)
Ileana Cotrubas (one of my favorites too)
Angela Gheorghiu
Sylvia Sass
Alfred Deller
Dietrich Fischer-Dieskau
Matthias Goerne (I love this great musician whom I saw in 2001 in Salzburg accompanied by the immense Alfred Brendel, forming a magic, harmonious duo at the Mozarteum)

Gwyneth Jones
Irmgard Seefried
Elisabeth Schwarzkopf (*Ariadne auf Naxos* and the Lieder of Hugo Wolf)
Elisabeth Söderström (for Janáček)
Hans Hotter
Hugues Cuénod
and Jessye Norman (whom I have heard so many times)
Leontyne Price

Amira Casar is a European actress born in England and raised in England, Ireland, France, and Wales. She studied at the Paris Conservatory of Dramatic Art and has been in more than seventy feature and television films including the internationally acclaimed *Call Me by Your Name* by Luca Guadagnino. She has worked with directors Carlos Saura, Catherine Breillat, the Brothers Quay, Bertrand Bonnello, and Werner Schroeter among many others.

THE WILL TO POWER,
THE WILL TO FEAST

Thaddaeus Ropac

My first overwhelming experiences with the existential element intrinsic to opera were direct-
ly connected with the Salzburg Festival. It is a daunting realization: of the one hundred years
of the Salzburg Festival, I can look back on almost forty of them! Since it was the performanc-
es in Salzburg that significantly shaped my opera experience, I would like to describe one
production from each decade, not only because I have vivid memories of them, but because
I think that each one of them was done by an individual who set out to find answers to the
question of the fundamental nature of opera. Four examples of such innovators, who were
never satisfied with what they had achieved, are Herbert von Karajan, Peter Sellars, Martin
Kušej, and more recently Asmik Grigorian.

August 15, 1987: Großes Festspielhaus, the Vienna Philharmonic under the direction of
Herbert von Karajan featuring American soprano Jessye Norman. In addition to the overture
to *Tannhäuser* and the "Siegfried-Idyll," which were performed at this matinee, I particularly
remember Isolde's "Liebestod" from the opera *Tristan und Isolde*. The great singer's passing
in September 2019, which sent the music world into mourning, revived this memory all the
more poignantly.

August temperatures in 1987 were relatively subdued, but passions were all the more
inflamed when the last note of Isolde's "Liebestod" had faded. Being an inexperienced op-
era-goer at the time, I was overwhelmed by the wave of enthusiasm that swept through the
audience, only narrowly escaping the spontaneous impulse to follow Isolde to her love-death:
"mild und leise wie er lächelt[e],: ertrinken, / versinken – / unbewußt – / höchste Lust!" The
magical interplay between the Vienna Philharmonic under Herbert von Karajan and Jessye
Norman's voice revealed layers of interpretation I had never imagined—it was like being
present at an archaeological excavation.

In *A Pilgrimage to Beethoven*, the young Richard Wagner wrote, "All my thoughts
became one wish: to see Beethoven!" Analogously, my every thought became one wish: to
see the next and then the next performance by such great artists.

August 16, 1998: the weather was radiantly fair that day, with a few scattered clouds, and very
warm. You could say something similar about the performance of Olivier Messiaen's *Saint
François d'Assise*, above all, the word "radiant." Peter Sellars's production was otherworldly

and George Tsypin's stage design simply breathtaking—at times, you didn't know where to turn and look first. After this performance, one would have liked to become a Franciscan friar, provided, of course, that this order still had anything in common with its namesake, to whom, according to his "Canticle of the Sun," the sun, the moon, and the stars became sisters and brothers, as did the winds, mists, and springs; fire and earth; the varied fruits with colored flowers and herbs; and ears of corn, and even death.

My eyes and ears were dazzled by all the chord colors Messiaen reflected in the birdcalls and the images on the multitude of monitors George Tsypin used in his stage set. One wondered how many birdcalls Messiaen might have collected to be able to compose such a piece of music, with all its harmonic twists, surprising innovations, all the way to the most organized form of disorder. According to legend, this collection amounts to more than a legion.

July 27, 2002: "Warm, partly cloudy, occasional showers" is what I found in the METEO-data database. Though for the life of me, I can't remember what the weather was like on that day, Wolfgang Amadeus Mozart's *Don Giovanni* in Martin Kušej's production remains indelibly etched into my hippocampus. Indeed, this performance plunged into me like a knife. I can't describe it any other way. Martin Zehetgruber's impressive sets also played a crucial part in this: from the Palmers stocking scene at the beginning, which had all the makings of a major advertising campaign, to the finale, in which a group of elderly women bares all, pointing their fingers at Don Giovanni and laughing. They were pointing, not so much with a moral index finger, one that extends to the high heavens as often seen in productions of *Don Giovanni* and their depictions of the Stone Guest or the Commendatore. Here, as is often the case— demonization is heroization. Indeed, in this production, the statue of the Commendatore resembled an automaton remotely controlled by a higher but questionable morality; you didn't know whether he was driven by some form of vindictiveness or if he was purely and mechanically following the logic of revenge.

Hence, even Martin Kušej's finger-pointing turned into a celebration. And if a certain morality inevitably arose in some places, it was exaggerated to the point of grotesque caricature. Here Friedrich Nietzsche's "Will to Power" became the "Will to Feast"—an idea I owe to Wendelin Schmidt-Dengler. Or rather, Giovanni's Will to Power was compounded by his Will to Feast, driving him to shamelessly exploit any festive occasion.

Almost like a stubborn child, he demands, "I want my feast!"—and his feast he will get. The feast is at the root of the creative principle underlying all other forms of exaggeration and hyperbole, all manner of excess and exuberance. And Martin Kušej succeeded in pushing this principle to the limit, letting the feast grow into a universal one of the senses—eyes, ears, nose, hands—into an almost complete encyclopedia of the feast. "A tutti in abbondanza" ("to all in abundance"), as Don Giovanni proclaims at one point.

One aspect, in particular, sets Martin Kušej's production apart from all the others: it threw into stark relief the fact that there can never be a sad feast. Even death and feast are perfectly compatible. In the end, this *Don Giovanni* was also a tragic farce about the death of the phallus—a farce elevated to a feast.

August 28, 2018: cooler with some rain—finally! You probably don't have to check the weather records to remember the "summer of the century" that broke heat record after heat record. Suddenly, all around us, the atmosphere was marked by sheet lightning and falling temperatures—except inside the Felsenreitschule where Romeo Castellucci's production of *Salome* ushered in a new aesthetic in direction, costumes, and set design. At the same time, Asmik Grigorian, Lithuanian soprano discovered by Markus Hinterhäuser, fundamentally transformed the figure of Salome. At first, she was the princess of the feast (even if it was Herod's sinister birthday party) who gradually became the princess of darkness.

The favorite line from the *Fledermaus* aria: "Ich lade gern mir Gäste ein" ("I like to invite guests") also applies to Oscar Wilde's Herod. The latter loves to invite guests, who in turn become witnesses of the increasing darkness that descends on the entire scene. We in the audience became witnesses of this darkness, which also, or rather, significantly, did not spare Salome. It's hard to find a better description of the state that gripped Salome in Asmik Grigorian's interpretation than the one in Gerhard Rühm's epilogue to his *Salome* translation (1983): "But the world Salome wants to be a part of is no longer hers. The wide-ranging monologue, elevated to a trance-like state, is an expression of total isolation from an environment lashing back at her with lethal blows."[1] It's as if he had been sitting next to me during this performance and written down this sentence in view of and listening to the voice and expression of Asmik Grigorian.

In essence, the world we had belonged to just a moment before was no longer ours after this *Salome* production, so profoundly and lastingly were we touched by the haunting images and voices Romeo Castellucci had put in our heads and ears.

[1] oscar wilde, *salome*, drama in einem akt.
nachdichtung von gerhard rühm (Frankfurt
am Main: Verlag der Autoren, 1983), p. 67.

World-renowned Austrian art dealer with galleries in London, Paris, Salzburg, and Seoul, Thaddaeus Ropac founded his first gallery in 1981. In the early 1980s, as a freelancer in New York City, he became acquainted with American artists such as Andy Warhol, Jean-Michel Basquiat, Keith Haring, and Robert Mapplethorpe, and was one of the first gallerists in Central Europe to exhibit these artists.

WORKING IN THE SHADOWS

Jérôme Brunetière

I am one of those people who has always worked in the shadows of a big opera organization. Currently, I am the "Secretary-General" of the Aix-en-Provence Festival—a lofty French term used to designate the individuals in opera houses, theaters, and festivals in charge of the public relations before, during, and after the performance.

My responsibilities entail coordinating ticketing, audience reception, communication, marketing, press relations, educational, social, and artistic services departments. I'm also managing the media: radio and television companies who film our productions for their broadcasts and websites. Furthermore, I spearhead the search for sponsorship abroad.

My first job in this domain was that of "Commercial and Marketing Director" at the Paris Opera starting in 2004, under the direction of Gerard Mortier. I was thrilled to accept the position, and the chance to work with the great intendant, although it brought a definitive end to my singing aspirations as a chorister at the operas of Lausanne and Geneva.

Between then and now, and with fifteen years of hindsight, I can see how the profession has evolved. I remember a colleague saying to me back in 2005, "Five years ago, we never looked at the sales figures because everything was sold out by definition." Indeed, in the early 2000s, the demand for opera tickets was far greater than the supply. Now in 2020, more or less, all opera houses are having severe difficulty filling seats. In response to this, our daily challenge in the back office has gone from juggling with an insufficient number of places to searching for a pro-active plan for filling them.

This downturn in attendance is all the more baffling given that the last years of the 1990s and the first years of this century marked the opening of many new opera houses: Opéra Bastille 1989, renovation of the Lyon Opera 1993, a new opera in Gothenburg 1994, Tenerife 2003, Valencia 2005, Copenhagen 2005, Aix-en-Provence 2007, and Oslo 2008, to mention just a few. From my current vantage point at the Aix-en-Provence Festival, this downward slope has not been as steep for major European festivals as it has been for opera companies, largely thanks to the loyalty of international opera goers. However, let it be said that if the productions at Aix-en-Provence still show a very high attendance rate, this is thanks to concerted efforts and innovation in communication and marketing on the part of our team, as well as the emergence of an energetic educational program.

However, regardless of whether we're referring to opera houses or festivals, can we really talk about an opera crisis? Apparently yes, because we can observe this phenomenon

in all countries where opera is an established tradition and in the territories of Asia or the Middle East where new opera houses have opened. But are these necessarily the signs of an inevitable decline? I'm not convinced.

In the meantime, one victim of this temporary decline is undeniably the repertoire: the public is less and less amenable to taking risks with the new, preferring what they consider to be sure values, meaning the hit-parade of the repertoire. Consequently, the opera houses are taking fewer risks in their programming choices to the detriment of contemporary creations and the twentieth-century repertoire, a bit like Hollywood where assured returns at the box-office and the sure-to-win blockbuster recipes complete with prequels and sequels dictate the rules of the game.

The 2019 Festival ticket sales demonstrate this wariness of the new: *Tosca* was sold out with 98 percent occupancy for eight performances, while barely 65 percent of the seats were occupied for the three performances of Wolfgang Rihm's *Jakob Lenz*, an opera that premiered in 1979.

What can we do? Marketing teams must increase their inventiveness in communicating to spectators, using all the resources and advertising available to persuade them to choose the widest variety of shows on the season's playbill—and not just the favorites. Time has shown us that these concerted efforts, aimed at people who are already operagoers, are effective and have become more and more fine-tuned as the marketing teams implement them and gain experience.

A more significant challenge yet is that of reaching new spectators. Europe's iconic opera houses are situated in the centers of our historical cities, yet what happens inside these monuments is not visible. It's challenging to promote opera to someone if they've never crossed the threshold of an opera house—you don't fall in love with opera by reading a post on social media. Therefore, it is essential to create opportunities for individuals to experience a first opera performance to whet their appetites.

I enjoy asking opera fans about "their first time" or how their love for opera began. The stories sometimes resemble a "love at first sight" scenario with a new companion or perhaps being taken to the opera as a youngster by a grandmother or an uncle—the revelation can take place at any age. Therefore, organizing this baptismal experience has to be a priority for opera houses.

Thinking back to my own "first time," if I had not sung in a children's choir in the north of France and if this choir had not been invited to sing the children's chorus in *Tosca* and *Carmen* at the Lille Opera, I would not have developed the passion, which led me to pursue this profession so ardently.

As a result, I feel strongly that educational programs are essential, especially for a younger public. When we inaugurated ours at the Festival d'Aix-en-Provence back in 2007, many asked why an educational program in a festival only lasting a few weeks in summer? The fabulous results of this initiative quickly put an end to all controversy.

More than 5,000 people participate in our educational programs and conferences every season. The approach is multi-faceted and adaptable to the various categories of participants:

school children, young students from junior and high schools, and adults from different groups and associations.

One of our signature initiatives, OPERA ON, is aimed at young people aged twenty to thirty. These young adults, who are not all in university, have a wide range of pursuits and professions and are consequently more dispersed and difficult to reach. Therefore, we have to find a way to convince them to register individually for a program about something unknown and which a priori doesn't interest them. However, in the age of social networks and influencers where the number of "likes" and "views" are paramount, how do you create enthusiasm? Quite simply by making sure that those who have attended the show have "liked" it!

With this in mind, we developed a core of young opera enthusiasts/influencers who are encouraged to pursue their passion through opera-related activities during the year and then rewarded with quality seats at reduced prices for the Festival—on the condition that they bring their friends! Wager won, we managed to build up the young spectators' loyalty by offering them evenings to meet artists and activities to familiarize themselves with the new productions on the season's playbill. When July comes around, they are provided good seats at 9 euros (against more than 150 at the regular price); their enthusiasm is overwhelming, and they return year after year!

The popularity of the OPERA ON has been immense; consequently, the five hundred places offered each season are never enough to meet the demand. However, such an initiative comes with a price tag, and it goes without saying that reducing tariffs generates a short-fall, which must be compensated by sponsorship. Despite this, we are initiating yet another program for the over-thirty generation to avoid the jump between the reduced rate and the standard rate being prohibitive.

One of OPERA ON's many positive repercussions is that young people recommend new works to their elders. For example, their enthusiasm for Rihm's twentieth-century masterpiece *Jacob Lenz* and director Andrea Breth's extraordinary staging helped build awareness around this powerful work and overcome prejudices regarding contemporary operas. Proof that the experience of seeing opera for the first time leaves a lasting impression, which one transmits to others.

Nowadays, we go less to the opera through social determinism or family tradition than in the past, and for this reason, opera institutions have the collective responsibility of taking on the role of meeting and attracting the public. As a result, when students from Aix or Marseille who discovered opera at the festival go on to build their futures and careers in Europe and abroad, they will take that experience with them, and with it, the desire to cross the threshold of the opera house wherever they are.

The other reason why I believe opera is not in decline is that the quality of opera productions never ceases to grow. A new generation of singers with impeccable technique, endowed with real acting talent, is graduating from conservatories and academies and beginning promising careers on the world's stages. Festivals and opera houses, even smaller ones, have high-quality orchestras; the staging requirements have never been higher. Opera is in good health!

As one of those working from the shadows assiduously searching for inventive paths to bring new spectators to the opera, I know that we can only accomplish this over time. The good news is that the results are there and have already demonstrated that opera is far from living its "Last Days."

Richard Peduzzi,
Untitled, 2004
Gouache and pastel on
paper, 6.5 × 17.5 cm
Design for *Hercules*, Georg
Friedrich Händel, Festival
d'Aix-en-Provence, 2004.
Direction: Luc Bondy
Courtesy of the artist
© Richard Peduzzi

General secretary of the Aix-en-Provence Festival and newly designated director of the
Academy and of the Mediterranean program of the festival, Jérôme Brunetière has been
particularly active in expanding opera to new venues and audiences.

RUTH BADER GINSBURG
AT THE OPERA

David Pittsinger

As I sit in front of John Jay's bookcase, personal library, and letters, I can't help but draw the parallels of our country's first Chief Justice, abolitionist, and Founding Father to one of our most influential contemporary Founders—Ruth Bader Ginsburg. She was an architect of women's rights, gender equality, and made it unlawful to discriminate based on race, religion, gender, creed, or homophobia, and forged and refined how the law is applied with equality and justice for all. Our newest "Founder" will be remembered for elevating the status of humanity with her towering intelligence, wit, sense of humor, and humility; all this through her daily example seen in her relationships with colleagues, family, friends, and artists alike.

I first met RBG at The Glimmerglass Festival in 2002 while singing in a new production of Händel's *Orlando*. We were told just before the curtain went up that she and her security detail would be sitting in the audience. My throat started to get tight, and despite the 92-degree heat and high humidity, a cold sweat began to drip under my heavy makeup and heavier costume. I noticed her immediately: small, impeccable in a cotton print dress. A detail: her shoes were in her lap; I guessed it was so her feet could be in direct contact with the cool cement floor in the theater. Then I saw her take her shoes and put them on the floor. Upon meeting her after the performance, feeling at a loss for words and socially clumsy, I asked her if she enjoyed the performance and why she put her shoes back on the floor. She said she felt as if I were singing only to her and didn't want to make me feel like she could possibly be any hotter than I was. I told her I was singing to her and that the cold sweat she put me in was a welcomed one in her presence.

Thus began our friendship. A later performance of *South Pacific* at the Kennedy Center had RBG and her friend and colleague Justice Scalia in the front row. Afterward, she came backstage and complimented me on the performance and the relevance of this work in our country's past and present.

She then asked me to sing on a "musicale" in the chambers for the Supreme Court. Justice Scalia began making suggestions for specific arias. They both knew the repertoire better than most opera/theater/concert impresarios; RBG was known as The Supreme Impresario. Being invited to sing for the Supreme Court was the greatest honor I could imagine especially coming from someone I had grown to love and idolize. She had great taste but never had to "justify" it or make an argument for it; unlike in a court and law, it was subjective, not

objective. Her example of having differing opinions and being in disagreement with someone without being disagreeable was a life observation and lesson for me. Her support of artists, encouraging our storytelling, and vulnerabilities elevated her in our eyes and elevated all humanity. The early Founders of this country would be as proud as we are. She is loved, missed, and never forgotten as her example lives on. Rest in power, strength, and peace, our beloved RBG.

September 2020

American bass-baritone renowned for his dramatic portrayals in the world's major opera houses. David Pittsinger's wide-ranging repertoire includes many Baroque operas and the Mozart protagonists up to great dramatic roles such as Scarpia. He has also been acclaimed for his many performances of Nick Shadow in Stravinsky's *The Rake's Progress*.

SEMPRE LIBERA

Wolfgang Titze

The 25th of August, 1959, in Salzburg, was one fateful day that abruptly changed the trajectory of my life. I had just listened breathlessly to Glenn Gould's interpretation of Bach's *Goldberg Variations*, and I was in shock. The experience of this heaven-sent genius had made it crystal clear to me that I had no future as a pianist. When I returned to Vienna, I told everyone that my piano career was over, and I would change to a different course of study.

On my way to the 1966 Salzburg Festival, I visited writer Thomas Bernhard on his farm. In the course of the long evening we spent together there, I told him my Glenn Gould story. Years later, I was in for quite a surprise when I read his new book *Der Untergeher* (The Loser) in 1983. It tells the story of a pianist who abandoned his career after hearing Gould in Salzburg. In 1986, I met Bernhard again in Salzburg but did not broach the matter with him. I recently mentioned this coincidence to Markus Hinterhäuser, who said he thought that I had probably provided Bernhard with the inspiration for his book. So much the better if, on top of everything, my decision had the wonderful side-effect that the impact Glenn Gould had in Salzburg is now forever inscribed in our literature.

The end of my piano career also marked the beginning of my strong dedication to opera. To cover the cost of my studies, I worked as an extra at the Wiener Staatsoper from 1960 to 1964. It was one of the most exciting periods in the house's history, with Herbert von Karajan as director and, towards the end, with Rudolf Nureyev as dancer and choreographer. These were decisive years for my understanding of opera and its complex integration of several art forms.

Richard Wagner aptly described this synthesis of the arts as a *Gesamtkunstwerk*, which is frequently translated as "total artwork." The crucial point here is that equal weight should be given to each art form involved. Wagner's entreaty was that each of these exercises restraint for the sake of the whole; above all, the music should not be allowed to eclipse the drama. Let me repeat—the music must not be allowed to eclipse the drama.

But that was more or less the case in those days. The main focus was on the conductors and most of all on the singers—as evidenced by heated and passionate discussions in the standing room section. It was incredibly inspiring to experience Herbert von Karajan (the dictator), Karl Böhm (the gracious one), James Levine (the introvert), Leonard Bernstein (the exuberant one), and Claudio Abbado (the elegant one) at once as personalities and artists at work. As diverse as their characters were, so was the music they brought forth as conductors.

But the singers were put even more in the spotlight. It would be beyond the scope of these lines to give even the most cursory consideration to the richness of these voices. Still, who could ever forget Luciano Pavarotti's Stretta ("Di quella pira," *Il trovatore*), which he repeated three times in a row, concluding each time on a never-ending high C. Or Birgit Nilsson's interpretation of the "Liebestod" from *Tristan und Isolde*? Or so many others… All of these are instances of ramp singing, strongly frowned upon today, whereby the singers stood right at the front of the stage, directly facing the audience, with a few gestures of course, but, above all else, with a voice.

The stage productions were not as important then as they are today though stage designers such as Günther Schneider-Siemssen and Jean-Pierre Ponnelle were the tried and tested companions of Herbert von Karajan, as was Otto Schenk. The Karajan productions I remember most vividly for their staging are his *Tannhäuser* and *Parsifal*. The more exhilarating the music, the quieter and more static the action on stage. Black, dark blue, and dark green curtains created a gloomy and, at its best, mystical atmosphere. Back then, things only got exciting when Franco Zeffirelli staged his groundbreaking *Bohème* in 1963 (with Mirella Freni and Gianni Raimondi). This production is still in the Vienna repertoire and delights audiences to this day. But basically (and this was reflected in the opera reviews) the merits of the stage production were only addressed after the analysis of the musical performance.

In the 1970s, my career led me to move to Frankfurt.

With General Music Director Michael Gielen (1977–1987) at the helm, the Frankfurt Opera became one of the leading opera houses at a time when the term *Regietheater* (with a strong Germany focus) was coined. I can still remember vividly the excitement that ensued when Ruth Berghaus staged *Der Ring des Nibelungen* in Frankfurt in 1985. Siegfried walked around the stage dressed in track pants and a gym shirt, shadowed by a boy wearing the same outfit. A brilliant idea, which made it clear that Siegfried had never outgrown his boyhood clothes. At the time, this was enough to cause an outcry in the press. Today, ideas like these would be considered normal in a production. Some years earlier, in 1976, the so-called *Centennial Ring* of Pierre Boulez and Patrice Chéreau had already caused the "scandal of the century" in Bayreuth. Turmoil broke loose during the performances, continuing outside the Festspielhaus; Chéreau even received death threats. A similar-looking scandal took place when Peter Sellars brought out his Da Ponte Cycle in Boston in 1984—and subsequently in Europe—with his modern interpretation of *The Marriage of Figaro*, *Don Giovanni*, and *Così fan tutte*.

What took place? During this period, staging gained significantly in importance. The director would become an artist who brought his personal interpretation to the realization of the work—this inevitably ushered in the idea that every artist should be allowed to impose their interpretation. There were fierce discussions about this development and the "excesses" of *Regietheater* in particular. Of course, there were valid arguments on both sides, especially in other countries where the director—often in agreement with the conductor—would make changes to the dramatic content as well as to the music. Conservative operagoers and critics alike claimed that if the developments of the last twenty years continued in this direction, the operatic genre as a whole would be in danger.

I would argue that every artist should be given the freedom to develop his or her interpretation. In this context, I would like to return once more to my "hero" Glenn Gould, who once said: "If you can't record a piece differently than the way it has been recorded in the past, then it is not worth recording." Yves Klein, the co-founder of the Nouveau Réalisme movement, put it this way in the 1950s, "Art is absolute freedom, it is life. As soon as it is caged by something, freedom is under threat, and life becomes a prison."

What is often overlooked in these fierce debates is that the demand for the freedom of artistic expression naturally applies equally to all art forms within the opera: the conducting, the singers, and the directing.

Let's start with the conductors.

For them, freedom of interpretation has always been a given. Is it not baffling that, according to long-term records kept in Bayreuth, the total duration of *Der Ring des Nibelungen* is sixteen hours on average and differs by more than two hours (Knappertsbusch, being the slowest, contributed the most to this large discrepancy)? Nikolaus Harnoncourt, the revolutionary whom I'm not the only one to revere, explored the idea of "Musical Discourse" ("Klangrede") through the use of original historical instruments in his Concentus Musicus, among other things, thus providing us with an entirely new understanding of the composers and their works. As he said, "How can we play music in yet another way instead of forever harping on the same old string that was common in the mid-1950s?" In Salzburg, Mariss Jansons offered an unforgettable *Lady Macbeth of Mzensk*—pure Shostakovich, and then, a few weeks later, Kirill Petrenko conducted the same piece in Munich in an almost lyrical style—quite fitting to the colorful staging by Harry Kupfer. Or, Teodor Currentzis and his musicAeterna—in my mind, he is the Glenn Gould of young conductors— always searching for new interpretations. But isn't that exciting, isn't that precisely what makes and keeps alive every form of art—never standing still, never merely repeating, but always on the lookout for new iterations?

When it comes to singers, we should keep in mind to what extent the range of their tasks has grown over the past decades. Above all, consider how much the immense pressure to combine singing and acting has changed the art form and how it inevitably leads to highly diverse interpretations. For example, I will never forget Natalie Dessay as Zerbinetta in the Paris production of *Ariadne auf Naxos*. She sang the wonderful aria "Großmächtige Prinzessin" in a bikini and with her body in a backbend—there could not be a more compelling expression of her role as leader of a dance troupe. Or Marlis Petersen, who sang a breathtaking Lulu in Munich, fully engaged in the physical embodiment of her role. Or the great Christopher Maltman as a "boxing" Oedipe in Salzburg. And all this is achieved without compromising the quality of the singing. On the contrary, the intensity of the overall experience for the viewer/listener is increased significantly.

Another major factor contributing to the raised intensity of the operagoers' experience is that in almost all the opera houses today, they can read the text on the monitors. As a result, the audience acquires an improved understanding of the events on stage and becomes more involved. An additional challenge for the director to live up to! With the help of surtitles, the psychology of characters and the plot's inner meaning become considerably more trans-

parent for the viewer, much more so than reading a summary ever could. Furthermore, he or she is finally exposed to the art form of the libretto—and thus to the opera's original form as a unity of word and singing. The weight given to one art form over the other has been the subject of highly diverse discussions for centuries. "Prima le parole? Prima la musica?" is the question that has frequently elicited controversial answers. Richard Strauss's last opera, *Capriccio* (based on an idea of Stefan Zweig), addresses this question in an almost philosophical manner. Ultimately, this leads to the only possible conclusion: in opera, words and music form a unity, in the form of symbiosis—in that they complement and inspire each other. This insight brings us full circle to Richard Wagner's entreaty mentioned earlier, namely that with the *Gesamtkunstwerk*, "Every art form needs to exercise restraint for the sake of the whole. In particular, music must not be allowed to eclipse the drama."

In these brief personal recollections, it has become apparent just how much the balance has already shifted; you can no longer compare the opera of the 1960s with today's performance practice. Indeed, what has taken hold since the beginning of the twenty-first century amounts to a quantum leap. Inevitably, the danger is that the balance between the art forms involved in opera will be thrown out of joint altogether. Opera must be preserved as an integral art form. Therefore, we must ensure that music does not devolve into mere film music and that directing does not become pure show. More importantly, neither the

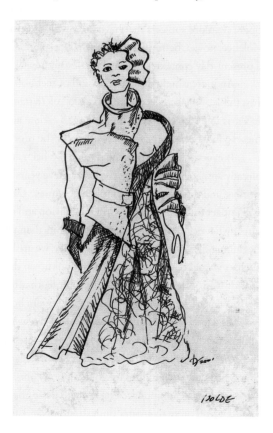

Daniel Libeskind, *Isolde*, 2001
Ink on paper, 30 × 20.5 cm
Costume design for
Tristan und Isolde, Richard
Wagner, Saarbrücken State
Opera, 2001.
Courtesy Studio Libeskind

music nor the plot should be demolished and deformed to the point where we can no longer recognize the original work. Let's not forget, the composer and librettist are still the creators of an opera—everything that follows is artistic interpretation.

If this principle is firmly embedded, we can continue the progress made in recent years. Opera does not exist in a vacuum—it has and will continue to imbue the cultural environment that fulfills and influences us. Otherwise, it runs the risk, in the interim, of fossilizing and being relegated to a thing of the past. Therefore, I would venture to answer the implicit question in the title of the present book, *The Last Days of the Opera*—and its allusion to Karl Kraus's doomsday scenario—with a much more optimistic outlook:

> "all that we have experienced in recent years is not only a new form of directing—it is the beginning of a new, forward-looking form of opera."

There are several reasons for this. One of the most crucial being that more and more people from related art forms have shown interest in and commitment to the opera. Visual artists and architects act as stage designers and directors; many choreographers and theater and film directors are magnetically attracted to the opera. These encounters between the arts engender a cross-fertilization and, in turn, a new stage language.

Another reason is the increased focus on contemporizing narrative content. Classical operas explore subjects that have been with us throughout human history—love, hate, sex, violence, power, betrayal, and so forth. Doesn't that challenge us to transpose these plots into a present-day context? They are as relevant now as they ever were and will continue to be.

An increasingly rapid succession of technological leaps has taken an important role. Just think of the heavily criticized version of *Tristan und Isolde* by Bill Viola and Peter Sellars in Paris in 2005, with the stage-filling, by some accounts, intrusive video artwork, which inescapably became the main focus—now the production is a classic.

Is everyone aware that the iPhone has been around for only twelve years? And can we already anticipate today what the next twelve years will bring in terms of technological innovations, and thus also in our minds and cultures? Do we have any idea today how social media will impact future generations, their behavior, and aspirations? At the present moment, they already have radically different visual habits than previous generations. And that's only the beginning. If we think another step further, we are bound to realize that future technologies, such as virtual reality and other, as yet unknown digital formats, will also change the opera world. It is quite conceivable, for example, that the opera will find entirely new forms of performance—both inside and outside of opera houses.

As a passionate enthusiast of so-called "New Music," namely the music of the twentieth and twenty-first century, I am optimistic that these developments will bring about a fusion of the forms of expression characteristic of classical and modern operas. Could this reconciliation possibly spark impulses for contemporary music? Could this be an accelerating factor for the upcoming generations to engage with these challenging compositions more profoundly? Could it lead them to greater understanding and appreciation of this music of their age?

This idea has frequently occurred to me in recent years when I compared productions of "Old" and "New Music."

There are many more examples of silver linings. I am thinking, for instance, of the unforgettable production of the opera *Jakob Lenz* by Wolfgang Rihm in Aix-en-Provence (directed by Andrea Breth); of *Das Mädchen mit den Schwefelhölzern* by Helmut Lachenmann in Zurich (as a ballet in the choreography of Christian Spuck); or of *Orest* by Manfred Trojahn (directed by Marco Arturo Marelli) in Vienna, an achievement I will never forget. And almost all of these productions bear comparison with those of Krzysztof Warlikowski, Romeo Castellucci, Simon Stone, and other "modern" directors and their predominantly classical repertoire.

The opera is, after all, this unique combination of different art forms—so why shouldn't theater be the element that transforms the viewers more and more into listeners, thus bringing them closer to the music, which cannot be perceived as beautiful ad hoc—treasure must be acquired through intensive learning. Perhaps this harks back to how we had to learn to understand Glenn Gould—and applies here today and in the future.

Born in Vienna, Wolfgang Titze studied to be a business consultant in the United States before founding his own consulting company in Europe. He later became co-founder of the global consulting company Gemini Consulting. He and his wife have built up a major art collection, which was featured in the exhibition *Love Story* at the Belvedere Museum, Vienna, in 2014.

SEMELE IN CHINA

Lady Linda Wong Davies

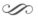

The KT Wong Foundation has now been in existence for over a decade. Our aim is to be a catalyst for the creation of global dialogue by means of innovative, accessible and relevant work for worldwide audiences.

The origins of the Foundation go back more than a decade to a time when my father, Dato Wong Kee Tat, had recently passed away. I wanted to do something to commemorate what he had done in business as well as in the world of philanthropy, but I wanted to do it in my own way in order to make it more relevant to my generation.

Born in Indonesia, my father emigrated to Singapore and finally to Malaysia, where he and his brother started their business empire and became two of the many successful "Overseas Chinese."

Though they didn't speak much English, they both had a great love for western classical music, especially western opera. We were brought up with classical music, or French, Italian, or German opera, reverberating throughout the house every Saturday and Sunday.

Hence, if the inspiration was initially my father and his cultural interests, which I inherited, the spark was his death—an event that inevitably concentrates one's mind on one's heritage and on what one wants to do with one's life.

At that time, I was thinking about the growth of China and about what our motherland could bring to the rest of the world apart from mere economic might.

Forming a Foundation in my father's memory and naming it after him were ways in which I could honor him and my heritage. Of course, western classical music was key, just as performance was key. I also wanted to bring Chinese culture to the world: not just traditional culture (5,000 years of it!), but also contemporary Chinese culture, in order to explore how China would create its own role in a globalized world.

I wanted to create platforms as catalysts for cultural diversity and for all sorts of artistic disciplines: our mission continues to be to build cultural bridges involving different countries.

The Foundation seeks to commission, to produce, to sponsor, or to be—in the largest sense of the word—a patron, not only for Chinese work, but also for work from the rest of the world: to bring the old into the new, but also to give new work clear cultural or historical references enabling it to mean something to today's generation and to the generations still to come.

This is what informs me, my team and my board when we look at different projects. It is important to have goals and a mission statement, but the work has to have wider references if it is to stand a chance of remaining relevant.

Our projects usually begin with China—though not necessarily only China: we always ask ourselves not only what we can bring to China but also what China can bring to the rest of the world.

Though our remit is wide, from the beginning, opera has played an important role in our task of cultural exchange. One of our largest projects was Händel's great oratorio *Semele*: 2009 was the 250th anniversary of the composer's death, and I thought that here was a wonderful opportunity to bring Händel and Baroque music—so beloved of the British public, but at that time unknown in China—to a huge market hungry for something new and different.

I also liked the idea of an oratorio based on the Greek myth of Semele from Ovid's *Metamorphoses*. 2008 was the year of the Beijing Olympics, when the whole world began to comprehend the new power of China. Here was an eighteenth-century Baroque opera whose story had a very interesting meaning for a newly emerging country.

Händel's heroine is a beautiful young princess with ambitions to become a goddess. That reminded me of what it was like to be a part of contemporary China—an outwardly, upwardly mobile society that was changing right before our eyes, making *Semele* a suitable tale to bring to Chinese audiences.

Of course, the plot has great tragedy and great humor, but it's also a tale of love, obsession, sex, revenge and jealousy—all the themes of a Chinese soap opera! The score in itself is, of course, outstanding, with many wonderful arias one after another, a bit like a Händel hit-parade!

We needed a great creative figure to design and direct this eighteenth-century opera, and I found one: it was my dear friend, the great collector and gallerist Pearl Lam, who introduced me to Zhang Huan, one of China's greatest avant-garde artists—perhaps even a bit of a renegade.

Some people were shocked when I picked him. First of all, until I met him, he had never even been to an opera; secondly, he didn't speak much English. In any case, there was something in his body of work that spoke to me.

I had the whole of Congreve's libretto translated into Mandarin and sent him some recordings. I felt that he would understand this story about gods and humans, with all their frailties and foibles, and he did. He had also come upon a beautifully carved five-hundred-year-old Ming temple that was completely intact and which would become the inspiration for his set design and his narrative.

Zhang Huan gave us an extraordinary interpretation. Co-produced with the Théâtre de la Monnaie in Brussels, the production has gone on to be staged in Beijing, Toronto, and at the Brooklyn Academy of Music in New York.

Semele was the first full Baroque opera to be staged in China: until then, the operatic diet all across the country was mostly Puccini, Verdi and Rossini, with some Mozart every now and then. Back in 2010, when *Semele* was invited for the first time to the Beijing Music Festival, this was exotic fare indeed, with a tantalizing twist of being designed and directed by one of China's most famous artists.

Our production had a flying Semele, some nudity, lots of rollicking sex onstage amongst the chorus—now dressed as Buddhist monks and nuns—and even Sumo wrestlers; but apart

from the five-hundred-year-old temple, one of the more salient features of the production was a dressed-up donkey with a ginormous phallus, producing (in Zhang's Huan's eyes) some distinctly rustic Chinese humor.

I have never understood why Zhang Huan wanted Sumo wrestlers, and I will never forget interviewing a pair of them—fully clothed, of course—in a famous duck restaurant in Beijing. However, Peter de Caluwe, my wonderful co-producer at La Monnaie, was more indulgent than I was, and so they remained in the show, which was definitely one of the most exciting and beautiful ever created at La Monnaie. Peter had such confidence in me and Zhang Huan that he programmed *Semele* to open their 2009 season, resulting in nine sold-out performances.

I think it says a lot for maestro Yu Long and myself that we charged ahead to put on the show despite all the nightmarish logistical and myriad governmental obstacles that were put in our way. It had only one performance in Beijing, with full cast and chorus, costumes, lighting, backstage crew from Europe and orchestra! And we still had to fight to secure the one available harpsichord in the whole of China!

Another collaboration I'm very proud of is Benjamin Britten's children's opera *Noye's Fludde*, which we brought to China staged by a then very young director, Oliver Mears, originally for Northern Ireland Opera in Belfast. Now the artistic director of the Royal Opera in London, Oliver wanted to do it in a zoo, which I thought was a brilliant idea.

We were the first to bring a Britten opera to China. It was quite an endeavor because its Biblical story of Noah is obviously religious, and China does not allow religion. So how could we bring it and make it presentable?

I decided to concentrate on the environmental issue of water—still a big problem today in the twenty-first century—and also on something which we now call biodiversity but which Noah had already practiced in the pairing off of the animals.

When we co-produced the opera with the Beijing Music Festival, the Chinese authorities let it pass, though I was flatly refused the use of the Beijing Zoo. It really was just beyond the pale!

Beijing Music Festival then told me that they had an empty space in a shopping center in the middle of the city. Now Britten did not specify that he didn't want *Noye's Fludde* to be performed in a shopping center. He had said that he didn't want this little opera to be performed in a concert hall or an opera house, only in churches, school halls and community centers, but he never mentioned a shopping mall…

And so that's where we went—to a shopping center in the middle of Beijing, and then on to the urban jungle in Shanghai, where we were allowed the only green patch left in the middle of the Shanghai high-rise district. The production has continued to be restaged in many countries.

The Foundation's relationship with the Beijing Music Festival has remained strong. It began in 2010, though my friendship with its founder, maestro Yu Long, goes back much further—we are partners in crime in our pursuit of bringing to the country the best and the most innovative performers, orchestras and productions. In the summer of 2016, we jointly

presented another Britten opera, *A Midsummer Night's Dream*, in Robert Carsen's iconic staging (itself celebrating its 25th anniversary), which was originally created for the Festival d'Aix-en-Provence.

The Beijing Music Festival has gone to places where many fear to go, regularly pushing boundaries—something that is dear to the heart of my Foundation!

I'd like to think, for instance, that the Foundation was again a pioneer in bringing another famous British composer to China. George Benjamin's *Written on Skin* is a project, which I had spent three or four years promoting and preparing the ground for before bringing it to the Beijing Music Festival and also to Shanghai.

Considered by many to be a masterpiece of the twenty-first century, *Written on Skin* finally materialized in 2018. I had it translated from leading UK playwright Martin Crimp's original libretto by one of the best young playwrights in China. It went on to blaze its way through both Beijing and Shanghai!

In 2013, the Foundation had helped to bring *Parsifal* to the Beijing Music Festival via the Salzburg Easter Festival, which was performing Wagner's final music drama to mark the 200th anniversary of his birth. Both Yu Long and I wanted to bring it to China. The problem would be not only that it was too long but that it was also, of course, again too Christian in a communist country where religion is not allowed.

Yet once again, we were able to achieve this. One might never imagine that there are some 2,500 members of the Wagner Society in China, but for this extraordinary *Parsifal* production, they flew in from every part of the country, and the two performances have seared themselves into the collective memory of Beijing audiences.

Relevance is always central to our thinking in terms of the operatic work we initiate and support, but today, due to Covid, a bigger question might concern the relevance of opera itself.

We must ask ourselves whether the models we are used to are still relevant. Is opera sustainable in its current form? Can we create something more efficient without sacrificing the things that we value about it?

I'm optimistic that we will find a cure and that everything will eventually go back to normal, but do we want to go back to what we had before? Or do we want to create something different instead? And if so, how should we go about doing this?

I don't think that artistic patronage will disappear. On the contrary, I think that people will realize that the current dearth of performances of opera, dance, theater, recitals and concerts is causing great strain within society, not just creatively, but also psychologically and spiritually, and especially amongst the young—the artists of today and tomorrow.

The Foundation always has projects on the back burner, but everything in life is about timing. Talking and listening to people is vital, as well as exploring how we can foster collaborations.

I am optimistic that in the end, things will level out. Though this may not be a popular remark, there are some things that need to go because they have been inefficient: that's just the way it is. Hopefully, we will have a leaner, tighter type of artistic economy in the future.

There will be fewer things happening, but patrons will inevitably be besieged with many more requests for help; possibly, they will think of different ways of helping organizations. Yet I want to take a longer, Chinese point of view of things—never just a two-year view, nor even a three-year view, but rather a five, ten, or fifteen-year view of where patronage and culture could be—should be—as we move forward into the future.

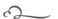

Born in Singapore to Chinese parents, Lady Linda Wong Davies grew up in Malaysia. With the aim of building cultural bridges between China and the rest of the world, she set up the KT Wong Foundation in memory of her father. As both a commissioner and a producer of new works, the foundation has supported many organizations and cultural institutions worldwide since 2008.

THE FUTURE OF OPERA.
NOTES OF A GRUMPY SPECTATOR

Margery Arent Safir

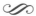

In the early 1960s and 1970s downtown New York arts scene, everyone ran around saying, "What are you working on?". Everyone answered, "The opera," Laurie Anderson told me in an interview. By that they meant the "work," *opus*, not "opera" as we habitually understand the word. Well in advance of the vogue of "multidisciplinarity," *that* opera, traditional opera, was "multidisciplinary" by definition: *Gesamtkunstwerk*, the total artwork, combining music, lyrics, movement, visual art (sets), costume design, narrative. Being "multiple" was opera's singularity. But today, everyone is working on an "opera." Installations feature music and visual art, performance art features music and film, museums set dance among visual artworks. Everything is everywhere as artistic disciplines meet on and off of the stage.

If opera is everywhere, if everything has become "opera," where is "the opera"? If what in the past was opera's specificity has now been so roundly co-opted, where can the opera go in the future?

I asked singer-songwriter-composer Rufus Wainwright, "When you compose the music and lyrics for a pop song, which is more important, the music or the lyrics?" "The lyrics," he responded. When he had written two operas, I asked him the same question again, but with regard to opera. "Which is more important, the music or the lyrics?" "The music," he responded.

I agree. The lyrics to opera music are rarely if ever great literary works. The most stunning aria can at times come down to "Please pass the mushrooms" (This is an actual quote from the supertitles to a Russian opera). Through music and voice, dramatic opera can profoundly unravel split-second emotions and human states into something much longer and larger, but the narratives themselves are for the most part variations on the themes of love and death, loyalty and betrayal, and almost never with a happy ending. For years Richard Wagner dreamed of writing a Buddhist opera. He never managed to do so, and perhaps the obstacle was that a Buddhist ending would have led to the sublimation of romantic love whereas for the romantic Wagner, the end had to be tragic and fatal. Only in *Wagner Dream* by Jonathan Harvey and Jean-Claude Carrière did Wagner's Buddhist opera get composed: in an imagined moment out of time between suffering a fatal attack and his death, Wagner composes the opera in his head, never to be transcribed or performed.

I have been invited here to give my personal account as a spectator, as to the future of opera. Faced with such a generous invitation, I will limit myself to fully staged classical opera and turn to my list of personal pet peeves: a kind of process of elimination to determine

where, in my view, opera should *not* go in the future. Numbering three, the pet peeves all go in the same direction. Each targets an "add on" whose "sin" is distraction that subtracts from the fundamentals of traditional opera: the music, the voices, the spectacle.

Supertitles

Once upon a time, a synopsis in the program sufficed to give the spectator the storyline of an opera. While often complicated by the number of characters and their relationships, the plot is rarely complicated. Once a spectator (or this spectator) read through the Act-by-Act synopsis, who cared if the tenor was singing in German or Italian, Russian, French or English? With the general storyline in your head, you could sit back and listen to the music.

No longer. Today, whether we are at the Met in New York, La Scala in Milan or the Paris Opera—the sole and blessed exception being Bayreuth—written words are foisted upon us *during* the opera. The lyrics are imposed in not-to-be-ignored supertitles or back-of-seat titles or side-of-stage titles. Wherever they are positioned, they constitute the intrusion of the written word into a vocal and instrumental and visual performance. Suddenly, we are not just listening, we are *reading*, an entirely different activity. Nor, as I have mentioned, are we reading great literature. The words, with rare exceptions, are painfully banal, and most often translated as if by Google.

The betrayal is dual. The words reveal in real time how miserable the lyrics of most operas are (not all, one thinks of poet/librettists such as Felice Romani and Arrigo Boito). Until the advent of supertitles, this was a secret, with many in the audience not understanding the language in which the opera is sung and even when speaking the language not always able to decipher the sung words. The second and most egregious crime of these forced-fed written texts is that they take our eyes (and mind) away from the stage and our ears away from the music. There is no way that we can avoid moving our eyes up to the titles and back down to the stage, or down to the back of seat titles then back up to the stage without fragmenting our focus and concentration on what is happening on the stage itself, whether musically or in movement or mood.

There was a time when the key advice to a playwright was, "Show, don't tell." These unwelcome opera supertitles tell. Our state of attention is divided, physically, cognitively, emotionally. The willing suspension of disbelief is broken as we take time out from the performance to consult a kind of "explanation" of what we are seeing. More serious still, our ears are taken away from the music and voices. As we read, we are hearing the words we read, and that competes not only with what we see but also with what we can absorb musically. Why, then, go to the opera at all?

Moving Images

A partner in crime of supertitles is the superfluous use of video art on the opera stage in a misguided attempt to make opera "cool," "contemporary." To illustrate what I see as a misuse of moving images, let me evoke a very commercially successful production of *Tristan und Isolde* featuring a video by Bill Viola. This was billed as a fully-staged Wagnerian opera

in a major opera house. It was not a concert version. Dominating the stage was Viola's giant video, while in a corner stood two figures dressed in black, Tristan and Isolde. They sang as if in concert, simply playing to each other while inevitably the focus of the audience's eye remained on the constantly moving video. Now the video was very nice in and of itself. It would have been stunning in an art gallery or as an installation. But it had nothing *stricto sensu* to do with the action of the opera, except that there was a sea. The sheer size and brightness of the video compelled us to look at it, with little competition coming from poor Tristan and Isolde, relegated to their corner and nearly invisible. Listening, even to Wagner's magnificent music and vocals, was a challenge, a struggle to keep the eye from inexorably being drawn to the moving "light show" of the video (not to mention the supertitles). I finally closed my eyes so that I could hear the music.

Now, the fine print to my complaint. I have seen video used effectively in a concert version of an opera, notably a video by Francesco Vezzoli featuring Cindy Sherman for Rufus Wainwright's *Prima Donna*. Projected behind the singers on stage in the magnificent Odeon of Herodes Atticus beneath the Acropolis, the video was not only beautiful and intriguing but also helpful. Since the opera was not being staged, the video created the atmosphere, underscored the narrative by showing us the aging diva that we were not seeing act the role on stage. It added a dimension that would have been present in a staged opera but absent from a concert version. By contrast, the Viola video was irrelevant, taking the place of what should have been a fully-staged opera and reducing it in essence to a concert version.

Contemporary Dress

My final entry into this trio of "devices" in contemporary productions of classical opera is one where I can already hear voices rising up against me in protest: the use of today's modern clothing. This is not a plea for historic dress. Abstract, fantasy dress can be brilliant and carry meaning. But commonplace modern dress? Whatever classical opera is, it is not normal, everyday life. It is a spectacle, and a grand one. The décor, the sets, the costumes, all of this is part of what makes opera not only a total artwork but also a larger-than-life one. Why make it banal? What is gained by seeing *Don Giovanni* wearing an Armani suit? Or Donna Anna throwing herself on her father's dead body in a housedress? It is not the collar that makes the priest. The opera is relevant or not by its content, not the performers' dress. And in an art form that is gloriously "not like the man on the street," what is achieved by presenting the protagonist looking like the man in the street? The man in the street does not walk around singing his emotions in majestic voice. Isn't it easier to accept someone acting in a not everyday way when he does not look "everyday"? Why take an artificial art form if ever there was one, and that is part of its charm, and reduce it to the familiar? Beware the director who wants at all costs to be "original." "Original" is not always better.

Hearing all this one might think that I am a grumpy spectator, which at times I am, or that I am old-fashioned and opposed to innovation in opera, which I am not. To establish the latter, let me conclude with an example of what for me can be the opera of the future. Not the ridiculous that I have described, but rather the sublime.

The example comes again from Wagner: *Der Ring des Nibelungen*, directed by Robert Wilson in a production sadly not often reproduced. We know that Wilson's theater or opera is not naturalistic. It is abstract. We know that the lighting is the most important element of the décor. Wilson, a visual artist, states something crucial that reflects on all I have written here: "My challenge as a director is to make the audience hear the music better." I can love a Baroque opera both in music and in décor, a huge ship on fire, grand ballrooms with chandeliers and waltzes. Wonderful! It is not only abstraction that attracts me. But for *Der Ring*, how better to represent the gods than by abstraction? How better to allow us to hear music than by keeping to the utterly essential the movements on stage? How better to tell the story than by light? I was mesmerized, by the music, of course, but also by the exquisite beauty of the choreography of movement and light on stage, by the simplicity of sets that literally "set the stage" without insistence. As a spectator, I was given the time to integrate what I was seeing with what I was hearing, with who I am and what I am imagining and feeling, to construct my vision in the spaces in-between.

This is grand opera, an artform outside of the "daily." Let it live that way, without subjecting it needlessly to passing fashions in technology, décor, or dress.

Remember *Alice in Wonderland*'s Queen of Hearts eyeing her gardeners' heads, and with me order "Off with the Supertitles." Take heed of videos in opera: like nudity in film and sex scenes in novels, cheer their use only where they enhance the artwork. Go wild, revel in twenty-first-century dress for twenty-first-century operas, but do not force it like Cinderella's shoe on the bodies of seventeenth-century works. Relieved of such "superimpositions," the opera will dazzle well into the future; and this grumpy spectator—like those of her ilk to come—will again take in the music, feast eyes on the spectacle, grapple with the emotions, live the illusion, and gratefully, joyfully succumb to its allure.

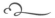

Margery Arent Safir is founder and artistic director of The Arts Arena International and Professor Emerita of Comparative Literature.

SOURCE OF INSPIRATION TO CHANGE THE WORLD

SPEECH ON THE OCCASION OF THE 150TH ANNIVERSARY
OF THE WIENER STAATSOPER (ABRIDGED)

Laetitia Blahout

Impressionist painter Edgar Degas described everything in opera as artificial—light, decorations, the hairstyles of the ballet dancers, their busts, and smiles. Only the effects it all produced were real. That's probably a perfect description of the world of opera: a world of illusion, a posh venue for people who are still stuck in the last century. It's nothing but smoke and mirrors, a pompous charade, a waste of money at the highest level; a place where so-called celebrity guests, such as aging building-developers and their young sweethearts, bask in the limelight.

Don't worry; the biased views I have just cited do not reflect, of course, my own. I consider them to be mere clichés; the world of opera is not populated by illusions; the flamboyant costumes, sets, and masks only add a charming touch to the experience, to the magic of it all. I believe that, on the contrary, the world of opera is, above all, also one for young people; it is an art that is necessary, especially in our world today.

Close your eyes for a minute and transport yourself to your childhood. What did music mean to you back when you were still free and innocent enough not to read too much into feelings? What's the first thing that comes to your mind? The beauty of the music that enveloped you? The community that bonded you and your friends when you sang together? Or the ideas that some of the lyrics evoked in you? All of this comes to my mind, but above all, music fills me with a sense of security.

I think I'm not the only one when I say that music is a safe anchor in my life, a source of strength. I can express and unfold my mind through it and let it calm me down, and seek strength in it. Music has no rules; it is free to do anything it pleases—and ironically, it's precisely this freedom and unpredictability that gives me security. But what can it do, what does it want to do, is it allowed to do, and what must it do?

Music can make social and political statements; music can even change the world! But it doesn't have to. It can serve purely aesthetic purposes, as well. Music is not only in the hands of the composer but also in those of the listener. And what listeners read into the music is purely subjective.

Theater can make a huge difference. As we all know, words can change the world. Theater is thought-provoking, at least I hope it is for most of us because, in my mind, anyone who leaves a theater uninspired and without a thought in their head might just as well stayed at home. In dark times, for example, under the Nazi dictatorship, severe restrictions were placed on theater,

opera, and the arts as a whole. People were afraid of the emergence of dissenters, maverick thinkers, or skeptics. Censorship has been imposed on our country many times in our history—authors, books, and plays were banned. The fact that it strikes fear among those who seek to control the people proves just how powerful theater can be, how powerful it is supposed to be. But as long as there are among us thinkers and idealists out to change the world, as long as there is theater, and as long as art lives on, we will have a functioning society.

I consider opera to be the master class of the arts. Word meets sound; song meets instrument; art meets art. Timeless stories are told in opera, eternal and ubiquitous problems are explored, and the freedom of music meets the content of theater.

The Wiener Staatsoper is steeped in tradition and history. It's a house of art and culture. Key figures in the history of music, such as Gustav Mahler and Herbert von Karajan, have stood at its helm as directors, and ever since its opening on May 25, 1869, it has served as a premier center of the arts in Austria and, I would even go so far as to say, in Europe.

Even though I'm praising the art of opera in glowing terms right now, I must confess that I have attended opera performances far too rarely. But each time I've been to the Wiener Staatsoper, it's been a magical, memorable event for me, and I think it's terrific that the Wiener Staatsoper is strongly committed to getting children and young people excited about the enchanting world of opera. Children's operas, backstage tours for school classes, live streaming on the Internet—who knows, perhaps the Wiener Staatsoper will no longer exist a few decades from now, maybe this form of art will die out with our grandparents, and everything will be relocated to the Internet. I, for one, hope this won't come to pass; experiencing music live with all my senses is just so much more meaningful and rewarding. I would love to see the Wiener Staatsoper stay true to its traditional values. Because it's a hub of the arts and culture, it's all these things to me; it's a safe space, one for people who change the world, one dedicated to the necessity of art. Our Wiener Staatsoper!

Tradition doesn't have to mean boredom. And the world of opera is for everyone. Yes, operas are not just for "elderly" people; operas are for those who want to change the world, seek security in music, or simply enjoy its beauty. Young and old.

We, the young people, in particular, are called upon to consider what we can and want to contribute to the future of our world. Because in the world we live in today, there are several things I would love to change, both on the political and the social level. Change, even a revolution, begins with a single thought. And many such thoughts are found in operas. So let's take inspiration from music, theater, and art. Let's summon the inspiration to change the world.

Winner of the 2019 Austria-wide student speech competition, Laetitia Blahout presented the discourse reprinted in the present publication at the "Birthday Matinee 150 Years of the Opera House on the Ring" at the Wiener Staatsoper on May 25, 2019.

The Critics

THE OPERA CRITIC—PAST, PRESENT, FUTURE

Eleonore Büning

An evening at the opera is a serious matter. Not just in the case of the so-called *seria*. Since Mozart and Da Ponte, at the latest, even the protagonists of the *buffa* don't always have it easy; even a *comique* can have a fatal end. Ironically, one of the fundamental contradictions of this prestigious synthesis of the arts is that the opera critic, of all people, has become a professional laughingstock.

This is illustrated, for instance, by *The Muppet Show*, where two disheveled elderly opera critics named Waldorf and Statler regularly sit together in the proscenium box, picking apart everything happening on the stage below and cracking corny jokes ("Wake me when the show starts" / "It's already been on a while" / "I see. Then wake me when it's over"). The cartoons created by British tuba player Gerard Hoffnung poke some more subtle fun at critics. He shows us how to spot them in a crowd: they scribble in notebooks, stare into space, read the score with a sharp pencil, and two complementary drawings illustrate the maxim, "It is not dignified for the music critic to applaud except in the interval."[1] In one of his Munich stories, opera fan Eckhard Henscheid recounts how an opera critic stopped by the Augustiner-Bräu for a beer on his way to work, got stuck there, and only made it to a *Don Giovanni* premiere midway through the second act, shortly before the descent into hell. The usher guarding the door to his box wouldn't let him in because he was late. So he went home to write a lengthy review, chock-full of routine formulaic expressions ("convincing in the leading roles…," "master on the rostrum…").[2]

It's perhaps no coincidence that many of the jokes leveled at opera critics involve a lack of interest or cluelessness. Or a form of conceit that is, apparently, customary in the industry and which Joachim Kaiser once set out to defend in the spectacular lecture he gave in Graz in 1967. And just like in any caricature, Kaiser's coquettish self-criticism naturally contains a grain of truth. Kaiser explained that simply by writing a review, the critic was already compelled to start imagining things: "Among critics, vanity is an occupational illness." Precisely because their efforts are nonessential, both for society and the music business, the importance

of critical subjectivity must all the more clearly and forcefully bring itself up as a subject of debate—"The fifth wheel feels free and important. That instills vanity…".[3]

Opera critics falling asleep as soon as the show begins is a classic. That they only wake up when the audience applauds at the end is too. This topos, first, affirms that the opera critic is to be considered part of the entertainment-hungry, relaxation-seeking crowd in the auditorium and, second, asserts that the opera critic, as a general rule, flippantly fails to do his or her actual job. Which consists in informing and enlightening the public, thus serving the higher purpose of human education—a job description that Eduard Hanslick had still explicitly claimed for himself.

Hanslick, on whom the tormented Beckmesser caricature in Richard Wagner's *Meistersinger* was modeled, was the first music critic to radically professionalize the process of writing criticism. He penned a vast number of opera and concert reviews, no longer as a sideline, as had been customary up to then, but as a full-time job. He summed up his approach thusly: "I have always stuck to the principle of speaking only to the audience, not to the artist. The critic who imagines himself as exerting an educational influence on artists is caught in a pleasant delusion. As a rule, the singer or virtuoso deems only praise to be accurate, never criticism […] If my many years of critical endeavors have actually produced some benefit, it consists solely in their gradual educational influence on the audience."[4]

Eighty years and two world wars later, Theodor W. Adorno saw things differently. He called criticism a "caricature that is actually becoming such a widespread reality that a listener frequently learns whether or not he liked a performance from the review he reads the next morning." The task of criticism, he wrote, was rather to provide support to the works of art, to help them "unfold their essence." That's a high bar, not least because, unlike in Hanslick's time, the opera repertoire has come to be dominated by the "dead" works of the past and an ever-shrinking canon of the same old thing. Adorno acknowledges that the ideal opera critic who influences contemporary opera creation is a utopian dream and could never exist in real life. And as for all the other brands of critics he observed all around him in a musical consumer world corrupted by capitalism, he, of course, thought they had no right to exist at all; neither the traveling "musical diplomat" and the philistine peddling "informative music appreciation," nor the phrase-mongering, facile, gossip-hustling type "clinging to artists like a bedbug."[5]

At the beginning of the nineteenth century, opera criticism was still subsumed under theater criticism, which in turn was coupled with literary criticism—and these three types of writing were inspired by the lyrical ambitions of Romantic authors who were themselves musicians, actors, or poets. And here's how that came about: already during the first onset of the formation of a bourgeois cultural public sphere, i.e., around 1730, when music-criticism journals began to flourish, it was initially primarily composers who wrote for composers. This was about problems of musical composition, instrumentation, and the discourse within the trade. In the wake of the French Revolution, new forums emerged in news sheets and journals, which were frequented by a broader music-loving public from outside the trade. It included not only connoisseurs but also the "dilettantes"—in the Goethean sense, this term has a positive connotation. And from that point on, music lovers wrote for music lovers. Some were full-time lawyers or court officials and administrators; others were artistic

directors, poets, or writers, including eminent figures such as Ludwig Tieck, Heinrich von Kleist, Clemens Brentano, Amadeus Wendt, Ludwig Börne, Carl Gustav Carus, and Christian Dietrich Grabbe. E. T. A. Hoffmann, still half composer, already half poet, also wrote important opera reviews. So did Heinrich Heine. The latter liked to toy with the notion of not knowing anything about music. Heine penned the bon mot: "We don't know what music is. But we know what good music is, and we know even better what bad music is; for we have to listen to the latter more often."[6] Franz Grillparzer, too, wrote opera reviews from time to time. In his review of Carl Maria von Weber's *Euryanthe*, he argued that: "No opera should be approached from the perspective of poetry—from this vantage point every dramatic-musical composition is nonsense, but from the perspective of music."[7]

Early on, the discourse of opera criticism thus reflected a contradiction that librettist Voltaire had already acutely touched upon and that Oscar Bie defined as one of the essential antinomies of the opera genre: "Does the music lead the way or the poetry? Is there an agreement on this? A forest of opinions [...] has arisen around this question."[8] Now, one could have certainly expected Bie and the other opera critics to assume the role of the ranger of this forest. After all, most of them, from Hanslick to Kaiser, have embraced the maxim "prima la musica"—on the one hand; but on the other hand, they never considered or realized that their own opera criticism always and consistently contradicted this maxim. The lion's share of an opera review deals with non-musical issues. That's convention; that's the rule of thumb. It is valid throughout the history of music, up to the present day, and has been taken to heart by all the opera critics mentioned by name in this essay, as well as by those not mentioned, from Julius Korngold and Paul Bekker to Max Marschalk, Hans Heinz Stuckenschmidt, and Gerhard Rohde. From Jungheinrich and Brug to Sinkovicz, from Mösch to Schweikert and Pachl. By the way, about 90 percent of the time, the opera critic is still male. Why? No need to worry about pronouns here? Are women perhaps too smart for this profession after all? Or not vain enough? In any case, there are now more renowned female conductors out there than renowned female opera critics.

A classic opera review is conservative. It is dedicated to the plot, libretto, history of the material, and performance, as well as the cultural and socio-political implications, if applicable. Moreover, ever since evening show directors became artistic directors, and they, in turn, became creative, original geniuses; they also discuss directorial ideas in great detail: "On average, seventy percent of the scarce column inches are used for all of this. Two sentences are allotted to the conductor. One closing sentence must suffice for the entire ensemble of singers. Here, we are regularly treated to appalling platitudes, devoid of any informational value regarding the quality of the singing. [...] Presently, the only genuine critiques of singers to be found in the arts pages are obituaries—all of them by Kesting."[9] However, it should be added that especially Jürgen Kesting, as a German studies graduate, belongs to the group of lateral entrants into music criticism who, like the poets of the Romantic period, write from a fan-zone perspective.

There have always been, and there still are, renowned opera specialists, especially among Wagner and Verdi fans, such as political scientist Udo Bermbach or medievalist Peter Wapnewski, who never comment on music at all. Instead, they approach the phenomenon of opera

with a childlike, naïve passion that Marcel Prawy (the fantastic Viennese prototype of Adorno's "artist-clinging bedbug," and likewise a lateral entrant) once summed up in a simple formula: "That which I love, others should love, too." Many a beautiful hymn of opera criticism has blossomed from the compost of this type of empathy. Sprouting next to them and equally prominent, we find outrageous lapses of judgment. Mistakes are part and parcel of this game.

Any attachment to the subjectively experienced truth of the contemporary mindset entails the risk of being blinkered. History shows that since the beginnings of music criticism, any given current point of view—that is, someone's own perspective—had to appear to the critic as the only objective and authoritative one. Let's take another cursory look back: Johann Friedrich Reichardt, a critic and renowned composer of singspiels fully in tune with the art of his time, trashed Mozart's opera *La clemenza di Tito* in 1796 for its overly "slavish imitation of conventional Italian forms."[10] Hanslick, the avowed Brahms enthusiast, vigorously supported efforts to thin out the traditional repertory canon, but he wasn't satisfied with the premieres he reviewed either. Puccini's *Bohème*, he wrote, was a "crude musical insult," Wagner's *Meistersinger* gross nonsense.[11] As the third and last example, finally, there was Hanns Eisler, composer, poet, and

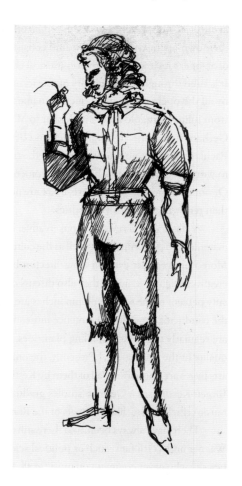

Daniel Libeskind, *Tristan*, 2001
Ink on paper, 30 × 20.5 cm
Costumes designs for
Tristan und Isolde, Richard
Wagner, Saarbrücken State
Opera, 2001.
Courtesy Studio Libeskind

politician. In July 1928, writing for *Die Rote Fahne* (The Red Flag), he invented the scathing short review. The plot of Hindemith's opera *Cardillac* was summed up in one sentence; its main character was portrayed as a "demonic money-grubber." As for the music, it was a "vapid, utterly phony affair"—"Someone could indeed be murdered up on stage, and yet the rather pretty flute duet in the orchestra would still carry on." The performers, including Otto Klemperer, went completely unmentioned, which is considered the maximum penalty a critic can dole out. His "rather pretty" was particularly brazen. The author was apparently spoiling for a fight. As an advocate of the working class, Eisler condemned outright a luxury art that, already for reasons of cost, remains the exclusive preserve of the upper ten thousand. Seen through these wire-rim glasses, of course, any opera is worthy of condemnation, including Debussy's *Pelléas et Mélisande*. Eisler deemed it a boring piece, "a superfluous opera for superfluous people [...] that cannot be remedied even by the most meticulous performances."[12]

In retrospect, and perhaps somewhat wistfully, it should be noted that the Golden Twenties, with their culture of controversy, seem to have been a golden age for opera criticism as well. The brief era of the Berlin Krolloper, which in an attempt to renovate the genre from the ground up and reconcile the aspirations of the avant-garde with the concept of folk opera, got a significant number of brilliant artists to put pen to paper. People ventured to hold opinions. For the first time, people concerned themselves with aspects of the performance. The age of the interpreter was dawning. Conductors turned into magicians, pianists into keyboard lions, stage managers into directors.

Today, the opera review is one of the few types of text that still has a chance to land on page one of print-media art sections with a picture every now and then. As a rule, this is owed to the image, no surprise here. Nazi symbols, nudity, animals, children, or Kalashnikovs always sell, because according to statistics from the Swiss Readerscan method, sex and crime attract the interest of a majority of the population. However, since the text teased by the image deals mainly with the ideas of the directorial team, the opera critic thus reinterprets the interpretation of a work; he automatically maneuvers himself further into a minority niche. Opera criticism becomes a translation of a translation. It degenerates into a game of telephone—and who still cares?

On the net, it could be hundreds of thousands. 400,000 to 600,000 opera-hungry fans from all over the world follow the streams of the major state opera houses per performance—according to their own figures. The critic is also part of this crowd. He can now stay at home, in his pajamas like everyone else, to watch the premiere stream of *Der Rosenkavalier* over a glass of wine. As a member of the press with special access, he can even scroll back if he feels he may have misheard something under his noise-canceling headphones. That's one of the advantages of new media in the age of Coronavirus. However, what the critic subsequently has to say has long been said by everyone else in the chat room. That's one of the disadvantages of new media. As a consequence, the opera critic will no longer be needed in the future. Kaiser's "fifth wheel" can now be jettisoned.

Long before the Coronavirus helped accelerate digitization in the classical music business, opera fans had already taken to writing themselves the opera reviews they would have

always loved to read. There are dozens of new blogs and forums on the web that are working diligently to get rid of the opera critic. They are called "Wotans Opernkritik" or "Klassik begeistert" or "Der neue Merker." Here, fans write for fans. Free of salient points, apologetic, and endlessly long, without pausing for breath. Opera creators write for opera creators. They pat each other on the back. Opera agents have also long moved on to join in the competition for the scarce resource of attention. Large and small houses and festivals provide, in addition to their core business, the journalistic coverage of the music and make it available for free use in fanzines and on the Internet. Remember, "What I don't write about never happened." That's what my mentor, leading critic Heinz Josef Herbort, used to say to me back in the good old days at the editorial conference of *Die Zeit*. Of course, he wasn't serious. It was supposed to be a joke.

[1] Gerard Hoffnung, *The Hoffnung Companion to Music* (New York: Dover Publications, 1971), n. p.

[2] Eckhard Henscheid, "Top-Don Giovanni. Von unserem Sonderkorrespondenten," in *Über Oper. Verdi ist der Mozart Wagners* (Berlin: Ullstein, 1982).

[3] Joachim Kaiser, "Zur Praxis der Musikkritik," in *Studien zur Wertungsforschung* 1 (Graz: Symposion zur Musikkritik, 1968), p. 25.

[4] Eduard Hanslick, "Musikkritik. Gespräche mit Billroth," as cited in Eduard Hanslick, *Musikkritiken*, ed. Lothar Fahlbusch (Leipzig: Reclam, 1972), p. 21 ff.

[5] Theodor W. Adorno, "Reflexion über Musikkritik," in *Studien zur Wertungsforschung*, cit., p. 8 ff.

[6] Heinrich Heine, "Über die französische Bühne, neunter Brief," 1837, as cited in Heinz Becker, *Der Fall Heine-Meyerbeer. Neue Dokumente revidieren ein Geschichtsurteil* (Berlin: De Gruyter, 1958), p. 131.

[7] As cited in Imre Ormay, *Sie irrten sich, Herr Kritiker* (Leipzig: VEB Deutscher Verlag für Musik,1967), p. 149.

[8] Oscar Bie, *Über Oper* (Berlin, 1913), as cited in the Schott edition, 1988, p. 25.

[9] Marcus Felsner, *Operatica. Annäherungen an die Welt der Oper* (Würzburg: Königshausen & Neumann, 2008), p. 49 ff.

[10] J. F. Reichardt, *W. A. Mozart: La Clemenza di Tito* Almanach Deutschland, 1796, as cited in Horst Seeger, ed., *Der kritische Musikus* (R. Reclam: Leipzig, 1966), p. 51.

[11] Eduard Hanslick, "Die moderne Oper," 1875, as cited in *Musikkritik*, cit., p. 101 ff.

[12] Hanns Eisler, "Relative Stabilisierung der Musik. Zu P. Hindemiths 'Cardillac' in der Krolloper," in *Die Rote Fahne*, July 3, 1928; Hanns Eisler, "Claude Debussy: Pélleas und Mélisande (Städtische Oper)," in *Die Rote Fahne*, November 12, 1927; as cited in Hanns Eisler, *Gesammelte Werke*, Vol. III/I Schriften 1924–1948, ed. Günter Mayer (Leipzig: VEB Deutscher Verlag für Musik, 1973), p. 82 and 41.

Eleonore Büning studied musicology, theater, and literature at the Free University of Berlin, where she earned her doctorate with a dissertation on the reception of early Beethoven. She was music editor first at *Die Zeit* in Hamburg, then for over twenty years at the *Frankfurt Allgemeine Zeitung*. She has authored numerous books and has been chairwoman of the jury of the German Record Critics' Prize since 2011.

A CRITICAL JUNCTURE FOR
OPERA CRITICISM

Gianmarco Segato

The year 2020 seems like the perfect pivot point around which to assess the state of opera journalism, to reflect on the major changes which have swept through this little corner of the writing industry in the last ten years, and to cautiously speculate where it is likely to end up once the new decade is finished.

As Editorial Director of the small, feisty, and long-lived arts journal, *Opera Canada*—which, appropriately, celebrates its 60th anniversary in 2020—some of the topics I will discuss might have a particular North American slant, but I think it's a safe bet that these will be more than a little recognizable in an international context.

One of the most significant developments of the 2010s has been the rise of the opera blog. Based mostly in larger urban cultural centers, these independent platforms stake their niche by offering reviews, artist profiles, preview pieces, and news stories about local productions, as well as some editorial commentary. Keen opera fans, industry types, and artists can now turn to blogs like *Schmopera* (Toronto), *Parterre Box* (New York), *Seen and Heard International* (United Kingdom), and *Bachtrack* (the United Kingdom with international coverage)—to name just a few of the more prominent examples—to find an online community of fervent opera lovers willing to discuss the latest Regietheater deconstruction of *Carmen* or to whine about casting and repertoire choices at their local company. These blogs rely almost exclusively on writers willing to contribute their work free of charge, with only a few generating income through advertising or crowd-funding sites such as *Patreon*.

While much of this blogged content is of high quality, the writers vary significantly in their experience, resulting in less than comprehensive opera reviewing and artist interviews that can border on the sycophantic. However, my purpose here is not to heap criticism on the opera blog phenomenon—I'm sure my browser history would betray just how often I visit these sites myself—but merely to lay the ground for what the "legacy" media is up against. In other words, in a world where multiple reviews of the latest *Ring* cycle in Munich are mere clicks away, is there still a place for professional opera writing, and, if so, what form should that take?

It's no secret that in the last decade, at least in North America, art criticism in so-called "traditional" media has been reduced to a mere flicker of what it once was. Almost without exception, legacy media in major cities have furloughed staff critics from their rosters in favor of freelance writers. In some lucky cities, full-time posts for classical music writers have been

salvaged with the help of the San Francisco-based Rubin Institute for Music Criticism, which has funded positions at the *Boston Globe*, *Dallas Morning News*, *Pittsburgh Post-Gazette*, *Seattle Times*, and *Toronto Star*. If it weren't for this generous philanthropy, the classical music scenes in these cities would likely receive little to no regular coverage.

In early 2020, my home city's leading newspaper, the *Toronto Star*, announced it would source all future arts coverage via newswire services, leaving just a couple of freelance theater critics and the aforementioned Rubin-funded classical music position as the only homegrown contributing art writers. This means that unless Canada's national paper, the *Globe and Mail*, decides to assign one of its freelance writers to a show, there are vast swathes of professional arts presentations that will not merit a mention in traditional media. And if the Rubin money runs out, that could very well mean no coverage for Toronto's burgeoning opera and classical music scene in the near future.

From a North American perspective, the situation seems a lot better in the United Kingdom and Europe, where major media still employ dedicated classical music and opera writers with recognizable bylines. But who knows how long this will last in an age where success is measured by online clicks? In the tightly knit world of arts journalism, it's no secret that arts and lifestyle sections (which increasingly seem to be lumped together) are becoming less willing to assign staff to write performance reviews since they do not garner the degree of online traffic demanded by advertisers and investors.

It is clear that the online realm has posed some daunting challenges for traditional media, be it competition from relatively cheap-to-run blogs or the web-based, for-profit model that fuels most news conglomerates. Now, formerly print-only and specialty publications like *Opera Canada*—together with sister, English-language magazines like *Opera*, *Opera News* and *Opera Now*—must somehow distinguish themselves in a crowded market. How do we compete with the instant satisfaction of endless amounts of mostly free content that even a niche area like opera can offer online? More importantly, where does specialty opera media fit into this world, and what is its purpose?

Part of the answer might lie in reckoning with legacy media who have abnegated their responsibility in the cities they purportedly serve. At the most basic level, if a newspaper is not prioritizing the coverage of local opera companies, then that job falls to specialized opera publications in ways that are even more crucial than before. Commissioning an experienced writer to review a performance then becomes as much about saying "this happened" as it is to comment on a soprano's high notes.

Above and beyond an opera publication's mandate to fulfill this kind of "recording" function is its unique ability to provide well-researched, in-depth, long-form journalism. In a world of blogs and reviews with truncated word counts, this is an area where specialist publications truly have little competition. In recent issues, *Opera Canada* has published meaty features dealing with the participation of BIPOC artists in opera, women singers' views on traditional female roles in the era of #MeToo, transgender opera artists, and the growth of the "indie" opera scene across the map. Given the current economic climate in journalism, there is little chance that topics like these would receive in-depth coverage in a blog or newspaper.

This kind of writing requires journalists who are comfortable speaking to leading artists, navigating complex mazes of publicity teams and agents, and spending hours researching and fact-checking. These writers more than earn the modest fee a magazine like *Opera Canada* can offer them—but at least there is a fee.

Beyond offering topical, long-form features and reviews, opera journalism can play an important role in critiquing the very institutions that produce the art. It's rare to find mainstream media and blogs taking on this function (*Parterre* is the exception, with the critical eye it keeps focused on the Met). Opera institutions, so often perceived as fragile and on the verge of collapse, nonetheless need to be subjected to the same degree of fair scrutiny which all public institutions face. My publication recently found itself at the receiving end of some rather censorious attitude after we published a feature criticizing the opera program at one of Canada's leading arts incubators. Days after the piece appeared in print, I received a call from the institution's Executive Director of Communications (a former journalist) accusing the magazine of not supporting opera and pressuring me not to publish the piece online. At the same time, we were receiving notes from artists involved in the program thanking us for voicing their frustration—we had obviously struck a nerve. We had served a useful journalistic purpose publishing a piece to which few other media outlets would have directed resources.

Having touched on some of opera journalism's recent developments, let's turn our attention to where it all might be going. As new operas increasingly take on contemporary subject matter for their librettos, and as directorial concepts continue to question the sexist, colonialist, racist underpinnings of much of the repertoire, some artists and companies are beginning to question who exactly should be allowed to critique their work. In early 2020, Toronto theater artist Yolanda Bonnell—who is of indigenous Anishinaabe and South Asian heritage—asked that only critics who identify as IBPOC (Indigenous, Black, and People of Color) be permitted to write about her play, *Bug*. Bonnell explained, "There is a specific lens that white settlers view cultural work through and, at this time, we're just not interested in bolstering that view." Her request proved controversial in the usual social media spheres and forced many editors and writers to question assumptions previously taken for granted.

Assigning the appropriate writer to review any given performance can be a challenge; however, demands like Bonnell's add another set of considerations. More and more, opera writers need to grapple with complex and divisive societal issues while still offering well-considered criticism, though some would argue that the latter should no longer be part of the equation. As part of the Bonnell story, many commenters opined that since reviews no longer have any bearing on the box office, they should be summarily dispensed with. One local theater production recently asked that "love letters" be sent their way instead of critiques. This intense discussion around the old-fashioned notion that reviews can affect ticket sales, especially as part of an online conversation between young urban theater artists, was surprising. As far as opera goes, the most compelling case for the viability of the stand-alone review is its ability to spark discussion and lay down for posterity a unique artistic event. So for the near future, at least, opera reviews seem to be here to stay, though who will be permitted to write them is up for debate. It will be increasingly important and necessary to seek out a

diverse pool of writers representing marginalized groups that have previously been shut out of the conversation.

On a more macro level, one cannot help but wonder how the strangely symbiotic relationship between opera critics and opera artists will change in the coming decades. As much as singers may gripe about critics on their social media, most are still quite happy to use glowing quotes for their websites and house program bios. However, in the age of shameless social media self-promotion, one could certainly see a day when gushing praise from independent critics will be superfluous for artists and institutions. What's more, opera companies are now producing their own copious amounts of in-house content to better control their messaging. Having recently assigned a writer to preview an upcoming production, I set up interviews with the company's Public Relations department only to be deflated by an email from the same company that featured their own, virtually identical, homegrown interview with the production team. As this trend seems unlikely to abate, the role of independent, objective media will likely skew even more towards the type of reporting that casts a critical eye on the industry, away from superfluous promotional previews and interviews.

At *Opera Canada*, we have started to invest considerable time and effort in developing a new crop of opera writers by hosting internships from local university journalism programs and by taking on a mentoring role with the Emerging Arts Critics Program (in conjunction with the Canadian Opera Company, National Ballet of Canada, Toronto Symphony Orchestra and Soulpepper Theatre). We have discovered through these alliances a generation of young, keen writers ready to grapple with the complexities of an art form that combines many diverse elements. The field of opera criticism desperately needs young blood to self-renew and stay relevant. The question remains as to where and how these budding critics will ply their trade, how they will garner monetary compensation, and to whom their work will speak.

Arts administrator, writer, journalist, and educator, Gianmarco Segato was
program manager at the Canadian Opera Company before becoming director
of Canada's oldest arts publication *Opera Canada* magazine. Presently, he is an artist
manager with Dean Artists Management in Toronto.

IN PRAISE
OF THE EPHEMERAL

Christian Merlin

In March 2017, the Lyon Opera invited its audience to climb into a time machine. The director, Serge Dorny, widely recognized as forward-looking, in this case, took the risk of looking back, with three productions, which had marked the art of opera before the turn of the century: *Elektra* directed by Ruth Berghaus in Dresden in 1984, Heiner Müller's *Tristan und Isolde* in Bayreuth in 1993 and Klaus Michael Grüber's *L'incoronazione di Poppea* at the Festival d'Aix-en-Provence in 1999. Restaging these productions raised some troubling questions: was the opera house becoming a museum? What remains of the staging when its author is no longer present to renew it? Would their twenty- to thirty-year-old aesthetics not appear dated? Can we crystalize an art form that only exists in the moment of its performance?

We could always reply that it's common practice to restage old works. Josef Gielen's production of *Madama Butterfly*, which premiered on September 19, 1957, at the Wiener Staatsoper, was performed until March 2, 2020! The current *Barbiere di Siviglia* in the same establishment is Günther Rennert's production from 1966. Hence one could argue that the Lyon revivals are nothing exceptional—if it weren't for the fact that the spirit is radically different. The Wiener Staatsoper is a so-called "repertory" theater; therefore, the old shows have not returned to the house because they never left! From revival to revival, they are part of the company's history: they are part of the heritage. Sets and costumes are stored in warehouses; the assistants in charge of supervising the revivals (*Abendspielleiter*) know the movements by heart, which they hardly need to restage with the soloists from the ensemble who also know them by heart. Otherwise, there is always the video as a fallback—the rhythm of alternating performances in a big repertory house, leaving no time to rehearse the revivals on stage.

However, the Lyon Opera had never presented these productions in loco, and therefore, the sets and costumes had to be newly built. So it was not a question of historical continuity but historical reconstruction. Reviving these productions, which had shocked with their modernity at the time, permitted a younger generation to discover them, while their elders relived their emotions of yesteryear, a bit like Proust's madeleine. It was also an opportunity to experience the aesthetic of another age and to measure its timelessness.

It was a fascinating experience for the author of these lines, who had attended two of the three premieres. Seeing them again took me twenty years back and made me feel the passage of time. The circumstances of listening (place, time, context, performers) were different, and I had evolved; it was an opportunity to measure the gap between the immutable and

the transient. The experience underlined the relativity of contemporary judgment, to the point of sparking wonder at how Müller's *Tristan* could have shocked in 1993: yesterday's revolutionaries are today's classics.

The Lyon experiment was praised but also met with skepticism. In particular, from the director of the Festival d'Aix at the time of the premiere of Grüber's *Incoronazione di Poppea*, Stéphane Lissner, who went so far as to phone me to discuss the production in Lyon, which had annoyed him. He shared an argument worthy of reflection: having observed Grüber at work, he could affirm that the famous director was continually changing his staging according to the singers' personalities, just as the set designer Gilles Aillaud didn't hesitate to modify elements of the scenography. For the Lyon revival, neither Grüber nor Aillaud were still alive, and their show, which they had conceived for the open-air Théâtre de l'Archevêché, was given in an indoor venue. What does one lose (or gain) by trying to glue back on the wings of a butterfly whose existence is ephemeral?

So here we are at a standstill, especially considering that putting on a show long after the death of its creator is not only a matter of course in repertory theaters, but now also in *stagione* theaters. From Munich to New York, Hamburg, and Milan, productions by Jean-Pierre Ponnelle, who died in 1988, are still on the playbills. And Franco Zeffirelli's *La bohème*, created in 1963, still has a bright future ahead at La Scala. Is the permanent renewal that we expect from the conductor and the singers not just as necessary for the staging? Opera critics are often admonished for devoting large sections of their articles to the stage direction. Yet isn't this understandable precisely because this is the dimension destined to last, with the likelihood of revivals, while the cast changes regularly? Might it not be that the staging is perennial, whereas the conductor and singers are ephemeral?

In addition to the principle of revivals in repertory theaters, production sustainability has become an essential consideration due to two other significant trends: co-productions and live broadcasts (television, streaming, cinema). Consequently, what was valid in time has now been extended to space: we see the same shows everywhere, whether from one co-producing theater to another or on the screen. You don't need a degree in economics to understand that in an age obsessed with profitability when applying "economics of scale" has become crucial, fingers point to opera for being expensive and elitist. Coproducing is a mutualization of costs that has become unavoidable nowadays. But at what price? Is opera not "facing the music" of standardization with a paring down of the overall offer, is quantity not replacing diversity?

Moreover, when a crisis as unprecedented as the Covid-19 pandemic shakes the world of entertainment to its roots, we hear renewed praise for the repertory system as a sustainable economic model. Indeed, it has its advantages: it builds up a reservoir of works and spawns a pool of singers ready to perform. Unlike the *stagione* theater, where one production follows the next and a new guest artist steps into the spotlight each time, the repertory theater operates on the troupe system where the artists have long-term contracts. With the repertory system, it is possible to put a significant work on the playbill at little cost in a short time: one that would take the *stagione* theater years to produce. Once in Vienna, having just arrived for Halévy's *La Juive* that was to take place at the Wiener Staatsoper the following evening,

the theater called to inform me that due to the illness of the leading tenor Neil Shicoff, they were obliged to cancel the performance. But finally, a good old Otto Schenk production of *La traviata* was pulled out instead, with the remainder of the cast taking on the leading roles, all without any preparation! In this kind of situation, the audience rivets their attention on the performers—they know the staging by heart, their interest lies in the cast. This kind of production is perfectly suited to many opera fans who primarily focus on the singing and the singers, the orchestra being background music and the staging just lively décor. As the reader might have guessed, this is not my point of view.

I began to attend the opera in Nice in the 1970s, at the age of ten. The performances fired my childhood imagination and hence smote me for life. But as I refined my judgment and began to have points of comparison, I also perceived gaps. At the time, the Nice Opera played a different work every week: one on Friday evening and one on Sunday afternoon. Two or three great singing stars such as Montserrat Caballé, José Carreras, Régine Crespin, or Plácido Domingo would arrive for the dress rehearsal, sometimes with their own costumes; a common practice after the war. Their aura was so stupendous that the audience barely noticed the orchestra, which, accustomed to either sight-reading or playing the works by heart, had rehearsed very little in any case. Nor did anyone care about the staging, which consisted of little more than "blocking" the singers' movements and gestures around outmoded sets.

This system can be attractive when the artistic means deployed are of the highest standard, especially when one can count on a first-rate orchestra, such as those of the German-speaking houses of Vienna, Munich, Berlin, or Dresden. Yet, we cannot deny that the repertory system functioned best in the days when the staging was merely a sketch and the director more of a coordinator than an artist. I will never forget my first trip to Berlin, staying with friends who said to me on my arrival, "What if we went to the opera? Tonight they are performing *Aida*. The production is all right, we've seen it about twenty times already, but it should be interesting because so-and-so is singing Amneris." Having grown up under the Parisian *stagione* system, the idea of going to the opera as if going to the cinema, seeing a show for the twentieth time because a new mezzo is singing, was a discovery.

Later, in Vienna, I discovered the workings of the "Turnus," a rotation system whereby the musicians substitute one another during the run of the same work; I enjoyed spotting the changes in the musician's placement in the different sections from one night to the next. This method exists in all theaters of the same kind, whether in Frankfurt, Leipzig, or Mannheim. At first, I was impressed by this practice and the players' capacity to sight-read *Tristan or Rosenkavalier*. However, I did notice that on some evenings, they obviously hadn't rehearsed—or at least not together. Therefore, it is not surprising that some conductors, anxious to instill their artistic concept, began to rebel. The greats such as Claudio Abbado or Christoph von Dohnányi finally broke with the Wiener Philharmoniker because the administration could not guarantee them the same musicians for the whole series. Though Dominique Meyer increased the number of orchestral rehearsals, the "Turnus" system persists today. With its mixed repertory and *stagione* system, the Paris Opera guarantees, at least, a sufficient number of rehearsals, including for revivals. It has also done away with the

replacement of musicians at the last minute, a common practice that conductors had to make do with until the mid-1990s.

However, now that the staging has become an essential component of opera performance—as important as the singers and the conductor—the repertory system seems obsolete. Since the 1970s, opera has become an integral part of the performing arts and is no longer just about singing. Inspired by the examples of Wieland Wagner, Visconti, Giorgio Strehler, and Jean-Pierre Ponnelle, maverick directors such as Patrice Chéreau and Harry Kupfer made opera a total artwork, uniting music and theater. Instead of just directing traffic, the stage director became an artist in his own right. Today it is customary to compare the visions of Sellars, Carsen, Wilson, Tcherniakov, or Warlikowski just as vehemently as one does the tempi of Rattle, Thielemann, Muti, or Gardiner.

These directors might exasperate some while fascinating others, but at least they leave no one indifferent. However, do their re-readings of the great works stand up to repetition? Is there not a risk that eventually these will lose their surprise effect? Although exciting and exhilarating, does the constant quest for the new not risk turning old before its time? And then, can this need to discover unique aspects of a work each time become a drug? "How can we live without the unknown in front of us?" asked René Char.

A repertory theater makes productions to last, and therefore there is less risk-taking; in a *stagione* theater or in a festival where productions rarely reappear, there is more room for risk. Hence the temptation to ask directors to produce shows for the repertory that are more consensual: a bit like a politician who, hoping to obtain a new mandate, avoids bold and potentially unpopular policies that might prevent his re-election.

When it comes to a production that is at best too daring, at worst a complete flop that the theater is obliged to replace after only two years—the economic disaster is not far off! I prefer a destabilizing but thought-provoking show to a beautifully smooth one. Opera does not adapt well to lukewarmness. That is why in 1973 when Rolf Liebermann took over the fossilized Paris Opera, he decreed the state of "permanent festival." It may be a utopia, but what would art be without utopia?

Landmark productions, like those of the Liebermann era, are characterized by intricate theatrical work, which requires a long preparation period. The director allows his staging to evolve throughout the rehearsals, adapting to the specific singers, which is impossible if they don't return to oversee the revival themselves. Aware of the problem, Robert Carsen, whose productions tour worldwide, tries to be present as often as possible or send a team of assistants who know his work well enough to preserve its spirit. In 2004, when I said to David McVicar that I would soon be going to Lille to see his *Don Giovanni*, which I had missed in Brussels, his reaction was immediate, "Oh please don't! It's not my show!" And he explained that he wasn't overseeing this reprise and that he didn't know the singers. Later on, as a successful director, he would no longer have these scruples, and his productions became much more interchangeable and easier to redo. When an assistant director takes over a repertory show, it's as if you said to a conductor, "Today you're going to play Karajan's interpretation, tomorrow you'll do it Bernstein-style." It's like copying, so you have the outer shell without

the inner drive. The same is true when a production has been tailor-made for a performer: Michael Haneke's *Don Giovanni* starring Peter Mattei fits the Swedish baritone so perfectly that I can hardly imagine seeing it with another singer.

However, the repertory system is not necessarily "Schlamperei," the lax routine denounced by Gustav Mahler, and we should acknowledge its merits. For example, when a staging rejected by the public at the premiere ends up being accepted a few years later without protest, such as one of the greatest scandals of Gerard Mortier's era at the Paris Opera—Krzysztof Warlikowski's *Iphigénie en Tauride*! Patrice Chéreau, who received death threats in Bayreuth the first year of his *Centenary Ring* cycle and an eight-minute standing ovation at the final performance four years later, said, "The audience is the same in both cases, but the opera viewer being fundamentally conservative, he accepts novelty, only once it has become a tradition!" I have to admit that I have experienced some great evenings at the opera with productions that were old before their time but energized by the most extraordinary singers alive, such as the breathtaking encounter between Anja Harteros and Bryn Terfel in *Tosca* or a first-class *Trovatore* with Anna Netrebko, Marcelo Alvarez, Ekaterina Sementchouk and Ludovic Tézier. In such productions, the focus is so intent on the singers that I have little memory of the staging or the conducting. Still, for those moments, in how many other dull evenings did routine replace inspiration? I'll never forget the *Parsifal* premiere at the Bavarian State Opera in July 2018: the brilliant direction of Kirill Petrenko, the stratospheric interpretations of Jonas Kaufmann, Anja Kampe, René Pape, and Christian Gerhaher wrote opera history in golden letters. The transcendence of this musical performance made us forget that the staging and scenography were non-existent. Needless to say, the day someone will revive this production with other performers—I won't go back.

The first to reject the very principle of the repertory system was Richard Wagner. Bayreuth foreshadowed the festivals that later flourished in the twentieth century, with the idea of art as a unique, transcendent experience, escaping routine and entertainment. Some may object that at Bayreuth, they repeat the same production several years in a row. True, but this is where the spirit of the "Werkstatt Bayreuth" comes into play, whereby the director can perfect a show each consecutive year. Thus, Chéreau's now legendary *Centenary Ring* was profoundly reworked between 1976 and 1980, the first year having revealed glaring imperfections. But once the four-year period is over, a festival production continues to enrich our memories and feeds our reservoir of emotions. And even if we end up idealizing the experience over time, at least it is never overshadowed by weariness or obsolescence.

The Swiss poet Gottfried Keller, who had influenced Wagner's concept for Bayreuth, made the striking statement: "A theater that is open seven days a week all year round is devoid of solemnity, the performance being nothing more than a way of killing time." This sentence could have been Wagner's, who hardly had words harsh enough for the Paris Opera at the time, condemning its series of shows as consumerist. Not unlike Brecht, who would later refer to "the culinary art."

Wagner was against the idea of an immutably fixed theatrical text and stressed the importance of improvisation, which explains why he preferred Molière to Racine: the for-

mer being an actor, the latter a writer. Above all, he admired Shakespeare, in whom he saw a representative of the blessed era of non-literary theater, namely that of mimes—a period when the playwright was not a writer but a practitioner of the theater. The Wagnerian ideal of the play was "fixed improvisation" (*Über die Bestimmung der Oper*, 1871). In his essay *Über Schauspieler und Sänger* (1872), he emphasized that the poet must "forget himself," "fade away" in the face of the "mimed realization" of his work.

Is not "mimed realization" what staging is? Conceived as perpetual renewal, it is a unique event each time. Nothing is less reproducible than a successful opera performance. One can, of course, as we have seen, obtain good results by attempting such a reproduction. However, at the irretrievable loss of what Walter Benjamin referred to as the "aura" (*The Work of Art in the Age of Mechanical Reproduction*, 1935), I am aware that declaring outright that the miracle of opera can only be unique is a provocation at a time when the genre is under pressure to find an economic model allowing it to survive.

How should we not be pleased, for example, that Chéreau's *Elektra*, premiered at the Festival d'Aix-en-Provence on July 10, 2013, has, since the death of its fabulous director, been seen in Milan, New York, Helsinki, Berlin, and Barcelona? However, the emotional shock I received on the evening of the premiere was such that I prefer to cherish it rather than attend any of these further performances. Is it the fear of being disappointed? Of not reliving the intense sensations, walking for hours through the streets of Aix-en-Provence, away from the crowds and mundane conversations, to absorb the emotions that had assailed me during the performance?

I prefer to see it instead as a search for transcendence. Among the enchantments of a successful opera performance is its unique, exceptional character. It's a matter of the moment, and unless you're Proust, it's challenging to capture that moment eternally. Goethe's anti-hero, Faust's tragic dilemma was that if he immortalized the moment ("Verweile doch, du bist so schön!"), he would die immediately.

Nowadays, staging is no longer a question of conservation but of renewal of perspective, like the victory of haute couture over prêt-à-porter. During a lecture I gave on opera staging in our time, a listener who did not share my tastes argued that, whereas he did not see any drawback to a modern approach for new works when it came to heritage.

I hardly let him finish his sentence, telling him that I did not consider opera as a heritage but as a living art, forever renewed. It reminded me of Wieland Wagner's response to the detractors who reproached him for betraying his grandfather's work: "An opera should not be classified as a 'historical monument'." Hence, if we are living the "last days of opera," all the more reason, even if it is utopian, to glorify what defines the beauty of the operatic experience: its ephemeral character.

Musicologist and opera critic notably for the French daily *Le Figaro*, holding an "agrégation" in German and a doctorate in literature. Christian Merlin is lecturer at the Charles de Gaulle University – Lille III.

THE OPERA
AND ITS CRITICS

Manuel Brug

Inspirer, investigator, analyst, agitator, accuser, appeaser, observer, reporter, stimulator, carper, chronicler, classifier, discoverer, commentator, teaser, lover, learner, motivator, presenter, researcher, relativist, judge, promoter, contemporary witness.

So many job qualifications, the list goes on and on, equally varied and contradictory in itself. It's a profession that, by now, is hard to put in a nutshell. What is a music critic today? Firstly, I might as well keep using male pronouns because the number of women in this line of work is negligible. While journalism, in general, has become less male-dominated, men still rule the music business, the classical music caste, and the international opera circus.

Secondly, the business has changed in a dramatic but also quite exciting way. Unfortunately, the business aspect has, as well, and in an even more dramatic manner. Opera, which originated in Europe, is largely dependent on city and state subsidies. Media, however, apart from the state-run broadcasting organizations in smaller countries like Austria, is beginning to feel the icy wind on its face.

When I happily took up this dream job thirty-two years ago, after a short period of meandering, everything was right in the world and based on precise arrangements: you had the artists on one side and opinion makers on the other. They had little to do with each other, and they weren't eager to, either. Things were produced in one place and reviewed in another, usually extensively, because there was room in the papers back then. And the printed word, the newspapers, called the tune.

The *Süddeutsche Zeitung* in Munich, a city abundantly permeated by music with two opera houses, six orchestras, no Baroque but the *Musica Viva* concert series, was once pervasively overseen by the pope-like Joachim Kaiser, and had on its payroll: a chief of the arts section, permanently employed music critics, and at least half a dozen additional permanent freelance writers. In addition to these, there were influential cultural correspondents capable of reading music in Frankfurt, Vienna, Hamburg, Berlin, London, Rome, Madrid, and Paris. Together, they formed a crowd of people with opinions, views, temperaments, and missions. They were hired to write special articles and flown to places when it was, or appeared to be, important.

No one questioned the critic's profession or area of expertise or the music business he was part of. Of course, opera has been dead since it was invented four hundred years ago, and yes, after Auschwitz, people continued writing poems. The critic was a respected authority or at least an important figure in the whole game. The relationship between artists and critics

was a delicate one, even in those days. Some writers sought the proximity to central celestial bodies, such as the heavenly twins Herbert von Karajan and Leonard Bernstein. They were "embedded" journalists, even if they weren't aware of it in those terms.

Others for whom even going to a launch party would have been a deadly sin sought to achieve objectivity—something which never existed, especially not on the part of those wielding dogmatic judgment. If he wants to take himself seriously and to be taken seriously by others, every critic, then as now, must proceed from his admittedly incomplete knowledge. Then his growing hearing and visual experience will allow him to compare, evaluate, and finally make judgments. Where do we stand today? What did we experience? Compared to the old days, seen without sentimentality from a contemporary perspective, these are all tools that you have to learn to use. It's as easy to arrogantly lambaste something in haste as it is to deliver swift praise and gushing superlatives.

No one can be unique and exceptional forever and ever. It's also vital to weigh mediocre, workaday artistic practice sympathetically, with an open mind, with a non-routine approach, and ultimately prepare it in a verbally appetizing manner. Because we don't write for the industry, but to edify and, to some extent, cultivate the reader. Critics need to entertain and mesmerize, sometimes also lecture people and occasionally seduce. Because we, too, want to be part of the game, attract attention, and the biggest possible audience.

You know, we are a minority, both as reviewers and as spectators. In this driven, hectic era of TV ratings and click rates, there is a growing awareness of this fact. Culture remains a minority program. And all the more so, the more complexity it takes on. By now the critic, of all people, as an expert, as a guide through the incessantly and wildly proliferating jungle of styles, isms, opinions, manners, and fads, appears to represent a dying genre in an era of "anything goes," "everyone can," and, above all, "I have a relevant opinion."

These days, everyone looking at a computer and a mobile phone thinks they're a qualified critic. It allows them to hate and love as much as they want. On their blogs, on fan pages, and increasingly less under professional circumstances. And on the other hand, you have the institutions that run their channels in an ever more professional fashion, able to reach fans/customers directly, sprinkling as well as indoctrinating them with the sweet droplets of their PR ambrosia. When will we get fully industry-sponsored opera influencers? The only thing standing in the way is the low number of estimated followers that could make them attractive as an advertising vehicle.

Who, then, is still relevant today? The challenge is to ensure, with the last remnants of a hopefully independent, direct authority, the survival of a few templates into a new, somehow shimmering media age. Straight talk, no agenda. Utmost curiosity and open-mindedness towards any concept, as absurd as it may be. But then really speak your mind. That's rarely a comfortable place to be: putting knowledge to use, giving reasons, but without the plaintive cry that everything was better in the old days. Which, incidentally, it rarely was. Nostalgia is a much-indulged idealizer.

There's nothing wrong with being in the know about the industry's mechanisms or being acquainted with its key figures. Of course, a journalist wants to be noticed, but not at any

price. Sometimes it's not a bad thing to put into perspective the hysterical waves sweeping across social media. It's essential to accompany your audiences, to be in it for the long-term, to set the record straight, to not only focus on the most recent success or the latest bankruptcy.

Also, to follow and reflect on societal developments. The contemporary critic doesn't see himself reflected in Goethe's comments ("'Tis a critic, I vow! Let the dog be struck dead!") nor in the lines of Vienna's beloved Georg Kreisler ("It's part of my duty to destroy beauty as a music critic"). In his furor as well as in his love, he resembles the vision we find in Georg Christoph Lichtenberg's aphorism: "He cannot hold back the ink, and when it gets the better of him, he usually besmirches himself the most."

So maybe he'll sully himself. But in the name of a cause, which he loves, because no one would become a critic for the money these days. And this cause, the opera, for example, continues to be threatened because it is expensive and all too rarely innovative. Even though it certainly ranks as a world cultural heritage. For one, German minister Monika Grütters wanted to put a preservation order on the German theater system with its more than eighty stages, or half of the opera world. The critic, too, shares in the responsibility of letting this legacy continue to flourish, thrive, and remain fresh.

You cannot marvel at an opera in a golden frame inside a museum. It is not a finalized work of art. It must be staged, vitalized, examined, and diversified again and again at considerable cost. But its origin still has to be recognizable; the autonomous voice of this highly complex synthesis of the arts needs to be heard, not only its interpretation. It's a fine line to walk, and it takes professionalism but also courage, audacity, and a love for the metiér. In the opera business, sensations are always very expensive, but are they lasting?

The opera has been around for over four hundred years; therefore, it's a young artform but also a rarefied, elaborate one run by specialists. It's all the more beautiful that there are, again and again, those few precious occasions, treasured all the more in the heart and mind, where everything is right—the place, piece, time, cast, interpretation, and reaction. Then they all sit together in an auditorium, the realizers, recipients, and reviewers. And in the breathtaking end, they are what looks like one big ball of happiness made up of reveling bundles of endorphins.

As one of Germany's best-known cultural critics and journalist for *Die Welt*, Manuel Brug has been writing about classical music, dance, theater, film, television since 1988.

9.

Paths

Utopie and Dystopie

OPERA:
"LA GRANDE BOUTIQUE"

Alexander Neef

Gerard Mortier

Gerard Mortier is widely considered to have been a radical, but I don't think he thought of himself as one. He always drew a very clear line between what could be done and what could not be done aesthetically, and he stuck to this. Though I belong to another generation of directors and feel freer in my choices, Mortier will always remain my mentor. One thing he said, which resonates with me more and more, is "There is no democracy without the theater."

I find this political aspect of art paramount—not in the sense of everyday politics, which is not what we do, especially not in opera, but political in the original sense of the Greek word *politikós*, which contains the words *polítēs* for citizen and *polis* for city, meaning things of concern to our society and environment. If you go back to why the Athenians invented the theater: the theater was intended as a gathering place for the community (even though women were not allowed to attend); it was the place to address issues relevant to their everyday lives and to dramatize these situations by putting them on the stage. This permitted people to look at their problems differently and to walk away with individual and collective solutions.

It is difficult to do better than the Greek tragedies, Aeschylus, Sophocles, and Euripides, and it is astonishing how pertinent they are today—two and a half thousand years later. These stories go very directly to the heart of our existence, touching on both the universal and the personal. The moment of *anagnorisis* is when a protagonist discovers his or her "tragic error" and finally experiences understanding, discovering the true nature of the situation. This was something that could be discussed afterward as a group or grappled with as an individual. Today this process is essential because it forces us to look at ourselves in a way we would never do in an everyday situation. Be it an opera, a play, a painting, or a sculpture; if we learn how to interact with a work of art, we can acquire skills for problem-solving and solutions, which are transferable and applicable to daily life. What worries me is that we are losing those skills because we are training people to learn one thing and do one thing—then we complain about the absence of a generation of leaders! Being a leader means addressing situations others are not prepared to handle, and this requires creativity. I believe the arts can be crucial in developing these capacities.

Education

The critical questions are: how do we interact with art today, how are we prepared through our education to interact with art, and what are we getting out of it? We are living in a very

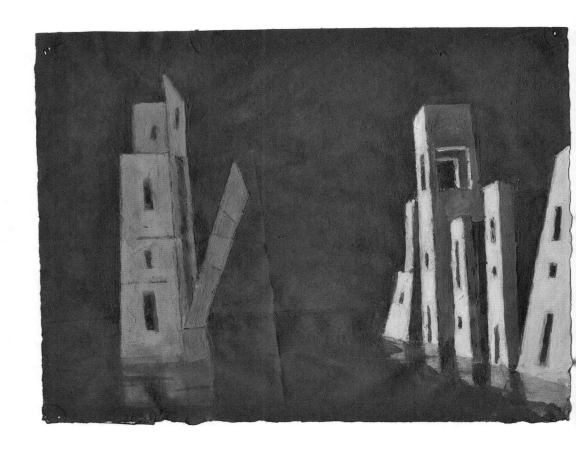

Richard Peduzzi,
Attaque, 2019
Oil and gouache on paper,
17.2 × 21.7 cm
Design for *Les Vêpres
siciliennes*, Giuseppe Verdi,
Rome Opera, 2019.
Courtesy of the artist
© Richard Peduzzi
(Photo © Frédéric Claudel)

utilitarian age. If we look at the trajectory of education, thirty years ago, the goal of a university education was not to get a job or earn money, but to come out as a more knowledgeable person. Today, people go to university to get a job; this contradicts the original idea of the university. The problem is that the skills you acquire through interacting with literature and works of art are not immediately tangible, measurable, or something you can cash in on, which is why arts programs are the first to be eliminated from school curriculums. But without the arts emptiness installs itself, and as a society, we will have to pay the price for this void at some point.

When I think of my upbringing, ours was not a household of great means or where there was an interest in high culture; my parents did not listen to opera at home. But thanks to radio programs and my German public-school education, which included two hours of music education every week from grade one to grade thirteen in addition to other forms of art education, literature, and languages, I got exposure! Some are not receptive, and then it is hard to bridge the gap, but if you are receptive and you are exposed, you will catch the bug. One of my main concerns with public education is how they are eliminating the arts programs. There is nothing more equalizing than free education. Social mobility is the result of free education. It is crucially important to society to provide these opportunities because it is not about where people come from, but the chances made available to them that make the difference.

Europe vs. America

Mortier's radicality lay in his intransigent opinion that opera is not entertainment; for him, it was far more. The notion of entertainment is more prevalent in America, where private funding is essential, more so than in Europe, where we still have state support. But the tendency is creeping in here as well. In Europe, we didn't question public funding until recently because the arts and opera are part of our culture, our identity; in France, we refer to it as our "patrimoine." However, there are more and more people here asking, "Why does opera not pay for itself? Why is it not self-sustaining?" This will soon become the predominant tendency.

Comparing the Paris Opera as I remember it when I left there in 2008 to take over the Canadian Opera Company in Toronto to how it is today in 2020, I am struck by how much the environment has changed, especially regarding its relationship with the government. When I left, the state was still paying two-thirds of the bill; today, it is 45 percent. This is a significant drop, not as drastic as it has been in the United States and Canada, but more and more, the future of this institution is going to depend on its capacity to raise funds. The Metropolitan Opera needs to raise 140–150 million dollars a year; we are not there yet, but if you look at the trajectory, it is clear what is to come.

Therefore, when you talk to the government or donors, they have the right to ask, "So why are you here?" And that is a question the Paris Opera did not have to answer until a few years ago. The Paris Opera began in 1669 during the reign of Louis XIV and was called the Académie Royale de Musique. It has existed as an institution ever since. It had its consecrated role, and now that role is being questioned. The question is not whether or not it should exist,

but one should revisit the arguments for its being here. And the idealistic arguments or more informed arguments from the 1980s and 90s don't convince people anymore.

High Culture Pyramid

Opera is not an art form for the masses, and it never was, but every French citizen doesn't visit the Louvre several times a year either. We have to recognize that, in truth, only 8 to 10 percent of the population participate in "high culture." But then you don't know who is included in this percentage, which is where the elitism creeps in. Someone once said, "L'excellence pour tous c'est le vrai élitisme" (Excellence for everyone is true elitism). This should be our goal, but the challenge is to make it easily accessible without bringing down the quality of the product. I'm very much a believer in a healthy pyramid of cultural activities, but a healthy pyramid needs to have a top—if the pyramid is flat, it doesn't work! If high culture is strong at the top, it affects the lower levels— or the general offer. As we say in Germany, "the fish stinks from the head." The idea of the pyramid is to pull people up, not to push them down.

It is essential that while trying to improve accessibility to the arts, we don't give in to the principle of the lowest common denominator. Often what we consider as accessible or non-accessible for specific audiences is tainted by what we know personally. Initiating audiences with no cultural routine or canon to opera is a particular challenge. Except for the Metropolitan Opera in New York, North American audiences are much less familiar with the operatic canon than European audiences simply because none of the smaller companies can afford to give the *Marriage of Figaro* or a great classic every year. At the Canadian Opera Company, we perform the most popular operas only every five to seven years. The result is that each time we give one of these, a large part of the audience has never seen it before; therefore, the way we do it becomes the reference. The idea that Verdi, Wagner, and Mozart are turning over in their graves because we have taken liberties with their works is not coming from audiences who are seeing these for the first time. The same is true for new works and atonality, which are more problematic for the initiated than non-initiated. New audiences don't care much about atonality if there is a strong theatrical frame to the piece. This is why I don't believe there is one ideal first opera for everybody: some people see *La bohème* and think it's the worst thing they could imagine, whereas others find it corresponds perfectly to their ideal of what opera should be.

La Grande Boutique

While planning my future tenure, I would like to revisit the idea of *La Grande Boutique* regarding this institution's totality and its potential for drawing new audiences.

The term La Grande Boutique translates as department store, which is obviously not what we are, but the Paris Opera also has many departments, each dealing with a different aspect of opera. What I want to offer as director is an invitation to all to wander in and explore our *Grande Boutique* and all the various departments, the mainstage opera, mainstage ballet, as well as the amphitheater and chamber music concerts. Not everything is for everybody, but we invite you to wander in and explore.

Nobody is afraid to go next door to the Galeries Lafayette or the Printemps—why are they so scared of walking in here? If the truth be known, the walking in part is much harder than actually experiencing a performance. How can we help newcomers who want to come in but are unsure whether or not opera is really for them? Surmounting these fears has everything to do with psychology and communication, and in this area, American houses are way ahead of the game. They have implemented diversity on all levels: artists, staff, the governing body, and this makes all the difference when it comes to reaching out to new audiences.

The time has come for the big performing arts companies to hold up the mirror and recognize that we sit aloof in these vast fortresses. The Paris Opera has two magnificent fortresses: the Palais Garnier, which is more human, and the Bastille, which is more intimidating. But even coming into the Garnier can be incredibly daunting, nevertheless, we expect new audiences just to walk in.

I want to think about this house as a place where people can come in and explore on their own terms. Regarding Mortier's radicality, one has to recognize that in his propositions, there was nevertheless a rigidity about what art could and should be. I am not as categorical as he was. I think we need to be a little bit more generous and not say: if you can't have it this way, you can't have it at all. We used to sit in our fortresses and say this is how we produce opera, and if you don't like it, that's too bad for you. We are not living in that era anymore. There has been a significant power shift from those who produce opera to those audiences who consume them and who now feel they should have their say.

New Media/Streaming

Even if the audience is less knowledgeable than it once was, it is much more empowered and accustomed to controlling the rules. New media is responsible for this attitude. When I grew up, if the television or radio show started at six o'clock, you had to be there because that was when the show began and if you were late, you would miss something. Back then, there was the eight o'clock news, and everyone would gather to hear it; it was considered an authoritative source. If you wanted to hear opera on the radio, there was the Met Opera Broadcasts, but you had to switch on the radio on Saturday at a precise time; if you switched it on two hours later, you would have missed the first act. Today we have to imagine that new audiences struggle even with the idea that they have to be in a specific place at a specific time. Therefore, we have to realize that opera makes incredibly high demands for the non-initiated to meet and reinforce our communication and education programs accordingly.

Today more and more people interact with their entertainment and information, and they are deciding not just when but what they want to hear. You go on Twitter, and there is your timeline, or you go on Facebook, and it is always there, always refreshed, and available when you want it; even at three o'clock in the morning, there will be content for you. It is the same with all the streaming services; whatever is on Netflix, you can watch any time you want; you don't have to wait a second.

When it comes to opera, streaming is great, and opera in the cinema is great, but the show only truly happens in the theater. Cinema will never replicate the way it really is. The

authentic operatic experience is a live experience where you feel the sound vibrations in the space of the theater. One day we will perhaps be able to replicate that, but we will never replicate the gathering of people in a space at a given time and that shared experience.

In the end, though the audience is more empowered in the way in which they consume their entertainment, they are completely disempowered to draw their own conclusions about it. When you sit in the theater, you have to be your own cameraman; you have to make decisions and take responsibility. We are always waiting for people to tell us what to do, which is why today there are alarming political issues because people cannot assess and manage their situations.

Cathartic Power of Opera

People often say to me: I'm going to see my first opera, is there anything I have to prepare? I always answer don't prepare anything, don't ruin your experience before you've had it. Opera is a complex, sometimes daunting art form— it is not as easy as watching something on Netflix. The most important thing is that an attachment should occur with the first experience: once there is an emotional response, the listener will want to explore it intellectually. I think this is the right way of attacking the problem. The great thing about opera is that you can consume it in many different ways; there is a visual angle, musical angle, the story angle. Opera can be a powerful cathartic experience, and if people experience that once, they will want to come back again and again—it's a form of addiction. However, first people have to be drawn in; they need exposure: this is true for opera, all the performing arts, and literature. Ideally, this exposure should start at an early age through the educational system. Art should not be something outside our daily lives or something exceptional; it should be an integral part of our routine. I believe there is much more art in people's lives than they recognize.

Opera can be a ritual, which is "structurant" or formative, and I think we need a certain dosage of ritual and protocol in our lives. We need it because there is so little to hold on to. Les Galeries Lafayette is a cathedral of consumerism and immediate satisfaction; there is no protocol in binge buying and on-line shopping. Opera is an art form that is incredibly rich with meaningful and deep content—and entertaining frankly—however, it involves a ritual that we take part in at a given time and place.

Multiple Crises

At the moment, we are not facing one crisis but several. There is an information crisis; today, we have so much information that we cannot process it all. Here in France, I have gone back to reading several newspapers; it is highly stimulating to read the *Figaro* and then *Le Monde* and *Libération* and get all these very different viewpoints. It reminds me of the time when I was growing up, and we were encouraged at school to read more than one newspaper, for example, the *Süddeutscher Zeitung* and the *Frankfurter Allgemeine*. Thus, we were exposed to two entirely different points of view on international and domestic affairs; then, we could decide which one was right or perhaps conclude that there was no one answer. People are less inclined to do that nowadays, though it has never been more urgent.

Today there is a tendency to over-simplification, whereas the theater is a place of complexity. This complexity is a disadvantage in so much as it makes opera less adept at change than other art forms due to the diverse energies involved, the artists, technicians, logistics on all levels, security, and long preparation period. However, complexity is also a virtue, and delving into opera intellectually, emotionally, psychologically can play an essential role in providing people with the tools to manage complexity in their own lives.

From the point of view of the ecological crisis: we have to be more responsible regarding our resources in the theater; energy is a big issue in our business, and the more sophisticated our shows become, the more costly they are energy-wise. If we want our audiences to build awareness, we have to think and act about ecology to have credibility as an institution. For example, if our stars could agree to stay in one place for a more extended period rather than doing five productions at once in different cities around the globe, this would be far better for the environment. We have to come back to the idea that we cannot have it all, all of the time.

There is a crisis of authority and credible leaders. Being an intendant is like being the mayor of a small village, and the only way to do that well is by listening to people. The great thing is that in listening to people, you end up finding solutions you would never have imagined. The director's office at the Bastille is the size of an apartment. But this was built in the 1980s when your office would tell everything about who you were. We have to rethink all of this. We should no longer be defined by the size of our offices but rather by the content we can provide internally and externally. It was the other way around for the longest time. Things have changed; just being there does not suffice; you have to justify your existence continually.

How does opera fit into this moment of multiple crises? I believe it has a role to play in helping people to deal with complexity; through the theater teaching people how to problem solve—like in Athenian times. Yes, it is a challenging moment in France and now globally with the Corona crisis; nevertheless, there are huge opportunities in crises, and we have to be ready for these in the opera as well.

Based on a conversation with Denise Wendel-Poray on February 29, 2020

Alexander Neef studied Latin Philology and Modern History at the Eberhard Karl University in Tübingen. In 2000, he began his career as production manager at the Salzburg Festival for two seasons, before joining the artistic administration of the Ruhrtriennale. From 2008 to 2020, he was general director of the Canadian Opera Company. He became director of the Paris Opera in September 2020.

A CONSUMMATE UNIVERSE

Clemens Hellsberg

"Know'st thou what will be?" ask the Norns in the Prelude of Richard Wagner's *Götterdämmerung*, and without an answer to this quintessential question of human life, they resort to a doomsday vision, proclaiming, "No more speaketh our wisdom! / The world now shall hear us no more." The Delphic oracles given to Gyges, Croesus, Alexander, or Pyrrhus are of course the stuff of legend, but the powerful of all ages had to face the question as to the viability of their dominions. Even the Norns don't know of a way to escape the inexorable chain of causality, which is why the rope of Destiny by which they had been bound since time immemorial breaks. From the Pharaohs, the Assyrians, and the Romans to the empires of Genghis Khan and Kublai Khan, the most extensive in world history, and all the way to the empire of the Habsburgs, "on which the sun never set," time has swept away empires that once appeared imperishable. We only know about them from our history books and the testimony of art that has outlived the centuries and millennia.

"They are hasting on to their end, / who now deem themselves strong in their greatness. / Ashamed am I to share in their dealings; / to flickering fire again to transform me, / fancy lureth my will: / to burn and waste them who bound me erewhile, / rather than blindly sink with the blind, / e'en were they of gods the most godlike." That is what, at the end of Wagner's *Rheingold*, Loge, the demi-god of fire (and thus of change) foresees for the future of those holding the reins of power—their downfall, to which he will contribute. Just as all global empires, Wotan's reign is built on conquest and violence, and it is this primal sin and its resulting defectiveness that determines its date of expiration.

In one of his conversations with his confidant, writer and poet Johann Peter Eckermann, Johann Wolfgang von Goethe noted that he could "not but think that the demons, to tease and make sport with men, have placed among them single figures, which are so alluring that everyone strives after them, and so great that nobody reaches them. Thus they set up Raffaele, with whom thought and act were equally perfect; some distinguished followers have approached him, but none have equaled him. Thus, too, they set up Mozart as something unattainable in music; and thus Shakespeare in poetry."[1]

The art form of the opera was also marked by perfection when it was designed on the drawing board, so to speak, and taken directly to the stage at the end of the sixteenth century in Florence. It was the product of theoretical considerations and intellectual games undertaken by a group of highly educated poets, musicians, philosophers, humanists, and patrons

who developed an ideal of the classical drama and transferred it to the present. It reached a climax as early as 1607 with Claudio Monteverdi's *L'Orfeo*, which became a touchstone, although opera took on very different forms over the centuries.

Of course, at times it was also on the wrong track, for instance with the pasticcio of the eighteenth century where, in accordance with the whims of prima donnas or star tenors, arias and ensembles from various works by the same composer, or even by different ones, were strung together, and a new plot was created to make that possible. This practice may well have led to the demise of the opera, had Christoph Willibald Gluck not opposed it head-on. During his brief sojourn in London he had also used the pasticcio technique, but in the context of his operatic reforms, he denounced the "singers' vanity" along with the "composers' excessive complacency" and called for "simplicity, truth, and naturalness" on the opera stage ("la semplicità, la verità e la naturalezza," as he wrote in the preface to Alceste). Inspired by "postmodern theater," this patchwork concept pops up occasionally with one or the other production, but let's hold out hope that the immortalized note added to a *Lohengrin* violin part of the court opera orchestra by violinist Johann Czapauschek, member of the Vienna Philharmonic from 1879 to 1913, remains a caricature and will not become a vision. The scene in question is the one in which Elsa vows to never ask Lohengrin his name or where he comes from, whereupon, in Wagner's words, he is "deeply moved" and "lifts her to his breast in a transport of joy." With about three and a half hours to go to the end, he tells her, "I love you!"—the note reads, "At this point Czapauschek suggests a great fanfare and ending the opera!"

"What is truth?"[2] reads one of the most important sentences in the Gospel According to John. It is not spoken by Jesus, but by Pilate, and in John, the question remains unanswered (as opposed to the apocryphal Gospel of Nicodemus, which was penned at a later date), perhaps also because the Roman governor is not expecting an answer to begin with. Friedrich Nietzsche who, reflecting on this question with brutal consistency, wrote in his biting polemic *The Antichrist* that "in the whole New Testament" Pilate is the only "figure worthy of honor."[3] Even if we don't follow his radical approach, there is no doubt that the question of truth is as important as the one about the future.

In April 1917, which is to say, in the midst of the horrors of the First World War, Max Reinhardt wrote in a memorandum that contributed significantly to the founding of the Salzburg Festival: "In addition to many of the most important phenomena revealed by our times, we must take note that the arts, especially the theatrical arts, have not only held their own during the ravages of this war, but have proven that their existence and maintenance are essential necessities. The world of appearances, which we might have expected to become entirely unhinged by the terrible reality of our days, has remained completely intact and has become a refuge for those remaining at home, but also for many returning from outside, seeking balm for their souls. It has become apparent that the arts are not merely a luxury for the rich and sated, but food for the needy."[4]

According to Reinhardt's insights, the "world of appearances," which is to say, the world of the stage remained intact amidst the "primal sin of the twentieth century," because, in

contrast to the real world, it is truthful. "Appearances govern the world, and justice is only to be found on the stage," that's the moral of (and the most famous quote from) *The Parasite, or The Art to Make One's Fortune*, Friedrich Schiller's translation of *Médiocre et rampant, ou Le moyen d'y parvenir*, a comedy by Louis-Benoît Picard. It also contains the lines, "The web of falsehood entangles the best; and the honorable cannot succeed; sneaking mediocrity prospers better than winged genius."[5]

On the stage, there is neither room for "falsehood" nor "sneaking mediocrity," and even the "winged genius" moves along the precipice of failure. A case in point is the memorable open dress rehearsal of Verdi's *Il trovatore* with Italian tenor Franco Bonisolli who was, in many respects, the ideal troubadour. At one point he prematurely stopped singing, which earned him (undeserved) boos from the audience, whereupon he lost his nerves, threw down his sword and left the stage of the Wiener Staatsoper before the "Stretta." One of the most famous numbers in opera history was subsequently played without a tenor, albeit with tumultuous side effects that even Herbert von Karajan's forceful appeal for calm was unable to quell. The ensuing scene ranks as one of the most remarkable in the history of the "House on the Ring." Marcel Prawy, the unforgettable chief dramaturge who was synonymous with dedication to the opera but was not always treated as his merits deserved, stepped out in front of the curtain and said, "Opera can be cruel." His words perfectly summed up the situation and the suffering to which artists are exposed. To a certain degree, every live performance is cruel, just as (all too often) life itself is. "Ridi, pagliaccio!" ("Laugh, clown!")—is a maxim of the theater, and especially of operatic theater, but one we are not always able to live up to.

The world of the stage is defined by overwhelming emotions, which, in their last consequence, compel unconditional veracity. Combining them with music, the most abstract of all the arts, has created a universe that provides the ideal environment for the most natural of all instruments, the *vox humana*. Here, it acquires the ability to "pierce to the depth of the heart," as Leonore says in *Fidelio* (and, interestingly, does not sing). And the tension between text and music ("Prima le parole – dopo la musica!" or "Prima la musica – dopo le parole!" is the theme of Richard Strauss' last opera *Capriccio*) will always fascinate and inspire artists in both of these "camps." Of course, as Mozart observed, good music will even make us forget an inferior text: "Besides, I should say that in an opera the poetry must be the obedient daughter of the music. Why do Italian comic operas please everywhere—in spite of their miserable librettos—even in Paris, where I myself witnessed their success? Just because there the music reigns supreme and when one listens to it all else is forgotten."[6]

"Know'st thou what will befall?" We know that in mythology, just as in the course of history, gods and vast empires perish; centuries-old social systems have shattered and humanity is increasingly forced to face up to global problems as well as the profound changes they entail. Still, in the fifth century of the history of this comprehensive art form, it is by no means unreasonable to hope that *The Last Days of the Opera* are still a long way off and it will continue to weather the storms of time. Because in the future, countless people will

feel the same as Wolfgang Amadeus Mozart, the greatest of all musical dramatists, who wrote the following about the phenomenon of the opera in a letter to his father on October 11, 1777: "I only need to be in the theater, hear voices—and oh, I am already completely beside myself."[7]

[1] Oxenford (ed.), *Conversations of Goethe with Eckermann and Soret* (London: George Bell & Sons, 1875), p. 414.
[2] John 18:38.
[3] Friedrich Nietzsche, *The Antichrist* (New York: Alfred A. Knopf, 1924), chapter 46.
[4] Max Reinhardt, "Festspiele in Salzburg. Denkschrift zur Errichtung eines Festspielhauses in Hellbrunn" (1917). In: Franz Hadamowsky (Hrsg.): *Max Reinhardt. Ausgewählte Briefe, Reden, Schriften und Szenen aus Regiebüchern*, mit einer Vorbemerkung von Helene Thimig-Reinhardt und einem Vorwort von Josef Stummvoll (Wien: Prachner Verlag, 1963), p. 73–78. English translation by Alexa Nieschlag: Max Reinhardt, *A Festival in Salzburg. Memorandum regarding the Construction of a Festival Theatre in Hellbrunn* (1917), www.sfsociety.org/wp-content/uploads/2018/12/Max_Reinhardt_Memorandum_1917.pdf
[5] *The Parasite, or the Art to Make One's Fortune: A Comedy in Five Acts*, imitated from the French by Schiller and translated into English for the use of Learners by J. S. S. Rothwell (Munich: John Palm, 1859), p. 100.
[6] Wolfgang Amadeus Mozart in a letter to his father (Vienna, October 13, 1781). In: *The Letters of Mozart and his Family*. Chronologically arranged, translated and edited with an Introduction, Notes and Indexes by Emily Anderson (London: Macmillan, 1997), p. 773.
[7] *Ibid.*, p. 305.

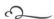

Clemens Hellsberg studied musicology and ancient history at the University of Vienna, and violin at the Vienna Academy of Music. From 1980 he played as first violinist in the orchestra at the Wiener Staatsoper. From 1997 to 2014 he was chairman of the Vienna Philharmonic Orchestra. His book *Democracy of the Kings* is the standard work on the history of the Vienna Philharmonic.

VICTIM OF FEAR—OPERA OF THE FUTURE

Thomas Schmidt

The most wonderful and fortunate coincidence of my life was to have been born into a family of theater artists whose strong and empathetic center was my grandmother, an opera singer whom I was blessed to experience on stage for several years. As fate would have it, I now teach at the Frankfurt University of Music and Performing Arts, a strictly Nazi conservatory in its time, which had barred my grandmother from enrollment in 1937. In spite of it all, she pursued her musical path and celebrated her successes, from *Carmen* and *Káťa Kabanová* to the *Fishwife* in the world premiere of Paul Dessau's *The Condemnation of Lucullus* at the Berlin State Opera. Thus, theater and opera have had a significant influence on my sentimental education—and have stayed with me since my childhood.

In the *Gesamtkunstwerk* that is the opera, more than four hundred people work night after night to ensure a successful performance—they make the opera the largest artistic factory in the world. And yet those on the outside see only what transpires on stage, see the tip of the huge iceberg of theater without being able to appreciate the work and tenacious presence of the many who contribute to it.

There is one caveat in all of this: if only the professionalism displayed by performers and singers on stage was also exhibited by the management of these theaters! What a great utopian place the opera could be: a vessel that takes in the ideas of both young and experienced artists of all backgrounds and carries them out into the world.

Quite independently of the question as to where opera is headed aesthetically, its content and music are to a large extent shaped by social discourses and the structures and conditions that frame and anchor the opera business. As one of the most beautiful and sophisticated cultural techniques, it is the product of a fusion of theater, music, and literature that, like no other art form, has for decades now been walking a tightrope between a growing loss of legitimacy and artistic exaltation (e.g., Bayreuth, Salzburg, et al.).

And so, while opera is trying to survive in broad niches and on lighthouse projects, it is being all but forgotten by public audiences—or is not even within the reach of general public perception. A look at modern stakeholder theories shows why this presents a problem: they clearly state that modern cultural enterprises cannot survive without the integration of their stakeholders. They need to ensure their support and approval. While politics, subsidies, and donors are of great financial significance, they merely provide material security; the opera derives its legitimacy through support from within and without, which is to say, from

the communities that form the ring, as it were, into which it is fitted. Probably the biggest failure of the opera is to put in second place its stakeholders—the audiences, the residents of the city, and its own employees—instead of weaving them into webs of small, interlocking communities that surround each house, firmly planted in the ground of its home environment where it can and is supposed to be an "open" house.

At the expense of its stakeholders, these days, an upper-class bourgeois audience is still first in line to walk red carpets at premieres and after-show parties boasting far too much glitz and champagne. It is little wonder, then, that the young crowd—who is supposed to be the opera audience twenty years from now, at the latest, so that the institution could live on—is not inclined to visit the opera or perhaps even regards it with contempt. The younger generations are hardly familiar with opera, which suggests that it is increasingly failing as the important educational institution for young people it used to be and is thus undermining its own legitimacy. There are even plenty of people who love music and opera but shun performances for fear of not being dressed appropriately or not being fluent in the etiquette essential to navigating a milieu they feel is alien to them. One way forward for the opera would be to become once again a kind of "people's opera" that appeals to all audiences so as to regenerate itself and regain legitimacy with a broader public instead of small elite circles. If it cannot attract, interest, and win over these generations for opera and theater through clever new formats, new contemporary operas, and more outreach, it won't be long before only lieder recitals and old, by then legendary opera recordings will remind a select group of "aficionados" of the once rich opera repertoire. Hence, the biggest challenge for the opera of tomorrow will be to get these groups involved in order to plan and shape the future together with them.

What I have to describe here from a critical but involved perspective sounds dramatic and will take on an increasingly dramatic tone—with the sole aim of re-establishing opera as a strong cultural tool that is capable of reflecting, anticipating, and accompanying developments in society through its music and powerful imagery. But let's start with the criticism and then move on to the utopian vision, because there is one more failure that needs to be called out for what it is: instead of transforming opera houses into modern enterprises, the old structures dating to the turn of the century before last have been left intact or were reformed only here and there in a makeshift fashion. Thus, opera houses are still run by only one or two people: the omnipotent intendant and the general music director. The entire responsibility lies upon these one or two persons—mostly men: functioning as a CEO, they are in charge of all final decisions, the house's overall artistic style, as well as all aspects of its internal and external representation. This is an outdated and worn-out model that was developed at a time when the tasks of a theater director were still manageable and nothing compared with today's requirements.

The opera is a pre-modern, autocratic, and patriarchal cultural institution, which is based on structures that hamper the potentials of teamwork, learning, as well as innovation while imposing excessive physical demands and a culture of overwork on its ensembles and employees. The apparatus is still divided into large silos comprised of technical depart-

ments, workshops, administration, the artistic department, and the orchestra; structurally and contractually, these areas operate separately, yet for each project, they have to be harnessed together and aligned towards a common goal. The fact that opera companies deliver shows night after night is owed to the collaborative efforts of a collective form of art where employees, who are otherwise constrained by hierarchical structures, are allowed to outdo themselves creatively through individual efforts. The working context of this artistic enterprise holds many contradictions.

The outdated leadership and management model have led to missteps that have accumulated at opera houses and major multi-genre theaters in Germany, Austria, and Switzerland. Leadership crises have ensued—more than fifty over the past ten years. Most recently in Karlsruhe, where the intendant was dismissed in the wake of protests staged by the most important stakeholder group, the employees; a course of events that speaks to the level of distress the staff must have experienced.

The outdated management model and excessive pressure placed on directors—most of whom are trained solely in the arts—to manage their institutions in a contemporary fashion make it abundantly clear what is really missing, and that is *leadership*. It is the essential instrument for managing the house and its staff in a manner that promotes development; in addition to adequate training it requires, above all, empathy, foresight, strategic skill, and innovative strength. A leader is one who appreciably stands back from his or her own interests in order to become the top steward of the company and its employees—it is a counter model to the long-standing tradition of opera houses whose leaders are the center of attention, brook no rivals, and reap the fruit of opera teamwork in the media as well as on the political stage themselves, instead of sharing them with those who planted, watered, nurtured, and harvested them.

The reforms urgently required today will entail the biggest cultural shift at opera houses in roughly the last one hundred and forty years. But just as back then the establishment of a bourgeois intendant model replaced the old feudal system of management, a present-day modern intendant (director) is called upon to shed the ambitions of the bourgeois intendant and place the interests of the staff and the house as a whole at the center of his or her activities. This also includes joining forces with those who previously served as second-level leaders in order to form a real management team at eye level where joint responsibility is assumed and collective decisions are reached. Modern management teams who split the duties of a directorship among four, five, or six people—depending on the size of the house—will not only be able to boost their energy by cultivating their fields of activity in a spirit of shared responsibility and unified strength. Such models lead opera companies to become highly resilient and less susceptible to leadership failures, which can be identified, assessed, and remedied by the team at an earlier stage. This model is equivalent to the classic model of the board that is common in the business world, at NPOs, or foundations where the board includes a rotating speakership position or elects its own spokesperson (not leader!).

The old leadership model that was instituted by autocrats and patriarchs—hardly any opera houses are headed by women—creates another problem, as has been demonstrated

by the stark results of a study I conducted across the theater industry of the German-speaking world in 2019. It surveyed 2,000 opera and theater artists in Germany, Austria, and German-speaking Switzerland ("Macht und Struktur im Theater" / "Power and Structure in the Theater"). The borrowed and entrusted power is abused and used against those who have put their trust in their *intendant* and rely on him for their protection. The findings are devastating: two out of three participants in the study have been, or are, directly affected by abuses of power by their superiors over the past two years. Over 50 percent of artists face toxic power contexts that severely impact working conditions, and one in three have been subjected to moderate to severe psychological and physical abuse, ranging from initial bullying and discrimination all the way to sexual assault—often without ever receiving support from others. Most employees are afraid to stand up against a stage, opera, or artistic director and to subsequently testify, as well, even if by doing so they could protect their traumatized colleagues.

Fear has long taken hold at almost all theaters. It is rooted in the omnipotence of artistic directors, general music directors, and stage directors who decide on the casts, dismissals, as well as future careers not only in their own theaters but at other theaters: it only takes one phone call to one of their confreres to make or break a career. For many involved, fear thus becomes a dominant factor, and they are never given an opportunity to perform to their full potential. "No passion so effectually robs the mind of all its powers of acting and reasoning as *fear*," this was already stated with great clarity by Edmund Burke in 1757. These conditions have since tended to become more severe at theaters due to increasingly complex requirements resulting from economic, technological, and environmental considerations. If this fear could be overcome in theaters and opera houses, a new culture and artistic facility would set in, leading to inspiration and entirely new surges of artistic development, which we need to safely guide opera into the future.

In this context, another aspect laid bare in this study needs to be taken into consideration: the accumulation of power and the frequency of assaults at theaters. French philosopher Michel Foucault describes power as the multiplicity of force relations and working conditions (1977). On the one hand, power acts as an essential lubricant that keeps an organization running, and at the same time it is, as Crozier puts it, the "raw material of collective action" (1993). We can describe power as a positive force when it is put at the service of the opera and its employees. According to sociologist Max Weber, who hailed from Erfurt, Germany, what power also means is being capable of "imposing one's will within a social relationship even against resistance" (1922), which is to say, a person able to turn a situation in his or her favor possesses power. Those who have power are accorded the freedom to assert their interests against the will of the many. Thus, it is little wonder that intendants are the perpetrators of fear and abuses of power in more than 60 percent of the cases. Twenty percent are spread among other superiors at various levels (division directors, department heads) and again just under 20 percent among colleagues in teams, departments or ensembles. Here, good leadership would mean that the management team of an opera would swiftly and transparently address all instances of power abuse, ban from the opera those who tend to chronically

engage in such behavior, and give ultimatums to others. A set of rules that could result in a *Code of Conduct* would limit and regulate power, and mediators along with other points of contact could shape processes and communication within the organization in such a way that anyone who does not feel safe is immediately given the opportunity to speak, obtain information, and find help.

The most important step would be to remove the intendant from his throne and lift his "immunity." As long as theaters are largely managed and controlled by political supervisory bodies, it should be their responsibility to amend existing contracts, restrict rights and, accordingly, use the appointment of new directors as an opportunity to constrain power from the outset and select individuals/teams more inclined to engage in leadership and integration than in self-realization and abuse of power. New intendants should possess psychological and well-trained management skills that enable them to run an opera in cooperation with staff as well as other stakeholders and allow for true participation. That way, opera will be better equipped to successfully and sustainably reclaim its place among the communities of the twenty-first century. But until then, modern discourses on digitization, justice, diversity, parity, and participation must also find their way into opera companies, onto their stages, and into their auditoriums. So far, they have been largely omitted and never taken into serious consideration. To be sure, opera theaters, more than any other artistic discipline to date, have shown how diversity can become an important aspect of presenting vocal and musical achievement on stage. But these principles have not found their way into the concept of the *entire* opera business to an equal degree.

Artistic freedom is not infringed upon in any way in such a reform process; it remains a valid principle and is realized on the level of artistic production. At the management level, a theater has to worry about the future, about good leadership, about promoting development and innovation, and about establishing the theater as an organization that is always in the process of learning. On this level, artistic freedom has hardly any part to play, neither in real life nor as an argument wielded by directors with the aim of asserting their interests and preventing these important reforms from being implemented. Even though some aspects of artistic freedom are also manifest at the management level, for example when it comes to preventing political and/or economic interference in programming and content, this has more to do with the political determination to follow one's own ideas and reject interference. Artistic freedom is always a concept; it cannot serve as a management tool. To manage an opera according to this principle would mean denying it a future.

Fear, discrimination, injustice, and abuse of power must have no place in an opera of the future. But, as always, the devil is in the details and in the first steps towards reform. How do we move forward? And with whom? Whose support do we need? And what is the first step?

Opera will endure as a great, complex, and important art form and cultural technique. It will also survive the current crisis of leadership, which is deeply rooted in its operational culture and structures. Awareness is always the first step. The conclusions drawn from it generate action. As a result, the opera will pursue different paths, none of which will necessarily be alike. The process of uniformization that marked the past decades—where the same

repertoire with the same stars and the same supreme tonal and musical standards circulated, among others, throughout the forty opera houses and major opera divisions at multi-genre theaters that still exist in Germany, Austria, and Switzerland—needs to be overcome. Not only do we need new structures and leadership, we also want a new, refreshing repertoire, novel and open formats, interdisciplinary collaboration with other fields of art—and, above all, let's be less strict and harsh with ourselves, and others. If opera becomes lighter, more joyful, and more heartfelt, both in the manner in which it is run and in its repertoire, without trimming its sails and without wantonly succumbing to populism, it will again reach those who have stayed away from its events in the recent past. A first step in the right direction would be to tweak the economic aspects of productions in such a way that ticket pricing can follow a supply-side approach—primarily targeting those who have been unable to afford opera for so many years. That will make the opera a place of the future that belongs to its stakeholders. Let's open the doors together, and open them wide, let's roll out red carpets deep into the communities.

Thomas Schmidt headed the Master's program in Theater and Orchestra Management at the Frankfurt University of Music and Performing for the last twelve years. He was the managing and later the executive director of the German National Theater in Weimar between 2003 and 2013. His books, *Theater, Crisis and Reform* (2016) and *Power and Structure in Theater* (2019), both provided essential impulses for the current reforms in German, Austrian and Swiss theater organizations.

A CONTEMPORARY
OPERA HOUSE

Sven Hartberger

The question as to *The Last Days of the Opera* is posed with such blatant rhetorical intent that even its rejection is rendered moot. Who, in all seriousness, would want to read the outpourings of some opera scholars asserting their rock-solid conviction that even in the most distant future, people will still enthusiastically listen to *The Magic Flute* and *Tristan*? Who would want to engage in further assessment of the need for contemporary interpretations of historical material? Or study tables of data showing an increase in the number of performances and growing public interest in a supposedly endangered art genre? Or point to the commendable regularity with which big new houses are built to host its performances in Europe and the US, the enormous efforts invested in these undertakings, and the considerable amounts of funding poured into their ongoing operations?

No, the question regarding "the last days" or, rather, "the future" of the opera is not directed at the viability of a repertoire that has remained in a state of ossification for almost a century. In this respect, there is hardly need for concern in the foreseeable future. However, what constitutes the problem is exactly the carefree attitude that comes with the undeniable success of even the most conservative and backward opera houses. It sparks the desire to think about the currency and future of a genre that has apparently become a historical one. The actual subject of the deliberations called for under this pithy headline is thus not about the so-called repertoire, but rather about the spirit and purpose of the whole shebang as well as assumptions regarding the antiquated nature of the form as such. It is precisely these assumptions that the following three short sections will attempt to explore. A brief opening argument in favor of its relevance to the present aims to lay to rest the notion that the opera as such could be outdated, as alluded to in the subject of this anthology. The second section is dedicated to the question of why we are rarely able to experience this relevance in the real world of the opera, the corollary being that there is regular speculation about its imminent demise. The third section discusses possible paths by which the opera could reclaim its place in contemporary culture after being widely, and not without good reason, perceived as a historical art form.

1. On the Relevance of the Art of the Opera

Any consideration of the contemporaneous or antiquated nature of the genre must be preceded by an appreciation of the essence of this special art form. What are the key characteristics of the opera? In what way and form do these central features live up to present expectations?

Gerard Mortier's book *Dramaturgie d'une passion* points the way ahead for the opera and answers these questions with a concise appreciation of Claudio Monteverdi's Music-theater creations, stating that, "It is as if—by connecting words and music—reason and feeling were to be raised to the same level, so as to create, through dramatic action, a place for reflection and emotion." They have the extraordinary ability to take into account both ratio and emotio as equal sources of knowledge, insight, and understanding and consult both in the same moment. This not only constitutes the special power of the art form, but also highlights its extraordinary timely significance, especially at the beginning of the twenty-first century. Independent of the subject individual works focus on, the opera has a fundamental potential to counteract the mathematization of our language and thinking, which Hans Zender, one of today's most important composers and philosophers of music, quite rightly describes in several of his essays as the root of many of the troublesome developments in recent human history. More than any other art form, the opera has what it takes to form an antidote to an exuberant rationalism that is not by a long shot as rational as it believes itself to be, to reopen the doors for an urgently needed return to the diverse forms and functions of human mental activity. It is precisely this quality that opens up the possibility for the opera to approach its subjects via radically different avenues of thought and experience.

Hence, it is not the relevance to the present of the art genre as such that appears questionable. Rather, this raises the question as to the extent to which the current practice of the art form is harnessing its potential.

2. Opera at the Beginning of the Twenty-First Century. A Brief Stocktaking

A sober look at the season schedules, performance praxis, and audience structure of the vast majority of Europe's opera stages leads to a quite clear conclusion (the same is even more true for the US). Conclusion? Wherever this question is raised at all, there is little disagreement about the answer. At the beginning of the twenty-first century, the opera is an art form produced for an audience of academics and high school graduates of advanced age and is consumed by them, preferably in the form of the familiar tried and trusted, as a sophisticated, culturally refined evening entertainment program. Only to a very limited degree is it a place of engagement with current social and political issues (or even simply new currents and findings in the arts), and it is certainly not a place for anyone looking to experience negotiation of the most pressing problems of our time through the means of art.

Of course, you can always say that *Rusalka* is really a visionary take on the extinction of species, and that *La bohème* is actually about skyrocketing housing costs. But, first, with the exception of theater and stage directors and dramaturges, nobody really believes that. And, second, the courageous new approaches to reading the old dramatic texts are only rarely matched with a similar re-reading of the corresponding scores, so that things often turn out lopsided in a pretty glaring fashion. What's more, the vast majority of European opera houses were built in the nineteenth century. The lion's share of the repertoire performed there also originates from that period, closely followed by compositions not from the twentieth and certainly not from the twenty-first century, but from the eighteenth century.

No matter how you look at it, our opera houses are and will remain museums. Some of them are helmed by dedicated directors who strive for contemporary contextualization of the works they perform, which are on average one hundred and fifty years old. But more than a few of them are, of course, also highly satisfied with the admirable musical quality of their productions, achieved today not only by the big houses, but also by medium-sized and small ones. Still, the list of operas they stage has hardly seen any new additions for almost a century.

What, then, is the answer to the question regarding the artistic, creative, and political power and energy of an art form? At the beginning of the twenty-first century, its most frequently played dramatists seem to be Aeschylus, Sophocles, and Euripides. Its most vibrant composers and their musical oeuvre hardly ever find their way onto the big stages before the age of sixty—and even then only by way of exception, and as a rule, with no more than a single work, which, moreover, is invariably given only a brief run but never a place in the repertoire. Let's perhaps begin with the political and societal significance afforded to the genre in the live praxis at its performance venues. In his *Dramaturgie d'une passion*, Mortier very convincingly derives the duties the opera bears in this connection both from the historical roots of the genre in the drama of the ancient Greek polis and from the massive financial contributions by the public sector. Both of these factors provide the grounds for the duty of social and political commitment that is intrinsic to the essence of the opera. This includes, above all, "breaking through the routine of everyday life; calling into question the acceptance of economic, political, and military violence as a normal part of life; creating sensitivity among the community towards the fundamental issues of human existence that cannot be regulated by law; and affirmation that the world can be a better place than it currently is."

At least the big houses demonstrate only scant readiness or intention to actually embrace this calling. You'd be forgiven to think that the opera has grown old. It has a proclivity for opulence, it's putting on a bit of weight, and when it comes to its contemporary productions, it appears to have become surprisingly conventional and ossified. Pointed engagement with urgent societal issues or current events is often found more in advanced repertory productions than in newly premiered works. The latter palpably speaks to the way the genre has retreated into philosophical, lyrical, and self-reflective musings. It references the present only by way of general discussions of the human condition without ever getting its hands dirty with the banality of the real world.

Here's an example: anyone demanding that helpless people be drowned in the Mediterranean or transferred to camps notorious for rape, torture, and killing, such a person is a murderer. He or she is so regardless of the reasons behind his or her demand, at least before the moral law (and most likely under the provisions of all European criminal codes, as well). And the verdict will not be a lot more lenient on someone who urgently recommends turning away when faced with the death throes of the drowning, calls for an end to the NGO madness, proposes close cooperation with those filling these concentration camps with inmates, and suggests we get used to seeing ugly images. Only five years ago, such attitudes were still confined to the booze-fueled rants of bar-room politics. Today its proponents have been

promoted to the highest government offices. Hardly anyone would claim that European opera houses have reacted to this paradigm shift in any noticeable way.

Or, I am penning this contribution to the anthology in Austria. Not long ago, this country was run, for as much as one and a half years, by a federal government that included as ministers three men who had repeatedly spoken out in favor of allowing the re-establishment of the Nazi Party. They called it an important requirement for free and democratic thought. During their time in power, their party did not fail to issue threats and take measures against artists whenever it was able to do so (by cutting public funding). But not a single one of Austria's opera houses has given the slightest cause for complaint to those advocating a re-assessment of the Prohibition Act 1947, which prohibits, among other things, any potential revival of Nazism. A look across the country's borders does not present a different picture. In Italy, fascist Salvini was able to count on the goodwill of the economic establishment and the indomitable silence of the Scala di Milano along with that of all other opera houses in the country. In France the streets are on fire, but there have been no reports that the opera had anything to say about it. In Germany, too, it appears that it is not exactly opera houses that are found on the frontlines of the fight against rising fascist movements. Do I have to say more about the political power and energy of the current practice of this art form?

And yet, there is no lack of creative and artistic power on the part of authors, composers, and theater makers, as visits to theaters, cinemas, concert halls, and alternative venues show. But try as anyone might, it's impossible to claim that the opera industry is engaged in fostering this energy and power the way it is supposed to, or that it even affords them the space that would allow them to unfold and develop. After all, the central profile of our opera houses is that of institutions preserving an outmoded heritage. Even the occasional incursion of contemporary creations does little to change this picture. What's more, they are mostly only entered into the temple of repertoire in watered down form, their authors being only moderately inclined towards avant-gardist practices to begin with.

3. The Path to the Present

While the art form of the opera possesses artistic and societal potential of the highest order in today's world, putting it to use in the current industry environment and the genre's actual arrival in the present moment is fraught with obstacles, the greatest being canonized repertoire. The repertoire as such is of crucial importance, because any full-blown opera is a work of enormous complexity. Really gaining access to its text, score, plot, and scenes requires repeated engagement. The problem lies in the ossification of the repertoire, and the last work to join its ranks was obviously Richard Strauss' *Capriccio* (1942). Taking a convenient shortcut from there to the present by staging often bombastic and hypertrophic commissioned works, opera houses have for decades kept from their audiences seventy years of musical development. In reality, this amounts to little more than cheap marketing that draws short-term attention and international media coverage while doing next to nothing for the opera as a contemporary form of art.

The path that takes this art form to the present leads exclusively through the consistent renewal of the repertoire. What ultimately counts is the audience's artistic, creative, and

musical sensibility, which is crucially shaped by the works favored and regularly staged by the industry. At least a third of the current repertoire needs to be replaced by works from the second half of the twentieth century if this art form is to actually arrive in the present moment. It is only on this basis that the broad audience the opera depends on can find access to the operatic creations of our time.

This process must ensure that the new will not quietly and bashfully trickle away into the bedrock of the repertoire. The renewal of the repertoire is a challenge that must be addressed vigorously by the major houses, and it has to be communicated with credible conviction. This long-overdue renewal requires as its flagship an opera house of the present, equipped with equal means as its art historical counterparts, tasked with presenting the great repertoire of the last seventy years on three hundred evenings a year. Building such a house is a great European project that the Union should get behind collectively. The city that will host the new house will become the center of an art form whose current praxis is antiquated, but whose idea and power is alive and relevant as ever.

Austrian author, translator, and dramaturge active in the cultural sector since 1980, Sven Hartberger was artistic director of the Vienna Opera Theater (1989–1999) and artistic director of Klangforum Wien (1999–2019). He is on the board of mica - music austria, an independent, non-profit association, to support Austria-based musicians.

OPERA WITH A WORKSHOP CHARACTER — FRANKFURT AND THE CONSEQUENCES

Michael Boder

Let me begin by declaring my love for the opera company as a sociotope. Walking into the stage entrance of an opera house immediately brings to my mind the notion of the *Gesamtkunstwerk*, or, the total work of art, that incorporates all artistic genres. As an orchestra conductor, one is, of course, used to bringing and holding together diverse musical elements. The instrumentalists alone form different microcosms that merge into the whole of a symphonic work. In opera, however, this spectrum additionally spans all kinds of professions that work towards a single goal, namely to make a performance possible.

The cosmos of opera includes not only the performing artists, an orchestra, and a ballet, but also very practical professions, some of which may no longer exist in real life, such as an armorer. Or, take the occupational profile of a costume designer. Skilled craftsmanship is not the only requirement for this job—ideally it also takes an understanding of the historical context of costumes, political and social conditions, or geographical backgrounds. We can think of this cosmos as one of those wimmelpictures (aka hidden object pictures) I couldn't get enough of as a child. One is overwhelmed by the immensity of the whole affair and always discovers new details on closer inspection.

Another analogy that comes to mind is the opera house as an ocean liner that has something different to offer on every deck. Traversing this ship, we encounter people from all educational and social walks of life, certainly a number of hard-working and some well-to-do folks, but also those occupying the steerage decks. They all share a common goal, namely the one destination port of their journey. And that's roughly how I feel about the opera experience, because everyone involved, from stagecraft people to performers to audience members, they all embark on a journey over the course of an evening that only finds its fulfillment in the overall result.

Before we turn to the world of modern opera, let's take a brief look back at the interplay between music and theater. I am convinced that theater has served as a conduit for all musical revolutions—I would only exclude Johann Sebastian Bach and, later, Ludwig van Beethoven. This is true for Claudio Monteverdi in the early days of opera as well as for Mozart and Wagner—and I submit that even Gustav Mahler actually wrote operas. With Mahler, these compositions are called symphonies, but they are always dramatic sound paintings that tell a story—operas for the listener's inner stage. Stravinsky is another great example. If one were to expunge from the history of music his three ballets, what would be left of him in terms of

the broad impact of his musical innovations? The list of examples that speak to the power of music in connection with the stage can be easily continued into the twentieth century—from Alban Berg and György Ligeti to Hans Werner Henze or Aribert Reimann.

Coupled with images, new steps in the development of music are always met with greater acceptance than in the concert hall. This has to do with the fact that pictorial representation is completely associative and altogether unfamiliar sounds can thus be introduced into our listening habits; we can embrace them in the context of visual imagery. Rarely is contemporary music received as well by a wide audience as in movies. But the opera, too, has always served as a conduit for musical innovation: in terms of harmony, style, the introduction of larger orchestras, or the use of unconventional instruments. Richard Wagner, for example, brought about a turning point in music history when it comes to the use of the viola in the orchestra. It was Wagner who first freed the viola from the secondary role the instrument had played at least until the Classical period.

The opera has always spawned musical innovation that was subsequently continued in other genres; perhaps with the exception of chamber music, where virtuosity and skill has continually fueled progress in musical literature. I guess it was only a matter of time until, after the end of the world war and as a consequence of the social upheavals of the 1960s, an opera house would harness this revolutionary potential in the area of staging as well.

Ever since 1977, when Michael Gielen became its General Music Director, the Frankfurt opera has been regarded by many as the birthplace of "modern *Regietheater*" (German for "director's theater"). While relatively few world premieres have been staged in Frankfurt—that was only a very small part of its offerings—Ruth Berghaus, Hans Neuenfels or Alfred Kirchner have set new standards in interpretation.

At the time, Frankfurt was a very special environment where audiences were not as staid and culinary as in Munich, and not as lackadaisical as in Hamburg either, something that has, of course, changed in the meantime. Frankfurt also had a heterogeneous population, which not only included lots of bankers, but also a sizable number of proponents of Germany's 1968 movement. At the time, the shake-up at the town's opera house was so dramatic that large sections of the audience refused to go along with the new paradigm and had to be "replaced." The traditionalists stayed at home or decided to attend opera performances elsewhere, and Frankfurt had to attract new operagoers.

A different set of people began to flock to the opera, because in Frankfurt the battle had been won for the equality of music and stage. In this vibrant cosmos, Klaus Zehelein, the future opera director and intendant, helped restore the role of dramaturgy to its rightful place.

Perhaps the Frankfurt of the early 1980s was something like the fountainhead of today's dramaturgy. Up until Frankfurt, conductors were responsible for the music and directors for the stage. Zehelein, serving as the dramaturgical hub of the opera house, relentlessly made his case to all those involved until they followed his lead. For nights on end, directors, conductors, and dramaturges fought over all the details of their productions—even at the pizzeria around the corner from the opera house. Michael Gielen would stop by after the show around midnight to join the discussion: How should we evaluate narrative content

from a historical perspective? How can it be translated into a visual language? What are the means by which this can be achieved?

Zehelein was the agent of change in this melting pot of interests, and he was able to work out solutions through conflict. It was not because they got along well that they were doing theater together, but because they came from different backgrounds and the resulting friction generated an enormously productive heated atmosphere. It is this kind of energizing intensity that is missing these days because collaboration is often conducted in self-referential and hence predictable teams. Nowadays, we see more groups touring from one house to the next, bringing productions to audiences in their tried and trusted artistic language. Conductors frequently only join them at a very late stage or take over when the process of staging has been completed.

Gielen was aiming for the equality of music and stage, and he had to convince the orchestra, choir, and soloists to join him on this path. What's more, because he had the intellectual acumen to fully recognize the potential of a new music theater, it was a highly inspiring time for all those involved. Of course we had all read Adorno, but it was only in Frankfurt that we came to understand him.

The most important intellectual point of reference for the work coming out of the Frankfurt Opera House was probably to be found in the Berlin of the interwar period. In the realm theater, it was Erwin Piscator who pursued this holistic approach. And all of the forces at work at the Kroll Opera House explicitly aimed at a renewal of opera as an art form. Around 1930, Otto Klemperer premiered works by Schönberg, Janáček, Krenek, and Stravinsky at the Kroll Opera House, among others—and he did so after getting the best directors of his time on board, as well as hiring successful visual artists, such as László Moholy-Nagy and Giorgio de Chirico, as stage designers. After the Second World War, this ambitious endeavor was continued under Walter Felsenstein at Komische Oper Berlin; many of the later protagonists in Frankfurt also hailed from this tradition.

Another defining factor of the Frankfurt years were the locally based and available singers who were willing to go along with this new approach to staging. It was only much later that the international conductor and singer merry-go-round began and we started to travel to the extent that we do today. The advantage of the Frankfurt model was that the protagonists lived in town and thus participated in the learning process we were all going through. Walter Raffeiner, for example, was the heroic tenor under Gielen's directorship and performed in numerous legendary productions.

The Frankfurt years cracked open the old way of thinking and fostered a new mindset that lingers to this day. It was a powerful force that arose from the convergence of different currents and disciplines, perhaps comparable to the melting pot that Vienna was around 1900, when all the arts—from literature and visual arts to music and architecture—merged into an epoch-making panoply of work. Of course, the backing of political decision-makers also played an important part in this process of renewal. That also explains why it was only fifteen years after the 1968 movement that this transformation took hold of the opera world, too. In their political functions, decision-makers first had to set out on that legendary "long

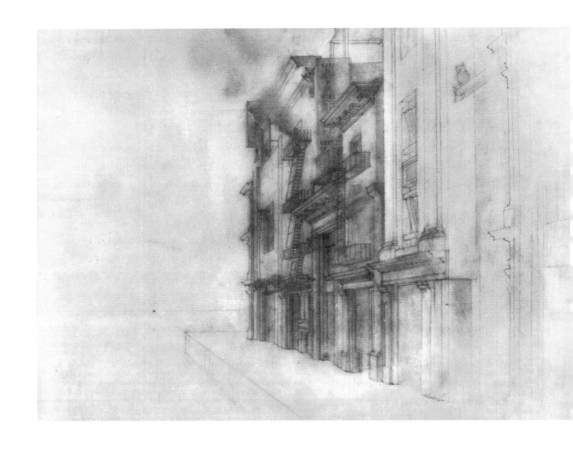

Richard Peduzzi,
Untitled, 1974
Graphite on tracing paper,
22 × 30 cm
Stage design for
Götterdämmerung,
Bayreuth Festival, 1976.
Director: Patrice Chéreau
Courtesy of the artist
© Richard Peduzzi

march through the institutions" in order to establish the framework for artistic activity at state-run establishments.

An anecdote from 1981 perfectly illustrates this turning point: one day, the highly progressive-minded Frankfurt city councilor in charge of cultural affairs, Hilmar Hoffmann, went to the box office to buy a ticket for Neuenfels' *Aida* production, in which, of course, Aida appeared as a cleaning woman. And the ticket agent at the opera suggested Hoffmann might be better served if he went to *Aida* in Wiesbaden, because the performance in his own house was not to be recommended.

The Frankfurt movement gradually spilled over into the entire opera world and has, of course, by no means produced only interesting results. I have seen numerous productions by people who served as young assistants at the time. After watching the seventh *Don Giovanni* in an underground parking garage—if I may be permitted this exaggeration—you do start to wonder where all this is going. Deconstruction has outlived its usefulness, just like actionism has in the visual arts. What was considered back then as avant-garde, and above all necessary, is nothing like that anymore.

Over the past forty years, we have seen that engagement with contemporary music has immensely improved the quality of musical interpretation. In terms of technical skills, today's musicians have reached a point where they can play almost anything and no longer resist new works out of insecurity. What was considered unsingable thirty years ago is now standard practice for university graduates and no longer a venture into unknown territory. This matter-of-course approach to interpretation has also made today's audiences more open to new music. Perhaps they are now even more open to experimentation than some artistic directors who are hampered by economic constraints more than they were forty years ago.

The genre of opera has come under pressure. Much can be attributed to economic dictates, lack of education, or relentless globalization. But I would argue that a reinvented opera could hold its own, especially in big cities like Frankfurt or Vienna. In Vienna, the opera is situated in the center of town—not just physically—and there is great potential due to the large number of people who are receptive to new developments; and there is the cultural environment from which an operatic *Gesamtkunstwerk* emerged more than a century ago. Then as now, cities are spaces of friction for different milieus struggling for balance between preservation and renewal. If discussions of the kind we are accustomed to when it comes to the redesign of urban spaces could also be sparked about our collective activity in the world of opera, perhaps an opera with a workshop character will once again emerge. An opera with a future, that is.

The German concert and opera conductor Michael Boder is considered a leading exponent of twentieth-century music and known for his meticulous and sensitive interpretations of new works. Chief conductor of the Royal Danish Theatre, he also conducts regularly at the Wiener Staatsoper, including the premieres of Friedrich Cerha's *Der Riese vom Steinfeld* and Aribert Reimann's *Medea*.

"TAKING THE EXISTENCE OF A WORK OF ART ONLY AS A PRETEXT"

GEORGE STEINER

Michael Lewin

"The presence of a work of art derives from what questions it poses to us at the time; but if we are not willing to let the work of art itself speak, but an environment through secondary, superficial, and take the existence of the work of art only as a pretext, it does not speak and does not ask. It becomes meaningless."

In his landmark 1989 book *Real Presences*, George Steiner argued that while the presence of a work of art derives from the contemporary issues it touches upon, we still need to let the work itself speak, not an environment of a secondary, superficial nature. If we take the existence of the work of art only as a pretext, it will neither speak nor raise issues. It will be rendered meaningless.

At the time, Steiner's polemic elicited an extraordinary response among the art and intellectual community, but like so many exhortations, it was soon buried beneath glib speeches and superficial analyses, and especially those who should have heeded these words of warning the most smothered them with a fierce embrace.

The opera has basically been dying for as long as it has existed. The death of the opera was actually announced at the same time as its birth, because if we are to take seriously the original intentions from which it is said to have emerged, it could almost be called a botched experiment. No, the thinkers and artists of the Florentine Camerata did not achieve the reincarnation of the Greek drama more than four hundred years ago. What emerged, however, was a monster that didn't have the slightest intention of fading away again any time soon, but, on the contrary, grew rapidly, became independent and, in no time at all, escaped aristocratic salons to conquer private theaters. Within a few decades after its birth, it also instigated the rapid emergence of bourgeois opera houses and, thus, was soon fully beyond anyone's control. According to the current doctrine, about ten years after Jacopo Peri's *Dafne*, which is considered to be the first opera, the genre saw its first enduring masterpiece with Monteverdi's *Orfeo* in 1607; about one hundred years later, the first of Händel's forty-five operas followed, and another seventy years on, Mozart's *The Marriage of Figaro*, probably the Mount Everest of today's opera canon, had already premiered. Another hundred years went by before the famous Tristan chord was struck for the first time, forever changing the course of musical history.

And so, born out of a commendable fallacy, this art form spread and developed with an incredible momentum that is almost impossible to fathom today, until in the twentieth

century it came up against its natural limits in a rather brutal fashion. It may well be that in our day and age the opera attracts a larger audience than ever before, but the relevance of the art form has faded compared to previous centuries.

On the one hand, this crucially has to do with the fact that opera was born in an age when the distinction between serious and entertainment music as we understand it now did not really exist. Of course, compositions were created, on the one hand, for religious services and, on the other, for aristocratic—or less aristocratic—salons, and later for the stage, but they were mostly written by the same composers and drew on the same musical sources. Until the beginning of the twentieth century, so-called novelties were the focus of interest for an audience that was virtually addicted to new works.

On the other hand, the radical changes the tonal language underwent in the twentieth century ultimately led to the splitting off of the entertainment-oriented forms, the musical theater and the operetta, while new opera works strove to follow the ever more rapidly developing shifts in tonal language and thus remained the preserve of an ever smaller and increasingly intellectually inclined audience. At the same time, the educational framework from which opera had been born was quickly fading in relevance around Europe, so that the direct connection to the content of the works and their immediate accessibility were increasingly eroded as well.

The result of this development is well known: a tiny fraction of the estimated 60,000 operas composed since the end of the sixteenth century constitutes the nucleus of today's operatic canon; even though the past decades have seen an expansion of the repertoire, ranging from Renaissance music to the classics of the twentieth century—plus regular, dutifully served world premieres—all in all, we are still talking about no more than a hundred operas that are *constantly* being restaged.

We are now, and basically have been for some time, pondering whether we are actually approaching the "last days of the opera." Of course, the events unleashed by the pandemic since March 2020, which have severely impacted the entire art scene and the opera world in particular with unrelenting force, have unexpectedly made this question a lot more virulent and urgent. At times one could indeed get the impression that in this situation, nothing was more unimportant than art, and with a bit of good will, one could empathize with artists who suddenly felt completely isolated and irrelevant. In truth, however, just as in all areas of society, the corona pandemic has only accelerated developments in the opera world that had been a long time coming.

The question of how much innovation this art form can still put forth, or how much novelty is actually demanded, would be worth a separate discussion, but, in my view, that is not the actual core of the problem. I believe that the art form of opera would, in fact, even endure in the long-term if it were admitted that it is, to a large extent, a museum. Does that mean we should dispense with new works altogether? Of course not. We need to continue to engage with living composers—not least in order to be able to adequately perform the great masterpieces of the past. But the problems associated with operatic works created over the past hundred years, including their difficult acceptance by a wider audience, cannot be ex-

plained by their rapid change of tonal language alone; above all, there are also content-related issues that seem to have been deliberately glossed over for the longest time.

I have always been reluctant to embrace rigid categorization of works of musical and theatrical art. Many a blithe and cheerful opera exhibits the finest operetta qualities, many an operetta leans, in a carefully measured manner, in the operatic direction (thus sometimes even forgoing its actual strengths), and many a stage work that is classified as a musical or light music today would effortlessly and glamorously hold its own in any opera repertoire alongside the undisputed masterpieces of the genre. Of course, the opera shouldn't draw on or align itself with other genres of musical and theatrical expression. But stronger side-by-side presence and co-operation—as has always existed, to some degree, in the German municipal theater system—would, in many respects, also benefit the world's great opera temples in the long run.

If we take an increasingly aging audience structure to be a harbinger of the "Last Days of Opera," and if in many places there is certainly reason to fear that the art form is losing its appeal to younger generations for good, we should perhaps ask ourselves whether the artificial and pointless distinction between opera and other areas of musical and theatrical stage art has maybe always been a vain and arrogant approach that is now threatening to suffocate the genre.

Apart from what has been said so far, however, we have much deeper problems, as well, and they directly affect the institutions that produce opera these days—still in a rather exclusive manner. First of all, the basic structures of these institutions—regardless of whether they operate on a repertory, stagione, semi stagione, festival, or whatever other basis—are in essence still mostly built on the foundations of the nineteenth century, the period when the genre began to be institutionalized. This need not be a disadvantage in itself, as long as we see it as based on an *evolving* tradition. But the problems we face in furthering and rethinking the development of "what we inherited" or what "tradition" is clearly did not begin in Goethe's or Mahler's times.

These art institutions, which date back to the nineteenth century, were for the longest time decisively and primarily shaped by artists. (The majority of them were, and still are, what we today call interpretative artists; composers were rather the exception. For obvious reasons, the question as to who or what an artist actually is cannot be discussed in greater detail here.) One of the main problems the opera is faced with today is of course that the artists have gradually ceded responsibility for its institutions. Now the major opera houses are thus necessarily shaped almost exclusively by professional business managers and artistic directors.

On the one hand I certainly do not believe that we can turn back the clock (or should even wish to do so), and the problem was initially brought about by the artists themselves who were no longer willing, or no longer felt able, to run these institutions. On the other hand, there have always been managers, impresarios, artistic directors, business directors, or whatever you want to call them. Ever since the inception of opera. At all times, they had their place and legitimacy. The problem we are facing today is that they are also expected to single-handedly shape the artistic direction of their houses—and unfortunately, more often than not they fail on that count.

Basically, an art institute that is not *shaped* by an artist is *not* an art institute. Even if we had already come to accept the fact that the opera is *purely* a museum, it would still—or even more so—need of this type of artistic influence. For the performing arts to exist in real terms, they must be continuously recreated, and that can only be achieved through a lively and innovative approach—which we need to follow if we want to prevent the art form from suffocating on its own past. "The true hermeneutic of drama is staging," writes George Steiner. He also observed that the sum of our understanding lies in further performances. This is where the artists, with all their talent, skills, and knowledge, are called upon to take the lead, but they have largely withdrawn from managing the institutions, at the latest since the 1960s.

For the most part, the handful of later attempts by artists to assume comprehensive responsibility after all did not work out favorably. It is not hard to see why, because compared to earlier times, today's artistic directors are shouldered with tasks that artists can hardly be expected to excel at, namely to continually justify the existence of their art form vis-à-vis the sponsors of the institutes. Issues between artists and cultural policy makers, however, go back as far as the nineteenth century, if not further. Not only in Vienna, where Mahler, Karajan, and others were thwarted by the cultural authorities of their home country, but in all the places where art was sponsored or facilitated by the government the antagonism between politics and art has always been the crucial breaking point. Basically, cultural policy makers are, unfortunately, very often—and to this day—at the root of the problem. It is a problem that affects the field of publicly subsidized theaters, and thus practically all of Europe, and it has even become alarmingly more acute over the past thirty years.

When I started in my profession in the late 1970s, you could still find, here and there, quite impressive personalities in the field of cultural policy and administration. They were educated, competent, and committed, and therefore also relied on their own informed and sound judgment, while being anything but indifferent to the standards and development of the institutions entrusted to them. Likewise, due to their education and expertise, they also acted in a responsible manner when it came to filling management positions. Nowadays, 99 percent of those in charge are completely unsuited for the task assigned to them, if only for reasons of education and personal development. In recent years, cultural policy has been reduced to providing sinecures for contenders in the political arena who were unable to grab a bigger piece of the pie. They act accordingly: no major disturbances, if possible, no scandals, and as long as ticket sales are satisfactory, the contracts of incompetent directors are extended again and again until the institution they helm has been rendered completely irrelevant from an artistic point of view. And until a more desirable employment is found for the politician or official sidetracked to the cultural sphere, he or she will, above all, seek to steer clear of any controversy that could affect their future political career. Speaking of finding: due to ostensible democratization and the resulting legal provisions, finding directors has become extremely convenient for these clueless politicians thanks to invitations to apply for positions and search committees, which often rely on the services of highly paid headhunters who have no experience or competence in the field of culture whatsoever. These people are no longer responsible for anything and, if need be, can always blame applicable regulations and the decisions of the selection committee.

The idea that the politicians in charge should not be solely responsible for appointing the leadership of and managing the cultural organizations entrusted to them alone was fundamentally wrong from the start. What do we need politicians for if they do not take care of the essential tasks of their office? Aside from the fact that usually, the composition of these commissions is shamelessly manipulated and it is rarely possible to understand why anyone was appointed to them, such an intermediary body would be completely unnecessary for competent cultural policymakers and, on closer inspection, they are also counterproductive. The purported transparency such bodies are supposed to create is, in fact, a farce. Our politicians are democratically elected. They should decide. After all, that's what they signed up for. Already the legally mandated job vacancy advertisements for every executive position are in reality likewise pseudo-democratic and highly dishonest. The ones most suitable for the job won't apply anyway. Should the occasion arise, they will accept an invitation if they are assured that a selection committee will select them anyway, which in turn can only be achieved if the committee is put together in a manner that ensures this outcome. It is possible to manipulate the advertisements in a targeted manner, as well. So what is the point?

In the days when artists often held leadership positions, the difficulties they faced in managing their houses increased over time, and in many cases their own artistic productivity began to suffer as a result. We know where this leads. When forced to choose, an artist will always decide in favor of his or her art and against everything that stands in its way.

So, what to do? First of all, it would seem politically imperative to give culture a permanent role in governments, a ministry of its own, and to select the representatives in charge of it solely on the basis of ability, education, and moral aptitude. But currently, the opposite is the case in Europe. In many countries and cities, culture is no more than an irksome "appendage" to another ministry or department—or, what's worse, subordinated to the chancellor, which is justified with the lie that the administration treats culture as a "top-level priority." By now, artists have learned to understand this as a dangerous threat.

At the theaters themselves, the question remains as to how to deal with the situation going forward after the artists forfeited management responsibility. As mentioned earlier, there have always been managers—but they were usually not given front-row seats and, above all, were not the ultimate authority in artistic matters. Now, I am always happy to concede that, here and there, there were, and still are, personalities capable of running a house effectively and successfully in spite of it all. It is just that unfortunately, these exceptions are very rare and that is not the point here. This is about taking stock of where opera as an art form stands today and what its problems are. Thus, this discussion can never be about a few exceptions, but must proceed from the honest admission that the overwhelming majority of today's opera directors are, for a variety of reasons, hopelessly out of their depth—especially when it comes to the artistic profile and, above all, the concrete artistic work at their houses.

The problem managers face is that, whether they are appointed by a supervisory board or the representatives of political sponsors, at the end of the day they always have to operate like politicians. The reasoning and decision-making of managers will hardly ever be informed by artistic considerations, it will always be guided by pragmatic concerns. That is their job.

They are supposed to meet the expectations of their immediate superiors, have to keep up, as much as possible, with the back and forth of day-to-day politics, and to a degree they will—consciously or unconsciously—always act in a speculative manner in order to live up to presumed "public" expectations. Often, both of these things have very little to do with the immediate artistic requirements of an opera house and, above all, with the works that are to be produced. Of course, it has all the more to do with the fact that, just like politicians, they strive to be re-elected or re-appointed every four to five years, which is always a compelling incentive for non-artists—due to the lack of other options. For this reason, he or she frequently bases his or her artistic decisions more on the question "What's in it for me?" than on considerations as to "What will it add to the work?".

The primary focus of their empathy is therefore, inevitably, not always beneficial to art or artists. (If anyone still had any doubts about that, the recent experience of how artists were dealt with during the pandemic should dispel any lingering illusions—of course, there are, as always, a few laudable exceptions, but their number is sadly negligible.) Unlike a manager, an artist is, for starters, preoccupied with the independence of his artistic endeavors. An artist is, first and foremost, an artist, and a true artist, a great artist, will have no other way than to always think primarily in artistic terms. His or her empathy is focused chiefly on art, or the work of art, then on the artists who work alongside him or her, and then, of course, on his or her own career, but the latter is at least not as directly affected by and dependent on decisions of a non-artistic nature as that of a professional director. In any case, an artist still has his or her art.

Most importantly, however, the "only-managing" directors for the most part don't have the key skills it takes to manage an opera institution: in order to enter into direct dialogue with the works they are to present and produce, it is above all indispensable to be able to read music. But those who are unable to engage with the original—and the only way to go about that is to read the score—will ultimately treat the work of art only as a pretext and not as a necessity. Any decision, be it artistic or organizational, can really only be made on the basis of an intimate knowledge of the original. In the end, he or she who cannot read music is incapable of identifying the needs of a business where music is the name of the game. This is, by the way, also—and especially!—true when it comes to scenic realization. We'll get to that later…

Over time, however, all this resulted in further structural problems at opera houses, because the limited knowledge and skills many of today's artistic directors bring to their job led to the development of occupational profiles in their environment that had previously played no or only a minor role. For starters, there are the dramaturges, those high priests who embody "the supremacy of the secondary and parasitic" (again, George Steiner) par excellence and who, in recent years and decades, have acquired ever-increasing importance as well as almost inexplicable influence on the fortunes of opera companies. Very often, the opera director, due to a lack of knowledge and ability in the musical field, thus also sees him or herself unable to set the main guidelines for the program on his or her own. If this crucial task is delegated, however, or is at least largely carried out under the guiding influence of others, the question very quickly arises as to what his or her position is really good for. Be-

cause, on top of that, other positions such as "casting director" have gained in prominence in recent years. Many professional directors thus not only put program planning, but also casting policy largely into the hands of others. So, not only is the director not shaping the program, he or she is also *not* casting the shows.

What's more, many of these professional directors are helplessly at the mercy of the musical groups of the house. Often, orchestra boards dictate the required number of rehearsals, always with an eye to having as few in-house rehearsals as possible to allow orchestra members to pursue well-paid side jobs. Things are not much different when it comes to the choir. When I think of the countless hours I have wasted in the course of my career trying to convince these kinds of artistic directors that rehearsal schedules for a new production cannot be drawn up in the form of a rigid plan, but that consideration must be given to the length, individual difficulties, and the performance history at their house! Each and every one of these opera managers with no musical education is always ready to sacrifice, without hesitation, a first-rate conductor in order to keep a third-rate director on board. In short: the lack of education and knowledge regarding the work and the music leads to a betrayal of the foundations of an opera company. Ask what the special skills are that this sort of director brings to a house, and you will frequently hear that "He is a great talent at networking." The phone book has thus replaced the score as the basis of opera.

Under the circumstances thus described, the position of an intendant is actually largely redundant, as everything else is usually taken care of by an administrative director anyway. So, who is in charge of artistic matters? In order not to be misunderstood, I should like to emphasize again that, yes, there is the extremely rare dramaturge who is actually an opera expert and, even more rarely, can read music and draw his or her understanding from the original. But these woefully few are, ultimately, just people who lack the courage or energy to take responsibility themselves. The same is true for the casting crew: yes, there are three, four, maybe five people in the world with a real understanding of voices, vocal technique, as well as the requirements of singing and the stage, who know the works and the challenges associated with them from reading the score, and who have genuine empathy for singers. But here, again: please take your place on the front lines! The professional requirement of a director in a field of art is, above all, to design the program and hire the best artists he or she can possibly get to perform it!

So, where do we stand at this point of our assessment of today's opera business? After the great composers had long ceased to dominate opera life, the baton was passed on to the conductors for a period of several decades—pun intended. Conductors, as the natural successors of composers, have withdrawn from the responsibility that comes with working at the front line; dramaturges and cast directors wield influence from behind the scenes without assuming responsibility. But that's not how things work. An art establishment must be led and guided artistically—without wavering or compromise. Art and democracy have never been easy bedfellows, even if no one wants to hear that today.

At present, however, many conductors act like second-tier minions and allow themselves to be sedated by excessive salaries. If you talk to them individually, almost none of them will find the present situation satisfactory. Every one of them also knows exactly where

things are going wrong artistically and where there is room for improvement. But very few of them care even remotely about anything outside of their own productions—and even there, they rebel against incompetent directors, unacceptable interventions in the work, the poor acoustics of sets, and inadequate casting, but usually only behind closed doors and with their fists clenched in their pockets. These days, most music directors act, at best, in the manner of well-paid principal guest conductors, instead of doing what their training and artistic ethos would lead them to do, namely, to be the composer's advocate.

It bears repeating: this is an attempt to take stock. It is not about a collection of recipes on how to solve the artistic leadership problem at our opera institutions. They have to be led, after all, and looking at individual houses today, it is easy to tell whether its management is still guided by some creative influence or whether a professional director is cluelessly planning away, bereft of any artistic insight—or, of course, has others do the planning—and his or her institution is, slowly but surely, running on empty.

As mentioned earlier, we will not turn back the clock, but we will have to think hard and fast about whether the artistic aspect needs to be given more weight again than the routine of the supposedly factual. Even a cursory glance into the history of the great opera houses will reveal that it was almost exclusively the great artists who shaped these institutions; I can hardly think of any exceptions. Now, the ranks of the professional intendants certainly have included, and still include personalities who bring to the table at least an artistic background or artistic past, or are educated and intellectually astute, and—it bears mentioning—have the moral prerequisites it takes to develop genuine empathy for the art and works of art. Such managers are then also capable of clearly grasping the problems and needs of the house they are heading. Sadly, there is, again, only a handful of them, but they are the ones who are most likely to be willing, of their own accord, to bring in a real artist to work on a production and invite him or her to engage in long-term creative cooperation.

If this sparks an artistic discourse, this kind of dialog will even create an opportunity. After all, dialogue starting from different perspectives can form the basis for genuine reflection, and this is something we have known since Plato, at the latest. This, however, requires an ideal personal relationship between the two, because, given today's existing structures, the external relationship between artistic directors and conductors is not a simple one. In quite a number of German cities, for example, musical directors are appointed directly by the theater's sponsoring body. Sometimes at the suggestion of the director, but in practice, often the contracts the two of them sign don't "harmonize" all that well. But even if (general) music directors are appointed or hired directly by the intendant, the problem usually remains virulent, due to the notorious contractual clause, which states that the final decision always lies with the intendant. Yet, there is no reasonable solution to this problem, because today, the intendant is responsible, in every respect, to the body sponsoring the house; as a result of the recent nonsensical conversion of many houses into limited liability companies, he or she is even personally liable, in some cases to a considerable extent.

At the moment, we can only highlight the problems—a solution will be hard to come by under in the *existing* structures and, at the same time, the deplorable state of today's cultural

policy in Europe. Consequently, we will have to work as best as we can with compromises and hold out confidence that in the future, hopefully, more competent cultural leaders will, once again, appoint professional artistic directors who are up to their task intellectually as well as morally, and who not only allow for, but desire and encourage the influence of a music director they consider their equal, on the basis of his or her achievements, reputation, and personality.

In places where things are working well today, one can sometimes still find that stable artistic standards shape the musical field, which must necessarily always form the foundation of any opera house. Under these circumstances, the rare top performances of the genre are still possible and serve as testimony to what the art form is still capable of today—that is, if for once the work becomes the focus of attention again and is not just taken as a pretext. The issue here, of course, lies not only with current circumstances and artistic directors alone, but to a considerable extent with the musicians themselves, who are often only willing to embrace their artistic responsibility to a certain point.

Yet, as I have pointed out above, it was largely the conductors who used to single-handedly shape and lead the opera houses. They were, naturally, well equipped to do so by virtue of their position, education, and knowledge. And so, we have to ask ourselves why, by now, the few capable conductors still around today have left the arena voluntarily and why this has met with so little objection. I have already touched on the fact that, under current social and political conditions, most contenders are wary of assuming sole responsibility, not least so as not to compromise their own artistic endeavors. Nevertheless, it remains inexplicable why they only rarely and inadequately take charge of the responsibility that is still entrusted to them in the context of their work as music directors or even of simply heading a production.

Musical talent has existed at all times; it keeps flourishing today, and probably always will, as long as music continues to play any role at all in human life. But why has the conductor's position in the music industry changed so dramatically, why—let's be frank here for a moment—are they delivering modest performances on most evenings? Studying history is always worthwhile—not to indulge in a wistful look back at better times, but to find an explanation as to why some things worked in the old days that are, apparently, exceedingly difficult to recreate today.

To begin with, here, too, one of the main causes lies, not least, in the increasingly radical decline of education over the past hundred years. Most of the eminent conductors of the past were intellectual luminaries of their time. In the cases of Hans von Bülow or Hermann Levi this is sufficiently well known; Thomas Mann, never one to lack self-confidence, was quite proud for being able to keep company with Bruno Walter, just as Ernst Bloch considered himself fortunate to be friends with Otto Klemperer. As his diaries and writings show, it was part of Furtwängler's character to engage in complex philosophical reflection, and the list goes on and on. Beyond their already enormous musical horizons, all of them were well-educated intellectuals who were no strangers to cross-disciplinary links to other art forms, philosophy, and the most diverse human sciences. But these days, the silly old Kapellmeister one-liner "I can read the score, what do I need books for?" seems to have become the mantra of the con-

ductors' guild. The intellectual background, the historical foundation of the art form and its works are of little interest to the vast majority of today's conductors, and that is why they are no longer capable of adequately realizing the great masterpieces of the past on a musical level.

Today, people like to forget that, by the standards of their time, in most cases the great composers of the past were also remarkable intellectuals, or at least extraordinarily educated individuals. At the time Beethoven was composing his *Pastorale*, he immersed himself in Kant's *Universal Natural History and Theory of Heaven*; Richard Wagner was, as we know, exceptionally erudite and well-read (the entirety of both of his libraries are now on public display in Bayreuth); Richard Strauss drew on the strong foundation of his impressive upper-middle-class liberal education, and Gustav Mahler could almost be called a Goethe expert. Understanding the greats of the past, therefore, requires much more than a basic ability to read the score, to have a good ear, and perhaps even to play an instrument. The ability to grasp and creatively capture the full complexity of art requires a broad horizon, matching intellectual capacity, and, above all, the will to comprehend and realize the vast array of cross-references between the time of its creation, the history of its reception, and our present age. Conductors who fail to rise to this challenge will remain narrow-minded specialists, no matter how talented they may be.

Opera is, in its best moments, perhaps indeed the most complex and fascinating art form there is. But how can it be rendered comprehensible and stirring in our time when it is mainly shaped by people who, on an intellectual level, are ill equipped for the job? Of course, there is something else today's conductors *share* critical culpability for. Aside from the mediocre shape many opera institutions are in from a musical point of view and the resulting poor musical rendition of the great masterpieces, their frequently disastrous scenic realization is even more the product of their partially limited focus. This sad trend originated, to a considerable degree, in the German-speaking world, which is still home to more than 100 opera houses. In these parts, a highly positive and important approach that emerged in the late nineteenth and early twentieth century has, over time, morphed into a two-headed monster. One of its heads represents an uncritical, backward-looking attitude which fails to understand that the only thing that keeps theater alive is continuous renewal. The other represents a development that sprang from a legitimately progressive approach that has turned into a meaningless, pseudo-intellectual exercise born of secondary knowledge and superficial education, and which threatens to stifle opera just as much as artistic stagnation. The leadership in charge today lacks the courage to chop off these two heads, perhaps out of fear that a third, even worse one, could grow in their place.

As with so many aspects of musical stage art, the impulse for scenic renewal originally came from the great composers—and here, once again, first from Richard Wagner. We know surprisingly much about Richard Wagner the conductor; in comparison, very little is known about the director of the same name, in spite of the books the director wrote and the notes his assistants from the Bayreuth years penned. What is nonetheless certain is that he set the spark for scenic innovation; even though, by his own admission, he ultimately failed in this endeavor, particularly in the realization of the *Ring* premiere. In his wake, it was not least

the great conductors of the turn of the nineteenth and twentieth century who gave further essential impulses for a scenic renewal.

Even though Gustav Mahler was only able to realize just a few productions before the end of his directorship, his and Alfred Roller's names remain associated with the scenic reform achieved at the Wiener Staatsoper, in the same way that Otto Klemperer's is with similar developments at the Krolloper in Berlin in the late 1920s and early 1930s. What is much less known today is that, at the time, Toscanini in Milan, Fritz Busch in Dresden, and Glyndebourne and many others also strove for credible scenic renewal of the opera stage. Not everything panned out, but a number of valuable approaches emerged that others could build upon after the devastation wrought by the Second World War. Additional key impulses came in the 1950s and 1960s, courtesy of Wieland Wagner in Bayreuth as well as the directorial schools of the GDR.

From the very beginning, any kind of innovation in opera was met by fierce resistance from traditionalists, who would have preferred to keep everything the way they had experienced it from childhood. If it was only for this antagonism, the development that opera theater took up until the 1950s and 1960s could still be considered quite satisfactory. Up to this point, the impetus and the will towards scenic renewal of the opera stage emanated exclusively from people who took the original work as their sole starting point and inspiration, who were able to develop a contemporary interpretation of masterpieces for their own time, while also drawing on the most intimate and detailed knowledge of its creation.

At some point, however, the train of innovation took an unexpected turn down a track with no destination and no end. There's nothing wrong whatsoever with diversity in art—on the contrary! But there is with aimlessness. It's hard to pinpoint today exactly when opera theater, steered by pseudo-intellectual marauders, began to veer into a territory of utter senselessness. But all of a sudden, people appeared on the rehearsal stages of the world who, while they continued to be called directors, did not even have the basic qualifications and often not even the will it takes to adequately stage operatic theater on the basis of existing works.

The evolution of professional opera direction as we understand it today commenced fairly late, at about the same time as the trend towards increased revivals of older works and greater complexity of newly created operas took off. At first, directors from the field of spoken theater also played an important role in this process, freeing opera from rigid role clichés and stereotyped scenic staging. In those days, some of the directors who came from acting were still highly musical artists, and this ability of theirs was plainly evident in their acting productions. This was certainly possible as long as the texts were still brought to German theater stages in a manner that rendered them somewhat recognizable in terms of their structure and did not merely draw on them as a sort of quarry.

Of course, ever since theater in the German-speaking world has largely moved in a direction where plays are considered only as templates and starting points for a show, drama directors started to have a much harder time with opera, because in opera the score—and thus the form—remains the defining factor. On top of this, there is the problem that, as the development of direction progresses from scenic realization to independent interpretation,

the essential information it builds on cannot be derived directly from the work without the ability to read music. It was especially the singers who increasingly suffered from this regrettable development. Well-prepared and musically trained, they would arrive at rehearsals, only to be confronted with ideas that could hardly be justified by anything contained in the work itself.

It is no wonder then that some of them had enough at some point and thought they could do a much better job themselves. A fallacy that should have been predictable, because singing involves a high degree of technique and discipline—and directing is of course also a profession one has to learn and that, if one takes it seriously and intends to live up to today's demands for contemporary staging, requires not only enormous skills and qualifications, but likewise technique and discipline. Today, almost all directors fail, at the latest, during the first choir rehearsal! Who among the current directors of productions still has even the basic knowledge and, indeed, the technical skills necessary to competently lead a choir rehearsal? There are very few left and you can probably easily count them with one hand.

However, theater directors who increasingly found opera difficult to handle and singers who dabbled in directing were only the beginning. In recent years, the floodgates have opened. By now, operas have been staged by set designers, film directors, painters, actors of all stripes, architects, as well as video and installation artists. No one batted an eye when some of them proudly announced in the media that he or she had never before set foot in an opera house. I'm sure it won't be long before they'll be asking the doorman, the company doctor, or the fire safety officer. And why not? Now that a fireworks artist has already staged a production…

I have no idea why in the most complex art form known to man, some people think that any dilettante can come up with a valuable contribution to opera. From stage managers and prompters to choir and orchestra members all the way to singers and, last but not least, conductors, every one of those involved must be able to read music fluently, almost all of them have years of education and training as well as a demanding selection process behind them and, with regular practice and elaborate daily preparation, have dedicated themselves to a profession they all pursue in a responsible and committed manner. Is the director, of all people, the most important artist in a new opera production after or next to the conductor, really the only one who doesn't need any qualifications?

Of course, what I noted at the outset regarding the difficulties pertaining to non-artist directors applies to a greater extent to the artists themselves. Just as someone lacking insight into and understanding of the works that are to be performed cannot, under any circumstances, shape a musical and artistic institution, so an absolute non-musician cannot direct the staging of a musical work. It is simply and inherently impossible, because the truth of the matter is that the essential information pertaining to a musical work of art always lies in the music. If someone is illiterate, can they direct a Shakespeare play? Of course not. And if we conceive of directing as interpretation and not merely as somehow arranging the enactment of scenes, someone who can't read music can't bring music, musical theater, or operas to the stage.

No outsider would ever believe what conductors and singers have to deal with at rehearsals nowadays. Directors who are not only not familiar with the music, but also barely acquainted with the content of the plot, let alone the libretto are, unfortunately, no longer the exception, but have become a depressingly common phenomenon. They openly and proudly declare that they aren't interested in the music at all or, for that matter, in the theme of the narrative, and on the rehearsal stage, they will spend half an hour directing a dialogue between two characters who don't interact in this scene at all.

But even when a director has studied the text, even if he or she has delved into the work, its genesis, and origins, he or she is usually afflicted with the noxious disease of having to come up with an "idea" at all costs. "Stringent work on the text does not require us to come up with any new ideas" and "Ideas are the lice in the heads of directors," one of Germany's great men of the theater, Heinz Hilpert, once said. To no small degree, this obsession with imposing something on works from the outside, instead of exploring what is contained within them, is destroying the enthusiasm for opera and its future. The great Austrian artist Alfred Hrdlicka once said, "I'm not struck by an idea, but by something I notice," and, in response to a related question, Walter Felsenstein said something to the effect that he would so much love to work on the interpretation, but he never got around to doing so, because there was hardly enough time to stage what was written in the score. Those who are able and willing to engage with the original, who are not afraid of the questions a masterpiece raises in our time don't need to embark on a frantic search for ideas. They are fully engaged in probing, to the best of their knowledge and ability, these questions that a true masterpiece poses in a new way in every era.

Directing, if we were to take it seriously again, is a profession. A very difficult, complex one, one that requires a broad set of qualifications, skills and abilities. Perhaps a new generation of directors will come along who have no connection with the recent scenic past but who are dedicated to the effort and fascination of creating a new brand of opera theater and, in a sincere manner, are willing to face up to the complex challenges of this unique art form—that is certainly a possibility.

In this context, I would like to return to the idea of a stronger coexistence between musical forms of theater that I touched upon at the outset of my remarks. If you had a theater that showed operas, but from time to time also featured one of those original productions of an outstanding musical, everyone would very quickly realize that the latest and most successful works of this genre not only achieve a perfect interplay of text and music—as do the masterpieces of opera—but also one of the original and its staged realization. The more recent musicals that came out in the past few years all featured innovative theater as well, precisely because it was, in each case, developed *from the work itself*. In no way, however, do I want to advocate for renewed efforts to bring musical directors to the opera stage. That has already led to enough failures in the past. I would, all the more, like to encourage a new generation to take to the director's desks, one that is able to read and understand the works and is ready to base their realization on the masterpieces themselves. We would be experiencing a whole new era of opera, one that would suddenly appear as a truly vibrant one.

We don't want old-fashioned theater, and we certainly don't pine for rotten, outdated productions that exist only in the nostalgic memories of older audience members and which, in the real world of today, have nothing to do with the original intentions of their directors anyway. This is not about conservative or progressive approaches, but about theater managers, conductors, directors, and, last but not least, singers turning their attention back to the work of art itself and not just using it as a pretext. Perhaps the last days of the opera will then lie much further away in the distant future again than we rightly fear today, giving coming generations the chance to gain an unobstructed view of this unique and complex form of art. Since we are, after all, already calling the great works of opera masterpieces all the time, perhaps we should finally make up our minds and treat them as such again.

Michael Lewin is one of the most renowned international artists' managers in the field of classical music. In the 1980s and 1990s, he also emerged as an editor and author of numerous books and essays. This article is his first publication in more than twenty-five years.

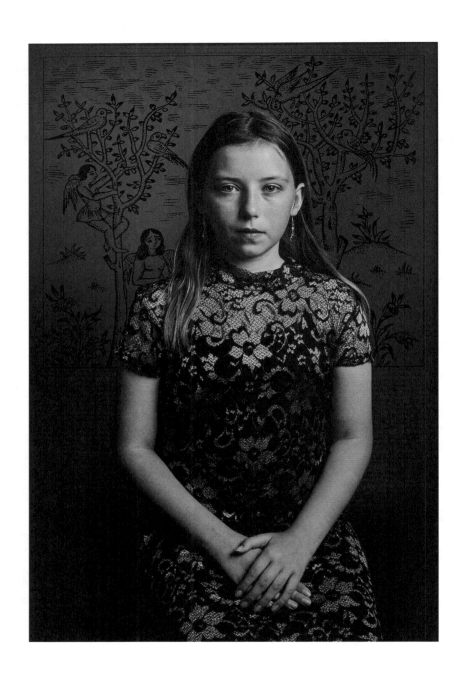

Shirin Neshat, *Raven
Brewer-Beltz* from *Land
of Dreams* series, 2019
Digital C-print with ink and
acrylic paint, 182.9 × 121.9 cm
Courtesy of the artist and
Gladstone Gallery, New York,
and Brussels

POETRY AND OPERA.
A LOVE STORY

Sophie Reyer

Vienna—a shining texture of contrasts, remindful of the notions of "Dream and Reality" as well as "Death and Eros," along with a roster of great names from European cultural history. Because there is hardly another metropolis where art and culture have flourished, and still flourish, as abundantly as in the imperial and royal capital. One only has to think of the composers of the First Viennese School or of Wolfgang Amadeus Mozart who remains beloved, appreciated, as well as promoted here to this day. But at the beginning of the twentieth century, too, Vienna was a concentrated hub for magnificent achievements in the fields of literature, painting, architecture, and music that is unrivaled in its density.

As I was born in this metropolis, is it any wonder that the world of classical music reached into my life early on? Already at the age of four, I saw a performance of *Peter and the Wolf*—and my first picture book, which had been on my gift wish list, was one that told the story of Mozart's *Die Zauberflöte*. As far as I can remember, I wasn't able to read yet at the time, but my father played a few arias for me when I was still in kindergarten and I was immediately taken with the music. When I unwrapped my present, however, I was a little disappointed. A Super-8 film that I still occasionally watch today shows me holding my illustrated *Die Zauberflöte* book and exclaiming, "I thought it was a big fat book!" In any case, that's how my great love story began.

And so, a *Zauberflöte* book in Vienna marked the start of my great love affair with music. This is how "Sophie's World" took shape. It's a world in the former imperial capital, which continually oscillates between language and sound, scans poetry for its sounds, and seeks to discover the metaphors of music. A rich world in which, nevertheless, the morbid Viennese mindset is fully intact, because only where something dies can something new emerge—like the Königskinder who drown in order to be united in death. As I recall it, what was particularly fascinating about *Die Zauberflöte* to me as a child was that the plot, acting, and sound seemed to be intricately woven into a grand, fairytale-like whole—the essence of the opera. It combines all genres in the same way that rites did, from which, it is safe to assume, art and its various genres only split off over the course of millennia. Here, in the resounding world of Mozart's music, everything seemed to be one—words, sounds, and movements formed a kaleidoscope of colorful, magical impressions. Already as a child, I found this unity to be so perfect and engrossing that I, of course still wholly intuitively, decided to engage with and preoccupy myself with this symbiosis of language, sound, and narration. I frequently sat at

the piano, spinning musical yarns, mixing them with words, and in my mind I embedded them in stories. At the time, it was just a game; but already at a young age, and without knowing what I was doing, I thus tried to feel my way towards the unity, which is formed by these different artistic means and represents the essence of opera. I was particularly fond of writing songs. And so I became preoccupied with composition at an early age. It wasn't all that easy, because, as much as my parents wanted to support me, they had no experience in this area—my father had taught himself to play the guitar and was a passionate autodidact. For a long while, I was therefore left with piano lessons, singing in a rather mediocre church choir, and little understanding of harmony. Still, I was smitten with a love for music early on, and I was persistent! And so, it came to no one's surprise when, at the age of twelve, I had to write a musical together with my best friend, and thanks to a few supportive people from the church choir, we were actually able to get it performed. On top of that, my first work was even appreciated in the media. And so, we even read in one of the papers, "Two Girls Create a Chance for Themselves!" Yes, and that was also the end of it! Because, unfortunately, in the art scene, women have to take things into their own hands to get the ball rolling.

If we can start from the premise that an opera consists of a dramatic work set to music, which is performed by an ensemble of singers and an orchestra, then this first try can undoubtedly be considered an attempt at an opera. While the type of vocals it involved was not as artificial as with Wagner, the narrative was strongly reminiscent of the fairytale-style plot of *Die Zauberflöte*. But the aspect of staging also played a vital part in this endeavor. Aside from singing, the performers—all of them flocked together at Christian summer camps— were acting and dancing, and they did so on a theater stage that was designed and spiced up using the means of painting, architecture, props, and stagecraft. This first piece was created almost entirely through an intuitive process. All on my own and without any idea of harmony or other compositional practices, I now began to regularly jot down the scores and lyrics of songs that were swirling around in my brain in the form of sounds. I also sang and played these songs myself, which is why the aspect of opera has always been a kind of concept that is basic to my musical and artistic practice. When I was eighteen, after an entrance exam that was very difficult for me, I also began to study at the Vienna Conservatory. But I felt that the undead dead of this metropolis were inhibiting my inspiration, and for this reason I soon enrolled at the University of Music and Performing Arts in Graz. There I enjoyed and suffered a sound education—in retrospect, I think that both of these words apply here. While at the end of these five years I was able to compose five-part fugues without a piano, even when pressed for time, I was gradually less and less able to enjoy the music I was listening to, whether it was a piece developing in my head or a recording of an existing composition. All of a sudden, I was scrutinizing everything I heard, and the inspiration had vanished into thin air.

It's hardly any wonder, considering the fact that at the age of twenty-one, I had already heard on multiple occasions that women were incapable of composing like men because they had a different brain. This gradually wore me down and, ultimately, soured my love for sound in combination with words and narration. After a long period of abstinence, in which I dedicated the three years following my graduation exclusively to studying screenwriting

and composing poetic texts, I mustered the courage to approach the matter in a different way. And I began to discover a new genre for myself, namely the melodrama. In contrast to the opera, the vocal technique used in the melodrama is a lot closer to the spoken word and the narrative moment is thus an entirely different one—which was right up my alley as a writer. I reached a complete turning point in my approach of conceiving language and sound as a unity and developing composition techniques for literary texts. While I had previously approached the dramatic moment more from the perspective of sound, I now took the exact opposite path, approaching sound through language and beginning, for instance, to conceive of instruments as metaphors. Thus, cellos became a symbol of "raped" female bodies, and I had them creak and groan under vehement pressure from the bows. But the musical language also took on a much more visual quality, the words no longer had to be squeezed into the corset of the voice. Rather, the voice had to adapt its interpretation to the words—it was a new approach that greatly changed my way of thinking about language and sound.

From what angle does an artist approach his or her material, I now asked myself after having tried every conceivable approach. Ultimately, I came to the following insight: working with language on a structural level can be informed by musical techniques. It is not for nothing that concrete poetry draws on various concepts from the visual arts and music.

Thus, in the world of 1960s Vienna, the collage became important and mathematical principles were applied to texts. Inspired by the development of twelve-tone music, the technique of construction is applied, novel compositions of individual language elements are created by means of aleatoric procedures or other principles. Words are detached from their sentence structures, are freed from the context of language, and a new "contrainte" is imposed on them. It is not for nothing that Eugen Gomringer called his poems "constellations."

In all of my considerations during these crucial and highly difficult years, opera—or rather, melodrama, which of course split off from opera—always remained the genre most important to me and closest to my heart. The theater scripts I wrote over the following years were, therefore, actually more like scores. I could even think of my dramatic texts as operas, because every one of my characters has its own composition technique that is consistently developed throughout to shape their contours. Here, sexuality, sexualization, and the sounding out of inter-gender boundaries have been, and still are, important components, which go back to my experiences during my university years majoring in composition. Thematically, however, I have since been, and continue to be, interested in exploring the topic of sexuality in the context of femininity, due to my history as a woman composer. Here, the string instruments in particular turn into violated female bodies of sound, are incorporated into the staging and dramatization, and are made to screech, creak, and roar by means of modern playing techniques. But this is in no way about subverting old and traditional forms; rather, I have tried, and keep on trying, to understand, question, and critically examine the genre of "opera"—especially in the context of femininity and sexuality. For any good artistic work can never be anything other than a reflective network of quotations that feeds on successful historical examples. It cites them, cuts them off, spices them up—in the ideal case succeeding in breaking them up and developing them into a fresh, exciting, and unique form. And so

from that point on, I began to study the great dramatic works of musical and literary history in order to understand their essence and, above all, to read and analyze them in the context of femininity and sexuality.

So, what is it about sexuality and sexualization in traditional operas? Because this essay is by no means intended to simply draw on biographical attitude and personal preferences, but rather to analyze these in the context of existing works. Therefore, let us celebrate here one of the greatest—male—composers, Mozart. Of course, there is a bit of cheating going on here, because especially Mozart is anything but a "male" composer in the classical sense of the word, as is already evident in the choice of his female protagonists. Yes, the characters in his works show an extremely varied and layered image of women! Promoted as a genius, Mozart was undoubtedly extremely gifted—be it on account of circumstances, the pressure from his father, or his neural predisposition. And if we take a closer look, another particularly striking aspect of his work is the highly diverse image of men we find represented by the protagonists of the composer's operas. Right?

In this context it is fascinating to take into consideration the ideas spelled out in a book by philosopher Søren Kierkegaard. Because he held a magnifying glass to the figures of Papageno, Don Giovanni, as well as the characters from *Così fan tutte*, and looked at them in the mirror of his time—and he did so with regard to the theme of sexuality. The chapter "The Immediate Erotic Stages or the Musical Erotic" in Part A of *Either/Or* is dedicated to the possible forms of sexuality in the context of Mozart's music—and he arrives at the conclusion that there are three different stages in the development of sexual experience.

Kierkegaard refers to the initial form simply as the first stage, the next two in this triad are called the second and third stage. So far, so good. The curious thing about his observations is that Kierkegaard bases each of these categories on a figure from Mozart's oeuvre. Thus, delicate Cherubino from *The Marriage of Figaro* represents the first stage. Kierkegaard calls this level of development that of dreaming, in which sexuality is not yet fully awakened, desire is only vaguely intuited and felt in the form of romantic rapture. This takes place in a kind of game. Is it any surprise, then, that the part of the cute Page—who is, of course, actually male—"is pitched to suit a woman's voice" as Kierkegaard puts it? Exactly, it's not. As with plants, we read here, male and female traits still reside in one and the same flower. What bliss—at this stage, desire and lust coincide and, as we can see, this turns out to be a tremendous source of inspiration for Donna Elvira, Susanna and the other women surrounding Cherubino. Right? Kierkegaard calls this form of desire immature and "unnatural"—betraying an attitude that calls homosexual leanings into question and was the product of its time.

But let's move on to the second stage, which is exemplified by Papageno, the hero of my childhood and the funny protagonist of *Die Zauberflöte*. Here everything is marked by the spirit of departure. Because Papageno embarks, in the full sense of the classic journey of the hero, on a voyage of exploration and thus tests his limits. The music literally seems to bubble over with the joy of discovery and cheerfulness, a delight in the quest for the unknown, when he sings:

Der Vogelfänger bin ich ja
Stets lustig, heißa! hoppsasa!
Ich Vogelfänger bin bekannt
Bei Alt und Jung im ganzen Land

The bird-catcher, that's me,
always cheerful, hip hooray!
As a bird-catcher I'm known
to young and old throughout the land.

In his actions, Papageno is thus free as a bird, he roams the world and takes it as it comes. Here, the woman is a kind of prey that is caught and laid claim to—this is encapsulated in the metaphor of the birdcage that Papageno always carries around with him. This vagabond is driven by an urge to explore, one that is marked by tremendous, yet ever cheerful desire. In this way every girl, be it Pamina or the three ladies, is immediately romanticized and idealized. Desire has no specific object yet, must first submit itself to a kind of "trial by fire," which is brought about by the Queen of the Night and her spitting rage.

The third stage, finally, is represented by Don Giovanni. Paradoxically, however, if we follow Kierkegaard, he remains nothing more than a kind of screen. Exalted and stylized as a superhuman seducer, Don Giovanni here becomes the metaphor par excellence for an individual who only knows how to manifest himself in relation to women. Even though Don Giovanni is the source of the desire, he lives on nothing but them, much like a zombie or vampire. What would the womanizer be without his playmates? Yes, here the love for women takes on an altogether different form of urgency—not at all in the sense of Papageno's playfulness and mischievousness. Thus Don Giovanni's entire existence is meaningless without women; indeed, every breath he takes seems to be built on confirmation from a feminine exterior. Without women, Don Giovanni has no purpose, he is nothing without them. Consequently, Mozart also defines this protagonist as one who represents desire itself. Empty instinct seems to be the protagonist—and also the suffering it entails, as the somewhat darker and sadder character of the music of this opera attests to. It's no surprise, then, that the (un)dead father has to appear as a kind of deus ex machina in the last act, right?

The exciting aspect here is that Kierkegaard always views desire as something that is directed. While Cherubino has something within himself that is the object of his desire, Papageno oscillates between these worlds, whereas Don Giovanni seeks confirmation solely in an external reality.

But hold on, this would mean that desire is a purely masculine thing and can always be directed only at women. At this point, of course, women will have to object right away, as much as they may otherwise appreciate this philosopher. Can the force of life only be a male one? After all, if we are talking about the physical world, it is ultimately woman who give birth to life. However, what the philosopher omitted in his essay is that our composer, Mozart, juxtaposed his male characters with images of strong women, namely that of Donna

Elvira, who appears to be equally matched with the womanizer when it comes to the ardor of her feelings. Anyway, what we are left with at the end of this perusal is a want to hear Mozart, to immerse ourselves in his work and its complexity. Time and again. And staging and interpreting it in a gender-critical manner!

I do not believe that the genre of opera has lost its contemporary appeal—neither in the area of the classics nor in that of new works. The only thing that needs to end is this essay. And will I end with the mark I like to begin my poems: with a colon—because after a colon, everything is possible, starts over, fresh and anew—and into the open!

Austrian author, poet, philosopher, and composer, Sophie Reyer also writes novels and plays.
She has published more than seventy books and won numerous awards.

TALENT IS DEMOCRATIC, BUT OPPORTUNITY IS NOT: BARRIERS TO ACCESS AND WHY OPERA MATTERS

Sita Thomas

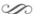

In the summer of 2020, as I write this piece, the world is facing one of the utmost crises of the twenty-first century: the global pandemic of Covid-19. It has led many people to question our humanity, our relationships with each other and our environment. It has led us to deal with death, loss, trauma and grief; to carry out extraordinary acts of kindness and heroism; to connect virtually, and to share digitally. We have been led to test, to create, to take risks, and ultimately to rebuild. As a theater director, I have questioned my role in society as an artist. Our theater industry in the UK shut down overnight. Rehearsals were canceled, productions and theaters closed, and many artists lost their income. Without the civic spaces I had been functioning within, I questioned what could I offer and how I could be of value and serve those in need right now? I wondered: do the arts, theater, and specifically opera serve any purpose or have any relevance in such a devastating context?

My relationship with opera began at the age of fourteen when I was cast as a dancer in a production of *Turandot* at Swansea Grand Theatre. I remember feeling frightened backstage in the wings, listening to the powerful unfamiliar sounds of the singers, and watching the towering figures in thickly-coated makeup and masks glide past me onto the stage. Years later, having moved to London and embarked upon my career as a director, I rushed with excitement to attend my first opera at the English National Opera: Verdi's *Otello*. The ticket I could afford meant that I was sat what felt like several football pitches away from the stage and orchestra; however, I found the atmosphere compelling, enchanting, even entrancing. Then out came Otello. He was a white man. In a narrative that centralizes issues of race, why was a white man playing a black character in 2014? I left feeling stunned and confused. My first experience of opera in London made me deeply uncomfortable; it seemed that the world of opera was decades behind the huge cultural and socio-political strides made in terms of racial equality, let alone in terms of casting and representational practices on stage. Was opera meant or intended for someone like me?

I have always been drawn to work with live music and dance, and as I developed my career as a theater director, I had a formative experience as assistant director to Jude Kelly at the Southbank Centre. It was a production of Leonard Bernstein's *Mass*, a theater piece for singers, players and dancers. Marin Alsop conducted the orchestra comprising young musicians of Chineke! Junior Orchestra and the National Youth Orchestra of Great Britain. The cast of four-hundred was led by Tony-award winning Paulo Szot and featured professional dancers and singers, as well as school groups and community choirs. This large-scale piece

felt pertinent and relevant for several different reasons. Jude's directorial interpretation made connections with the original context of the piece—the assassination of John F. Kennedy and a moment of crisis in America—with contemporary politics. Through the use of film projections, she displayed images of global movements including Me Too and Black Lives Matter, making powerful statements about the role of activism and the need for change now. The talented cast felt truly representative of diverse contemporary society in Britain, something that Jude had addressed purposefully when bringing together different already existing groups and through the casting process. Through the production period, young primary school children developed the confidence to perform in front of the large audiences in the Royal Festival Hall; participants affected by homelessness came together through the joy of singing; skilled young black, Asian, and ethnically diverse musicians had the opportunity to work with a world-renowned conductor. I was part of a transformative process that sought to break down barriers, to empower individuals, and to give opportunities to a vast array of people—from a broad range of demographics—to take part in and experience high-quality culture. Yet Jude's mission here was an exception to the norm. There are many aspects of the cultural sector and particularly the operatic industry that remain shackled by entrenched hegemonic paradigms of gender, class, race, and many other aspects of inequality. Cultures of opera-making and opera-going remain exclusive rather than inclusive, homogenous rather than heterogeneous. And for opera to remain relevant, to remain necessary in today's dystopian world, extensive changes need to be made rapidly in order to ensure its future.

In July 2020, amidst a catalog of closures of established theaters, staffing restructures and redundancies, with thousands of arts workers losing their jobs, the Royal Opera House announced the cutting of its entire team of casual staff. This was of course devastating for the livelihoods of all of these workers. Attention in the press and on social media was drawn to the salary of the highest earner at the institution; Sir Antonio Pappano earned a basic salary of £115,000 for the financial year 2016–17 and additional fees that year exceeding £650,000. Chief Executive Alexander Beard earned a salary of £286,095. While these figures may be comparable to international rates afforded to their similarly established and accomplished industry peers, the disparity between such figures and the culling of thousands of hard-working casual staff was difficult to reconcile. Unlike other commercially funded opera buildings, the Royal Opera House receives the largest amount of public funding of any arts organization in the UK through Arts Council England. If opera wants to secure future audiences, such barriers of elitism and wealth inequality must be confronted. The demographics of opera makers, performers and audiences remain narrow due to structural inequalities and limitations to access. It must diversify in every aspect of the sector. In order to justify such a large amount of public spending, opera houses need to serve a civic function for the many, not the few.

This is where schemes spearheaded by individuals who make it their mission to challenge the status quo of the operatic industry and to achieve mainstream accessibility are powerful and invaluable. The Jette Parker Young Artists Programme (JPYAP), headed by Elaine Kidd at the Royal Opera House, supports the development of artists at the beginning of their careers. In 2019, I was recommended by the National Theatre (where I had been working as a staff

director) to the JPYAP new training program for directors. The ambition of the program was to open up opera as a destination for a broader pool of artists who are underrepresented in the Royal Opera House's creative talent pool. During the program, we were given access to tours around the entire building, both front of house and backstage; we took part in workshops in cavernous rehearsal rooms; visited the wondrous empty auditorium; directed opera singers and pitched a directorial concept for an opera. Katie Mitchell was a guest director, and her guidance and expertise led to a pivotal moment in my personal artistic development. The program continued during lockdown. We would meet weekly online via Zoom, and Katie guided us through aspects of the opera-making process, from working with conductors and singers, to navigating technical processes and to pitching operas to institutions. During this time, we were all navigating the ever-changing climate as the pandemic swept across the world. In the wake of the death of George Floyd that led to global Black Lives Matter protests, I showed up to a session and really questioned: what is the point? Why does opera matter right now? When it is inherently built upon racist and sexist structures and practices, upon whose shoulders does it fall to make the change? Who holds the power, and where does power need to be conceded? Ultimately what the opportunity to be part of this program afforded me was the inspiration to empower myself. This month, I was lucky enough to join Katie on her Women Opera Makers Workshop as part of the Académie du Festival d'Aix-en-Provence. The focus here was on empowering women composers, authors, stage directors and conductors through a focus on concrete career development tools. The result for me was not only an acknowledgment of the hegemonic patriarchal structures that exist historically, but of the knowledge and power within me to navigate these, to be a valuable artistic leader and ultimately a cultural changemaker.

Whether it is through opera or theater, television or film, regardless of the artistic medium, the barriers are the same to varying degrees. The levels of progress and change differ according to the strategies implemented by organizations and individuals. The time is now to dismantle all of the barriers to access that have existed for far too long, to implement programs of meaningful participation, to create opportunities for underrepresented and marginalized groups, and to work together to produce stunning acts of creativity and excellent high-quality cultural engagement for all. This must be for everyone if opera is to remain relevant to future generations. Opportunity is not democratic or meritocratic; structural imbalances are evident in all aspects of society, and certainly in the opera industry. Equality, accessibility, diversity and anti-racism need to be embedded in every part of the production of opera, not side-lined, marginalized, or added as an afterthought. Barriers to access need to be removed to ensure the art form flourishes artistically and economically when opera houses open once more.

Welsh-Indian theater and filmmaker currently based in Cardiff, Sita Thomas is artistic director of Fio theater company, creative associate at Wales Millennium Centre, associate artist at National Youth Theatre, and Headlong Origins director. She holds a PhD examining issues of cultural diversity in Shakespearean performance (University of Warwick) and a Master's in Movement Direction (Royal Central School of Speech and Drama).

DETERMINED
TO KEEP SINGING

Jessi Parrott

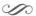

It's the last day of the first year of my BA in English and Theater, and I'm sitting in one of the dressing rooms backstage in Warwick Arts Centre. I'm surrounded by my fellow Chorus members, who are chatting and laughing as they snatch a quick pre-show snack between our Tech rehearsal and our opening—and only!—performance of our English-language *The Magic Flute*. I've already eaten (I get anxious about having food in public at the best of times, because the quirks of my cerebral palsy make it a spectacle even without the additional tension of first night nerves). I'm also already dressed. Today's been a long one. It had to be, because timings were tight, which meant it was easier for me to be in costume from the moment I woke up. That way my personal assistants could help within the (relative) comfort of my adapted room in halls, instead of dealing with a difficult body in an environment that's still pretty unfamiliar, even though this is my second show with Opera Warwick since I started my course.

So, while my friends mill around, scurrying into the bathroom in shifts (our lot got the bigger one, on my account), I stare absentmindedly into the mirror in front of where I parked my powered wheelchair. I need a moment to meditate. To center myself in a space for which I feel at once too big and too small. Too big because my presence—or more particularly that of my chair—in this room is a pain. (I've tucked my back wheels in as best as I could, and I have the mirror to keep tabs on the foot traffic behind me, but I'm conscious that one wrong move could mean a sprained ankle for someone else. And "break a leg" isn't a literal instruction.) Too small because I'm only nineteen; yet this is somehow not only my second show but my first attempt as an Assistant Director. As my eyes drift to the middle of the mirror again, my concentration having been briefly broken by a bump against my backrest, all I can think is "How did I get here?"

On one level there's an easy answer to that: I joined the society mid-way through my first term, in the chorus for another Mozart (*The Marriage of Figaro*), persuaded by a course mate who knew I was feeling lost in the strange land of Student Drama. Since then, seminars have been punctuated by rehearsals with a regularity as soothing as the measures of a musical score; that is, when I haven't had to leave because a sudden flare up of spasms means the only sound I'm capable of producing is an agonizing scream. (That would never do, of course, so whenever it happens I grit my teeth until the tightness is too much and silent tears are streaming down my cheeks and my breathing is so shallow I can barely speak, never mind sing.)

But, on another, the backstory is much more complex. Because I was lucky—my North London primary school put a huge focus on music, so we learnt about the traditions and techniques

that came from across the many cultures of our diverse student body. It was also what's known as a Resource Base: a sort of hub for all the state schools in the area, regarding pupils with Statements of "Special Educational Needs." So kids like me were encouraged to participate, and actively, too. And "classical" music was definitely in my consciousness. I actually started with the tenor horn. That stereotypical "first instrument," the recorder, was way out of my reach—even back then, before the avalanche of chronic pain that characterized my adolescence, my left hand didn't behave well enough to be reliable. Whereas with a tenor horn (plus a clever stand, made by my music teacher from some plastic tubing and a spare mouthpiece), I could play singlehanded. Literally. The same was true of a keyboard, if not a "proper" piano. The electronic chords allowed my fingers to focus on the rest of the piece without worrying I was missing out the building blocks. But there's only so far technology can take you—or at least, there was when I was young! So, as holding heavy brass, or sustaining the pressure on the keys required to keep a note steady, got harder, I realized there was one instrument I could use independently. My voice.

Cue finding the courage to join the school choir. And not caring (too much) that the portable platform staging left me no option but to park my chair beside it. Or that, when we went to sing at the Royal Albert Hall as part of the Camden Youth Music Festival, if I wanted to sit by my friends in our school's spot, I had to leave my chair entirely and be carried. Then supported to stand and sing. Even though that undermined the feeling of independence I'd found through singing in the first place. Otherwise I couldn't have participated at all—and I wasn't going to give the opportunity up. Nevertheless, the mixed emotions of that evening left their mark.

How could something that felt so freeing in one sense feel so restricting in another?

I carried that question through my last years of primary school. It only got bigger and louder as I grew. Because it was as though, having found the one thing my body could do on its own, I wasn't allowed to embrace it fully. (At university, thanks to politically-aware tutors, I learn that this is the Social Model of disability—where people are disabled by the barriers of their environments. But at school it just—just!—felt unfair.) And in Year Six, this was confirmed during our end of year musical. Not only was I separated by the staging, but a massive cast on my foot following an operation meant I was conspicuous for what, in my mind, were all the wrong reasons. I stood out; even though I couldn't stand up.

The journey that culminated in that experience floats through my thoughts as I wait in the dressing room. It is joined by many memories—mostly a jumble of jostling self-doubt. But that show feels particularly pivotal, for two reasons. It was one of the early times that I internalized my anger about inaccessibility, thinking my body was to blame. It also reminds me that it hasn't really been all that long since I've registered the existence of opera as an art form. A mere three-and-a-half years, in fact.

Because, despite all the musical education I've been musing on, we didn't really explore choral music. At least not in the sense I think of it now. Whether that sense is right or not, I'm uncertain. Surely anything sung as a choir is, by definition, choral? And I try not to be presumptuous about putting parameters on expression. I've had enough experience of other people's attempts to do that to me. But, thinking in terms of genre, or perhaps era—it was only at the age of fifteen that I learnt that what I knew as "classical music" was actually an umbrella term for a much wider-ranging

lyrical landscape. And that change in my comprehension came about thanks to a soprano choral scholarship with the Music of Life Foundation. A charity supporting young deaf and disabled singers and musicians, they held auditions at my secondary school (a "special" school I'd chosen in the hopes of finding a community). I was picked, along with some friends, to sing as part of the *Messiah* being held at St John's Smith Square. The confidence we were given, and the inclusive atmosphere (the inaccessibility of the venue again notwithstanding), has ensured I've been obsessed with Händel ever since. And it also taught me that "independence" doesn't have to equate to being totally alone. Far from it. And interdependence might even be more fun. Because you can forge lifelong friendships with the people who share their score with you. On the surface, it's a practical solution, to minimize page turns. But beneath that I now know there's the community spirit of the choir. And those two things, practicality and partnership, when combined, can lead to playfulness.

Or, to use an academic term that, on this July evening in 2011, I have yet to discover: what Mia Mingus calls "access intimacy." The deep meaning found in connections created because of access requirements.

Although I don't have the vocabulary to articulate it at this point, I'm aware that similar sentiments were what made me brave enough to join Opera Warwick. Thanks to Music of Life, and then to my singing teacher, I had a precedent for the sort of support I needed being provided. Of course, it hasn't always been easy. My own battles with my body are still raging, and my insecurities are deeply embedded. So much so that, in early rehearsals for the overture of *Flute*, I was desperate to drop out of the dance. I was worried it would look weird. As I think on it now, I realize it was probably a reflex formed in response to the show in Year Six. But my friend Sita Thomas (who was choreographing) took me aside—and told me, "You are allowed to take your space."

We've only known each other an academic year at this point, I observe to myself, in my mind, in the mirror. But her words had such an impact that I took them to heart. I took my space. As I will do again when we go on tonight. And my chair won't be an inconvenience.

The opposite. Because it's actually functioning as a useful prop—a rest for the head of the massive monster that tries to attack Tamino.

This scenario doesn't solve everything. Nothing ever could. And I'm already conscious that the attitudes in the industry outside our university bubble aren't nearly as adaptable or accommodating. It's why, even with my background with Music of Life, I was so surprised by the welcome I received from the society. And even here, in Warwick Arts Centre, I can't get into the choir stalls for concerts when we aren't doing shows. Like at the Royal Albert Hall. Except I'm too big to be carried now.

But still. It's a start. And I'm determined to keep singing. So I do.

Jessi Parrott is a performer, playwright, poet, and mezzo-soprano based in London. She has cerebral palsy and uses a powered wheelchair; her work thus pushes boundaries often faced by the disabled. Her PhD research positions disability as an employment issue in theaters and television stations in the United Kingdom, exploring the link between representation and recruitment practices.

OUR MINDS
ARE INFECTED

Andrea Breth

One gets the impression that at most opera houses, artistic directors and general directors, as well as dramaturges, have little or no appreciation for the art of theater-makers. Most general directors are administrators, and they also administrate the artists; they decide whether an artist is right for this or that work; they serve the market, confuse art with craft. They bring in so-called stars who inevitably find that scenic rehearsals are too long, believing that their voice and popularity are sufficient. You would hope that now, amidst this crisis, people would pause to think, and some real reflection on the métier of opera would occur. But this doesn't seem to be happening.

Artists are good when they can work on their own terms and are not just being "bought" once the so-called program has already been decided. Authors, painters, or film-makers choose what they want or need to engage with intellectually. In the opera business, too many people have a say—and the word "business" alone should make you dubious. Paradoxically, the actual artists involved rarely have a voice. Nevertheless, they are expected to deliver good results. But what a good result looks like is highly discretionary. Is it good because seat sales are great? Is it good because the critics give their blessing?

It's time to reconsider the opera "system."

In 1927, the young Karl Böhm became music director in Darmstadt, where he championed the works of young composers, such as *Wozzeck* by Alban Berg in 1931. Young singers were discovered and promoted, effectively paving their career path. The Wiener Staatsoper had a permanent ensemble and a Mozart ensemble. The singers defined the style of the house; they traveled little. In the GDR, the State Opera House had a permanent ensemble; Walter Felsenstein created fantastic working conditions for himself and his artists. I don't want to bore you with further examples.

Growing commercialization has destroyed the ensembles. Stars are flown in, rehearsal times are cut short, and the agencies join in on the act, negotiating huge fees, while ensemble members are cast in minor roles. Is it remiss to go out and find singers who have wonderful voices but are not famous because they haven't been discovered yet? Big names are often more important than the composers. Concert posters feature conductors' names in big letters, while those of composers are relegated to small print at the bottom. The artistic team is often deemed entirely irrelevant when it comes to marketing content; what counts are the singers' names. It goes without saying that voices play a major role in opera, more so than the singer's physique, but sometimes you wonder if, in *Don Carlo*, for example, King Philip isn't younger than his son.

Compared to what doctors who fight for human lives earn, the fees of top stars are as unacceptable as those of corporate CEOs. Perhaps the pandemic will teach us a simpler, humbler, more rigorous approach and not just one that consists of looking mainly at sales figures. Unfortunately, at the moment, it is more apparent than ever that politicians have no interest in promoting culture. Anyone who wants can buy CDs and DVDs; streaming is convenient too, and it's free. The shared experience of a theater performance, the magic of the rising curtain, the secret behind it revealing itself, stories told in a myriad of ways—that's balm for the mind and the soul. But if we forget to introduce children to theater at an early age, we will lose our audience. Theater for children doesn't have to and shouldn't be childish, but it ought to build on narrative styles that set it apart from those of YouTube formats. It needs to speak a poetic language, which is only possible in a theater. Music-theater is always something removed from the sphere of reality. It is artificial, as is the art of singing, but the singing voice is not a digital medium, and neither is the stage.

As artists, we must always find novel forms, develop new perspectives, listen deeply to the musical textures. Not for the sake of self-realization, but to immerse ourselves further into the depths of the work at hand. Every one of them has a surface and, at the same time, an abyss, which we are not safe from falling into, and that's a good thing. It's nice to find an opening for ever-new and bold points of view and forms of representation.

I have recently become more interested in modern operas, and I sense greater freedom in these structures. I get bored with recurring repertory programs, and I feel the same way about theater plays. I find it quite unnerving when a city has several opera houses, and all play

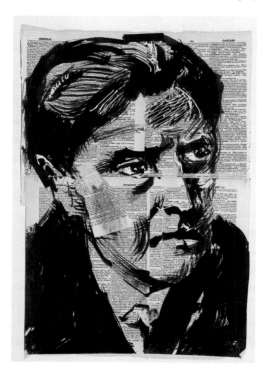

William Kentridge, *Portrait of Man IV*, 2013
Indian ink, red pencil, and white-out on found pages, 49 × 34 cm
Design for *Lulu*, Alban Berg, Amsterdam Opera, 2015.
Director: William Kentridge
Courtesy of the artist

the same operas. The lack of imagination, especially now during the pandemic, has become even more apparent. Streaming is not the only thing one could do.

We are going to be confronted with a world that will appear increasingly alien to us, and our experiences will no longer necessarily be reliable—the demands will often be overwhelming. The ever more rapid pace, catastrophes caused by humans themselves, all of this raging over us—how should we react, how can we deal with information overload?

Naturally, uncertainty causes fear. It is difficult to foresee anything and, therefore, impossible to know whether the opera will continue to exist or not.

All we can do is wish for it to live on, but we may be hanging on to an illusion. On the other hand, stories give meaning to our lives. They provide us with identity and ground us in something bigger than ourselves, which broadens our horizons. When stories extend beyond death, they become all the more beautiful. Leaving behind a poem, a composition, a picture, a book, or a film is seen by many as a consolation. But history has shown that leaving behind a cultural legacy is not synonymous with success.

Nonetheless, we could all try to make the world a slightly better and more beautiful place, and to that end, we need art, words, music, and songs. But do politicians still want culture at all? The pandemic may deliver society from this "superfluous" affair, as the wanton neglect of all cultural institutions leads to the closure and cancellation of museums, theaters, and music events, auditoriums are filled with a desolate atmosphere due to distancing measures. At the same time, densely packed airplanes head for overcrowded vacation destinations. The reasoning behind this is hard to fathom. Working from home, streaming, and more digitalization are the death of opera and drama; collective experience and discourse with others are critical to both genres. Opera and drama are not going to change the world. But we can try to interrogate existing social problems together, and we have to defend against the anti-cultural mindset in politics and against all those who confuse culture with consumerism.

On that note, it's also hard to comprehend that large corporations are subsidized by governments in the order of millions when we know that corporate tax evasion costs the state vast sums in lost revenue. It's a very worrying process and shows how little culture counts in the world of politics and business. Paradoxically, the virus is making a utopian dream come true—never before has the environment been protected so effectively on a global scale. The virus has risen to global stardom on the Internet; we're talking about nothing else these days. To avoid the virus, we move our contacts and cultural exchange to the Internet, so our minds become infected as well.

A different era is dawning, and no one knows what's to come. Only the imagination survives; it's more important than knowledge, because as Einstein noted a long time ago—knowledge is limited.

Andrea Breth is one of the most important theater and opera directors of the present day and recipient of numerous prizes and awards. From 1992 to 1997, she was artistic director at the Schaubühne Berlin am Lehniner Platz, and from 1999 to 2019 resident director at the Burgtheater Vienna. She has been voted several times as "Director of the Year." Her production of *Jakob Lenz* by Wolfgang Rihm received the award for best performance of the year 2015.

I WILL NEVER FIND THE HOW
IF I DON'T KNOW THE WHY

Markus Hinterhäuser
Conversation with Philipp Blom (May 2021)

Philipp Blom: *Markus Hinterhäuser, let's talk about the future of opera, about the question as to whether opera can have a future as an art form. Historically, opera was closely linked to a very different kind of society, and it finds itself in a very different environment today. Has it become a museum piece of a bygone art form?*

Markus Hinterhäuser: I wouldn't say that! Of course, opera is an art form that's closely linked to the aristocracy and bourgeoisie of the nineteenth century, and it was shaped by its patrons and their world. As Gerard Mortier once noted, it has its origins in urban life and culture. But still, even though political and social realities and mechanisms have completely changed, the major, the great works of opera literature provide us with profound insights into humanity's most existential questions, into what is called the human condition. Opera offers ample opportunities to not just ask questions, but to provide clues to answers, as well; in the best-case scenario, it's able to open spaces and lead to a different kind of insight. It's about the unfolding of the truth, about the seriousness of engaging with the work of art, and this can only be done on the basis of its continual interrogation. I have to know why I'm doing something, then perhaps I'll be able to find out how I need to do it. But I'm never going to find the how if I don't know the why!

The interrogation is, I think, a very important point. Because, based on my understanding, opera is a bourgeois art form…
…definitely, yes…

…and it belongs to a certain bourgeois culture that, by now, can no longer be taken for granted. You can lead a bourgeois existence today without going to the theater or the opera, without reading books or having learned to play an instrument—without all these old bourgeois customs. Society's concept of culture has shifted, which I think is a critical factor.
On the other hand, opera, unlike theater and the visual arts, is still subjected to rather immovable, bourgeois mechanisms of reception. There is a strained relation between the experience that musical drama can, or perhaps should, convey today and a highly fixed, or even rigid, notion of what the possibilities of the art form are. This tension, it seems to me, is rather unhelpful when it comes to appreciating the wonder of opera in all its grandeur, beauty, and vitality.

You mean the expectations people bring with them when they go to the opera?

That too, yes. Expectations have to do with experience, with memory, with a highly subjective formative perception. If you go to an opera with a familiar title—whether that's *Carmen*, *The Magic Flute*, or *Fidelio*—in your mind these titles can almost turn into dictatorships of associations the moment you enter the opera house.

However, many opera narratives have lost a great deal of credibility. I'm talking about the emotional or biographical resonance a plot can have. With a number of operas, it has become increasingly difficult to sympathize with the characters on stage due to our changing moral values.

From today's point of view, that's of course true, yes. Apart from the so-called confessional operas, the opera always focuses on very elementary feelings or instincts: power, love, hate, desire, jealousy, and the conflict between our experience of real life and what we dream it to be. These are simple, existential worlds of emotion, which are further intensified by the music, and basically, nothing has ever changed about these worlds of emotion to this day. But of course, we have no way of comparing what these feelings mean for us—we live in an altogether different social environment, have completely different ways of life, opportunities, and possibilities to live out these feelings. And so, we are left with no other option than to keep on re-examining the narrative material, scrutinizing it under an imaginary microscope, and, as Paul Valéry put it, allowing for "the intervention of the present." This has nothing to do with simplistic contemporizing, and much less with the politics of the day. You have to think bigger than that. The scores appear to be cast in stone, but they've been breathing for hundreds of years, they speak to us. And why are they still alive and breathing? Because they are interrogated over and over again. Only this process of re-examination can ensure that the opera remains a vital force. Vitality is, of course, not about small-mindedness, it's about courage, openness, and agility. We must be capable of allowing changes of perspective even on some of the main figures of opera literature. In the context of contemporary society, we cannot help but take a different angle on a character like Don Giovanni who, devoid of empathy and in a dangerous frenzy, races towards his own downfall.

And he meets an end that isn't pretty.

It's indeed not a good ending, it rises to the level of Greek tragedy. Opera certainly isn't always just a pleasant experience. There's hardly anything more uncomfortable than *Elektra* or *Salome*, but these narratives that defy the imagination, these profiles of psychological extremes can have a cathartic effect on the viewer, can perhaps open up the possibility of redefining one's outlook on life. These plots are tough, really tough, but they also offer a glimpse into the disturbing mystery that we ourselves are. At the same time, we are increasingly adopting an entirely different mode of judgment that is made out to be political and can be subsumed under the, by now somewhat tiring, term of political correctness. What does that mean for art, what does that mean for the art form of opera? How are we going to deal with Otello in the future, how do we approach Don Giovanni, the true embodiment of egregiously incorrect behavior? And what about *Carmen*? This image of femininity, the gypsy girl—I'm sure you can't even call her that anymore—the bullfight, and on top of it all, the whole thing

takes place in a cigarette factory! Political, social, and moral values are subject to continuous processes of transformation, and we are called upon to not only to be cognizant of these changes, but to deal with them in a clever and creative manner.

When we talk about the essence of opera, of the potential for reflection or insight that it opens up to us, we also have to talk about historical memory and what the genuinely theatrical experience is all about—when people transform themselves into other people. Opera produces a representation of the current condition of human instincts, and these instincts are still with us, but they are lived and evaluated in a different context. Trying to legitimize, beyond the here and now, the validity of a production solely, or predominantly, on the basis of its performance tradition sounds like a weak proposition. I'll give you an example. We did *Salome* in Salzburg. How do you deal with the severed head of Jochanaan today? What "freedom" do you afford a director when it comes to staging this utterly disturbing moment?

Romeo Castellucci found a remarkably elegant solution to this problem!
Elegant? He came up with an image that no one could have anticipated. "I want the head of Jochanaan," but what you saw was Jochanaan's body—without the head. Everyone expects to see Hamlet holding a skull in his hand when he soliloquizes "To be or not to be, that is the question." In *Salome*, everyone expects to see a bloody, severed head presented on a silver platter—but because this image is predictable, it's not all that shocking anymore. It's probably more of a shock if it's omitted on stage. Something similar happened with *Salome's Dance of the Seven Veils*. In Castellucci's production, it contained not a single moment of movement, only tiny flashes of lightning that sometimes struck the young girl's huddled body. Then her body would tremble, but all the great movement was left entirely to the music. And then there was the geometry of the piercing gazes of her dreadful stepfather and her equally dreadful mother. Like laser beams, they were directed at the nearly naked Salome who didn't move, couldn't even move. Unbelievable! That was infinitely more shocking and provocative than any predictable scene. Provocation as a strategy usually follows really simple patterns of "provoking" in the etymological sense, of "pro-vocare," of evoking a completely different space of thought and emotion. That's what it's all about, isn't it?

But there's a certain school of directing that is still strongly represented, especially on German-language stages, where you know beforehand—almost regardless of what is being played— what you're going to see on stage. Someone gets wet, is naked, rolls around in dirt, or yells and screams, and it doesn't resonate with you at all. It may have been provocative sixty years ago, but now it's just predictable and tiresome.
That's exactly what I mean when I talk about provocation as a strategy, meaning something very simple, highly transparent, and really, really boring. Provocation as evoking resonance, that sounds a lot more interesting, doesn't it?

Let's move on to another topic. Digital media have radically changed the way we listen. Today, entertainment dominates almost all areas of our lives, and the opera must hold its own in this

environment. The opera finds itself in a position that is diametrically opposed to the one it held in previous centuries. Back then, winters and evenings were long, and anyone who didn't have to work had nothing else to do but to play parlor games, read long novels, listen to lousy piano players, and go to the theater or the opera. It's not like that anymore. How can an art form like opera that requires such a long attention span maintain its ground?

The primal force of opera is the theatrical element, the moment. It's this moment that can touch every fiber of your body through the greater intensity evoked by the music, the truthfulness of song, and the power of stagecraft. That's how opera can and will always be able to prevail!

Can or should opera, as an art form, aim to renew itself when it finds that its emotional connection with the audience is waning? And is it even a worthwhile goal to launch this endeavor?

It's certainly worthwhile. But I don't believe that the emotional connection with the audience has become weaker, quite the contrary. No other art form sparks more heated or even fever-pitched debates; no other art form compares with opera in terms of appeal and hypnotic power. What's more, we are seeing an ever-growing desire for auratic experiences, which opera can supply. Aura is an interplay of nearness and distance. This is extraordinarily interesting—especially considering that Walter Benjamin speaks of the aura as "the unique appearance of a distance, however near it may be." This movement between closeness and distance is also a crucial element in opera. "When people die, they sing songs," writes Russian poet Velimir Chlebnikov. This is another thing that takes place in opera, and only in opera: Death becomes song, the soul becomes song, the spiritual becomes song.

Markus Hinterhäuser
Austrian pianist and cultural manager with a particular commitment to contemporary music,
founder and longtime director of the Zeitfluss Festival (Salzburg Festival) and the Zeit-Zone series
(Vienna Festival). Presently director of the Salzburg Festival, he continues his career as a pianist.

Philipp Blom
One of the most influential historians of our time; his works—including several
bestsellers—have been translated into sixteen languages and have won numerous awards.

10.

The Big Machine

Dream and Reality

OPERA IN THE TIME
OF CORONA

Peter Gelb

With Coronavirus presently putting entire cities out of action, not to mention opera compa-
nies, *The Last Days of the Opera* may be too tame a title for this anthology.

Already vulnerable to shifting cultural tastes that have a direct impact on attendance
and increasingly challenging economics, hopefully, Coronavirus will not be a knockout blow
for opera.

Of course, at the Met, we're on the front lines of the battle to keep opera going. One of
the Met's board members apocryphally cites Winston Churchill as having said that the only
undertaking more complicated than putting on opera is waging war. With its 3,000 full-time
and seasonal employees, including the members of fifteen different labor unions, the Met
is a complex organism involved in an intense fight for opera's survival—even though in my
fourteenth season as the Met's General Manager I sometimes feel like Sisyphus, rolling the
boulder up the mountain, only to see it roll back down.

In a never-ending effort to stimulate old audiences and win new ones, we launch one
entrepreneurial effort after another while continuing to tinker with the daunting economics
of high labor costs and the necessary reliance on the generosity of our donors to balance our
$300 million budget. So far, we have managed to find the path that has kept us in business.
But temporary success is not necessarily a harbinger of future longevity.

Opera's halcyon moment was in the late 1800s to early 1900s when arias by Verdi and
Puccini were so popular that their melodies were whistled in the streets of Milan, home of
La Scala. Opera was the hit music of its day.

Over the past hundred years, opera has gradually moved from the cultural mainstream
to a niche art form, a result of changing times and tastes, a prolonged period of passive man-
agement, and the elimination of arts education in our nation's public schools.

In the 1950s and 60s, it was still possible for Maria Callas, the larger-than-life diva, to
capture the world's imagination. She appeared on the cover of *Time* magazine. For the open-
ing of the new Met at Lincoln Center in 1966, the *New York Times* ran a banner front-page
headline. In the 1970s, the quick-witted soprano Beverly Sills guest-hosted for Johnny Carson
on America's most popular late-night talk program. And Pavarotti and Domingo remained
household names in the 1980s and 90s.

But today, opera's reach is much more limited. Its top stars, like the fiery Russian so-
prano Anna Netrebko, every bit as great as Callas, are not known by the general public. The

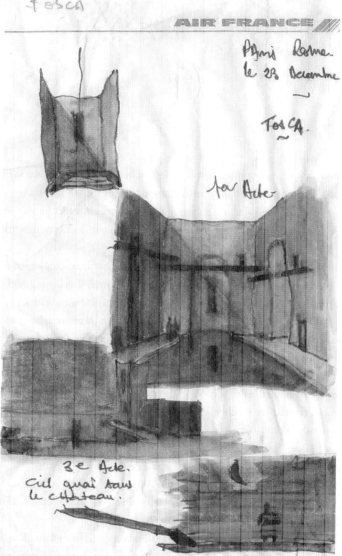

Richard Peduzzi, Untitled, 2009
Watercolor on Air France
paper, 18.5 × 10.5 cm
Design for *Tosca*, Giacomo
Puccini, Metropolitan Opera,
New York, 2009.
Courtesy of the artist
© Richard Peduzzi

mainstream news media, reckoning that opera's appeal is narrower, has reduced its coverage. Opera has been caught in its own vicious cycle of downsizing.

In Philip Glass's recent memoir, *Words Without Music*, he wrote that upon graduating Juilliard in 1966, his first professional gig was composer-in-residence for the Pittsburgh public school system, a federally funded job in which he composed music for high school chamber groups, orchestras, and marching bands. Those were still the days when virtually any public-school student in the nation was entitled to free musical instruments, and the arts were taught as a regular part of the curriculum. It's no wonder that the audience for opera was much bigger then than now.

The declining popularity of opera was also hastened by a lackadaisical approach to modernizing the art form in the second half of the twentieth century. Content at the time with high subscription rates, opera companies did little to entice new audiences. They allowed the art form to grow stagnant, rarely introducing new work and not moving the needle on theatrical values. As the noted theater and opera director Richard Jones said of the Met in 2004, "That's where singers park and bark."

Meanwhile, the music critics had, for decades, lived in collective denial about the waning popularity of opera and classical music, positing that declines in audience attendance were merely cyclical. According to them, there was nothing to worry about, even as their own ranks were decimated by budget cuts at newspapers that were reallocating their resources toward pop culture.

As the Nobel-winning playwright Eugene O'Neill once said of his critics, "God bless every bone in their heads."

In recent years, coming to terms with the fact that their audiences were aging and that their subscription ranks were declining, the leaders of opera companies both here and abroad finally sprang into action. Today there is a sense of urgency and purpose at the major companies. If opera ultimately falters, it will no longer be for lack of trying.

From the beginning of my tenure at the Met in 2006, a host of new artistic and public initiatives were launched. We were beginning the balancing act of connecting the Met to a broader audience while trying not to threaten our loyal, older audience, who not only bought tickets but also provided the bulk of our contributions.

Not unlike a political platform for change, in 2006, we announced the Met's new strategic plans. These included a dramatic increase in the number of new productions each season, with a new roster of the world's greatest theater directors at the helm, as well as an even greater emphasis on securing more performances per season from the best singers and guest conductors. We announced a strong commitment to producing and presenting contemporary work, including commissions, and expanding the Met's repertoire with previously neglected masterpieces. (We've now presented twenty-four Met premieres over the past fourteen seasons.) We established a new plan for family opera presentations during the holidays, which resulted in our shortened English-language *Magic Flute*, which has become a Christmas staple for young operagoers and their families. We instituted a new initiative in media, with the global digital distribution of our live content to opera lovers.

All of this was devised as an effort to tear down the Met's elitist image and make opera more accessible.

In order to get things off on the right foot, our very first opening night, in September 2006, was transmitted live and free to an audience in Times Square, which was closed to traffic for the occasion by Mayor Michael Bloomberg. By presenting ourselves in Times Square, we dramatically demonstrated our plan to engage the public. Thousands of opera lovers and casual visitors experienced grand opera in the heart of New York City, watching the premiere of Anthony Minghella's new production of Puccini's *Madama Butterfly* simultaneously on numerous giant screens, from Budweiser's to NASDAQ's. We've been doing it every September on opening night of the season since then.

That first season of my tenure also marked the launch of our Rush-Tickets program, whereby we made available expensive orchestra seats for only twenty dollars (now twenty-five dollars). We also invited the public to free open dress rehearsals, offered visual art exhibitions, and started a round-the-clock Met channel on Sirius satellite radio, among other brand-new audience-building initiatives. All of these projects were embraced by the public and continue today.

Perhaps the single most impactful of these new activities has been *The Met: Live in HD*, our series of live performance transmissions into movie theaters and performing-arts centers around the world. This venture was inspired by the Met's live radio broadcasts, which have now been taking place for eighty-eight years. Shortly after my appointment to the Met, Beverly Sills showed me a photograph, taken in the 1950s, of a community in a Midwestern town, gathered around a small radio in a gymnasium, listening, rapt, to one of the Met's Saturday matinee radio broadcasts. When the Met began these live radio broadcasts in 1931, it was the first company in the performing arts to utilize media to reach a national audience. Since then, the Saturday matinee radio broadcasts have provided cultural enrichment for several generations of Americans and for decades have been heard all over the world.

This is what inspired the idea of attempting something new with our live high-definition transmissions into movie theaters. The concept was simple: to strengthen the bond between the Met and its audience by providing as much live content as possible. While it was very challenging to negotiate the rights with our fifteen unions and to persuade the performers that this would be a path to stimulating new interest in opera, we now know that it was well worth the effort.

Just as sports teams excite their fans with a constant flow of coverage of their games over the Internet, on the radio, and onto television and large screens in sports bars, we are now following a similar course. It works because opera fans are equally passionate about opera.

Now hundreds of thousands of opera fans are united ten times each season as we transmit our 1:00 pm matinee performances live into movie theaters and performing arts centers from San Francisco to Moscow, spanning eleven different time zones. Our northernmost live outlet is Tromsø, Norway, inside the Arctic Circle, and our southernmost venues are in southern Argentina and Uruguay. Further east, in Asia, Australia, and New Zealand, where the time difference is too great, the transmissions are shown on a time-delayed basis. This

season, our transmissions are being seen in more than 2,000 theaters in seventy-three countries and on every continent except Antarctica.

To serve our global audience, we utilize six different satellites that carry signals encoded with subtitles in eight different languages.

More than twenty-nine million people have seen the Met in movie theaters so far. Who would have thought that millions of people would be enjoying grand opera and a hot dog for less than it costs to attend a baseball game?

We have won new fans while also satisfying old ones. Now, when audiences arrive from out of town, most of them have already been introduced to the Met through our HD programs. They enter our theater, already knowing us from afar. The movie-theater audiences revel in the backstage camera work, where we offer a veritable live opera reality show of stagehands executing high energy and risky scene changes, and divas opening their dressing room doors to our Steadicams.

The HD programs have also had a profound impact on our casting and have helped reinforce good acting on our stage since singers know that even when they're not singing, they might be seen in a close-up reaction shot. This makes them stay in character throughout, which is a benefit to the audience in the opera house, as well. Long gone are the days when the Met used to keep food stashes available in hidden corners of the stage for Luciano Pavarotti, who would snack between arias.

The prospect of singing to a live, worldwide audience also inspires our singers to greater vocal achievements. When the stakes are highest, like for the greatest athletes who break records at the Olympics, our stars inevitably sing their best on a Saturday matinee HD transmission. Impressed by the originality and success of this venture, the Harvard Business School undertook its own case study.

All of these efforts to expand interest in opera and the Met locally and internationally have helped to keep us going. We've also significantly increased our own educational efforts by bringing more students into the opera house and by making our electronically captured content available as teaching tools in school districts across the nation.

But we're certainly not resting on our laurels since we must continually think of new ways to fill our 3800-seat theater. Our strategic plans called for the launch of Sunday matinees, a performance day popular with the public but long prohibited by the Met's unions. These began this season, thanks to new labor agreements that now permit them. Other new plans are in development.

With the recent arrival of our dynamic new Music Director, Yannick Nézet-Séguin, we are taking bolder steps in commissioning new works and in collaborating with performing-arts companies in other parts of New York. Gifted with extraordinary talent, limitless charisma, and internet savvy, Yannick is the ideal music director of a big opera house seeking to rebuild its audience in the twenty-first century.

Together, we recently announced commissions of composers Missy Mazzoli and Jeanine Tesori, the first female composers commissioned by the Met. We've also announced the first opera by an African American composer, Terence Blanchard, as well as forthcoming collaborations with the Brooklyn Academy of Music and the New York Public Theater.

Will all these efforts continue to win new audiences in the coming seasons? We believe the answer is yes. Will new generations of donors emerge, even while wealth is gravitating toward tech and finance sectors whose billionaire leaders so far have shown little interest in the performing arts? Time will tell. As my first mentor, the legendary impresario Sol Hurok was fond of saying, "If the people don't want to come, you can't stop them."

On the other hand, at the end of our recent documentary film, *The Opera House*, which starred the legendary nonagenarian diva Leontyne Price, she asks, "Will the Met endure? Trust me, my dear. It will."

We hope to prove Leontyne right. We're certainly doing all we can to make her words ring true, Coronavirus or not.

March 2020

Director of the Metropolitan Opera, Peter Gelb has been at the forefront of arts management since the 1970s. As manager of the Boston Symphony Orchestra, he brought the group on a groundbreaking tour of China in 1979. In 1982, Gelb began producing the Met's series of televised opera broadcasts making more than twenty-five televised productions. From 1995 until joining the Met in 2006, he was president of Sony Classical records.

THE OPERA AND THE
DESIGNING SPIRIT

Nikolaus Bachler

"That designing spirit"—this is how Rainer Maria Rilke characterizes the ancient singer Orpheus: is this not what defines the artist?—he who "loves most in the figure's élan the moment of turning." This notion translates into an outlook that is of crucial importance when it comes to how the art form of opera is faring these days. Art is always in the here and now; it has passed and will be in the future; it is in motion. Thus, as Rilke notes, the artistic gesture is always to "seek transformation."

I'm not out to complain. Since its invention, the opera has lost none of its appeal: young and old, conservatives and progressives, the well-to-do and student bohemians, along with all the freaks, nerds, machos, hipsters, intellectuals, and emotionalists, they all get together to indulge their desire for opera and let the stage and the music touch them to their very emotional core. Opera stands at the center of society, it is relevant with respect to its form and its themes, and it represents a creative counterpoint to a model of society where the consumer economy and the *zeitgeist* often run wild. Even a pandemic cannot snuff out the desire for opera performances, but it reminds us of how fragile and vulnerable the social fabric is when it comes to artists. Art is in jeopardy, like all common good, like any democracy, and everything rooted in spirit and freedom.

If I think purely in terms of content and aspects intrinsic to art, rather than in the context of changing societal conditions, where does opera stand as an art form? Where will it stand in the future? This is the point where I reach my limits as I am neither a prophet nor a fortune-teller and have no way of predicting the aesthetic forms that the future will bring. I am just someone who, on the one hand, seeks people who expose themselves to the art form of opera with all their creative drive and energy and, on the other, people who want to confront themselves with this art. Therefore, I prefer to pass on the question of what opera is doing for the artists, which is to say, for those who work to create it. Committing oneself to opera is in itself a vision. As institutions, our job is to serve and empower the artists. After all, who is stopping us from offering composers, singers, conductors, or directors an opportunity to realize their ideas today? What matters is the aspiration to provide artists with a space for their creative work, to afford them the freedom they need to develop their talents.

However, to not let myself off the hook quite so easily, I will try to offer a few thoughts as to how my intuition works when it comes to art. Because, of course, I have to look for people whom I am convinced will keep the art form of opera alive. To get this right, it is

worth keeping in mind why the opera was, and still is, such a successful experiment in the world of art: since 1607 in Mantua, the magnificent singer Orpheus in Monteverdi's opera of the same name mourns the death of his beloved Eurydice, accuses the gods, pleads in song for the return of his wife from Hades. Enchanted by his singing, they allow him to lead her back, and he trips over his own hubris by failing to meet the only condition the gods set for him, namely, not to turn and look back at his love. Not to look back? What does that mean? I can only conjecture that perhaps his mistake was to hold on to his beloved image of the past, forgetting that, even if Eurydice had returned to the world with him, both of them would no longer be the people they were before, transformed as it were through their experience of suffering, pain, and disruption. Was his look back a false hope, then? The only remedy for artists is to give form to their inner fractures, render them tangible for all those who experience their world as torn between hope, joy, and suffering. The mythological aspects of opera are parables for the relationship between art and life—or, in contemporary terms, opera offers an image of our world, which touches those who allow themselves to be touched.

Since the birth of opera, one thing has remained the same: summoning all the affective power of music, the performers on the opera stage expose themselves to the pain, joy, and suffering that exist in this world. The characters confront their present through stories—only the forms and sounds, that is, the aesthetics have changed. The love of Orpheus sounds differently with Monteverdi than with Gluck, Křenek, or Philip Glass; the sound spectrum has expanded and undergone transformation, just as our world has changed with regards to perception and perhaps even cognition. One thing has remained the same: the trick of the opera, to reach, through music, the innermost emotional core of the human individual. As long as people allow themselves to be touched by music, opera stands a chance of survival.

Opera has often been declared dead. And indeed, a lot has changed. The music sounds different today; styles have changed both in singing and staging. We experience Mozart as we do Wagner or Berg or Messiaen or Widmann—past and present are equally alive and serve as inspiration to each other. Fierce battles between composers, for example, about old and new styles, have subsided just as today, the discussion over historical or modern performance practices is no longer divided along ideological lines. We communicate about opera through new channels; it is also experienced outside of the temple—hopefully in the company of others, but everyone for themselves, as well, wherever it suits them.

My credo is and will remain: the artists define the content and form of the opera. As a theater, we can provide them with a safe place—in the here and now.

First an actor, Nikolaus Bachler became artistic operations director of the Schiller Theater in Berlin, artistic director of the Vienna Festival, then of the Volksoper, the Burgtheater in Vienna, and the Bavarian State Opera in Munich. He currently directs the Salzburg Easter Festival.

A PLEA FOR A
NOBLE PURPOSE

Peter de Caluwe

Over the last sixteen years, I have been working with my team and collaborators at La Monnaie in Brussels to combine intelligently but also in a playful way, opera, dance, theater, concert, recital, chamber music, and community work and inscribing them organically in the geographic, constitutional, social and political context in which we work. It continues to be a happy and passionate adventure, with the determined aim of leaving the institution ready for the next generations. When I leave the Operahouse of the Capital of Europe, I will have had the chance to work for the house for almost twenty years. That long-term engagement needs a basis and a vision—a purpose that must be a noble one.

I nurture a profound belief in the classical music and arts sector as a living archive of our common history and memory, thus my engagement to make opera, dance, and related art forms highly relevant contemporary and popular genres. Our ethical obligation is to narrate stories from the past to today's and future generations. Indeed, these great and timeless works reveal essential truths about ourselves and offer a basis for a profound exploration and discussion about our world and society.

The Greek classics have been an inspiration for me: Greek democracy (admittedly, a slightly different concept than the contemporary one) and the ideas of Pericles in which the arts and competitive sports formed part of the yearly gatherings during which citizens fulfilled their democratic obligations. They celebrated in sharing life experience and moral values alongside narrating stories and myths from the past, creating new works, and ensuring spiritual, intellectual, and bodily health altogether. A similar idea of rediscovering and empowering this civic community feeling is my drive to create events where people can meet and find a *katharsis*—a moment of shared emotions offered by the complete immersion in theater, dance, and music performances.

This centuries-old ideal still has this very same potential today, even if the idea of democracy is under pressure all over our continent. Fighting ignorance remains a primary role for the artistic community to play. It is not easy, and all too often, we are tempted to deliver populist speeches and find easy solutions for complex problems.

But for me, it is vital that subsidized institutions maintain the obligation to respect and defend the basics of this model. We need to continuously and without compromise strive toward uniting our backgrounds and traditions to a universal and shared experience of a genuinely civilized community: educated, open, welcoming, tolerant, and inspired by projects

available for the most significant possible numbers. Respect for our differences is essential in this. The search for the origins offers vital knowledge to understand the past and the present better and construct the future.

Purpose. Before brainstorming about the *how* and the *what*, the first question must be *why*. It is not about the ingredients in our kitchen, or the quality of the products displayed, nor about the chemistry reached in our cooking (I like the comparison of an opera house to a good restaurant!)—it should be about *why* we cook. That reflection about the noble purpose of our work makes all the difference.

I would summarize that purpose as follows: to elevate consciousness about society and our *condition humaine* through the profound experience of art. Culture has to be seen as a catalyst of inspiration and upliftment that offers an antidote against banalization and mediocrity.

Opera is a political art form that can act as inspiration for life as a community; we are not here to (only) offer simple entertainment. By looking into the mirror offered to us, we recognize ourselves, our strengths and flaws, our hopes and fears, our joy and desperation. The intense experience of art can help us to find empathy for others. By its essence, the re-markable combination that the art form of opera offers us can only be harmonious. Together with a healthy balance between reason and emotion, this is key to our success.

Mission. The mission of any leading opera house should be to be a lighthouse of ideas, of-fering discovery and emotion, interacting between various communities and ages, attracting the audiences of today and tomorrow, nurturing talent development for artists and artisans in their different *métiers*, thus gaining recognition as an inspiring reference in the field of artistic creation.

That vision offers a long-term strategy for a strong external image and a recognizable internal organization. The following e-words can perhaps better help my understanding of this.

Engagement. Art and artists no longer intend to nor can change the world, even though the creative and contemporary interpretation of the past's achievements offers us a mirror to confront ourselves with our history. Art, therefore, has the capacity to emote and be relevant. It does not mean we have to present only society pleasers or be proud and relaxed about what we have achieved. I prefer to keep a certain ambition to make people reflect on how we organize our lives on a personal and on a community level. Art can offer us different visions of life. And it can help solve problems and conflicts.

We should not try to translate tradition but understand it, translate it for ourselves, as people of today, and more importantly, learn from it. Tradition is essential for the understanding of our world and keeps our memory alert. By watching the world and its evolution candidly, we enlarge our perspective. Opera can do this in a way that no other art form can. On top of that, it reinforces our European common good and our shared history. Putting the spotlight on that patrimony can help us create better cultural and, therefore, social cohesion.

Europe. The idea of Europe comes in here with significant importance. Coming from the official capital of Europe, I live with this concrete reality every day. To have the potential to bring together so many different cultures, nationalities, and traditions to celebrate various art forms in one place is a distillation of what a unified continent should be.

Unified through culture and education instead of economy and politics, which have largely failed to build a common basis for our continent. That common base exists in culture. To stress what is essential, especially today in a world where leadership and the foundation of our democracy are questioned.

What we refer to as "Europe" was historically far larger than we know it today. *Europa* herself was a Phoenician, and her name became a symbol for the unification of the orient and occident. Her domain encompassed the whole of the Mediterranean, the territories of Rome and Charlemagne, and engendered the stories of Cleopatra, Cassandre, Dido, and Medea, which are the essential myths of our culture. In literature and theater, Shakespeare, Euripides, Dante, Erasmus, Racine, Goethe, Cervantes, Schiller, Hugo, Pushkin, Ibsen, Gombrovic, Tolstoy, Hofmannsthal, Strindberg, Schnitzler, Claudel... have told and retold so many European stories and histories. The same applies to Mozart, Gluck, Verdi, Berlioz, Offenbach, Wagner, Rimsky, Enescu, Bartók, Debussy, Berg, and Schönberg, Strauss, Szymanovski, Britten, Messiaen, Boesmans, etcetera. An astounding amount of material is waiting to be used and represents the most challenging of canvases.

The retelling of numerous shared stories of love, war, hatred, passion as well as those of pure happiness and joy can achieve what a political system and economy alone cannot by breaking down artificial walls between people, informing them without rancor of their common roots and rediscover their multi-layered identity through sharing a universal language. These convictions have been a motor for my engagement and motivation. What's more, opera and dance can, as art forms that do not depend on a mono-language, help us reconstitute something that comes close to a European "soul." Today, like in the times of Stefan Zweig and other great thinkers, it is always towards the arts, literature, and theater that we turn in periods of doubt and crisis. Then as now, it is from the artistic community that we hope to get the strength to protect our continent from the nationalistic egocentrism, fear, and hatred that blighted previous generations.

Elitism. Whether our cultural mission must be considered elitist is not a question that I find interesting. I realize all too well using the word is dangerous, especially today, and can be misinterpreted, but I wish to plea for a different interpretation, closer to the original meaning of the term "elite." I prefer not to separate so-called higher or lower culture. Culture is an attitude of openness and curiosity, and those can hardly be considered elitist terms. I reject the banal negative connotation of the word elite from the Latin "eligere." Without the artistic and philosophical convictions of a civilized few, Western culture would not be where it is today. Thanks to the often daring and innovative initiatives and the investment of those who have strived to make the difference, we kept advancing; later, these trends became popular.

Like Stefan Zweig, Thomas Mann, Romain Rolland, and many contemporaries of the past and today, it is my firm conviction that we need to keep believing in the *elite of the spirit* to make our society better. We should not be afraid of the word in itself and firmly believe that we can broaden its meaning by talking about it in its most positive sense. For me, this kind of citizenship can be a central concept in bringing back our so-called elitist art forms to the largest possible public.

Equity. Most of our opera houses are situated in truly European "metropoli" in the real sense of the word. Therefore, they have the full potential to become a primary venue to discuss these issues, attracting all those interested in art and in sharing thoughts about culture.

An intellectual and open level of confrontation between today's major thinkers needs to take place. From here, we can work on more coherence for our continent through the magnificent scores, plays, and works of art that have been created over the centuries.

Our cities have the vocation and reputation to bring together the most important artists, established as well as new, to create a true celebration of what remains of our democracy. In realizing a true *Egalité*, *Fraternité*, and *Liberté*, art clearly should not be only entertainment for the rich or well-off; everyone has an equal right to enjoy culture and find fulfillment in it. This is not conflictual with the elitist idea: again, the elite is the very best, and this very best is deserved by all. We must offer "food for the mind" and entitle people of all generations to participate in one way or another, beyond merely attending performances, via education, social programming, lectures, debates, and community projects.

Education. Our sector has a significant role to play in the field of education, with education through the arts as a basis for modern citizenship and culture as a primary reference for our common European history. Here lies a significant challenge for all our cultural institutions, and I feel very committed to the plea for empowerment through the arts.

What better place to reflect on this than in our theaters, where among our audiences, influential international personalities from the business economy and politics come together, not only to enjoy top-quality entertainment but to refuel and challenge their minds. We need to nurture the power of art and influence the often-conflicted worlds of leaders in politics and enterprise with the model of harmony as—perhaps—a gentler way forward than their constant struggle for power and influence.

I do not consider this point of view as naïve. It might, at its best, be idealistic, but this is precisely what is now brewing in the younger generations: a desperate need for content and meaning as well as the refusal of vain emptiness. It is the search to belong to a larger context, a context we can help provide.

Schools, universities, and cultural organizations for the younger remain the primary targets; more than ever, we need to invest time and talent in something too often neglected by the responsible educational sector itself. We need to include kids and adolescents from diverse backgrounds in real projects in which they are directly confronted with the experience of music, singing, theater, and dance. I consider myself lucky to have been able to work on

several community projects now, and I see the benefits of working with these target groups and how it has changed their daily lives and helped with integration in a society that becomes more complex(ed) by the day.

Ethics. It is our ethical obligation to maintain and invest in these educational domains, empowering individuals and the organization alike.

We should become ethical training centers as an antidote to the constant flow of miserable economic, environmental or political news that risks, without a humanistic and artistic strength, to depress our spirits beyond hope of recovery. We must reflect on how to engage in this necessary change of mentality, how to be a mirror that reflects the truths and mistakes of previous generations, how to make sure that we can become a real *fitness center for the mind*.

We are the one and only sector where striving for harmony is our only reason for existence; without harmony, our product cannot exist. But this harmony applies to the way we work as well as to the values and ethics we represent. By achieving harmony in how we produce and organize our daily work and communication, we aim to be a model for a healthy society, one in which democracy is taken seriously, and the sense of participation is critical. Our best appeal to the society that finances and supports us is that they can find inspiration in our model and reap numerous rewards from our work in return.

Ecology. Connected to this reflection, I want to mention essential reflections about durability on many different levels. Awareness of our footprint and thinking about responsible dealing with products, materials, recuperation (rehearsal sets, for instance), how we come to work, and how we organize the artists' mobility and the audiences to come and see our performances are part of this education program. I have become a staunch defender of the idea of Green Opera, which engages us in talking about the way we organize our productions and the way we consume them and adds to our societal responsibility. It is a moral engagement we need to prioritize for the next decades.

These are the kind of consistent long-term reflections on durability and investments on many different levels, linked to future generations and connected to the DNA of our product and enterprise, that will make the difference in years to come between those creative institutions that will remain in the forefront and those that will disappear in the grey middle-class houses.

Quest. I realize these considerations about leadership in the arts might sound idealistic, but to try and get the best of their talents out of people, artists, and the public alike inspire me with immense motivation. That is why this is the only possible working method for me, one that continues to prove successful and which I consider to be a realistic and forceful way of leading a company today.

It is perhaps not a coincidence that one of my favorite quotes stems from the great Austrian writer Stefan Zweig: "Who has once found himself won't lose anything in this world."

The quest for the secret of oneself and the understanding of others constitutes a fundamental basis for my work and private life. In his novel *Confusion of Feelings*, Zweig suggests that experience and enthusiasm are essential if you are to lead and motivate others. Furthermore, a sense of conviction and strength of character are crucial precursors to free thought and enable one to break free of the anxiety of the youth and the expectations all too often imposed by society. Indeed, it is only someone who has known confusion who can lead a fully conscious life—we need to have had our achievements questioned before we can carve out and maintain a place for ourselves in the world.

After his studies in literature and theater history, Peter de Caluwe joined Gerard Mortier at La Monnaie in Brussels as a dramaturge in 1986. In 1990, Pierre Audi invited him to join the Amsterdam Opera first in communications and later as casting director, and from 1998 onwards, artistic coordinator. Since 2007, he has been the general manager of La Monnaie.

VARIETY NEED
NOT BE RANDOM

Matthias Schulz

Every city is different and distinguishes itself from any other city through its structures and dynamics.

An opera house is usually a municipal or state theater and should always play a relevant part in its city, the region, and in community life. The mere fact that it "takes place" and exists in people's minds acts as a first significant cornerstone for much of what emanates from it.

This raises a whole host of questions—how is the house perceived around town? What are people's expectations? What prejudices do we encounter, what are the barriers and obstacles standing in the way of going to the theater? How can we ensure that we are, and remain, anchored in society—and what kind of society are we talking about? Answers to these questions are always colored by subjective factors, perspectives, and interests. In most cases there are consequently numerous, sometimes contradictory or controversial answers. This is certainly the case in a city like Berlin whose complex urban society is shaped by people from diverse backgrounds.

The positioning of an opera house—in the form of its appearance, content planning, and program—has to be considered in connection with the history of the house, its structure, its resources, and against the background of the current social environment. Being an indispensable part of society forms a fundamental building block for a long-term collective commitment to the institutional framework of today's theater, orchestra, and opera landscape. That is also what accounts for the high level of public funding.

This should however not be taken to mean that programs ought to be developed solely on the basis of demand or in accordance with the prevailing tastes of the times. Limitations of this kind should be ignored in the initial phases of program planning. Constant compromising to achieve consensus has little to do with art. Even at government-subsidized opera houses that are steeped in tradition—or perhaps especially at such institutions—artistic freedom must rank as the top priority.

The work of an opera house is always caught between the conflicting demands of quality and quantity; constraints of time and money are constantly breathing down our necks. But if we try to measure and assess art and culture purely from the point of view of economic profitability, we will certainly get ourselves into a pickle. Through indirect profitability and multiplier effects, funds that the institution receives in the form of subsidies flow back again to a much greater rate than people often assume. Cultural wealth and diversity is one of the

most important location factors. When seen from a broad economic or business perspective, cultural institutions like opera houses are actually very profitable and rewarding for society. If we take into consideration the fact that cultural institutions can build identity and large parts of the citizenry favor living in a culturally rich environment, the promotion of culture seems more than a sound investment. Most people do not want future generations to live in a culturally poorer environment than they themselves enjoy. The basis for that is art. Theater can—as long as it isn't robbed of its artistic freedom—generate national and international impact and appeal.

In *What's Wrong with the Arts is What's Wrong with Society*, economist Tibor Scitovsky writes that art is like a capricious god one must respect and esteem in order for it to unfold its beneficial powers as a gift. If you try to force the gift from the deity, as rulers and governments have done again and again, this god will turn away. We should always keep this insight in mind and on occasion express it with even greater clarity to politicians and the public. The commitment and support shown by private donors can also be attributed to overall positive effects on the community.

Basically, it is important to stand by the art form of the opera. At first glance, this statement seems self-evident, but in view of a variety of discussions it is not. Opera is a lavish and expensive art form that requires an extraordinary commitment of resources. This core statement is not to be confused with a hidebound mindset and stagnation. "Commitment to the opera" is not in contradiction with opening it to the present, but rather calls for just that—opera is, in the best sense, too much of everything. It provides us with a platform that harnesses in unison multiple forms of expression and experience. In this respect it represents a unique, productive, excessive demand or challenge and a highly complex art form that does not, and is not intended to, produce simple answers.

To my mind, this makes it all the more important to ensure that opera is not a closed system but is perceived as significant by people from as many walks of life as possible, by audiences with different backgrounds and experiences. This is about being pervious to impulses emerging directly from the society we live in. Through the collaboration of artists and staff as well as the audience's response to the opera, these impulses are translated into a realignment with reality. They can challenge things that are taken for granted and thus bring about an opening, both in terms of content and structure and on the level of communication.

From an aesthetic point of view, the opera is at a dead end. At the beginning of the 1990s directors such as Gerard Mortier, together with artists such as Bob Wilson, La Fura dels Baus, Ursel, Karl-Ernst Herrmann, or Christoph Marthaler, were able to develop a new concept of opera and promote novel and, above all, more abstract, aesthetic approaches. Apparently, though, what is initially introduced as new is then continually repeated and evolves into a new standard. Continual reiteration of styles renders them established, they are considered as a token of "high quality" and "good" art.

Increasingly, however, interest in this trend is declining again, and new ways of rediscovering old forms need to be found. We must allow for the type of diversity that defies categorization, which is to say, we should reject the direct, automatic retelling of stories just

as much as a dogmatic commitment to deconstructing and reconstructing plays. Advocating for deconstruction just to come up with a fresh idea is the wrong way to go. The same goes for the counter-proposal: the preservation of the museum veneer, the self-adulation of a self-contained system. By now, theater makers have also run the gamut of shock elements. Thus, we should rather hone in on the force lying beneath the surface, between the categories. I am most touched by opera productions that seem conventional at first, but where something drastic takes place beneath the level of appearances. Fully explaining things to the end kills the theater. It must instead be about depicting the ambivalence of life in a manner that enables the audience to better face the complexity of our world.

Currently, the names of a few stage directors dominate the programs of the big houses. In order to escape the tendency to the same old thing, it's important to resist the lure of interchangeable productions and to repeatedly open up staging opportunities to directors who don't yet have a seat on the merry-go-round of established artists—accepting the risk of failure. Of course, the craft itself is essential, but we must regularly facilitate "breakaway" opportunities and collaboration with artists from other disciplines (even if this requires additional support and time). Otherwise the opera business will constantly serve up only a few names that can be appreciated almost anywhere in Europe.

It takes a vision and long-term strategies to make a difference in today's world, but not only that. We need to muster the courage, conviction, and commitment to explore new avenues for bringing together things that appear disparate upon first glance, and to examine and embrace new social developments. It is of crucial importance to include forms, formats, and themes in the program that appeal to a heterogeneous audience, to make the opera accessible to them and attract their interest.

In addition to established works from various eras that are probed as to their contemporary relevance, it is important to create spaces for new and commissioned works to shape the present. Working with directors, librettists, composers, and conductors to explore new approaches and ideas before the work is completed brings a surge of creative energy to a theater. Opera houses need to continually live up to their responsibility of "commissioning" works; at the same time, the operas of the twentieth and twenty-first century have to find their way into the repertoire. At the Berlin State Opera this was achieved, for example, with the premiere of Beat Furrer's *Violetter Schnee* or the new production of a revised version of Jörg Widmann's *Babylon*.

We should, however, not only focus on great opera on big stages, but take a broader view of the mission of an opera house in a city. Berlin State Opera is facing up to this challenge, for example, with its "LINDEN 21" series. It promotes the development of new works, premieres, alternative forms and formats, as well as cross-over collaborations that facilitate encounters between opera theater and artists from the fields of performance, visual art, and dance. This allows other modes of production and reception to emerge. Beyond the large opera and stage apparatus, a more short-term, flexible, and accelerated way of working is thus rendered possible, along with a different kind of music theater, and a freer approach to the narrative matter and the work.

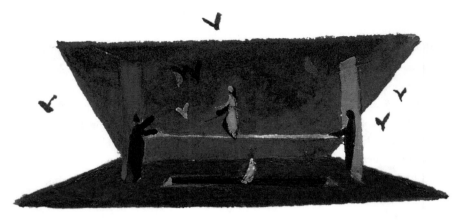

Richard Peduzzi,
Funambule, 2020
Gouache on paper,
9.4 × 23.5 cm
Courtesy of the artist
© Richard Peduzzi
(Photo © Frédéric Claudel)

New pieces often require new forms—including ones of collaboration. What this means is reconsidering or rethinking established forms of artistic work and adapting working methods to needs and rehearsal conditions. It takes the willingness and flexibility of all staff members. Furthermore, it requires openness on the part of the orchestra and the musical direction if they want to do justice to new formats and complex as well as ambitious works. Because musical quality is a prerequisite for a successful performance when it meshes with the artistic aspirations and challenges of stage design and direction. Equality among the arts means moving beyond the commitment to musical excellence and quality so as to muster the openness and motivation necessary to collaborate on the creative development of solutions. You also need to show readiness to step outside the comfort zone of the familiar. You need to find time and space to communicate and participate in processes that are untested and don't always provide a direct path towards a goal.

Within the programming process, various personal artistic styles, forms, and formats create inner references that engender different perspectives on and approaches to works—whereby not everything needs to or can correlate with each other. However, connections between the premieres at the big house and concert, youth, and more experimental programs create associations and cross-links, thus providing points of reference and suggesting deeper engagement with different parts of the program.

Ceremonious solemnity and ivory tower posturing ought not to be encouraged, even if opera is not an everyday affair. When it comes to the accessibility of opera and new perspectives—as well as to the backstage goings-on and how things are created in an opera—it is important to find ways of countering the principle of "a chef won't let anyone look into his or her pots." For many people, there's hardly anything more interesting than cooking shows.

The fascination for the medium of opera must be carried into the city in order to create access points to opera. What is taken for granted in the world of opera is often stranger to the outside world than those in the know might think. At Berlin State Opera a process of opening up in this spirit is made possible with projects such as "Out of the Opera," the children's orchestra "Opernkinderorchester," and the children's opera program "Kinderopernhaus." "Out of the Opera" has members of the Staatskapelle not only perform in the orchestra pit or concert hall, but also at various bars throughout Berlin. As members of the "Opernkinderorchester," which was launched in close cooperation with the music schools of the state of Berlin, more than eighty children are able to experience up close professional orchestra life during voice rehearsals with music teachers and musicians from the Staatskapelle, attending rehearsals and workshops, as well as concerts and performances that form the program's annual highlights. In this fashion, the "family" of the State Opera expands, and the same applies to the "Kinderopernhaus," which is active across six of Berlin's districts and serves as one of the State Opera beacons of outreach—here, over a hundred children collaborate on cross-district opera performances in which the children themselves play the protagonists on stage.

Furthermore, opera has a responsibility to create experiences that have sentimental value. Yet it would be unreasonable to think that opera as an institution could compensate for everything that needs to happen in schools. If we want children to have access to musical education at an early age, regardless of the support they may receive at home, there is nothing that can replace schools as the first and most versatile place for musical encounters and learning. One music class per week alone is not enough! Schools should support music teachers in developing, or participating with their students in, a wide range of continuous educational activities that complement the curriculum, and in paving the way for cooperation, initiatives, and projects that bring music to life in the classroom. It is also vital that every child is given the chance to learn an instrument. School should also be a school of hearing.

Opera is a grand journey, an intense and collective experience that demands attention for hours and allows us to immerse ourselves in a world that contrasts starkly with everyday life. Opera is by definition not efficient. But it is precisely in the anachronism of opera that one of its chances for the future lies: it requires us to embark on the greater story arcs that involve a different perception of time. It engages nearly all of our senses. Delving into the experience of a performance, we enter a protected space, as it were, a place of deceleration. It is an authentic experience in an increasingly digitalized world that can become overwhelming in its complexity. Opera cannot change the world, but perhaps it will help us to better endure the ambivalences of life and contribute to our being empathetic human beings.

Pianist and cultural manager, Matthias Schulz was head of the concert division at the Salzburg Festival and managing director and artistic director of the Mozarteum Foundation in Salzburg. Today, he is artistic director of the Unter den Linden State Opera Berlin and was recently appointed artistic director of the Zurich Opera House.

THE RIDE ACROSS LAKE CONSTANCE

FROM OPERETTA TO OPERA, FROM OPERA TO MUSICTHEATRE

Alfred Wopmann

When opera is not perceived as a symbol of prestige, a museum piece, or some culinary event, Max Reinhardt's observations come to mind: "The arts are not merely a luxury for the rich and sated, but food for the needy." And, "For a mass audience, the best is only just good enough." A hundred years have passed since Max Reinhardt wrote these lines and the world has changed drastically. The opera is currently faced with an unprecedented level of competition from today's event culture, television, streaming, and the Internet, among others. This raises the question of whether opera can stand its ground at all alongside all these low-threshold offerings of information and entertainment. Reinhardt was convinced that if theater wanted to reach a large number of people, it had to be popular without sacrificing its artistic aspirations. Even if this sounds like trying to square the circle, the Bregenz Festival has demonstrated that it's possible. It was a risky but successful ride across Lake Constance.

The fulfillment of this claim took shape between the 1980s and the first decade of the twenty-first century. In artistic, organizational, and architectural terms, it marked the biggest transformation in the history of the Bregenz Festival to date. This period saw the beginnings of a departure towards hitherto undreamed-of and courageous musical and scenic formulations, which have since established themselves as an independent "Bregenz dramaturgy."

The Bregenz Festival abandoned its previous program, which had been dominated by operetta, and made it its mission to treat its audience to modern-day operatic theater as a contemporary form of musical popular theater. The big challenge now was to find works that could live up to these aspirations. Even though there were some objections at first, I was firmly convinced that *The Magic Flute*, the mother of all operas, was the appropriate introductory work for a large audience. As far as the elements are concerned, *The Magic Flute* on the Seebühne (the floating stage just off the shore of Lake Constance) proved to be quite a trying experience, both for the performers on stage and the crowd in the auditorium.

Already the ancient Egyptians appreciated the importance and the magic of water and celebrated their Isis and Osiris cult on the Nile. When today's operagoers hear the first chorus of *The Magic Flute* ring out across the lake half-way through the performance, they witness one of the secrets of open-air theater: the unification of art and nature. Opera shows in a natural environment rely on the magic of music and the magic of the human voice, which expresses itself through the miracle of singing. Of course, like the sound of the orchestra, it would hardly be audible without electro-acoustic amplification. Equally essential is the cor-

respondence between acoustic and optical perception, so that speech, singing, and orchestra can be localized via directional hearing. Furthermore, the stage structure needs to be enlarged so as to make up for the distance between the floating stage and the auditorium. But the stage design itself also has to be augmented on a symbolic level as it needs to hold its own vis-à-vis the realism of nature and create a counter-image with a magical pull.

This is exactly what the "magicien du théâtre" Jérôme Savary achieved through the imaginative vision that inspired his visual worlds. This new, visually spectacular style of staging made the opera immediately accessible to a large audience. The content of *The Magic Flute* is expressed through clear contrasts: the worlds of the sun and the moon; the battle waged by the Queen of the Night against Sarastro; Eros in opposition to love; facing danger and trials under the protection of music and its magical instruments; the flute and the magic bells. The story of *The Magic Flute* culminates in the unification of all opposites through the love of one couple, Tamino and Pamina, and the ultimate achievement of becoming human.

Let me highlight three examples from Savary's magical imagery that were met with surprise and amazement from the audience. They had never seen or heard anything like this before: the appearance of the Queen of the Night at the top of the Magic Mountain, wrapped in an overlong cloak strewn with gleaming stars; the appearance of the three child-spirits, floating, as spirits of the air, on a cloud above the auditorium towards the Magic Mountain; and finally, the unforgettable trial by fire and water, where the Magic Mountain was illuminated from within and became a "burning" volcano, and Tamino and Pamina were subsequently threatened by a thunderous waterfall.

This first venture convincingly proved that the opera is far from dead, and that it can captivate and touch audiences through its music, message, and visual expressiveness. In Bregenz, this new language of imagery and visual design opened a new chapter in the performance history of a classic opera. The otherwise elitist institution of opera thus became part of a common popular culture, opened itself up to all segments of the population—irrespective of education, origin, and age.

A vital contribution to the success of *The Magic Flute* was made by the Vienna Symphony Orchestra. It has also been key to the continuing popularity of opera at the Bregenz Festival for many years. People were able to experience the positive impact of opera theater and not its more negative manifestation, which involves random alienation and distortion. The Bregenz *Magic Flute* was hugely successful with the audience and the press. It was brought back by popular demand in 1986, which led to the introduction of a biennial schedule of staging new opera productions on the lake stage.

Public perception of Bregenz was, and is, focused primarily on its floating stage, but unjustly so, because ever since the new Festspielhaus opened in 1980, opera aficionados have also been treated to an indoor opera performance every year. So as not to compete with the major opera houses, it is important, especially for festivals, to stage events that are out of the ordinary. For this reason, a dual strategy was developed: rarity operas are produced as an alternative program to the lakeside performances, they have come to form a second pillar

of the Bregenz dramaturgy. Opera lovers get to see and hear rare gems in Bregenz that are otherwise hardly ever seen on stage.

I first chose *I puritani*, a bel canto opera that is tough to stage without the star power of singers of the likes of Edita Gruberová. In the wake of these beginnings, which were, unfortunately, only musically successful, the production of the early Verdi opera *Ernani* caused quite a row. An Italian opera star insisted on performing his part in a fashion that had already become a tradition, and came into conflict with a young, ambitious director, who had quite different ideas about the style in which he wanted to stage this piece. An open quarrel ensued, the director had a nervous breakdown, and threats to walk away from the project mounted. The situation deteriorated to the extent that the entire production ended in failure.

This led me to shift the concept of the "rarity opera" program in the direction of current musical theater, to create a balance between music and scene, and to pay closer attention to the topicality of the interpretation of works and its references to the present. These ideas were put into action in an exemplary manner with the staging of the oratorio opera *Samson et Dalila* by the production team of Steven Pimlott (direction), Tom Cairns (stage), and Aletta Collins (choreography). The personal tragedy of Samson and Delilah, the conflict they experience between their devotion to God and worldly love, and the persistent presence of the history of Jewish suffering deeply touched the audience. It also attracted such enormous attention and approval (including from the press) that we decided to schedule additional performances of *Samson et Dalila*, just as we had done before with *The Magic Flute*. The enthusiasm among the audience also gave us reason to believe that some of them may have been motivated to attend opera not only at the Festival, but elsewhere as well.

Continuing my efforts to find opera rarities, I placed great emphasis on contemporary themes and the validity of the message that was conveyed. This was the case in 1990 with Alfredo Catalani's opera *La Wally*. It deals with the issue of the emancipation of women, which has lost none of its relevance to this day. Just as interesting, in terms of subject matter, was the performance of Tchaikovsky's opera *Mazeppa* in 1997—on the eve of the collapse of communism. However, to this day, nothing has even come close to the tragedy and urgency brought to the stage in *The Greek Passion* by Bohuslav Martinů, which focuses on the refugee crisis and migration at the gates of Europe. All the opera rarities performed at the Bregenz Festival, of which I have mentioned only three examples, were celebrated as rediscoveries and enjoyed an astonishingly high level of acceptance among the audience. They are proof that opera in its contemporary forms is an absolutely viable genre.

A milestone in the development of sophisticated open-air opera theater was set with the production of *Der fliegende Holländer* by the leading team comprising David Pountney (director) and Stefanos Lazaridis (stage). This was a work that seemed particularly suited for a naturalistic performance at the lake. The performance, however, consistently defied any superficial expectations: water lost its significance as a realistic prop, because how could the violent storm, with which the opera opens, be unleashed on a calm lake on a balmy summer evening? Hence, water was interpreted as an ambiguous symbol. It stood for Daland's power as a shipowner and served as an allegory of Senta's dream vision of the flying Dutchman, in

which the wind and the waves become metaphors of the state of her soul. The Dutchman's ship was not a ship, but a black, revolving cube, a prison of souls holding him and the dead souls condemned with him to roam the sea forever without rest. They appeared in brightly lit windows like crucified figures.

This new and bold approach to the staging of operas amazed not only the audience, but the press as well. For the first time, international media spoke of a new Bregenz dramaturgy. Over a period of two years, *Der fliegende Holländer* sold 94 percent of seats—further proof that the opera is by no means dead, but truly alive and kicking. This gratifying development did not go unnoticed with politicians either, which is why the Festival was granted a three-year subsidy guarantee by the federal, state, and municipal governments in 1989, following its organizational transformation into a limited liability company. With this, the government recognized, above all, the importance of making the art form of opera accessible to a wider public, and it enabled the Festival to reinvest the profits it had generated in the company.

Consistently pursuing the Bregenz dramaturgy approach, in 1993 we ended up producing Giuseppe Verdi's *Nabucco*, one of the best-known and most popular operas of all time. With our lakeside production, we wanted to avoid at all costs the impression that the world-famous "Chorus of the Hebrew Slaves" was the main event of the evening. But this was not the only reason why we wanted to turn Verdi's Risorgimento opera into a present-day drama in which the biblical and historical dimension of the work was juxtaposed with the tragedy of today's Middle East conflict. Nebuchadnezzar, the tyrant who had provoked a racial conflict, was brought into the present by an oversized portrait of Saddam Hussein. The duality of the characters was matched by a duality of symbols of faith: a golden and black wall representing Babylon and a white temple wall symbolizing the Hebrews. By raising and lowering the walls, the constellation of power and oppression was visible to everyone, and it was starkly illustrated by the prayer ceremony of the Israelites beneath the inclined wall on which the Babylonians celebrated their victory. It seemed important to us to find a contemporary metaphor for the Babylonian god of Bel. Thus, we replaced Bel's animal head with a crane carrying Nabucco, allowing him to glide in victoriously over the white wall of the Hebrews. Another memorable moment, a "coup de théâtre," was the glaring lightning, accompanied by thunder, that split the Babylonian wall in two the moment Nabucco declared himself a God.

But even before the premiere came around, we experienced the miracle of catharsis in the course of a dress rehearsal on July 17, 1993. An audience of 7,000 had gathered in the stands and when the chorus was about to begin, they suddenly saw themselves confronted with a magically rising iron grid and a mass of prisoners crowding behind it. The first bars of the famous "Chorus of the Hebrew Slaves," of "Va, pensiero," had begun when, first, a few drops fell and it quickly began to rain ever more heavily. The interplay of Verdi's music and the rain that felt like a sign from above intensified the audience's emotional response to the extent that, on both sides of the grid, spectators and performers turned into a single choir, holding out in the pouring rain until the last note of the music had faded away. We understood for the first time what the catharsis of the Greek tragedy is really about. It is felt when a huge crowd suddenly forgets everything around them, is overwhelmed by the shudder of

compassion, experiences moments of existential dismay, and everyone becomes aware that there is something greater than the self. Anyone who experiences such a moment is going to remember it for the rest of their lives.

Following its premiere, Nabucco became the most spectacular success to date, attracting nearly 318,000 visitors over two festival summers and playing to full capacity audiences throughout.

In 1995–96, the fiftieth anniversary of the Bregenz Festival was drawing near. The first "Bregenzer Festwoche" had already been held in the Gondola Harbor in 1946. Memories of the newly won freedom after the end of the Second World War were in the air again, and so the idea suggested itself to follow *Nabucco*, the opera associated with Italian independence, with *Fidelio*, the German liberation opera. After putting this work on the program, the Festival faced the greatest challenge of its history.

In search of links that connect this work with the world we live in today, set designer Stefanos Lazaridis set out to visit the former concentration camp Mauthausen. On his way there, he passed rows of houses with well-tended gardens that had already existed at the time of the concentration camp. The road that led directly to the camp was only a few minutes away. The proximity of these two opposing worlds inspired Lazaridis, after in-depth discussions with director David Pountney, to create the basic framework of his pictorial vision for *Fidelio*, which consisted in the sculptural intertwining of a pretty row of bourgeois houses and a dungeon. The dungeon was located above the houses and was at first obscured by a backdrop showing clouds and the sky. When the latter was lowered, it revealed the image of the mental and material prison of a society collaborating with Pizarro; Rocco, a bright yellow VW parked in front of his door, dug Florestan's grave in the allotment garden. No wonder that many of the Austrians and Germans in the Festival audience, who had the mirror of their own history held up to their faces with this image, offered a mixed response, as did the media. Heiner Müller called this phenomenon the difference between success and effect: "The effect results from conflicting opinions and the ensuing discussion. Only then do you know that you've produced something new and haven't fulfilled expectations but irritated them." Positive voices were supportive of the fact that this anti-culinary *Fidelio* raised the painful subject of the responsibility for the Holocaust. A complaint frequently voiced by traditionalists was how ridiculous it was to present a brightly lit high-security prison instead of the dark and dreary dungeon described in the libretto, thus contradicting Florestan's cry of "God, what darkness here!" And many did not appreciate the minister's "Deus ex Machina" appearance, which morphed into a self-staged political show featuring cheerleaders, fireworks, and banderoles deriding the ideals of *Liberté*, *Égalité*, and *Fraternité*. While others thought it served as the perfect backdrop that amplified the uniqueness of Leonore's act of liberation, namely, of rescuing Florestan out of love from the clutches of Pizarro, the criminal.

Never was that ride across Lake Constance more challenging than during the production of *Fidelio*. But, as they say, nothing ventured, nothing gained. While in the first year, astonishingly, 100 percent of seats were sold, only 91 percent were filled in the second year, the overall average being 95 percent.

As the tremendous artistic success of the popular operas also translated into considerable economic success, and as revenues outpaced costs, it subsequently became possible to finance, and thus revitalize, less popular operas and contemporary works. Surpluses from ticket sales on the lake were allocated—in terms of pure cost-benefit calculations—to uneconomical productions, such as rarity operas that were performed only six times, or commissioned operas on the Werkstattbühne, which were often shown only twice. Fifteen percent of popular-opera proceeds were used to stage *The Greek Passion*, for instance, and 10 percent paid for the production of the commissioned opera *Nacht* on the Werkstattbühne.

Since 1994, a host of modern composers have been featured in Bregenz, including Scelsi, Kagel, Berio, Neuwirth, Zender, among others—but especially works by Georg Friedrich Haas. After studying his music in great detail and trusting my ears, which are honed by my long years as an orchestral musician, I commissioned Haas to write a new opera for the Festival. In 1996, we listened to the result at the concert performance of the Hölderlin opera *Nacht* and, owing to its great success, saw the stage premiere in 1998 on the occasion of the opening of the new Werkstattbühne. Peter Rundel conducted the Klangforum Wien and Philippe Arlaud was responsible for direction, stage design, and light design.

Suddenly the music world took notice. There you had a composer who had, without a doubt, written avant-garde music with micro-intervals and a seductive, sensory appeal. Haas talks about a basic human desire for beat tones in music, the pleasure in "off-key" intervals, when tones that are very close in pitch, but still a hair's breadth apart, microtonally rub up against each other. This is an element that brings life to the music, as is the case with "slendro" in gamelan music or the ragas in Indian music. One thing very close to Haas' heart is the phenomenon of spatially varied sound. This cannot be produced in conventional concert halls, but only in open spaces, such as the new Werkstattbühne stage. Here, musicians and singers can move around the audience and thus create the phenomenon of mobile sound, which magically draws the audience into a new sound experience.

In his preface to the opera *Nacht*, Haas explains what connects him with Hölderlin. It's the loss of utopias, which marks our present moment, too, and became painfully apparent when his creative process coincided with the outbreak of the Bosnian war. But Haas' opera also reflects on a historical parallel: the failure of the utopian vision of the French Revolution. It brought about the opposite of what it had been expected to achieve and ended in the horrors of Jacobinism. Haas was awarded the Ernst Krenek Prize for his opera *Nacht* in 1998, which marked the first step in his international career as a composer.

The final and most decisive quantum leap came in 1999–2000 with the production of Giuseppe Verdi's *Un ballo in maschera* (A Masked Ball) on the lake stage. A new leading team with Richard Jones and Antony McDonald was responsible for direction and stage design and succeeded in finding a metaphor for this piece, which he derived from Ulrica's prophecy of death.

Inspired by the imagery of the Dance of Death woodcuts by Renaissance artist Hans Holbein the Younger, a huge skeleton held King Gustav III's "Book of Life" in its hands, which was juxtaposed with a crown as a symbol of worldly power; the king's dance towards

his death was represented by choreographic symbols and figures taken from a dance manual. In the final ball scene, the mysteriousness of the plot was heightened by the enigmatic giant heads of one of Max Beckmann's self-portraits—before the skeleton's monumental hand wiped the king into a floating coffin. Conductor Marcello Viotti and a superb ensemble of singers made the Festival with the most unusual pictorial metaphor of its history a resounding success. For the first time, a picture of the Festival literally went around the world. It appeared in the *Life 1999 Album: The Year in Pictures* and was named "Stage Design of the Year" in the *Opernwelt* critics' poll. But the most essential statement was made by Horst Koegler in the 2003 Yearbook of *Opernwelt*, which reads, "with the 1999/2000 'Masked Ball', at the latest, Wopmann proved that open-air performances can achieve the same level of artistic excellence as the productions of an opera house." This was also confirmation that opera can even appeal to large audiences if we take risks and focus on quality. There is absolutely no need to descend to the banality of cheap show effects, in order to spark interest in this art form even from groups who have never given any thought to opera.

The original version of *The Greek Passion*, as reconstructed by Aleš Březina, was staged in cooperation with the Covent Garden Opera in Bregenz in 1999. As refugee crises have proliferated around the world, it has become emblematic of the twenty-first century. The London premiere of this opera in April 2000 was a very special event. Kubelik and Martinů had offered the original version to the Covent Garden Opera forty years earlier, but it had been rejected at the time, ostensibly due to its poor quality. At that same venue, of all places, it was now celebrated as a triumphant success. Martinů's visionary work gained acclaim from audiences and the press, and it won the Laurence Olivier Award for best opera production of the year. Thus, one of the most important operas from the middle of the twentieth century was belatedly rehabilitated. With the critical confrontation of the rejected, freezing refugees celebrating Christmas up on the mountain, while the villagers down in the church repressed the memory of the murder of Manolios with Hallelujahs and Glorias; this original version deeply touched the London audience.

The rediscovery of the original version of *The Greek Passion* sparked a Martinů renaissance throughout Europe, as Aleš Březina, director of the Martinů Foundation in Prague, has confirmed. Few know that the composer was a refugee himself all his life. Fleeing the Nazis, he first sought refuge in Paris and eventually had to emigrate to the United States. When he returned to his home country, the Communists saw him as a thorn in their side, and he accepted an invitation from Paul Sacher to settle in Switzerland. When a composer and one of his most important operas, such as *The Greek Passion*, attract so much attention and the work is widely performed on account of its quality and timeliness, the question as to "The Last Days of the Opera" seems moot.

With Martinů and Haas, the Bregenz dramaturgy reached its prime, and it has stayed its course ever since. That said, the question of whether we are living in "The Last Days of the Opera" remains urgent, because we have to ask ourselves where the art form is headed and whether it has a future. We have seen that the "Museum of Operas" works, even with a mass audience. The eternal repetition of between thirty and fifty works of the common

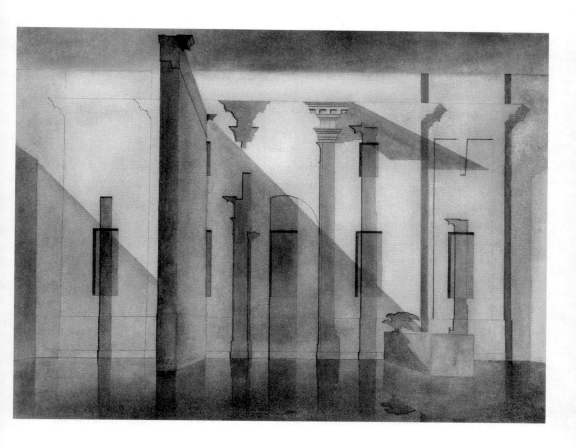

Richard Peduzzi,
Untitled, 1984
Watercolor and pastel on
paper, 22 × 30 cm
Design for *Lucio Silla*,
Wolfgang Amadeus Mozart,
Théâtre des Amandiers,
Nanterre, 1984.
Director: Patrice Chéreau
Courtesy of the artist
© Richard Peduzzi

opera canon is not up for discussion, and not even the less common rarity operas seem to be in serious danger. But what about the opera composers living today? Only a handful have produced operas that, after a successful premiere, played for a second night, or was maybe even shown several times. But I would suggest that this is precisely the criterion for quality and acceptance by audiences and the press—and ultimately the prerequisite for making it into the repertoire over the course of many years of development. Even though I am well aware that only posterity will decide whether artists and their creations will live on, I would now like to throw a few names and works into the ring that I think have what it takes to find their way into a successful future: first and foremost Wolfgang Rihm and his *Jakob Lenz*, Salvatore Sciarrino and his *Luci mie traditrici*, George Benjamin and his opera *Written on Skin*, but also Thomas Adès' *The Tempest*, or Manfred Trojahn's *Orest*.

This list could certainly include other works by these composers, as well as the names of other important contemporary opera composers. In my personal estimation, this very subjective selection should also include Austrian composer Georg Friedrich Haas. His achievements have been recognized with major awards such as the Grand Austrian State Prize and many international awards, his works are performed around the world by the most eminent orchestras and conductors, such as Simon Rattle, he has a lifetime professorship at Columbia University in New York, and he holds part-time lectureships in Basel and Graz. The compositions he is currently commissioned with, by prestigious Austrian houses, among others, extend into 2023. His opera premieres have seen repeat performances by popular demand, which attests to the appeal of his music. After Bregenz, his opera *Nacht* premiered in Frankfurt, Germany, in 2005 and at the Lucerne Festival in Switzerland in 2011. Almost all of Haas' operas have played at several venues—*Koma* saw its world premiere in Schwetzingen in 2016, which was nominated Premiere of the Year by Opernwelt and taken up by the opera houses of Klagenfurt, Austria, and Dijon, France, in 2019.

Clearly, traditional operas are staged and played far more frequently than contemporary ones, but there's no denying that present-day composers of distinction are succeeding in ensuring the continued existence of the art form of opera, not only at the moment, but far into the future.

Epilogue

Almost twenty years have passed since I left Bregenz. In the meantime, the artistic directorship has changed hands twice, the Bregenz dramaturgy has been retained, and occupancy figures, as well as the self-sufficiency rate of between 75 and 80 percent, have essentially remained the same.

What's the point, then, in titling my essay "The Ride Across Lake Constance"? Where's the danger here of thin ice cracking under my feet? It lurks on the lake stage. If we take into consideration that 90 percent of total proceeds are generated by performances on the lake—or, I should say, must be generated—the risk weighing on the opera company Bregenz Festival becomes obvious. Let me give an example to illustrate this point: In 2011–12, *Andrea Chénier* by Umberto Giordano was performed on the lake stage. The claim that this was a

popular opera was quite presumptuous, the realistic assumption to proceed from would have been that it was only known to a small minority of the Seebühne audience. The result of this venture was pretty sobering. Occupancy dropped from the usual 95 percent to 70 percent, prompting our commercial director to quip, "One more artistic success like that and we're dead."

The lessons we learned were that we needed to exercise even more caution in choosing pieces suitable for a mass audience. But it's not just what you're doing, it's also how you're doing it. This is where the ice becomes really thin again, because there is a danger of sacrificing the selected opera to spectacle and sensation.

If Richard Wagner's *Der fliegende Holländer* were to fill the stands only because a stuntman in Senta's costume does a salto mortale from a thirty-meter-high lighthouse into the pitch-black lake, then "The Last Days of the Opera" would indeed be upon us.

After his studies in psychology and philosophy, Alfred Wopmann began as an orchestral musician and stage manager at the Wiener Staatsoper. In 1972, he made his debut as a stage director in Dortmund. After that, he began focusing on open-air theater at the Théâtre Antique d'Orange, and from 1983 to 2003, he was intendant of the Bregenz Festival. From 2004 to 2017, he was chairman of the supervisory board of Bühnen Graz.

OPERA AND
"L'HOMME DU THÉÂTRE"

Stéphane Lissner
Conversation with Denise Wendel-Poray (June 2021)

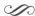

Denise Wendel-Poray: *You've been directing theaters since you graduated from Lycée Henri-IV in 1972 when you created the Théâtre Mécanique, a small theater in the 7th arrondissement of Paris, where you directed and wrote plays and headed the administration until 1975. You began your career in public theater in 1977 as general secretary of Le Centre Dramatique d'Aubervilliers—known as "La Commune," then you co-directed the Centre Dramatique de Nice from 1978 to 1983 before taking on the festival Printemps du théâtre between 1984 and 1987. You were appointed general director of the Théâtre du Châtelet in Paris in 1988, putting you on track to become one of the most influential opera administrators of the twenty-first century. Of all the theaters and festivals you have headed from—La Scala, to Aix-en-Provence, to the Paris Opera—and all the others in between, which one brought you the most artistic satisfaction?*

Stéphane Lissner: The most emotionally powerful, the most extraordinary, unexpected, the most changing every day, was my collaboration with Daniel Barenboim for several years at La Scala. The beauty of the theater, the relationship of the artists with the theater, these were extraordinary years. The history of the theater is exceptional, a theater that is at the center of the operatic world and always will be. In comparison to the Paris Opera or Covent Garden, there is something unique about La Scala: its history, first of all—it's an eighteenth-century theater, already there are not that many, the omnipresence of Verdi, and at the same time, it's a theater with an international aura.

How did you change La Scala during your tenure there?

I changed the work method, made it more organized, with complete preparation months in advance. For me, it was essential to create new work standards: the rendering of stage models, design projects, costume building, co-productions, television, everything organized well in advance. This allows you to do much more and in addition to that, you can save a lot of money. Also, I brought in directors from contemporary theater: Patrice Chéreau, Calixto Bieito, Luc Bondy, Dmitri Tcherniakov, Mario Martone.

La Scala, compared to Naples, is perhaps much more traditional, but what makes this theater unique is that it is a local theater, situated in the heart of Milan but still known worldwide. La Scala is a theater where 60 percent of the subscribers live within one kilometer of the theater. There is no other like it. I don't believe that the Viennese make the Wiener

Staatsoper their own, I know that the Parisians don't make the Paris Opera their own—for the Milanese, La Scala is *their* theater, they criticize it, they love it, families from generation to generation inherit their places. La Scala embodies a powerful history; it is the cultural center of the city, the cultural temple of the city. Along with Ferrari, Fiat, Gucci, Prada, the most important brands of Italy, La Scala is one of them.

What were your most notable productions?
There have been many, for example, *Tristan und Isolde* staged by Patrice Chéreau, with Daniel Barenboim conducting. The last scene and the "Liebestod" with Waltraud Meier were extraordinary; *Lohengrin* with Jonas Kaufmann under the direction of Claus Guth was a very intense moment. Also, by Guth: *Die Frau ohne Schatten* was one of the most beautiful opera performances I've ever seen. Another great success was Benjamin Britten's *Death in Venice*, staged by Deborah Warner.

Also, in the tradition of La Scala, you have given prevalence to new operas.
Already at the Théâtre du Châtelet in Paris, I commissioned new works, for example, Philippe Manoury's *60e Parallèle* on a libretto by Michel Deutsch. The work was commissioned by the Théâtre du Châtelet and IRCAM and staged by Pierre Strosser. I have commissioned several operas: *Phaedra* by Hans Werner Henze in 2007 at the Vienna Festival; for La Scala, I commissioned *Quartet*, by Luca Francesconi, based on the play by Heiner Müller, freely inspired by Choderlos de Laclos's *Dangerous Liaisons*. In this rewriting, the two characters live simultaneously in a boudoir before the French Revolution and in a bunker after the Third World War. The work was a huge success, with sixty-five performances in five cities in less than six years; it has had a career unseen since Ligeti's *Le Grand Macabre* (1978). There was also *Co2* by Giorgio Battistelli, staged by Robert Carsen. At the Paris Opera there was *Bérénice* by Michael Jarrell, *Trompe-la-Mort* by Luca Francesconi, an opera which reduced Balzac's multi-volume *Comédie humaine* to two hours.

Another of my commissions was Marc-André Dalbavie's *Le Soulier de satin*, based on Paul Claudel's play, which just opened at the Paris Opera. Stanislas Nordey directed the opera as if he were directing Claudel—like a theater production—not an opera production. He staged the work theatrically based on the text. But, like Chéreau, he wasn't going for something sensational; it was dark, austere. The characters are those of Claudel; there are no transpositions or attempts to "choquer les bourgeois"; he remained theatrical for six hours.

What was the reaction?
The public loved it, but the artistic project of the Paris Opera doesn't interest the government, no personality from the Ministry of Culture came to see the show, a world-première, French composer, French director, in the language of Claudel—nobody came! A complete lack of interest. But in general, I can say that during my term at the Paris National Opera, unlike in Italy or Austria, very few politicians attended our shows on a regular basis and that's a great pity.

How do you explain the disinterest on the part of the political elites?

The state's relation to the opera, as well as that of the unions, is an absolute catastrophe. And the theater is caught between the unions and the state and unable to assume its role in giving opera the support it deserves. Our politicians are not interested in music, even less so in opera, nor culture, nor art in general.

It sounds like your tenure at the Paris Opera was not the most inspiring one.

Even though my team in the Paris Opera was great and we managed to create new shows and a richer relationship with the audience, I have to admit that the Paris Opera was by far the less interesting venture compared to the Théâtre du Châtelet, for example. I had a wonderful time there; Chirac was mayor of Paris, they were very interested in what we were doing, they came to see, they criticized, they were present, they supported us. What is terrible is that today's politicians are not interested; all they want is to avoid strikes.

What was the turning point? When did attitudes change?

I left the Châtelet in 1998 and took on the Aix-en-Provence Festival. There was no change. It was at the turn of the 2000s. It starts already with Nicolas Sarkozy; culture is no longer a priority. And unfortunately, the left-wing government of Hollande, which appointed me to the Paris Opera, didn't hesitate to cut the budget. At the moment when the government policy does not encourage the artistic project, we are lost. An opera house is not a company like the national railway; it does not "produce" a material good; it is a cultural institution, not the stock market. We imagined and expected a lot from Emmanuel Macron, who supposedly loves Rossini and culture.

Nevertheless, to be fair, during the pandemic, the State and the Ministry of Culture spent a lot of money on culture and music. The Centre national de la musique alone received around 500M, not to mention the "artistes intermittents". What was unacceptable and unnecessary was that during the lockdown, bookstores were shuttered—when we don't understand what a book means for humanity, we are lost.

Even before the pandemic, the lack of interest on the part of politicians was damaging, especially for the promotion of new works.

Yes, the problem was there; we were already doing fewer and fewer new operas due to economic constraints, box-office concerns, seat prices. At the Paris Opera with Emmanuel Macron, I was not allowed to lower the cost of tickets, though I remain convinced that in reducing it, we would finally be able to reach a normal public, not only the elite. If we lowered the price of tickets, we would be able to order more new operas for two reasons: first, because young people would be able to buy tickets more easily, and second, if the economic stakes are lower, the risk is lower. By dint of mounting, mounting, mounting—the Paris Opera is now at 60 percent of self-financing—which means the more we advance, the fewer risks the director can take because he can't risk not making his 60 percent. If he loses money, they will tell him: "Sir, you did not manage it well!" But in the end, the state does not know how to

manage; it is the state who does not understand the stakes of a cultural institution. The sad reality is that they would be happy if the Opera would propose only *Traviata*, *Carmen*, and *The Magic Flute*! These are masterworks, but they alone are not enough!

Regarding the Paris Opera, the state is incapable of understanding the stakes, as much for opera as for dance. It's catastrophic that there are civil servants at the Ministry of Finance who are capable of asking, and I quote: Why we don't do "low-cost" opera? It leaves you speechless; the theater is caught in a vice.

Beyond producing opera, an opera house employs hundreds of full-time professionals, it trains dancers, singers, technicians, a theater is an archive, a learning center, a village where all the different professions work together to build a production, surely those in power see the value of this.

I've given a lot of thought to that question in the past: what is the mission of an opera house? Does it stop with the representation and re-mounting of the seventy or so operas in the repertoire (every ten years a new *Don Giovanni* or a new *Traviata*), or can we consider that the opera has a social and a public mission?

I think so; the future of the opera will be a mission and a social and in-depth digital project (it's not enough to have a production platform to do streaming). But, of course, that goes along with producing opera; that's the primary function of the institution. Along with the conservation of an art form, as you say, an archive.

But next to that, if the theater does not invent a social project in which one has to reflect on ways to enter into the family circle, meet new friends and adepts; if the support from the state only goes to producing opera, the theater no longer has legitimacy.

Naples seems to be the ideal structure to explore these ideas.

My idea was to have a platform of production and to have a certain number of artists and intellectuals talk about opera, but not as much intellectually as socially. For example, a group of artists from a quarter of Naples proposed to involve people from these areas who wouldn't generally come to the theater. There is also the idea of bringing people from different quarters and factions to understand and overcome prejudice and work together. There are former theaters in areas where people don't go because the Mafia ran them to the ground—how can these places function again?

Invite artists who are not directly concerned by opera, not just singers, directors, or conductors, but young film directors and theater actors; I think this is an absolute necessity.

What struck me already in Paris was to what degree we are blocked in our opera world. I had sensed this in earlier times, perhaps less at Châtelet because I was young, but we saw in Aix when we managed to open the Grand Théâtre de Provence, and the Academy, for example, the renovation of the Théâtre de Jeu de Paume, the outdoor theater at the Grand Saint-Jean. We tried to open with innovative spaces or rehabilitating ignored venues. Yet, even with all of this, I realized there was a problem at the base: the artistic project was limited to opera.

So the question is how we could change that, widen our horizons? Then came the onslaught of technology through the internet in the last twenty-five years, and we began to understand the possibilities and implications of these new technologies. As I already said, I think we have to get out of the schema, the template, and open up. There is the inside and the outside; we are so much in the inside, turned inward, introspectively that we are suffocating, we don't know how we are going to get out of all of this, we live through the same crises we experience the same things, we recycle, we are caught in cycles, we repeat schemas. I think that these cycles will always exist, but we have everything to gain from listening to those not directly concerned by the opera "business." But to achieve that, we have to open the doors.

How will you achieve that, and with whom?
With the people who are working with me at the moment in Naples, we defined a project; we are in the process of realizing the first projects: Neapolitan cuisine, Neapolitan museums, architecture, art galleries. With the great gallerist Lia Rumma, we will do a project about the Palazzo Donn'Anna, the building where she lives, as does the famous football player Dries Mertens. So I asked for a film to be made about these two personalities who live in this same building: the renowned gallerist and the famous football player, who are they? What is the popularity of football compared to high art? The dark story in the cellar of the palace beneath their sublime apartments and terraces. According to legend, the famous noblewoman Donn'Anna would choose among the most handsome fishermen, invite them to spend a night with her, and at the first light of dawn, murder them by making them fall from the palace terrace into the sea. According to a second version of the same legend, she brought the murdered fishermen into underground caves overhanging the sea with a small rowing boat. It is said that the souls of the fishermen still wander through the house, looking through the large windows.

You have everything you need there to make a sensational opera.
There are lots of other stories in Naples; that's the richness of the city, like this incredible woman who has a clandestine restaurant in her kitchen. The first projects are already decided; we'll see. For Palazzo Donn'Anna, we are filming at the moment.

So you will remain a long time in Naples.
I am not sure about that. I love to live and to work in this incredible city. But I must admit that the current situation of the opera world deeply concerns me. When you see the Wiener Staatsoper, three hundred operas a year for buses full of tourists, with singers who don't rehearse, directors who can't work correctly because the singers aren't there and the conductor who arrives and doesn't even know what's being said in the ensembles, what's the point?

The opera world is in a compromised situation from which it will perhaps never free itself, and that is deadly.

Mortier already sensed it when he refused the star system; when you have theaters of more than 2,000 places to fill, and you need those famous singers, but they no longer rehearse, not one of them. So instead, they sing three or four performances; the directors work with

their replacements, the conductor arrives and says that's too far back, that's not good, too high up, and so on, he didn't conduct a single full rehearsal.

I saw a conductor in Paris who hadn't seen a single rehearsal and felt he could criticize the show.

Why continue with this? If certain cities want to treat opera like a tourist attraction, let them do it. You go to the Albertina, Belvedere, have a Tafelspitz, buy some clothing, go to the opera and you've "done" Vienna.

That's not my idea of opera; for me, it's a genre that unites theater and music, today it's a genre that doesn't unify the theater with music, and finally, musically, we are working less and less.

If we don't want to face up to that, it's finished! If we don't revise our approach radically, it's dead.

The great stage directors don't want to work in opera houses anymore; they prefer the festivals where they have more time. But, unfortunately, by making compromises, they end up disrespecting their own work.

We, the directors of theaters, have to insist on rehearsals.

Today, the world is made in such a way that singers no longer want to rehearse.

And this has become normal; it's not normal; this is not why we chose this business, at least that is not why I chose this business. It's to support the artist: it's time and money, now there is only money.

Are you nostalgic of the years of Patrice Chéreau, Luc Bondy, the Wiener Festwochen?
The Festwochen is a festival; we could do much more there than in an opera house; there were ideas that we wanted to defend, and we did so. With *De la maison des morts*, I said to Luc; we need six weeks of rehearsals; Chéreau will not do less; if we had said three weeks, he would have refused. We didn't work only with stars, and we rehearsed. If having no time is an ultimatum, due to budget constraints, directors will finish by accepting, but it will be to the detriment of their work.

Luc wasn't cynical, but he always had reservations towards opera; it was never as important as the theater for him. So when he accepted the Metropolitan Opera contract for *Tosca*, he knew there would be limits and that he would be criticized, but at least he had the time to work. The big problem is time; as a director, if you don't have the time with the singers, they take old habits, you don't construct a character with them.

No, I'm not nostalgic; I'm happy with what I did. Peter Brook, Luc Bondy, I worked with the best and had a deep attachment to them. And now they are dead. Luc, Patrice. I have the feeling that we lost these "Hommes de théâtre," and now we have only "Hommes du spectacle." With those like Chéreau, Vitez, Jean Vilar, we lost the "artisan" side of the theater. How have we transformed this art? Is it the video? Are we overly fascinated by technology? We have used it more than we should have perhaps; the "Homme de théâtre" knew how to begin with the raw material of a work, the text, he reflected on how he was going to express its meaning and transmit it to the public. It's that point of departure that is gone.

You brought a new generation of directors to opera, Mortier hired Krzysztof Warlikowski for Iphigénie en Tauride in 2006, and you continued to engage the Polish director throughout your tenure not to mention Romeo Castellucci, for Moses and Aaron at the Paris Opera in 2015.

There are exceptional people like Castellucci—it's not entirely negative. But that's another form of work. For example, his Mozart *Requiem*; why is it an exceptional production? He researched the idea of disappearance—very simple, but through his vision, it had an impact. The image takes the prevalence over everything else. In his *Orfeo*, death is the real-life coma of the young girl.

With Castellucci, there is always a moment where reality makes an intrusion into the theatrical sphere—it's gripping.

Castellucci gives us propositions that no other does. We need more of this if opera is to have a future.

French theater director, Stéphane Lissner was appointed director general of the Théâtre du Châtelet in Paris in 1988, and general manager of the Orchestre de Paris from 1994 to 1996. The direction of the Aix-en-Provence Festival was entrusted to him in 1998. Formerly the director of La Scala, Milan (2005–14) and of the Paris Opera (2014 to 2020), he is now director of the Teatro San Carlo in Naples.

The Architects

OPERA HOUSES FOR THE TWENTY-FIRST CENTURY

Pier Luigi Ciapparelli

Starting in the last two decades of the twentieth century, the theme of performance architecture seems to have eclipsed that of the museum in the international debate. This is reflected in the international competitions announced on several continents by municipalities and public and private institutions and the many achievements in centers of various sizes. The interest of several starchitects in these structures not only bears witness to the important place they hold in the architecture industry but has also given rise to fresh debate and formal innovation in the sector's research.[1]

In particular, for structures intended for operatic productions, defining the state of the art is made all the more complicated by the problem of identifying it according to the criteria that have hardened into the bastions of eighteenth- and nineteenth-century tradition, which survived well into the last century. Since the early 1950s, this kind of structure has often been part of a larger performing arts complex with halls of different sizes, or a multipurpose cultural center—in this latter case, flanked by museums, convention halls, educational facilities or even accommodations. The phenomenon gained momentum in the first two decades of this millennium, during which time we rarely find buildings conceived in isolation from a complex and endowed with a single space.

The *mise en espace*, or semi-staged, performance of operas in auditoriums that are, by definition, lacking a fly tower, progressively expands and changes the definition of the "venue" designated for opera. An emblematic example of this is the Da Ponte-Mozart trilogy presented between 2012 and 2014 at the Walt Disney Concert Hall in Los Angeles in three different productions signed respectively by Frank Gehry, Jean Nouvel, and Zaha Hadid. Especially in smaller cities, the venues specifically intended for stage plays or light musical genres, are not infrequently designed with the possibility of hosting operas in mind.

To these considerations must be added the reuse of spaces originally intended for a different purpose and converted into venues for opera performances—one example is the Ulumbarra Theatre (2016) in Bendigo (Australia) by Y2 Architecture, created from an abandoned prison—and productions in public places.

Likewise, the design and construction of an opera house has become such a complex undertaking that it now requires the consultancy of different professionals supporting the architect; first among these are the acoustical engineers, for example from the famous firms Arup Acoustics, Artec Consultants, Nagata Acoustics, and Marshall Day Acoustics, whose contribution makes it possible for the architects to optimize the quality of the sound in the spaces they are designing. Alongside this are the technological advances in stagecraft systems. In this respect, the commercial interests of opera in large urban centers, with multiple productions rotated in the weekly calendar, depend on the availability of increasingly sophisticated technological equipment to be able to offer such a wide range of shows, along the lines of what was implemented at the Opéra Bastille in Paris (1983–89), designed by Carlos Ott. Here there are large storage areas situated on two levels below and around the main stage, for stowing various stage sets, thus making it possible to rehearse one show and perform another in the course of a single day.

The results of these complex studies also give a sense of the wide range of reinterpretations that the models developed by leading figures in western architecture have had in different geographic and cultural contexts.

A factor that can be noted in many of the most recent constructions is the urbanistic significance of the projects, often aimed at renewing urban areas that are outlying or in any case suffering decay. While we can perceive aspects of a functional nature behind these choices, such as the difficulty of finding extensive building plots in historical centers, or the possibility of locating facilities such as large underground parking, today impossible to omit, another driving force is the clear intention to create new cultural hubs outside of the congested city centers. Unlike phenomena such as the "theater mania" in France in the second half of the eighteenth century, which was stimulated by real estate speculation, or the "recovery campaigns" in nineteenth-century Italy in which theater became the focal element of urban planning, situating itself at the confluence of wide roadways, now the projects often look to the suburbs, which are sometimes characterized by abandoned industrial sites, seeking to change their face through the cultural function. Or, in case the project involves an undeveloped area, a freer approach to the environment at large is triggered.

Waterfronts

A recurrent theme is the contact between the building and a waterfront, natural or artificial, perhaps prompted by a seminal structure from the post-Second World War period, the Sidney Opera House (1955–1973), by Jørn Utzon, still today an important model for architects. The mirror effect on the bay waters and the relationship with the surrounding landscape, together with the nautical suggestions on the exterior of the Danish architect's masterpiece, presumably inspired the "aquatic" connotations of some recent complexes, in particular the Norske Opera & Ballet in Oslo (2000–08), by the Snøhetta group, and the Copenhagen Opera House (2004, inaugurated 2005) by the Henning Larsen firm. The former, further confirmation of the trend to move performance to the city outskirts, also proposes the extraordinary solution of the rooftops that become a city square overlooking

the sea, used as a space for circulating and entertainment open to all citizens, as well as to operagoers.

This feature—the use of the space surrounding and even within the structure well beyond the performance times—had interesting consequences that can be traced back to previous experiences like the "gallery" entrance to the Teatro Carlo Felice in Genoa (1982–89), conceived by the architects of the reconstruction—a team headed up by Aldo Rossi and Ignazio Gardella—as a covered piazza, a passageway and filter between the city and the theater.

The meeting of the water and the landscape has found interesting developments in the East, where there has also been a rise in the number of opera houses, giving an indication of the growing interest in this genre, emblematic of Western culture.

Paul Andreu's magnificent National Center for the Performing Arts in Beijing (2007) rises up a short distance from the Forbidden City. Surrounding it is a pond that contains and conceals the access system by means of a sixty-meter long, fully immersed tunnel that leaves the exterior silhouette of the structure completely closed, like an inaccessible place. It is an idea totally at odds with the exterior appearance of the great temples of opera that spread in the course of the nineteenth century, following the example of French and Italian models, where the emphasis put on the entrance to the structure, often preceded by porticos with columns or piers, was functional to the self-celebratory ritual of the public already before the performance. Andreu's discreet solution perhaps corresponds to the obsolescence of this custom, in line with the less elitist more mainstream character of operagoing nowadays.

Again in China, Arte Charpentier Architectes' Shanxi Grand Theater (2008–2012) in Taiyuan, situated near the Fen river, offers yet another interesting approach to the theme with the highly original entrance serving as a link between the two volumes of the opera house and the auditorium: a covered esplanade, accessed by steps and also functional for outdoor events, conceived as a big window overlooking the city, with views of the river and the mountains in the distance.

Equally extraordinary is the structure designed by MAD Architects for the Opera (2010–18) at Harbin, a large city in the north of China. Its sinuous form rises up, inspired by the Songhua river and the surrounding swamp area, contributing to creating a cultural center together with the neighboring Labor Recreation Center, signed by the same firm. The liquid element almost physically laps at the complex's edges, as much in the site's natural landscape as with the reflecting pool spanned by a pedestrian bridge linking the two structures; a large circular plaza opens out before the service entrances for the two interior halls. The pedestrian walkways offset the sheltered passages climbing up to the structure's roofs, culminating at the top in an open-air panoramic space, here, too, with views oriented towards the landscape and the city.

We can see in each of these two Chinese creations a contemporary language evoking the strong relationship between the theatrical structures of classical antiquity and the natural environment. It is a theme that has also beguiled great Japanese masters, such as Arata Isozaki and Tadao Andō.

In a completely different context, the theme of water turns up again in two other recent constructions in the Middle East, with formal interpretations that attempt a mediation with

the local architectural culture, another avenue of study already explored in the twentieth century, for example, in the Cairo Opera House (1985–88) by the Japanese Nikken Sekkei firm.

The first is the Dubai Opera House (2012–16) by Atkins Architecture's Janus Rostock. Unlike the previous examples, this performing arts center is located in the downtown area of the capital of one of the United Arab Emirates, on the shore of Burj Lake, an artificial body of water. The structure, one of the few inaugurated in these two decades that is not part of a complex, rises up like a transparent vessel, inspired by traditional Arab boats. However, on the entrance side, the technological shell is covered by a second, perforated metal skin with motifs derived from the Islamic decorative tradition. It is a device that, while providing a protective screen for the innermost façade, has the merit of conceptually linking the structure to the context.

Similarly, more subtly and in a scale more appropriate to the landscape, at Architecture-Studio's National Theater of Bahrain in Manama (2007–2012), overlooking the lagoon, the mix between the western-style glass box and the local technologies took shape in the flat canopy made of woven aluminum sheets supported by thin metal elements: it wraps around the structure and imitates the texture of the wicker roofs of traditional dwellings. The spaces of the auditorium and the stage emerge, unified in a single volume covered by gilded steel sheets, over the continuous canopy below. It is an elegant re-elaboration of the perfect expedient which, from the Enlightenment debate to the great nineteenth-century structures, assigned the task of revealing the building's function on the exterior primarily to the rooftop covering the auditorium, especially if it had the appearance of a large spherical dome.

This solution seems to have been cast aside in large-scale constructions, in favor of a continuous envelope that not only hides the various functional parts of the building—auditorium, fly tower, foyer, among others—but above all is meant to emphasize its impact, sometimes even egocentrically, on the urban context or countryside more than its recognizability as a performance venue. This affords the architect greater freedom in the overall definition of the forms, which increasingly assume a catalyzing and spectacular character. It is further confirmation of the fact that, more generally, architecture for the performing arts aims today to create a visual experience for the spectator even before the enjoyment of the event itself.

The Building Envelope

There is the single envelope, such as that of Paul Andreu's Oriental Art Center (2002–04) in Shanghai, whose five petals—the three largest of which contain an auditorium each, one of which is intended for opera—make up the whole in a unified form. This is alternated with systems divided into several separate envelopes, such as in Michael Wilford & Partners' Esplanade National Performing Arts Center (1992–2002) in Singapore, where the roof shells of the two auditoriums, with woven elements in aluminum and glass, here contained in separate volumes, combine to make up the iconic element of the complex and to highlight its primary role.

In the catalogue of the most frequently used shell forms—cocoon, flower, irregular polyhedra, to mention just a few—the adoption of one type or another is often explained in relation to the site.

At Guangzhou, for example, Zaha Hadid's vision of the Opera House (2003–2010) configured as two enormous pebbles can be traced to the architect's desire to reconnect with the image of the Pearl River, a natural element that marked the history and the shape of the city.

The natural metaphor is also taken up by Vittorio Gregotti, who described his Grand Théâtre de Provence (2003–07) in Aix-en-Provence as a hill in counterpoint to Cézanne's Mont Sainte-Victoire, which can be seen from the tree-lined belvedere created above the fly tower and "for which the volumes of the new theater become a sort of urban metaphor."

The belvedere is accessed by means of ramps and terraces climbing up from the round space of a pedestrian square situated below street level. The result is a structure connected on several levels and designed following a concept antithetical to that of an isolated architectural element.

In other cases, the inspiration derives from history: in Philadelphia, the vast roof of Rafael Viñoly's Kimmel Center for Performing Arts (1998–2001) was inspired by the glazed vaults of the great nineteenth-century exposition pavilions, a suggestion already proposed by Jean Nouvel in his exemplary modernization (1986–1993) of the Opéra de Lyon. This option not only is perfectly suited to contexts characterized by existing historic structures, such as the seventeenth-century town hall opposite the theater in Lyon, but the formal reference to the containers of the international fairs also proved to be an appropriate look for a contemporary performing arts venue without falling back on the usual stylistic features of the classical repertoire handed down by the nineteenth-century *zeitgeist*.

Quite another thing was the exuberant configuration of the reticular envelope, an abstract "golden mask," designed by Dominique Perrault for the enlargement of the Mariinsky Theater (2003 and 2009) in St. Petersburg, never realized. It highlighted the contrast with the forms of the existing nineteenth-century buildings and the context, while creating in the upper part of the structure observation points oriented towards the city and open round-the-clock to the general public.

Transparency and Permeability

Common to many of these creations is the transparency of the roof, emphasized by the night lighting that gives the architecture a catalyzing role in the perception of the city skyline. It is a transparency that often extends to the façades or involves the entire envelope, setting the spaces that surround or precede the auditoriums into relation with the exterior.

The most recent research into this theme has often led back to Mies van der Rohe's design for the Mannheim National Theater (1953), where two auditoriums with a "fan" layout face one another and are linked at the center by the shared facilities inside a large glazed "container."

More than two decades earlier, Walter Gropius had anticipated the dematerialization of the external envelope, albeit only in the part relative to the auditorium, in his Totaltheater (1927), conceived together with Stefan Sebok to host the new, highly technological mass events of the German stage director Erwin Piscator. Although both remained just on paper, there is no doubt that design professionals are still today fascinated by these two hypotheses, in part probably due to another aspect that consistently shows up in the most recent construc-

tions: the independence of the auditorium with respect to the envelope and the importance of the interstitial spaces between them, often a part of completely original projects.

Once the rigid separation into functional areas—still present in theaters of the late nineteenth century—declined, it was precisely in the fluidity conferred on the auxiliary spaces that already in the second half of the twentieth century new lines of research were explored. The main façade was often reduced to a simple transparent diaphragm that revealed the entrance areas to passersby.

Among the earliest concrete realizations of this plan, which certainly anticipated later orientations, was Werner Ruhnau's MiR in Gelsenkirchen, a building little known in architectural histories, but certainly futuristic for the time when it was inaugurated (1959). The broad glazed foyer, in its turn separated by a similar diaphragm from the service stairs to the auditorium, realizes the aims of the two great German masters of the Modern Movement. But the building is all the more interesting because it introduces the integration between architecture and contemporary visual arts: the reliefs by Robert Adams and Norbert Kricke respectively on the exterior walls of the box office and of the smaller auditorium, with, in the interstitial spaces, works by Jean Tinguely and Yves Klein, whose *Gelsenkirchner blau* monochromes are an integral part of the foyer space, and the external envelope of the larger auditorium designed by Paul Dierkes, all bear witness to a fortunate composition that seems also to have influenced creations of our own millennium, such as the contributions of artists Joep van Lieshout to the realization of the auditorium of Bolles+Wilson's Nieuwe Luxor Theater (1996–2001) in Rotterdam and Cecil Balmond to Toyo Ito's project in Taichung, discussed below.

Thus, you go to the theatre not only to attend a musical performance, but also to contemplate works of art: it is a subtle way to reconnect the observer to the idea of *Gesamtkunstwerk*, which opera has yearned for since its origins. The example of the MiR, moreover, seems to have had further developments, as documented by Gallery Met, the space for visual arts exhibitions active within the context of the Metropolitan Opera in New York, open even during performance intermissions, just to mention one of the best-known examples of art galleries within operatic institutions.

Some interesting experiments focused on opening the auditorium's hall towards a view of the city or of the landscape by literally eliminating the back wall of the musicians' podium or one of the sides of the audience seating. However, this line of research does not seem to have involved buildings for opera. In these, the need to completely enclose the stage has relegated the characteristic of permeability to the entrance façade or to the entire building envelope. Behind these, the foyer is often distributed over a few levels connected by stairways and well-defined walkways, replacing the concept of a monumental and representative enclosed space with that of an itinerary carried out on several levels that the public is invited to walk along, also during the intermissions. The ritual that over the centuries has traditionally accompanied the enjoyment of opera is thus not suppressed, but instead finds a more dynamic configuration in these vertical interior paths.

Moshe Safdie moves in this direction for his Kauffman Center for the Performing Arts in Kansas City (2000–2011) where three spaces, one of which is intended for opera,

are preceded by a gigantic wave-wall leading into the entrance foyer divided into curved balconies that recall the forms of the Guggenheim Museum in New York.

A monumental interpretation of the foyer, similarly accompanied by the transparency of the main façade, is instead offered by Jean-Marie Charpentier in his Grand Theatre (1998) in Shanghai. Here, the glass box with a square plan, topped by the vast curved roof, together suggest the symbols of the earth and the sky in the Chinese culture, and they allow a glimpse of the marble-clad interior space with pilotis, stairs and galleries symmetrically arranged, reinterpreting in a contemporary key the large entrance areas of nineteenth-century western theaters.

The adoption of the open plan for the system of entrances and foyers has posed the problem of their relationship with the space occupied by the auditorium since the post-Second World War period. Here, the widely used building envelope, suitable for concealing this volume from view on the exterior, is offset by the emphasis given to the passage areas through appropriate cladding, exalting their form. In Lyon, Nouvel chose a metal cladding that matches the materials used for the vertical connection systems, and he suspended the volume of the auditorium over the entrance level, creating a surprise effect for whoever enters, followed by the subsequent impact with the theater hall, clad in wood and dark leather.

Elsewhere, precious wood paneling on the exterior of the auditorium, in the foyer, heralds the use of the acoustic material par excellence in the theater interior, as in Oslo and Copenhagen and in many Asian examples, an expedient presumably inspired by the desire to repair the excessive contrast that in previous decades had characterized the widespread use of reinforced concrete in the connective spaces with respect to the better "acoustic" performance of materials used in the balconies inside the theater.

The Bond with Tradition

Two key design elements are still valid today, ones that are indeed at the origins of the so-called "teatro all'italiana": the floor plan, calibrated in its acoustic and visual effectiveness, and the relationship between the stage and the auditorium. On this last aspect, present-day debate seems not to have questioned the certainties of more than four hundred years of performances. The frontal arrangement with a strict separation between the two elements is still consistently upheld.

Architects seem to have met the challenges proposed by avant-garde theater of the second half of the twentieth century regarding possible interaction between artists and the public nearly exclusively in terms of the spaces for prose and experimentation. The thread linking several interesting achievements along this trajectory—from the pioneering Jerry Herman Ring Theatre (1951–53) at the Coral Gables campus of the University of Miami, by Robert M. Little and Marion I. Manley, to the most recent renovation of Erich Mendelsohn's Universum Cinema (1926), by Jürgen Sawade (1981), to mention only two of the many advances—can be identified in the flexibility of the auditorium, adapting to various arrangements. With the exception of the episode of Renzo Piano's well-known staging for Cacciari-Nono's *Prometeo* at the Venice Biennale (1983–84) and a few other cases with ephemeral connotations, these are in any event experiences extraneous to the world of opera, which, however, it is hoped

will show greater openness in the future to the possibilities offered to directors by these accomplishments of architectural design.

To this can be added the developments of philological performances, now no longer limited to the repertoire of the seventeenth and eighteenth centuries, leading to the orchestra seating according to the performance practices of the time and a careful definition of the proscenium, the most delicate detail in designing the opera space. These issues were meant to be addressed by endowing some elements of the proscenium with versatility, making the arrangement flexible, in terms of both the dimensions and the levels, along with the possibility, as in Dubai and at Arata Isozaki's Nara Centennial Hall (1991–99), of moving the roof, walls, and floor of the area intended for the public, allowing different configurations.

For the planimetric types, the desire to stick to tradition often invites a return to the "horseshoe" or "fan" arrangement that Gottfried Semper proposed again and again in his projects, later consecrated in the Wagnerian temple of Bayreuth, alternated with reworkings of "U"-shaped arrangements of baroque derivation as in the already-mentioned Lyon opera house.

Variations are offered by the interpenetration of several types derived from the past, as in the Teatro degli Arcimboldi in Milan (1996–97 project and 1999–2001 realization) by Vittorio Gregotti, where the "fan" arrangement, topped by two wide cantilevered balconies, is divided by a thick semi-circular wall in two sectors placed at different levels.

Elsewhere, the curve typical of the traditional Italian hall is renewed in the tectonic approach to the orchestra pit, in the materials and its expression. This can be seen in Nicosia at the KPF studio's National Theater of Cyprus (2003–2011), where a set of reinforced concrete ribs of varying shape is inserted on a "horseshoe" arrangement, defining the form of the hall, with wood paneling in the perimetral shell and in the areas with balustrades. On this solid framework rest continuous galleries, and at the last level, a light row of boxes, sloping down from the back towards the stage, used to house the lighting units for the shows. This solution recalls those with "stepped" boxes invented in the Emilian milieu in the seventeenth century and widely disseminated by the Galli Bibiena family, and reintroduced in the twentieth century in various interpretations, by Carlo Mollino in the reconstruction of the Teatro Regio di Torino (1965–73) and more recently by Nouvel in the renovation at the Lyon opera house, oft-mentioned here, and, finally, by Safdie in the Mauriel Kauffman Theater in the Kansas City complex, noted above.

The work of another great master of the Modern Movement, the Aalto Theater in Essen (1959–1988), with its broken outline and asymmetrical structure endowed with two continuous galleries and the pronounced jut of the semi-circular proscenium, seems to be a likely precursor to the most innovative research on the subject, further developed in original configurations of the auditorium's volume.

Hadid, for example, in her design for the Guangzhou opera, not only repeats the asymmetrical structure but takes the layout of the galleries to a further level, fragmenting them into various sectors, diversified in height, and unifying the whole with the roof and the outer walls, thus forming an image that has sculptural qualities, almost evoking a natural cave.

Precisely this last reference is deliberately invoked by Toyo Ito in the National Taichung Theater, Taiwan (2005–2016), for a complex conceived as a "sound cave." This image is

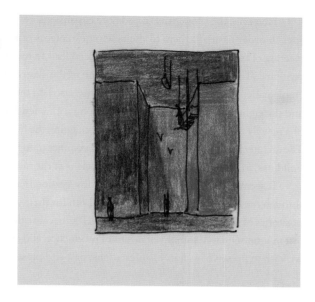

Richard Peduzzi, Search of ideas,
preparatory sketch in disorder,
Don Carlos of Verdi, February 2021
Ink and colored pencil on paper,
12 × 8.8 cm
Courtesy of the artist
© Richard Peduzzi

powerfully conveyed by the external volume and then, inside the building, by the passage areas all the way up to the large auditorium intended for opera performances, where the overhanging roof with a central opening and the corrugated walls imitating natural surfaces play a major part.

The similarity is even more tangible in the main hall at Harbin, where the elevation is characterized by large openings made in the walls concealing the galleries for the spectators and the lighting systems and extending to the roof that seems to gather together the entire vertical development, also thanks to the homogenous Manchurian ash cladding that extends to the flooring.

Beyond the individual linguistic variations, the suggestions coming from the Expressionist architecture of the twentieth century are not unrelated to these developments, and in particular Hans Poelzig's well-known projects for the demolished Grosse Schauspielhaus (1919) in Berlin and the Festspielhaus (1919–20) in Salzburg, never carried out, just as, more in general, the use of wood in the paneling, beyond the acoustic requirements, betrays the desire to return to nature.

Daniel Libeskind takes a different tack in the Bord Gáis Energy Theatre (2008–10), part of the large Grand Canal commercial complex in Dublin. Here, it is not so much the structure that is innovative, as the interior architecture of the auditorium cadenced on the long sides by tilted piers supporting galleries with brightly lit balustrades—elements in keeping with the architect's deconstructivist poetics—while large metallic roof panels perform the two-fold function of optimizing the acoustics and closing off the volume of the theater with a fragmented surface.

A Living Memory

In spite of all these experiments, which we hope will continue, it is clear that the architects have focused their attention more on the exterior form of the theater than on innovations to the auditorium, which, instead, is usually approached by drawing on solutions used in the past, or in any case consolidated ones, perhaps to meet the public's expectations.

However, the propensity to promote expansions and renovations for many historical sites in order to adapt them to the new requirements of the stage demonstrates that the meeting of tradition and innovation can indeed lead to results that are not necessarily conventional. The example of the modernization of the Teatro alla Scala in Milan (2001–04) is emblematic; conceived by Mario Botta, it was based on the conservation of the auditorium and the eighteenth-century outbuildings along with a few later additions, and the creation of a new fly tower and an elliptical annex containing the facilities for the theater personnel. The architect's idea was to graft the two new volumes onto the axes suggested by the existing buildings, in continuity with the original nucleus of the monument and later additions.

It seems fitting to conclude with the observation that the future of opera also passes through the re-use of historical structures, both for their value as cultural assets and as depositories of the memory of a tradition, as well as because they represent the living—and not just in-a-museum—testimony of means of production and enjoyment of a musical genre that we wish to preserve in all its manifestations, past and present.

[1] For further discussion of the themes and projects treated in this essay, see also: Denis Bablet, Jean Jacquot, Marcel Oddon (eds.), *Le lieu théâtral dans la société moderne* (Paris, Éditions du Centre Nationale de la Recherche Scientifique, 1963); Hannelore Schubert, *The Modern Theater. Architecture, Stage Design, Lighting* (London: Pall Mall Press, 1971); Gaelle Breton, *Théâtres* (Paris: Editions du Moniteur), 1989; Mario Pisani (ed.), *I luoghi dello spettacolo*, exhibition catalogue (Forlì, Galleria Comunale - Cesena, Galleria Comunale, October 12 - November 11, 1989) (Rome: Officina Edizioni, 1989); Mario Panizza, *Edifici per lo spettacolo* (Rome-Bari: Laterza, 1996); James Steele, *Theatre Builders* (London: Academy Editions, 1996); Sergio Rotondi, "La costruzione del teatro. Idee e problematiche dell'età moderna," in *Rassegna di Architettura e Urbanistica*, nos. 98/99/100, May 1999–April 2000, pp. 7-91; Leo Beranek, *Concert Halls and Opera Houses: Music, Acoustics and Architecture* (New York: Springer, 2004); Pierluigi Fiorentini, Giuseppe Nannerini, *Teatri e auditori* (Rome: Edilstampa, 2004); *GA Contemporary Architecture*, no. 4, 2006, special *Theater* issue, edited by Yukio Futagawa; Michael Hammond, *Performing Architecture. Opera Houses, Theatres and Concert Halls for the Twenty-First Century* (London-New York: Merrell Publishers, 2006); Marino Narpozzi, *Teatri: architetture 1980-2005* (Milan: Motta Architettura, 2006); Daniele Abbado, Antonio Calbi, Silvia Milesi (eds.), *Architettura & Teatro. Spazio, progetto e arti sceniche* (Milan: Il Saggiatore, 2007); Orietta Lanzarini, Alberto Muffato, *Teatri e luoghi per lo spettacolo* (Milan: Mondadori Electa, 2008); Mario Panizza, Viviana Gori, Francesco M. Mancini, *Edifici per la musica* (Rome: M.E. Architectural Book and Review, 2012); Denise Wendel-Poray, *Painting the Stage. Artists as Stage Designers* (Milan: Skira, 2018); Charlie QiuliXue (ed.), *Grand Theater Urbanism. Chinese Cities in the 21st Century* (Singapore: Springer Nature, 2019); George C. Izenour, *Theater Design* (New York: McGraw Hill: 1977); Richard and Helen Leacroft, *Theatre and Playhouse. An Illustrated Survey of the Theatre Building from Ancient Greece to the Present Day* (London-New York: Methuen, 1984).

Graduate in Architecture and PhD in History of Architecture at the University of Naples Federico II, Pier Luigi Ciapparelli has published on specialized magazines such as *L'Architettura cronache e storia, La Nuova Città, Il disegno di architettura, Napoli Nobilissima*. He is full professor in History of Theatrical Architecture, History of Architecture and Elements of Architecture and City Planning at the Academy of Fine Arts of Naples.

WERNER RUHNAU'S THEATER IN GELSENKIRCHEN — A PLACE OF DEMOCRACY

Axel Fuhrmann

The Musiktheater im Revier in Gelsenkirchen, Germany, opened in 1959. One of the most remarkable new opera buildings of the postwar period, it owes its aesthetic beauty to the consummate coherence of architecture, visual arts, and urban environment. A gigantic glass front separates the inside from the outside. Transparent from both sides, like a permeable cell membrane, it ensures that city and opera house, society and art become one, are able to meld with each other. Coming from the city, the viewer looks into the interior of the two foyers. From the inside, one looks out on the city. Yves Klein's large murals—the largest ever created by the French artist—grace the walls of the upper foyer, suffusing it with an inimitably radiant blue. The stairways to the balconies, which are visible from the outside through the glass façade, soar up a white, curved wall that encloses the auditorium.

Designed by architect Werner Ruhnau, this music theater building remains visionary to this day, its defining theme being the democratization of theater on the basis of the Attic democratic model. To this end, it aims to overcome the conventional separation of auditorium and stage, of outside and inside, of social and cultural experience. Ruhnau's edifice is both a monument and a memorial. It recalls the increasing democratization of opera, which began in Germany in 1870/1871 with a war, was stifled under the Nazis, and completed after the Second World War in a liberal democracy.

The middle classes and opera entered into a special relationship at the end of the nineteenth century. The victory of German over French troops in the Franco-Prussian War of 1871 injected enormous reparations payments into the German Empire, triggering un-dreamt-of economic growth and a tremendous building boom. Between 1871 and 1915, opera houses were built in a number of major cities—Frankfurt, Cologne, Düsseldorf, Ham-burg, Hanover, Nuremberg, Essen, and many others—with civic commitment and co-financ-ing from big industrialists. While the opera house was previously a lieu of the nobility, it now became that of the burghers. Its magnificent façades and foyers are becoming prestigious symbolic spaces reflecting the growing self-confidence of the bourgeoisie and its identification with urban culture.

After the First World War, German opera houses initially flourished again, became vibrant arenas of experimentation for the arts that now thrived freely and vigorously but soon fell victim to the greatest global economic crisis of the twentieth century. And after the National Socialists seized power in 1933, they became propaganda institutions controlled by

Joseph Goebbels' ministry. In 1945, after the bombing raids of the Second World War, the music and theater buildings lay in ruins.

It was only after the establishment of parliamentary democracy and with the onset of the "economic miracle" that opera houses were built again in Germany. Outstanding opera houses were created in Mannheim, where Mies van der Rohe had also submitted a design, in Essen, on the basis of a design by Finnish architect Alvar Aalto, and in Gelsenkirchen. The economic status of all social strata had improved, including that of workers. Now, in an education and school system that was equally accessible to all, they and their children also had access to cultural and musical education and demanded cultural participation.

No other new opera building of the postwar period is so clearly a manifestation of the democratization of society and its participation in opera culture as the one that is situated in the working-class town of Gelsenkirchen in the Ruhr region, which was shaped by coal and the mining industry. It is safe to assume that nowhere else in Germany the identification of all sections of the population with *their* music theater, its artists, and productions is as strong as it is here to this day.

With his opera, operetta, and musical theater building, which was open and permeable both from the inside and outside, architect Werner Ruhnau created in Gelsenkirchen in the 1950s what stands, in hindsight, as a monument to the democratization of the aesthetic experience of opera. As a work of art, opera itself refers to socially relevant content and presents it to society in the form of text, music, and staged interpretation, so that society can engage in a discourse and debate about it. In the same vein, Werner Ruhnau created a place of democracy with his architecture, which expresses precisely the following: it opens itself as an architectural work of art to society and, on the other hand, invites society through its open glass front to engage with the music and the theater, including its statements, interpretations, and opinions.

The *Gesamtkunstwerk* of the opera—consisting of architecture, visual arts, literature, and music, of the kind Richard Wagner once conceived as the "opera of the future"—is a mirror of society, charged with its spirit, values, hardships, conflicts, emotions, desires, traditions, and visions. All the creative professionals involved in producing opera in the form of a *Gesamtkunstwerk*, all the librettists, composers, stage designers, directors, singer-performers, and musicians together formulate, free in their opinions, with each opera production a thesis they contribute, as part of a liberal democratic discourse, to critical debates on contemporary issues.

With a transparent architecture that almost compels artistic and democratic discourse in society, the Musiktheater im Revier is a symbol of freedom of expression. However, opera can only express opinions freely, be creative, or critical of society, and appeal to one and all when it operates in a society that can call itself humanist, free, and democratic. As soon as dictators or nationalist, totalitarian systems exert influence on opera, its management echelons, and/or artistic decision makers, opera will have no future. And future means free interpretation of a freely chosen repertoire, free selection of narrative material and compositional style, as well as aesthetic freedom when it comes to the design of costumes, props, lighting, and space.

The future of opera will depend on society and the constitution it fights for, on its education, its culture of debate, as well as the state of its political and economic foundations. Only a democracy that is aware of, and defends, its values and humanist ideals can provide the environment opera needs to continue to thrive and develop freely.

After studies in musicology, linguistics, and marketing, Axel Fuhrmann started a career in media, joining SR Fernsehen Südwest as director and producer of music documentaries in 1993. Today, he heads DokFabrik in Bielefeld producing music documentaries for ARD, ZDF, ARTE, and international broadcasters, filming artists such as Diana Damrau, Daniel Barenboim, Jonas Kaufmann, and many others.

MUSIC AND ARCHITECTURE—OPERA AND STAGE DESIGN

Stephan Braunfels

I never understood the famous dictum that "architecture is frozen music." As an architect who dithered in his youth over whether to become a musician, a pianist, or a conductor, I became so deeply immersed in both architecture and music that I developed an ever better sense and understanding of the fact that architecture is *architecture*, and music is *music*.

One thing, however, has always connected architecture and music: measure and number as the basis of beauty. Third, fifth, fourth, octave—the ratios 1:3, 1:4, and 1:5 as well as 1:1, 1:2, or 1:8 not only create pleasant sounds in music but aesthetic proportions in architecture, too. My fascination with these simple, clear relationships has grown more and more, because they are not only "tangible"— that is, visible and audible—but also strikingly beautiful. As long as these ratios were expressed in human measurements, such as feet or cubits, which is to say, before the introduction of the meter at the end of the eighteenth century, architecture was always "well-proportioned." A window or door measuring 3 × 5 or 4 × 8 feet is better proportioned, more beautiful, and better than a window measuring 0.95 × 1.65 meters or a door measuring 1 × 2.10 meters.

Losing the "human scale" in the nineteenth century was just as painful for architecture as the abandonment of tonality in the twentieth century was for music. Now, music doesn't have to sound "beautiful" to ring "true"—but are ugly buildings more "true" than beautiful architecture? Pure sound and beautiful proportions have a lot in common. That's why during the Renaissance, which is arguably the "most beautiful" period in the history of architecture, the theory of proportions used in building design was derived from music. What sounds good in music—third, fourth, fifth, octave—also had to produce the best proportions in architecture.

I guess it was always just the image of "frozen" music that irritated me. Perhaps it's better to put it this way: architecture is embodied music, built music, music that has taken on form. The fact that my buildings are considered "well-proportioned" is surely owed to my preference for rational, recognizable proportions—1:1, 1:2, 2:3, and 3:4, that is to say, musical ratios. Giving it clarity and openness, making it perceptible and comprehensible, these are essential prerequisites for beauty to become a conscious experience.

My great love for the opera added another deep connection to music, and in my old age I have had the privilege to create several stage sets. As an architect, I wanted to create clear, minimalist architectural spaces on stage that represented not only the places and the

action, but also the music of an opera. Like Adolphe Appia more than a hundred years ago or Wieland Wagner over fifty years ago—the two great innovators of stage design—I didn't want to create "decoration," or symbolist "images," but architectural spaces reduced to the basics, which capture and spatially represent the content and music of the respective opera. And spaces that put those performing the story, the people on stage, at the center of the opera. This is also true for acoustics, as good stage sets need to support and strengthen the singers' voices, and must not drown them out or let them fade away.

The first stage design I got the chance to do was for *Lohengrin* by Richard Wagner. In 2006, it was the first in-house production of the Baden-Baden Festival, co-produced with La Scala in Milan and Lyon Opera (a DVD was released by arthaus). Already the famous beginning of the overture, where the Lohengrin motif that runs through the entire opera emerges from unreal high string passages, inspired me to create an architectural image. Transforming again and again, it marked the beginning and end of the opera. In the first act, a semicircular amphitheater rises from a bright mist where the Brabant court sits in judgment on Elsa—until Lohengrin appears in a dazzling beam of light, which symbolizes the swan, and rescues her.

At the moment when Elsa asks the "forbidden" question in the third act, the—deliberately unreal and abstract—bridal chamber abruptly changes back into the court arena, from where, following his Grail narration, Lohengrin vanishes again into the swan's beam of light. Upon Elsa's pleas for rescue, the back wall suddenly begins to burst open and a slowly widening, ever more glaring strip of light shines through, blinding everyone in the room—including the audience. The appearance of the "swan" that guides Lohengrin from the beyond of the Castle of the Grail to this evil world is thus depicted as a "miracle" that overwhelms and enthralls the court. Here, I took inspiration from Barnett Newman's "zip" and James Turrell's magic lighting effects.

As an architect, I've always been intrigued by the mysterious line from Wagner's last opera, "You see, my son, time here becomes space," which Gurnemanz, keeper of the Holy Grail, says to "pure fool" Parsifal—who goes on to become Lohengrin's Father. As Lohengrin appears in the light beam of the swan, it very gradually grows wider until it encompasses the entire courtly arena, so that upon Lohengrin's miraculous arrival time and space seem to merge into one.

My fascination with the art of capturing the entire mystery of an opera in a stage set goes all the way back to my school days. I only knew Adolphe Appia's and Wieland Wagner's stage designs from books and pictures. But to me they have always appeared more contemporary—due to their being more timeless—when compared to most of the scenery we see today. I grew up in Munich with the sets of Jürgen Rose, who succeeded time after time in creating scenic designs that in themselves already depicted the content of a play or an opera—often in the form of a minimalist unitary set.

In Act II of *Lohengrin*, I chose a different image: a vast, never-ending staircase that was intended to represent the stairway leading to the happiness that Lohengrin and Elsa will never attain. Giant staircases have always caught my imagination, and they have also become a bit of a trademark of my architecture. And so it was my wide outside staircase leading up to the

library of the German Bundestag on the banks of the Spree River in Berlin that prompted renowned opera director Nikolaus Lehnhoff to choose me for the sets of his last, the "ultimate," production of Lohengrin. As a young director, Lehnhoff had been Wieland Wagner's assistant in Bayreuth—I had come full circle in wonderful way.

I have always been fascinated by steps and terraced surfaces, and that has a lot to do with music. It is closely related to the visualization of differences in height or spatial depths through steps and terracing as well as to the use of crescendi, sforzati, and Baroque-era "terrace dynamics" so as to render the development of sound perceptible. Architecture "stands," music moves and "takes time"—with stairs and terraces, architecture, too, is infused with dynamics and movement. Thus, "space" that represents "time" takes shape in architecture, and on the stage.

For my second stage design, at the Deutsche Oper am Rhein, I was invited to choose the opera—it could only be *Fidelio*! Beethoven was the first composer I consciously listened to during my childhood; the *Seventh Symphony* and his *Eroica*, the Piano Concertos No. 4 and No. 5, Wilhelm Furtwängler, Artur Schnabel, and Edwin Fischer shaped my musical worldview.

With the very first scene of *Fidelio* I again wanted to create an image that put the whole opera in a nutshell; I wanted to reconcile the contrast between the seemingly cheerful singspiel of the first act with the brilliantly composed opera in the harrowing dungeon world of the magnificent second act. And so, from the start everything was set in a prison, which brought entirely different depth and meaning to even the light arias, duets, and tercets at the beginning of the opera. Together with director Amélie Niermeyer, we also decided to integrate parts of Leonore, the original version of *Fidelio*. Leonore's "betrayal" of Marzelline now gave more weight to the first act, which Beethoven had smoothed out in the final version.

The "family quarrels" Rocco has to deal with take on an entirely different weight when the constant knocking of the prisoners is not just audible but also visible, when the listener can see Leonore's captive husband, Florestan, during her great aria, in which she expresses her remorse for the love she feigned for Marzelline—and which was scrapped in later versions of the opera. That's why from the very beginning of our *Fidelio* production, everything takes place against the backdrop of all the prisoners behind bars.

Creating a stage set to make the music sound different—more essential and profound—to me that seemed, and still seems, to be a great approach to making opera more deeply evocative for musical people, and at least engrossing for the unmusical crowd. Listening to the famous "Chorus of the Hebrew Slaves" and *seeing* the chains and bars slowly open before the prisoners emerge from their dark dungeons into the sunlight, that greatly enhances the effect of one of the most stirring choruses in all of opera history. This is how stage architecture can actually become music: the architecture where this music is played changes and heightens its message.

Performances in ancient ruins such as the Baths of Caracalla in Rome or the Verona Arena are known to inspire more excitement and enthusiasm than those in city theaters. However, inside of traditional opera houses—where the acoustics are vastly superior to

those of the more popular open-air theaters—clever stage design can render an opera more impactful by greatly amplifying the effect of music and giving depth to content on multiple levels. Marzelline's aria, one of the most beautiful in *Fidelio*, takes on a completely different meaning when sung on a precipice instead of in the kitchen.

My third stage design was for an early opera by my grandfather Walter Braunfels, an eminent late Romantic-era composer. He was one of the most frequently performed composers in Germany in the 1920s, along with Richard Strauss, but was banned by the Nazis in 1933 for being a "half-Jew." His Protestant revolutionary opera *Ulenspiegel* was unearthed a hundred years after its premiere and played at the wonderful Gera opera house—probably the only opera house in Germany that also hosts a concert hall. My grandfather had discarded and then forgotten this work after his conversion to Catholicism and the world success of his opera *Die Vögel*. Beautiful as my radically minimalist stage designs were—they were conceived entirely in the style of Adolphe Appia and Jürgen Rose—a production at the Brucknerfest in Linz, Austria, which followed shortly thereafter, did far better justice to this stirring opera because it was set in an old factory hall. The famous Linz tobacco factory by Peter Behrens provided an ideal setting for a plot depicting the uprising of Flemish irregular troops against the usurpation of Charles V—you felt as if you were witnessing firsthand the war in Eastern Ukraine. The whole room became the stage, the singers/actors were within arm's reach, the audience in the midst of a theater of war. It made me realize all over again that old factory halls can not only be turned into the most impressive art exhibition and museum spaces, but also into the most fascinating opera houses.

Opera productions in old factory halls usually have no stage scenery—the oftentimes huge, darkened room serves as both stage and set. Nowadays, acoustic deficiencies can be compensated almost imperceptibly by modern electronic reverberation technology. And it is not only war operas that remain unforgettable to me—ones like *Ulenspiegel* or *Die Soldaten*, the magnificent production shown, as part of the Ruhrtriennale, at the Jahrhunderthalle in Bochum where the auditorium was moved back and forth along a very long central stage area. The staging of Mozart operas, too, can be even more thrilling in old factory halls than in conventional opera houses with their peep-box stages.

The most striking and memorable *Don Giovanni* production I have experienced played at an old, abandoned electric power station in Berlin—*experienced* because even, or especially, with Mozart, the music one has heard a thousand times sounds new and contemporary in "wild" spaces. What's more, the team behind this Berlin production had come up with a highly original solution to the old controversy over whether it would perhaps be better to present operas in the language of the country they are performed in so as to make them more audience-friendly. The "lower classes"—Leporello, Zerlina, and Masetto—sang in German; the "nobility"—Donna Anna, Donna Elvira and the Commendatore—in Italian. Don Giovanni switched between languages, depending on who he was talking or singing to. It was delightful!

In spite of my enthusiasm for transforming old factories, electric power plants, or streetcar depots into grandiose exhibition or opera halls, I would also love to *build* an opera house

and a concert hall. Ever since Scharoun designed the Berliner Philharmonie sixty years ago, concert halls have presented us with the big question: "vineyard" or "shoe box"? For hundreds of years, the orchestra sat facing the audience, and it was Scharoun who finally created a wholly new type of concert hall with his "Zirkus Karajani" which opened in 1963, where the audience is gathered in close proximity to the orchestra on vineyard-like terraces rising around it on all sides.

The advantage of this solution is that all members of the audience are close to the action and get a wonderful view of the musicians and the conductor. The downside is that the acoustics are different in all the seats—behind the orchestra it's even pretty bad. That is why the classical form of the concert hall is considered by many to be the (far) better solution. Known in the trade as a "shoe box," it has the shape of an elongated rectangle and often includes narrow side galleries. When it comes to acoustics, it is vastly superior to the "vineyard" style hall.

Nevertheless, Scharoun's innovation has been copied hundreds of times around the world. That is, until the concept was taken a bit too far with the Elbphilharmonie in Hamburg. The hyperdeveloped acoustics of the fancy funnel-shaped hall are "sensational" only for inexperienced listeners—for connoisseurs of sound it is unbearably garish, which has led to a rebound in popularity of the "shoebox" model. Orchestras have always favored the classic rectangular-shaped halls. Especially since they have seen continuous improvement in recent decades—with ascending parterre, slightly rounded corners and openings as well as reverberance chambers with operable doors in walls and ceilings. In terms of acoustics, the most excellent example is the concert hall in Lucerne.

Between "shoebox" and "vineyard" there is also a hybrid form that is the secret favorite among the cognoscenti. At the Leipzig Gewandhaus, the orchestra sits facing the audience, but the audience is spread out across steeply sloping, terraced seating areas. This hybrid form has been adopted almost to a tee by some of the world's best concert halls, such as the famous Suntory Hall in Tokyo.

In addition to acoustics, opera houses are also supposed to provide as many visitors as possible with the best possible view. That's also the reason why the most modern and outwardly crazy opera houses built in recent decades—from Utzon's Sydney Opera House to Calatrava's opera houses in Valencia or Tenerife—are on the inside conventional tiered theaters with a classic horseshoe layout. The most renowned and most frequently "copied" model in the world is the Semperoper in Dresden. Be it in Glyndebourne, Oslo, or Copenhagen, the interiors of all the new opera temples—including the new Mariinsky Theater in St. Petersburg—exactly follow the soft, somewhat broader horseshoe layout of Gottfried Semper's Dresden design.

It was also Semper who, after his Dresden opera house, developed a new, downright revolutionary form of opera theater. For a Wagner festival theater in Munich, he designed a "theater without tiers" with an amphitheatrically widening, steeply sloped parterre, so that one could see the stage equally well from every seat, never having to twist sideways. Furthermore, the acoustics were greatly improved compared to the tiered theaters with their closed

boxes. Unfortunately, the Wagner Festival Theater in Munich was never built. But Semper's idea was realized by Wagner in Bayreuth and subsequently, in a scaled-down version, in Munich's Prinzregententheater, as well. Aside from the "classic" Semperoper in Dresden, to my mind the latter is one of the two best opera houses in the world. Semper's amphitheater was further developed by modernist architects; for example, Bauhaus architect Walter Gropius created a type of theater where the audience was seated in an ascending oval auditorium, in the laterally offset center of which the circular stage could also rotate.

Christoph Schlingensief came up with an even more fantastic idea. For his "African opera house" in the opera village he was planning in Burkina Faso, he asked me to draw up a design where the audience was seated in the middle of a circular, "endless" stage running around a circular auditorium that was supposed to be able to rotate. Sadly, Schlingensief passed away shortly thereafter, and his intriguing concept remained a vision.

A stage forming a panorama that runs around the audience, where the musical action can move around the auditorium, and the audience, seated at the center of the surrounding stage, can turn to watch the opera scenes—so far, such an opera house has never been built. Music and architecture, time and space—Schlingensief's visionary "Opera for Africa" could solve Richard Wagner's enigma of "Time here becomes space" by letting architecture become music and music become architecture.

German architect, Stephan Braunfels' first and most famous project is Munich's Pinakothek der Moderne which opened in 2002 and is one of the largest new museums in Germany. He designed sets for a production of *Lohengrin* in Baden-Baden in 2006.

THE AMBIVALENCE
OF MODERNITY

Daniel Libeskind

The ambivalence of the music is part of the ambivalence of modernity. *Tristan und Isolde* is mysterious, intriguing, and full of life. It talks about subjects that have to do with life in general: Death, Light, and Darkness. The ambivalence of Wagner's creation is palpable in the musical structure, which involves transposition and the use of diminished chords. The famous "Tristan chord," which opens the first act, moves away from traditional tonal harmony toward tonal ambiguity and atonality.

The music of Wagner is still contemporary and reflects the issues of our society today. We live in a time of ambivalence where there is a whole spectrum of different kinds of expectations, which do not add up; there is a lack of unity. In his book, *Modernity and Ambivalence*, the philosopher Zygmunt Bauman talks about how modern civilization promised to make our lives understandable and under our control—this has not happened, and we have lost faith that it ever will. However, he sees our postmodern age as the time for reconciliation with ambivalence and encourages us to learn how to live in an irredeemably ambiguous world. With this idea in mind, the mystery and complexity we have in opera are more crucial than ever to delve into and experience.

Therefore, Wagner is not the end of the phenomenon, but only the beginning, and his ambivalence continues to haunt the contemporary art scene as much as it haunted it in the nineteenth century. It was fascinating for me to create the sets for *Tristan* because they were based on the idea of continuity and dis-continuity and the mythology of completion, which is not a completion. My set design does not deal with the narrative, the symbolic or the psychological, but with the music itself, with its structure, which is of course based on the structure of Wagner's libretto. The musical space contains the story. The set is not always abstract, and the music is not always abstract either; on the contrary, it's often figurative. Music deals with transformation, in other words—not with metaphors but with metamorphosis. Any design that begins with the music has to confront the music, and not just be nice formal sets with good lighting.

When I did the sets for *Saint François d'Assise*, I was not surprised to discover that Olivier Messiaen's inspiration was Wagner, given the many similarities, such as the vast proportions of the work or how Messiaen's idea-and-character themes function like the Wagnerian leitmotif. Like Wagner, Messiaen wrote his own libretto, which functioned as a literal blueprint for the music. There was affinity but also ambiguity when you consider that Messiaen had

been imprisoned by the Nazis, that Wagner's music and writings were strongly associated with the Third Reich, and that even today Wagner is *persona non grata* in many parts of the world—this did not stop Messiaen from being inspired by it. So we have to distinguish these harmful political ideologies from the music itself. Of course, Wagner was a bigot, a hater, and an anti-Semite; however, we have to look at the music separately because it's an independent work that's not connected to the rhetoric of words.

However, this does not mean that we should erase the biography of the creator from his artwork. Anyone who delves into Wagner's writings and philosophy of revolution will see how he then turned that revolution against all sorts of minorities. Knowing this and its origins and its aims will inevitably influence how one hears Wagner's music and its aesthetic impact.

Even in architecture, Le Corbusier, who worked for the Vichy government, and an admirer of dictators, this is perceptible in the work, and you cannot ignore it; you cannot separate his beautiful work from his ideas. His ideology is palpable in his work; his desire to efface all of Paris's history and create a new city, for example.

There was an ambivalent relationship between modernism as a concept and fascism. If you look at brutalist, fascist, and modernist architecture, there is a clear relationship. Therefore, you can admire the works but with the knowledge of what motivated them.

The Architect as Composer

I believe one should create architecture like music, communicating through emotion directly into the soul. Like music, architecture is both concrete and elusive. In both fields, the "composition" is played out through space and time. Schönberg's unfinished opera *Moses und Aron*, composed in 1932, served as an inspiration—a literal one—for the Jewish Museum in Berlin. What I designed was mathematically very close to Schönberg's use of twelve-tone technique. Hence, the music isn't only a metaphor or a verbal concept; it's a structural feature of the building, measurable in its proportions, in the void, and the acoustics of the void. One can hear fragments of silence following the echoes on the visitor's footsteps; these are part of my response to Schönberg's incomplete opera. The museum also generates its own unexpected musical resonance through the specific acoustical conditions inherent in the different spaces: the Holocaust Tower, the Memory Void, and the Sackler Staircase. There is a para-architectural method, which is based on Schönberg's music, inscribed onto the building.

Opera as a Living Archive for All

Classical music and opera are like a living archive of our shared history and memory. Opera is a huge work of art and has an incredible impact on our society and continues to do so. It is a living archive containing traces from the past, which cannot be erased and unexpectedly create spurs into the future. A living archive with unexpected revelations in it, which were perhaps not apparent to previous generations, but that today's generation is attuned to. This is why we have to bridge the gap and bring future generations into the opera house.

With the Bord Gáis Energy Theatre on the Dublin Docklands, which I completed in 2010, I tried to change the bourgeois paradigm of the opera house with the massive chande-

liers and gigantic lobbies and spaces, which don't make sense in the contemporary world. I wanted to create a secular way to enter the opera house, which didn't contain this hierarchical notion of here is where the elite goes to listen to music and the feeling that kids and other people are not welcome inside.

Reducing the lavishness, of course, had a huge impact economically, and in the end, I was able to build the opera for 10 percent of what most opera houses cost. I think it's essential that opera shed its elitist image of being for the privileged few and become what it was intended to be—a work of art for a mass public. My parents were factory workers in New York; they had to save up money to buy tickets for the New York City Opera. They were true opera lovers!

This inequality today, income inequality, more and more worldwide, is why we need to create a space for opera and make it accessible and transparent in ways that get rid of this opacity of power, which was established to propel a single economic and cultural group. We cannot rebuild all of the great nineteenth-century opera houses based on this hierarchical model; however, we can find ways to open them up. For example, when I designed the exhibition *Berlin-Moscow/Moscow-Berlin 1950–2000* at the Martin Gropius Bau in 1993, I created a structure outside to signal to the people that the exhibition was stretching beyond the traditional boundaries of the museum. There was also a compelling piece inside the museum consisting of two gigantic wedges inserted into the museum's central atrium. The exhibition dealt with the artistic kinship between Berlin and Moscow throughout the first half of the twentieth century; this piece represented the resistance, social struggle, and creative impulse against the injustice and barbarism of the times. The open space between the wedges provided an area for gathering and events associated with the exhibition.

At the moment, I'm preparing an installation in Moscow and Dresden for the exhibition *Dreams of Freedom* dedicated to Romantic paintings from the State Tretyakov Gallery and the Albertinum. The exhibition combines German painters such as Caspar David Friedrich, Carl Gustav Carus and their contemporaries in Russian, such as Alexei Venetsianov and Alexander Andreyevich Ivanov. Romanticism was a time of radical change, and it's fascinating to compare these corresponding groups in a context where traditional boundaries were breaking down, and the liberal ideas of the French Revolution were spreading throughout the continent. In reaction to this, conservative governments in Russia and the German states sought to limit civil rights and impose censorship on art.

Similarly, as with the Martin Gropius Bau exhibition, I'm trying to build something to communicate to the people inside and outside of the museums in Moscow and Dresden that things have changed. With *Dreams of Freedom*, we are spreading the idea of freedom as an ongoing struggle, and it's especially important that this be heard in countries that don't have it. Likewise, in the opera, my view is that you have to use every means available to signal to the public that it's no longer this black box of illusion, but that opera has a relevance out there in today's world whether it was written in the seventeenth or the twenty-first century. I would love to work again on a new opera or on a great classic, which could have urgency if interpreted in a certain way, to get it out of that closet of forgotten dreams and transformed

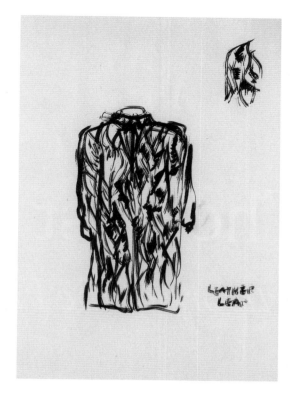

Daniel Libeskind,
Leather Leaf, 2001
Ink on paper, 30 × 20.5 cm
Costume design for *Tristan und Isolde*, Richard Wagner, Saarbrücken State Opera, 2001. Costume and stage design Daniel Libeskind
Courtesy Studio Libeskind

into something that would inspire people. Operatic works were written to inspire, they were wonders when first performed, and they can still inspire today. Many great operas are seldom performed. I think there are many ways to show the magnetism, the complexity, the ambiguity, the magic of the stage, the magic of opera as something which is in the present tense and urgent in our lives.

This text is the summary of a conversation with Denise Wendel-Poray, February 25, 2020

Daniel Libeskind is a German, Polish-American architect, artist, professor, and set designer. He is known for the design and completion of the Jewish Museum in Berlin, Germany, which opened in 2001. On February 27, 2003, he won the competition to be the master plan architect for the reconstruction of the World Trade Center site in Lower Manhattan.

The Last Days

Artwork of the Future

THE CHANGES WE NEED TO MAKE TO SECURE THE FUTURE OF OPERA

Katie Mitchell

There's a problem with opera. And that problem is that its workforce—on its stages, in its orchestra pits, backstage, and in its administrative offices—does not reflect a diverse and inclusive society; neither do the stories from its core repertoire (or the way in which they are predominantly staged) reflect or speak to this diverse and inclusive society. No surprise then that the majority of people who watch opera come almost entirely from a narrow white demographic.

This problem is at the heart of any conversation about the future and durability of opera.

I love the art form with its unique synergy between music and drama, and I've had some of my best directing experiences ever working in opera. But I don't like how it sometimes makes me feel as a woman, let alone as part of a diverse society. It just feels old fashioned, out of date and completely out of touch. And it's not just that it feels like this to me (as a free-lancer moving in and out of opera organizations); it's that many people working full time in the sector are perfectly happy with the status quo and don't understand that the way they are thinking and what they are making is out of touch with so much of the society around them.

If you talk with a young person today from an East Asian background about Puccini's *Madama Butterfly*, it's impossible to defend the fact that mainly white women play the role of Cio-Cio-San (something entirely unacceptable in any other art form). Or if you are teaching a group of young secondary school children, there's no way to explain away the misogyny in the libretto of Mozart's *Così fan tutte*. The old argument often rolled out by senior opera practitioners about the beauty of the music somehow mitigating the racism or misogyny in the librettos just won't wash with the young.

I was recently involved in a Q &A session in Munich with some teenagers who had just read the libretto of Bartók's *Bluebeard's Castle*. A bespectacled young boy spoke up fiercely about the gender politics of the story (where a young woman ends up being incarcerated), saying, "It's just not possible to tell this story today, it's just wrong and it shouldn't be told," and all the other children in the group clapped in response.

It's not only the original content that frustrates the young; it's the way that gender or racial stereotypes get rolled out in the interpretations of the material. I remember watching a recent dress rehearsal of *Carmen* where there were two singers of color in the chorus. One of them was selected to perform a sexualized dance sequence, which was quite clearly play-

ing into old-fashioned and offensive stereotypes of exoticism and fetishization about men of color. It left me squirming in my seat with embarrassment. In another example, a white male director recently added in a gang rape to *William Tell* without any thought as to how this would affect (or trigger) a totally unprepared audience or how inappropriate it was for him to stage it in the first place given his gender. I'm not saying that men cannot stage female experience and vice versa; I'm just saying that if men are going to stage rape (particularly if they are adding it into a libretto where it does not exist), they need to be sensitive to the fact that one in three women have been raped.

Of course, as a white heterosexual woman, I am not best placed to articulate the perspective or outlook of different identity groups, like the ethnically diverse or people with disabilities or the LGBTQI (Lesbian, Gay, Bi-sexual, Trans, Queer or Intersex) communities, but I can speak from the point of view of what it's like to be a woman working in opera. I can tell you about low-level sexism, like being asked daily by a rehearsal room pianist, "Are you a happy girl now?" or how it feels when you are sacked by an opera house for "not liking the opera enough" after presenting a feminist deconstruction of *Così fan tutte*. Or about a meeting with a German opera dramaturg who, when I asked about his opera house's code of conduct on sexism, was keen to tell me that there was no sexism in his opera house and, indeed, as far as equality was concerned, he had also "talked to a lot of women," and they had told him that women "did not want power"; it just wasn't something that interested them.

These are just some—sadly—of hundreds of examples. The thing that strikes me again and again is how unconscious these biases about gender or race or disability are and how the larger opera community absorbs these views into their ranks instead of calling the individuals to account for their views and stepping through a proper HR procedure. For me, it's just a daily annoyance of having to spend time cutting through layers of sexism so that I can just get on with my job. And I'm sure my experiences would chime with people from other intersections of marginalized or underrepresented groups in terms of any discrimination those groups may face in the workplace.

Inclusion is not only about race, gender, and sexuality; it also intersects with the question of class and social background. In the United Kingdom, for example, opera is dominated by Oxbridge choral scholars and middle-class music graduates, many of whom have economic support from their parents. There are, of course, many scholarships available at a training level for people from poorer backgrounds and in the opera houses themselves, but this is just a drop in the ocean when it comes to opening up the field to a wider social and economic demographic.

The lack of representation of certain social groups in opera is not only an issue when it comes to the way the opera industry is staffed; it's also reflected in the way the stories in the operas are told on stage, where the audience is likely to see a more middle-class version of a working-class reality because they are performed and directed predominately by middle-class people. Many productions of operas like *Carmen* or *La bohème* set in poorer communities are full of performance clichés reflecting the unconscious class bias of the people making them. And the performances would not stand up to scrutiny from sections of the communities

experiencing the levels of poverty or breadline wages the characters describe. In writing this, I'm taking into account the fact that the operas are set in different times to our own. I'm also not calling for opera staging and acting to have a documentary lifelikeness; it's more a question of absorbing into the art form the perspective and experience of a wider cross-section of the society we are living in.

The second major challenge for the future of the art form is the particular nature of the limited repertoire, where a relatively small number of titles are repeated over and over again across all the opera houses of the world. All of these operas are historical and pose very particular challenges when it comes to staging them today.

When you pull these historical operas through time and re-plant them in our time period, you not only pull through the beautiful musical branches and leaves, you also drag in the dirty roots of the gender politics or racism of the time the operas were written in. And if you do not deal with this root toxicity by addressing how the material is cast or staged then, it can look like you are condoning the original racism, misogyny, or disablism. It's just not enough to suggest that we all live in an inclusive and diverse time and expect the audience watching these old cultural artifacts to pick their way thoughtfully through them and carefully separate out what is proper and what is not by modern-day standards. No, we the artists have to take the lead and address the toxicity thoughtfully in the production concept, the staging, and the casting.

With this in mind, we also have to reflect on the fact that operas are mainly staged by white men who aren't necessarily the right people to lead this crucial and thoughtful re-framing of the material from the point of view of modern society, let alone ethnically diverse or LGBTI communities, as their experience is necessarily limited by their color and background.

I was struck recently by a description of the white male hegemony in Caroline Criado Perez's wonderful book, *Invisible Women*, about gender bias. It suggested that the white male identity group doesn't see itself as one of many identity groups making up a society; they see themselves as the norm and all other identity groups as a block group outside their norm. I often reflect on how much things would change for the better if the white male hegemony identity group were to understand themselves as just another identity group.

What, I wonder, would it be like? Would a white male conductor working on *Così fan tutte* defer respectfully to the experience of a black female director when it came to dealing with the gender politics or the casting of black singers? Would a white artistic director only go ahead with *Madama Butterfly* if he could find an East Asian singer for the role? Would the musicians consider changing the music so that a trans woman could play Violetta in *La traviata*? It would mean a more relational and respectful collaboration between different identity groups resulting in more diverse casting, staffing and interpretations of the classic repertoire, which would—in turn—allow the art form to appeal and speak to a much broader cross-section of the community where it is staged. Of course, it would take time, and you would have to intervene at the training level and ensure recruitment occurs across a much broader spectrum of identity groups, but I think it would be well worth it and would secure the future of opera.

It's not only that we have to address how we stage these historical operas and who directs them; the industry also needs to create more new operas that invite in artists from a wider variety of identity groups—as librettists, composers, singers, directors, conductors and so on. That way opera can slowly start to build up a different canon reflecting the society we live in, both in terms of the stories told and who tells them.

There are, of course, many new music initiatives from organizations like Aldeburgh Music, *enoa* at the Festival d'Aix-en-Provence, and Amsterdam Opera, but the new operas tend to have only one brief outing of a run or sidelined into a studio performance space. And, sadly, diversity and inclusivity are not always at the heart of them, and the new operas created can continue the old pattern of stories by and about white middle-class men.

As well as creating new operas to widen the canon, we also have to put more artists from more diverse and intersectional identity groups on our stages and in our orchestra pits.

And the audience needs to see the equivalent diversity across our music staff and creative teams, particularly in the leading roles of directors and conductors. And we need to find a way to reduce ticket sales on a larger scale so that people from less privileged sectors of our community can come and watch opera.

If opera doesn't put all of these measures in place, I fear it runs the risk of becoming redundant.

I regularly invite classes from my daughter's state school in south London to watch orchestral rehearsals in the theater at the Royal Opera House. The school kids reflect the diversity of that part of London with a fifty-fifty balance of white students to students of color, and many kids coming from underprivileged backgrounds. I always make sure the kids get the best seats in the stalls near the front so they can look at what is going on the stage at the same time as watching the players in the orchestra pit, and I am always interested in watching their reactions and hearing their feedback. But I often wonder what it feels like to be a fifteen-year-old girl sitting in that large auditorium, looking out at everyone working around her—the orchestra, the conductor, the singers, the lighting team, the stage management, and so on—and not seeing anyone else of color anywhere in sight or any woman in a leading position, except me. I wonder what that says to her about the opera industry and how she'd feel about entering it? Are we welcoming her in or without even being aware of it, are we telling her not to bother?

The music department at that same school does regular concerts at the end of every term, and I vividly remember the first concert I went to. The concert started with the least experienced students and slowly made its way through to the most experienced ones. The more experienced and stronger the players became, the more and more of them were children of color until the concert ended with a brilliant viola solo by a young black sixteen-year-old boy and a Bach partita violin solo by a thirteen-year-old tiny black girl who played so breathtakingly well that we all ended up giving her a standing ovation. How is it, I reflected, that this is the reality in a state school, and yet it's not being reflected in our opera world? What, I wondered, happens to all those students and particularly those two exceptional final players? Where do they take their talent?

I know I am not alone in thinking about these things, and there are many important individuals and organizations across Europe reflecting on exactly how to make a difference. There are people like Émilie Delorme, who during her time at the Festival d'Aix-en-Provence forged a diversity program and set up a yearly female empowerment workshop, and Elaine Kidd, who runs the Jette Parker Young Artists Programme at the Royal Opera House and is leading workshops for directors from diverse backgrounds to be introduced to opera practice. Then there is the new initiative at English National Opera where four black, Asian, and ethnically diverse string players were introduced into the orchestra earlier this year—as were four new chorus members.

All of these small steps are critical to changing the thinking of the people who make opera and how we stage the core repertoire so that it speaks to a wider cross-section of the society we live in. I fear that if the opera world does not meet these new challenges of diversity and inclusivity, then the interest in the art form will slowly fade and it will ossify, becoming a geeky minority sport with no relationship to the society it is rooted in.

So, yes opera has a problem. But if the opera establishment can take on board the uncomfortable truth and start to put in place building blocks for attracting more diverse talent whilst addressing outmoded storylines and staging, it should have a beautiful, relevant and influential future. If opera doesn't like change, it will like obsolescence and irrelevance even less.

Katie Mitchell is an English stage director for both opera and theater. From 2008, she started working regularly in Germany, Holland, France, Denmark, and Austria. Her first production for the Schauspiel Köln, *Wunschkonzert*, earned her a place at the Theatertreffen in Berlin. She is a resident director at the Schaubühne in Berlin, the Hamburg Schauspielhaus, and had a seven-year artist-in-residency at the Aix-en-Provence Festival.

INSIDE THE EXPANDING LABYRINTH OF THE OPERA

Christian Jost

My love for the opera was sparked by vinyl records. It was simply listening to operas that attracted me to them when I was twelve. Sitting with my headphones on in front of the record player in the library of my parents' house, reading the score or the liner notes booklet, depending on what I could get hold of, I immersed myself in Elektra, Cio-Cio-San, and Don Giovanni. I was in a state of rapture, caused by engrossed listening and a formative process that was so intense and lasting that it led to my later opera work. It was not a visit to an opera house, nor the images of a spectacular stage set, all that came much later, but putting on my headphones and being absorbed in *Don Carlos*, *Pelléas et Mélisande*, and *Parsifal*.

To this day, the opera has never left my mind because it was in these very moments that the first associations formed in my mind. I heard the music, the vocal lines, and their words. A new world opened up inside of me and laid the foundation for a lifelong fascination. Music is a cosmos of sound surrounding a story like heart and soul, a force able to expand the substance of a story into infinity. A universe that grew as long as I knew how to engage with it as a listener. I perceived the narrative at hand as a kind of impetus for the composer to let his world of sound drift off into an ocean of symphonic music. An immense sonic field that I entered as a listener and that, like a voyage of discovery, would first stir me and grip me emotionally and then linger in my mind for days. Of course, all I had done was listen to an opera. I had made no trip and hadn't even left the house; I had just sat there, put on my headphones, and listened to a complete opera recording from my parents' record collection.

Music reverberates in our bodies and minds. The more complex its content, the more profoundly and intricately layered we perceive it, thus leading us into an inner world that we either want to keep on following or turn away from. Opera can create an entire cosmos within us, and in doing so, unfolds before us the complete palette of the human condition in sounds and spaces.

Over the last twenty years, I have composed ten operas; I could say that composing operas forms the center of my artistic life and my life as a whole. In the same way, I plunged myself into musical works with complete abandon; when I compose my operas today, I try to capture structures that create a pull comparable to the one that sparked my lifelong commitment to opera.

The selection process and the subject matter itself form the framework of the opera. Before I begin with the composition, it is put to the acid test. I have to be convinced that

the narrative material has the potential to make me, as a composer, drift off into my sonic cosmos. Therefore, the story is the gateway into a musical world, neither representing the work's psyche nor being its key element. An opera's story is its framework; like the trimmed hedges of a garden labyrinth, the plot forms its outer structure. Following the course of the branching paths results in the music, which draws us further and further into the work, into the labyrinth.

This briefly outlines what I consider to be the essence of opera and the credo of all my operatic work. Therefore, the eternal question of whether opera's primary element is the music or the words is moot for me—opera is not text with a soundtrack. Moreover, the composition does not only provide a musical subtext to the events on stage. The music of an opera is, in equal measure, its heart and soul, and I think one has to internalize this to understand the essence of opera.

My commitment to the opera is, therefore, a musical one. Even if my intent follows innovations in the narrative, simply because it is in my character to do so and I am magnetically drawn to a fascinating story, the creative musical development within the narrative framework is the driving force behind my operatic work.

And so, in sounding forth, my music follows the idea of a structural improvisation, which develops, through a process, from musical nuclei. This results in an organic structure, a stream of consciousness in which one element evolves into another, much like in the course of a journey. This leads to condensation, and atmospheric trajectories of tension that segment and advance the dramatic design of the whole.

I arrange my librettos in such a way that they provide me with precisely the necessary latitude for moments of dramatic culmination and tonal density. In turn, they allow for a compelling overall arc to take shape, which leads the storyline to a level of symphonic musical magnification. Seamless instrumental transitions weave together the individual dialogues. The instrumental flow is only interrupted by an external break if the work requires an intermission due to its length. Regardless of this, the scene always ties into the symphonic pull, the "symphonic stream of consciousness." The plot virtually floats in a river of sung text and symphonic orchestral music—an organic structure, which in jazz is called the "third way," or Modern Creative. My work is always about an organic flow and living breathing, transforming the freedom and groove of jazz and the strict structure of classical music or Neue Musik into an independent form.

The protagonists of my operas are designed so that the individual singers encounter a soul to which they can, and wish to, give a human form that comes alive in song. I compose lines that lead directly into the heart of the character and provide singers with musical material that takes them on a voyage of discovery into the personality and atmospheric aura of the protagonist they will play. However, the actual narrative may be constructed, then provides the clues and the necessary leeway that makes dramatic culmination and tonal density possible. Thus, it follows my compositional principle of transforming essential moments in the story into orchestral instrumental passages and thereby transforming plotlines into musical transcendence. In this vein, a musical arc can be traced that will take us into the depicted

events—let us participate in them to create a more profound sense of empathy, which is of existential importance for any process of artistic sublimation.

With the invention of music, humanity made its masterpiece. Music is the transcendence of life and opera its most complex form. A form that, like life itself, is in perpetual motion and development. And that's true not only for the great variety of interpretations on stage but also for its essential core, the continuous creation of new works.

One of the leading contemporary composers internationally, Christian Jost has had a decisive influence on musical creation in the past decades, including in the field of opera. He has served as composer-in-residence for several German orchestras and has received numerous awards for his operas; *Hamlet* was voted "Premiere of the Year" in 2009.

OPERA—AN OPEN ART FORM

Beat Furrer

A historical perspective on the voice in opera reveals to us how the idea of being "human" evolved through the centuries. The human voice itself tells a story that runs from the allegorical or mythical all the way to contemporary figures—from Monteverdi to Mozart and on to Rossini, Wagner, Berg, and Janáček, just to name a few turning points. Reaching beyond the words of the libretto, it calls out to us, relaying the history of the human condition with deeply moving immediacy.

It reveals to us its reality and connects it with ours, speaks of its pain, its happiness, and its fear, which finds resonance in us, the listeners themselves. Beyond the semantic content of its language, it tells us about so much more and touches on deeper, hidden layers of meaning. The represented figure disappears, as it were, behind the reality of its voice.

"What cannot yet be said, can perhaps already be sung," is an apt description of the utopian potential of opera. However, the caveat Heiner Müller added was, "But when everything is said, the voice becomes saccharine," that is, it freezes in beauty, becomes clichéd and rhetorical.

The great and brilliant moments of an opera performance are neither retrievable nor can they be preserved; the risk of failure always plays a role in them. These are moments in which the scene, text, and music complement each other in a manner that forms a subtle balance and creates a new space. Without explanatory duplication, the voice itself tells its story, is directly received by the listener. He or she makes the narrative his or her own. Whether I close my eyes or not, whether I'm familiar with the libretto or not, I am captivated and inspired in a manner far beyond discursive understanding. My body sings along on the inside and enters into a relationship of resonance with the Other.

It is the sound of the voice that actually constitutes the character of the protagonist.

"All opera is Orpheus"—All opera is transcendence. Just as the opera moves beyond the boundaries of the genres involved—those of set design, words, and music—the voice transcends the boundaries of the represented figure. Orphic transcendence crosses the threshold of the radically different—of the underworld, of death. Orpheus is the ancient figure of mediation between man and nature.

And yet, there is hardly an art genre today that is barricaded by prejudices and fixed opinions to the same extent as opera, and which thus prevents, or makes it more difficult, for many to engage with it on a substantive level.

Whose opera am I talking about? About the museum-style institution that is frozen in beauty, that administers only the small remnants of this wonderful tradition and is in the

process of letting it wither away through a lack of ideas, ignorance, and insufficient awareness of its responsibility to society? No, I am talking about the possibilities this very institution, in conjunction with creative forces, can open up for society, and about opera houses who have recognized just that. And this is not just about music or theater. Everything is at stake.

Vocal culture should be able to continue to evolve! Otherwise the great tradition will run dry. The medium of opera needs to be "interrogated" as to its potential for the future, new narrative forms have to be found, something new must be created—only in this way can tradition open itself up to the present and at the same time continue to live on as vibrant cultural memory.

Especially in today's digitalized world of unprecedented changes, which include the radical destruction of social structures as well as nature, i.e., the basis of our own existence, we find ourselves speechless and amazed, robbed of our capacity to act, relegated to the role of spectators. It is particularly today that we need art and the opera—we must find the breathing room and a new language to grasp what is happening to us. We are in dire need of a new aesthetics and vibrant contemporary art that latches on to the great traditions and opens them to the present.

Our theaters have reduced their repertoire more and more to the great "hits" of opera history. In the process, the extraordinarily rich early history of opera, which is still open to interpretation and development, as well as the majority of contemporary works, have almost completely fallen to the wayside. It takes political will, courage, and foresight as well as awareness of the urgency of supporting institutions that are going through processes of transformation to fix this. Ticket sales cannot serve as the sole justification for these changes, the question must also be raised whether it is actually art that is produced at these houses. An art that creates open spaces within the walls of necessity and the ostensive lack of alternatives to political decisions, an art that provides us with a mirror reflecting knowledge and experience of reality—reality, as opposed to a digital parallel universe.

Opera as an open art form, as an art leading into the open.

The Nakedness of the Voice: FAMA

> *[...] by day and night it lies completely open.*
> *It is constructed of resounding brass*
> *that murmurs constantly and carries back*
> *all that it hears, which it reiterates;*
> *there is no quiet anywhere within,*
> *and not a part of it is free from noise;*
> *no clamor here, just whispered murmurings,*
> *as of the ocean heard from far away,*
> *or like the rumbling of thunder [...]*
> *nothing that happens, whether here on earth*
> *or in the heavens or the seas below,*
> *is missed by Rumor as she sweeps the world*
> Ovid, *Metamorphoses*, Book XII

Everything is present. A voice speaks. Like a film zooming in on the protagonist's face, in *FAMA* the relationship between orchestra and voice is transformed in such a way that in the wake of the dense choral and orchestral sound of Scene 1 that bursts with energy, the instruments gradually regroup around the audience in order to ultimately focus on the voice itself in a "long shot" (Scene 6), with instrumentation reduced to the contrabass flute. The orchestra turns into a resonance chamber, an extension of the larynx. The House of Fama, the starting point of the story, has transformed into the protagonist's inner space. Here the voice becomes perceptible in its intimacy and vulnerability.

Scene 3 is a virtuoso *Sprechstimme* aria. This Figure is composed of a torrent of words and wildly associative, mercurial thoughts. They encompass observations, premonitions, desires, projections, dreams, and fears. At first, all this is articulated in playful and coquettish verbal cascades, which are ultimately drowned out by the awareness of a hopeless situation that leads to despair. In Scene 3, instrumental sound is closely interwoven with that of the speaking voice. It becomes the resonating space of language. The instruments appear to carry its words onward, to amplify them, to distort them, or to weave them into a network of other voices.

Then, darkness.

Following the choral island of Scene 4, the voice of Scene 5 appears to have been disembodied. It speaks about a dream through a funnel, which it directs towards the audience.

In the subsequent Scene 6, bright light again falls on the protagonist. She stands in front of the mirror: "How strange my voice sounds, is it me who is talking? I certainly have a totally different face than I usually have." Voice meets identity. In this moment, the actress represents nothing (no *Fräulein Else*) but herself—the actress's voice.

Scene 7 is a giant crescendo that empties into noise—the noise inside the house of Fama. Then a foreign voice speaks, it is the orchestra, now positioned behind the audience. As if from another world.

Theater of Voices: Wüstenbuch

The form of *Wüstenbuch* (Desert Book) is articulated through changes in the relationships between voice and orchestra, progressing from scene to scene.

A theater of inner voices like Ingeborg Bachmann's visions and poetic visitations through the (spiritual) deserts within us. The poet's distorted diary becomes the basic model of an endgame for Music-theater and opera. Every narrative structure is fragmented, the protagonists remain trapped in their own stories. There are no dialogs. As with the various narrative levels of lost myths, the actual story is suspended as a result of various interpretations and reflections of the simultaneous non-simultaneous.

The quality of the voice itself becomes the subject. It is instrumentally colored, instrumentally distorted or reproduced by the orchestra. Scene 1 is based on a text by Händl Klaus, spoken by myself, which I analyzed electronically and then reconstructed orchestrally. While in Scene 1 the "speaking" orchestra is reduplicated by an actor speaking the same text, in Scene 7 the orchestra "speaks" the same text all on its own—as if tracing tracks in the sand. Here the ancient Egyptian poem from *Papyrus 3024* appears, "Death stands before me today like…"

The voice finds its resonance in the sound of the orchestra, which is superimposed to the point of incomprehensibility, resulting in a choral bundling and spatialization of voices. The sound of the orchestra carries forward the voice. As this discontinuous narrative unfolds, each character remains trapped in his or her story. Traces of gestures, that which has already taken place, forms a unified whole. The song of an imam, transcribed from memory and reconstructed orchestrally, interrupts scene 1. The absent voice.

It is a theater beyond action, it is one of voices in space.

The Text Machine—La Bianca Notte

La bianca notte is the inversion of *FAMA*. The singing moves into different levels of stylization, from linguistic to instrumental expression, from creatural sound to scream, from shouting to recitative *parlare cantando*, and through different orchestral spaces. The orchestra colors the voice or the voice is montaged into an orchestral structure that is continuously transformed, from harmonic to metallic, from instrumental sound to scream.

La bianca notte is a walk through the nocturnal city. Industrious reason is asleep, there are cries, whispers, scraps of conversation, and the sounds of the harbor. We hear the creaking of ship masts and chains, the pounding of waves against the quay wall. All this evokes phantasmagorias, images, and stories.

The protagonist crosses the city in one night and, as in a dream, is thrown into different temporal settings. The whole scene resembles a cubist tableau. He encounters real characters as well as ones from the past. Dialogues are montaged in a kaleidoscopic form. This does not involve questions and answers, everyone remains in his or her narrative, his or her text. Solos are also montaged as dialogues with the self in such a way that a separation of the (sound) spaces is created within the monologue. It is as if the protagonists were calling out to each other across an abyss.

A group forms around Dino, which comprises Regolo and *il russo* as well as two female voices, Sibilla and Indovina (the fortune teller). Indovina is from another time, stolen from an Italian opera, as it were, and acts as a silent observer of events. Sibilla engages in an *amour fou* with Dino and the two take refuge in the phantasmagorias of ostensible simultaneity. Their love founders a short while after their encounter in Scene 8. A dream, which is represented by voices complementing each other in the collapse of both text levels.

Regolo on the other hand embodies the Mephistophelian counterpart. He hails from the same darkness as Indovina. That night, Regolo takes Dino to the poorhouse. Here they encounter the poet and violinist *il russo*, who bears the facial features of Dino. Dino (as *il russo*) is confronted with his own failure, his own end.

Dino's last words are, "Io non vivo, vivo in uno stato di suggestione continua." (I do not live, I live in a state of continuous fascination.)

What remains is the night, appearing as a utopian space, *u-topos* of other possibilities, as well as a zone of madness and every form of hopelessness. The night, the disappearance of firm outlines and contours, is the theme and starting point of the musico-dramatic narrative. Only gradually do figures and their stories emerge from the darkness. Just as in *FAMA* whose

house seemed closed on the horizonless horizon, so here, in *La bianca notte*, the darkness of night between foil and *follia* (madness) closes itself off to the parabolic end of the narrative.

La bianca notte could thus also be read as a critique of the dark sides of modernism, in which the individual is turned into an outsider, the artist is relegated to the margins of society and becomes a functional appendage of the universal machine of stupidity: everything obeys the laws of a terrible dialectic of Enlightenment.

In the end, however, Dino is no longer the poet Dino Campana who sought to live a life of fulfilment, both in the realm of love and as an artist between the times. He is left a complete anonymous with no identity who is forced to realize that there is no place for him in society anymore and that his love for Sibilla is bound to fail. What's more, his quest to prove the existence of his self is in shambles, but this is what he was trying to build as a writer in search of himself, in accordance with those inner voices that give expression to another reality. In the end he loses his name—there is only namelessness, a total loss of identity: "Io mi chiamo Dino e come Dino mi chiamo Edison … Sono una stazione telegrafica […]" (My name is Dino and like Dino my name is Edison … I am a telegraph station). And then, "Io non vivo, vivo in uno stato di suggestione continua."

I have tried to approach an idea of opera by way of three examples. Opera as an interplay of sound, text, stage design, and the bodies of performers in motion.

In other words, what conditions facilitate those moments that we call theater? What are these more secret moments of a subtle (im)balance between the protagonists, how do these special instances of an ambiguous space emerge, which is, ultimately, augmented in the unknown? In the interstices of the imagination of floating encounters. What is it that really brings it about, this spontaneous appearance of another possible world behind things?

For the time being, I will try to translate this image into the compositional mirror writing of all things living. It seems essential to me that new paths through the narrative will open up to the listener again and again. Opera as an open art form, as an art leading into the open.

It is evident that in *FAMA*, for example, when the protagonist refers to the glass between her and her mirror image (Scene 6), the instrumental sound evokes the material presence of the glass. When she talks about her "totally different voice," the sound of the contrabass flute becomes the "different voice"; when she speaks about the glistening of the lake (Scene 5), the whistling sounds of the flutes and the high accordion are imagined as light. Her words "Who's playing the piano so beautifully down there?" open up the imaginary abyss that I mean. It is the opposite of an illustrative doubling, the expressive content appears, on the verso of the composition, so to speak. Sound becomes physical presence—physical presence becomes sound. A story is always told. But how? I ask myself this question again and again with every new piece.

Swiss composer and conductor, founder of Klangforum Wien, Beat Furrer has created an extensive oeuvre since the 1980s, ranging from solo and chamber music to works for ensemble, choir, orchestra, and opera. He has been a professor of composition in Graz since 1991.

TOWARDS A RENEWAL OR COLLAPSE
OF THE OPERATIC GENRE

Bernard Foccroulle

For over half a century, opera has benefited from a new lease on life. There are several explanations. However, three, in particular, seem essential to me: firstly, opera has profited from a substantial broadening of the repertoire to include the ancient and the new; secondly, there has been considerable diversification in performance practices and styles, both vocal and instrumental; and thirdly, directors—notably from the theater world—have brought the strength of their invigorating interpretations of the great classics. In this way, opera succeeded in gaining back an audience, which had begun to lose interest in the middle of the twentieth century in favor of cinema, and other seemingly more contemporary forms.

Can we consider that opera will continue to develop in the twenty-first century on the same basis with these same elements? I sincerely doubt it. You can't expand the repertoire *ad infinitum*, especially if new works don't play a central role. Today the diversification of performance practices is so highly developed that one can hardly imagine what further aspect could arise and revolutionize these.

Opera should always be a collective art form, an art carried out by a team of artists. Unfortunately, I've remarked a growing gap between conductors and directors and a weakening of their dialogue. The other tendency is for directors to develop their work in an autarkic context where the music is forgotten. I recognize their essential contribution to the dynamics of theater in the last fifty years. However, I fear burnout due to *Regietheater* techniques whereby the relationship to the operatic work itself becomes secondary to the concept and prone to narcissism on the director's part. Also, the systematic use of stunts and images, which testify to a simplistic desire to provoke or attract attention, or *faire scandale*, which becomes tiresome and trivial and engenders a new form of pedantry. Admittedly, there have always been more or less talented artists, more or less successful performances; true "genius" remains an exception. At present, we indeed see impressive productions of the great classics but also an increasing number of failures. Of course, there is room for subjective judgment, but it is nonetheless worrying. Except for directors such as Peter Sellars, Dmitri Tcherniakov, Katie Mitchell, Simon McBurney, and a few other greats, how many lesser directors are not tempted by sensationalism and voyeurism? Is this tendency to "novelty" at all costs not putting operatic performance at the risk of a creative burnout?

From my perspective, to maintain the relevance and impact of opera in the coming decades, opera administrators must focus on several challenges: making room for new works,

opening up to non-western cultures and rethinking in depth their relationship with the audience while developing new forms of participation. They must also take advantage of new media's multitude of possibilities, and this creatively and unconventionally.

All this is possible; however, the unprecedented development of commodification, which affects all artistic and cultural fields, works against this dynamic and places opera in a defensive position, in particular concerning the entertainment industries. Therefore, we should take nothing for granted, and it will take concerted action by major players in the business to slow down the process of standardization and dehumanization if we are to succeed in developing the cultural forms that our century needs.

From Oliver Messiaen to George Benjamin, the Emergence of a Repertoire of Contemporary Opera

In the second half of the twentieth century, hundreds of new operas enriched our four-hundred-year-old art form. The most important of these have survived; however, many have quickly disappeared from the repertoire. What are the reasons? Lack of artistic qualities? There are indeed perceptible aesthetic weaknesses such as weak vocal writing and a systematic refusal of narrative, or on the contrary, overly conventional forms. Nevertheless, the most significant problem is a lack of support on the part of institutions toward the composers, a lack of time and means made available to them, and insufficient touring of their works.

Fortunately, things are starting to evolve:

- Opera houses and festivals are co-producing more contemporary creations, programming, and promoting small and medium chamber operas.
- New narrative forms are emerging.
- Greater attention is being given to the text.

A substantial repertoire of contemporary opera has emerged at the hands of composers such as Olivier Messiaen, John Adams, Peter Eötvös, Pascal Dusapin, Wolfgang Rihm, Philippe Boesmans, Salvatore Sciarrino, Luca Francesconi, Georg Friedrich Haas, Fabio Vacchi, Harrison Birtwistle, Toshio Hosokawa, George Benjamin, Thomas Adès, György Kurtág, and many others from the "young generation." Thanks to multiple revivals, new productions, and the deepening and diversity of interpretations, these works live on. Opera houses must accept not only to commission new operas but also to program recent works and allow them to mature and grow. The recent popular success of Philippe Boesmans' earlier operas at the Paris Opera and La Monnaie, as well as the exceptional international reception of George Benjamin's operas, are encouraging signs.

After Benjamin Britten's large operatic frescos, the emergence of smaller forms has proven the vibrant creativity of the genre while demonstrating that opera is no longer by definition a "big machine" for soloists, choirs, and symphony orchestra. We can also be moved by a small group of singers and instrumentalists, achieving exceptional density and radiance through reduced means.

Increased Intervention from Other Artistic Disciplines

In Brussels and Aix-en-Provence, I have experienced that collaborations with artists from other disciplines were among the strongest and most forward-looking encounters, particularly with choreographers whose relationship to space, time, the human body, and narration differs profoundly from that of theater directors. I've had the privilege of working with Trisha Brown and Anne-Teresa De Keersmaeker, whose company, Rosas, was in residency at La Monnaie for over fifteen years. Both choreographers directed convincing opera productions, which are now landmarks.

For half a century, great visual artists have had a significant impact as stage designers for opera: David Hockney, Anselm Kiefer, Jannis Kounellis, Georg Baselitz, Jörg Immendorff, Anish Kapoor, Gilles Aillaud, and Eduardo Arroyo; not to mention professional stage designers such as the immense artist Richard Peduzzi, who together with Patrice Chéreau made a considerable contribution to theater and opera.

Indeed, for the past twenty years, visual artists have become involved in opera far beyond the scenic dimension. William Kentridge is now a reference in the opera world as both director and designer, and the Tannhäuser by Jan Fabre at La Monnaie in 2004 has left an indelible impression. There was also the unforgettable *Tristan und Isolde* in 2005 at the Paris Opera: a fruitful collaboration between Bill Viola, Peter Sellars, and Esa-Pekka Salonen.

I am delighted by the presence of more popular artistic disciplines such as puppetry, circus arts, and street arts on the operatic stage; these enrich the expressive possibilities and language of opera while returning to its original mission—that of being the transdisciplinary art form *par excellence*.

Opening up to Non-western Cultures

Born in Italy in the early seventeenth century, opera quickly became the quintessential European art. Today, it is acquiring a planetary dimension with countries with no prior tradition with new opera houses being built worldwide. However, is this movement of globalization a one-way street from the West to the rest of the planet? An avatar of colonialism? Or can we look forward to a form of globalization that is a two-way street and a constant exchange between East, West, South, and North?

There is no reason why non-western cultures should not enrich the operatic canon, as we have seen in dance or the visual arts. Robert Lepage succeeded in a brilliant integration of the Vietnamese water puppetry technique in his staging of *Le Rossignol* by Stravinsky. For the world premiere of Peter Eötvös's opera, *Three Sisters*, Japanese choreographer Ushio Amagatsu showed how eastern culture could enrich western opera.

Japanese composer Toshio Hosokawa combines eastern and western traditions in the most convincing way. Composer Guo Wenjing's work bears witness to an equally fruitful encounter between the Chinese and European traditions. Param Vir has composed works influenced by Indian and western traditions while the oriental forms of musical theater (noh and kabuki in Japan, or traditional Chinese opera) have facilitated intercultural encounters.

Arab culture does not have an operatic tradition; nevertheless, Arab composers such as Ahmed Essyad, Samir Odeh-Tamimi, or Saed Haddad are reaching out to Western opera through their unique techniques. With *Kalila wa Dimna* (Aix-en-Provence, 2016), composer Moneim Adwan approaches opera through an oral tradition, using writing only to note the essential melodic elements. The compositional process occurs subsequently, as in baroque music, where there is a code or performance practice known to each player and singer, which makes precise notation unnecessary.

It would also be interesting to explore collaborations based on an authentic intercultural dialogue between artists from significantly different cultural traditions in a joint, egalitarian, and creative venture. Peter Sellars has collaborated with African artists (the sculptor Elias Sime in *Oedipus Rex*), Asians (Thai dancers in *Persephone*), and Chicano (the artist Gronk in *Griselda*).

Krump dance made its appearance on the stage of the Paris Opera in the production of Rameau's *Les Indes galantes*, a collaboration between the artist Clément Cogitore and choreographer Bintou Dembélé.

Orfeo & Majnun (a co-production between seven European partners initiated by La Monnaie in Brussels and the Festival d'Aix-en-Provence beginning in 2018) was a participative, intercultural creation. It brought together three composers in a collective composition: Dick van der Harst, Moneim Adwan, and Howard Moody. Sung in English and Arabic, it combined two similar stories, *Orpheus and Eurydice* and *Leila and Majnun*. In each city, workshops carried out in the different urban communities preceded the performances. Finally, in Aix, an awareness campaign, which had spanned nearly a year, brought 7,000 participants together on the Cours Mirabeau to take part in the creation of *Orfeo & Majnun*.

Postcolonial Heritage

We have to recognize that colonialism's history still overshadows intercultural exchanges, and the profoundly unequal and unjust relationship, which has existed between the dominant and the dominated cultures, is still palpable. The "decolonize the arts" movement, which advocates the re-appropriation of cultural heritage by those who have been robbed of it, has taken on paramount importance. Given the wounds of history, it is not surprising that the movement has radical and sectarian elements. Notwithstanding, the more artists from communities and people who have been victims of colonization reclaim their respective heritages, the more it will be possible to create fair conditions for truly intercultural work.

Enlargement and Rejuvenation of Audiences and New Participative Forms

There is a perceptible "fatigue" in the world of opera today due to the depletion of new forms and the shrinking of the opera audience to an elite, *entre soi*—a tendency which is antithetical to a dynamically growing cultural environment. The revitalization of opera requires an opening up to the broadest possible audience, to citizens in all their generational, social, and cultural diversity.

This work is not to be confused with the modes of mass distribution, which give the illusion of democratization. HD transmissions in cinemas across the five continents are indeed positive in that they have made it possible to reach audiences hitherto very distant. Nevertheless, real democratization has to be accompanied by new participative, interactive forms, which leave a large place for public expression, taking them from the role of spectators to that of actors. In this respect, the project carried out for the past thirty years by the Birmingham Opera Company under the direction of Graham Vick is an essential reference.

At La Monnaie and in Aix-en-Provence, participatory projects calling on large choral groups have proved bearers of unparalleled artistic and emotional strength. For example, when Fabrizio Cassol brought together a choir of six hundred children in 2008, together with Malian musician Oumou Sangaré, American soprano Claron McFadden and the Belgian jazz trio, Aka Moon, he gave these young people an incredible artistic experience. When Simon Rattle directed three hundred amateur singers in Jonathan Dove's *The Monster in the Maze* in 2015, it gave them an experience which transformed their lives.

Strengthen Local Roots
The artistic policy of opera houses and festivals often aims to strengthen their influence, visibility, and prestige on the international opera scene. Isn't it high time to work equally and simultaneously to strengthen the local roots of these institutions? For example: contact with the region's best artists, with small and large cultural actors, with the educational and associative world, and with economic and political leaders. In a period of frantic globalization, this local anchoring will strengthen the institution's identity giving it a specific color, thus making it even more attractive to international audiences: there is no contradiction, in my eyes, between local roots and global influence.

Most importantly, opera houses must cease to be inaccessible citadels when in fact, they have every interest in networking with local institutions of all sizes, museums, dance companies, theaters for young audiences, socio-cultural associations, youth centers, and schools. This network is beneficial for all: it creates audience exchange and creative energies, giving birth to outstanding projects that would be impossible to conceive, and realize without these exchanges. My close relationship with jazz musicians such as Fabrizio Cassol and Kris Defoort has yielded exceptional results in terms of the work we have achieved and the ties which we have created through them on an international scale. At the Festival d'Aix-en-Provence, we experienced highly emotional moments with the participation of women from the Comorian community of Marseille as well as with that of young refugees, patients, and their caregivers, or with the Arab music choir of Ibn Zaydoun conducted by Moneim Adwan and many other ensembles in the region.

In this same spirit, performing *extramuros* in unorthodox venues, also contributes to a renewal of the practice and image of the opera. Whenever we were able to produce opera beyond our walls, in Brussels or Aix-en-Provence, it allowed us to train our loyal audience to move around to discover other cultural environments and to experience different forms of artistic creation. It also enabled us to meet new and first-time spectators.

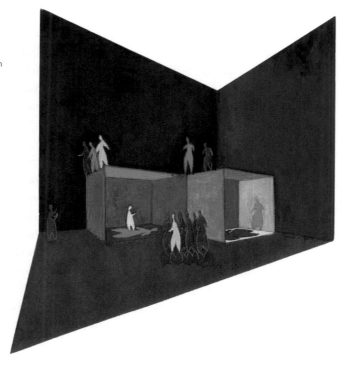

Richard Peduzzi,
Untitled, 2004
Watercolor on paper,
21.5 × 26 cm
Design for Georg Friedrich
Händel, *Hercules*, Festival
d'Aix-en-Provence, 2004.
Direction: Luc Bondy
Courtesy of the artist
© Richard Peduzzi

The Contribution of Non-European Countries to the Practice and Teaching of Classical Music
All over the world, non-European countries are contributing significantly to a new dynamic in European classical music, in particular in the area of teaching. A stellar example is El Sistema, a social action music program created forty years ago in Venezuela. Not only has this pedagogical method given rise to a proliferation of youth orchestras of unprecedented quality in Venezuela, at the same time, but France has also drawn inspiration from this method to promote classical music among young people, especially in disadvantaged neighborhoods.

I believe that the rise of choral singing in South Africa explains the emergence of major singing talents there. I'm also thinking of the development of classical music education in South Korea, Japan, China. Now great singers from all continents perform together at the Salzburg Festival, La Scala, the Royal Opera House, or the Metropolitan Opera in New York.

The Risk of Commodification
These developments represent an unprecedented opportunity for classical music of European origin and in particular for opera. The question is: will we be able to strengthen and stabilize this global movement and protect it from the risks of commodification? Are the educational initiatives that numerous opera houses and festivals are currently developing a belated and insufficient reaction or harbingers of a wave of expansion? What is certain is that concerted action by operatic institutions worldwide must be much more than an addition of efforts; it must constitute the qualitative leap necessary to block the commodification and accompa-

nying commercial practices. The aim is not to increase the number of "consumers" of the opera but to transform them into active and creative participants.

More generally, opera houses and festivals would be well advised to include "Cultural Rights" (in keeping with the Fribourg Declaration[1] in their fundamental missions) and to think of the production and distribution of artistic works in terms of "rights" of access and participation; this would constitute a paradigm shift for the cultural world.

The Dream of a New Lyric Landscape

My ideal operatic world would be rich with a tremendous diversity of aesthetics, forms, practices, and audiences. All continents have specific singing forms; far from erasing differences and extinguishing traditions, intercultural creations would magnify them, thereby revealing hidden treasures to us. The Birmingham Opera and its top-notch participatory productions have created dozens of followers around the planet. The participatory projects led by Cathy Milliken and Shirley Apthorp in South Africa, by Mark Withers, Anthony Heidweiller, or Airan Berg in Europe and many others worldwide have taught and enabled hundreds of thousands of amateurs to participate actively in operatic creations alongside the most experienced professionals. My ideal opera world would be one where young people form a substantial part of the audience, minorities regularly make their voices heard, and the great works of the repertoire are juxtaposed with the most diverse creations.

People might call me a utopian, a dreamer, a revolutionary. I answer that all of this already exists, on a small scale. The viability of these new experiments is more than well proven; it is up to us to ensure that they form the basis for the artistic development of tomorrow.

Post scriptum: I wrote this text before the start of the Covid-19 crisis in Europe. No one knows today what the consequences of this global health crisis will be, culturally, as well as socially, economically, ecologically, politically. For my part, I am convinced that we should above all avoid resuming "as before." The above reflections include several proposals for a different way of thinking and organizing artistic activity. I express the hope that a general movement of cultural and democratic renewal will arise because this is what our world needs most.

[1] The Fribourg Declaration on Cultural Rights promotes the protection of diversity and cultural rights within the human rights system. It is the result of twenty years of work by an international group of experts, known as the "Fribourg Group," coordinated by Patrice Meyer-Bisch. This Declaration brings together and makes explicit the cultural rights that are already recognized, albeit in a piecemeal manner, in numerous international texts.

Belgian organist, composer, conductor, and opera director, Bernard Foccroulle studied at the Liege Conservatory and founded the Ricercar Consort with violinist François Fernandez, focusing on the German Baroque. He was named director of La Monnaie in Brussels in 1992. In 2007, he succeeded Stéphane Lissner as director of the Aix-en-Provence Festival.

SOME THOUGHTS ON
THE FUTURE OF OPERA

Neal Goren

How We Got Here

Around the turn of the twenty-first century, some long-established American opera companies, including the Hartford Opera, Baltimore Opera, Opera Pacific, and Orlando Opera, folded in quick succession. Other regional companies took stock and realized that their donor base was aging and that younger people were not replacing that base. So, rapidly, in a scattershot manner, they analyzed what could be done to attract a new audience.

One troubling indicator was that opera donors reported that their children did not find opera relevant and, therefore, did not feel compelled to attend or donate to opera. I would posit that this younger generation felt that nothing about opera as they experienced it reflected their lives or the world in which they live.

In response to this dwindling interest, some American opera companies produced operas on subjects ripped from the headlines, such as *Jackie O*, *Harvey Milk*, *The Life and Times of Malcolm X*, or *Anna Nicole* in the hopes of attracting new audiences. However, although many older opera lovers liked the idea of expanding the operatic canon, they didn't like contemporary music and refused to support further forays into contemporary opera. The conflict seemed unsolvable.

I well remember attending the Opera America Conference in 2013, and witnessing the report of a respected administrator from an established regional opera company, who, nearly in tears, admitted that after more than thirty years in the industry, opera was now clearly in its decline and he was abandoning ship. He came to this drastic decision after years of tireless efforts to generate support for his company and the painful realization that they had all failed.

To my eyes, one significant roadblock to success was that opera companies were operating under the assumption that their future donors would look like younger versions of their existing donors: white, middle-aged, and arts-oriented. In other words, their concept of an expanded audience was limited by their past audience. Another roadblock was their narrow view of what opera could sound like, who could stage it, and how and where.

My Response To the Situation

This crisis coincided with the inauguration of the Gotham Chamber Opera, which I founded in 2000. As our name suggests, the company legitimized and promoted specifically the genre of "chamber opera," proposing eclectic programming and boundary-expanding productions. Indeed, many

of Gotham's shows challenged the prevailing notion that we must perform opera in purpose-built proscenium theaters. Luckily, our audiences responded enthusiastically to the novel concept that opera could be given in smaller, more intimate, and unconventional venues. In its fifteen years of operation, the Gotham Chamber Opera succeeded in significantly expanding the definition of opera.

By the late 2010s, judging from the massive increase in the number of new American operas written, their realization, the public interest they engendered, and audience attendance, it looked as if American opera and opera companies had made it through the crisis. However, this was no act of God or *zeitgeist*; instead, thanks to the Mellon Foundation, which pumped tens of millions of dollars into creating and producing contemporary American opera and audience-building. Nevertheless, despite the excitement generated by these new American operas, the demographics of the audiences, producers, and artists did not expand much. Now, with the Foundation's recent change in leadership and focus, the question is whether or not interest in these works will continue to grow without their generous support. If we look to the international opera scene—especially in Europe where companies have large government-supported budgets and are free to experiment with new repertoire and innovative productions—the same problem arises as soon as the public funding is reduced (which is the present trend) and they have to seek private sponsors. Then, survival becomes the priority, and anything considered remotely risky is jettisoned.

The Future

Thankfully, during the months of the Covid lockdown, audiences were able to view an enormous variety of operas online, from new works created specifically for internet viewing to archival videos of live performances from the world's foremost opera companies recorded on stationary cameras in the 1950s and 1960s. For little or no money, opera lovers were able to gorge themselves with hours of performances in the comfort of their homes. In the meantime, all the usual inconveniences of attending opera in person, such as locating parking, concerns about acquiring enough sleep after the performance to function optimally the next day, not to mention the subsidiary costs of babysitters, opera tickets, tolls, and parking, had disappeared. The result of this easy availability of opera content was that listeners crystallized their listening preferences in a way that would have taken decades of live opera-going. New listeners came to realize their particular musical tastes and make a commitment to pursuing those preferences. While some seasoned opera lovers decided that they never again wanted to view opera on a home device and longed for live performances, others realized they preferred to watch opera at home rather than enduring the annoyances mentioned earlier.

I predict that this crystallization of listening preferences will result in increased definition and specialization within the opera industry eg. Baroque or Contemporary. In the meantime, audiences will expect higher musical and theatrical standards, whether at home or in the theater. As home viewers become more sophisticated, they will be less satisfied with video streams of live performances and expect productions designed for the camera rather than a bland reproduction of the live experience. We are entering a period in which experimentation will be rewarded, and those companies with the most significant budgets

and those that exhibit the greatest nimbleness and creativity will indeed thrive, while the more intransigent ones will eventually fall by the wayside.

The past eighteen months have allowed us to reexamine ways to attain "relevance" in opera. I had long asserted that a classically trained voice is the best conductor of emotions, and since emotions are likely to remain relevant forever, so will opera. However, I was wrong in this belief: a classically trained voice isn't enough. For opera to move forward and gain new devoted audiences, opera must reflect the looks and sounds of the world we live in now. To look like the world we live in, opera will need to show inclusiveness at every level more than ever before; this means the artists on stage, the artistic team, the design team, the administration, and the members of the board.

As an attempt at relevance, opera directors have long been transposing standard-canon productions to the present or recent past. Occasionally this updating has reaped rewards, but just as often, it has rendered the text nonsensical and instead highlighted its lack of relevance. While updating is not a guaranteed solution to providing relevance, it can help the audience to feel closer to the material if it does not contradict the text or require textual alteration. But contemporary stagings of the classics are not enough; the multiracial casting of male and female characters in all roles will need to become the norm.

Moving forward, opera must also reflect the sounds of our world. The music of the great classics reflects the time in which the composers lived; why shouldn't new productions reflect ours? Moreover, the sound of our world today includes popular music; opera must embrace this musical inclusiveness. A great example of this is Terence Blanchard's *Fire Shut Up in My Bones*, which incorporates elements of jazz and gospel into its score. The new work opened the Metropolitan Opera 2021/22 season and became an instant hit with audiences and critics, selling out all performances. This resounding success should signal that if opera is to thrive and grow in the coming decades and centuries, the industry needs to explore how various branches of popular music can be employed successfully in opera. By doing so, we will expand our concept of opera while effectively creating new audiences.

During the pandemic, I founded a new company, Catapult Opera, which has initiated a series of micro-opera commissions from singer-songwriters from the world of popular music to explore which of these musical genres might intersect best with opera. Though government funding of opera is minimal in this country, luckily, a cadre of generous local opera lovers willingly support us.

Unlike my colleague from twenty years ago, today, we in the opera industry must remain nimble by assessing constantly changing audience preferences and keep in mind that past solutions will not apply to present circumstances.

Conductor and recital accompanist, Neal Goren is the founding artistic director of Gotham Chamber Opera, where he conducted all of the company's eighteen productions, which included works such as Mozart's *Il sogno di Scipione*, Milhaud's *Les Malheurs d'Orphée* and Purcell's *Dido and Aeneas* with period instruments. As a recital accompanist, he has performed with Leontyne Price, Kathleen Battle, Hermann Prey, and many others.

WHY SING?

Michael Jarrell

Opera is one of those rare moments when different forces come together, the work of the composer, the conductor, the director, the dramaturges, the technique, the singers. Of course, these are very different energies. But, all together, they create a work, which is not only about notes but also about a space created within a given time, and sometimes, something that is otherwise rare in music, namely a narrative element.

This is often the case with ballet music, as well. Stravinsky, for example, would never have composed *Petrushka* the way he did if it hadn't been intended for the stage. Based on a story, certain moments and actions were a consequence thus necessary for the whole. He had to resolve this musically. Thus, Stravinsky opened a new chapter, also for himself: it involved new forms and an entirely different concept of time. Another example: most likely, Stravinsky could never have conceived of *Le Sacre du printemps* as purely concertante music. This is also true for *Daphnis et Chloé* by Ravel or *Jeux* by Debussy.

In essence, opera theater involves an exchange, a give-and-take. The individual areas can benefit greatly from each other. I'm thinking, for example, of the world premiere of my opera *Bérénice* at the Palais Garnier in Paris. I had a fruitful exchange with director Claus Guth. Sometimes his way of looking at things helped me a lot and also opened up new possibilities. I was confronted with an artistic practice that was different from my own.

Here's an example: at the end of the opera, when it comes to saying goodbye, things become relevant and sensitive. That's when Berenice stops singing; she only speaks. The stage direction wanted her to slowly walk away into the background. Technically, that created a problem because you couldn't hear her anymore. We had long discussions, and in the end, the last three sentences were projected onto a screen on stage. I thought it was a great idea, which I would never have come up with on my own.

The idea of having her speak at the end is related to a separate matter that has been on my mind for a long time: why does anyone sing? What does that mean? Why this abstraction? In classical music, singing is the most immediate and, at the same time, the most removed instrument. In some ways, the voice can also sound highly artificial and distant. We all use our voices to express ourselves. Precisely that can make the singing voice seem far removed.

The question remains: why does someone sing on stage?

Several years ago, I had a commission from the Théâtre du Châtelet in Paris for a new opera. Thanks to a friend's recommendation, I had discovered *Kassandra* by Christa Wolf.

This book opened my eyes. As a child, I was taught in school that Hercules was a superhero and the Trojans were the "bad guys." In Christa Wolf's novel, a woman tells the story of the Trojan War from the losers' point of view. Suddenly I realized that our history had always been written from the victors' perspective. This is true right up to our present time; it applies to the Yugoslav Wars in the Balkans or the bombs that fell on Baghdad when I was working on *Cassandre*.

There is always a glaring difference between the official historical record and the individual's perception of events.

I decided to make this the theme of the opera and initially, I wanted to explore that very aspect. The idea was to present a juxtaposition of the perspectives of the victors and the vanquished. On the one hand, the words of Homer and, on the other, a soprano in the role of Wolf's Kassandra. But the more I kept working on it, the stronger my fascination with Kassandra's words grew, and the more I had doubts if I should have her sing at all. The one who was able to prophesy the future awaits her time of death is now only looking back and has essentially lost her "role."

Given the extreme isolation experienced by this woman and the intimate quality of her admission to being powerless, I couldn't conceive of an aesthetic sublimation of her words through song. In this context, what was the point in still singing on stage? For this reason, it became a speaking role.

This raises the question of the hierarchy between text and music. When do the music or the words take priority? When must the musical strand dominate words? When does the music allow time for words? When is it necessary that every sentence is intelligible, and when is it secondary? Sometimes it's enough to get the gist of what's going on.

I have called this piece a "spoken opera" because the words are almost always subordinate to the flow of musical time. Sometimes the actress has to speak at speeds that are unfeasible in spoken theater.

With my opera *Galilei*, after Bertolt Brecht, I again gave a lot of thought to the treatment and arrangement of the voice: when must something be spoken? When do words take on so much meaning that they need to be emphasized? This opera is composed around a principal structure, a kind of crossing-over between the two leading voices. In the beginning, Galileo is a successful mathematician, and Andrea is a little boy. Galileo sings, and Andrea speaks. At the end of the opera, on the other hand, Galileo only speaks. He tells us that he no longer belongs to the world of science. He essentially lost his voice when he recanted his theory, and from that point on, was only able to speak. Andrea, by now a young mathematician who belongs to the world of science, has taken over his master's voice and sings.

Language, of course, is an essential element. Every language has its structure, contour, and melody of speech. Our mother tongue shapes our sense of hearing and our perception of music.

A long time ago, I listened to a recording of the first Paris production of Alban Berg's *Wozzeck*. That performance was in French.

Wozzeck has always been a very important opera to me. It opened the door to a new world to me as a young composer. Büchner's play sometimes uses a fairly common, rather direct language. These words inspired Berg, and he composed for that very language. There is no question as to why he is singing. However, in French, *Wozzeck* doesn't work at all; the words come across as artificial and fleshless. The French language works great in *Carmen*; in some ways less well in *Pelléas et Mélisande*. But with *Wozzeck*?

Language is the core element, the nucleus of an opera. When writing an opera, the composer responds to the words, the structure of the text, and the melody of speech. It is often challenging to deal with words that have an unambivalent meaning. The phrase "I love you," for example, is really hard to put to music. It's highly charged. Just singing away is simply not going to work.

Art helps us reflect on our lives; that's why humans have been creating it since time immemorial. Our world has become highly complex, and music reflects that complexity. Especially the opera. Nevertheless, I will continue to write for the opera. When an opera gradually takes shape, there are moments when you sense that the entire team is pulling in the same direction, and when different approaches and energies lead to a shared, unified whole, that's when things become fascinating.

Michael Jarrell is an internationally acclaimed Swiss composer whose operas, such as *Cassandre*, have been performed in major opera houses. He has been honored with several awards. In addition, he holds teaching positions in his hometown of Geneva and in Vienna.

THE LAST 36,524 DAYS OF THE OPERA OR, THE CONDEMNED LIVE LONGER

Georg Friedrich Haas

Many people believe Neue Musik has been dead for a hundred years. In the 1920s of the last century, music lovers understood that the days of intellectual experimentation were over and a new era of a less anemic modernism was dawning. Later, that "new music" was killed by the Nazis and the Stalinists, because, in their violent worldview, it was "degenerate" or bourgeois.

After the Second World War, Neue Musik was artificially kept alive in tiny circles (in Germany, for example, in the cities of Darmstadt and Donaueschingen). In the meantime, "moderate modernism" was bursting into vibrant life across concert halls and radio stations.

In the 1970s, I learned at the conservatory that the "really new" thing was to no longer want anything new. (This delightful paradox, however, had the slight disadvantage of not being true. After all, music that was not new has been composed at all times. It's just that it always fell into oblivion right away.)

In the 1990s, Neue Musik was so dead that a couple of extremely savvy composers felt compelled to invent a "second modernity." In the twenty-first century finally, a broader interest in dead new music emerged: the concerts in Donaueschingen are sold out months in advance, the Darmstadt Summer Courses are hopelessly overcrowded, and festivals such as Wien Modern or Musica Viva attract a wide and regular audience. Personally, I also have ample opportunity to feel how dead that new music is, for example, every time I work on my worlds of microtonal harmony.

Irony off.

Opera is no more dead than Neue Musik. There will always be people who are captivated by the magic of opera and music theater that is interpreted right before their eyes and ears by living, real people. Just as there will always be those who seek to experience new musical sounds and forms of expression.

Interestingly, the current repertoire of opera houses is largely comprised of music from the past—magnificent music that still touches us deeply from across the distance of centuries. Unfortunately, many of the messages conveyed by these works can no longer be understood without analogous transposition to our current reality, and we perceive only vaguely their relevance from a great historical and cultural distance.

Some of the concessions that were made to the taste of the times or to censorship are unbearable today. I cannot listen to *The Magic Flute*, for example, without feeling deeply pained by some of the hideous lines that are uttered to the sounds of its divine music. This music cannot and must not be tampered with, and the libretto can hardly be changed without harming it in the

rocess. At this point, the scene has to step in and create the distance that, in spite of it all, allows ... to appreciate the truths that Wolfgang Amadé Mozart revealed in his works.

Within a repertoire that consists mainly of pieces that have long become familiar fixtures, it is a sheer necessity to inject into the performances the explosiveness, radicalism, and innovation that was an integral element of these operas when they were still new. The ideal case of a provocative production is far more in line with the concept of fidelity to the original than one that merely amounts to pretty illustration. However, just as with Neue Musik, it isn't always easy to distinguish the disturbingly new from the unsuccessful in opera direction. But bad art is not a problem; it fades away on its own.

If an opera is composed *today*, it doesn't need dramaturgy that translates its message for the present age. Because it *is* the present. It needs a direction that understands the written work and allows it to become a reality on stage—no more, no less. Unfortunately, this has to be achieved within an organization that specializes in looking at every existing score in a completely new light as a matter of principle; in exploring aspects that almost certainly never even crossed the composer's mind; trained, for decades, in keeping a critical, at best affectionate, distance to the actual content of the score.

Some of my colleagues react to this situation by composing soundtracks that can easily be added to any production—and are then proud of the fact that their art is somehow "practice-oriented." I certainly don't begrudge them their short-term success.

But it makes me think of György Ligeti who once couldn't resist the temptation to grab one of the dummy guns lying around on the stage floor during the final applause and point it at the director (and at some of the singers). And it reminds me of Kaija Saariaho's pained face when she recounted in a conversation how the content of one of her operas was turned on its head by its direction. I remember productions of my operas where "directorial ideas" completely or partially ruined my music drama, deprived the singers of the fruits of their painstaking and precise work, and denied the people in the audience a potentially intense experience.

Because I know how huge and powerful the musico-dramatic potential can be that unfolds when the scene and the music join forces and combine their energies. I was fortunate to experience this during the staging of some of my own works, for example by Stanislas Nordey in Paris, Oslo, and Graz in 2008, by Graham Vick in London and Berlin in 2015, and by Immo Karaman in Klagenfurt and Dijon in 2019. And so, I am basically optimistic about the future. Because opera is just as vibrantly alive as Neue Musik, the two can come together. They will find each other.

A hundred years from now, Neue Musik is going to celebrate the bicentennial of its death. With premieres of works whose sound worlds we cannot even dream of today. And then, the next last 36,524 days of opera will commence.

If, that is, our world is not destroyed by disaster first. Because then—and only then—will there be no more new music. And no opera.

One of the most important contemporary composers, Georg Friedrich Haas was born in Austria, lives in New York, and teaches composition at Columbia University. His works are performed worldwide. Five of his operas were staged in the 2021/22 season alone, plus a new ballet at the Berlin State Opera. In a 2017 *Classic Voice* poll of the greatest works of art music since 2000, pieces by Haas received the most votes, and his composition *in vain* topped the list.

OPERA IS A
SCARY MEDIUM

George Benjamin
Conversation with Denise Wendel-Poray (July 2020)

Denise Wendel-Poray: *"Opera is a scary medium," you say, "but that adds to its beauty. It's not prepackaged; it's not frozen. It's performed live, in all its complexity. It can go terribly wrong, but when it goes well, some special communication can happen." What is it that is frightening about opera? What can go terribly wrong with opera? What are the dangers and pitfalls of the whole genre?*

George Benjamin: What can go wrong? There are so many risks associated with operatic performance that the few truly great evenings I have witnessed, in retrospect, seem almost like miracles. I have witnessed malfunctioning props, frozen curtains, collapsing sets, conductors lacking dramatic instinct, bone-dry acoustics, pretentious and mal-conceived productions, restless and noisy audiences… It takes one fuse, a single screw, a missed high note, a badly timed cough—and the entire performance is harmed and may even struggle to recover.

Considering the weight of responsibility on singers' shoulders alone, it seems astonishing that the art form can function at all. They must learn their roles by heart, projecting clearly over the orchestra without forcing the sound or exaggerating the vibrato. Diction has to be crystal clear and yet melodic arches must be allowed to soar, breathing and stamina have to be under control, the intonation secure, rhythms coordinated with a conductor maybe fifty meters away whose (hopefully) clear beat they can only glimpse in a monochrome television screen out of the corner of their eye. They are obliged to deal with costumes and sets, act convincingly and subtly, move their bodies and limbs adroitly while connecting their own interpretation seamlessly with the director's vision for the whole work. Beyond all of this, there is that intangible extra element—"ingredient x"—whereby, through sheer talent, mastery, and force of personality, singers are able to seduce the audience into the heart of a work, a place where the listener can lose awareness of both time and space to enter a form of transcendental suspension.

So, it is a challenging form.

But this sense of danger—even if only felt subliminally—is also opera's secret weapon. As every beat of the score unfolds, and the production progresses second by second, an all-encompassing tension unites performers and public. A profound and sustained silence within a full opera house—one of the world's most beautiful sounds—is a sure sign of the medium's potency when all its elements fuse successfully.

What are the pitfalls for you as a composer and conductor?
At the London premiere of my first operatic piece, *Into the Little Hill* at the Royal Opera

House's Linbury Theatre in 2008, there was a sudden power cut a few minutes into the score. Performers and audience waited in total darkness for what seemed ages; eventually ushers—armed with torches—moved everyone out into the foyer. Hours later, the electrical problem persisted and so, thanks to determined musicians and a very patient audience, the performance was eventually given in the theater's bar, ending around midnight.

A few years later, at the Royal Opera House's main stage, I had to conduct a performance of my *Written on Skin* with two protectors (the work's baritone role)—one miming onstage, suffering from a very bad sore throat, the other singing with a score from the edge of the stage.

Conducting at the climactic mid-point of *Written on Skin* at its Dutch premiere, I became aware of a plethora of wrong notes in the orchestra and then instruments dropping out, one after one, until all that remained was an embarrassed silence. The orchestral lighting in the pit had accidentally been switched off and the players could not see their music. I shouted with maximum force, "We need our lights please" and in a matter of seconds all was restored, though my use of the word "please" apparently caused more than a little amusement amongst the Amsterdam audience.

As for potential pitfalls for a composer—they are surely too many to name, though I will mention three which have very much concerned me:

- How to approach narrative in a way that seems authentic to the twenty-first century, without invoking naturalism, romanticism or expressionism (in this matter, and so much else, collaboration with an inspired and imaginative playwright has proved absolutely essential).

- How to musically support and underpin vocal lines—without blatant instrumental doubling or a restricted harmonic language—in order to help singers to find their notes (and therefore avoid the distorted vibrato which results from pitch insecurity) as well as exploring the fertile interface between vocal and instrumental harmony.

- The challenge facing any opera composer of any age: how to maintain diversity—in characterization, invention, momentum, color, and contour—to reflect the ever-developing drama (and arrest potential boredom) while still sustaining unity of idiom, tone and atmosphere from first till last bar.

You refer to "performed life"; this is how the Athenians thought of theater as something relevant to their everyday lives, something they could learn from. Is this possible with opera?
Yes – and a very substantial "no" as well. For opera is the art form most distant from "everyday lives." What could be further from normal life than a tenor and soprano ululating in a foreign language while facing a silent though animated conductor, with dozens of noisy (though barely visible) instrumentalists blowing, striking, and scraping meters beneath their feet?

And we do not usually sing in "real" life. At moments of ecstasy or grief it seems natural—even essential—to burst the frontiers of speech into song; when we comfort an infant

or mock an adversary—or, as part of a group, we pray, march, labor or celebrate—the urge to sing is often hard to resist. But it's not our habitual means of communication.

Singing exalts words, transmuting them into another dimension of expression; it extends both their meaning and their sound, contorts their rhythms, and exaggerates their consonances and vowels. And when the sumptuous continuum of instrumental sound is added, we enter an abstract world of great richness though ever further from reality.

At the same time, we tell stories in operas, myths and tales about human beings; in its greatest manifestations, opera speaks of the deepest within us, confronting us with essential truths about our nature and existence. For many, despite its innumerable (and constantly mutating) codes of communication, opera paradoxically seems to achieve this with greater force and immediacy than any other art form. However, I remain reticent about the use of the word "learn"; opera is not the best medium to preach manifestos or pronounce sermons—far from it—and in any case, I am allergic to didacticism on the stage.

Live performances have been silenced now for several months; how do you see opera moving on from this dark watershed in its history and our world?
We are living through a strange and disquieting period; as I write these words, the unhindered resurgence of operatic life still seems very distant. This is causing untold frustration and anguish to everyone involved in this world, though out of such challenging times, creative renewal can be engendered, and I am optimistic that live opera—having survived dictatorship, fascism, war and famine in the past—will flourish again.

And as for new Music-theater, issues of environmentalism, racism, populism and resurgent nationalism have strongly come to the fore during the Covid-19 crisis; from such pressing dilemmas, creative thought will expand and diverge; certainly some of it destined for the lyric stage.

English composer, conductor, pianist, and teacher, George Benjamin is well known for operas *Into the Little Hill*, *Written on Skin*, and *Lessons in Love and Violence*—all with librettos by Martin Crimp.

BETWEEN PERFORMANCE ART
AND OPERA: A COMMON GROUND

Laurie Anderson

Conversation with Denise Wendel-Poray (February 2022)

Denise Wendel-Poray: *You are one of America's most renowned and daring creative pioneers, known for your multimedia presentations and innovative use of technology. As a writer, director, visual artist, and vocalist, your groundbreaking works span the worlds of art, theater, and experimental music. What have you learned from your fifty years of making art that could inform us about strategies for the future of opera?*

Laurie Anderson: I've never liked opera in the traditional sense or that way of singing; I'm more interested in opera in the broader sense of the word—a work. I'm preparing a new show for Manchester International Festival, which I'm calling *Ark* and am referring to as an opera. When it comes to opera, the fact is that once an opera house is built, it tends to stay there, and people tend to try to fill it with something and think that that's an important thing to do. I've been interested in works that can be heard differently, in different venues, and I think this could be interesting for opera as well—getting out of the traditional theater.

Going back a few decades and to traditional theaters, your performance piece United States *opened the Brooklyn Academy of Music on February 3, 1983. The work was divided into four parts, comprising seventy-eight titled segments, some musical and some spoken, and it took eight hours, split over two nights, to perform. Was this not getting very close to opera?*
I guess it was the closest thing to opera I've done and it was much more conventionally staged than performance art usually is. Because of the proscenium there was a clear divide between the performer and the audience, like in traditional theater.

Your voice, the operatic dimensions, a narrative about the profound disaffection and disenchantment of our society, a cri de coeur *against the progressive dehumanization of the world.* United States *was revolutionary.*
I was in my time, and in that sense, it wasn't really revolutionary. I was very influenced by Bob Ashley, his television operas and other theatrical works, his use of electronics, extended techniques, unorthodox methods of singing or of playing musical instruments, unusual sounds, and timbres; it was a surreal, multidisciplinary approach. *Automatic Writing* (1979) and *Perfect Lives* (1983) are my favorite operas because his way of using the spoken word musically is astounding. *United States* also involved intertwining narratives and use of electronic instruments—vocoder, harmonizer, synclavier—but it's not an opera; it remains a performance piece.

You were invited several times to the Festival d'Automne in Paris, where you had tremendous success, in particular in 1999 with Songs and Stories from Moby Dick, *a ninety-eight-minute performance that some referred to as a techno-opera. Opera or not, you had a supporting cast—a bass player and four male singing actors who take on several roles of shipboard characters; how do you like working with others on the stage?*

I do like it a great deal, but it's also crucial for me to keep the element of improvisation; this is an essential part of my practice. It's harder to do this with a bigger group where things have to be more scripted. I've been experimenting a little with a piece for Denmark for the CLICK Festival, which takes place in the Culture Yard, an old shipyard in Elsinore harbor. It's a complicated vocal/spoken piece, divided into four groups, all wearing earphones, and you hear it on headphones as well—perhaps this technology could be interesting for opera. There have been important explorations at CLICK between science, art, and technology and a broad interplay between Danish and international artists, researchers, and students.

Technology can certainly play a role in opera; for example, the American stage director, playwright, and artist, Jay Scheib will direct a virtual reality Parsifal *in 2023 in Bayreuth. You were head of the jury of the "Immersive" section of the Red Sea Film Festival in Saudi Arabia alongside BAFTA winner Victoria Mapplebeck and Saudi street artist Sarah Mohanna Al Abdali. What is the potential of virtual reality?*

The potential, I'm not sure, but I do recognize something in it that has become more and more important to me, which is the body. For example, when you're in a movie, and you really love the film and are really engrossed, and afterward you get up and say: where's my coat and you feel a bit lost. With VR, it's the opposite, you need to use your body; you need to turn your head, move your body, get up walk around. I can't say what its potential will be, but in immersive film, you need your body to participate, and this is new. I would say that opera is the same; there have been many operas you walk through. I'm not against sitting in your seat; I mean, I think you can have a very intense mental experience by doing that. But I am more interested in things that you can walk through, much more of an installation than a work made for stage. I think it's a wonderful road for opera as well to be inside the drama and it can be very thrilling. We don't know yet to what extent VR will work in different domains, and of course, it's very much a question of economics and presentation.

With the pandemic, we've learned a lot about virtual performances, staying put, and streaming rather than physical presence.

One of the things we've learned in the pandemic is that there are other ways to do things and different ways to communicate. With regards to opera, it's time to think about resources, and opera sucks up massive resources: choruses, costumes, the opera houses, all very beautiful and elegant, but they are on their way out, I hope. People traveling around the world, carting all their things here and there. On the other hand, the pandemic made me appreciate live events even more. Paradoxically, I love doing things live, and at the same time, I like being able to communicate electronically. I'm trying to be open to both, so it will be interesting,

and I have no way of predicting which way it will go. Many musicians I know who have not been touring for a couple of years are thinking, of course, we want to get back on the road and see live audiences, and at the same time, many are trying to find alternatives to that. So the question is, do I absolutely need to bring my music to your town, take a flight. Is that really important? So I've been experimenting with things that are next door.

At the same time, I recognize that nothing can replace actually being in a place. In Saudi Arabia, for example, for the film festival, women on the street would come up to me and say, "Would you like to come home to dinner?" So that's my hesitation about saying we shouldn't travel—you won't get invited by a woman with a veil.

Opera is very much about the moment and the occasion; it's hard to replace that with online.
I'm thinking about opera live broadcasts; there is a lot of experimentation with that, live opera being done in one place and heard elsewhere. I mean, you still have that sense of occasion that you don't want to give up. For example, when I did the Norton Lectures, I didn't want to put them online until the end of the series because I liked the idea of showing up somewhere at a specific time, I wanted at least the illusion of occasion by setting a time and doing it then, rather than just having things available around the clock. It was kind of sad because I wasn't able to do a lecture before a live audience until the last one, and only eight people were able to attend. But what finally changed my mind about putting the lectures online was that I needed to see Agnès Varda's 2018 Norton Lectures, and there they were online.

Varda broke the barriers between film and the visual arts; I loved Faces Places *or* Visages Villages *in French, the film she did with French photographer and street artist J.R., traveling around rural France, creating portraits of the people they came across.*
I've noticed that especially the French are very good at this: a French village, short stories in the tradition of Balzac, strung together, which is a very interesting way of thinking rather than jamming it all into a long film or jamming it into an opera of four-five hours.

I was wondering, regarding the places you're going, like the Manchester Festival and the CLICK Festival, Saudi Arabia, how are people on the ground reacting in those contexts? Do they understand your work?
I've worked many times at the CLICK Festival, and they are incredibly open, flexible, technically excellent. Recently, it was a bit of a strange situation because the director said: I need to spend a pile of money in December, what can you do to help me. So I came up with that project involving a talking orchestra with headphones. It must have been quite a slush fund because it covered headphones for fifty people, directors, he had people, actors, musicians come in from Copenhagen. I learned a lot in doing this, and I dug that he understood electronics; you didn't have to start all over with him.

I made a similar proposal to an unnamed museum here in the United States, and they didn't understand at all what I was talking about. Headphones why? Fifty people from the scene: visual artists, actors, writers, musicians, who all know each other, there's a scene? They

had no idea. They simply don't have a Rolodex like that; they don't know any artists. But that tells you how things are put together in a much more corporate way here—over-curated rather than artist-run exhibitions.

Perhaps operas have become too corporate as well, which is why they are out of touch with wider audiences.

Yes, and a shift in audience could make opera a different thing. I went last night to a New York Phil concert that had some interesting things: Beethoven, Berlioz, and counter-tenor Anthony Roth Costanzo, a newly commissioned work and a piece by American composer Julius Eastman, *Symphony No. II - The Faithful Friend,* which was truly amazing. So, I think the curating of this kind of thing is getting to be pretty exciting, and there's a lot of branching out. The New York Phil did this kind of Cabaret thing also with Anthony Roth Costanzo and Justin Vivian Bond called *Only an Octave Apart.*

Do you think that opera can carry a political message, as many of your works do?

I do many things that are in the world of melody and color where you'd be hard-pressed to say what they are about. So, in some ways, a work can be political, and in other ways, it can remain quite opaque. I am very interested in works that unfurl in a narrative way, like *Manifesto: Art x Agency*, an exhibition at the Hirshhorn Museum that examined the art-historical impact of artist manifestos from the twentieth century to the present day. Based on German artist Julian Rosefeldt's film *Manifesto*, starring Cate Blanchett, at the Hirshhorn, it was presented as a multi-channel film installation, exploring how artists used manifestos to engage with the political and social issues of their time.

Art as a tool in shaping history. You've invited Afghan conceptual artist Rada Akbar to present work in conjunction with your Hirshhorn retrospective exhibition, The Weather. *Could you tell me how this came about?*

I met Rada recently in Paris, where she is living in exile—there's another good example of being somewhere else and meeting someone, so again, I break my own rules. Several of her friends have been left behind in Afghanistan and killed. She makes dresses; her sculptures are dresses. We will be having a discussion on International Women's Day on March 8. It's improbable that we'll be physically together for that, so it's once again a situation where we collaborate without being in the same room. The talk is a run-up to *A Fashion Show for Spirits* at the Hirshhorn featuring her clothing/sculptures. It's part of an ongoing project, *Abarzanan*, which means "Superwoman" in Dari Persian. It explores the issues of women and power, perception, and photography and will come together with my *Fully Automated Nikon* from 1973, currently on view in the Hirshhorn retrospective.

We met through New York-based producer Neal Goren who founded Catapult, *an online opera series featuring fifteen-minute operas, many commissioned from singer-songwriters from the world of popular music. Could you tell me about your work for* Catapult?

They asked me to do something, and I said, I can't compose anything resembling traditional opera, but what about a soap opera and Neal said fine, so that's what I'm hoping to do. And that's been great fun; it's on a "green screen," which involves filming a person or adding visual effects in front of a solid color. Then, by digitally removing or "keying out" that color, you can drop that scene onto the background of your choice in postproduction. So in the end, it's a little film with singing. Is it an opera? Yes, unless you require opera to have a big stage, a stage manager, orchestra, singers, and the works.

What if you were asked not to compose a new piece, but to direct and design one of the great classic operas in a traditional theater, Le Cid, *for example—the opera which inspired your first international hit "O Superman?"*
I would jump at the chance.

cꝛ

American artist, composer, musician, and multi-media artist, Laurie Anderson was initially trained in violin and sculpting. She pursued a variety of performance art projects in New York during the 1970s, focusing particularly on language, technology, film, and video. She became more widely known outside the art world when her single "O Superman" reached number two on the UK singles chart in 1981.

"WE NEED TOGETHERNESS, NOT SEPARATION. LOVE, NOT SUSPICION. A COMMON FUTURE, NOT ISOLATION"

Hans Ulrich Obrist
Conversations with Denise Wendel-Poray (January and May 2020)

Denise Wendel-Poray: *You have been a champion of the artist and political activist Gustav Metzger (1926–2017), who spoke out about, not only the biological extinction of our species and our own demise, but the disappearance of cultural phenomena. Opera is a four-hundred-year-old cultural phenomenon, a living archive of our common history and memory; it is also at risk of becoming a commercial machine producing only a small fraction of the existing repertoire, mainly the late nineteenth-century favorites for elite audiences while forgetting the other three hundred years and contemporary works. How can Metzger's thinking help us?*

Hans Ulrich Obrist: We worked with Gustav Metzger at the Serpentine Gallery for almost twenty years. Before 1996, Metzger was at the heart of my *Life/Live* exhibition at the Musée d'Art Moderne in Paris; it mapped out and celebrated the British artist-run spaces of the 1990s. At the Serpentine in 2009, we did the first extensive exhibition of his work in the United Kingdom. It included the auto-destructive and auto-creative works of the 1960s, the *Historic Photographs* series, which responded to major events and catastrophes of the twentieth century, and works exploring ecological issues, globalization, and commercialization. Metzger always said that artists should address the dangers that society faces. That's why he asks the art world to use art agency to get people to wake up to the threat of destruction, saying at the opening of exhibitions that destruction is taking place in and of nature at an unprecedented rate. So, his was not only a wake-up call for climate change but also for extinction. Following the exhibition in 2010, there was a two-day conference on the subject of extinction, the *Mass Extinction Conference: A Call to Act*.

At the Serpentine Gallery, we have appointed a curator of General Ecology. Ecology has to be at the heart of everything we do; the commitment must be in every aspect of what we produce. We launched a General Ecology Project to address the environmental debate inviting artists to create work in collaboration with specialists from other fields, musicians, scientists, and writers. One project was the opera *Time Time Time* by composer Jennifer Walshe and the philosopher Timothy Morton. It explored the multiplicity of temporalities at the heart of being human: ecological time, evolutionary time, time travel, longitude, time expansion and contraction, alternative timelines, and parallel universes.

With regards to opera, you have to consider the notion of ecological time, "slow programming," longer duration projects, which expand beyond the museum's conventional

confines and opera houses and create different rules to the game. Very practically, we have to think about the impact of what we do. In our field, it's not only about reducing travel but also about inviting local resources. That is why we came up with an exhibition called *do it*, which began in Paris in 1993 with Christian Boltanski and Bertrand Lavier, where artists conceive instruction recipes and how-to manuals with which a work can be realized and done again and again—reinterpreted.

Pierre Boulez wrote in 1963: "Why compose works intended for each individual performance? For me, the pre-determined performance no longer coincides exactly with the current state of musical thought, with the evolution of musical technique which, frankly, turns more and more towards the search for a relative universe, towards a 'permanent discovery'—comparable to a 'permanent revolution'." This idea of permanent discovery was significantly developed in Boulez's artistic project but has never really been applied to opera.

In opera, this could develop into a global dialogue with one work interpreted in different ways by local protagonists. In practical terms, rather than having these tours, maybe you could apply the *do-it* idea whereby the score itself could evolve and adapt to the context and the local artists.

You speak of global dialogue; one of your mentors was the Martinican writer and philosopher Édouard Glissant. How can we develop a global dialogue in opera? How can we apply Glissant's "archipelagic thinking" to opera? How can opera, which is anchored in European culture, show the world's diversity?

I think that we could apply the methodology of Glissant to opera. I met him in the early 1990s, and since then, he has been a guide—he died in 2011. His writings are like a "toolbox" that I reach into every day. Glissant distinguishes two kinds of thinking: "continental," which functions through self-reference and demarcation, and "archipelagic," which is manifold and does not systematically delimit, divide and differentiate cultural differences. In archipelagic thinking, culture is a constant exchange and mixing process. Everything is related to everything and must always be thought of in its diversity—just as the boat routes of the Caribbean archipelago create a network of exchanges.

The traveling exhibition *Cities on the Move*, which I curated together with Hou Hanru, was based on Glissant's ideas for forms of global exchange that do not homogenize culture. The exhibition toured to various locations for two years, starting in 1997 in Vienna. It traveled to New York, Bordeaux, Denmark, Bangkok, and other places. It involved architects, artists, filmmakers, and designers and attempted to recreate an ever-evolving city within a given space. What we wanted was to create an oscillation between the exhibition and the venue. There was a program of performances, screenings, and discussions that evolved depending on the place. This approach could function in opera as well. In a Glissantian way, my exhibitions would always continue to evolve; they would go from city to city like *do it* and learn from the context involving local artists. Perhaps there can be a Glissantian way to do opera. Taking the same opera, cast, and so forth, from one city to

the next is hugely problematic because it is a form of homogenization. What about using local artists and not just flying the production in.

Another inspirational figure for you who is more directly linked to opera is the Russian impresario Sergeï Diaghilev (1872–1929), founder of the Ballets Russes.

Yes, because though it was not recognized at the time by that name, Diaghilev's was a completely interdisciplinary form of curating, which is what I try to do. He hugely expanded the scope of ballet, which was not an independent art form at the time, by bringing together the greatest artists, composers, dancers, and choreographers. Diaghilev was my inspiration for *Il tempo del postino*, a group show, which I co-curated with Philippe Parreno and that was first given at the Old Opera House during the Manchester International Festival. It featured performances by artists Olafur Eliasson, Koo Jeong A, Dominique Gonzalez-Foerster and others, fifteen in all. Later in Basel, there were new contributions, one by Thomas Demand and one by Peter Fischli and David Weiss. The idea we had together with Philippe Parreno was to ask: What if an exhibition was not about occupying space but about occupying time? Each artist had fifteen minutes on the stage: there was an atonal composition by Liam Gillick, a dance of the curtains by Tino Sehgal, Doug Aitken produced a piece in which three cattle auctioneers gave a non-stop bidding war, Olafur Eliasson's *Echo House* involved a mirror coming down in front of the stage reflecting the audience while the orchestra played back to them the sounds they were producing.

But to achieve something like this, you need theater directors who are willing to take the risk, like Gerard Mortier. Regarding *Il tempo del postino*, most directors were not open. We discussed the project with Mortier, who liked the idea but said at the time that the Parisian public was too conservative for this kind of thing. Alex Poots, who ran the Manchester International Festival at the time and now runs The Shed in New York, supported the project.

Another collaboration with Alex Poots was *Richter Pärt*, a work developed for the Manchester International Festival that featured a choral composition by Arvo Pärt performed amidst Gerhard Richter paintings, including his wallpaper and his Jacquard tapestries. At The Shed, this became *Reich Richter Pärt*, an immersive live performance and exhibition in two parts, which brought together the *Richter Pärt* with a new collaboration between composer Steve Reich and Richter. Both works explore the shared sensory language of visual art and music. The *Reich Richter* collaboration, a Shed commission, draws connections between Richter's mathematical formula for his "Patterns" series and Reich's rigorous, repetitive musical structures. This was performed in synchrony with a moving picture work by German filmmaker Corinna Belz.

Steve Reich is featured in your book A Brief History of New Music, *which includes interviews with Pierre Boulez and avant-garde composers Elliott Carter and Karlheinz Stockhausen, as well as pioneers of electro-acoustic music Pauline Oliveros and Iannis Xenakis. All of these composers experimented at once with the transformational power of music and non-conventional*

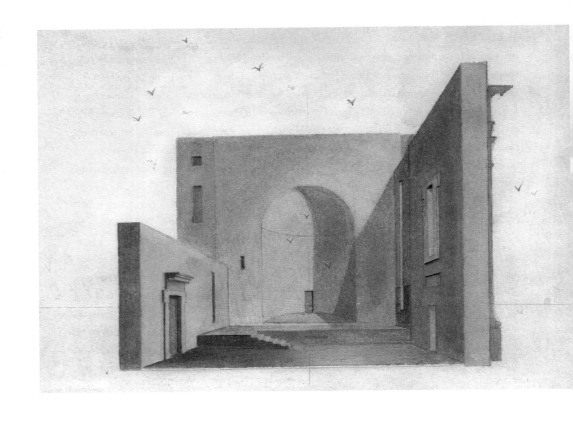

Richard Peduzzi,
Untitled, 2013
Watercolor on paper,
22 × 30 cm
Design for *Elektra*, Richard
Strauss, Festival d'Aix-en-
Provence, 2013.
Director: Patrice Chéreau
Courtesy of the artist
© Richard Peduzzi

venues for their performances. I wonder how much the formality and ritual of opera houses are conducive to experimentation.

You have to open up the opera house. One concrete example is the *Museum in Progress* (https://www.mip.at) projects that began in Vienna in the 1990s, which used techniques to overcome the distance between everyday life and places of art to reach a far broader public than traditional museums. It developed new ways of presenting different forms of art in cooperations between economy, art, and media. I'm thinking about how Xenakis worked together with science, with music, with architecture; he worked first with Le Corbusier and later with Messiaen. I was also very interested in Stockhausen, Éliane Radigue, as well as Pauline Oliveros, who developed the practice of Deep Listening and Sonic Awareness, or the ability to consciously focus attention on both musical and environmental sound.

Technology could play a more significant role in opera. It's not surprising that the big "unrealized project" of Xenakis *Robot Opera* was an opera with robots. In the 1960s, *Experiments in Art and Technology (E.A.T.)* developed collaborations between artists and engineers. Two Bell Labs engineers, Billy Klüver and Fred Waldhauer, joined forces with artists Robert Rauschenberg, John Cage, Robert Whitman, and others to form the *9 Evenings: Theatre and Engineering*, which led to the creation of the "Experiments in Arts and Technology" organization. The group expanded the artist's role in society and explored the separation of the individual from technological change. It would be fascinating to see how we could bring such a polyphonic project into mainstream opera houses. How could a *New Experiments in Art and Technology* function in the opera? What about an Artificial Intelligence Opera? Perhaps you need an artist who doesn't just come in for one production but who works as a permanent member of the theater's direction team.

A lot is possible, but it seems that we take steps forward, and then it all moves back—action/reaction. When you think about revolutionary American projects like Experiments in Art and Technology, *how radical they were, how they were possible despite the censorship of the Cold War and then when support for public art dwindled in the 1980s, how they disappeared; how can we adapt our institutions now in the wake of Covid-19, which is ravaging the performing arts, to achieve positive and sustainable developments?*

It's a dramatic time and a time of precarity for artists and everybody. We need a New Deal for the arts. We need an art stimulus project on the scale of the Works Project Administration (WPA) introduced in America in 1935, a New Deal Agency which employed millions of job seekers during the Great Depression. The WPA included musicians, artists, writers, actors, and directors who were engaged in large arts, drama, media, and literacy projects. The idea is highly relevant for the current moment, both in terms of supporting the economy and of helping and caring for artists. We have to look to the American Pragmatist philosopher John Dewey. His book *Art as Experience* (1934) advocates a continuity between the refined and intensified forms of experience attributed to the work of art and the everyday events that form our experience. It is a manifesto for the democratization of art and was one of the many

primary inspirations for my own *do it* exhibition project. It's particularly urgent right now that art institutions find ways to go beyond their walls and reach everyone. If there was ever a time when the world needed visual artists, musicians, actors, opera singers, it's now. It's our collective responsibility as public institutions to support artists by making our platforms available to them in the interest of free expression, truthfulness, and a hopeful future. As the artist and poet Etel Adnan says, "We need togetherness, not separation. Love, not suspicion. A common future, not isolation."

Swiss art curator, critic and historian of art, Hans Ulrich Obrist is artistic director at the Serpentine Galleries, London. He is the author of *The Interview Project*, an extensive ongoing project of interviews, as well as numerous books including *Ways of Curating* (2016). He is also co-editor of the *Cahiers d'Art* review.

OPERA, THE ULTIMATE FREE SPACE

Tilda Swinton
Conversation with Denise Wendel-Poray (May 2022)

Tilda Swinton: When I even begin to think about my relationship to opera, I realize it's such a nascent thing. I only came to know opera a little, I guess, about twenty years ago. What I value it for is partly that it's all about impossibility. The impossibility of expressing one's deepest emotions. There is no articulacy, there's nothing to follow, there's just a sense of abandon, it invites you to abandon yourself. It's not an intellectual exercise, that's what I really love about it. And I have no doubt that there is an intellectual aspect to opera and that people write very intellectually about it and think and argue very intellectually about it, but for me it has more to do with the Id than the Superego.

Denise Wendel-Poray: *The instinctual part of the mind rather than morals and values.*

Its foundational battery is inarticulacy and, since that's the principal reason why I'm interested in being a performer at all, it chimes a deep bell in me; a performance that is built on an idea of perfect fluency holds no real practical inspiration. And it's the acknowledgment that it's actually just a gesture built on an expression—where one expresses one's full heart —that really speaks to me; the jewel of all art, let's face it, is that it's built on that premise of impossibility, or at least extreme difficulty. And maybe this is true in opera more than in other art forms. The fact that someone has to break into song to communicate their heart brings this impossibility to the fore.

In much of opera, you have to intentionally avoid critical thinking or logic to embrace the unreal or impossible; it's the willing suspension of disbelief.

Unreal and inarticulate; for me, an artist in any field who glosses over or suppresses inarticulacy or pretends it doesn't exist is missing the trick, which is that communication to one and other, with one another, is incredibly complex. I believe that communicating the uncommunicable is what art is for, to put it in simple terms, and opera really goes for that; I mean, it really shines all the light in all the corners. And builds its house on the attempt, this humble acceptance that it's almost impossible to be understood but will give it a try.

What moves me about opera, and this is coming from someone who does appreciate language very much, is how the words are bottom of the pole in terms of this search for meaning and communication. Not only because we're often dealing in different languages, and it's often very difficult to hear them, and, frankly, the words are often pretty unsophisticated—just someone shouting "I love you" over and over again—but this moves me because

it is clearly at that moment impossible to say anything else. So, saying it over and over allows it to lift up out of the lyrics and into the music. It has such élan, it is such a hopeful gesture, for the creators of opera to say that the words just won't cut it, we've got to go HERE. And I say this, aware that I don't know enough about how operas have been traditionally constructed to say how often the music comes first and the lyrics come after.

It's the famous argument "Prima le parole, poi la musica or Prima la musica poi le parole." The relative importance of the words versus the music in opera has been contested from the very beginning. But the weight of each component has shifted back and forth, often provoking operatic "reforms" such as Gluck's Orfeo. *But opera was founded on an ideal balance of the two. For me, the composers who have best achieved that balance are Monteverdi, Gluck, and Benjamin Britten.*

As a toddler opera lover, I'm already aware of why I love Benjamin Britten so much. It's something about the passion, the lyricism, the blood—*Peter Grimes*, for instance—that filters through this somewhat Plantagenet English sensibility. Not only in terms of the vernacular of the music but also in terms of the narrative, that pressure cooker building up.

There's this audibility, almost rawness of the words in works like The Rape of Lucretia *or the poems of Wilfred Owen in the* War Requiem.

Jarman

I had two magical encounters with opera thanks to Derek Jarman, the first in 1988 for an opera by Sylvano Bussotti, *L'ispirazione*, at the Maggio Musicale Fiorentino, and that same year, we began shooting Britten's *War Requiem*. In *L'ispirazione*, I played a character called Futura; she uses *Sprechgesang*. The thing was, we went into rehearsals, and no one had explained to me that when you do an opera, you arrive and everyone already knows their parts. And there was, naturally, the assumption that you could read music. I thought it would be like theater, it was at a time when I was still working in the theater, and my memory of that was fairly fresh. So, I thought that we would all sit around a table to discuss and tease it all out gradually. But instead, there was someone at the piano and someone with a baton—the score with fifteen rungs on the ladder and GO!

Sounds like a nightmare!

It WAS a nightmare! It must have been very amusing for the others there because it was certainly a long time since they had been with someone who had no clue about opera. But then I worked with a coach, and I came to love the production and working with the music. It was an early moment of realizing how the anchors for me in performance are different from those described by what I refer to as "real actors." I don't recognize my own practice in that of most actors, but when I talk to dancers or musicians, and singers, I recognize myself more closely. The dancers work with space and the musicians with rhythm; I realize I fall somewhere in between.

If you take something like Apichatpong Weerasethakul's *Memoria*, the presence I provide in that film is much closer to dance than anything else in my knowledge. Because of the importance of the sound and the score in the experience of the film, which is more closely attached to what I learned on that first day with the role of Futura. That was like the thick end of a wedge that I've been working away at traveling along all these years, towards an ever finer point.

The End

Interestingly enough, the film I'm preparing for next year is a musical directed by Joshua Oppenheimer about the end of the world. Joshua made two documentaries, *The Act of Killing* and *The Look of Silence*, about the perpetrators of the 1965 Indonesian genocide, in which over one million people were murdered. This is his first non-documentary film. It is called *The End*, and it's about the last human family, living in a bunker twenty years after the world has ended due to environmental collapse. Getting back to what we were saying earlier about communication, this is about people finding communication with one another very difficult. And it's during those moments, when they can't express themselves with words, that they break into song.

I particularly like that it's a small cast of seven people: mother, father, girl, boy, friend, doctor, butler. And not one of us is a singer, and I'm so happy about that because we're all going to be working with our own voices. The music by the American composer Josh Schmidt is incredibly difficult, and I say this with real glee—incredibly difficult. So exciting.

What have you received so far; do you have a score?
Just one piece, and though we won't be shooting until next year, I've been studying with a vocal coach on and off over the last year or so. I'm loving it because it is such mysterious territory for me, and I relish learning new things. I've just been working with that one piece, but it's perhaps the most difficult one. A concern I have is what I refer to in my learner's language as "the shelf," you know, that shelf between the speaking voice and the singing voice, and that rather than leaping over it, I want to crash through it. I talked a lot to my voice couch, Fiora, about it, and she assures me that you can crash the shelf, which is what I want to do. For that, we are building up my muscles around the shelf. She's been encouraging me when I wake up in the morning, and things are the most relaxed to play with it, in a sort of a yawning position. I suppose not only to build up my muscles but to build my confidence of being there, on the precipice, not to avoid it. Anyway, to me, this is all so fascinating. So not having sung before, even though I played with *Sprechgesang* as Futura in *L'ispirazione*, this is challenging.

But Sprechgesang *is already very close to singing; you have to read a score, be precise with the rhythm and modulate the voice as indicated on the score*—Pierrot lunaire *is often performed by trained classical singers.*
I'm wondering how that early experience with *L'ispirazione* and *Sprechgesang* influenced my work since, as a speaking performer. I've never thought about that before, but I'm sure it's had a real effect. Frankly, I prefer not to speak in film with a script; I'm very well aware of

that, which is one of the reasons my recent work with Joanna Hogg is so valuable to me because it's all improvised—one only speaks when one has something to say. And so technically, practically speaking, it's not about, oh well, I know I have to say this thing next, so I have to fashion some kind of fakery around it coming unbidden out of myself; you are genuinely in that space when you improvise. It comes up; you don't have to wrap a pretense around it coming up. It just genuinely does come up of its own accord. And I suppose in that way, it's a bit like song: I have something I need to say to you, and out it comes.

War Requiem

With L'ispirazione, *you had to hold to the strictures of Sprechgesang in precise accordance with Bussotti's score. How did you approach the* War Requiem *by comparison?*
Derek and I had made, I guess you could call them silent films, with scores by Simon Fisher Turner that were laid on afterward. But in this instance, we knew that we wanted to make a film of the *War Requiem.* So it was made in a very traditional, silent film way, of having the score blasting into the studio as we worked.

The Sanctus

It's all about responding and having no plan, just to hear and listen and respond. It was quite a risk, only four minutes and one take. To break it down, in the film, because we imposed a slight narrative on it, I'm the sister of the soldier, and I've become a nurse. In the *Sanctus,* in this stylized Niobe moment, I'm in a state of grief and mourning, a state of emotion and expressing it in a way that the men don't in the film. And even I don't anywhere else. The *Sanctus* is a moment, a little *huis clos* of really feeling the pain. What that piece shows is the music being able to say stuff, do stuff, things that she can't reach without it.

The music unlocks something in her; she responds to the music physically, as you say in this Niobe moment, an ocean of sorrow washing over her.
It's a response to the music, and as I understand it, the music touches on all of this: there are moments of joy of absolute transport into a kind of bliss, and then there's grief that keeps on boiling up or crashing down. It's about trying to stay on the tight rope and react to the music and surf whatever it elicits.

I Am Love

With these two works directed by Jarman, you are interpreting opera and oratorio from the inside; you are one of the performers. But opera is also very present in your films as soundtrack, those of Joanna Hogg and Luca Guadagnino in particular. How does this influence you as a performer?
With Luca, by the time we began to shoot *I Am Love* in Milan, we'd been talking about the film for years and had always talked about it as having this score by John Adams, who at that point had never contributed any music to any film.

We were literally choreographing certain shots according to pieces of his music, and I remember one day we were doing a shot of me walking down the street, and just before

we rolled, Luca played me a burst of *Nixon in China* or something, and then I was walking according to this mood. Just knowing the scope of the frame with the mood of the music had a big influence. And I said to Luca, that this was getting a bit dangerous because we were becoming married to this score and if we didn't get the rights to Adams' music, it might be wall-to-wall Wagner… So I got a bit worried, and I wrote to the one person I thought would know Adams, and it reached him. We had a very nice exchange and then we met in London. It was a tense moment when we screened the film for him, Luca and I sitting behind him. We'd done this quite cheeky thing of chopping up his music, like a sort of smorgasbord of his back catalog. We weren't asking him to make anything new. And in the end, he stood up and said he absolutely loved it and gave us the rights to the music. So we have John Adams all over *I Am Love*, as we had dreamed, which is a rare and priceless blessing. And a massive relief.

The Metaverse

I wonder what's going on with opera in the metaverse. Because when you think about what we've been saying about opera, this attempt at communication built on inarticulacy, yet it's built on a kind of passionate, transformative mojo. That's all the language that the metaverse uses, and I wonder who's working on this in opera.

Opera in a virtual-reality space where users can interact with a computer-generated environment is being experimented with, but less as an online experience. The American director and video artist Jay Scheib will be doing a virtual-reality Parsifal *in Bayreuth in 2023—but this is for those present—perhaps it could have other iterations outside the opera house in a second phase.* When I think about when I was a teen or even a young adult, the lazy way of thinking about opera was this financial structure: extremely expensive, so only rich and sort of square people could go to it.

Yes, old, rich, and square. The Royal Opera House.
Exactly, that was the whole character of opera when I was growing up. The Royal Opera House and nothing else. There was no way of reaching it. Some of us who were privileged enough saw it young, and then it was relegated. It wasn't perhaps until Milan when we were making *I Am Love*, thanks to Luca, who is a huge opera lover, that I went a lot to the opera at La Scala. We saw the *Queen of Spades* and then the incredible Russian director Dmitri Tcherniakov's production *The Gambler* by Prokofiev. In the space of two months, the top of my head sort of blew off. This was my "coup de foudre"; it felt so radical! That's what I love about opera, how radical and narratively transgressive it can be.

What I'm wondering is how it can be made clear to young people that it does have that radical aspect. And that's why I thought it could even enter a kind of metaverse iteration, making its power more available—particularly its transformative power, as we described earlier. And there's that mistake about it, that it's highly material, like a castle that's unreachable, a wall that's impossible to climb. And I think dematerializing it or making it clear to young

people that that's genuinely a mistake made about it would be a major step. There are surely a lot of people working on that recontextualization, trying to infiltrate it.

Opera the Ultimate Free Space

I would think of opera as the ultimate free space. Although, on second thoughts, perhaps I would reserve that for cinema. But, maybe, let's say it's the original prototype for cinema.

When cinema was invented, some said it was the true total artwork.
Cinema takes it to the next level. There's a much closer relationship between opera and cinema than theater and cinema. I'm often impatient with forced attempts to associate theater and cinema because I feel that's a misunderstanding. I feel opera and cinema have a much closer relationship tied to something more visceral and experiential. Less literary. But in a way, to use these labels like this is unfair and imprecise of me, because lots of people are shaking up theater and taking risks in transforming its remit.

I'll never forget our night at the opera; we were there in the loge watching Robert Carsen's Wozzeck *at the Theater an der Wien. Watching you—one of today's foremost actors and filmmakers—watch an opera performance was fascinating to me. There were moments when the attention was more focused on the pit than the stage; it was equally dramatic in the pit; we were right over the orchestra.*
That evening made me realize why the variations in where you sit change the experience. From our vantage point, it becomes more refracted and messy, and for me, messy is a term of great affection. You see all the workings of it. One of the things I love is just this visual impact of seeing someone on the stage wearing anything from a Viking helmet to a massive dress. And then, in the pit, you have these modern people wearing black jackets and bow ties; in one shot, you have the modern, current practitioners weaving away. There is something about the transparency of it that is so radical and modern. The further back you sit, the more it's like cinema—only "the screen."

Classic theater architecture is anything but democratic: there is the optimal view from the royal box, then the first loge, the parterre, and then way up the steep stairs to the "poulailler" where the students and the opera fanatics and specialists cram together.
That makes me think of one of my favorite films, *The Red Shoes*. A young composer, Julian Craster, is sitting up in the Gods in an opera house with fellow students—as you say they're all complete experts. It is the first performance by their professor Palmer, and Julian realizes after the first few bars that Palmer has stolen his music. And there's a beautiful moment a little later, Julian has written a letter to the impresario of the ballet company, Lermontov, a Diaghilev character, to reveal the circumstances. Lermontov asks Julian to play one of his own works at the piano and after hearing him realizes that he was the true composer of the piece. Then Lermontov says this invaluably wise thing: " It's much worse to have to steal than to be stolen from." I think that says so much about the fragility of what we all strive for.

That takes us back to what you said about inarticulacy, the impossibility of expressing one's deepest emotions, that the jewel of art is that it's built on that premise of impossibility. And that this same chimerical quality is what makes it the ultimate "free space."

When going to an opera, I have this magical setting in my spirit, saying, "anything can happen today." And that's a great compliment to an art form that it can do that to somebody, even to someone who is an artist. There's this wonderful line in *Orlando* when she talks about being in love as like having a hook through your nose and being pulled through the waters of love; I feel like that's what my response to opera is. It is my hallucinogen of choice…

Tilda Swinton is a British actress known for her daringly eclectic career and striking film presence. She has made over seventy films and has received numerous prizes including an Academy Award, The British Film Award, three nominations for the Golden Globe Awards and a Golden Lion for Lifetime Achievement at the 77th Venice International Film Festival.

Clément Cogitore,
Les Indes galantes, 2017
Video, 6 min
Production 3ᵉ scène - Paris
Opera. Courtesy of the artist

Richard Peduzzi
Sketchbook

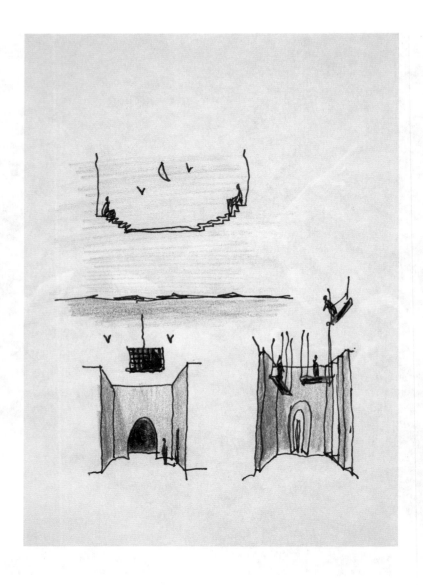

Richard Peduzzi, Search
for ideas, preparatory sketch
in disorder, *Don Carlos*
of Verdi, February 2021
Ink and colored pencil
on paper, 29.7 × 21 cm
Courtesy of the artist
© Richard Peduzzi

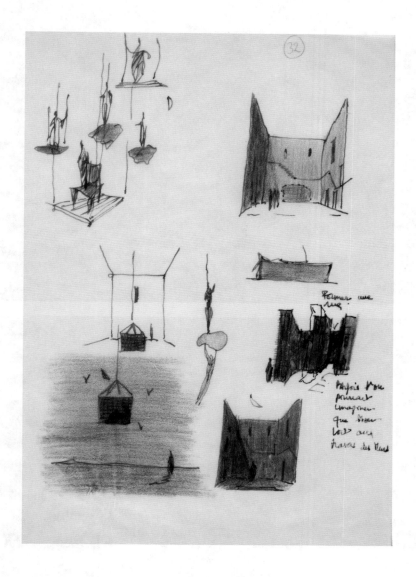

Richard Peduzzi, Search
for ideas, preparatory sketch
in disorder, *Don Carlos*
of Verdi, February 2021
Ink and colored pencil
on paper, 29.7 × 21 cm
Courtesy of the artist
© Richard Peduzzi

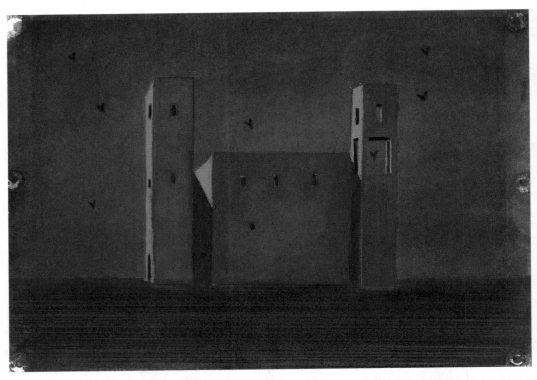

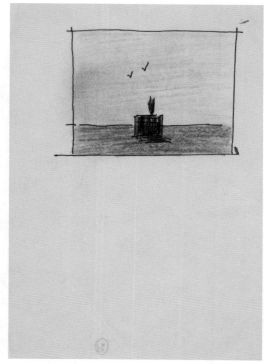

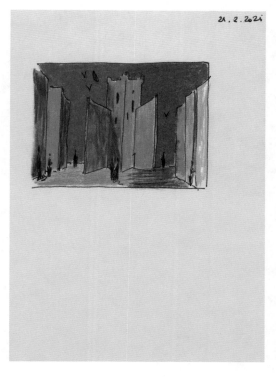

Richard Peduzzi, Untitled,
2021 (new version)
Gouache and oil on paper,
21 × 30 cm
Design for *From the House
of the Dead*, Leoš Janáček,
Wiener Festwochen, 2007.
Director: Patrice Chéreau
Courtesy of the artist
© Richard Peduzzi
(Photo © Frédéric Claudel)

Richard Peduzzi, *Bateaux,
voyages*, 2021
Oil and gouache on paper,
21 × 28 cm
Courtesy of the artist
© Richard Peduzzi
(Photo © Frédéric Claudel)

Richard Peduzzi, Search
for ideas, preparatory sketch
in disorder, *Don Carlos*
of Verdi, February 2021
Ink and colored pencil
on paper, 12 × 9.6 cm
Courtesy of the artist
© Richard Peduzzi

Richard Peduzzi, Search
for ideas, preparatory sketch
in disorder, *Don Carlos*
of Verdi, February 2021
Ink and colored pencil
on paper, 14.5 × 10.5 cm
Courtesy of the artist
© Richard Peduzzi

Richard Peduzzi, Search
for ideas, preparatory sketch
in disorder, *Don Carlos*
of Verdi, February 2021
Ink and colored pencil
on paper, 12 × 9.6 cm
Courtesy of the artist
© Richard Peduzzi

Index of Names